THE POLITICS OF THE MARVEL CINEMATIC UNIVERSE

Politics and Popular Culture
Linda Beail and Lilly J. Goren
Series Editors

THE POLITICS

OF THE MARVEL CINEMATIC UNIVERSE

Edited by
Nicholas Carnes & Lilly J. Goren

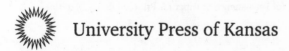 University Press of Kansas

Published by the University Press of Kansas (Lawrence, Kansas 66045), which was organized by the Kansas Board of Regents and is operated and funded by Emporia State University, Fort Hays State University, Kansas State University, Pittsburg State University, the University of Kansas, and Wichita State University.

Library of Congress Cataloging-in-Publication Data

Names: Carnes, Nicholas, 1984– editor. | Goren, Lilly J., editor.
Title: The politics of the Marvel cinematic universe / edited by Nicholas Carnes and
 Lilly J. Goren.
Description: Lawrence : University Press of Kansas, 2023. | Series:
 Politics and popular culture | Includes bibliographical references and index.
Identifiers: LCCN 2022010692
 ISBN 9780700633883 (paperback ; acid-free paper)
 ISBN 9780700633890 (ebook)
Subjects: LCSH: Superhero films—United States—History and criticism. | Motion pictures
 —Political aspects—United States. | Marvel Studios. | Marvel Comics Group.
Classification: LCC PN1995.9.S76 P65 2023 | DDC
 791.43/652—dc23/eng/20220329
LC record available at https://lccn.loc.gov/2022010692

British Library Cataloguing-in-Publication Data is available.

Printed in the United States of America

10 9 8 7 6 5 4 3 2

The paper used in this publication is acid free and meets the minimum requirements of the American National Standard for Permanence of Paper for Printed Library Materials Z39.48–1992.

For Alex, who melted this old fool's heart.—NC

For my superheroes, Eli and Sophia, and Ralph and Sally.—LG

Contents

Part Three An Expanding Universe

Part Four Conclusion

Afterwords

Foreword

This book does not start with me punching Hitler in the face, nor does it end with a long-awaited dance with Peggy Carter. My name is Steve Rogers, but I hail from St. Louis instead of Brooklyn, and regrettably, there is no serum to increase my height beyond five foot seven. I am not the world-saving Steve Rogers you have seen in Marvel Comics or the Marvel Cinematic Universe (MCU). Instead, this Steve Rogers is a political scientist at Saint Louis University who happens to share a name with a comic book legend.

I was supposed to be named James, but my mother called me Steven after holding me for the first time.[1] Growing up, my Rogers name led to references about beautiful days in neighborhoods. But since the widely successful Marvel movies, I have been subjected to a different set of pop-culture references. Restaurants often do not believe that carry-out orders are for "Steve Rogers" until they run my credit card, and a UPS driver once rang my doorbell and proudly said, "Delivery for Captain America!" One of my coauthors almost exclusively calls me "Cap," and when other political scientists search for me online, they find a screen full of vibranium shields instead of graphs about state legislative elections.

While I am not the Steve Rogers with whom you are likely most familiar, the fictional Steve Rogers and I both deliver messages about politics in our work. As a political scientist, I research (the lack of) political accountability in state legislative elections (Rogers 2015; 2016; 2017). For instance, each state legislature, on average, passes over twice as many bills as Congress (Justice 2015). However, most people do not know who their state legislator is, let alone what he or she does day to day, raising questions about how voters make their decisions in state legislative elections and broader questions about accountability in our federal system in the United States.

To a *slightly* larger audience, the *fictional* Steve Rogers highlights critical issues of obedience, accountability, and the collective good, making comic book readers and movie watchers think critically about how our society is structured. Rogers is a hero created by the military who is willing to defy orders in order to protect the greater good. He is both emblematic of and skeptical of

1. Despite their initial preference for "James," my parents' names are Peter Rogers and Susan Flowers and not Steven Rogers and Natalia Romanova (see *Next Avengers: Heroes of Tomorrow*).

political institutions; he embodies America's highest ideals and criticizes how our country falls short in practice. As he says in *The Avengers*, "When I went under, the world was at war. I wake up, they say we won. They didn't say what we lost." Rogers's skepticism of political institutions continues in *Captain America: Civil War*, in which he battles some of his closest friends in order to resist oversight of the Avengers through the Sokovia Accords. (For more on these topics, see the chapters by Galdieri and Saideman in this volume.)

The fictional Steve Rogers is just one of the hundreds of characters in a multiverse that explicitly and subtly makes audiences ask questions about the political world around them. Fortunately, as Nick Fury brought together the Avengers to save the world, Nick Carnes and Lilly Goren brought together more than twenty-five political scientists to take stock of the many lessons that the MCU teaches audiences about politics and society. And you don't need a political science degree to read it! This book is written for political scientists who want to learn more about the popular culture phenomenon that is the MCU (more on that in chapter 1), but it's also written for fans of the MCU who want to take a deeper dive into the many political and social dimensions of this expansive story.

I am confident that you will enjoy this book and learn a few things about politics and the MCU, whether you are a fan of research such as mine or the work of the *other* Steve Rogers.

Political scientists! Assemble.

Steve Rogers
Saint Louis University

Acknowledgments

Our greatest debts in writing this book are to the authors of these excellent chapters. It was their ideas and energy that propelled this project from the beginning.

This book started out as a Twitter conversation among a few political scientists in the summer of 2019. That conversation grew into an in-person gathering at the 2019 Annual Meeting of the American Political Science Association in Washington, DC, in August, and that gathering spawned a miniconference in April 2020 at the Annual Meeting of the Midwest Political Science Association in Chicago. As the word spread about the project, more scholars joined in, sharing new ideas and enriching one another's work.

At some point, the effort took on a life of its own and became unstoppable. When the Midwest conference in Chicago was canceled due to the pandemic, the team rallied and held every panel on its original scheduled day and time via Zoom, a technology that was relatively new to most of us back then. Our authors crafted fascinating and engaging chapters about the Marvel Cinematic Universe, even as they learned how to teach online, managed the care of loved ones, helped their own children through "Zoom school," recovered from illness or trauma, moved across the country, and just tried to manage life that had been turned upside down over the course of the previous two years. In the midst of it all, they still regularly replied to our emails and edits and engaged seriously with our suggestions and criticisms, often responding with comments about how this project was fun, enjoyable, and a great distraction during the pandemic and how pleased they were to be contributing to this book. We can't thank them enough, and we have enjoyed working with each of them. The authors of these chapters are superheroes in our eyes, and we are grateful to be able to share their voices with you in this fantastic volume.

We are also grateful to them for bringing the two of us together as editors. Before that first Twitter conversation, we (Lilly Goren and Nick Carnes) had never met. Two years and a hundred Zoom calls later, we're watching each other's backs like Hawkeye and Black Widow. We are both political scientists, but we came to this project from very different albeit complimentary perspectives: Nick brought a lifelong passion for Marvel, and Lilly brought expertise on the politics of popular culture. Nick's organizational skills and facility with Dropbox management have been immeasurably helpful assets for this project, to

say nothing of his thoughtfulness, good cheer, and wisdom. Lilly's intellectual breadth and superhuman ability to connect ideas and draw out insights have made the book vastly richer. This unexpected collaboration turned into a very pleasant project to manage during a pandemic.

We were thrilled to be able to work on this book with the team at the University Press of Kansas (UPK), led by David Congdon. We are grateful to our excellent anonymous reviewers, who offered useful and important critiques and helped make the book stronger and knit together the various analyses in the diversity of chapters. We are honored that this volume is the inaugural book in the new UPK series on Politics and Popular Culture.

We also wish to thank Donald Pepka and Ethan Gay, who provided invaluable research assistance while we've prepared this manuscript for publication.

Above all, we want to thank our families. They made it possible for us to attend the conference and virtual conference that kick-started this effort, they supported us during the editing and revising processes, and they joined us in watching and rewatching countless Marvel films and television shows. We hope they had some fun along the way. To Keri, Joe, Alex, Charlie, and Preston, and to Ed, Eli, and Sophia: Thank you for your love and support.

THE POLITICS OF THE MARVEL CINEMATIC UNIVERSE

CHAPTER 1 AN INTRODUCTION TO THE POLITICS OF THE MARVEL CINEMATIC UNIVERSE

Nicholas Carnes and Lilly J. Goren

The Marvel Cinematic Universe (MCU) is a cultural leviathan. In 2009, Disney purchased Marvel Entertainment for $4 billion, including its subsidiary film production company, Marvel Studios. Since then, *the MCU*—the collection of multimedia Marvel Studios products that share a single fictional storyline—has grown from two feature films to (at the time of this writing) twenty-seven interconnected movies, a half-dozen short films, five streaming Disney+ series, and more than thirty print titles. This MCU content has also inspired several shows produced by Marvel Television (before it was folded into Marvel Studios in 2019) that draw key plot points from the MCU films, including six Netflix series (*Jessica Jones, Luke Cage, Daredevil, Iron Fist, The Punisher,* and *The Defenders*) and two broadcast shows on ABC (*Agent Carter* and *Agents of S.H.I.E.L.D.*). Going forward, more than a dozen Marvel Studios films and television series are planned or in production, vividly demonstrating the MCU's success at weaving together stories about scores of heroes and villains, creating punctuated narratives that complete some arcs while opening paths for new characters and events.

The financial success of this artistic franchise is unparalleled in modern media history. At the time of this writing, eight of the twenty-five highest-grossing films of all time are MCU movies, as many as the DC Comics, *Star Wars, Harry Potter,* and *Jurassic Park* franchises combined (Ward 2021). In 2019, MCU films grossed over $5 billion at the box office, a figure that exceeded the respective gross domestic products of forty-nine *countries* that year.[1] The budgets for MCU films usually run in the $100 to $200 million range, but they still generate enormous returns.[2] *Avengers: Endgame* made back its exorbitant $350 million price tag on opening weekend in the United States alone (Box Office Mojo 2019) and passed the billion-dollar mark in just five days, a world record (Tartaglione 2019). Even MCU products that aren't beloved by critics or die-hard fans still generate sizable returns, drawing on the impressive loyalty of the MCU audience and the success of each MCU film at engaging new segments of consumers. In an industry where film studios, production companies, and executives are "driven by market demands that emphasize reliance on

proven formulas" (Franklin 2016, 10), the MCU has become one of the safest bets in Hollywood.[3]

Along the way, the MCU has become a touchstone of contemporary American life. Most Americans have seen at least one MCU film, especially younger Americans, including 73 percent of adults aged thirty-five to fifty-four and 82 percent of adults between eighteen and thirty-four (Statista 2021).[4] The Marvel characters who have appeared in the MCU are virtually ubiquitous in public spaces, where images of mainstay heroes and villains are emblazoned on everything from clothing and apparel to food products at the grocery story to tattoos. Not only do people buy tickets to the films, but they engage with the narratives and the heroes and villains that the MCU has created in myriad aspects of daily life. The most-read Wikipedia article of 2019 was the entry on *Avengers: Endgame* (Buchholz 2020).

What lessons is this hulking, hegemonic media franchise teaching the public? What might we learn about ourselves and our understanding of the world from this cinematic juggernaut?

As scholars of politics, we are most interested in the MCU's *political* lessons.[5] Intentionally or not, the MCU sends fans scores of messages about a wide range of subjects related to government, public policy, and society. Some are overt, like the contentious debate about government and accountability at the heart of *Captain America: Civil War*. More often, however, the politics of the MCU are subtle, like the changing role of women from supporting characters (like Black Widow in *Iron Man 2*) to leading heroes (like Black Widow in *Black Widow*).

The MCU, moreover, is itself a product of contemporary politics and society. Many of its stories seem to be direct responses to the pressures and problems of the day. Racial injustice, environmental catastrophe, and political misinformation aren't just contemporary social ills, they're also key thematic elements of recent MCU blockbusters like *Black Panther*, *Avengers: Endgame*, and *Spider-Man: Far from Home*.

Because the MCU caters to immensely broad domestic and global audiences, MCU content can also be powerfully *constrained* by real-world politics. Stories and plots often conspicuously tiptoe around political issues that might divide audiences or somehow drive down ticket sales. Sometimes filmmakers finesse stories to avoid offending global audiences; as Franklin (2016, 3) notes, "70 percent of the revenue of American film is derived from foreign sources," and so "the content of American film is constantly under scrutiny for cultural disconnects." In Marvel *comics*, for instance, the mystical sanctuary of Kamar-Taj is based in Tibet, but in the Marvel *Cinematic* Universe, Kamar-Taj is located in Nepal, a move seemingly designed to ensure that films like *Dr. Strange* would not be banned in China, one of the most lucrative markets for American cinema (Shaw-Williams 2016).

The effects of political and social currents on the MCU can be subtle. In Marvel comics, there have been openly LGBTQ heroes since the character Northstar came out in 1992, and today there are dozens of LGBTQ Marvel characters, some headlining their own monthly comic series (like *America Chavez: Made in the USA*). In contrast, the MCU has been slow to incorporate LGBTQ protagonists; the first explicit reference to a protagonist with an LGBTQ identity occurred when the antihero Loki disclosed that he was bisexual in the Disney+ show *Loki* in 2021, a full thirteen years into the MCU's history (and even then, only in the more financially cautious environment of a Disney+ streaming show, where revenues do not hinge on the reception of any one show or film). As one regular MCU critic noted in the *Washington Post*, "In pursuit of profit, [the MCU] has largely surrendered the ability to explore grown-up questions about sex and romance and prioritized a certain political neutrality" (Rosenberg 2021a, 1). As Marvel Studios works to ensure that its films appeal to vast domestic and international audiences, the MCU can be a driver of contemporary political and social currents, but the MCU can also be *driven by* those same forces.[6]

This book represents a modest effort to understand this interplay between contemporary politics and society on the one hand and the MCU on the other (specifically, the canonical MCU movies and Disney+ shows and the MCU-adjacent Netflix and ABC shows). In the chapters that follow, scholars of politics analyze how the MCU presents a wide range of political and social issues. This subject is vast, of course; the MCU is a story of truly staggering proportions. The goal of this book is to draw on the perspectives of a diverse group of academic researchers in order to shed light on the complex interactions between contemporary politics, the business of filmmaking, and the popular culture phenomenon that is the MCU.

The Study of Popular Culture

Many people think of politics and popular culture as essentially separate domains of life. Politics means things like voting, elections, campaigns, political parties, interest groups, and the day-to-day work of politicians and governments. Compared to this conception of politics, popular culture—the entertainment, music, cinema, advertising, fashions, ideas, and habits that animate everyday life in a society—might seem distant and far removed. What do the two have to do with one another, exactly?

One answer is simply that politics can powerfully influence popular culture "texts" like cinema and fiction; art reflects life, after all. There are scores of overt representations of politics in entertainment media, from television series

like *Scandal* or *House of Cards* or *Veep* to classic films like *Mr. Smith Goes to Washington* or *Dr. Strangelove* or *The Manchurian Candidate* to contemporary movies like *Lincoln* or *On the Basis of Sex* or *Thirteen Days*. And this has always been true: Shakespeare's plays were the height of popular culture during the Elizabethan age, and they often centered on political figures (*Julius Caesar* or *Henry V*) and engaged with politics even in the context of comedies (*All's Well That Ends Well*) and romantic narratives (*As You Like It*). The impact of politics on popular culture can often be subtle. The Cold War between the United States and the Soviet Union undoubtedly influenced many elements of the *Star Wars* films in the late 1970s and early 1980s, from costume choices to anonymous Storm Troopers representing "the Empire." Likewise, 9/11 and the Global War on Terror undoubtedly influenced many elements of the MCU, where the heroes usually battle not hostile nations, but terrorist organizations, rogue agents, corrupt infiltrators inside government agencies, and unexpected and spectacular attacks. Like popular culture texts before it, the MCU is influenced by the politics of its day; the franchise opens in *Iron Man* (2008) with Tony Stark selling missiles to the US government in war-torn Afghanistan only to be wounded by an IED and kidnapped by terrorists (see also Jenkins and Secker 2022).

Just as contemporary politics can influence popular culture and entertainment media, popular culture and entertainment can, in turn, influence how people think about the political world; life can imitate art. Decades of research have found that entertainment media can color our views about the serious business of politics and government. If you've ever objected to how a movie depicts an issue or social group—or tried to steer friends and family members away from a TV show that doesn't align with your political values—academic research suggests that you're on solid footing. As Mutz and Nir (2011) note (about fictional content, but the argument seems to apply to all popular culture texts), popular culture artifacts (like the MCU) are often inspired by real-world events, consumed by people with less fully formed political opinions, and effective at generating powerful emotional responses that truly impact audiences. Popular culture products are often scoured by audiences for real-world lessons (What morals can we take away from *A Christmas Carol*?), and people often spontaneously draw on popular culture when they talk about real-world political and social issues (President Obama mentioned *Mad Men* in a remark about gender pay gaps during one of his State of the Union addresses, and many candidates for office have invoked Jack Bauer, the fictional character from the show *24*). Perhaps most importantly, people simply consume far more entertainment and popular culture media than political news, documentaries, and other "hard" political content, making popular culture a more likely source of many people's views about the political world (e.g., Kim forthcoming).[7]

In other words, the relationship between politics and popular culture is not a one-way street. On the contrary, the reason that political debates sometimes erupt around the contents of entertainment media (like the controversies around the depiction of single motherhood in *Murphy Brown*, openly gay characters in *Ellen* and *Will and Grace*, torture in *24*, and on and on) is that entertainment media is itself a site where politically relevant messages are sent and received—pop culture is itself an arena of contemporary politics. As Beail and Goren (2015, 19) note, "The 'examples' of fictional multifaceted situations provide an overt connection between fictional presentations and cultural artifacts and the 'real world' of politics. So much of electoral politics is also about controlling 'the narrative' and sending messages to voters in one form or another. These two aspects of politics integrate electoral politics and popular culture without much acknowledgement." Perhaps the best evidence that popular culture both represents and influences how we think about politics is the simple fact that people with political agendas so often fight over what *ought to be* depicted in popular media.

And that is, in a nutshell, one of the premises of academic research on popular culture. If we want to understand any society, including our own,[8] we need to consider and understand the content of its popular culture, which is a product, a driver, and *a crucial part* of any society's politics.[9] Scholars of popular culture investigate important "texts" (which in this context mean not just written words but also films, TV shows, music, performances, and other media) and interpret the images and ideas presented in them. They treat popular culture as a form of *political theory*, a collection of descriptions of political works and ethical principles for judging society, government, and power. They analyze popular media, exploring meanings on and beneath the surface and asking what important texts teach us and whether their messages are socially valuable. Scholars treat popular culture as another lens through which to understand politics, and not just the overt kinds of politics we often think about, like voters and campaigns, but also broader considerations of power, influence, representation, gender, race, sexuality, and the many less tangible political aspects of our lives.

Speculative Fiction, Political Imagination, and the MCU

One of the most powerful effects of popular culture, and fiction in particular, is that it can encourage audiences to contemplate ideas that depart sharply from the status quo, to engage in what scholars call *social or political imagination*. Scholars refer to fiction that does so as *speculative fiction*.[10]

Probably the best-known form of speculative fiction is *science fiction*. Sci-fi

texts provide a rich space for political imagination, and scholars of political science and political theory have, in turn, engaged seriously with concepts developed in these imaginary spaces. (Think of the impact of Ayn Rand's sci-fi novels on contemporary political thought.) Science fiction allows creators and audiences to contemplate universes built differently than our own. How might power be wielded if it were held in different hands? How might citizens respond to threats from extraterrestrial beings who are "others"? How might a world without religion operate? Part of the appeal of science fiction—and perhaps its signature contribution to culture and society—is that it creates opportunities for people to think far more expansively about politics and society than the real world might otherwise encourage them to. Science fiction creates imagined spaces in which we can consider stories that may be much different than what we see around us in the real world.

Horror is another subcategory of speculative fiction that often allows for the kind of political imagination that can ultimately contribute to political science and political theory. Horror focuses on common fears and anxieties but takes them to disturbing extremes; what we often see in horror narratives is some fear come to life, given form and made into a sort of avatar. This in turn illuminates some of the real-world concerns that politics, political structures, and society are designed to mitigate or eliminate; as political theorist John Nelson (2015, 25) notes, "the gist of horrors is facing the evils in everyday life." If politics, government, and society are ultimately about providing stable structures and normalizing the use of power, horror allows for the considerations of many aspects of human life that are to be contained by these structures (but that are often never really eliminated because they are a part of human nature).

Horror has long been a space for the same kind of social and political imagination facilitated by science fiction. The genre tries to push the parts of our thinking and our psyche that we often want to obscure: consider Shakespeare's *Macbeth*, Bram Stoker's *Dracula*, Mary Shelley's *Frankenstein*, Edgar Allan Poe's *Murder in the Rue Morgue*, Shirley Jackson's *The Lottery*, Margaret Atwood's *The Handmaid's Tale*, or Jordan Peele's *Get Out*. Horror, like science fiction, often involves narratives that are familiar enough that we can clearly make out the structures of our own real-world societies, but shaded and different enough to facilitate experiments in imagination. This is often the shocking part of the horror genre: when the evil or the threat becomes realized and we see how the community reacts to the presence of "the monster." It is no accident that so many horror narratives leave audiences wondering "who the real monster is"—one of the intellectual functions of the genre is to invite us to imagine how our society would respond to extreme versions of our deepest fears and in the process learn some deep truths about the real world that we live in.

If horror facilitates political imagination through fear, *fantasy* fiction

facilitates it through wonder and a sheer lack of narrative constraint. Whereas horror and science fiction narratives are usually somehow bound to the real world (or facsimiles of the real world), fantasy narratives invite audiences to suspend disbelief even further, allowing for things like magic—truly nonscientific phenomena—to exist in the fictional narrative. Even so, fantasy provides space to think about how our real world might be different. Just as science fiction invites us to imagine scenarios and social structures that differ from our own, and horror shines a light on our deepest anxieties, fantasy provides myriad opportunities for political and social imagination.

Superhero fiction can belong to any of these categories, depending on how it is executed. For its part, the MCU presents audiences with each of these forms of speculative fiction.[11] The MCU is vast—it has grown to include scores of characters, events, worlds, and films—and it is far from monolithic in production or style. On the contrary, the twenty-seven films have been directed by twenty different teams and run the gamut from superhero origin stories to spy thrillers to comedy heist movies. The MCU weaves a range of speculative fiction genres into a single coherent story, often by varying stylistic points at the level of the individual film or show. The *Iron Man* and *Captain America* films invite us to engage in the science fiction exercise of imagining how the world might be different if a billionaire invented a flying suit that gave him the combat capacity of a small army or if a good man were injected with a serum that gave him superhuman strength and agility at the start of World War II. *Jessica Jones* probes our deepest fears about loss of agency and physical exploitation. The *Thor* films allow audiences to imagine how power, loss, and redemption might play out among a family of gods. Of course, most MCU and adjacent films and shows engage with multiple forms of speculative fiction: the Red Skull in *Captain America* invites us to contemplate the horrific prospect of physical disfigurement and the fantastical concept of Norse magic, *Jessica Jones* engages with superheroes enhanced by both science and magic, and the magic of Asgard in the *Thor* films is somehow rooted in advanced science.

Moreover, the MCU weaves together multiple kinds of speculative fiction in a way that *cultivates active engagement through immensely long-form storytelling*. Its narratives are threaded together across dozens of films and shows, connecting characters and ideas temporally, commercially, and artistically. This in turn nurtures audience interaction on a scale rarely seen in science fiction, fantasy, or horror, which makes the texts less static and more dynamic. Fans parse films, shows, and even previews for connections, meanings, and hints about future plot developments. They develop fan theories as elaborate as the films themselves. This kind of engagement sets the MCU apart even from other superhero fiction and other Marvel films produced outside Marvel Studios (like the Fox *X-Men* movies). Above and beyond the normal effects of speculative

fiction, the expansive nature of the MCU encourages audiences and fans to engage with the narratives, the character arcs, and the imaginary spaces created by these interwoven stories in a way that is unique in media history.

If speculative fiction is a potential site of political and social imagination, the MCU should be a top priority for scholars of political science and political theory. It is a world-leading popular culture product that engages audiences in unprecedented ways and that is situated in the exact fictional genres that often invite audiences to think expansively and critically about politics and society.

So what exactly is the MCU saying about politics?

What's in This Book?

Understanding how politics is discussed in the MCU is more challenging than it might seem at first glance. The sheer volume of political content is staggering, especially when we understand "politics" to encompass not just voting, elections, and government but also—more broadly—social situations in which power and resources are contested. In this view, politics involves many aspects of human interactions, including questions of power and position; gender, race, sexual identity, and ableism; colonialism, imperialism, law and order; and much more. When we think about politics in these terms, it is clear that the task of studying every aspect of the politics of the MCU is well beyond the capabilities of any one scholar. The MCU and adjacent content are too immense, and the range of social and political topics they engage with are too numerous for any one researcher, discipline, or perspective to do justice to them all.

As such, this volume assembles a diverse team of academic researchers who represent a wide range of methodological and topical concentrations within and beyond the fields of political science, philosophy, media studies, and social criticism. Some of us are first and foremost scholars of cinema or popular culture; others are scholars of democracy, political theory, civil-military relations, and other topics who have recently turned our attention to the colossus that is the MCU. Some of us are scholars who regularly study media like Marvel (Goren), and others are Marvel fans who happen to be political scientists (Carnes). But all of us are aware of—and ourselves impacted by—the ubiquitous fictional narratives that make up the inescapable MCU.[12]

This volume focuses primarily on the twenty-three Marvel Studios films released during Phases One through Three of the MCU (2008 through 2019; for a complete list, see the Appendix) and the eight MCU-adjacent Marvel Television series released on Netflix and ABC during the same period. We do not take a position on the question of whether the Marvel Television shows take

place in the same fictional universe as the Marvel Studios films and shows; when we talk about the Marvel Television shows, we simply use phrases like "Marvel cinema" or "MCU-adjacent" in recognition of the fact that these shows may not take place in the same fictional reality as the undoubtedly canonical Marvel Studios films and Disney+ shows.[13] None of our chapters focus more than briefly on the many *other* films or shows that feature Marvel characters but that were not originally set in the main MCU fictional narrative, like the Fox *Fantastic Four* and *X-Men* films, although those are undoubtedly worthy popular culture artifacts. Our chapters also only occasionally reference what is known as *the Marvel Universe*, the interconnected fictional stories depicted in Marvel's print media (comics), a subject that has been extensively analyzed in other books (see, for instance, Brown 2021; Howe 2012; or Wolk 2021). Because this volume was written during the transitional period between the MCU Phases Three and Four, some of the chapters that follow reference Phase Four MCU content, like the MCU films and Marvel Studios Disney+ shows released in 2020 and 2021, but our primary focus is on the MCU's first major contribution to American popular culture, the period known as "the Infinity Saga." Although many popular commentaries and a few academic studies[14] have analyzed how individual political issues are depicted in MCU films (see, for instance, Manicastri 2020), we believe this is one of the first books to take stock of a broad range of political lessons that the MCU conveys to audiences.

This book is organized around four topics that we think make good starting points for understanding how the MCU engages with politics and society. The chapters that make up Part One of this book focus on how social and political issues are depicted in the origin stories that are a staple of the MCU (and the superhero genre more generally). Origin stories are foundings; they shape our understanding of the character, and they also provide important context by describing the community in which the hero exists. Part One of this book is not a systemic analysis of *every* origin story in the MCU, unfortunately (that would require another entire book in itself), but rather highlights several ways of thinking about the origins of superheroes and superheroics. The chapters in Part One also think about the place and role of the MCU in our contemporary political and cultural environment. In understanding the narratives that explain how superheroes get their powers, we also understand how those heroes are situated within their own societies and why we are so drawn to superheroes as a means of solving difficult or intractable problems.

Part Two explores the MCU's depictions of "traditional" comic book subjects like power, government, and the military, the topics that often animated the Golden Age of print comics. While this book examines many different dimensions of politics, Part Two pays the closest attention to the *overtly* political content presented in the MCU. We see discussions of civil-military relations, the

positive and negative presentations of real governmental entities, imperialism and colonialism, how superheroics have become embedded in our expectations for policy solutions, and the representation of social anxieties as seen through the villains of the MCU.

Part Three considers the questions of diversity and representation that have come to loom large in contemporary discussions about comics and comic cinema and popular culture more generally.[15] This section of the book opens with a collection of chapters about gender in the MCU on both the big and small screen, as seen in characters like Black Widow, Captain Marvel, Jessica Jones, and Peggy Carter. Part Three then considers how numerous other aspects of society are represented in the MCU: masculinity, sexuality, "nontraditional" families, and even how the continent of Africa is "seen" in these films.

Of course, the topics covered in each major section of this volume naturally overlap and intersect in important ways, and we try to call attention to those connections with asides in each chapter that refer readers to other chapters, often in different sections of the volume (*inspired in part by Marvel's practice of adding footnotes in print comics —NC). Like the MCU films we study, the chapters in this book are interrelated narratives presented in an order that we think makes sense, but they do not tell a linear story, and they link to one another in myriad ways resembling a web more than a single sacred timeline.

Like the films and television series we study, moreover, these chapters are not monolithic in their style. They explore topics ranging from power, nationalism, and heroism to gender, family, and relationships. They explore these issues from a host of perspectives and through different aspects of the MCU. The methodological approaches vary from quantitative assessments to more theoretical analyses. Some chapters focus on just one or two shows or films, while others take a more sweeping approach, drawing lessons from dozens of MCU films. Some reach conclusions that we might think of as negative or critical, others reach conclusions that are laudatory.

Naturally, this volume's breadth sacrifices some depth. Any one of the chapters in this book could probably be a book in itself. This volume is an anthology, but each of its chapters deserves its own solo run.

Most importantly, this book is meant to be accessible both to academic researchers who engage with popular culture and to people outside academia who are interested in the MCU. The chapters that follow are written in a style that doesn't assume any prior exposure to political science and/or MCU content (although obviously either or both might help a reader more fully appreciate this book). If you've never taken a course in media studies, or if you're only vaguely aware of the plots of most MCU films, you should still be able to learn from this book's many takes on this immensely important multimedia

franchise. That is, as with any MCU film, you should be able to start here, although prior exposure can only deepen what you take away.

We hope this volume will give people who care about politics and society a window into the important content of the MCU, and we hope it will give fans of the genre a window into the MCU's wide-ranging political subtexts and add a new layer to their understanding of this complex cinematic universe.

Three Critical Lenses

As a final word of introduction, we wish to call your attention at the outset to three important critiques that are often raised regarding the politics of superhero fiction. These perspectives are woven throughout the chapters in this volume. The first is that superhero stories *encourage a sort of political complacence* by depicting worlds in which the major problems can only be solved by impossibly exceptional individuals; they leave readers hoping that a "hero will save us" and in the process discourage people from thinking in terms of the sustained, collective, often unglamorous community and political action that is usually necessary to solve problems in the real world.

Second, and related, critics have noted that superhero stories often focus on *restoring the status quo* rather than addressing the world's existing problems and injustices and ultimately changing the world for the better. As one critic put it, the MCU "is the most dominant entertainment property in the world because audiences know exactly what they're going to get from it: a world in which order is always neatly restored after catastrophe" (Rosenberg 2021b, 1). In this view, superhero stories might not nurture—and might actually *limit*—political and social imagination by implicitly presenting the status quo as the ultimate good worth preserving and thereby discouraging people from imagining different and better futures.

Third, concerns about *representation* have dogged superhero stories from the genre's inception in the early to mid-twentieth century: who are the heroes and villains, what social groups are they drawn from, how are people from different social groups depicted, and what lessons do those choices convey? Of course, questions about representation are important for every genre of popular culture and entertainment media, but they loom especially large in superhero stories, since the protagonists are often presented as avatars of virtue, as literal *superheroes*, and the antagonists are, in turn, often presented bluntly as villains. In this context, the choices that creators and artists make about representation are especially weighty. If straight white men are usually the heroes, if women are usually damsels in distress, if people of color are usually presented

in stereotypical and degrading ways or depicted as villains, those choices can have real consequences for how audiences see not just the imaginary world of superhero fiction but also the real world that we all inhabit. Representation in superhero fiction matters because it can affect stereotypes, prejudices, discrimination, and the prospects for social change in the real world.

Do these three critiques apply to the MCU? There are no straightforward verdicts—these are complex points, after all—and the chapters that follow present different and sometimes contrasting perspectives on these broad and important critical lenses. For our part, we would simply note that the MCU is a varied and fluid collection of stories. That is, the extent to which these critiques apply may be evolving over time. Early MCU films more often seemed to foreground superheroics and focus on restoring the status quo from a novel outside threat; in contrast, Phase Three films more often grapple with the grand challenges facing the United States and the world, problems that seem to push audiences to think not just about saving the status quo from a villain but also to contemplate pressing real-world problems like racial injustice and political misinformation.

Likewise, *representation* in the MCU seems to be evolving quickly. During Phase One of the MCU—the first four years and six films—the most important heroes were all white men: Iron Man, the Incredible Hulk, Thor, and Captain America. The central character of the narrative, Tony Stark, was a coarse playboy who made sexist jokes, still early in his character's moral arc. Phase One's culminating big-event film, *The Avengers*, centered on an all-white team with just one female member, and her enhanced abilities included sexual seduction. However, by Phase Three of the MCU—2016 to 2019—much had changed. Of the eleven films in Phase Three, two had women in title roles (Captain Marvel and the Wasp) and one was headlined by a Black man (the Black Panther). New teams and films introduced female characters who were not sexualized and were in fact openly critical of efforts to treat them as weak or as objects of romantic conquest (Gamora and MJ). Tony Stark, although never really apologizing for his past behavior, dropped misogynist jokes from his repertoire of cocky behaviors and generally adopted a more somber demeanor and an increasing focus on saving the universe.[16] The latest MCU offerings have made missteps, of course—many fans and critics accused the final fight sequence in *Avengers: Endgame* of something like gender tokenism[17]—and the MCU is still a long way from true equality in representation. But just as Jeffrey A. Brown (2021, 16) observed in his recent analysis of contemporary Marvel *comics*, the MCU seems to have "begun to redress past mistakes and provide a more diverse and sensitive range of heroic characters."[18]

Just as the politics of the MCU are fluid and changing, so are the ways in which we, as audience members, observers, and fans, consume these cultural

artifacts. A decade ago, the MCU was a collection of movies that audiences watched together in theaters. Then it grew to include MCU-adjacent broadcast and streaming series. In 2021, it grew to include the first film simultaneously launched in theaters and on the streaming platform Disney+ (*Black Widow*). Going forward, streaming TV will remain integral as Marvel Studios rolls out a robust slate of new streaming MCU shows designed to buttress subscriptions to the Disney+ service by releasing new content at regular intervals. Obviously, the MCU did not start this trend; the ways that we view film and television have become increasingly fragmented and novel in general, and the global COVID-19 pandemic has only accelerated disruption and innovation in this area of media. It is too early to tell how these fast-moving developments will ultimately play out in the connected fictional universe that is the MCU, but with the politics *and the mode of delivery* constantly in flux, we suspect that there will always be room for future analyses of the politics of the MCU.

For the time being, we hope this book helps shed some light on this important topic and that it will be a window into academic research on questions about representation, politics, power, society, and the business of the MCU. And in doing so, we hope that this book will help illuminate the broader media empire that is Marvel Entertainment and the broader landscape of American popular culture. To our readers who are first and foremost interested in politics, society, and media criticism, we hope this book's careful and critical look at the MCU will be a window into an immensely important aspect of the media environment. And to our readers who are first and foremost Marvel fans, we invite you to once again face front: we hope you will find this book to be a warm introduction to some of the scholarship on media, popular culture, and political science and a fresh take on the ever-expanding MCU.

Notes

1. GDP statistics were taken from the United Nations online dashboard available at https://unstats.un.org/unsd/snaama/Basic (July 1, 2021).

2. Eight of the last ten MCU Phase Three films took in over $1 billion in ticket sales worldwide (and the two that did not, *Dr. Strange* and *Ant-Man and the Wasp*, took in over $900 million and $800 million, respectively).

3. It is harder to precisely estimate the financial returns of streaming shows, but each of the first three Disney+ MCU shows reached number one in global viewership ratings during its initial release period. It is also telling that Netflix moved forward with subsequent seasons of *Jessica Jones*, *Daredevil*, and *Luke Cage* not long after each show debuted, suggesting that they, too, were lucrative investments.

4. Even among viewers over age fifty-five, a slim majority—51 percent—have seen at least one MCU film.

5. This volume quotes, describes, and analyzes Marvel cinematic content. The copyright for this content belongs to its original creators. All quotations, excerpts, and summaries in this volume are used for education, review, criticism, and/or commentary under the doctrine of fair use.

6. Of course, American cinema was not always as beholden to international political pressures as it is today. For most of the twentieth century, American films and television operated in a more hegemonic manner: the major markets for US cinema tended to be Western and often primarily American, and films created in the United States could always be modified and adapted for international audiences. Today, however, Marvel Studios typically releases films simultaneously around the world, in part to reduce the market for illicit pirated copies of its films and in part to capitalize on fan engagement and the spectacular nature of the films themselves.

7. See also Delli Carpini and Williams (1994) and Kaid, Towers, and Myers (1981, 162). On the last point, see the literature on "cultivation theory," in particular Jamieson and Romer's (2014, 31) discussion of cultivation theory, first-wave research (e.g., Doob and Macdonald 1979), and modern work on cultivation theory that demonstrates persuasively that repeated exposure to certain kinds of media can shape people's perceptions of reality (e.g., Busselle 2001).

8. Americans are no exception. On the contrary, we are responsible for a disproportionate share of the popular culture that is consumed around the world, and certainly in our own country.

9. As Jeffrey P. Jones (2010, 24) notes, "Politics occurs for many people in what one author calls our 'media surround': the forms, types, places, and contexts in which media are inserted into our lives."

10. Of course, as Almada (2021, xiii, emphasis added) notes, in a very real sense, "*All* fiction is speculative."

11. Many recent pop culture products have similarly managed to straddle all three genres, often through expansive long-form storytelling, as in the animated series *Adventure Time*.

12. This book was born out of a lively Twitter conversation about the gender politics of the film *Captain Marvel*. That conversation prompted an informal meeting at the next major political science conference, which in turn grew into a collection of essays and a formal miniconference the following year—much of which transpired during the COVID-19 pandemic.

13. "The various TV shows were [previously] considered official canon, with *Agents of S.H.I.E.L.D.* and *Agent Carter* taking place in the same world as the movies," but after Kevin Feige was promoted to chief creative officer of Marvel Entertainment, he made public statements that suggested that "none of the previous episodic adventures were considered canon and the MCU's small screen expansion would begin in earnest with *WandaVision*." As one entertainment site notes, "To hammer the notion home even further, Disney Plus has now moved the aforementioned shows to the Marvel Legacy collection alongside Fox's Fantastic Four and X-Men pics, making it clear that whatever took place across the multiple seasons of each doesn't play an official role in continuity anymore" (Campbell 2021, 1).

However, the same site also reported that there have "been rumblings that previous TV characters [may] return in future Disney Plus productions" (Bone 2021, 1), and indeed, the subsequent arrival in December 2021 of Matt Murdock in *Spider-Man: Far from Home* and Wilson Fiske in *Hawkeye* suggest that Marvel Studios may be "recanonizing" the Netflix content. However, it is still unclear at the time of this writing whether these characters are truly the same as those depicted in the Netflix series *Daredevil* (or, for instance, variants from the MCU who resemble characters in an alternate Netflix continuity), so for now, we remain agnostic on this point.

14. For an analysis of another important subject, religion and myth in the MCU, see Nichols (2021).

15. Popular culture has long been examined as a space where feminism can be seen and also where the achievements of feminism may be constrained, as a space where contemporary feminism was able to grow and has, to a degree, been co-opted. See Zeisler (2016) and McRobbie (2009).

16. Phase Four seems to hold even more promise for diversity in representation; a straight white man did not headline any of the first four Disney+ MCU shows, and only three of the first ten Phase Four MCU films have white male title characters (Dr. Strange, Thor, and Spider-Man)—and those three are all sequels to films from previous phases.

17. See, in particular, Kristin Kanthak's interrogation and analysis of this particular scene in her chapter in this volume.

18. This in turn raises a larger question, namely, why exactly there was so little diversity in Phase One of the MCU. We can imagine a wide range of possibilities, but we will leave this question to future work.

PART I ORIGIN STORIES

BUILDING WORLDS

Three Paths toward Racial Justice in *Black Panther*

Allison Rank and Heather Pool

Part of the success of the Marvel Cinematic Universe (MCU) is its imaginative world-building. Audiences encounter individual heroes and heroines whose actions inspire them to stand up against domination and injustice. But behind the protagonists and providing the contexts in which their actions may be interpreted, scholars of politics also see a striking variety of social and political systems: a small band of scavengers led by a pirate captain (Yondu Udonta in *Guardians of the Galaxy*), tyrants who do not tolerate discussion or debate (Thanos in the *Avengers* series and Ronan in *Guardians of the Galaxy* and *Captain Marvel*), monarchs driven by their notions of the common good (Odin and then Thor in the *Thor* movies and the country of Wakanda, ruled by the Black Panther, in *Black Panther* [*BP*]), and even liberal democracies rife with the challenges of securing order in a political system where power is diffused and contested (Xandar in *Guardians of the Galaxy* and the United States as it appears throughout the MCU).

While many scholars and journalists write about the origin stories of superheroes themselves, we are interested in how an imaginative political world— the pan-African state of Wakanda as depicted in *BP*—might help us imagine how to confront the legacies of racism and colonialism that shape our existing world. In this chapter, we draw on a branch of political philosophy called social contract theory, which, like the world-building that exists in the MCU, provides an imaginative framework by which to assess the criteria of legitimate government and how such a government might respond to injustice. Social contract theories, in essence, offer origin stories of the liberal democracies that arose in the eighteenth century. We then turn to contemporary philosopher Charles Mills's claims that social contract theory's location in European philosophy meant that it promoted *equality* among whites while at the same time assuming and creating *inequality* between whites and nonwhites; Mills calls this the "racial contract."[1] Drawing on Mills's work, we argue that *BP* shows the potential of an African nation positioned as a witness of—but not a party to—the racial contract; Wakanda provides a unique, creative vantage point from which to view our contemporary world. From this perspective, the

dialogue between T'Challa, W'Kabi, Killmonger, and Nakia outlines three potential paths to address real-world racism and neocolonialism, each with its own corollary in Black political thought: Malcolm X's endorsement of separatism (W'Kabi), Frantz Fanon's justification of the necessity of decolonizing violence (Killmonger), and Frederick Douglass's hopes for the realization of liberal institutionalism (Nakia).

Origin Stories in Political Thought

While the world-building of contemporary superhero comics is flashier, more entertaining, and more remunerative than philosophical tomes written centuries ago, such dusty tomes have helped humankind imagine, and then create, new ways to organize its political worlds. Consider, for example, the world of feudal politics characterized by hierarchy and dependence that fell in a cascade from divine-right kings down to lowly serfs, where each person occupied a place in a fixed hierarchy, ruled by tradition, and owed allegiance to those above and protection to those below. The rise of philosophical liberalism in the seventeenth century (itself an heir of the earlier scientific revolution) served to argue against God as the only legitimator of rulers' authority, against a hierarchical valuation of individuals, and against arguments that superior force was the primary route to order. Philosophical liberalism justified constraints on executive power and imagined the people's consent as a fundamental source of legitimacy; these imaginative frameworks—collectively known as social contract theories—served as blueprints for the rise of liberal states (such as the United States) in the eighteenth century.

The world-building vein of philosophy embodied in the social contract tradition makes it a philosophical precursor to the world-building that occurs in *BP*; it squarely considers questions of power, human (or nonhuman) agency, individuality, collective survival, responsibility, resource distribution, and fairness. These and other big and politically relevant questions pervade political philosophy as well as Marvel's universe.

Like the MCU, political philosophy and political theory include several canonical works in the social contract tradition that build imaginative worlds. Driven by real conflicts, existing injustices, tyrannical domination, and religious wars, social contract theorists writing in the seventeenth (Thomas Hobbes and John Locke) and eighteenth (Jean-Jacques Rousseau) centuries imagined the origins of legitimate government through an exercise called a "thought experiment" (Hobbes [1651] 1994; Locke [1689] 1980; Rousseau [1755] 2012). Their thought experiments considered humans to be in a "state of nature," a prepolitical world where no government exists. Assuming individuals in this

state to be free, equal, and rational, social contract theorists argued that because no power existed in the state of nature that could adequately protect bodies or property or fairly mediate conflicts, the "state of nature" inevitably devolved into a "state of war," where "life, liberty, and estates" were insecure.[2] The purpose of these thought experiments was to provide a remedy to this problem: to imagine the creation of a government whose legitimacy arose from the consent of the governed and whose purpose was to secure as much of the freedom and equality that had existed in the state of nature as possible. Once established, such a government provided protection so that citizens could pursue "commodious living" free from the "inconveniencies" of the state of nature.[3] This imaginative device appears in the opening scenes of BP, where the audience learns an origin story of five tribes constantly warring over a rare mineral; they eventually consent to stop fighting, join forces, and establish the kingdom of Wakanda. Once established, the king protects his people from outside invasion, adjudicates conflicts, secures property, and ensures order, all of which a legitimate state in the social contract tradition ought to do.

History suggests that this philosophical narrative does a decent job of explaining the evolution of Western liberal democracies since the seventeenth century; its narrative weight stabilizes existing liberal democracies in moments of crisis and calm. It helps Americans and citizens of other Western liberal democracies transfer power peacefully after elections, establish constraints on executive power, create fair and transparent procedures for political processes, ensure equality before the law, and generally ground their understanding of legitimate government. When we say that philosophical narratives are worldbuilding, then, we mean that they helped create our existing political worlds.

But these same narratives—based on assertions of universal equality, freedom, and rationality—do a terrible job of explaining why liberal democracies colonized and dominated vast swaths of the globe in the seventeenth through the twentieth centuries. The historical record makes clear that vast portions of the world were not left to their own devices to establish their own versions of a social contract; instead, Europeans and Euro-Americans killed, colonized, or conquered vast populations in North America, South America, Africa, considerable parts of Asia, and Australia/Oceania. For many places, then, the organizing reality of political life for centuries was violence rather than consent. This actual history of global domination by states whose philosophical foundations assume equality and freedom suggests that we need a better way to imagine how to repair the injustices and legacies of racism and domination: that the abstract freedom, equality, and rationality assumed by the social contract theorists has been fundamentally skewed by race. Given this juxtaposition, it seems fair to argue that the thought experiments of classical social contract theory cannot make sense of or address the painful history of actually existing

structural racism and colonization perpetuated by nations whose commitment to equality, justice, and consent have racial limitations.

If social contract theory cannot account for the persistence of structural racism, what can? Political philosopher Charles Mills (1997) put forward one influential answer, namely, that the very idea of a social contract grew up alongside and drew on an implicit *racial* contract that held that white people owed one another civility and equality but that other races were uncivilized and inferior. This racial contract *appears* to be the true foundation of the social contract.[4] Europeans and their colonizing settler heirs relied on the social contract narratives of a prepolitical "state of nature" to imagine the inhabitants of other continents as primitives whose lack of rationality and ties to tradition meant they would benefit from rule by rational and free European races. The tacit racial contract assumed that while whites were capable of self-government and possessed the freedom and rationality necessary to consent, nonwhites—thought to be ruled by ancient traditions rather than secular reason, communal property rights rather than individual ones, and paganism rather than Christianity—were not and did not. As a result, whites were justified in ruling nonwhites while treating fellow whites as equals. While it seems contradictory that a tradition premised on equality and freedom among citizens of a given state would turn to colonization and the conquest of people outside it, Mills contends that the answer was there all along in social contract theory's depiction of some human societies as primitive and warlike.[5] Some human societies (specifically, those consisting largely of white people) were perceived as having the ability to advance beyond such behaviors, while others (those consisting of nonwhite people) were not.

Mills went on to argue that Western society's racial contract obscures the reality of a racialized world from whites themselves (especially after the shift from legally supported discrimination to formal legal equality), leading to what Mills calls an "epistemology of ignorance." Whites believe in the basic social contract (with its implicit depiction of nonwhites as less socially evolved), which in turn leads them to overlook how the world they created privileges them.[6] The result is that the assertions of the social contract, including universal equality, freedom, and rationality, have been reserved for whites. Since the law now formally forbids racial discrimination, if/when nonwhites fail to reach the bar whites set for themselves, whites (wrongly) assume that nonwhites failed because they are simply inferior.

Some examples drawn from Mills may clarify the significance of this claim. Mills (1997, 1) begins his book with the claim that "white supremacy is the unnamed political system that has made the modern world what it is today." Mills argues that white supremacy is neither biologically nor divinely ordained but instead is a *political* phenomenon. At the level of geopolitics, white countries

industrialized earlier, have vast economic resources, and hold greater power in international institutions such as the UN and World Bank. How did this come to be? Mills (1997, 34–35), following historians and economists, argues that white countries obtained their wealth early through colonial plunder and conquest. While the rise of European hegemony is described by many scholars as "autochthonous" (a Greek word combining "self" and "soil," meaning it arose organically), this assumption obscures the reality that "the profits from African slavery helped to make the industrial revolution possible" and that the "exploitation of the empire . . . was to a greater or lesser extent crucial in enabling and then consolidating the takeoff of what had previously been an economic backwater." The result is that "colonialism 'lies at the heart' of the rise of Europe" (Mills 1997, 35).[7] The world imagined by the social contract turned out to be a world where whites justified the exploitation and domination of nonwhites and then proclaimed themselves innocent of injustice and without responsibility. Given this context, Wakanda serves as a powerful, if imaginative, counterfactual device—a site of world-building that imagines a different history, thus giving us a vantage point from which to consider possible responses.

Black Panther as the Origin Story of Wakanda

The social contract theorists assume a political equality that obscures how race shaped contemporary geopolitical borders, the distribution of economic development and wealth, and the contours of daily life. Mills, in turn, insightfully outlines the ongoing work of a racial contract as a work of political imagination that powerfully structures our social and political institutions and ultimately our daily lives.

What might audiences gain from watching a fictional narrative centered around a nation that exists as a witness to the racial contract but not a party to it? Ryan Coogler's *BP* provides us with an opportunity to imagine a Black nation that entirely avoided the violence of colonial conquest and the economic domination of neocolonialism by remaining separate from the world and hiding its vast wealth and technological prowess. Because Wakanda was never colonized or colonizer, it gives us a normatively desirable way to imagine an "Africa" that must determine for itself how to engage with a world where white supremacist violence is pervasive and should—in the name of the universal justice and dignity that the social contract asserts but has failed to provide—be challenged.

Whereas most earthbound MCU films are set in real places (with the exception of the fictional country of Sokovia in *Avengers: Age of Ultron*), the kingdom of Wakanda is entirely fictional and worthy of a film of its own. As political

geographer Robert A. Saunders (2019, 144) argues, "Wakanda presents as a country-sized superhero, one with its own *secret identity* to protect. . . . Killmonger's goal then is to *un-mask* Wakanda (Faithful 2018), i.e., reveal to the world its true identity as an untapped superpower."[8] And yet Wakanda is a strange mash-up of "Africa." Saunders (2019, 144–145) writes,

> Mapping in the comics and the film suggest it lies in the interior of Africa somewhere northeast of Lake Victoria; however, culturally Wakanda draws inspiration from west African and southern Africa more than east or central African peoples (the displayed garb collectively representing a diversity of style that would require Wakanda to occupy more than half of the continent, stretching from Algeria to Lesotho and Ghana to Ethiopia). Aerial shots that appear in the film suggest its location in the meridional areas of the continent (filming locations include South Africa, Uganda and Zambia); yet architectural and religious references to the Sahel and Egypt abound. In other words, Wakanda is all over the place.

Wakanda—holding a true monopoly on an incredibly rare metal out of which uniquely powerful technologies and weapons can be forged—has cloaked its true self from the rest of the world, appearing instead as a typical "Third World country" that is ruled by dynastic elites, possesses primitive technology, and survives through subsistence agriculture. Because of its tremendous wealth, the film implies, Wakanda was never colonized (although how this happened without alerting the world to its resources is left unsaid). Commentators note that this vision of a powerful, wealthy, noncorrupt African country is important in a world where few of those terms apply to existing African countries (Haile 2018). In essence, Wakanda masked itself to match the social contract's racist assumptions about people of color, shrewdly turning whites' epistemology of ignorance to its own advantage.[9]

Furthermore, fictional Wakanda's wealth is actually "autochthonous" in ways that European countries' wealth never was; its resources—human as well as natural—were used by former Black Panthers to shield Wakanda from international white supremacy that shaped, or rather *deformed*, the rest of the world. Its internal politics seem more in line with the legitimate commonwealth imagined by Hobbes: an all-powerful sovereign ruler whose power derives from a moment of consent and whose sole job is to protect his people (Hobbes 1994, ch. 17). This self-contained wealth is derived not from exploitation but from its own soil, which positions Wakanda as a better example of legitimate government than European nations.

While the contours of the racial contract have led us to expect a white sovereign on a black continent, we see here an ancient, legitimate, and powerful

Black sovereign on a Black continent, ruling a prosperous people. Well aware of the racial contract's threat, Wakanda simply withdrew from the world, powerful enough to protect itself without appearing wealthy enough to draw colonization. Certainly, *BP* is about T'Challa taking up a particular ancient identity. But given the technological enhancements that support the Black Panther's powers as well as the need to constantly nurture one herb to ensure the continued lineage, the character also relies on the hidden Black wealth of a powerful but masked Black nation that has persisted through time. The film contextualizes Black Panther as not just a superhero but also the ruler of a powerful and technologically advanced nation that has avoided exploitation by trafficking in stereotypes supported by the racial contract, and in doing so, it helps us imagine Black leadership differently: not only T'Challa's leadership of Wakanda but Wakanda's potential leadership of the world.

The Wakandan Debate: Three Responses to Global Racism and Neocolonialism

Our contemporary moment demonstrates that America's—and the world's—race question remains unsettled: from the eruption of Black Lives Matter protests in response to George Floyd's murder in May 2020 to the US government's Muslim ban and efforts to limit legal immigration and refugee claims to debates over Confederate statues and flags. Yet only recently has this increased racial awareness translated into the mainstream success of various television and movie projects that center Black American experiences and are written, directed, or produced by Black people and star Black actors; in recent years, *Moonlight*, *Get Out*, *Scandal*, *black-ish*, and other shows and films about Black Americans have been well received by critics and audiences.[10] Capitalizing on the newly available political and cultural space, the question of how to address the historical harms of slavery and colonialism lurks in the fore- and background of *BP* as the film lays out three approaches that fictional Wakanda might take in response to the actually existing world beyond its borders: a world fundamentally shaped by the racial contract.

The characters of W'Kabi, Killmonger, and Nakia present to T'Challa a range of positions regarding the extent of Wakanda's political responsibility to others. First, as argued above, Wakanda's prosperity and ability to avoid colonization stem from its purposeful masking of its wealth and technology—in effect, its true identity. W'Kabi, military leader of the Border Tribe, appears to represent Wakanda's view prior to King T'Chaka's surprise reentry into the international community, which was announced at the United Nations in *Captain America: Civil War*. This view seems most in line with T'Challa's instincts as a new ruler

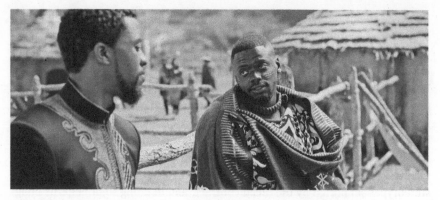

W'Kabi advocates an isolationist view of Wakanda: "You let the refugees in, they bring their problems with them. And then Wakanda is like everywhere else." From *Black Panther* (2018).

to preserve the status quo. W'Kabi argues that the threat posed to Wakandan resources and prosperity by allowing non-Wakandans to immigrate is too great; doing so would destroy what makes Wakanda Wakanda.[11] In W'Kabi's words, "You let the refugees in, they bring their problems with them. And then Wakanda is like everywhere else."

This has been Wakanda's position for centuries; its resources are finite, and in a world where Blackness has been used to justify white violence and the oppression of Black peoples, exposing Wakanda's true wealth would only invite white exploitation. Thus, Wakanda must isolate itself so that its wealth and way of life may be maintained for Wakandans alone. This view has an important analog in Black American political thought in Malcolm X's arguments for Black separation. Malcolm X, in his early days as a disciple of the Nation of Islam's Elijah Muhammad, argued that there was no good reason to seek integration into a system that had caused tremendous harm to Black people.[12] Seeking to separate from white tormentors, then, was superior to white supremacist segregation because it was a realization of Black independence *by choice*, whereas segregation means not being free to make that choice. For Malcolm X, only once Blacks were free from the corrosive effects of white domination could Black people truly be free. The "American Dream" was, for Black people, "an American nightmare" (Malcolm X 2004, 167–168). As W'Kabi points out, Wakanda has maintained its independence in precisely the way Malcolm X imagined; by virtue of its secret weapon, Wakanda has avoided being colonized and colonizing by never revealing its true self. But the price has been allowing injustice to happen to others when Wakanda might have prevented it. Wakanda's stability through isolation has come at the expense

of the aid it might have rendered to fellow Africans, both in Africa and in the diaspora.

Killmonger offers a second and more radical approach. After deposing T'Challa by defeating him in ritual combat, Killmonger orders the Wakandan army to distribute Wakandan weapons and technology to oppressed people of color all over the world, providing them with the tools needed to overthrow white domination. From Killmonger's perspective, Wakanda has no obligation to join an international community that is organized around white supremacy and has consistently served that master rather than the causes of human dignity or justice. Nor should Wakanda offer limited relief missions or accept refugees while leaving the systems that produce those refugees intact. Instead, Killmonger forcefully argues that the only way for Wakanda to appear on the world stage is to use its considerable wealth and technological prowess to take power from whites and redistribute it to oppressed people of color. Rather than Blacks and other people of color being on the bottom, they must take back what is rightfully theirs and establish themselves on top. Killmonger's argument is not that domination is bad and should itself be eliminated but rather that he would rather dominate than be dominated, and he is willing to do whatever is necessary to ensure that. He would like to replace white supremacy with Wakandan supremacy.

Several scholars and media critics have critiqued BP's treatment of Killmonger. The film's introduction of Killmonger shows him correcting a white museum curator (an "expert") of the "Museum of Great Britain" regarding the origin and composition of an axe. The curator identifies it as coming from Benin in the seventh century, but Killmonger corrects her, stating that it is made of vibranium from Wakanda; she is deeply skeptical (and soon dead from poison, as Killmonger and Klaue steal it). As Curtis (2019, 275) argues, when this ancient, dusty, incorrectly identified piece in a colonial museum ends up in Killmonger's hands, "the object also becomes a symbol of an alternative and vibrant future rather than an inanimate relic from the past. The ignorance of the white expert and this temporal shift in the function of the artefact become important early markers of the film's politics." This moment opens our imagination to the possibilities of Wakanda embarking on a different kind of international engagement.

Yet over the course of the film, Killmonger shifts from "the role of anti-hero to full blown, tyrannical super-villain. In the process, the radical black politics he represents is recast from legitimate and perhaps necessary to illegitimate and dangerous" (Curtis 2019, 276).[13] Rather than change the categories, Killmonger merely seeks to invert them.[14] While Killmonger's initial analysis of race and oppression aligns with Mills's insights in *The Racial Contract*, as the

Killmonger argues for a more radical approach, namely, for Wakanda to use its considerable wealth and technological prowess to take power from whites and redistribute it to oppressed people of color. From *Black Panther* (2018).

film progresses, he exhibits "a perhaps less-than-self-conscious but troubling identification with the colonial oppressors he claims he will unseat when he echoes a perennial slogan of various Western empires and says, 'the sun will never set on the Wakandan empire'" (D'Agostino 2019). When we first meet Killmonger, he provides a plausible and justified argument for Black revolution through transformation. Yet as soon as he obtains a position of leadership in Wakanda, his actions destroy Wakandan culture rather than preserving or governing it. His willingness to kill his girlfriend, assault and murder Wakandan elders, and burn the entire supply of the heart-shaped herb that provides the Black Panther's powers suggests that it is not justice he craves but power.

Just as Malcolm X's arguments for Black separation serve as a philosophical precursor to Wakanda's status quo, Killmonger's stance as well as his downfall reflects a nuanced reading of a category of Black political thought best exemplified by Frantz Fanon. Fanon argues in *The Wretched of the Earth* that because colonizers have ruled through force and ignored calls to free the colonized that are justified by reason or equality, violent responses by the colonized are justified. Echoing Killmonger's position, Fanon (2004, 51) writes,

> In its bare reality, decolonization reeks of red-hot cannonballs and bloody knives. For the last can be the first only after a murderous and decisive confrontation between the two protagonists. This determination to have the last move up to the front, to have them clamber up (too quickly, say some) the famous echelons of an organized society, can only succeed by resorting to every means, including, of course, violence.

In seeking to theorize how oppressed Algerians—particularly those in agrarian rural sites—reclaimed their personhood by destroying the colonizer, Fanon

(2004, 51) may seem to glorify violence, going so far as to argue that at the individual level, "violence is a cleansing force." But a closer reading of Fanon's (2004, 86) *The Wretched of the Earth* demonstrates that while the spontaneous violence of decolonization is inevitable (as well as serving as a primary force for the unification of the colonized into a political community), after the first thrill of violent resistance, the leaders "rediscover politics" because "neither the heroic fight to the finish nor the beauty of the battle cry is enough." Thus, while revolutionary violence may be and likely is a necessary first step toward liberation, it is an incomplete one. It may help the oppressed regain their personhood, but it is not sufficient to build a new country. That requires a change not only in condition but also in consciousness. It also requires a carefully nurtured solidarity that builds worlds rather than destroying them. Killmonger's history as an assassin and destabilizer in service to US imperial projects suggests that participating in imperial violence and conquest may stunt a person's ability to act morally as a result of having served a corrupt definition of justice:[15] Killmonger's service and experience have led him to embrace violence as a comprehensive solution rather than the incomplete beginning of revolution and to imagine destroying the colonizers as the only necessary step to destroying colonization. While Fanon's work justifies violence as a first step toward decolonization, Killmonger seems to glorify violence as decolonization.

The last view—Nakia's liberal internationalist view, which bookends the film—is that Wakanda should join the global community and help those who have been held back from self-development by imperialism and colonialism. We meet Nakia at the start of the film in the midst of an undercover effort to discover Boko Haram's central location so she can free the women and young men held there. T'Challa objects because such a display of power might unmask Wakanda's wealth and technology. Nakia challenges his understanding of the proper role for Wakandan resources, arguing that Wakanda has an obligation to help the exploited and downtrodden, first, because it can and second, because no one else is. While Wakandan War Dogs have been stationed in cities around the world, they have served merely as eyes and ears. Nakia imagines a different response: these spies might instead help rebuild the communities that white supremacy and its enforced racial segregation have left poor and exploited.

For most of the film, T'Challa remains unconvinced that Wakanda has any obligation to help those outside its borders; he understands an obligation to *his* people in Wakanda rather than to *people* in Africa or of African descent.[16] This does not change until the last scene of the movie, when the kingdom of Wakanda purchases the city block in Oakland that includes the condemned apartment building where Killmonger's father was killed, aiming to turn it into a Wakandan technological and cultural outreach center. While engaging in

Nakia outlines a liberal internationalist view that Wakanda should join the global community and help those who have been held back from self-development through more conventional mechanisms such as foreign aid. From *Black Panther* (2018).

international affairs through traditional systems of aid and trade, as well as accepting refugees, may seem radical to T'Challa, Nakia's position aligns with liberalism's promise (that powerful people and nations have a responsibility to protect the vulnerable and address injustice) with a particular focus on addressing the harms done by the racial contract. Moreover, it recognizes the role that a powerful Black nation might play on the international stage.

Nakia's view, like W'Kabi's and Killmonger's, has a precedent in Black political thought. As recently excavated by Juliet Hooker (2015) in "A Black Sister to Massachusetts," Frederick Douglass's vision of multiracial democracy, built on immigration and Black solidarity that transcends the boundaries of the nation-state, might be read as supporting the type of intervention that Wakanda eventually embraces. Douglass, one of the foremost Black abolitionists prior to the Civil War and one of the staunchest critics of the US government's betrayal of Black people after Reconstruction, saw what the United States *could* be if it lived up to the ideals stated in the Declaration of Independence. Douglass turned from his critique of the limited nature of US democracy (limited because it was *white* democracy) to the Haitian Revolution, where he found inspiration for multiracial democracy. Hooker (2015, 692) notes that "at key junctures Douglass' concern with black freedom led him to look for models of political agency and black self-government in other parts of the Americas, such as Haiti, which he recognized as a state founded by fugitive slaves (in other words, a maroon state)." Douglass held up Haiti as the exemplar of Black political agency because it overthrew slavery to establish the first Black republic and might serve as "a refutation of the slanders and disparagements of our race" (quoted in Hooker 2015, 693). Hooker (2015, 690) argues that in writing about Haiti, Douglass develops a "conception of democracy informed by

black fugitivity." Hooker (2015, 691) identifies the following as key themes of black fugitive thought:

(1) taking seriously as political activities the survival strategies of fugitives: secrecy, concealment, flight, outlawry, etc.; (2) a concern with the creation of autonomous, and at times clandestine, spaces where black political agency can be collectively enacted, which is often coupled with a rejection of the strategy of seeking inclusion into existing racial states due to pessimism about their ability to be reorganized on bases other than white supremacy; (3) embracing the intellectual orientations arising from fugitivity, such as "speaking out of turn" to reveal racial injustice, and imagining alternate racial orders, futures, and forms of subjectivity.

While it has not experienced the trial by fire of slavery, Wakanda's awareness of the racial contract led to a political choice to conceal and further develop its technological prowess (themes 1 and 2) while the proposed reengagement, despite happening through liberal mechanisms of trade and outreach announced at the United Nations, focuses on an alternate racial order in which a wealthy Black nation unmasks itself for the benefit of the African diaspora and with the ability to match colonizer nations with equal if not superior state power (theme 3). Thus, we suggest that the MCU's world-building of a fictional Black state might help us imagine, and then build, worlds differently . . . much as the ideas of the social contract theorists helped build actual political worlds.

Each of the positions taken by W'Kabi, Killmonger, and Nakia raise questions about how we ought to address the legacies of colonialism, slavery, and racism in our world today. That a blockbuster film manages to open such important questions while also being a rousing action film is truly impressive. While T'Challa ultimately embraces Nakia's strategy to engage positively with the broader world, the initial centering of Killmonger's revolutionary vision opens a space for viewers to debate the legacies of colonialism and slavery without explicitly addressing US policies and politics that have worked to continue rather than interrupt those legacies. Saunders (2019, 140) argues that through this change in setting,

BP sculpts an alternative geopolitical vision of what a "black world" could be . . . while reminding the viewer of how it actually is: a messy, imbricated realm that spans the globe and one maintained through forgetting and remembering the past. BP thus critically engages with the political geographies of European imperialism, the slave trade, national

liberation, pan-Africanism, and the US Civil Rights movement, all of which are defined by a polysemous, transatlantic imaginary of *shared blackness* grounded in various Black Power movements.

This vision of a contemporary African movement toward justice for Blacks and what Faithful (2018) calls a "Redemption of Blackness" is a point of view rarely seen on the multiplex screen. As Haile (2018) notes, "The film's righteous anger is grounded in a real America with real problems, while its hopes lie in a fictional country distinctly removed from the reality of Africa." The narrative of Wakanda's engagement with the broader world thus offers a wide-ranging structural critique that both Blacks and whites desperately need to see so that we can all imagine that another world is possible.

Importantly, Wakanda also serves as a glorious display of pan-Africanness and Black identity. A number of scholars have critiqued the film's effort to pull together territory, dress, architecture, and religion from literally "all over the place," offering "'African bingo' representations" and "presenting an un-deconstructed 'Africa as country' frame to a global audience" (Saunders 2014, 144, 147, referencing Mokoena 2018, 14). Yet, for all its shortcomings, we agree with Haile that there is imaginative value in this depiction. After acknowledging the proliferation of Africanness depicted in *BP*, Haile (2018, 3) writes

> I've thought extensively of the burden placed on Coogler, on what an American production of this magnitude owes the continent that cradles its story, keeping in mind what centuries of false narratives about Africa have failed to convey. I believe it is this: A film set in Africa—unable by its very nature to be about Africa—whose cosmology, woven from dozens of countries exploited by empire, consists of its joys. It is a star chart of majesties more than simulacra.

Steven Thrasher (2018, 5) argues that one of the film's most substantial contributions—as a cultural artifact and as a political narrative—is that it "dreams of and conceives of an intact Black body—both the intact national body of Wakanda as well as the actual intact body of T'Challa in his suit." Rather than Africa being envisioned as a site of loss, Wakanda—the homeland of Black Panther—is imagined as a site of abundance, joy, power, and stability. While many superhero narratives involve world-building, the MCU's take on *BP* does more than build a fantasy world on a faraway planet; it instead gives us an imaginative *political* space to think through the effects of and responsibility for repairing the harms of colonization in this one. Coogler's genius, deftly drawing on discrete strands of Black political thought without naming them as such, is in providing viewers with a starter set of tools to help them imagine a world in

which the racial contract is exposed, named, and rejected with the backing of a powerful African nation so that we can get to work building an actual world in which the goals of the social contract can be realized for everyone.

Notes

1. It should be noted that Carole Pateman's (1988) analysis of the gendered assumptions of the social contract in *The Sexual Contract* precedes Mills's (1997) critique of the racial assumptions and implications of the social contract in *The Racial Contract* by about a decade. For more on the gender limitations of the social contract, see Kanthak in this volume.

2. Hobbes (1994, ch. 13), Locke (1980, ch. 3), and Rousseau (2012, "Discourse on the Origin of Inequality") all use the language of a state of war—a war of all against all—dread of which leads to the creation of the state. "Life, liberty, and estates" is Locke's (1980, ch. 9, 66) description of what each individual possesses as a result of being born, which legitimate government ought to preserve to the greatest extent possible.

3. Hobbes (1994, Ch. 13, p. 78) argues that "commodious living" is possible only when subjects are protected by a sufficiently powerful sovereign. Locke's (1980, ch. 2, 12) state of nature downgrades the human response to conditions of insecurity in the state of nature from pervasive terror to mere "inconveniencies."

4. Mills argues that this is the case even though all the white people in the world did not get into a room and consent to this structure at a single moment. Mills (1997, 20–21) writes, "Although no single act literally corresponds to the drawing up and signing of a contract, there is a series of acts—papal bulls and other theological pronouncements; European discussions about colonialism, 'discovery,' and international law; pacts, treaties, and legal decisions; academic and popular debates about the humanity of nonwhites; the establishment of formalized legal structures of differential treatment; the routinization of informal illegal or quasi-legal practices effectively sanctioned by the complicity of silence and government failure to intervene and punish perpetrators—which collectively can be seen, not just metaphorically, but close to literally, as its conceptual, juridical, and normative equivalence [such that differences like geography, culture, or religion] all eventually coalesced into the *basic* opposition of white versus nonwhite."

5. As Locke (1980, section 34) writes in the *Second Treatise*, God gave the world the "industrious and rational" so that they could cultivate the earth and increase its yield; the "quarrelsome and contentious," who eschewed private property and focused on satisfying communal needs rather than producing excessive goods for exchange, were to be ruled over by the industrious and rational. In essence, they were excluded from the political community and could be legitimately ruled over since, according to Locke, they remained in the state of nature.

6. Describing the epistemology of ignorance, Mills (1997, 18) writes, "In effect, on matters related to race, the Racial Contract prescribes for its signatories an inverted epistemology, an epistemology of ignorance, a particular pattern of localized and global cognitive dysfunctions (which are psychologically and socially functional), producing the ironic outcome that whites will in general be unable to understand the world they themselves have made."

7. Here, Mills references Blaut (1992, 3).

8. Saunders references Faithful (2018).

9. Consider, for example, the response of CIA Agent Ross to Klaue's claims that Wakanda is awash in vibranium. In chapter 9, "Interrogation" (please note that all chapter numbers and titles used in references to *BP* are from the DVD), CIA Agent Ross is interrogating Klaue. Klaue asks Ross, "What do you actually know about Wakanda?" Ross replies, "Shepherds, textiles, cool outfits." Klaue responds, "It's all a front. Explorers searched for it for centuries . . . El Dorado, the Golden City. They thought they would find it in South America, but it was in Africa the whole time. A technological marvel, all because it was built on a mound of the most valuable metal known to man. *Isipho*, they call it. The gift. Vibranium." Klaue schools Ross and the audience on the wonders of vibranium. Ross basically laughs him off, saying, "That's a nice fairy tale, but Wakanda is a Third World country, and you stole all their vibranium." Klaue corrects him, noting that he is the only outsider who has seen Wakanda and made it out alive; vibranium is everywhere. Ross confronts T'Challa, who dismisses Klaue's claims (shrewdly using Ross's ignorance to maintain Wakanda's disguise).

10. While the media has long portrayed Blacks on screen, recent work depicting the Black American experience through Black points of view have eschewed both respectability politics and simplified stereotypes. As Darnell Hunt (2017), dean of social sciences at UCLA, notes in a 2017 report commissioned by Color of Change, "Over 90 percent of showrunners are white, two-thirds of shows had no Black writers at all, and another 17 percent of shows had just one Black writer. The ultimate result of this exclusion is the widespread reliance on Black stereotypes to drive Black character portrayals." This is beginning to change in the last handful of years. *Moonlight* received Academy Awards for adapted screenplay, best picture, and supporting actor along with nominations in five other categories and assorted wins and nominations from the Directors Guild of America (DGA) and the Golden Globes. The American Film Institute named *Get Out* one of the ten best films of 2017 while Jordan Peele received an Academy Award and a Writers Guild of America Award for original screenplay, and the film grossed $255.5 million worldwide. Renewed for a seventh season on ABC as of this writing, *black-ish* has produced two multiseason spin-offs (*mixed-ish* on ABC and *grown-ish* on Freeform). While the series has ended, *Scandal* was in the center of the popular culture zeitgeist, became a dominant network television show in the age of fragmented television, and continued to reflect the success of Shonda Rhimes's capacity to create and run popular television shows that are widely watched and generate substantial advertising dollars.

11. *BP*, chapter 6, "Extradition." The dialogue is as follows:

> T'Challa: Nakia thinks we should be doing more.
> W'Kabi: Like what?
> T'Challa: Foreign aid, refugee programs.
> W'Kabi: You let the refugees in, they bring their problems with them. And then Wakanda is like everywhere else. Now if you said you wanted me and my men to go out there and clean up the world, then I'd be all for it.
> T'Challa: But waging war on other countries has never been our way.

12. Malcolm X (2004, 69) argued that "the black masses don't want segregation nor do we want integration. What we want is complete separation. In short, we don't want to be segregated by the white man, we don't want to be integrated with the white man, we want to be separated from the white man."

13. Curtis references Hardt and Negri (2000, 23, 327).

14. This inversion reflects James Baldwin's (1993) critique of Elijah Muhammed and the Nation of Islam's inversion rather than transformation of the White/Good, Black/Bad paradigm (and, by extension, Malcolm X's earlier arguments for separation) in *The Fire Next Time*.

15. One of the most riveting parts of *The Wretched of the Earth* is Fanon's recollection of his experience serving as therapist to French police officers who had tortured Algerians fighting for decolonization. Fanon notes how the experience of torturing people as part of their job led to deformed personalities and a loss of moral sense (see Fanon 2004, ch. 5).

16. We can see T'Challa begin to shift when Agent Ross, wounded in the firefight during Klaue's escape when he jumped in front of Nakia and saved her life, is taken back to Wakanda. Faced with an American CIA agent dying or potentially revealing Wakanda to the world, Okoye argues that they should leave Ross. Nakia points out that Ross took a bullet for her and asks, "Are we now supposed to let him die?" Okoye points out that if he recovers, his duty will be to tell the US government about Wakandan resources. T'Challa responds, "I cannot just let him die, knowing we can save him."

CHAPTER 3 TONY STARK AND THE CLASSICAL HEROISM OF THE MARVEL CINEMATIC UNIVERSE

Ari Kohen

That's the hero gig, right? Part of the journey is the end.

Comic books and the genre of film they've spawned are chock-full of heroes; that is their stock in trade. The characters wear special suits and possess powerful weapons; they fight against otherworldly villains who plot to destroy humanity. But at their core, the stories found in comics are profoundly human stories; if they were not—if they were excessively alien—they wouldn't find the readership, and the films wouldn't find the viewership, that they have. Philip Zimbardo (2007, 461) points to the value of the stories we tell about heroes: "We care about heroic stories because they serve as powerful reminders that people are capable of resisting evil, of not giving in to temptation, of rising above mediocrity, and of heeding the call to action and service when others fail to act."

Consider, for example, the enduring popularity of Superman as a comic book character and the underwhelming audience response to the film adaptations that have recently appeared on the silver screen. What accounts for the difference? The comics give readers ample time in the all-too-human world of Clark Kent, Superman's human alter ego; the films, by contrast, spend almost no time at all with Kent because they're limited to two hours in which Superman must accomplish his world-saving heroics. Without any investment in the story of Clark Kent, the heroism of Superman—like the character himself—is entirely extraterrestrial and, as a result, entirely outside the realm of the audience's experience. While critics point to the direction and cinematography of contemporary Superman films to explain their failure, the easiest explanation is that Superman simply doesn't resonate with audiences; his perfection, his ability to solve every problem with his alien powers, makes him entirely unrelatable.

The case of the films of the Marvel Cinematic Universe (MCU), which has seen amazing box office success over more than a decade, is quite the opposite. While there is certainly no shortage of superpowered individuals in these films, one of the main reasons that they have been almost universally successful is that the spine of the twenty-three films is the heroic arc of Tony Stark, the first character introduced to audiences in *Iron Man* (2008) and the central hero

of Phases One through Three, known collectively as "the Infinity Saga" (Ridgely 2019).[1] Whereas Superman is rarely depicted on the screen as Clark Kent, Tony Stark's nuanced character development often outshines the spectacle of his Iron Man alter ego.

The MCU's depiction of Stark's heroism has deep roots—it follows in the footsteps of classical battlefield heroism and subversive democratic heroism found in ancient Greek epic poetry (which is among the earliest recorded long-form storytelling in human history).

This chapter explains what heroism looked like in Homer's *Iliad* and in Plato's writings on the life of Socrates and then focuses on the character of Tony Stark, looking at the ways in which *strength* and *sacrifice* interact throughout the first three phases of the MCU while also highlighting the somewhat unlikely aspect of Stark as the central hero of the twenty-three-film arc (rather than, for example, the godlike Thor or the superpowered Steve Rogers). Stark is a great warrior, and he is most often portrayed as victorious in battle against a variety of powerful enemies. In this way, Stark mirrors Homer's Achilles. But Stark's greatest virtue isn't his technical skill, his puzzle-solving mind, his exorbitant wealth, or even his Iron Man suit; it's his humanity. There is ultimately nothing "super" about him or his heroism; he is actually "powered" by his weakness, the injury to his heart. Thus, time and time again, Stark also embodies the lessons of Plato's Socrates, namely, that true heroism is democratic insofar as one does not need to be extraordinary to do it, as it revolves around sacrifice for the good of others rather than for oneself or one's own glory. As I have argued previously, "The most heroic behavior—that which casts the best reflection back on the life of the hero—puts a premium on providing assistance to others, even when doing so puts the hero's own life directly at risk" (Kohen 2014, 8) That is why Stark's heroism resonates with us; it isn't simply that he is exceptional on the battlefield or that he sacrifices himself, as is true of Achilles, but that he, like Socrates, does so for the benefit of everyone else. (For alternative takes on Stark, see Daily and Cassino in this volume.)

The Mortal Hero

Tony Stark is, in many ways, a contemporary character modeled on the classical battlefield hero of the Homeric epics that I first discussed in depth in my 2014 book, *Untangling Heroism*. In particular, and in addition to his heroic deeds, Stark stands in contrast to the other superpowered characters who make up the Avengers and other, ancillary heroes in the MCU because, like Achilles in the *Iliad*, his mortality, and thus his humanity, fundamentally defines him.[2] Stark is like the Homeric heroes in this most important respect:

because he is a mortal human being, each of his choices matters a great deal because their number is finite. Indeed, much of classical heroism relies on the contrast between the mortal heroes and the immortal gods because without the presence of the gods, the stark choices facing mortals would seem less acute. As Seth L. Schein (1984, 53) points out, "Despite, or because of, their perfection, the gods serve as a foil to clarify by contrast the seriousness, or one might say the tragedy, of the human condition." In contrast to the choices made by the Olympians, which have no real costs for them one way or another, Achilles's decision to fight or to sail home is a truly difficult one because of the serious consequences that attend it:

> My mother, Thetis of the silvery feet,
> tells me of two possible destinies
> carrying me toward death: two ways:
> if on the one hand I remain to fight
> around Troy town, I lose all hope of home
> but gain unfading glory; on the other,
> if I sail back to my own land my glory
> fails—but a long life ahead for me. (Homer 1974, IX.499–506)

Thus we learn that Achilles is fated to die at Troy if he chooses to fight; alternatively, if he chooses not to fight, he is destined to live a long life and then to be forgotten. Unlike the gods, with their petty intrigues and their meaningless squabbles, Achilles must make a difficult choice that will determine the sort of life he will lead and for how much longer; once he chooses, the die is cast. As Schein (1984, 53) correctly points out, "The honor [the gods] are obsessed with winning and losing is not truly significant. In this respect, their existence is trivial compared with that of humans, who seek to make their lives meaningful by fighting for this reward until they are finally killed."

Achilles' recognition of his mortality, made especially poignant by the death of his beloved companion Patroclus, leads him to think critically about the kind of life he will live before he meets his end. He tells his mother, Thetis,

> Now I must go look for the destroyer
> of my great friend. I shall confront the dark
> drear spirit of death at any hour Zeus
> and the other gods may wish to make an end.
> Not even Heracles escaped that terror
> though cherished by the Lord Zeus. Destiny
> and Hera's bitter anger mastered him.
> Likewise with me, if destiny like his

Like the classic battlefield heroes of the Homeric epics, Tony Stark is defined both by his heroic deeds and by his vulnerability and mortality. In his first few moments on screen, he is wounded—almost fatally—by a roadside explosive. From *Iron Man* (2008).

awaits me, I shall rest when I have fallen!
Now, though, may I win my perfect glory
and make some wife of Troy break down,
or some deep-breasted Dardan woman sob
and wipe tears from her soft cheeks. They'll know then
how long they had been spared the deaths of men,
while I abstained from war! (Homer 1974, XVIII.131–145)

In the end, Achilles chooses to embrace the second of his possible destinies, to live a short, glory-filled life and to die at the hands of an enemy in a foreign land. He makes this decision with the certainty that he will not escape his fate, bringing his differentiation with the gods from whom he is partially descended into sharp focus. The lesson that Homer offers, through the story of Achilles, is that our lives are terribly brief, and so our choices are imbued with deep meaning and import.

There were, of course, other models of heroism in ancient Greece. Whereas Homer's epics depict warriors such as Achilles, Plato focuses on the choices of the mortal Socrates. On trial for his life for the crimes of corrupting youth and not believing in the gods of the city, Socrates notes that death is the eventual fate of every living thing, and as a consequence, one might consider how best to die. Rather than hoping to squeeze a few more years of life from his jurors by pleading with them or bringing his family forward on his behalf, Socrates argues that

as to reputation, mine and yours and the whole city's, to me it does not seem to be noble for me to do any of these things. . . . I have often seen

some who are just like this when they are judged: although they are reputed to be something, they do wondrous deeds, since they suppose that they will suffer something terrible if they die—as though they would be immortal if you did not kill them. (Plato 1984, 34e-35a)

This line of thought, characterized by Greenberg (1965, 56) as choosing to live "not life, but a good life," is an important component of my argument that Socrates's behavior should be regarded as distinctly heroic. Because he could likely avoid death and instead chooses to embrace it, Socrates is able to make a statement with his death. As Costica Bradatan (2007, 589) points out, "Socrates' death was the most effective means of persuasion he ever used, and over the centuries he has come to be venerated not so much for what he did when he was alive, but for the way in which he died." Just as Achilles announces his unwillingness to leave Troy for a life of safety once Hector has killed Patroclus, so does Socrates embrace death without fear, putting on a defense that is very likely to lead to his execution.

In line with the classical Greek heroes, Tony Stark's mortality is made evident time and again in the films of the MCU; in the course of *Iron Man, Iron Man 2,* and *Iron Man 3,* Stark is nearly killed six times. In the first *Avengers* film, Stark saves a battle-ravaged New York City from an alien invasion by flying into a wormhole with a nuclear warhead and is presumed dead by everyone. In addition to the very real possibility of his death, his weakness—the miniaturized arc reactor embedded in his chest—is either removed, damaged, or overloaded four times: twice in *Iron Man,* once in *Captain America: Civil War,* and once more in *Avengers: Endgame.* Jarvis reminds him early in *Iron Man 2* (2010), as Stark is suffering from palladium poisoning, "Unfortunately, the device that's keeping you alive is also killing you."

Stark's own mortality is often sharply contrasted with the seeming immortality of the heroes and villains with whom he is paired in the films. His fellow Avengers include Captain America, a seemingly invincible and ageless superpowered soldier; Thor, a godlike alien from another realm; and the Incredible Hulk, an enormous green rage monster created by a science experiment gone awry.[3] His enemies include Loki, the godlike alien brother of Thor; the alien Chitauri species, which possesses technology far beyond that of humans; and, of course, the mad Titan Thanos, whose possession of the Infinity Gauntlet renders him omnipotent and whose actions result, at least temporarily, in the erasure of half of all life in the universe. By any measure, Stark—even in his Iron Man suit—is no match for the majority of the characters with whom he comes into regular contact. As Stark himself tells Pepper Potts in *Iron Man 3* (2013), "You experience things and then they're over, and you just can't explain them. Gods, aliens, other dimensions. I'm just a man in a can."

Not only is Stark relatively small, weak, and susceptible to injury and even death, but the very source of his power exists as a reminder of a near-fatal injury. Without the reactor, Stark could not become, and cannot sustain, his alter ego, Iron Man. But it's also a constant reminder of the fragility of human existence; while it powers a supersuit, it's also keeping Stark's all-too-human body functioning by powering the electromagnet that prevents shrapnel in his chest from entering his heart.[4] Importantly, Stark is also—like all human beings—mentally fragile and buffeted by the fallout from his actions. Most notably, as a result of the Battle of New York, Stark suffers from post-traumatic stress disorder, and, as a result of his guilt for having created Ultron, he pushes for the Sokovia Accords that ultimately disempower the Avengers and lead directly to the Avengers Civil War.

From the very beginning, Stark—like all classical Greek heroes—is forced to confront his mortality and to decide, with the knowledge of his impending death, how he will live and what his legacy will be. In the first half hour of *Iron Man*, with Stark recovering from a bomb blast in a cave in Afghanistan, under heavy guard and forced to build a powerful weapon for the Ten Rings terrorist organization, he considers his options in conversation with the doctor who saved his life by implanting an electromagnet powered by a car battery:

Stark: Why should I do anything? They're going to kill me, you, either way. And if they don't, I'll probably be dead in a week.

Yinsen: Well, then, this is a very important week for you, isn't it?

It's this confrontation with his mortality—and the reminder that his legacy, if he dies in that cave, will be as a purveyor of weapons that kill and maim millions of people—that pushes Stark to build his first miniaturized arc reactor and Iron Man suit and to ultimately turn his back on the weapons industry that his father built, that he furthered, and that supported the billionaire playboy lifestyle he has been living. When Stark is forced to directly confront the finite nature of his existence, he immediately comes face-to-face with the recognition that the number of choices in any given life is limited and thus that each individual choice matters a great deal.

The Heroic Sacrifice

One of the central components of the Iron Man origin story is that, shortly after pushing Stark to consider his legacy, Ho Yinsen sacrifices himself so that Stark can make good his escape from his Ten Rings captors. In case anyone worried that the audience might miss the importance of this brief but crucial

relationship in shaping Stark's future, the dialogue makes sure to leave no uncertainty:

Stark: Thank you for saving me.
Yinsen: Don't waste it. Don't waste your life.

Stark confronts his captors in his Mark I suit and destroys the Ten Rings weapons—manufactured, of course, by Stark Industries—before rocketing away to be rescued by his friend Captain James Rhodes and then to return to the United States. His first major act, after eating a cheeseburger, is to call a press conference in which he announces that Stark Industries will no longer manufacture weapons. While this decision represents a financial risk, and while it sets up his eventual confrontation with Iron Monger, his father's business partner Obadiah Stane, Stark's truly heroic sacrifices come later and are modeled much more closely on the heroic sacrifices of the classical Greek heroes. Those sacrifices will be the focus of the remainder of this paper, as they involve life-or-death decisions.[5]

Life-or-death heroic sacrifice connects Stark directly to the classical heroes of ancient Greece, in particular Achilles's decision in book XVIII of the *Iliad* to sacrifice himself in order to avenge the death of Patroclus, returning to battle against the Trojans with the complete awareness that doing so will cost him his life. Not long before Patroclus's death, Aristotle makes clear to his comrades that he has thought carefully about life's pricelessness. Thus, when he chooses to resume fighting, he knows exactly what he is giving up.[6] He says,

Now I think
no riches can compare with being alive,
not even those they say this well-built Ilion
stored up in peace before the Achaians came.
Neither could all the Archer's shrine contains
at rocky Pytho, in the crypt of stone.
A man may come by cattle and sheep in raids;
tripods he buys, and tawny-headed horses;
but his life's breath cannot be hunted back
or be recaptured once it pass his lips. (Homer 1974, IX.490–498)

His sacrifice makes possible the eventual victory of the Greeks and the destruction of Troy; however, he makes that decision not for their benefit but to avenge Patroclus and to achieve everlasting glory for his unparalleled deeds.

While there is no doubt that Achilles will get his revenge by killing Hector, neither is there any doubt of the consequences of his doing so and the sacrifice

Tony Stark's heroic arc begins with the sacrifice of his fellow captive, Ho Yensin. Stark's own later sacrifices are modeled on the heroic sacrifices of classical Greek heroes. From *Iron Man* (2008).

he is making. As he mourns Patroclus's death, his mother mourns for him because she knows that this first death—at the hands of Hector—will lead, before long, to Achilles's own: "You'll be / swift to meet your end, child, as you say: / your doom comes close on the heels of Hektor's own" (Homer 1974, XVIII.108–109). Indeed, Schein points out that the majority of the action after Achilles receives the news of Patroclus's death symbolizes his own death. Homer "makes Achilles die symbolically, when both Patroklos and Hektor are killed in the armor so intimately bound up with his identity" (Schein 1984, 129). Furthermore, Achilles calls to mind his own mortality when he speaks about the armor that Hector took from Patroclus, noting that Achilles's "arms, massive and fine, a wonder / in all men's eyes" (Homer 1974, XVIII.93–94) were a gift from the gods to his mortal father, Peleus, when Thetis, a goddess, married him.

Indeed, the imagery that Homer uses to describe the reactions of various characters to Patroclus's death actually suggests their grief for Achilles. For example, Homer says,

> From the hut
> the women who had been spoils of war to him
> and to Patroklos flocked in haste around him,
> crying loud in grief. All beat their breasts,
> and trembling came upon their knees. (Homer 1974, XVIII.30–34)

Given this description, the women could well be mourning Achilles instead of Patroclus in this passage. As Schein (1984, 130) notes, "This effect is enhanced by the parallel passage a few lines further on, when Achilles's terrible

cry of grief reaches Thetis" and the Nereids all "now beat their breasts" (Homer 1974, XVIII.56). Hearing the lamentation of her son from her home in the sea, Thetis expresses her own grief:

> Now my life is pain
> for my great son's dark destiny! I bore
> a child flawless and strong beyond all men. . . .
> Now I shall never see him
> entering Peleus' hall, his home, again.
> But even while he lives, beholding sunlight,
> suffering is his lot. (Homer 1974, XVIII.58–67)

Finally, the description of Achilles's reaction to the news of Patroclus's death is itself laden with imagery that suggests his own death. As Homer depicts it,

> A black stormcloud of pain shrouded Achilles,
> On his bowed head he scattered dust and ash
> in handfuls and befouled his beautiful face,
> letting black ash sift on his fragrant khiton.
> Then in the dust he stretched his giant length
> and tore his hair with both hands. (Homer 1974, XVIII.25–30)

Schein argues that this vision of the mourning Achilles is closely tied, linguistically, to those of heroes who have been killed in battle. Though the translation is slightly different, Schein's (1984, 130) main point is as follows: "'Darkness' often 'covers' a man's eyes when he is killed; a 'dark cloud covers' the dying Patroklos. . . . On five occasions a man 'grasps' the earth with his hand as he falls 'in the dust.' The verb 'he lay' . . . is commonly used of warriors 'lying dead,' including Patroklos a few lines earlier . . . as well as of Achilles himself."

In the *Crito*, it seems to be principally important to Socrates to persuade the Athenians of the veracity of everything that he has said prior to his conviction. The most obvious way to accomplish this task, of course, is to sacrifice himself, for he has already averred—in the *Apology*—that he would not change his ways "even if I were going to die many times" (Plato 1984, 30c). To demonstrate his stated commitment to living a good life, Socrates chooses to "express himself by the most radical means, namely, his own body, *letting it die* in a most spectacular manner, so that nobody could ignore or not 'listen to' it" (Bradatan 2007, 592). Zuckert (1984, 293) makes a similar point: "Socrates' dying for his philosophy, while upholding at once his own justice and the justice of the city, can prove to the Athenians that philosophy is not the sort of thing they suspect it to be." Thus, he demonstrates his dedication to the pursuit of justice

and wisdom above even his own life and sacrifices himself so that others, even those who see themselves as his enemies, might reap the benefits of philosophy in the future.

Achilles and Socrates are viewed as heroes in large part because they choose to sacrifice themselves for an ideal. As J. Peter Euben (1990, 219) notes, "Socrates wants his fellow citizens to see that he, like Achilles, is more concerned with how one ought to live than with calculations of advantage and mere survival, and that for him to abandon these commitments would be cowardly." Of course, the views of the good life held by these two characters are wildly divergent, with Achilles focused almost entirely on everlasting glory and Socrates on virtue and wisdom. Nevertheless, in both cases, there is a clear choice to be made that directly concerns human finitude: either live a shorter, principled life or a longer life that ultimately rejects those principles. Achilles and Socrates both reject a longer life in order to embrace the principles that are of central importance to them. For Greenberg (1965, 73), this amounts to the notion that "heroes have formed a view of the good life which is so strict and so precious that they will accept infinite odds in the risk to preserve it."

In much the same way, Stark repeatedly sacrifices himself, and his friends repeatedly mourn for him before he is brought back from what everyone has assumed was his untimely death. Pepper Potts has an opportunity to prematurely mourn Tony Stark's demise in each of the three stand-alone *Iron Man* films—screaming his name as he and his house collapse into the Pacific Ocean in *Iron Man 3* (2013) might be the most pathos-filled of these—but it is only in the *Avengers* films that audiences are led to believe that Stark has died or will die. Stark's ultimate sacrifice, in *Avengers: Endgame*, is actually set up quite nicely in the first *Avengers* film. In the conclusion of that first teaming-up, Stark famously sacrifices himself in order to save New York City, and presumably the entire world, from an alien invasion. But Stark's sacrifice, in that film and later as well, is set up powerfully in a back-and-forth with Captain America Steve Rogers when all of the Avengers are unknowingly being pitted against one another by the malevolent power of Loki's scepter:

Cap: Big man in a suit of armor. Take that off, what are you?
Stark: Genius, billionaire, playboy, philanthropist.
Cap: I know guys with none of that worth ten of you. I've seen the footage. The only thing you really fight for is yourself. You're not the guy to make the sacrifice play, to lay down on a wire and let the other guy crawl over you.
Stark: I think I would just cut the wire.
Cap: Always a way out. You know, you may not be a threat, but you better stop pretending to be a hero.

Stark: A hero? Like you? You're a laboratory experiment, Rogers. Everything special about you came out of a bottle.

Rogers has taken an accurate measure of Stark up to this point. Despite his desire to change his life for the better and to act on behalf of others, Stark cannot fully shed the self-regarding narcissism of his life before the decisive moment when he became Iron Man in Afghanistan. For all his battlefield heroics as Iron Man, the flippant, self-centered Tony Stark of the congressional hearings in *Iron Man 2* seems not far removed from the Tony Stark we see in an *Iron Man 3* flashback to ten years earlier.[7]

Yet Stark is determined to make the difficult decision, to put his life on the line at the decisive moment of the battle. With the battle against the Chitauri seemingly unwinnable, the World Security Council takes decisive action, overruling S.H.I.E.L.D. Director Nick Fury and calling in a nuclear strike on New York City in a final attempt to stop the ongoing invasion. But Fury notifies Stark, who intercepts the incoming missile and flies it into the wormhole, ultimately launching it at and destroying the Chitauri command ship, which results in the destruction of the alien force on Earth. At the same time, Romanoff uses Loki's scepter to short-circuit the Tesseract, which closes the wormhole, and Stark is seen falling away from the exploding ship—his suit failing, his eyes closing—as the wormhole closes under him. Stark falls back to Earth and Hulk catches him before he hits the ground, but for a moment, everyone is certain that he is dead. Indeed, Stark believed the mission to save New York from both the council's nuclear warhead and the Chitauri invasion was a suicide mission; he believed, as he intercepted the incoming missile, that he was giving his life for the greater good of others. We know this because he calls Pepper on that final flight, attempting to connect with her as his last act before sacrificing himself.[8]

While Stark ultimately survives his heroics, unbeknownst to him or anyone else on Earth, a far more powerful villain than Loki and the Chitauri is pulling all the strings and will stand at the Infinity Saga's conclusion; the stinger at the end of *The Avengers* nicely highlights the foe who will ultimately claim Stark's life when the audience catches its first glimpse of Thanos. In the end, Thanos's near conquest of the universe provides Stark with multiple opportunities for heroism.

In the battle on Titan, Stark chooses to fight and to die in a last attempt to prevent Thanos from getting the Time Stone that Doctor Strange is protecting. Despite Stark's choice, Strange ultimately relinquishes the stone and saves Stark. While Stark cannot understand this choice, it's noteworthy that Strange—who possesses the Time Stone—already knows the future, having experienced 14,000,605 possible futures in order to find the one in which the

Avengers defeat Thanos. He knows what Stark can't, namely, that this battle with Thanos is only the penultimate one and that a living Stark will have an opportunity to travel through the quantum realm, gather the Infinity Stones before Thanos can do so, and use them to undo the Snap and fight Thanos to a different conclusion. Thus, Stark is prevented from sacrificing himself on Titan in what Strange knows would be a useless attempt to stop Thanos from obtaining the fifth of six Infinity Stones so that he will still be alive to finally defeat Thanos five years later.

The Other-Regarding Heroism of Tony Stark

For all of his battlefield heroics, which would fit very neatly into the world of Homeric epics, of course, Stark also embodies the Socratic virtue of sacrifice on behalf of others. Indeed, every one of the sacrifices made by Stark across the MCU films is on behalf of other people rather than for his own good. In this way, Stark takes up the Homeric battlefield mantle but subverts it by suffusing his heroic deeds with this distinctive Socratic heroic virtue. In both *The Avengers* (2012) and *Avengers: Endgame* (2019), Stark's heroic sacrifice seemingly saves not only his friends but also the wider world; indeed, Stark's final sacrifice in *Endgame* saves the entire known universe from the ravages of Thanos.

In many ways, the final battle is designed for another hero to take on and defeat Thanos, with Hulk, Thor, Captain Marvel, and Captain America each taking a shot at the Infinity Saga's principal villain. In an especially poignant moment, Thor insists that he—rather than Hulk—should be the one to bring back everyone who was snapped out of existence by Thanos because, he first says, he's the strongest Avenger and finally because he is desperate to "do something right for once" after having repeatedly failed. Even more than with the godlike Thor, the audience is primed for a showdown between Thanos and Captain Marvel, in no small part because her stand-alone film was released to theaters between *Avengers: Infinity War* and *Avengers: Endgame* and because, in the stinger after the closing credits of *Infinity War*, Nick Fury's last act before he turns to ash is to activate the heavily modified 1990s-era pager that calls her back to Earth. In the end, however, it isn't the straightforward power of these heroes that saves the day; instead, it's a sacrifice.

In this way, the entire Infinity Saga can be boiled down—with a number of interesting and fun diversions—to the hero's journey of Tony Stark. At the outset, Stark is the wealthy playboy who expands his father's fortune by selling weapons to the highest global bidder. But by the end of the saga, he makes the noble choice to sacrifice his life for the benefit of life throughout the universe. Stark is an unlikely hero from the beginning, and his unlikeliness is repeatedly

In the tradition of classical Greek heroism, Stark's heroic journey ends with a sacrifice as he wields the Infinity Stones to vanquish Thanos and his army, knowing that doing so will result in his death. As he does so, he repeats the words that began his life as a superhero: "And I am Iron Man." From *Avengers: Endgame* (2019).

brought to the fore by the existence of the superpowered beings who surround him. Stark's interactions with Thor and with Doctor Strange in the final Avengers films highlight the comedy of a situation in which an ordinary human being in a metal suit is paired up with a godlike being from another dimension and a time- and space-bending wizard. But the plot of *Endgame*, the final movie in the saga, is designed to highlight the sacrifice that Stark makes in its fullness by flashing forward early on and settling for the majority of the film at a point that is a full five years after the universe-altering events of *Infinity War*. Stark's personal sacrifice, in *Endgame*, is far removed from his similar-seeming sacrifice at the conclusion of the Battle of New York in *The Avengers* because the stakes are completely different *for him*.

With the extra time given to him after he is rescued by Captain Marvel and returned to Earth following Thanos's victory, Stark makes meaningful life choices that ultimately lead to his estrangement from the superheroes, such as Captain America and Black Widow, who seemingly continue the work of the Avengers. When they come to the realization that it might be possible to fix the universe-altering damage wreaked by Thanos by traveling back in time, they seek out Stark, who is living a seemingly idyllic life; in the five years since the death of Thanos, as the Avengers have struggled to come to terms with their loss, we see that Tony and Pepper have married and are raising a daughter, Morgan.

It's in this context that Stark initially refuses to become involved in the time-travel plot: he has too much to lose, he explains. Even as we know that Stark will, in fact, rejoin the Avengers and participate in the "time heist," we see the cost to Stark of his sacrifice; without those stakes, the power of Stark's ultimate

action would be blunted. He repeatedly cautions others about changing the current timeline, insisting that they not undo the present in some misguided attempt to change the past. Tony and Pepper understand that they have been lucky and that almost everyone else hasn't been so fortunate; while they remained together and started a family, other families were torn apart. Still, for Stark, the goal of the time heist isn't to go back and undo the Avengers' loss to Thanos; rather, it is to bring back to the present everyone who disappeared five years earlier. If successful, they will restore everyone who was lost five years earlier while also allowing Stark to keep everything that he gained in that time. Yet one doesn't need to possess Doctor Strange's unique abilities to know that Thanos is too powerful to be defeated so easily. Nor does one need to be an expert in stories about heroes to know that only a major sacrifice can bring resolution to a story with such a powerful villain. In the end, the Infinity Saga has led inexorably to one conclusion, just as Strange tells Stark in *Infinity War* that he experienced 14,000,605 possible futures and that the Avengers win in only one of them. While Thanos clearly believes it to be true of himself, it's actually Stark—like the greatest of the Greek heroes—who is inevitable.

The importance of Stark's heroic sacrifice is evidenced by the poignancy of the moments immediately preceding his death and by the scenes surrounding his funeral. But the massive hole left in the lives of his family and friends is perhaps best captured through Peter Parker's experience in *Spider-Man: Far from Home*. Throughout the films of the MCU, Stark goes on a profound journey in which he experiences changes in character and outlook; the battles he fights are dangerous for him, the odds are against him, and the sacrifices he makes are irreversible. He chooses to fight on behalf of others rather than for his own good, and while he possesses a truly impressive level of intelligence and mind-boggling wealth, he is still someone who is more like than unlike the people who watch his story unfold. Stark's heroism is the most meaningful to the MCU audience for the same reason as that of the classical Greek heroes: because it's the most human.

Notes

1. A notable quasi-exception is *Captain Marvel* (2019), in which the titular character has an undeniable "power problem" of the same sort that plagues Superman. While Carol Danvers is an interesting and profoundly human character, her powered alter ego, Captain Marvel, is capable, as far as the audience can tell, of accomplishing anything at all, including destroying alien spacecraft by flying into them. Although the film grossed more than $1 billion worldwide, this put it in sixth place for worldwide box office receipts. For a variety of reasons, including outright misogyny (Leon 2019), *Captain Marvel* did not receive the same positive critical reception as other Phase Three MCU films, and its domestic

box office total left it in fourth place, significantly behind *Avengers: Endgame* (2019), *Black Panther* (2018), and *Avengers: Infinity War* (2018). It was entirely unclear what Captain Marvel's role ought to be in *Avengers: Endgame*, and despite her superpower profile, she plays almost no role in the final battle between the Avengers and Thanos.

2. Stark has more than just his mortality in common with Achilles; as Iron Man, he is often portrayed as nearly as powerful as the superpowered and even godlike characters who populate his universe. Consider that the first time Iron Man and Thor come face to face, in *The Avengers* (2012), they fight to a draw over custody of Loki; similarly, using his Mark XLIV (Hulkbuster) armor, Stark ultimately manages to knock out the Hulk after dropping a building on him in *Avengers: Age of Ultron* (2015).

3. Whether Thor is a god or a being from another world, realm, or dimension is less clear in the MCU than in Norse mythology, but for all intents and purposes, he inhabits the space of a god in the early phases of the MCU Infinity Saga. He can fly, he wields a superpowered hammer as well as the power of lightning, and he seems generally impervious to conventional weapons. Only later, in the final films of Phase Three, do we see that Asgardians can be killed by other powerful beings and that Thor's powers are matched or even exceeded by those of villains such Hela and, of course, Thanos.

4. At the end of *Iron Man 3* (2013), Stark undergoes an operation to remove the shrapnel from his chest; this allows him to remove the electromagnet and the arc reactor from his body. When Stark reappears in the Iron Man suit in *Avengers: Age of Ultron* (2015), miniature arc reactors power the suit, but none are necessary to keep Stark alive.

5. It is crucial to note that Stark is not the only person to make a life-or-death sacrifice in the MCU, and thus he should not be the only hero under consideration. One is Vision, who insists that he be killed in order to prevent Thanos from obtaining the Mind Stone in *Avengers: Infinity War* (2017). But Vision is a superpowered android rather than a human being, and—despite a brief attempt to humanize him with a short, underexplored relationship with the Scarlet Witch, Wanda Maximoff—the character's death lacks the emotional stakes of a human being who sacrifices himself. The other sacrifice, which more closely resembles Stark's, is that of Natasha Romanoff, the Black Widow, who sacrifices herself in *Avengers: Endgame* (2019) so that Clint Barton, Hawkeye, can obtain the Soul Stone on Vormir, which is necessary to undo the Snap and restore the disintegrated to life. When they realize that a costly human sacrifice, in which one must lose what (or whom) they love most, is necessary, Black Widow and Hawkeye battle over who will give his or her life to obtain the Soul Stone. Their long, loving, platonic friendship leads each of them to be willing to die for the other: perhaps a moment of ultimate civic virtue and heroism. Both attempt to sacrifice themselves, falling simultaneously over the edge of the abyss. But it is Natasha who pleads with Clint to let her go and then releases his hand, dropping to her death as he watches in stunned grief. She is not vanquished; she chooses to give her life both for her friend and for the larger cause of restoring humanity. While Black Widow is briefly mourned by her friends on screen, the impact of her sacrifice is blunted by the way in which her character was used throughout the MCU. As a review in *Vanity Fair* notes, her heroic death feels like "a hasty exit for a long-sidelined heroine," as *Endgame* "never gives her or her death room to breathe" (Bradley 2019). Indeed, a stand-alone Black Widow film wasn't released until summer 2021, serving as a prequel to many of the events already depicted in the first three phases. The audience's relationship with Romanoff throughout the Infinity Saga is with an ancillary character, and her sacrifice of her life on everyone else's behalf feels markedly less significant than Stark's. On this point, Bradley (2019) says, "Tony Stark gets a lengthy, well-attended funeral; Natasha doesn't get so much as

a eulogy." More recently, with the advent of the late-2021 *Hawkeye* television show, the fallout from Natasha's death has begun to unspool a bit more, and its impact on characters such as Barton and the newly introduced Yelena Belova has been explored to some extent. However, if more careful attention had been paid to the Romanoff character throughout the MCU's first phases, her heroic arc would have been more clearly pronounced. The failure to more clearly craft Natasha Romanoff as a second human hero who could have stood alongside Stark, highlighting the way in which women can walk the same courageous and self-sacrificing path in the MCU as the men who have been regarded as the classical heroic actors, is a missed opportunity. There are a great many reasons why this would be important, not least that it would make a dramatic change in the way both men and women perceive the entire concept of heroism and in the way that extraordinary women, as well as men, could be recognized as truly heroic.

6. The same can be said of Homer's other hero, Odysseus, who turns his back on an offer of immortality after seeing the state of things for shades in Hades.

7. In almost every way, Steve Rogers is the hero that everyone expects. Not only is he handsome, superhumanly strong, and well-nigh invulnerable, but he is literally named "Captain America," defeated the Nazis, and wears an American flag–themed costume. What's more, he was initially chosen to participate in Dr. Erskine's World War II–era supersoldier project because of his heart, inherent goodness, fierce loyalty, and deep moral rectitude. The MCU plays on the audience's feelings about Cap all the way to the end, as he is shown to be the only human character who can wield Thor's otherworldly hammer, Mjolnir, which responds only to those who are "worthy," in *Endgame*'s final battle with Thanos. MCU fans cheer when Cap holds the hammer, but that moment ultimately proves to be just an enjoyable minor plot point that serves longtime fans.

8. These final calls to Pepper become something of a regular occurrence for Stark, as he also uses his helmet camera to record a message for her when he believes that he will die in a derelict ship floating in space at the beginning of *Endgame*.

CHAPTER 4 ENDURANCE IN MARVEL CINEMA

Letting Go of Compulsory Overcoming in Superhero Stories

Anna Daily

It is a story as old as stories themselves: heroes are born in trauma—their bodies, minds, and spirits are ravaged by sudden violence and tragedy, which change them forever. And yet they are heroes because they rise from the ashes, reborn and ready to fight for what is just. Overcoming trauma and disability is what makes a superhero. As Beth DeVolder (2013, 760) remarks, "The overcoming narrative is so entrenched in our collective cultural imaginary that many people cannot even imagine a different storyline"—a part of the cultural imaginary that the Marvel Cinematic Universe (MCU) superheroes help to solidify.

But what if overcoming were an incomplete way of understanding superhero narratives? What if trauma and disability were not just crucial features of superhero origin stories, but ongoing characteristics of their adventures? What if the continuance of trauma and disability were essential features of what continues to make and remake superheroes? This is exactly the claim that I advance in this chapter. I argue that trauma and disability are enduring aspects of many superhero stories in the MCU and that both are necessary to perpetuate these heroes' commitments to fighting for justice.

My chapter brings together two recurring themes in superhero stories: trauma and disability. Trauma and disability are devices that help to establish a story of overcoming—the dominant approach to understanding a superhero is that they are someone who has overcome significant personal obstacles to pursue justice (DeVolder 2013). While overcoming stories are often tales of inspiration, they are also deceptively limited and limiting because they depict trauma and disability as detractors from moral status. I propose that we reread these stories through an alternate framework that I call the lens of endurance. Endurance invites viewers to recognize the staying power of trauma and disability in superhero narratives, calling attention to their lasting effects and persistent sources of power in the heroes' pursuit of justice. Perhaps most importantly, it disrupts the stereotypical understanding of disability as an obstacle to overcome if one aspires to goodness.

I make this argument by examining the character arcs of Tony Stark, from the Disney-produced movies in the Infinity Saga of the MCU, and Jessica Jones, of the Netflix-produced Defenders television series. Tony and Jessica are good examples of characters who undergo repeated acts of trauma, whose disabilities remain central throughout those traumas, and for whom the combination of trauma and disability propels their pursuits of justice. While both characters appear to overcome their disabilities, this is facilitated by their respective classes and genders, which mask the ways in which trauma and disability remain central to their status as superheroes. The lens of endurance offers an important corrective to overcoming that accounts for the ways in which trauma and disability act as productive resources for pursuing justice rather than hindrances to that project. (For an analysis of a more reductionist depiction of disability in Marvel cinema, see Fattore's chapter on *Agent Carter* in this volume. For alternative takes on Stark as an exemplar of ancient Greek heroism or as an embodiment of problematic masculinity, see chapters by Kohen and Cassino in this volume.)

In the sections that follow, I first establish that Tony and Jessica are characters whose origins are rooted in trauma and disability. I provide evidence for the uncontroversial claim that these characters' core narrative arcs can be told as stories of overcoming. Then, more controversially, I demonstrate that these stories of overcoming are compulsory and audience expectations for these characters to overcome their trauma and disability are structured by their gender and class differences. This leads to a higher expectation of overcoming for Tony Stark—a wealthy (white) man—than for Jessica Jones—a poor (white) woman. In comparison, Jessica Jones's story of overcoming is more complicated and comparatively modest, showing how trauma and disability persist as personal growth is achieved. Her story disrupts the hegemonic expectation to master trauma and disability and allows for a new reading of trauma and disability as central, persistent features of superhero stories. I introduce this framework to show that both characters repeatedly undergo traumatizing events and that their resultant disabilities are central, lasting features of their pursuits of justice. I conclude by reflecting on how the lens of endurance alters the plane of trauma and disability representation in superhero media.

Origin Trauma and Resultant Disabilities in Marvel Cinema: Tony Stark and Jessica Jones

Trauma—psychically violent events that lead to complicated grief, recurring anger, heightened anxiety, and a host of other, often unpredictable reactions—is a persistent feature of the MCU's central heroes' origin stories.[1] Trauma is at

the core of the Avengers' Infinity Saga. Thor's eye is snatched out by Hela, his home plant of Asgard is destroyed before his eyes, and he witnesses the violent deaths of his father, mother, and brother. Steve Rogers watches in horror as his best friend and confidant, Bucky Barnes, plummets to his death, losing a battle against the formidable Hydra. Bruce Banner mourns the loss of control over his body and sense of self each time he awakens after a rampage as the Hulk. The adjacent ragtag Defenders are no strangers to trauma and grief: Matt Murdock and Danny Rand are orphaned at young ages, their childhoods quickly transformed into the serious business of rigorous martial arts training to stave off the formidable Hand. Luke Cage bears the trauma of violence in the prison system and the untimely death of his wife, Reva. Trauma is the uberdisruptive events that physically, emotionally, and psychically transform superheroes' worldviews. The transformation is inward, often triggering a cavalcade of emotions, including guilt, shame, anger, denial, avoidance, and fear, prompting superheroes to conduct a moral inventory. It is external as well, as many superheroes embody trauma in new disabilities and come to adjust to life as the inhabitants of "non-normative bodyminds [in a] normalized society" (Samuels 2017, 130). Trauma alone does not create superheroes; rather, it is the subjects' response to trauma that defines them. Superheroes channel the energy generated by traumatic experience and the resultant transformations into fighting for what they believe is just.

Trauma-cum-disability defines the origin story of the Infinity Saga's central hero, Iron Man, transforming him from a "playboy billionaire" into a morally driven vigilante. In *Iron Man*, Tony Stark, a high-powered weapons manufacturer, is traveling in Afghanistan on business when a deadly explosion rocks his motorcade. The attack, orchestrated by the rebel group the Ten Rings, kills several US soldiers, but leaves Tony alive and hanging on by a thread. The blast disables Tony by lodging deadly shrapnel in his chest. He is saved through emergency surgery that outfits him with a prosthetic, preventing the shrapnel from shredding his vital organs. Thus, in the span of just a few hours, Tony goes from being an unassailable economic elite—one of the richest and most powerful weapons manufacturers in the world—to a kidnapping victim, a forced laborer, and a newly disabled man, all of which compel him to confront his vulnerabilities in a way he never has before. Out of desperation, Tony builds the prototype Iron Man suit to escape his captivity with the Ten Rings, is rescued and returned home to the United States, and then single-handedly upends the core structure of his company, Stark Industries, when he publicly announces that it will stop selling weapons. Step by step, Tony's story exemplifies the superheroic story of overcoming. A man's world is turned upside down in an instant, leaving his body broken, and seemingly his spirit as well. Through a kind of "superheroic alchemy," he musters the strength and courage

to progress past that trauma, masters his body, perseveres against the enemy, and becomes the superhero—fighting the injustices of which he was previously unaware or unable to combat (Alaniz 2006, 309).

Despite striking aesthetic, scale, and narrative differences, at its core, *Jessica Jones* also contains the key qualities of the overcoming story, as a woman progresses through trauma and adapts to her disabilities to vanquish an evil enemy in the name of justice. *Jessica Jones* redirects our attention from the elite-centered story of Iron Man to the hard-knock tale of an orphan and sexual assault survivor. Jessica's origin story unfolds in two waves: first, her initial trauma and disabling as a teenager and second, her recovery after undergoing prolonged physical and sexual abuse as an adult. In the first wave, Jessica's life suddenly changes forever, like Tony's, when she is a passenger in a car. Teen-aged Jessica is arguing with her younger brother when the family car crashes suddenly into another vehicle after Jessica's father becomes distracted by the siblings' argument. Jessica subsequently wakes in the hospital to find herself alone and is told that she is the sole survivor of the accident and that she will be taken in by teen star Patsy Walker (later known as Trish) as an act of good-will and charity. A despondent Jessica quickly discovers that her new home is an abusive one, where Patsy and her controlling mother have explosive argu-ments over Patsy's career. During one argument, a stressed Jessica seeks refuge in the bathroom where she discovers that she possesses incredible strength after accidentally breaking a marble sink. Initially intimidated and confused by her new abilities, Jessica keeps them secret but then instinctually wields them for the first time to protect Patsy from Dorothy's abuse.[2]

Jessica's initial transition to hero unfolds over years rather than weeks, like Tony's. As a teen and young adult, she toys with the idea of adopting a secret identity ("Jewel") to become a superhero, but she ultimately utilizes her pow-ers intermittently in the name of good, acting on instinct rather than intention and often in defense of children. In one such moment, Jessica saves a young man from a brutal mugging in a New York City alley. Her slow ascent to su-perheroism is interrupted by Kilgrave, who, after witnessing the act, becomes enamored with her. Using powers of mind control, he kidnaps her, rapes her, and commands her to do violence against others for an entire year.

The second wave of Jessica's origin story takes place one year after her escape. Jessica, now a private eye, learns that Kilgrave, whom she has long believed to be dead, is stalking her. He reveals himself by sending the parents of a young woman to Jessica to find their missing daughter, Hope Shlottman. Jessica finds Hope abandoned by Kilgrave in the same hotel he took Jessica, where he has recreated the anniversary of her kidnapping. Jessica rescues Hope, still under Kilgrave's mind control, and reunites her with her parents. Unbeknownst to Jessica, Kilgrave has left Hope with instructions to kill her

In *Jessica Jones*, audiences experience the trauma that is often central to Marvel cinema, not through the lens of an elite such as Tony Stark but from the vantage point of a hard-knock orphan and sexual assault survivor. From *Jessica Jones* (2015).

parents upon their reunion, which she does. Their deaths send Jessica a stark message that Kilgrave will use any means necessary to avenge himself. In response, Jessica musters the resolve to push through her trauma, wield her powers for good, and stop Kilgrave's evildoing.

Tony's and Jessica's ability to overcome their traumas and conquer their disabilities exemplifies the core features of what disability studies scholars call "the supercrip." The supercrip is a trope in which a person with disabilities becomes a source of inspiration and wonder by defying ableist expectations of what a "normal" person ought to be able to do.[3] The supercrip calls attention to the assumption that people with disabilities are innately pitiable and that therefore, almost any achievement can elicit patronizing praise (Berger 2008, 648). Whether running the fastest mile on record or learning to tie their shoes, supercrips confer moral worth on disabled persons as mere sources of inspiration for the abled (Young 2014). Tony and Jessica are inspirational because they persist in the face of their disabilities. Ostensibly, Tony Stark's disability is the shrapnel lodged in his chest that threatens to pulverize his heart and necessitates the miniaturized arc reactor implant that he uses to power the Iron Man suits. For Jessica Jones, her superstrength apparently disables her, making her both a walking weapon and a target, and she learns to control it in order to track and defeat Kilgrave. Tony and Jessica are also disabled by the lasting effects of their trauma in the forms of complicated grief, alcoholism, and post-traumatic stress disorder (PTSD), which harm their daily lives, closest

relationships, and heroic missions.[4,5] But the corporeal dimensions of their disabilities are not strictly separable from their psychic dimensions; they are "bodyminded," or mutually constitutive. Tony and Jessica grapple with excessive drinking, sleeplessness, panic attacks, public brawls, property destruction, and crippling anxieties. They persevere despite all of this to confront the Ten Rings, Kilgrave, and others, to the awe of viewers.

The story of overcoming also amplifies the story of the supercrip by uniting disability and trauma, doubling down on expectations of self-pity and making the rise to superhero all the more impressive. The assumed "ordinary person" at the heart of the overcoming story is thrown into a violent situation that disables them, leaving lasting physical and psychic effects, and then dazzles onlookers as they persist against this pain and wields their newfound capacities to better the world. The overcoming story centers on tenacious individuals not just surviving tragedy but capitalizing on their trauma and disability to transform themselves into extraordinary individuals deserving of fame and acclaim (Schalk 2016, 73). Again, Tony and Jessica are no exceptions. Their trauma and disability represent a crossroads. At the peak of their origin stories, these would-be superheroes (a moment familiar to supervillains as well) must decide to either wallow in their misfortunes or make something of them. They become superheroes because they not only choose resilience over self-indulgence but channel that resilience into fighting for justice for themselves and others. Overcoming doubly commits to the moral sentiment that in the face of trauma and disability, hyperabilities wrought through strength and tenacity are the most valued characteristics of the subject.

Overcoming, the central message of the supercrip, mandates resilience as a moral imperative, misconstruing the messiness of trauma and its resistance to containment. In doing so, it bifurcates the subject into those qualities that make the superhero and those of being a superhero. As far as supercrips are concerned, disability is an obstacle to superhero status and, if left unmastered, threatens their essential quality, which is good moral character. What is underexplored in superhero supercrip stories is the extent to which the moral imperative to overcome aspects of the self is tied to the characters' gender and class status.

In the section that follows, I show how Tony Stark is the essential powerful subject at the core of the superhero Iron Man, whose trauma and disability are in tension with his masculinity and wealth. As a rich, intelligent, handsome, able-bodied man, Tony evokes contemporary expectations of invulnerability in almost every aspect of his being. The trauma and disability that propel him into becoming Iron Man seem to be "pit stops" on his way to the extraordinary, leaving little room for an alternative reading. Jessica Jones, by comparison, has much greater expectations of vulnerability built into her character because

she is poor, a woman, and a victim of sexual assault. Audiences are prompted to continually conceive of Jessica as a victim because she lacks the resources that would allow her to bootstrap her way out of her "misfortunes." The material dimensions of these characters' stories thus yield very different pictures of what "counts" as overcoming. Reading them side by side in the context of these gendered and classed dynamics allows me to disrupt the perception of compulsory overcoming in superhero stories as solely the product of the heroes' good character.

Compulsory Overcoming: Masculinity and Wealth Make the Hero?

The story of overcoming in the MCU is fortified by the subjects' social status, namely wealth and masculinity. No character demonstrates the compulsory nature of overcoming better than Tony Stark. After Tony returns from Afghanistan, having escaped the confinement of the Ten Rings, he proceeds to become the superhero known as Iron Man. Tony is the CEO of Stark Industries—a family business that has amassed him an incredible fortune—and he redirects the company from producing and selling weapons to other technological innovations, no longer wanting to be a party to funding the war in Afghanistan. But Tony does not divest from the manly pursuit of combat or weapons manufacturing. Instead, he begins to engineer a personal weapons system: a specially fitted suit that gives him the power of flight, superstrength, and a defense system called repulsors. Tony, the now one-man weapons system, takes to rooting out the evil lurking within his own company and in subsequent films helps to lead the Avengers in a series of high-stakes battles against alien forces bent on attacking Earth. While Tony's daring actions, headstrong personality, and expansive genius are lightened by his comparatively down-to-earth companions, James Rhodes and Pepper Potts, his story is a clear-cut narrative of overcoming. After the attack from the Ten Rings, Tony has the resources and the reasons to hide in his mansion, away from the world, never to be kidnapped or seriously threatened again. Instead, he harnesses his wealth, intelligence, and energy to emerge triumphant as Iron Man and run straight back into danger, not just as a man but now also as a superhero dedicated to fighting "the bad guys."

Tony is the picture of privilege: he is handsome, witty, intelligent, rich, and a playboy. He embodies what Garland-Thomson calls "the normate." According to Garland-Thomson, "The term 'normate' usefully designates the social figure through which people can represent themselves as definitive human beings. Normate, then, is the constructed identity of those who, by way of the bodily configurations and cultural capital they assume, can step into a position of

authority and wield the power it grants them" (Garland-Thomson 1996, 8). Tony has almost all of the "bodily configurations" and "cultural capital" that we might imagine one person could possess today: he is supremely wealthy—a capitalist born into the ownership of a multibillion-dollar corporation—he is straight, handsome, sexy, white, tall, and able-bodied with no outward signs of vulnerability. The fact of his being is what Audre Lorde calls "the mythical norm," which is the combination of social positions that amount to the ultimate position of privilege (Lorde 1987, 116). Tony's exceptional privilege is underlined by his origin story, told in *Iron Man*, where, a mere seventy-two hours before becoming disabled, he is honored at an awards ceremony in Las Vegas. At this time, splashes of Tony's life are shown to us: Tony at the top of his class at MIT before he is eighteen, posing for magazine cover photos, and rising to international fame in the tech and weapons industries by his early twenties. A narrator tells us exactly how we should think of this all-American man: "Tony Stark: visionary, genius, American patriot" (IM 4'20").

What stands out when we read these two stories side by side is how heavily gender and class contribute to creating the respective standards for their overcoming. Through all of these aspects of his particular position, the confidence we have in Tony to overcome trauma and disability is given to us by his normate status; he is the ultimate insider with the intelligence to justify his place at the top of the social hierarchy and a massive stock of resources to play with. These things enable Tony to make himself into Iron Man. His becoming a superhero is not just a moral awakening; it is also a defensive response to the violence he has inflicted on the people of Afghanistan as a weapons manufacturer, the former wrongs he has committed as a normate. And Tony suffers for those wrongs when he is kidnapped by the Ten Rings, leaving him scared and scarred. But he saves himself when he invents the miniaturized arc reactor that protects his heart and redeems himself through the new direction of his company. He leaves the cave to "step into a position of authority and wield the power it grants" by remaking his own capital, his body, and his everyday reality (Garland-Thomson 1996, 8). In this story, we do not just witness Tony's ability to overcome his trauma and disability; we are also told from the time that Tony, the "visionary, genius, American patriot," is introduced to us that we ought to expect it.

In many ways, Jessica Jones's story appears to be one of overcoming, like Tony's, but the expectations of that overcoming are tempered by her gender and relative poverty. At the start of season one of *Jessica Jones*, the title character is at a low: she self-isolates from the only person she considers family and shuns her neighbors. She resides in a dirty, barely furnished apartment in Hell's Kitchen—a rough-and-tumble neighborhood of New York City. She has no coworkers or professional colleagues with whom she is friendly. She

Tony Stark is the essential powerful subject at the core of the superhero Iron Man, whose trauma and disability are in tension with his masculinity and wealth. From *Iron Man 2* (2010).

drinks heavily day and night. She cannot sleep because of lasting nightmares and flashbacks of her former abuser, Kilgrave, whispering in her ear (JJ 1.1). It is unclear how much of Jessica's loner status is chosen or forced because her superstrength has led to her being labeled a "freak." Unlike Tony, Jessica's aloneness lacks glamour; she has no seaside mansion to hide in, no high-tech workshop to tinker in, no high-powered social favor to excuse her eccentricities (like that of an industry heir and CEO). She is a beautiful woman with a stubborn scowl who resigns herself to a seedy night job and seeks refuge at the bottom of a bottle of whiskey. Jessica embodies tragedy. She is a "waste," and she is wasting away in the aftermath of her traumas. Jessica's overcoming rests not on resetting the direction of a multinational corporation or the takedown of a terrorist organization but rather on finding some semblance of a "normal" life.

As season one unfolds, Jessica gradually emerges from hiding. She learns that she is being stalked by her abuser, who she thought was dead. When he re-enters her life, making himself known by kidnapping, abusing, and controlling a young girl in the same way that he controlled Jessica, she is compelled to fight back. This sets in motion her trajectory from recluse to reluctant hero. Along the way, she uses her powers in front of larger audiences, widens her circle of friends and allies (albeit reluctantly) to help her track and fight Kilgrave, and develops deeper attachments to her best friend, Trish, and love interest Luke Cage. At the end of the season, the stubbornly alone Jessica even utters a heartfelt "I love you" in what is, perhaps, the most important sign of her overcoming—an acknowledgment of her attachment to others. Jessica does not command a weapons system or gain international fame for her work as a superhero as Tony does, but she overcomes her trauma enough to start commanding her own life again.

A classic story of overcoming, *Jessica Jones* is powerful and inspiring, even as the tone surrounding Jessica as a character and her story is markedly different from that surrounding Tony Stark. Whereas *Iron Man* is rich in bright, primary colors, accompanied by upbeat rock music, and the settings are adorned with shiny, expensive objects, *Jessica Jones* hits a darker note with cool blues and purples, the opening shots taking place at night in the dingy back alleys of New York City, and gritty shots accompanied by a cynical Jessica speaking over saxophone-led jazz music. While we might attribute these differences to the intended audiences of the respective pieces (*Iron Man* is the first of a multifilm, multimillion-dollar movie franchise produced for theaters and intended to appeal to broad audiences, young and old, and *Jessica Jones* is a Netflix-produced television show catering to a more mature audience and attracting newcomers to the superhero genre), the differences nevertheless help to construct our expectations for the characters within those stories. The distinct film noir lens of Jessica's story curtails viewers' expectations of a rosy ending with a clean-cut, happy Jessica (Green 2019, 174).

Furthermore, while Tony is introduced to the audience as the normate, a picture of strength and ability, Jessica is depicted from the outset as a gruff but deeply vulnerable character. Her status as an abuse survivor is made abundantly clear in season one of *Jessica Jones*, and its effects on her life are revisited time and again. As Rakes (2019, 83) comments, "We see right away that trauma is an ongoing embodied disability for Jessica, who in the first episode uses a ritual of naming the streets of her childhood neighborhood to prevent a full panic attack" (Main Street . . . Birch Street . . . Higgens Drive . . . Cobalt Lane) (JJ 1.1). The panic attacks are not all that sets Jessica apart; her status as a social outsider is reflected in all the ways she "misfits" with contemporary social norms (Garland-Thomson 2011). For instance, we learn through flashbacks that Jessica is chronically underemployed and struggles to fit into a traditional job setting, either quitting or getting fired from almost every job she takes on. In addition, Jessica is labeled disabled in a way that Tony is not. Time and again, she is met with coded language that signals her outsider status in society, such as "freak," "gifted," "special," and "retarded" (JJ 1.11 22'50"; 1.4, 35'). Jessica's sarcasm and sour demeanor further reinforce perceptions of her as a wayward figure rather than a hero.

Time reinforces the gendered differences between Tony's and Jessica's stories. Despite both characters assuming a tough exterior, Jessica struggles to demonstrate her overcoming of trauma, while Tony quickly steps back into the "bad boy" persona of his time before the kidnapping. Tony's work to overcome his encounter with the Ten Rings began immediately after his return to the United States, where at a press conference announcing his return he also sets out his commanding new vision for Stark Industries. But Jessica has

been wallowing in the memory of Kilgrave's abuse for a year (JJ 1.1). Living alone in her dark apartment with little sleep and a nearly constant flow of alcohol, she has been merely surviving. Jessica's grappling with this history is intermixed with memories of her family, showing that the abuse she suffered from Kilgrave is entangled with and compounds her survivor's guilt as the sole survivor of the car accident. Together these are constant, inescapable reminders of her vulnerability to death, assault, and an utter lack of control with no recourse. While we learn that Jessica is one year out from escaping Kilgrave's control, his voice whispers in her ear as though he were ever present—and she reacts as strongly and instinctively as though he were. The stagnation of Jessica's life is palpable in the early episodes of the first season, as evidenced by her flashbacks and resultant self-medicating.

The temporal dimensions of their stories are mediated by the characters' economic realities. Tony, unlike Jessica, is able to quickly pursue overcoming because he has the material resources to do so. He is able to physically distance himself from the kidnapping by leaving Afghanistan by private jet and returning to a private mansion in the United States. The nature of his work as the CEO of Stark Industries makes him the ultimate decider of when and whether to return to the region—something he only does again in the Iron Man suit. And while Tony's origin trauma in the kidnapping was a violent shock to him and many others, the event itself was exceptional and unlikely to be happen again, a further sign of how his wealth generally insulates him from violence and tragedy. But the sources of Jessica's traumas are rooted in the ordinary with high chances of retraumatization. She lost her parents in a car accident, a leading cause of death in the United States, and survived sexual abuse, something one in six American women are estimated to experience in their lifetimes (CDC 2020).[6] Kilgrave's powers of mind control mean that he can reach Jessica literally anywhere and anytime, bringing harm to her through even one person—killing her, or worse, if she lets her guard down. Jessica lacks the monetary means to escape to another city or country, to start a new life, or to hide in a comfortable fortress. As Green (2019, 175) notes, "For Jones, Kilgrave's superpowers are a vice in which her own will has been disabled. But for we viewers, his powers are a metaphor for a social ill that is so commonplace in our supposedly open, gender aware society that it frequently passes unnoticed." The sources of Jessica's trauma are rooted in domestic social ills and give an inescapable context to her story, whereas Tony wields the wealth and power of the capitalist, which enable him to shape his context. The pace of their respective progress is a reflection of their ability to signal that progress by changing their material surroundings.

Despite her hardships, Jessica enjoys class, race, and other privileges that help her to be a superhero. She lives in poverty, but her best friend, Trish

Walker, is a child star turned popular radio host who routinely bails Jessica out of trouble, financially and otherwise. She is tenuously allied with Jeri Hogarth, a ruthless, high-powered lawyer who funnels clients to her private-eye business and in return provides Jessica with legal counsel. While she lives modestly as an adult, she grew up in a spacious home in a quiet suburban neighborhood before the untimely loss of her parents and brother. Her comfortable background and high-powered friends serve as reminders of how far Jessica has fallen, but they are also a safety net that allows her to subvert a number of obstacles. Additionally, Jessica's superstrength and hard demeanor are softened by her fair skin, dark hair, rosy lips, and tall, thin physique, giving the impression that she is weak, feminine, and unthreatening. For instance, her beauty distracts from the seriousness of her alcoholism, which Luke Cage calls attention to when he invites her into his bar: "You're hot, drinking alone; that tends to attract customers" (JJ 1.1, 22'39"). Her class competency, financial and legal support, race, and beauty all allow her to move confidently and without suspicion through parks, hospitals, restaurants, apartment buildings, and other spaces. Jessica's overcoming is made possible by her social position as much as it is wrought by mental fortitude.

Like the trope of the supercrip, overcoming narratives send a moral message that superheroism rests on a subject's ability to move past trauma and disability to pursue a greater good—justice. In advancing this message, overcoming also tells a story of inspiration. Together, Tony and Jessica suggest that across the dimensions of wealth and gender, in the face of trauma and disability, overcoming is possible. Together they reinforce the compulsory nature of overcoming because they show how improvement, regardless of condition, is necessary for wrongs to be righted.

At the same time, the story of overcoming is limited and potentially destructive to our understanding of disability as a condition of possibility. The message of the overcoming story is that lasting trauma and disability are incompatible with the pursuit of justice as a superhero. This message is strengthened when delivered through a normate character such as Tony Stark. For a character such as Jessica Jones—a woman living in poverty—the ability to overcome is no less required, even if our expectations for that overcoming are different from those for a wealthy white man. Overcoming prescribes a single trajectory for disabled characters: they must get past their disabilities in order to be their best moral selves. This puts disability in tension with high moral status and as a result forecloses conceptions of disability as a state of possibility itself. For these reasons, I argue that we need another lens through which to understand trauma and disability in superhero narratives.

In the section that follows, I posit another framework for understanding trauma and disability as it appears in the stories of MCU superheroes: the story

of endurance. Endurance disrupts the story of overcoming and its core moral signal by showing that trauma and disability are ongoing features of the superhero's narrative arc. Trauma is not simply a "one and done" deal, as it may appear when we examine origin stories, but rather constitutes recurring acts within a superhero's story and creates lasting effects that radiate throughout the superhero's commitments to fighting for justice. Disability in this lens is not an impediment, impairment, or incapacity to overcome but rather specialized features that make the hero distinct.

Lasting Trauma and Resilient Disability: The Turn to Endurance

If overcoming is rooted in the understanding that trauma and disability are features of the superhero's past, then endurance stories rest on showing that they are a part of a superhero's present and future. Here, I reframe Tony Stark's and Jessica Jones's character arcs through this lens and in doing so make three key claims. First, I contend that trauma is not simply a feature of these characters' origin stories but that traumatic events are repeated throughout their stories and the effects of that trauma linger. Second, I contend that disability in their stories is not overcome but rather is a resilient feature of these characters' being. Finally, I reject the claim that Tony and Jessica pursue justice in spite of their trauma and disability; rather, repeated trauma and continued disability are what propel them into fighting for justice.

Endurance also requires that we shift our understanding of disability itself. In the endurance story, disability is no longer a mere hindrance—an inherent form of difference for a would-be-hero to master—but is itself a complex resource and an important aspect of a hero's being. Here, I analyze them in reverse order because, as shown in the section above, Jessica's overcoming exists in closer proximity to her traumas and disabilities because she is a woman living in poverty. This proximity offers an opportunity to read her story through the lens of endurance more easily than Tony's. Trauma and disability are no less important in Tony's journey, but they are allayed by his wealth and masculinity. As in the overcoming story, I continue to read Tony as a disabled character by virtue of his wounds from the kidnapping as well as his PTSD. Similarly, I treat Jessica as disabled by virtue of her superstrength and PTSD. I show how they all continue to play integral roles in the characters' abilities to be superheroes.

Meeting Hope Shlottman is a pivotal moment for Jessica's ascent to superhero that forces Jessica to relive her trauma and reexamine her relationship with her superstrength (1.1). From the moment that Jessica steps into the hotel room where she meets Hope after she has been discarded by Kilgrave, Jessica must confront her own past. She finds an innocent girl, manipulated, raped,

and trapped by a predator who has turned her into an object of pleasure. Jessica watches as Hope becomes an object of destruction under Kilgrave's control, committing a homicide and mimicking an act that we later learn Jessica was forced into as well. She knows from experience that Hope will spend her life immersed in the memory of killing her parents and with Kilgrave's voice whispering in her ear that she wants to do it, even as the tiny voice in the back of her mind tells her that it is wrong (JJ 1.3). She knows that such memories lead to a dark hole of resounding guilt and shame. Because of this, Hope and Jessica have a unique connection in their trauma, making them allies. But this connection also makes Jessica feel responsible for Hope because she is a tool that Kilgrave has used to lure Jessica back into his sights. Therefore, although the memory of that trauma endears Hope to Jessica, Jessica is newly traumatized by discovering that what is happening to Hope is because of her. Hope is the embodied symbol of Jessica's unending trauma and an omen of what is to come, creating an imperative for Jessica to act.

Meeting Hope is just the first in a series of repeated traumas that keep Jessica pushing on to track, capture, and eventually stop Kilgrave. Along the way, Jessica must press on with and despite her disabilities. Her strength strikes awe into others and incites fear and anger in nondisabled persons, in particular her neighbor Robyn, who blames Jessica for the disappearance and death of her twin brother, Ruben. Jessica's flashbacks and hallucinations haunt her as she tries to find connection with others. Her nightmares keep her from rest. But they are all also fodder for her fight against Kilgrave, acting as physical and extraphysical reminders that she has the (dis)abilities to stop him in a way that no one else can. As the story progresses, Jessica watches in horror as Kilgrave's violence escalates—she finds Ruben with his throat slashed in her bed (JJ 1.7); she finds Kilgrave's father, Albert, after another of Kilgrave's captives has sawed his arms off (JJ 1.11); dark bruises remain on Trish's neck after a Kilgrave-powered attack by a police officer (JJ 1.5); Jessica encounters Jeri with dozens of tiny cuts all over her face, arms, and legs after Kilgrave commands her ex-wife, Wendy, to attack her (JJ 1.10); and Jessica's neighbor Malcolm reveals that his debilitating heroin addiction is Kilgrave's tactic to socially erase him, allowing Malcolm to hide in the open and spy on Jessica (JJ 1.4). Jessica never overcomes these traumas; rather, she (and her viewers) are confronted with the undeniable reality that the trauma is inescapable and she must persist through it. No amount of strength allows Jessica to avoid or stop that trauma and she knows as well as anyone that even after Kilgrave's death, its effects will linger. And yet she presses on—never helpless or impervious.

The repeated traumatic events are also keen reminders of why Kilgrave pursued her in the first place—her disabilities. Kilgrave is fascinated by Jessica's superstrength and marvels at her. He further obsesses over her prior

trauma—the loss of her parents—as he too was abandoned as a child and iden-tifies with her. Kilgrave views Jessica as damaged and himself as her savior. In his eyes, by possessing her extraordinary being, he validates his own extraor-dinary status. Those same disabilities are part of what she must utilize to stop him. Her strength, her intimate knowledge of his power gleaned through his abuse, and her grit all feed her commitment to fighting Kilgrave. Only she has the history and presence of trauma to keep reentering the fight, and further-more, it is the right thing to do.

Perhaps one of the most stringent reminders that Jessica's story is not one of pure, uncomplicated overcoming but of soldiering on with trauma and dis-ability is Jessica's relationship with happiness. At the end of season one, we see her in the same place where we met her, her disheveled apartment, with holes in the wall, glass scattered on the floor, few furnishings, and bare walls. She sits at her desk with a bottle of whiskey. She sends out a blank stare from under a furrowed brow. Her clothes are black and gray. Only Jessica's neighbor Malcolm remains, answering her phone for her—an act of help that she does not welcome. Her closest confidants take space from her—she does not recon-cile with her former lover Luke, and Trish returns to her own polished home in a wealthy part of town. Jessica remains lonely, burdened by a new memory of killing someone—an act she does not find solace in, even after bearing witness to all of Kilgrave's cruelty. There is no narrative telling us that she has moved on or resolved to heal. She simply is, sitting in the middle of everything that has happened. If this were a true overcoming story, then we would have clo-sure, such as a narration from Jessica about how she has moved on, a note or flower from Luke promising hope, or another symbol to signal the audience that Jessica will get better. Instead, we are left with Jessica in the same apart-ment, not unlike how she was when we met her—steadfast in the belief that happiness, comfort, and moving on are not for her (Green 2019, 182). Rather, she has achieved greater acceptance of who she is, a person with exceptional capacities that allow her to help others. Even if she cannot help herself, she endures.

Though less obvious, Tony, like Jessica, is also better understood in a frame-work of endurance. In *Iron Man 3*, Tony exhibits visible signs of PTSD, much like Jessica. I trace the story of Tony's trauma by going all the way back to *Iron Man*.[7] Tony exhibits signs of PTSD throughout the first movie in which he appears, and these signs continue throughout *Iron Man 2* and *The Avengers*. Tony's origin story exposes how the kidnapping in Afghanistan set in motion the anxieties that are the crux of his disabilities. After the kidnapping, Tony becomes filled with a desperate need to control technology and power as a way to protect himself against his own vulnerabilities. Recall that when we first meet Tony, he is quickly disabled as he visits Afghanistan to showcase

some new weapons to a US military outfit, as he is a major weapons developer. In the desert, Tony debuts "Jericho"—a show-stopping, multitargeting weapon that will raze enemies to the ground. Tony declares, "They say the best weapon is one you never have to fire. I respectfully disagree—I prefer the weapon you only have to fire once. That's how Dad did it; that's how I do it. Find an excuse to let one of these off the chain and I personally guarantee you, the bad guys won't even want to come out of their caves" (IM 14'35"). This speech foreshadows Tony's rise as Iron Man and sums up his entire approach to the Avengers. Following this moment, Tony's quest is one of continued attempts to overcome his own vulnerabilities to enemies whom he cannot anticipate—from Obadiah Stane (*Iron Man*) to Ivan Vanko (*Iron Man 2*) to the Mandarin (*Iron Man 3*) to Thanos (*The Avengers: Infinity War* and *The Avengers: Endgame*). He seeks to build and control ever greater weapons to "keep the bad guys in their caves."

What propels Tony to become Iron Man is the dual realization that he has yet to build the weapons system that will afford him the security he actively profits from and that his weapons are being used *by the wrong people*. Although he returns from Afghanistan and immediately announces that Stark Industries will no longer produce weapons, this is not entirely true. Stark Industries will stop producing weapons for the US military to buy because it has not been able to keep those weapons out of the hands of non-US forces. Tony does use the money, technological advances, and infrastructure of Stark Industries to develop dozens of Iron Man suits that he alone will control. I read Tony in this moment and the scenes that follow as someone who is reeling from the traumatic event of the kidnapping. Tony, because of his resources and intellect, is himself a target who will continue to attract violence and manipulation by groups such as The Ten Rings. Therefore, Tony makes himself, through the Iron Man suits, into an even more dangerous weapon in order to protect himself from becoming vulnerable, protect the people he loves, and attempt to secure the peace that he desires.

Going forward, Tony is driven by his need to control the use of violence and make himself the center of global force with the Iron Man suit. He confesses as much when appearing obstinate before Congress in *Iron Man 2*.

Senator Stern: Mr. Stark—do you or do you not possess a specialized
 weapon?
Tony Stark: I do not.
Stern: You do not.
Stark: I do not. Well, it depends on how you define the word "weapon."
Stern: The Iron Man suit.
Stark: My device does not fit that description.
Stern: How would you describe it?

Stark: I would describe it by defining it as what it is.

Stern: As?

Stark: It's a high-tech prosthesis. That is the most apt description I can make. . . . I am Iron Man. The suit and I are one. To turn over the suit would be to turn over myself . . . [and] I'm your nuclear deterrent. It's working. We're safe. America is secure. You want my property? You can't have it! But I did ya a big favor! I've successfully privatized world peace! (IM2 11'05").

In this scene, Tony reveals that the prosthetics he wears to treat one of his disabilities are about more than keeping shrapnel out of his chest. He has merged with the Iron Man suit in an attempt to exert control over potential threats of violence, protecting himself and the world as he sees fit. On the surface, Tony is a "lovable jerk" who puts himself in harm's way to the benefit of Americans. But what is less obvious is that Tony began this journey as a survival strategy after he found himself face-to-face with his own vulnerabilities. The same incident forced Tony to confront the consequences of being the CEO of Stark Industries, a man complicit in proliferating war and violence. This lasting memory never leaves Tony, and he consistently revisits the traumatic knowledge that he is responsible for death; his time as Iron Man is spent seeking to make up for that death.

The evidence of Tony's disabling guilt and anxiety, coupled with his genius and material resources, manifest in a compulsion to build more and more Iron Man suits. While it reaches its pinnacle in *Iron Man 3*, this trend begins in *Iron Man 2*. By *Iron Man 3*, Tony has created an army of Iron Man suits, now fully operable independent of his body but still under his complete control through the computerized system J.A.R.V.I.S. The suits arise at the same time that the signs of Tony's PTSD intensify: Tony experiences a series of panic attacks at the mere mention of the Battle of New York—at the pub with James Rhodes, in Tennessee with Harley at the site of veteran Chad Davis's explosion, and outside the car when he learns that the Iron Man suit is out of commission and that he will have to venture to the location of the Mandarin without it. Tony acknowledges his PTSD when he confesses to Pepper Potts that he is not who he was before the Battle of New York.

Tony Stark: I'm a piping-hot mess. Been going on for a while, and I haven't said anything. Nothing's been the same since New York.

Pepper Potts: [sarcastically] Oh, really? I didn't notice that at all.

Stark: You experience things. And then they're over. And you still can't explain them? Gods, aliens, other dimensions? I'm just a man; I can't. The only reason I haven't cracked up is because you moved in, which is

great, because I love you. I'm lucky. But honey, I can't sleep. You go to
bed, I come down here and do what I do. I tinker. Threat is imminent,
and I have to protect the one thing I can't live without. That's you. And
my suits they're—

Potts: Machines.

Stark: They're a part of me.

Potts: A distraction.

Stark: Maybe.

Tony Stark's self-destructive tendencies are prominent features of earlier
movies as well. For instance, in *Iron Man 2*, Tony drinks heavily to soothe him-
self from the knowledge that the arc reactor is slowly poisoning him, and he
is unsure of how to stop it. At first glance, his drinking appears to be a coping
mechanism and reaction to this stress. However, we could also understand this
behavior as part of a lasting effect of the PTSD from his origin story in *Iron
Man*. Furthermore, it is part of a pattern of self-destructive behaviors that feed
his insomnia and obsessions with control in *Iron Man 3*. When Tony confesses
to Pepper that he cannot stop building Iron Man suits, viewers are not witness-
ing a new chapter in his story but an old chapter revisited. Tony has been at
war with his own vulnerabilities for years, and throughout his arc in the Infin-
ity Saga, we continually witness his attempts to amass power through the use
of his Iron Man suits.

The obsessive need to keep growing his stockpile of personal weapons di-
rectly feeds Tony's returns to combat—the battles through which he seeks jus-
tice. Each suit propels him into a new conflict, and each conflict leads to the
building of more suits. Each conflict is a traumatizing event and each trauma
feeds Tony's compulsion to protect himself and his loved ones from further
harm. The cycle is one of exponential growth with each new threat to the
world growing bigger and more complex, incurring greater numbers of casu-
alties and requiring Tony to give more and more of himself. At the end of the
Infinity Saga, in *Avengers: Endgame*, Tony dies when he confronts and wields a
power, given by the Infinity Stones, that is so great that he could never create
and control it beyond a single, self-redeeming moment. In the final scenes of
the Infinity Saga we witness Tony returning life to Earth for the first time, mak-
ing up for all the destruction that he has been party to in previous films. Tony's
final act of atonement is the snapping of his fingers, bringing back the lives lost
in the "Snapture" with a spoken reaffirmation that his trauma and disability
are a part of what defines him: "I am Iron Man."

Endurance brings forward the centrality of trauma and disability in making
Tony's and Jessica's stories possible. At the end of their character arcs they have
shown clear signs of progression through forging meaningful relationships,

vanquishing enemies, and achieving new command over their disabilities. But even though these characters are transformed through trauma and disability, they are never rid of them. As these final scenes reveal, their past experiences with trauma—violence, loss, and helplessness—are with them until the end. Furthermore, reexposure to trauma and their remaining disabilities are what allow them to continue to be superheroes. Endurance shows that to be heroes, Tony and Jessica remain immersed in trauma and disability, achieving great things with them, however fraught.

Conclusion

The endurance framework is an important addition to understanding trauma and disability in MCU superheroes. It rightly complicates the story of over-coming but does not completely displace it. Most helpfully, it maintains the overcoming story's central insight, which is finding inspiration in superheroes. While supercrip narratives are troubling in the ways that they reduce disability to "inspiration porn" for an abled audience, superhero stories remain allur-ing because of their interplay between the ordinary and the fantastic. It is the marriage of superpowers with human stories that makes epic adventures and the characters within them compelling (Young 2014). Tony Stark and Jessica Jones do exactly this, offering divergent ideas of how characters with wildly different social statuses can surprise and confound after trauma. Where the collection of superhero supercrip stories falters is in the compulsory nature of overcoming. When superheroes cannot fail to overcome in order to be super-heroes, they lose their most compelling connections to their audiences, which are their abilities to be vulnerable, pliable, and mortal. And insofar as these narratives moralize overcoming, they obscure the ways in which superheroes trouble the line between good and evil, success and failure, right and wrong.

Thus, endurance should be positioned side by side with the narrative of overcoming, and I have attempted to provide evidence for each of these frame-works in the same character arcs, showing how they can coexist in imperfect harmony. Endurance complements the critical insights of overcoming with an understanding of traumatized and disabled figures as complex agents of jus-tice. The framework of endurance does important work in recovering the com-plexities of trauma and disability in superhero media. It also complements the critical insights of the supercrip, "the antithesis to that other despised master image of disability in mainstream culture: the sentimentalized, pathetic poster child wheeled out for telethons and tearjerkers" (Alaniz 2006, 306). While a superpowered supercrip read through the lens of overcoming posits that dis-ability is no excuse for limitation, endurance refutes this claim and makes it

possible to recover and claim inspiration in the supercrip without collapsing inspiration together with overcoming (Schalk 2016, 72). Instead, it brings to the forefront the reality that we do not need to erase trauma and disability to find disabled people inspiring. It highlights the dark reality that the pursuit of justice is not the opposite of justice but instead often brings new traumas, disabilities, and dynamics that superheroes must continually learn to navigate. Perhaps best of all is that the framework of endurance illuminates how disability is a condition of possibility. Where overcoming prescribes a singular path of improvement, endurance accepts improvement without necessitating it. Justice, from the perspective of endurance, is not the result of overcoming trauma and disability but something that becomes possible in their midst.

Notes

1. My conceptualization of trauma is informed by a grouping of medical institutions and organizations, including the American Psychological Association (2022), the Mayo Clinic (2022), the Academy of Cognitive and Behavioral Therapies (2021), and the Mental Health Foundation (2016).

2. Jessica's newfound strength is largely a mystery. It is not until season two of *Jessica Jones* that we learn that Jessica's abilities are the result of scientific experiments performed on her after the crash by the genetic technology clinic IGH. Initially, viewers know only what Jessica does: that a life-altering instant changed her family structure, her body, her mind, and her future.

3. By "ableist," I mean a set of expectations of performance based on an idea of a non-disabled person, someone whom we might (problematically) describe as "normal." For more, see Siebers (2008), Carlson (2001), and McRuer (2006).

4. For more on bodymind, see Price (2015).

5. Many scholars have commented that Stark and Jones exhibit classic symptoms of post-traumatic stress, including nightmares, insomnia, panic attacks, and substance abuse. For more, see Samuels (2017) and Rakes (2019).

6. See also RAINN (2020). Globally, this number is even higher, with almost one in three women having experienced violence from a partner or sexual violence from a nonpartner and the greatest prevalence for women in developing countries (UN Women 2021).

7. For a different perspective, see Samuels (2017).

CHAPTER 5 CAPTAIN AMERICA VS. JAMES MADISON

Christopher J. Galdieri

Who watches the watchmen? The conundrum of how to control those who possess great power has long captivated both political philosophers and the creators of superhero stories. In politics, how can a government possessing great power be constrained from using that power to harm the liberties of the governed? In superhero stories, how can individuals with extraordinary abilities be trusted to use those abilities for the common good rather than for their own enjoyment, profit, or evil ends?

Some superhero stories sidestep this question by casting their protagonists as defenders of the status quo, with antagonists who serve as negative examples and whose defeat restores the superhero's world to the one outside the reader's window. The Fantastic Four defeat Galactus, or Spider-Man beats the Vulture, and the people of their New York can then return to their normal business. Others, such as *Watchmen* or *Squadron Supreme*, present a world so transformed by the presence of superbeings that it bears only a passing resemblance to readers' reality; it can be difficult for readers to connect these stories' deliberations about how to control the powerful to real-world deliberations about how to hold the powerful accountable.

The Marvel Cinematic Universe (MCU) splits the difference between these two approaches. While superheroes, alien invasions, and other fantastical elements clearly distinguish the MCU's fictional universe from the world that viewers live in, the MCU nonetheless generally tends to resemble, in its broad strokes, the real world. And unlike stories that sidestep the question of how to regulate superpowered beings, MCU films routinely wrestle with difficult questions about how mortal governments and militaries can exercise oversight of superbeings such as Iron Man and the Avengers.

No character engages with these debates more than Captain America, played by Chris Evans in three solo films and four Avengers movies. Across these films, Cap presents a sustained consideration of what might restrain and control individuals with superhuman abilities. Somewhat remarkably, that consideration puts Captain America directly at odds with some of the best-known theoretical underpinnings of the US form of government, most notably articulated by James Madison in key sections of *The Federalist Papers*.

This chapter explores the differences between the two. Madison argues that

the structures and institutions of the US government will keep the federal government from exercising its power in ways that endanger Americans' liberties, even when individuals with less than pure motives hold office. The cinematic Captain America, by contrast, is wary of institutions precisely because they may be populated by people with hidden or sinister motives and argues that the only way to ensure that power will not be abused is to ensure that those who wield it are of good character.

That Captain America finds himself in conflict with the nation's fourth president and first political architect is consistent with the character's long—and often overlooked—history of ambivalence about the United States and its politics. When Steve Rogers socked Adolf Hitler on the cover of the 1941 *Captain America* #1, the United States was still officially a neutral nation in World War II. In the 1970s, Cap squared off against the Secret Empire, a supervillainous analogue to Watergate led by an all-but-named Richard Nixon (Englehart, Buscema, and Colletta 1974). One issue in the 1980s saw Ronald Reagan transformed into a monstrous reptile who fought Captain America in the Oval Office itself (Gruenwald, Dwyer and Milgrom 1988). A series that launched in the wake of 9/11 focused on domestic extremism and hate crimes, not international terrorism; soon after that, Captain America reflected on the bravery of French resistance fighters in what writer Ed Brubaker acknowledged was a direct response to anti-France rhetoric in the run-up to the American invasion of Iraq (Rieber and Cassaday 2003; Brubaker, Epting and Lark 2005). Many read a recent Secret Empire story as a commentary on the Donald Trump administration (Spencer, et al. 2017). Readers have followed the comics' lead; perhaps most dramatically, fans conducted a years-long letter column debate on the meaning of patriotism during the era of Vietnam and Watergate. Over the course of eighty issues, letter writers argued over "how a character designed to represent America should react to the changing cultural climate of the 1960s and 1970s. As the writers battled over their views of how Captain America should behave, each revealed personal views on what it meant to be an American during one of the more contentious periods of American history" (Stevens 2011, 607). A letter decrying Cap as a "defender of the Establishment" and a "glory monger" (Stevens 2011, 612–613) kicked off the debate. Some responses attacked the letter's author as "knocking patriotism" and "contemptuous of any and all ideals," while one archly noted that the establishment of the late 1960s was by and large a liberal one (Stevens 2011, 613–614). From these origins grew a sprawling exchange that touched on Vietnam, nationalism and universalism, and student protests before it ran its course.

Captain America comics have had the room to turn a critical eye toward American politics due in large part to the way writers have characterized Cap's relationship to the United States. While Captain America wears a

red-white-and-blue costume and fought in World War II, in his modern adventures, the character generally works with, but at a remove from, government agencies. Many stories have placed Captain America at odds or in open conflict with the government. This is possible because Captain America serves "the country, not the government" (Coates et al. 2019); as the character states in one famous sequence, he is "loyal to *nothing* . . . except the *dream*" (Miller and Mazzucchelli 2010). This distance from governing institutions makes the character a particularly trenchant vehicle for commenting on and critiquing American politics. Captain America, in the comics, represents an idealized, abstract image of America that the politics of a given moment will inevitably fall short of but toward which the country can always aspire.

The cinematic Captain America likewise offers a critique of American politics, but one that is broader and more theoretical than those of his four-color counterpart. In his film appearances, Captain America challenges established orthodoxy about the American government as it relates to power, authority, and the question of how to prevent power from being used for bad ends. Captain America argues, in deed and occasional word, that external controls and regulations on superpowered individuals are doomed to be ineffective at best and destructive at worst. Instead, Captain America argues that the only effective check on those who wield extraordinary abilities is the character of those individuals themselves. This position puts him decidedly at odds with James Madison's founding writings about American politics, which argue that institutions can and must constrain individuals of poor or sinister character.

Madison's Institutional Solutions to Deficits of Political Virtue

In the years leading up to the ratification of the US Constitution, James Madison, Alexander Hamilton, and John Jay wrote a series of essays—later termed *The Federalist Papers*—to sell skeptical Americans on the idea of replacing their young country's Articles of Confederation with a new form of government. The articles had foundered in large part because the government they created was, in an overcorrection away from the country's experiences as British colonies under King George III, too weak to address the problems of the United States. But many Americans were understandably wary of the more powerful federal government described in the Constitution. The proposed Constitution would create a president to serve as a chief executive of the government and commander-in-chief of the army and navy. Would this be a breeding ground for tyranny and a new monarchy? What would prevent the legislature, empowered in ways that the congresses created under the articles were not, from trampling the rights of citizens? Would the new federal court system subsume

state courts and serve as a precursor to the federal government absorbing the states that had just won their independence?

To some modern ears, these fears may seem overstated and hard to fathom, but in 1788, these were live issues. Madison, Hamilton, and Jay—writing under the pseudonym "Publius"—offered not just practical arguments but a fully formed philosophical exploration of the proposed US Constitution.

The challenge of self-government, they recognized, is that human beings are by nature self-interested and that this self-interest becomes dangerous when it is combined with the powers of the state. One way to limit that danger was to create a weak government, but the Articles of Confederation had failed precisely because they were weak. Madison and his compatriots needed to explain what, under the proposed Constitution's stronger and more robust government, would prevent the winners of elections from abusing their powers and using them to harm the losers or to remain in office permanently. What would protect Americans from the vices of those who would hold power under the new system of government?

Madison's response to these concerns was that the structure of the new government itself would counter and constrain those who would use its powers badly. He agreed with critics that there was no guarantee that the government would be populated with the high-minded and the virtuous; he went so far as to note that "enlightened statesmen" would not always be available to lead (Madison 2003a, 44). And this was precisely why the structure of the new government was crucial—that structure, Madison argued, was what would keep the flawed, ambitious, and self-serving in line. If men were angels, Madison noted, no government would be necessary, and if angels governed men, no controls on their government would be necessary (Madison 2003b, 252). But Madison's Constitution was written for flawed and fallen human beings, not for angels. By dividing the power of government among three different branches (one of which, the legislative, would further have its power divided between two chambers) and giving each branch the power to check or counter the actions of the others, the Constitution would ensure the liberty of Americans by making sure that everyone in government, regardless of character or intent, would have cause to keep an eye on everyone else. A president who abused his or her powers might be impeached and removed from office by Congress, for instance, while a Congress that passed a tyrannical piece of legislation could expect to see that bill vetoed by the president. Madison further argued that those serving in each branch would be incentivized to keep watch on the others so that even if the government were populated with untrustworthy individuals, the separation of powers among the different branches would nonetheless protect against abuses of power. While it could never be certain that those holding positions in the new government would be virtuous, they

would certainly have vices. Madison argued that the Constitution put those vices to good use—indeed, that they were central to the entire enterprise. By setting "ambition to counteract ambition" (Madison 2003b, 252), the constitution would ensure the protection of Americans' liberties.

Madison's view of the Constitution was an innovation in political thought. Earlier theorists of democratic self-governance had, like Madison, worried about the danger of ill-intentioned people winning power and then using it to bad ends. Many came to pessimistic conclusions that a democracy could endure only when its people and leaders were virtuous. Madison made a bold counterargument that vice, not virtue, would restrain the new government described in the proposed Constitution. In other words, Madison argued that properly constructed institutions can correct for deficits of virtue and good character. Arrange the government properly, arm the different branches with the capability to limit or check the others, and the vices of those who hold offices of public trust in that government will be stymied. The system, Madison promised, would do its work almost mechanically; as Kammen put it, the Constitution would be "a machine that would go of itself" (2006). Madison's answer to the question of who would watch the watchmen was that the watchmen themselves would keep a jealous and self-interested watch on one another.

Captain America's Institutional Skepticism and the Centrality of Character

One might fairly expect that Captain America, the living legend of World War II, would not be in fundamental disagreement with James Madison's view of America's political institutions and the people who populate them. Yet throughout his MCU appearances, Captain America repeatedly takes an opposite view, that institutions are only as good as the people in them and that all too often they are populated by people with ill intent who would abuse their power to serve their own selfish ends.

In an important sense, Steve Rogers is a different kind of hero than Tony Stark, whose narrative journey is about becoming a better and more heroic person, as Kohen describes in this volume. Steve Rogers, from the moment he is introduced in *The First Avenger*, is on the right side of his fights, whether he is battling a lout who complains about newsreel coverage of the war in Europe or trying to enlist in the army despite his frail stature, lying repeatedly on his enlistment forms in the hope of getting past the medical exam and sharing in the sacrifices his neighbors are making. Even as a civilian, Steve's personal sense of right and wrong, not external rules, guides his decisions. He is quite

willing to disregard rules that he thinks are wrong, as we see when he tries to enlist in the army despite his 4F status.

This pattern continues after Steve Rogers is transformed into Captain America. He rescues a group of Allied prisoners of war after being ordered not to; he goes to war against S.H.I.E.L.D. when he learns it has been covertly taken over by Hydra; he refuses to sign on to governmental oversight of the Avengers. And in every instance, the films bear out his decisions as the right ones. Where James Madison in *The Federalist* argues that political institutions, properly and correctly structured, can check the vices of those who wield power, the cinematic Captain America argues that institutions alone cannot rein in the powerful should they wish to misuse their power. Instead, it is the character of those who wield power that determines how that power will be used.

Several characters in the Captain America films personify this idea. The first is Steve Rogers himself. Before Steve undergoes the experimental treatment that turns him into a supersoldier, Professor Erskine tells Steve that he was chosen because he is "not a perfect soldier, but a good man." Erskine says that while the serum will give Steve strength, his years spent weak and frail will give him a respect for power and strength that other candidates for the treatment lacked. Before Rogers's selection, the director of the project wanted to choose another soldier, Private Hodges, but Erskine objected because Hodges, while already a strong and capable soldier, was in his view a bully and therefore not to be trusted with extraordinary power.

Of course, another character in *The First Avenger* presents an even darker mirror of Captain America: Johann Schmidt, the Red Skull, a Nazi officer who subjected himself to an early, untested version of Professor Erskine's supersoldier treatment. The treatment both disfigured Schmidt and made him superpowerful. Just like Steve Rogers, Schmidt also became more of what he had been before. But where Rogers is motivated by his belief in fairness and justice, Schmidt is driven by ego and a lust for power. He uses his newfound strength to found a rival organization, Hydra, to pursue his own interests in Nordic mysticism and to plan his own strikes against the Allied forces and nations. On a personal level, Schmidt revels in his superiority over other men. In their first meeting, the Red Skull tells Captain America that thanks to Erskine's work, they have both "left humanity behind" but that only the Skull "embraces it without fear." In the Red Skull, *The First Avenger* presents a cautionary counterpart to Steve Rogers: Johann Schmidt, a bad man given great power, uses it to pursue bad ends in the service of no one but himself.

The next two films, *Captain America: The Winter Soldier* and *Captain America: Civil War*, present the same basic take on the abuse of power, but with a different twist, namely, a good man who is controlled by bad people and used to accomplish bad ends. Bucky Barnes was Captain America's childhood

James Madison argued that political institutions could hold those in power accountable, but Captain America argues that it is the character of those who wield power that determines how that power will be used, an idea he encounters memorably in an exchange with Professor Erskine on the eve of his transformation into a supersoldier. From *Captain America: The First Avenger* (2011).

friend who enlisted in the army and ultimately became one of the "Howling Commandos" who fought Hydra alongside Captain America during World War II. While Bucky appeared to have been killed during the Commandos' final mission in *The First Avenger,* he was retrieved and revived by Soviet forces and Hydra. Together these groups brainwashed Bucky and turned him into "the Winter Soldier," a shadowy assassin kept in suspended animation between missions. Even after Bucky begins to shake off this brainwashing after encountering Captain America in *The Winter Soldier,* he remains susceptible to anyone who knows the sequence of words that trigger his programming, as happens in *Civil War.* Bucky himself remains a person of good character, and throughout both films, Captain America emphasizes to skeptical colleagues that Bucky is, despite his actions, a good man and Cap's friend. But Bucky's good character is for naught since he is not in control of his own actions. He does not choose or want to attack Nick Fury in *The Winter Soldier* or kill Tony Stark's parents in the prologue to *Civil War.* But because his preferences and his judgment have been superseded by the orders of those who reprogrammed him, he has no choice in the matter.

Bucky's role as the Winter Soldier represents Captain America's worst-case scenario: an individual of great power and good character is forced to commit bad acts, with no room for individual discernment or conscience, at the command of other, more powerful individuals. Where Madison envisioned institutions that would check the vices of those who held power, Hydra's control of Bucky represents a situation in which a virtuous person's virtues are checked in order to give free rein to the vices of those who control him.

The institutions presented in the MCU hold only limited promise for preventing the misuse or abuse of power. As Carnes notes in this volume, Marvel movies generally depict governments in a favorable light but depict them as both good and bad at times. The Captain America films are no exception to this pattern. S.H.I.E.L.D., the global intelligence agency, plays a complicated role in the Marvel saga. In the first *Avengers* film, Captain America works with, but not for, the organization when it assembles the Avengers to counter the Chitauri invasion. But he becomes suspicious of the agency when he learns that it has been studying Hydra technology leftover from World War II to help it develop its own weaponry. At the end of the film, the Avengers go their separate ways rather than become a standing team at S.H.I.E.L.D.'s disposal. If future crises arise, Nick Fury assures S.H.I.E.L.D.'s governing council, the Avengers will come together to meet them. By *The Winter Soldier*, Captain America's misgivings about S.H.I.E.L.D. have grown sharper. While he begins the film as part of a S.H.I.E.L.D. STRIKE team, he becomes uncomfortable in his role when he learns that S.H.I.E.L.D. is not giving him the full details of the scope and objectives of his missions. Later, he learns that S.H.I.E.L.D. is developing Project Insight, a worldwide surveillance system with the capability to strike at "dangerous people" instantly and without due process. Worse yet, Rogers discovers that Hydra has infiltrated and taken control of the leadership of S.H.I.E.L.D. over a period of decades, making Project Insight not just a troubling development but the potential triumph of an enemy that Cap thought had been defeated in World War II.

Hydra's stealth takeover of S.H.I.E.L.D. demonstrates Captain America's issue with institutions: they can be trusted only when those who are part of them are good people who are prepared to take risks and make sacrifices to hold them accountable. Cap's plan to stop Hydra from launching Project Insight reflects this viewpoint. He makes an appeal to the individual consciences of S.H.I.E.L.D.'s rank and file, telling them that they are all that stands between Hydra and "absolute control" of the world and that he is willing to bet that they will join him in opposing Hydra. In other words, Captain America tells the S.H.I.E.L.D. agents and staff that they must follow their consciences rather than their orders because S.H.I.E.L.D. has been corrupted. Only by exercising their independent judgment can they make the correct decision to resist. In one tense and memorable sequence, a nondescript S.H.I.E.L.D. technician refuses, at gunpoint, to initiate Project Insight and then says that he is following "Captain's orders." One suspects that Captain America would say he had given no orders to anyone or done anything but tell the truth and hope others would act accordingly. Similarly, Captain America's final battle with the Winter Soldier is not just a physical contest but one in which Cap's goal is to break through the reprogramming that robbed Bucky of his capacity for independent

judgment and action. In *Captain America: The Winter Soldier*, powerful and corrupt organizations can realize their goals only if they are able to impose their own judgment over that of the people who are part of them.

Tony Stark's plan for an autonomous global defense system in *Avengers: Age of Ultron* echoes Project Insight, with one key difference. Where Hydra would have controlled Project Insight, Ultron would have been answerable to no one. Stark feels that his system is a necessary step to protect the world from external threats such as the Chitauri invasion of the first *Avengers* film—threats too big to be left to mere humans to detect and combat. But for Rogers, Ultron is simply too dangerous and too unaccountable. Better to lose together against an alien force than live under the thumb of the unknowable and uncontrollable Ultron. By contrast, when the mysterious Vision emerges later in the film, Captain America is willing to trust him because he is able to lift Thor's hammer, an act that demonstrates his trustworthiness.

The most direct answer that the *Captain America* films give to the question at the heart of Madison's statement in *The Federalist Papers* comes in *Civil War*. The central conflict of this film is the dispute between Steve Rogers and Tony Stark over whether the Avengers will agree to be bound by the Sokovia Accords after a number of high-profile mistakes on the Avengers' part, including several deaths caused by the Scarlet Witch's powers during a mission in Lagos. The proposed accords would put the team under the supervision of a United Nations panel, which would have sole discretion over when and whether the Avengers acted. For Stark, the agreement will enable the Avengers to do their job better and is better than some alternatives that civilian authorities could come up with if the team continued to operate unchecked. For Rogers, the proposal is unacceptable for two reasons. First, he worries that oversight could prevent the team from acting when it is needed; while a UN panel might want the team to refrain from acting out of geopolitical concerns, Rogers tells Stark, "if I see a situation headed south, I can't ignore it." Second, and perhaps more importantly, the UN panel will be populated with what he calls "people with agendas" who might order the Avengers to go "somewhere we don't think we should go." This situation, from Rogers's perspective, runs the risk of turning the Avengers into a team of Winter Soldiers—removing the Avengers' ability to use their own judgment in favor of the decisions of officials whose motives may be less than pure. "We may not be perfect," he tells Stark, "but the safest hands are still our own." The alternatives hold the potential for the Avengers to lose their agency and be forced to become extensions of politicians' self-interested concerns.

Importantly, the film provides no indication that the UN has been infiltrated by an organization such as Hydra or that those on the panel have nefarious motives that would lead them to use the Avengers to further their own goals.

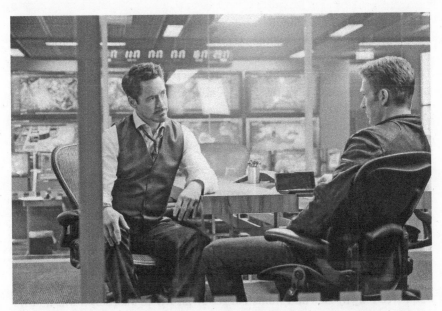

Tony Stark argues that the world needs a standing, formalized process to anticipate and respond to cosmic-level threats, but for Captain America, the proposed oversight is too risky to agree to, even at the cost of a strategic advantage over large-scale dangers. From *Captain America: Civil War* (2016).

As far as the audience knows, a garden-variety collection of bureaucrats and public servants would be sitting on this panel. And the Avengers' haphazard response to Thanos's attack in *Infinity War* suggests that Tony Stark has a good point about the need for some sort of standing, formalized process to anticipate and respond to cosmic-level threats. But for Captain America, the proposed oversight is too risky to agree to, even at the cost of a strategic advantage over large-scale dangers.

What is perhaps most notable about Captain America's position in *Civil War* is that it is both absolute and amorphous. At one point, he nearly signs on to the accords when Stark promises that "safeguards" could be added to them, but their détente lasts for just a few moments before Rogers once again concludes that the accords are unacceptable. There is no discussion of compromise or of revising the accords to allow the group more autonomy. The US secretary of state who proposes them to the team makes a strong case for oversight: given the power levels of the Avengers, individually and as a group, and the scope of their activities, the Avengers are simply too dangerous to be left to their own devices. The world needs to know that they are accountable to some sort of supervision. But reasonable points—ones that, if Thor's hammer or Iron Man's armor were replaced with the power to make laws or the power

to pardon, might sound familiar to James Madison—are no match for Captain America's intuitive sense that the accords are the wrong choice. The burden is not on Cap, in his view, to propose an alternative; his role, as he sees it, is to hold his ground in the face of something that's wrong. In this volume, Saideman uses the research literature on civil-military relations to consider the idea of oversight of the Avengers. But from Captain America's perspective, oversight conducted by institutions populated by flawed individuals—realistically, the only possible form of oversight—only raises the likelihood that the Avengers' power will be misused.

If institutions cannot be trusted to do the right thing, and some individuals cannot be trusted to do the right thing, then what alternatives remain? According to Steve Rogers, the solution is rooted in character. Good people will use their powers appropriately and to achieve good ends; they may not be perfect, and they may not succeed, but they will try. Those who would use great power against others and for their own benefit, such as the Red Skull, or those who would ensnare good people to use their powers for bad ends can be countered only by men and women of goodwill. Where Madison warns that we cannot rely on enlightened statesmen always being present, Captain America warns that we ultimately can rely only on the character of those who have power. Precisely because enlightened political leaders will not always be with us, we can be certain that any institution could fall prey to less than enlightened leadership.

The Founder or the First Avenger?

This is all well and good for Steve Rogers, who was pure of heart and noble in spirit even before he became a superhero. Even Baron Zemo, the villain of *Civil War*, acknowledges that great power never corrupted Steve Rogers. But can this approach—that the safest hands are those of good character—be generalized beyond Captain America himself? What about those who mean well but whose goodness is not itself a superpower? One possible avenue is mentoring or teaching, which the *Captain America* and *Avengers* series consistently value. *Age of Ultron* ends with Captain America and the Black Widow training a group of new Avengers. In *Avengers: Endgame*, five years after Thanos's Snap, Steve Rogers is leading a support group and encouraging people who are trying to put their lives back together. This subtly calls back to Sam Wilson, the Falcon, who was counseling veterans suffering from PTSD when he met Steve Rogers in *The Winter Soldier*. Another mirroring takes place at the end of *Civil War* when Bucky has himself placed in suspended animation in Wakanda until a cure can be found for his brainwashing. Together all of these examples from

the films suggest that Steve Rogers sees active mentoring as something that helps form people of good character and that good people can, knowingly or unknowingly, provide an example for others to follow.

Steve Rogers passes the mantle and shield of Captain America on to Sam Wilson at the end of *Avengers: Endgame*. The streaming series *The Falcon and the Winter Soldier* continued the adventures of characters from the Captain America films as well as some of the themes of the series. The series is based in part on a comics storyline in which the US government asserts ownership of the Captain America identity, fires Steve Rogers, and gives the name, costume, and shield to John Walker, a government agent who would follow orders with minimal concern about their ethics or morality (Gruenwald, Dwyer and Morgan 2011). In that storyline, Walker is unable to live up to the burden and the legacy of Captain America, and in due course, Steve Rogers resumes that identity. In *The Falcon and the Winter Soldier*, Sam Wilson returns the shield to the government, expecting it to be placed on display in the Smithsonian. Instead, Walker is quickly announced as the new Captain America but ultimately is similarly overwhelmed by the role. After Walker brutally and publicly kills a member of the Flag Smashers, an antinationalist organization, Wilson takes up the shield despite the misgivings that led him to give it up in the first place. While Sam feels that the symbolism and reality of a Black man becoming Captain America are more of a responsibility than he feels ready for, he ultimately accepts that Steve Rogers was right all along. In the series' final episode, Sam lays out a vision of his role as Captain America that perhaps points to a way to reconcile Steve Rogers's skepticism about institutions with James Madison's emphasis on them. After making his public debut as Cap, Sam declares that he is "still here" even though he knows many will refuse to accept him in the role due to his race and that "the only power I have is that I believe we can do better."

Steve Rogers's critique of Madisonian institutionalism comes from an idealized character in a fictional continuity. Madison had the difficult task of trying to create a governing framework for fractious states that were suspicious of centralized authority. *Civil War* shows that Steve Rogers is not much for deliberation and compromise in matters of governance. But if we give his perspective the benefit of the doubt and remember Sam Wilson's belief that something better is possible, a bridge to Madison emerges. Rogers's chief complaint against Project Insight, against Ultron, and against the Sokovia Accords is that they lack accountability and risk, making it impossible for the Avengers to act as they see fit. Even the potentially benign oversight of the accords, in Rogers's view, could be too much if it forced the team to act where it shouldn't or not to act where it needed to. Such an outcome would, for Rogers, be both unsafe and unjust.

Madison, like Captain America, was concerned with justice; he wrote in Federalist 51 that "justice is the end of government. It is the end of civil society" (Madison 2003b, 254). Madison's institutions are aimed at securing this end; the institutions themselves are not the end. Captain America, in his role as an idealization of the United States, can stand apart from government and other formal institutions of government and concern himself with that end first and foremost. That necessarily places him in tension, and at times at odds, with those institutions, as seen in the MCU and in many of the comics that inspired the films. That tension can perhaps be reduced when people of goodwill and good character occupy those institutions, and it can worsen when people of ill intent hold power within them. But to the extent that institutions fail to achieve justice, good people should, like Captain America, follow their own consciences and try to improve things and embrace the power—one that Sam Wilson does not claim for himself but rather ascribes to every person—to try to make things better. Indeed, this was what James Madison and his fellow revolutionaries did once in 1776 and again in 1787 and what other Americans have done in one cause after another in the years since, all the way to the present day. Steve Rogers may have his differences with James Madison the political theorist. But he has much in common with James Madison the revolutionary.

Notes

Special thanks to Jennifer K. Lobasz for an insightful critique of an early draft of this chapter.

"OPERATION: REBIRTH" AND THE MARVEL CINEMATIC UNIVERSE

Origin Stories as Founding Narratives

Ronald J. Schmidt, Jr.

Before there was a Marvel Cinematic Universe (MCU), there was the Marvel Comics Group (MCG), a hybrid form of popular entertainment that combined elements of successful pulp genres such as the Western, the teen romance, and science fiction monster stories to create a new serial set of superhero comic book adventures. The staff at the MCG built their stories with obsessive attention to continuity; their characters occupied real-world places, most of them coexisted in time, and they rested on a platform of ironic and tragic origin stories.

The source of power for Iron Man, the Hulk, Spider-Man, and the Fantastic Four (to name just a few) is the tragic accidents that leave them marked and isolated (for more on the role of disability in the MCU, see Daily in this volume). Their identity is tied to the contingent events of their origins, which they reclaim as destiny.

Like their counterparts in Marvel comics, the characters in the MCU have origin stories, although they sometimes depart from the tales in the comics. Perhaps the most striking difference is the extent to which origin stories in the MCU focus on *governments*; MCU origin stories are uniquely tied to the idea of the nation-state as a kind of ultimate representative actor. In that sense, many key origin stories in the MCU function almost as founding myths, stories that people tell about governments that give them legitimacy by retelling the history of a territory and its people in a narrative that reinforces the authority of the state. The origins of superheroes serve to identify not just a specific character but a whole community from which they arise. The grounding of extraordinary, "enhanced" people in *nations* that enable their origins is a story about the nations themselves.

Origin Stories, Founding Myths, and "Refoundings"

The use of origin stories to reify the identity of a political community is an old tactic. Noting the threat of what he termed "corruption," Machiavelli (1989, 223)

insists on the centrality of founding stories to the identity and survival of polities. Republics and religions change over time—sometimes growing stronger but eventually and inevitably growing weaker. In his *Discourses on Livy*, Machiavelli notes,

> The way to renew them, as I have said, is to carry them back toward their beginnings. Because all beginnings of religions and of republics and of kingdoms must possess some goodness by means of which they gain their first reputation and their first growth. Since in the process of time that goodness is corrupted, if something does not happen that takes it back to the right position, such corruption necessarily kills that body. (1989, 419)

A corrupted polity, in this view, can be restored by reconnecting to its identity.

In proposing this approach to societal preservation, Machiavelli subtly carries out the very tactic he is recommending (in a form that we might recognize in the ways that MCU origin stories retell founding myths). The source material from which Machiavelli draws, Livy's *Ab Urba Condita Libri*, does not, in fact, present a singular founding story for the city of Rome; rather, it describes a city with a multitude of foundings, many of which have different (and sometimes even contradictory) "excellences." (The Rome of the civilized Trojan prince isn't really defined by the same excellence as the Rome built by the feral and fratricidal Romulus.) Rome is, in fact, a city that altered its founding myth to suit its historical moment. By using Livy's book to tell his tale, Machiavelli signals that founding myths are important—and that they are often deliberately chosen and adjusted to meet the needs of present-day governments. In arguing for the concepts of nationalism and sovereignty, Machiavelli models an approach to maintaining sovereign nations over time, namely, teasing a singular narrative from a web of alternative histories in order to tell a story about how a state should have sovereignty over a given territory because of its political and legal history and identity.

And, in its own way, companies such as Marvel do the same. The history of the MCG was told and retold (and modified) to suit the needs of the day. Stan Lee (1976, 13) alludes to this idea in his characteristic winking fashion in the opening pages of *The Origins of Marvel Comics*: "Marvel Comics wasn't always Marvel Comics," he writes. "But let's not get bogged down in the first paragraph. We have to start somewhere." As Lee and his frequent collaborators Steve Ditko and Jack Kirby fashioned scores of origin stories in Marvel Comics in the 1960s, Lee also crafted metanarratives about the MCG itself. The MCG became, in Lee's telling, a creative hub known as "the Bullpen," a collaborative community of plucky, ragtag artists changing the superhero medium from the inside. In telling that story, Lee absorbs the history of the comic companies

that preceded the MCG in publisher Martin Goodman's stable of companies—companies that actually *did* have "bullpens" of writers and artists.

Lee does not actually return to *an* original story, however; like Machiavelli's "original goodness," Lee's origin stories—in Marvel comics and *about* the MCG—are reconfigurations of older tales, tales about the ironies of people finding their lives changed in unexpected, and sometime horrible, ways by the acquisition of great power, World War II propaganda rewoven into Cold War uncanniness. They are changing pictures of the changing American national culture.

For example, Captain America debuted at Timely Comics in March 1941 in a story by Joe Simon and Jack Kirby about a "super soldier" experiment that transformed a ninety-eight-pound weakling into a representation of American ideals. The Captain America of the early 1940s was a kinetic force, bursting with the energy of Jack Kirby's pencils, exploding across panels, flying across the cover of *Captain America* #1 to punch Adolf Hitler in the face. In the 1960s, however, Lee incorporated Captain America's origin story, via the experiment he redubbed "Operation: Rebirth," into a very different narrative moment. Just as he adopted what he liked from the history of Timely Comics into the identity that he forged for Marvel, Lee laid claim to the Captain America of the early 1940s, an antifascist defender of American democracy. And by writing, with Cap cocreator Jack Kirby, a story in which we learn that the hero had been in "suspended animation" since 1945, he wiped the poorly selling crime-fighting Cap of the late 1940s and the reactionary "Captain America: Commie Smasher" of the 1950s right out of the story. Cap returned to his origins as an average kid from Brooklyn transformed into a federally funded antifascist, but this return was actually a new story. The "new" Steve Rogers was a tragic anachronism defined more by his attempts to mourn his former partner Bucky Barnes than by war. By 1967, the Roosevelt-era antifascist hero had morphed, appropriately, into a Great Society patriot with a powerful commitment to racial equality.

In great Machiavellian fashion, the MCG mastered the use of origin stories—and the use of *changing* origin stories—as a means of drawing on and reinforcing the values of a community. The MCU, in turn, has served as another "refounding" moment, revisiting an older layer of narrative to create the appearance of continuity as the members of the imagined community change.

Defining a Genre

Livy talked about "a" Roman founding but actually introduced many, sometimes contradictory, founding stories. The practice of invoking a national founding while changing it is called "refounding." When Augustus subsidized

Captain America debuted in *Captain America* #1, a story by Joe Simon and Jack Kirby, in March 1941. His first cover depicts him punching Adolf Hitler in the face. From *Captain America* #1 (1941).

The MCU has served as a "refounding" moment, a time when Marvel creators revisit prior narratives to create the appearance of continuity while at the same time the membership of the imagined community changes. The film *Captain America: The First Avenger* even pays homage to the cover of the comic *Captain America #1*. From *Captain America: The First Avenger* (2011).

art that placed his family at the heart of the Roman founding, he was playing the role of a *re*founder. When Abraham Lincoln, in his address at Gettysburg, said that the United States was founded on July 4, 1776, as an experiment in democratic nation-building, he was playing the role of a *re*founder.[1] In the early 1960s, Stan Lee "refounded" Marvel Comics, retelling and altering the origins of World War II properties to create a new narrative framework around those characters and what he dubbed "the Marvel Universe." The Human Torch became the impetuous result of Cold War competition and science experimentation gone wrong; Captain America became a melancholy defender of New Frontier America.

The MCU refounds comic book properties again. What legitimating principle is invoked by the MCU films?

One of the most important defining features of origin stories in the MCU is that the superpowered are created by *global* superpowers, nation-states of power and influence. FDR's "Strategic Scientific Reserve" (SSR) created Captain America out of Steve Rogers; the USSR created the Black Widow; the Black Panther is the ruling monarch and symbol of the nation of Wakanda and the product of its environment and its history; the US military creates the

Howling Commandos and the Hulk. In the Marvel comics, the Falcon's origin story involved being trained as a superhero by Captain America (Lee and Colan 1969a; 1969b; 1969c). In the MCU, on the other hand, Sam Wilson is a former Pararescuer (US Air Force Special Operations Command); he was trained by the Department of Defense to fight and to fly his winged suit. In the MCU, superheroes come from the military bureaucracies and scientific establishments of nation-states—even heroes who came from other places in the comics.

Of course, nationalist foundings and refoundings are not the only origin stories in the MCU. The terrorist group Hydra, for instance, creates the Winter Soldier and is responsible for the illegal human experimentation that empowers Pietro and Wanda Maximoff (a parallel that Steve Rogers also notes). However, even extragovernmental organizations often have nationalist origins. S.H.I.E.L.D. is the creation of the millionaire industrialist Howard Stark, the former SSR agent Peggy Carter, and Colonel Chester Phillips of the US Army; in other words, S.H.I.E.L.D.'s founding is the product of capital, the military, and national espionage. S.H.I.E.L.D. may not always be associated with a nation-state (its relationship to the US government evolves throughout the MCU), but it is an organization made possible by and serving the military-industrial-intelligence complex. And S.H.I.E.L.D., in turn, goes on to empower Hawkeye, run missions for the Black Widow, and, via S.H.I.E.L.D. director Nick Fury's Avengers Initiative, found the Avengers. In the MCU, origin stories are usually rooted in nations and their interests.

Meanwhile, in outer space, this has all happened before. The Kree Empire, in competition with the Xandarian Empire, and, it seems, the Asgardians, has created its own police forces, superpowered and otherwise. Carol Danvers, the protagonist of *Captain Marvel*, is empowered as an unintended side effect of a Kree scientist trying to stop her planet's imperial ambitions and protect refugees fleeing from the Kree; the primary antagonist of *Guardians of the Galaxy* is a Kree fundamentalist terrorist trying to stop his planet's rapprochement with its interplanetary rivals. Myths of national identity run throughout the MCU; individual superhero origin stories emerge as national projects.

It is striking that the MCU origins of heroes are often *intentional* and *national*, not, as in the Marvel comics, accidental and tragic. Even Tony Stark—often an antagonist of the US government—is created on a battlefield in America's newest "longest war." His campaign of personal redemption (see also Kohen's chapter on heroic arcs and Daily's chapter on the role of overcoming in MCU narratives) drives him away from military and government at times (as when he builds "Avengers Tower" as an exemplar of renewable energy and struggles to be a better man for Pepper Potts and a better father than Howard Stark vis-à-vis Harley Keener, Wanda Maximoff, the Vision, Peter Parker, Morgan Stark, and even Nebula[2]). But his path often leads him back to

his origins in the Department of Defense and government; he is a champion of US government regulation of superheroes in *Captain America: Civil War* (see Saideman's chapter in this volume).

Good Man Out of Time

No character in the MCU better exemplifies national foundings and refoundings than Captain America. *Captain America: The First Avenger*, the MCU's first Cap movie, is a frame story; we begin and end the film in 2012. The MCU film, however, dives quickly into March 1942 and a mapping of the Captain America storyline within the larger MCU. We meet the Red Skull, but we also see a representation of the Norse Ygdrassil, and we hear of Odin. Later, we will meet Howard Stark and see a shield built from vibranium from Wakanda. In the twenty-first century, Cap is embedded within the larger MCU continuity.

In the MCU, Steve Rogers doesn't just embody the US Army; he's also working with S.H.I.E.L.D.'s predecessor, the SSR, an "allied effort," and works with an American colonel, a German scientist, and a British field agent. Even Rogers's unit in the army, the Howling Commandos, includes Americans of different races (segregated during the war) and British and French soldiers.[3] Captain America's social situation is premised on the ideal of "e pluribus unum," creating unity out of diverse nations and MCU worlds.

By telling his story via a temporal frame of flashback, the filmmakers situate Cap in his own origin story more completely than other MCU protagonists. Anthony Russo, codirector of *Captain America: The Winter Soldier*, *Civil War*, *Avengers: Infinity War* and *Avengers: Endgame*, said that Captain America is "such a great character" because he "hasn't been corrupted or compromised" (Wilkins 2018, 62). As a man who lives within his founding story, how could he be otherwise?

And yet the MCU's Captain America is strikingly uninterested in the politics of this position. His world may be populated by factions, but, especially for someone intended as a representative American figure, he shows no particular inclination toward the Madisonian activity of persuasion and interest politics. The political roles he sees and responds to are those of bullies and good men and women (or, at least, men and women with good intentions and instincts). That reflects his origin. The night before Steve Rogers undergoes Operation: Rebirth, he speaks with the man who invented the Super Soldier Serum, Abraham Erskine. Erskine has already told Phillips that Rogers, despite being tiny and sickly, is "the clear choice" for the experiment; now Rogers wants to know why. Erskine answers by drawing a contrast with Captain America's nemesis, the Red Skull. The Skull, Erskine tells us, is actually a Nazi scientist named

Johann Schmidt. Schmidt, it turns out, learned about Erskine's experiment and demanded to participate. The results include horrible side effects. "The serum wasn't ready," Erskine says. "But more important: the man. The serum amplifies everything that is inside so good becomes great, bad becomes . . . worse." He continues, "This is why you were chosen . . . a weak man who knows the power of strength and who knows compassion. . . . Whatever happens tomorrow, you must promise me one thing: that you will stay who you are. Not a perfect soldier, but . . . a good man." It's an odd sentiment, the night before what is intended to be a massive transformation, both of Rogers's body and of the world war. This would be a perfect opportunity, for example, to link Rogers's transformation to FDR's political campaign in favor of the Allies and in opposition to fascism (see, for example, Katznelson 2014). Instead, Rogers's body will change, and he will, if Erskine is right, become "great," but he must remain the same good man who told the professor that he didn't want to go to war to kill people but demanded a part in the fight to stop bullies.

That rootedness in his chosen self remains an important part of the MCU Captain America in all the films in which he appears. In *The Winter Soldier*, for example, Cap learns that Nick Fury has approved Operation: Insight, an example of what the Bush administration used to refer to as "preventive war" or "preemptive strikes" and that Fury refers to as "neutralizing threats before they happen." For Captain America, however, this is punishing people who haven't committed crimes, a policy of fear over freedom, "holding a gun to everyone on Earth and calling it protection," and he refuses to be complicit with it. An exasperated Fury says, "S.H.I.E.L.D. takes the world *as it is*, not as we'd like it to be. It's getting damn near past time for you to get with that program, Cap." "Don't hold your breath," Rogers says, and then he drives to the Smithsonian Institution's Captain America exhibit to take stock. He returns to his origin.

Complicating Nationalistic Founding Myths

From the "Tea Party" movement to the American left's own liberal hagiography, Americans deploy origin stories in support of their preferred policy positions but also as constituent parts of their own identities. We claim to find our purpose in the Declaration of Independence, our legitimacy in the Constitution, our identity in our national origin stories.

Nationalism runs through the origin stories of the MCU, but the MCU also complicates this impulse. After all, the character who most consistently trumpets tradition across multiple films, Ronan, is a genocidal fanatic in *Guardians of the Galaxy*: "They call me a 'terrorist,' 'radical,' 'zealot,' because I obey the ancient laws of my people, the Kree, and punish those who do not. Because

I do not forgive your people for taking the life of my father, and his father, and his father before him. A thousand years of war between us will not be forgotten."

Likewise, in *Thor: Ragnarok,* Hela, Odin's oldest child and the Norse god of death, returns to Asgard from exile. She is appalled by a byzantine frescoed ceiling depicting Odin and Thor making alliances ("peace through strength," no doubt, but peace all the same) across the "Nine Realms." Smashing through the fresco, Hela digs through the seismic narrative structures of Asgardian exceptionalism and literally uncovers earlier Asgardian propaganda, art that shows Odin and Hela conquering and killing: "Does no one remember me? Has no one been taught our history? Look at these lies! Goblets and garden parties? Peace treaties? Odin, proud to have it, ashamed of how he got it. We were unstoppable. I was his weapon in the conquest that built Asgard's empire. One by one, the realms became ours."

Hela powerfully reminds us that founding stories are inventions. Refoundings transform these inventions, but as part of the refounding sleight of hand, they invoke the authority of the story they change to reify their claims to power. The MCU reminds us of this maneuver as well. Romulus and Remus, in the old stories, were just found by the she-wolf, just as Donald Blake simply found a staff that transformed him into Thor or that radioactive spider found Peter Parker. But the origins of the MCU are nationalist projects, training programs that produce "enhanced" agents.

Machiavelli urges complex political entities such as nations to return to their foundings in order to shore up their identity and survive the threat of corruption. But he does this by citing Livy's Roman history, which begins by noting that Rome's earliest founding stories are diverse, contradictory, and quite possibly mythical. Machiavelli isn't exactly urging patriots to return to one true founding blueprint; he's showing them how to refound, to tell edited and transformed versions of old stories, designed for new crises but presented as old, authorizing historical events. In the 1960s, Stan Lee, Steve Ditko, and Jack Kirby refounded the Marvel superheroes of the 1940s; the MCU is a refounding moment that places national identity at the core of one of the most popular film franchises of the early twenty-first century. And like all refoundings, this attempt to reify our nations and our heroes points not to the given nature of its subject matter but to the construction of political identity going on all around us.

Notes

1. In practice, Lincoln's Declaration of Independence is different from the document envisioned by Jefferson, who was carrying on a conversation about the perfidy of King

George III with the enlightened members of the "republic of letters." Jefferson's Declaration was also not precisely the diplomatic proclamation envisioned by Richard Henry Lee and Samuel Adams, which had been promised to France and Spain as a way to clear the path for war loans. See Wills (2018).

2. Although he loses interest in her as soon as they return to Earth in *Avengers: Endgame*.

3. In this, the "Howlers" operate like the MCG Howling Commandos, who were themselves based on a favorite trope of the World War II US propaganda agency, the Office of War Information: the diverse democratic platoon that is forced to operate as a unified "band of brothers." See Koppes and Black (1990), Winkler (1978), and Schmidt (2005). In fact, *Captain America: The First Avenger* makes good use of the tropes of World War II propaganda in general.

CHAPTER 7 NOSTALGIA, NATIONALISM, AND MARVEL SUPERHEROICS

Lilly J. Goren

This chapter examines the narrative focus of many of the Marvel visual products since they are rife with the tension of nostalgia, casting the past in connection with the present and digging into an understanding of that past while using it to frame the present.

This is not only the case with Marvel—it is also connected to most superhero narratives since the superhero is brought in, usually, to restore order and eliminate a threat that would disrupt or destroy the order that audiences meet and see within the fictional storyline and universe. Thus, the narrative arcs of superhero films and television shows, in some ways distinct from those of the comic books, are often a restoration of a past social/political order that was threatened or destroyed by some sort of villain. This destruction can be as extreme as Thanos's Snapture and the destruction of half the life forms in the entire universe in *Avengers: Infinity War* and *Avengers: Endgame,* or it can be more personal and unique, as in Kilgrave's mental dominance and manipulation of Jessica Jones in Netflix's first season of *Jessica Jones.*

The contemporary Marvel Cinematic Universe (MCU) establishes an internal nostalgic narrative, integrating presentations of an American past from World War II or the early Cold War period or the post–Cold War period and threading those images and ideas into many of the films. These windows into an overtly heroic period from America's past are slotted into stories that have all been created for big and small screens since September 11, 2001. Captain America's successes during World War II or Captain Marvel's heroism in post–Cold War America present a dimension of our thinking about our political and social environments in previous periods as well as projecting a concept of how we may see ourselves today. The MCU leans into these nostalgic tensions while also projecting them into contemporary considerations. This layered nostalgia is directly connected to a form or kind of American nationalism, and the nostalgia and nationalism are braided together, which we also see in our contemporary politics. I hope to integrate these tensions, as observed in contemporary electoral politics and within popular culture, to elucidate the complex narrative that combines an embedded nationalistic longing with a subsumed understanding of nostalgic heroics and nationalistic glory. The MCU takes up

Captain America's heroics in World War II are one example of how the MCU establishes an internal nostalgic narrative, integrating presentations of an American past into many of the films. From *Captain America: The First Avenger* (2011).

these heroic and nationalistic narratives while also clearly folding in nostalgic waves—both factual, historical nostalgia and narratively constructed nostalgia.

Superheroic stories, especially serialized, intertextual franchises, often build on their own internally created nostalgia, and the MCU has been quite successful in connecting these internal threads. This chapter will tease apart the internal MCU nostalgia—which is more threaded and complex than simply a return to the ways things were before the big baddie came along to wreck everything—while making the case that these cultural artifacts are reflecting and generating a nationalistic nostalgia that is all too familiar in our contemporary political environment. Layering in superheroes to solve problems—especially problems that are generally political: threats to political power, societal stability, peace, and justice—especially over an extended period of time may also lead audiences toward unconsciously considering that this is the only way to solve sustained gridlock, acute ideological partisanship, and complex political and policy disagreements. And thus, we also see the ways in which electoral politics mirrors the narratives we consume in our entertainment: from political officials who are seen to have some sort of superpower[1] to policy solutions that depend on not-yet-invented mechanisms and capacities,[2] citizens are looking for superheroic solutions to mounting and extreme problems that we face, such as COVID-19, global climate change, and systematic racism.

The MCU, over the span of the past two decades (which has also been the post-9/11 period), has captured a certain amount of attention and box-office receipts in not only providing entertainment and escape—and the destruction of a variety of villains who want to hurt or destroy the United States specifically and who also pose a broader threat to humankind—but also absorbing fans and audience members in the intertextual engagement of heroes and

villains across a host of narrative properties and releases. Thus, the MCU has threaded together a kind of self-connected nostalgia while also weaving into the narratives a variety of nostalgic longings, given the movement across periods of American history, politics, and cultural inflection points.

Understanding Nostalgia

As a field of study, nostalgia is not simply warm recollections of a previous time or experience, though this may be one of its dimensions. The disciplinary field of nostalgia or memory studies explores the myriad dimensions of memory and the understanding of nostalgia and how it may operate within individuals, cultures, politics, and the like. Nostalgia and melancholia were seen as medical and psychological issues and the difficulty was seen and assessed by medical professionals during the Civil War in the United States, when it seemed to acutely afflict many of the soldiers fighting on both sides during the 1860s. *Nostalgia* was first developed as a clear concept by the Swiss physician Johannes Hofer in 1688, and it means a "longing for a lost home" (Knewitz 2017, 86). Svetlana Boym (2001, xvi) notes that "outbreaks of nostalgia often follow revolutions" but that nostalgia itself is not always about the past: "It can be retrospective but also prospective." Sabine Sielke (2017, 278) also notes that the United States is a setting of perpetual nostalgia because, as a country, it is constantly turning towards the future while always longing for a mythical past; thus, "America's self-conception can be conceived of as an effect of nostalgia that is future-oriented."

Nostalgia is multifaceted in its political uses, coming through overt electoral politics and referenda as well as cultural and popular portrayals. Thus, when we consider the framework and threads of nostalgia throughout the MCU, we should also consider how this framing and understanding translate back and forth to our real-life narratives, the ones we hear from politicians or those of government, history, and politics. The current climates in the United States and many sectors of Europe reflect another wave of nostalgic longing, especially as we find ourselves in the midst of a pandemic and long for the lives we lived before COVID-19 entered our world. But this longing is only the most recent and currently most acute nostalgic longing. If we consider the ubiquitous red "MAGA" hats of Donald Trump's 2016 campaign and think about the shorthand communication of a nostalgic longing within the United States to "Make America Great Again," it is the "again" that draws our attention, that is an expansive call for a return to a once greater past. The past that has apparently been lost.

The "again" part has always been the most complicating aspect of this nostalgic yearning. Is the "again" about the time when men had one career and

one job for the span of their working lives? Or is it about a time when there seemed to be a stability and order to life, one not constantly in flux or rocked by disasters, conflagrations, protest marches, and police shootings? Does the "again" refer to a time when there was a bipolar world in which enemies were seemingly clear and allies equally clear? Or is it about the role of the United States as the dominant international force "for good"—through its unparalleled military forces and vast economic wealth? The "again"—in making America great *again*—is the complicated understanding of a nation that has remade itself on a number of occasions, both in a romantic attachment to a mystical past and in the constantly promising horizon.

This narrative construction is, in many ways, the narrative history of the country and is also the narrative that we see regularly in cultural artifacts, from literature to television shows to comic books and video games. It is a historical approach to an affective sense, a conjuring of history and longing that is as dependent on actual facts as on the visual artifacts that cement the feelings and senses of those heroic past periods. The images and narratives that work into our collective understanding of "the past" construct an understanding of that past and build on nostalgic longing in such a way that we should interrogate those narratives and images, alongside an analysis of nostalgia, to understand whether there are embedded connections that may lead more fully to the way that the past is recollected and how that recollection impacts nationalistic understandings of self and nation. Boym (2001, xiii) explains that "nostalgia is a sentiment of loss and displacement, but it is also a romance with one's own fantasy." Boym (2001, xvi) also connects the personal approach to nostalgia and the political, noting that "nostalgia is about the relationship between individual biography and the biography of groups or nations, between personal and collective memory."

This toggling between the personal and the political is also where the individual's consumption of cultural artifacts that reembed ideas and images from particular times, with historical verisimilitude, may become problematic. Tobias Becker (2018b, 241) analyzes the term "nostalgia" itself and the growth of its use and understanding (or misunderstanding in some of his assessment) in the West, especially in the United States, the UK, and Germany, and finds that the term and the concept came into much more common usage in the 1960s and 1970s, and the meaning changed a bit as well:

> Almost all texts on nostalgia from the 1970s and 1980s, then, had two things in common. First, they saw nostalgia not as an individual emotion—or at least they were not interested in its individual psychological form—but as a collective cultural phenomenon, a "recognizable and distinctive

public mood," in short, a zeitgeist. And second, they all saw nostalgia consistently as negative and as, at least potentially, "positively harmful."

Nostalgia, as a field of study and as a means that is used within politics, is often put into action to describe problematic retellings of a nation's history. We are currently in the midst of quite a few states trying to manage how the history of the United States is taught and to determine how important it is to integrate the institution of slavery and racism into that conceptualization. Nostalgic concepts of politics also fit within the growing field of affective politics and political theory.

Nostalgic or memory studies as scholarly disciplines, or subdisciplines within political science and political psychology, focus on the affective impact of how we think of our pasts—our own memories or, in terms of politics, the collective memory of the past. Thus, the political understanding of nostalgia is connected to emotional impulses since, "as an emotion, nostalgia furthermore suggests that someone is acting emotionally and, hence, not rationally" (Becker 2018a). If nostalgic impulses or considerations are affective because they incorporate emotions, and if we can examine these impulses as we make connections to the heroic narratives that are often available and even embedded within our cultural understandings, this longing can be coupled with the myriad kinds of anxiety that many citizens acknowledge feeling and that are often at the root of their electoral choices. In many ways, nostalgia can be bundled with anxiety, which is an immensely politically salient emotion, and nostalgia—both personal and collective—often rests on an inaccurate or sanitized version of history or particular historical events, especially those that are cast in a heroic light. This anxiety—which Albertson and Kushner Gadarian (2015) analyze in *Anxious Politics: Democratic Citizenship in a Threatening World*, which Elisabeth Anker (2014) interrogates in her text *Orgies of Feelings: Melodrama and the Politics of Freedom*, which many political theorists often wrestle with in the context of neoliberal critiques of modern political life,[3] and which many political scientists are exploring within the burgeoning field of political psychology[4]—may well be at the base of much of the decision-making process that most citizens go through as they make political choices. At the same time, if this decision-making process is coupled with a sense of a more peaceful, more fulfilling past, this may prompt a weaving together of this kind of nostalgia with contemporary anxiety. This may make voter/citizens particularly open to political calls or rhetoric that combine this anxiety with this nostalgia.

I think that nostalgia is particularly key in considering the successful integration of the politics of anxiety. And it may be even more important to consider the nostalgic impulses that surround us in our cultural milieu since it is

possible that the toggling between the actual historical events and the narrative recreation of those events contributes to a cleaned version of the events of the past that may contribute to this nostalgic longing while also creating the heroic narrative that is overtly embedded within these historical events and draws on long-standing cultural understandings of the nation itself and its citizens.

The MCU and Nostalgia

A number of levels of nostalgia are at work in the multimedia blockbuster Marvel Cinematic Universe. These multilayered approaches are important in pulling in the audience and keeping them engaged with the MCU specifically. The narratives are generally nostalgia based, as already noted; this is generally the case with superheroes since they are usually tasked with returning society to a place where it was before the threat or the villain came on the scene. There are competing nostalgic desires in the Avengers narrative arc, especially the finale of MCU Phase Three, with *Infinity War* and *Endgame*. In the threaded narratives, Thanos is pursuing the Infinity Stones to essentially create a "former world" where there are fewer beings by eliminating half the beings in the universe. The Avengers themselves pursue and long for a world before Thanos snapped his fingers. They want to return to a world where their friends and colleagues are still alive, and in order to do so, they pursue a time loop where they go back in time to find the Infinity Stones before Thanos does, thus recreating a past more to their liking. Tony Stark, as Iron Man, is the most hesitant about taking these time jumps to keep Thanos from the Infinity Stones because Stark does not want to return to a world before or without his daughter. But even Iron Man, who has found deep personal fulfillment in the present, yearns to restore the lost elements of the past.

The MCU also has an internally structured nostalgia that is the result of the layering of the films and their narratives with reference to previous films and previous times. Easter eggs, callbacks, and references to other aspects of the narratives in other films or television shows are often considered "fan service"—something specifically embedded in the MCU storytelling to keep more committed fans satisfied and engaged. (See Carlee Goldberg's chapter on the contractual requirements for MCU actors to be available for film cameos and "callbacks" for other films.) But all of this so-called fan service is essentially an internally structured nostalgia built into each MCU artifact that connects the stories to each other thematically but also builds on our memories of what we saw in previous movies or television episodes.

Some examples of this structural nostalgia include the integration of Tony

In the Disney+ series *WandaVision*, the setting loops through classic sitcom tropes and styles to frame the life Wanda missed having with Vision because of his death. From *WandaVision* (2021).

Stark's father, Howard Stark, who has died but whom we see in embedded images of him and the world he wanted to create. Tony Stark views this as his birthright and as the future he is creating—even including his encounter with his father in the midst of the timeline engagement in *Endgame*. Another example of narratively constructed nostalgia is the fact that *Captain Marvel* is set in a different time—thus asking audiences to go backward in order to move forward in the Avengers story arc, allowing for the establishment of the Captain Marvel character herself, and thus opening up her integration into the Avengers finale. The entire narrative in *Doctor Strange* is about the ability to move back and forth in time, for good or evil. And Strange's trajectory is based on his longing to return to a period of time when his hands were uninjured. His pursuit of a solution to his personal problem brings him to his training with the Ancient One, which is a training in moving in and out of time and understanding his capacity to shape and see time. In the recently released Disney+ television series *WandaVision*, time is looping through sitcoms to frame the life Wanda missed having with Vision because of his death. There are weirdly warped constructions woven through the nostalgic touchstones that Wanda and the audience and those outside the Hex encounter in the sitcoms that are used to funnel Wanda's evolving life inside the Hex.

In analyzing this idea of structured nostalgia, considering it as a narrative

crafting of the integration of these internal references to previous films and television productions, *Endgame* is essentially, for the vast bulk of the film, the most substantial integration of this structural format. *Endgame*, in sending the Avengers back to a variety of different time periods and interactions, takes the audience on an adventure in structural nostalgia, visiting prior historical eras and previous films, characters, and dynamics. Time and nostalgia are not the same thing, but considerations of time are often connected to perceptions of a different era or period and the desire to return to a particular time, which is exactly what is happening on various levels in many of the MCU artifacts.

We can see how the superhero narrative and our daily political lives toggle together, in part because, as political scientist Leah Murray (2010, vii) notes in her book *Politics and Popular Culture*, "our political world has become popularized, or our popular world has become politicized." We are living in a time when politics and popular culture are often married. Politicians choose their clothing, and thus their choices about fashion, to indicate a message. Former president Barack Obama referenced *Mad Men* in the State of the Union Address to telegraph understandings of policy and thus policy changes. President Donald Trump, while perhaps operating more overtly with an understanding of the dynamics of television narratives, is not the only politician who tells us stories or embeds a narrative that shapes the way we consider politics itself. Supreme Court Justice Ruth Bader Ginsberg was known as "Notorious RBG," and she has been given a cape or a crown in various iconographic images. These are obvious and overt ways that politics and popular culture are braided together. And they are often what comes to mind when we think about politics and popular culture, but popular culture artifacts such as the products in the MCU also present audiences with political ideas and loop politics together with popular culture. This is particularly true for those popular culture entities, such as the MCU, that generate massive audiences and connected marketing campaigns.

Tracing the Superhero

Thus, the Marvel films and television shows provide us with a canvas to explore popular culture and politics, perhaps in less expected ways but with narratives that reflect our concepts of ourselves and our society back to us in some intriguing ways. What happens in these films? Mostly the same thing that generally happens in superhero narratives: there is some sort of threat, usually from an individual or entity that also has superpowers. The superhero needs to engage with this otherworldly threat in order to save some set of people or creatures. The threat, the antagonist, might be in quest of some talisman or may be in quest of domination or may be corrupt, or these three aspects may

be knit together in a substantial threat; regardless, this is usually the form of the problem. The hero must figure out the problem and then how best to solve it and then solve that problem, which generally includes protecting the lives of "innocent" and often righteous citizens. Sometimes those citizens are in a particular place—such as Asgard, New York City, or Wakanda—and sometimes they are not. The narratives themselves are mapped onto a previous narrative that had great pull in the United States: the Western. Aspects of the superhero genre are sometimes connected to the *hero's journey* format as well. What is most interesting in each of these contemporary examples is that the starting place, often for the hero (though not actually the start of the film), is in a utopian or otherwise seemingly functioning society, though these societies are often hidden or sealed off from others. This is particularly the case with *Black Panther*'s Wakanda, and Thor's Asgard was a pretty ideal place. *Infinity War* and *Endgame* posit that the universe and the creatures living within it are worth protecting, and the threat to Earth and elsewhere upended the capacity of these societies to function as they had chosen to do.

In the narrative projections of these films, there are highly functioning societies that have political structures in place that generally work according to legible processes and provide a stable universe for the citizens who live in them. Thus, the threat that is posed, in some form, is that these stable—and often peaceful environments—will be upended and thrust into a rather uncertain future. This future, in fact, given the threats posed by the villains or antagonists, may well be seen as the opposite of these fully functioning societies, presenting the prospect of a dystopian future if the destructive intentions come to pass, and there is generally a shared desire by the superheroes and citizens to return to the past before it was imperiled by whatever threat is the center of the narrative arc of the film or television show. The hero often wants to maintain the status quo, protecting against uncertainty, imperialism and dominion, and likely totalitarianism. Thus, in a certain respect, each hero provides a kind of gentle, nostalgic nationalism: keeping Asgard great, keeping Wakanda great, keeping the universe great. Not necessarily making them great again, so this desire is less about nostalgic longing than about the current, functioning state of affairs. We are often told that the society was good, or at least it was the world in which everyone understood their lives and how things function. Thus, the role of the superhero is to restore a kind of status quo, though this restoration rarely involves contemplating meaningful, positive social change. This is a bit of a tension at the heart of the superhero narrative since the superhero is usually called upon to restore society, to restore a way of life, to restore whatever it is that has been broken by the villain, but superheroes are seen as "exceeding their brief" if they move to undertake changes beyond what a restoration involves. This is where superheroes move into the more overt political

realm and into a role that is fundamentally undemocratic because they are not elected to their positions.

A sketch of certain forms of isolationism appears in some of these societies but also an echoing of Madison's words from *Federalist #37*, that the people who make up these societies have a certain repose and confidence in their character (Hamilton, Madison, and Jay 2003, 223). Undeniably, there is often a bit of snobbery involved as we see the vast spectacle of Wakanda's technological advances and capacities. In this context, there is a kind of tension around nationalism and isolationism, which is also where *Black Panther*'s antagonist, Killmonger, enters the dialog. In unpacking some of the antagonists in these films, what we find is that they are not as clearly "evil" or corrupt as villains often are in superhero films.

The structures of the MCU are tied to a collection of individual and coordinated superheroic stories, and with those stories comes the discourse around the way in which the superhero either discovered that he or she had certain powers or how those powers were acquired. These are the origin stories for the superheroes, and they vary, but they also carry with them an embedded nostalgic framework in our understanding of the person before he or she became superheroic and the person after he or she acquired or learned of his or her powers. Thus, many of the films themselves are structurally nostalgic since the hero usually demonstrates some longing for the previous simplicity or his or her life while also trying to normalize his or her new status and capacities. Even Tony Stark's "man in the can" or the Black Widow—neither of whom has actual superpowers compared to their colleagues—operates in a before-and-after context. Psychological narratives such as Netflix's *Jessica Jones* demonstrate a kind of complexity of this looping since Jessica recollects her life before she became superpowered and also recollects a life before Kilgrave was able to manipulate her superpowers. Thus, her nostalgic longing is for a past before her powers were corrupted. Most of the origin stories provide the hero with a chance to recollect a time that was simpler, before he or she became a superhero and had to learn to contend with these powers. This is a third kind of inherent nostalgia since the superhero narrative inevitably sets up a before and after in explaining how an individual came to have particular powers; thus, there is the nostalgia associated with remembering how a hero's body or life was prior to his or her heroic transformation.

Thor: Ragnarok: The Exception That Seems to Prove the Rule

Ragnarok presents the audience with a self-contained story (as do all of the MCU films) but one that is also connected to previous narratives and that is

immediately swept into the events of *Infinity War* and *Endgame*. This film, and the construction of a pretty straightforward unfolding of the superhero tale, highlights the narrative conceit that wrestles with what exactly the hero, in this case Thor, is supposed to protect and safeguard. *Ragnarok* has one of the straightest lines of the destabilization, and thus the nostalgic nationalism, that surrounds many of these narrative arcs. It does not need to tell an origin story, so the narrative really wraps around Hela's[5] return to Asgard and her destructive bent. Hela also becomes the most traditional of villains. Hela, Thor and Loki's sister, was banished when she wanted to pursue more imperial and oppressive ends than her father. She returns to claim her rightful throne and to continue her quest for extensive dominion and power. She certainly has the capacity to eliminate anyone who stands in her way, slaughtering civilians and other protectors, breaking Thor's hammer, Mjolnir, early on, and ultimately taking one of Thor's eyes as the final battle heats up. Hela can't be beaten by Thor, Valkyrie, Loki, and Hulk together; they need to resurrect Surtur to destroy Hela along with the prophesied destruction of Asgard (the Ragnarok). Hela is quite willing to sacrifice the people over whom she rules to pursue more extensive dominion. This conceit is in keeping with the original enemies that the superheroes were battling in comics: Nazis, Soviets, totalitarian or fascist threats, enemies often willing to sacrifice their own people for more expansive pursuits and power. Hela's threat is reminiscent of the bipolar world of good and evil, and it is a dystopian threat—civilian life in Hela's Asgard is frightening and uncertain, and the citizens continue to try to escape this newly oppressive regime. She may have been admired by Odin when she fought alongside him, but we learn that she essentially "pushed beyond her brief" and was shunted aside because of that.

Thor, on the other hand, is committed to Asgard, the place and the people. He is a small-"c" conservative and a nationalist. We see him speak lovingly about Asgard, knowingly about its myths and fables, and compellingly to Scrapper 142 to persuade her to recommit to her Valkyrian roots and to protect Asgard. The bulk of Thor's story in this film is his quest to return to Asgard to save the people, who are threatened by Hela's rule. We also see that the citizens have no allegiance to Hela. She literally needs to resurrect an army from the dead to protect her throne—and thus we can see the contours of her willingness to impose dystopian despair upon her people and others she might conquer. There is a starkness to the heroes and villains in *Ragnarok* that is more muddied in some of the other examples. We also see the shift in regime that brings about not only instability but also repression and fear.

Thor battles, in more ways than one, to return to Asgard to save the place and the people. Alas, he is only able to save the Asgardians by helping them escape the Ragnarok that he and the other heroes have put into action in order to

defeat Hela. Thus, in trying to restore Asgard, Thor actually destroys it, though not the people. He is unable to restore the status quo, but this is not really noted since Thor and the Asgardians are immediately swept into the events that unfold in *Infinity War*. There is no time or opportunity to see or establish a new Asgard as the events in *Ragnarok* unfold. When we do finally see a version of this new Asgard, it is in *Endgame*, where we see the entire universe in disarray and mired in grief, and Thor is languishing, spending his time drinking beer and being loud. The MCU, on the whole, has a typical nostalgic arc: we see and understand the status quo, a villain disrupts it, and the superhero then restores the status quo. The one time, in all these cultural artifacts, where this narrative deviates is on an alien planet; the story is immediately cut short by the start of another, more encompassing story, and the focal hero becomes depressed.

The villains of the past few years—such as Killmonger or Kilgrave or Thanos—have been complex, or their quests have been more complex than the often power-hungry, destructive, or psychopathically insane pursuits that dominate the genre—though again, *Ragnarok* is a kind of throwback here, with a much more traditional and conservative villain, as Cate Blanchett's Hela chews scenery and randomly kills off those who disagree with her. We have heroes who contend with antagonists who just want power and to express their dominion over others, and we have heroes who have to reshape time, but only so much, in order to undo the destruction of the villainous threat. In either situation, there is a call to the superhero to fix the problem, to restore the status quo that previously existed. Thus, both hero and villain are connected to the nostalgic impulses that weave through the narratives themselves. Hela's claim is that her birthright, her position as ruler of Asgard, was taken from her, so she is demanding another kind of nostalgic return to a rule that she claims is her right. With *Ragnarok*, we can see examples of these various nostalgic threads that are knit into all of the MCU artifacts. And we can also see the nationalistic impulses that are wrapped around the nostalgic longing, that the people and/or place that are imperiled claim a kind of just or appropriate right to return to the life they had before the big baddie showed up and took over/screwed up everything.

The Superpower Narrative and Nostalgic Impulses

The superpower narrative is generally a predictable one. It is fairly consistent across franchises as well. A status quo of some kind is threatened or disrupted by a threat, usually from a villain who wants something or wants power. At the same time, the origin story of the superhero unfolds in a generally expected

path: an individual is either exposed to something that gives him or her super-powers, or faces a crisis that prompts extraordinary powers to be developed or used, or some combination thereof. The MCU gives us quite an array of heroes who have a diversity of powers—super or developed—and we, as an audience, get to see how the powers work and often see how the hero comes to understand his or her power and capacity. We also see the limits of those powers, where the powers fail in certain contexts, or how a hero struggles to understand his or her own true self in the context of these extraordinary capacities. This is generally a consistent trajectory of not only the superhero's origin story but also the arc of the superhero narrative, with heroes meeting antagonists or enemies or those who want to co-opt or use the hero's powers for corrupt ends.

These images and ideas of superheroes have been coming at us in a variety of forms for decades. Their stories have become touchstone myths, and we have incorporated aspects of them into our thinking about politics and society. Even if you haven't seen any of the MCU films, most Americans can identify Iron Man, Black Panther, and the Hulk. And while the Hulk has been played by quite a few actors, most of us would be able to identify the big green guy as the Incredible Hulk. Depending on how many films we have seen, we have some idea of the kinds of powers that these heroes have and how they got them. One of the dimensions of our engagement with these films and television shows, and with their narratives, is that we expect to see a certain kind of story unfold, and we anticipate aspects of the narrative—not only the hero's superpowers but also the created tension of the impending destruction of a society, universe, way of life, or people and the superhero's efforts to restore order. Thus, our expectations set us up for a kind of nostalgic trajectory within the genre itself. Added to that trajectory is messaging about a soft or implicit nationalism since the threatened society is often held up as worthwhile, appropriate, normal, and expected. The MCU takes up *nationalistic narratives*—about real places, such as the United States, and fictional places, such as Asgard—while also embedding *nostalgia*—both factual, historical nostalgia, such as World War II battles or Cold War arms dealing, and narratively constructed nostalgia, such as the destruction of Sokovia or the elimination of half the living beings in the universe—in the stories and structures of the many dimensions of this cinematic universe. All of these impulses draw the audience in and provide a kind of anticipatory viewing: we know what to expect when we go to see a Marvel film. But we also may anticipate how we may feel, how and where we will be drawn into the narrative, and where our sympathies may lie. These ideas can also be transferred to our actual political life, possibly making us yearn for an earlier time when perhaps life was simpler, or seemed so. Similarly, the citizens in many of the disrupted or threatened societies in the films long for a return to their lives and their societies before they were destroyed or threatened. And

we, as political creatures, often turn to those whom we see as heroic to lead us, especially during confusing or threatening times. The call to "make America great again" fits quite seamlessly into this yearning; while the referent time is unclear, there is a clear impulse towards both nostalgia and nationalism in these four words on the campaign trail and in politics. Thus, the nostalgic and nationalistic impulses that are woven throughout the MCU are also woven throughout our own body politics in the United States and elsewhere. Sometimes we really do long for a hero to come along and fix everything—"I, alone, can fix it" is another refrain we have heard of late—as the heroes in the MCU often do. Alas, we are often the only ones who can actually fix that which is broken.

Notes

1. President Donald Trump defying the laws of politics, President Ronald Reagan as the "Teflon president," President Barack Obama's disciplined resolve and equanimity in the face of perpetual attack, and the "notorious" RBG and her workout videos, among others.

2. Such as the giant hose that will pump pollution into outer space and solve the global climate change problem.

3. See Panagia (2009), Dienstag (2020), and Schoolman (2020), among others.

4. See Brader (2006), Condon and Wichowsky (2020), and Marcus (2002), among others.

5. It is sort of Hela's origin story, but it is not all that extensive. She is just pissed off because Odin decided she was too imperial and too strong and banished her. It is also Valkyrie's origin story, explaining how she came to live outside Asgard and her role as a protector of Asgard. Interestingly, these aren't the only female characters in the MCU who get short shrift with regard to the telling of their origin stories.

PART II WITH GREAT POWER

CHAPTER 8 GOVERNMENT AS THE BAD GUY?

Nicholas Carnes

When Marvel Cinematic Universe (MCU) films depict politics and government, what kinds of messages do they send? Do they use governing institutions as foils to showcase the exceptional abilities of their protagonists? Do they depict politicians, intelligence officials, and military leaders as self-serving and un-interested in the public good, or powerless to save the world from existential threats that can only be defeated by superheroes?

Existing research gives us good cause to ask questions like these (and the many others raised in this book about how the MCU depicts political and so-cial issues). Fictional media often shape our views about nonfictional political issues in subtle and surprising ways. One recent lab experiment found that col-lege students who were randomly shown *Parks and Recreation*—a TV comedy with a strong female lead—were more likely to support women's real-world reproductive rights than those randomly shown another TV comedy, *How I Met Your Mother* (even though neither of the episodes they were shown mentioned reproductive issues; Swigger 2016).

Like past studies of how government is depicted in fiction, this chapter ex-plores how the MCU portrays the US government: politicians, the military, intelligence officers, and other government workers like police officers and firefighters. My analysis asks how often MCU films depict government officials, and whether the substance of those depictions is positive or negative—specif-ically whether MCU films depict government as corrupt and self-interested (a common concern in the long-running literature on nonfictional political media, like news and campaigns) and whether they depict government as ineffective or helpless (a concern that is specific to the superhero genre, in which stories typically focus on problems that can only be solved by powerful *individuals*, not the collective efforts of governments, interest groups, and engaged citi-zens). To answer these questions, I worked with three research assistants[1] to identify every scene in all twenty-three films in Phases One through Three that included some depiction of the US government. We then cataloged every char-acter and institution that appeared on screen and categorized whether those depictions of government were negative or positive.

Overall, government is remarkably prominent in the MCU: across the twenty-three films in Phases One through Three, representations of the US govern-

ment appear on screen for more than 20 percent of the total run time. What are these scenes saying about politics and government in the United States?

Why Scholars Care about Depictions of Government

Video and cinema have always concerned political scientists. In the 1960s and 1970s, as color TV and broadcast news swept the country, Americans increasingly began to get their news about politics and government from television rather than from radio or traditional print media like newspapers. At the same time, the nation experienced a steady surge in *political cynicism*: distrust of or low opinions about people in politics and government. Scholars of media like Michael J. Robinson and G. Ray Funkhouser argued that the two trends were connected. Television news, they reasoned, was faster-paced than traditional print media like newspapers, and TV had less "space" to devote to government and politics. Moreover, TV needed dramatic footage in a way that print did not; a newspaper story could engage a reader without a single image, but TV demanded a constant stream of gripping, moving pictures to keep the viewer's attention. As a result, scholars argued, television coverage tended to depict politics and government in ways that were distorted, sensational, and negative. And as the nation relied more on television for political news, the public became increasingly cynical about public affairs, given over to what Robinson (1976) termed "video malaise" (see also Funkhouser 1973).

Early work on cynicism and television news paved the way for what is now an extensive literature on how the media environment (not just TV news) depicts politics and government. Part of the reason that this topic has attracted so much attention is that the stakes seem to be high: research on the *consequences* of political cynicism took off in the 1980s and 1990s, and the findings were often bleak. Cynical people tend to participate less actively in politics, embrace more extreme positions and ideologies, oppose basic government services, and even break the law more often.[2] If the media were to blame for promoting cynicism, it would represent a stark departure from traditional ideas about the role of media in a democracy. The media environment should educate, empower, and entertain citizens, not turn them into a bunch of tuned-out cynics.

Yet in the decades since Robinson wrote about video malaise, scores of academic studies have argued that that the media do exactly that. Many have focused on *the news media*, that is, traditional political journalism. The most widely accepted perspective in this literature is probably Cappella and Jamieson's (1997) "spiral of cynicism" theory, which argues that news media often portray politics as a game and focus less on issues or policy and more on popularity, strategy, and scandal. Viewers find this kind of coverage entertaining

(e.g., Hamilton 2004), but it also promotes political cynicism and disengagement, creating a sort of spiral. A cynical public thinks that politics is just a selfish game, news that caters to that perspective makes the public cynical, and so on, and so on.[3]

Over time, similar concerns have cropped up in research on other forms of media. There is a literature on *campaign advertisements* that debates whether negatives ads promote cynicism and political disengagement.[4] There is a literature on the effects of *infotainment*, "nontraditional news that merge entertainment with informational content—like comedy talk shows, satirical news, and cable opinion news" (Guggenheim, Kwak, and Campbell 2011, 287).[5]

Understandably, as scholars have examined how government is depicted in political media, many have also wondered how government and politics are depicted in *fictional media*. Of course, audiences usually know the difference between fiction and nonfiction. But there are many reasons to suspect that fictional media can affect how people think about real-world issues.[6]

There are in fact scores of studies that show that fictional media can impact how audiences think about real-world political issues. A study in 1989 found that viewers who watched a drama about a Soviet takeover of the United States called *Amerika* subsequently became more hostile to communism and supportive of military strength. People who watch crime dramas tend to feel more favorably toward the police and punitive crime policies like the death penalty, people who watch traditional television dramas and sitcoms tend to feel differently about women's rights, changing portrayals of women and people of color on TV tend to predict changes in social tolerance, and depictions of violence in popular shows tend to increase people's fear of crime (even after controlling for actual crime rates).[7] Even in experiments—in which researchers show subjects fictional media at random to rule out the possibility that people are just selecting fiction based on their political views—fictional content like *Orange Is the New Black* and *Parks and Recreation* can influence audiences' real-world views about criminal justice, women's reproductive rights, the death penalty, radical political action, and even the president of the United States.[8]

How the government is depicted in fiction seems to influence political cynicism in some of the same ways as depictions of government in nonfictional political news. A year after Robinson wrote about TV news and video malaise, Kaid, Towers, and Myers (1981, 162) began studying a fictional drama called *Washington: Behind Closed Doors*. Following the lead of early research on TV news, they reasoned that "if one sees political figures and political institutions represented negatively in television drama, viewers might be expected to become more distrustful and cynical." Their study didn't produce clear evidence of a link, but subsequent research on more popular fictional content found clear evidence that depictions of government—good and bad—shape viewers'

trust in politics and government. Holbert, Shah, and Kwak (2003, 427) found that "viewing *The West Wing* seems to prime more positive images of the U.S. presidency." Mulligan and Habel (2012) found that undergraduates randomly shown the film *Wag the Dog*, a fictional movie about a president faking a war, were more likely to believe that US presidents had staged or would stage fake wars to manipulate public opinion. Hoewe and Sherrill (2019) found that regular viewers of fictional political shows with female lead characters expressed greater political interest, efficacy, and engagement. And Manoliu (2019) showed that college students who were randomly assigned to watch *House of Cards* exhibited more cynicism than those who watched *The West Wing* or *The Big Bang Theory*. Like political news and infotainment, fictional media seems to shape what people think about government.

Responding to findings like these, in recent years, a growing number of researchers have turned their attention to *content analyses of politics in fiction*, studies that focus not on establishing that fiction can influence people, but on understanding the political and social messages that exist in fiction in the first place.[9] Some scholars focus on fictional programming with obvious political implications, studying depictions of law enforcement in crime dramas, sexual victimization in prison shows like *Oz* and *Orange Is the New Black*, disobedience to orders in American military films, politicians in shows like *Madam Secretary*, and issue-related discourse in fictional political dramas.[10]

Even fiction that would seem at first glance to be far removed from the realm of politics and public affairs has been the subject of political content analyses. In their careful classification of fictional TV series and films, Eilders and Nitsch (2015) included "fantasy" programming; they found it to be low in political content and realism but also found that it sometimes features political characters and issues. Marshall (1981) analyzed children's books and mainstream television programs—sitcoms, fantasy, cartoons, and dramas—and found that government officials made up about 20 percent of the characters.

Every kind of media, it seems, sends important messages that can in turn influence cynicism and trust in government. What about the biggest movie franchise in the history of cinema?

The Two Big Concerns about the MCU

The MCU naturally deals with politics and government, at least some of the time. Films about superheroes always include supervillains, and supervillains usually attract the attention of law enforcement, the military, and the government. Of course, many of the films in the MCU are set in distant galaxies, and the entire franchise is set in an alternate universe. So although *Iron Man 3* is

The MCU prominently features fictional versions of American political institutions and leaders, like the fictional President Matthew Ellis. From *Iron Man 3* (2013).

set in the year 2012, when War Machine, Iron Man, and Pepper Potts rescue the president of the United States, they don't save Barack Obama, they save a fictional president named Matthew Ellis.

However, all of the core features of America's real-world political processes and government seem to be present in the MCU's fictional universe. In the MCU, the United States has a president and vice president, a Congress, a court system and prisons, an FBI, a CIA, a State Department, a military, a Pentagon, police officers, firefighters, government contractors, and mass media. In most ways, it looks like the real world—you can study at MIT or stroll through Washington Square Park in New York City—albeit with fictional additions, like the nation of Wakanda or a fictional government intelligence agency called the Strategic Homeland Intervention, Enforcement, and Logistics Division (or S.H.I.E.L.D.).[11]

One concern we might have about depictions of government in this fictional universe is simply that the creators of MCU films might be given over to the same tendencies that lead TV journalists to emphasize sensational or negative depictions of government. If hard news outlets can be tempted to emphasize negativity, scandal, and the horse race in order to boost the entertainment value of the content they create, we might worry that the same could be true of films that are created *first and foremost* to entertain. The MCU isn't a civics lesson; perhaps it depicts government as a game played by the self-interested, like so many nonfictional news outlets.

Unfortunately, moreover, the superhero genre itself raises another concern.[12] Most superhero stories focus on exceptional individuals addressing large-scale threats, the kinds of problems that are traditionally the domain of governments and militaries. For a story about a superhero to work, the problem at the heart of the story often *can't* be something that real-world governments can efficiently address. In superhero stories, the protagonist has to prevail where

other actors like the government cannot—otherwise, what good is the hero? As Dean (2019, 1) recently put it, "The threat might be too powerful—the police versus, say, Brainiac or Galactus wouldn't be much of a fight. The government might also be corrupt, incompetent, and/or indifferent to the problem at hand. Either way, it's up to one singular hero (or team of heroes) to save the day."

Superhero fiction, of course, can combine both of these negative depictions of government, as Dean's remarks suggest. If politicians are cynical and self-serving (in keeping with scholars' long-standing concerns about traditional news media), the government can hardly be trusted to respond to existential threats, leaving a void that can only be filled by a superhuman protagonist (in keeping with the genre-based concern). The ending of *Iron Man 3* is a case in point: President Ellis is betrayed by his treasonous vice president, and only Iron Man and his amazing friends can stop the villain.

Although there are good reasons to investigate how heavily the MCU leans on these kinds of negative tropes about government, there are also reasons to expect more nuance in the MCU. For one, the films are hardly monolithic; on the contrary, the first twenty-three MCU movies were directed by sixteen different teams, and they run the gamut from superhero origin stories to spy thrillers to comedy heist movies. Although a single production studio oversees all of the films (for more on this, see Goldberg in this volume), directors are given significant artistic license. (Director James Gunn recently reported that the only restriction Marvel put on the *Guardians of the Galaxy* script was that he feature Thanos. He even got to invent what became the canonical origin story for the Infinity Stones, the central weapons in the culminating films *Avengers: Infinity War* and *Avengers: Endgame*.) Whereas local TV news follows a similar format in most towns, the MCU films vary widely. As such, we might not expect *any* particular perspective on government and politics to be universal across the films.

Nothing in Marvel's larger history or ethos, moreover, would lead us to expect Marvel Studios to produce films that are especially negative about politics and government. Since its founding, Marvel has often blended the power fantasies at the heart of the superhero genre with moral fantasies about things like personal responsibility and the perils of intolerance. Stan Lee's nonfictional "Stan's Soapbox" column began running in Marvel titles in 1967, and the first installment stated plainly that although the purpose of Marvel Comics was "to entertain you," if "in the process of providing off-beat entertainment, . . . we can also do our bit to advance the cause of intellectualism, humanitarianism, and mutual understanding . . . that won't break our collective heart one tiny bit!" These are hardly the sentiments of an entertainment company with a blasé attitude about public affairs.

Does the MCU depict civil servants, politicians, and government as craven

and self-serving, or as incompetent and ineffective? Or do the MCU films do more than just lean on convenient and reductionist depictions of government?

Every Scene in the MCU That Depicts the US Government

To find out, I worked with two undergraduate public policy students who were subject-matter experts—serious fans of the MCU—and one more mainstream fan—a high school senior who enjoyed the films but had not seen them all—to identify and code every scene in the first twenty-three MCU films (Phases One through Three) that includes a depiction of the US government. We defined the US government as including politicians, military officials, intelligence officials, law enforcement, and first responders like police and firefighters. They could be based on real-world government institutions (like CIA agent Everett Ross) or fictional ones (like S.H.I.E.L.D. director Peggy Carter). Importantly, we did not count scenes that depict government officials acting in a *nonofficial* capacity; if they are off the clock, they were not counted as government. We also didn't count each film's title characters as government officials, since doing so would have meant, for instance, counting every scene with the Avengers as a scene depicting government (since the Avengers Initiative was a part of S.H.I.E.L.D.)—this approach didn't seem to us to be consistent with how audiences actually interpret the films. Instead, we focused on how government operated *around* the protagonists in MCU films, an approach that assumed that audiences identify with the main characters and experience the fictional world through the protagonists' eyes.

Our first task was to identify every scene that depicts government. To do so, my two subject-matter-expert research assistants watched every film and documented the start and end times and events that occurred whenever there was a representation of the US government on screen. My third research assistant, who was not a subject-matter expert, checked their work by doing the same for the six Phase One films; he did not identify any scenes that the first two missed. I then synthesized the research assistants' lists of scenes, resolving any nontrivial (greater than ten-second) discrepancies in run times (e.g., if one research assistant said a scene was thirty seconds and another said it was forty-one or more seconds, I would watch it myself), combining written descriptions, and addressing cases where one research assistant split a sequence of scenes into multiple entries and another treated them as one long scene (in those cases, I made the final judgment about whether the audience would interpret the sequence as one scene or several, although in practice this did not affect my findings, since I analyzed both the numbers and total run times of the scenes I was analyzing).

Our next task was to code the combined list of scenes to record the identities of the US government representations on screen. My two subject-matter-expert research assistants did this for every case, and I did as well (this also allowed us to check that the characters we counted as representations of the US government did in fact meet our definition and to remove cases that we had erroneously included in our first pass, which originally erred on the side of inclusion). In more than 95 percent of cases, at least two of the three of us agreed about the identities of the government actors in each scene (no small feat considering that many scenes include multiple characters and each coder had to make subjective judgments about whether they are acting on behalf of government).

My subject-matter-expert research assistants and I then went through our list of scenes and characters and recorded whether each representation of the US government was depicted negatively and/or positively and why. I then reviewed every scene and reconciled our coding; when one of us disagreed about whether a case was positive or negative (about 31 percent of the time for negative cases and 37 percent of the time for positive cases), I sided with the two-person majority; for the positive cases that were coded by only two people, I reviewed the scene and made a final judgment.[13]

Across the first twenty-three films in the MCU, we identified 413 scenes that depicted the US government, which together totaled more than eleven hours of screen time. To put it another way, the US government is on screen for approximately 21 percent of the 52.5 hours of film in Phases One through Three (a figure that aligns with Miller's 1981 finding that 20 percent of characters in entertainment TV shows were government officials).

Representations of government are present at vastly different rates across the different films, of course, as Figure 8.1 illustrates. Government officials are major characters in every film in Phase One: Colonel James Rhodes is the protagonist's sidekick in *Iron Man* and *Iron Man 2*, Lieutenant General Thaddeus Ross and elite soldier Emil Blonsky are the main antagonists in *The Incredible Hulk*, S.H.I.E.L.D. is an important antagonist in *Thor* and an important ally in *The Avengers*, and the military is omnipresent in *Captain America* (even without counting Captain America himself as a representation of government). After Phase One, government plays a smaller role in subsequent films—sequels to *Iron Man* and *Captain America* include government at rates that parallel their predecessors, and law enforcement figures prominently in the heist movies *Ant-Man* and *Ant-Man and the Wasp*. But Phases Two and Three also saw the advent of films that take place almost entirely in extraterrestrial settings (the two sequels to *Thor* and the two *Guardians of the Galaxy* films) and the film *Doctor Strange*, which is set on Earth and partly in the United States but doesn't include a single depiction of the US government that we documented.

Figure 8.1. Percentage of screen time that includes depictions of the US government. Credit: Author's data collection.

S.H.I.E.L.D. plays prominent roles in *Spider-Man: Far from Home* and *Captain Marvel*, but across the Phase Three films, the US government is about one-fourth as prominent as it is in the Phase One films.

Viewed this way, it is easy to see that the US government has played an important role in MCU films, even as the fictional universe has expanded. But has it played a negative role? Films like *The Incredible Hulk* might lead us to think that perhaps the MCU has leaned on traditional depictions of government officials as self-serving or corrupt (Bruce Banner spends the entire movie running from a military general and an elite soldier who are bent on capturing him and creating an army of genetically modified super soldiers). Films like *Iron Man 2* might lead us to think that the MCU depicts government as incapable of addressing problems that only superheroes can solve (when Congress

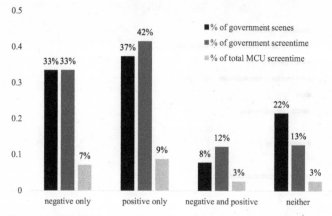

Figure 8.2. MCU depictions of government are more often positive. Credit: Author's data collection.

demands control of the Iron Man suit, Tony Stark fires back, "I just privatized world peace!").

Even so, overall, MCU films actually have a generally positive take on government. Figure 8.2 analyzes all 413 scenes that we identified, dividing them by whether they include a negative or positive depiction of government, or both (e.g., loyal and traitorous S.H.I.E.L.D. agents battling one another in *Captain America: The Winter Soldier*). In the MCU, *positive depictions actually make up the largest percentages of the scenes depicting the US government.* There are exceptions, of course—and even entire films with a negative slant on government (for a breakdown of Figure 8.2 by film, see Figure 8.A1 in the appendix). In *The Incredible Hulk*, the military is the main antagonist; 91 percent of the scenes featuring government are negative (and the rest are neutral). In *Thor*, S.H.I.E.L.D. is a constant impediment to the protagonist and his allies. In *Captain America: Civil War*, Steve Rogers rebels against the government. In *Ant-Man* and *Ant-Man and the Wasp*, the police and the FBI constantly try to foil the protagonists' heists. However, there are about as many movies with overwhelmingly positive portrayals of government: the military as heroic and admirable in *Captain America*, S.H.I.E.L.D. as a crucial ally in *Captain Marvel* and *Avengers: Age of Ultron*, CIA agent Everett Ross as adversary-turned-ally in *Black Panther*. Taken together, these twenty-three MCU films portray the US government in a decidedly varied but more often positive manner. There simply isn't a strong case to be made that the MCU as a whole is given over to cynical or reductionist depictions of government.

Looking at the specific positive and negative traits associated with government generally supports this interpretation. Table 8.A1 in the appendix lists the specific kinds of negative and positive scenes that we identified—everything

S.H.I.E.L.D. Agent Phil Coulson, like many representations of government in the MCU, assists the protagonists in their heroics, even apparently sacrificing his life in battle. From *The Avengers* (2012).

from scenes where the government saves the day (like when the military rescues Tony Stark from the desert in *Iron Man*), assists the protagonist, or helps civilians to scenes in which the government is a literal Abomination. We grouped the negative scenes into categories that roughly correspond with traditional cynical or reductionist portrayals of government—scenes where government officials are depicted as corrupt, dishonest, secretive, unfair, or self-interested—and "powerless in the face of global crises" portrayals of government as clueless or helpless.

Some negative depictions of government in the MCU fit in these categories, of course. Of the 18,362 seconds of screen time that include negative depictions of government, 4,593 seconds (25 percent) depict government using traditionally negative or reductionist characterizations, and 2,788 seconds (15 percent) depict government as powerless. The vast majority of negative depictions of government, however, depict it as a formidable antagonist. From brainwashed S.H.I.E.L.D. agents in *The Avengers* to the government-created Abomination in *The Incredible Hulk*, the most common negative depictions of government in the MCU are neither the traditional cynical nor "too weak to solve problems" negative portrayals of government. Rather, they depict government as a formidable obstacle to the protagonist's goals.

This could, of course, be viewed as a third kind of negative portrayal of government, or even a moral lesson not to let the government fall into the wrong hands. Either interpretation would essentially square with the basic conclusions of this analysis, namely, that the MCU does not depict government in a monolithically negative or reductionist way. There is no one stereotype or

negative frame that is deployed consistently across films. Government is prominent in the MCU, and when it is on screen, it is sometimes the self-dealing, dishonest, unconcerned-about-actual-policy government that academic studies of news media have long bemoaned, and it is sometimes the helpless-in-the-face-of-big-problems government that can be common in the superhero genre. But it is sometimes a worthy adversary or foe that the superheroes must contend with, and perhaps therefore a reminder of the fundamental significance of government.

Usually, however, when the government is on screen in the MCU, it is there to help.

Government as the Good Guy?

Decades ago, when Marshall (1981, 395) studied the content of children's books and mostly fictional entertainment programs on television, he concluded that government officials were depicted as "benevolent bureaucrats." In most cases, he found, government characters either comforted other characters or protected them from harm, and they were more likely than other characters to engage in self-sacrificing behaviors. Moreover, they were portrayed as more competent: "Government characters are more reliable, tidy, and timely than private sector figures in both samples."

In general, this characterization of government in entertainment media is probably a good deal rosier than the depictions of government in the MCU. But the MCU still routinely depicts the US government in similarly positive terms. Government characters protect superheroes from harm. They comfort civilians fleeing impending disaster. They risk their lives to help the heroes and foil the villains. The MCU isn't progovernment propaganda (but see Jenkins and Secker 2022); in its films, the government is often shallowly self-serving, it is often helpless, and it is often the opponent. But more often than any of these, in the MCU, the government is on the side of the good guys.

Of course, audiences take what they want from films. Many people wrongly hold up Captain America as a symbol of nationalism (see Galdieri's chapter in this volume) or the Punisher as a symbol of police officers. Viewers may very well notice and respond to the nuanced and often positive portrayal of government in the MCU, but it's also possible that the negative scenes might somehow make more of an impact or resonate more. Future research might ask how MCU films affect people's attitudes toward government.

Still, for its part, the MCU has plenty of positive depictions of government for audiences to see. When MCU films depict government, they are usually depicting someone good.

Appendix

Figure 8A.1. Scenes with negative or positive depictions as a percentage of all scenes featuring US government, by film. Credit: Author's data collection. All scenes were coded as negative, positive, neither (e.g., a scene depicting the US government without a clear positive or negative implication), or both (e.g., a scene depicting loyal S.H.I.E.L.D. agents battling traitorous S.H.I.E.L.D. agents, showing government representatives as both heroes and villains).

Table 8.A1: Negative and positive scene run times by type of negativity and positivity

Positive Depictions (in seconds)

Addressing major problems	**20033**
saves the day	663
assists protagonist	15992
recruits protagonist	953
assists protagonist and helps civilians	859
redeemed—assists protagonist	969
helps civilians	597
Generally positive	**1603**
powerful or effective	1307
admirable	108
honors the protagonist	188

Negative Depictions (in seconds)

Traditional negative depictions	**4593**
assassins	43
butt of a joke	217
corrupt	82
corrupt, helps a villain	48
deceives the protagonist	74
deceives the public	93
dishonest	214
golfing	24
oppressive	121
overreaching	300
secretive	58
seizes property	121
seizes property, disparages protagonist	25
steals research	99
suspicious	406
unfairly punishes protagonist	189
uses the hero as propaganda	247
traitor	1928
traitor, murderer	82
treason	123
shames the hero	99
Powerless	**2788**
clueless	61
defeated	229
helpless	23
in distress	291
in need of saving	517
in the way	149
inadvertently helps villain	125
ineffective	10
ineffective, seizes property	422
insecure	91
minor antagonist, helpless	143

oblivious	216
oblivious to danger	75
powerless	135
stood up by protagonist	301
Antagonist or opponent	**10981**
antagonist	2355
antagonist (brainwashed)	621
antagonist, albeit minor	436
antagonist, albeit unwitting	999
antagonist, inadvertently helps the villain	572
assists the villain	15
attacks protagonist	211
controls protagonist	83
hunts protagonist	1858
hunts protagonist, unethical supersoldier program	2349
mind controls good guy	263
minor antagonist	979
nukes New York City	82
resists working with protagonist	29
threatening	2
unethical supersoldier program	127

Credit: Author's data collection.

Notes

I am deeply indebted to my research assistants, Preston Massey, Christina Zhang, and Harry Wang. Thank you for making this research team perfectly balanced, as all things should be.

1. The research assistants included two public policy students at Duke University who were subject-matter experts—deeply knowledgeable MCU fans—and a third research assistant who was a more mainstream fan—a high school senior who enjoyed the films but hadn't seen them all.

2. On disengagement, see Cappella and Jamieson (1997) and Macedo (2005); but see Sears and Citrin (1982) and Southwell and Pirch (2003). On polarization, see Ansolabeher and Iyengar (1995). On public services, see Hetherington (2005). On lawlessness, see Tyler (1998).

3. See also de Vreese (2004) and Hibbing and Theiss-Morse (1995); but see Meyer and Potter (1998).

4. This literature has been somewhat mixed, with some studies supporting Ansolabehere and Iyengar's (1995) *demobilization hypothesis* and others finding that negative or attack advertisements do not decrease voter turnout (Finkel and Geer 1998).

5. In controlled experiments, infotainment has been found to promote cynicism (e.g., Baumgartner and Morris 2006), although observational studies have found that infotainment can be politically empowering in various ways (e.g., Baum 2002; Baum and Jamison 2006; Towler, Crawford, and Bennett 2020). For an interesting recent take on the larger effects of infotainment, see Owens et al.'s (2020) recent work on how young adults shown comic book versions of the Constitution learned it better than those shown the text.

6. As Holbrook and Hill (2005, 27) put it, "Media consumers do not appear to treat non-news information sources as inconsequential."

7. On *Amerika*: Lenart and McGraw (1989). On crime dramas: Holbert, Shah, and Kwak (2004). On women's rights: Holbert, Shah, and Kwak (2003). On women and people of color: Garretson (2015). On violence and fear of crime: Jamieson and Romer (2014).

8. On criminal justice: Mutz and Nir (2010) and Slater, Rouner, and Long (2006). On women's reproductive rights: Swigger (2016). On the death penalty: Till and Vitouch (2012). On radical political action: Jones and Paris (2018). On the president: Holbrook and Hill (2005).

9. Some focus broadly on how issues like race, class, and gender are depicted in fictional content (e.g., Dines and Humez 2002; Holtzman and Sharpe 2014) or how death is depicted in children-focused programming (Tenzek and Nickels 2019).

10. On criminal investigations: Davidson (2015); Wilton (2018). On prison sexual victimization: Storey (2019). On *Madam Secretary*: Schwind (2017) and McCauliff (2016). On fictional dramas compared to newsmagazines: Nitsch, Jandura, and Bienhaus (2021, 1), who find no differences in how ten issues are covered in terms of "relevance, pluralism, or democratic discourse norms," which they interpret to mean that "fictional TV series can offer the same content quality as political reporting."

11. Some scholars disagree that S.H.I.E.L.D. should be classified as a representation of the US government (for an excellent discussion of this point, see Saideman 2012). I count it as a US government organization here because I believe viewers interpret it that way; for instance, the S.H.I.E.L.D. entry on the MCU Wiki describes it as "an American extra-governmental military counter-terrorism and intelligence agency, tasked with maintaining both national and global security." Within the MCU storyline, S.H.I.E.L.D. was originally a US organization tasked with protecting the world from threats that it isn't ready to handle, which is why it operates largely outside the normal apparatus of US government. Its headquarters, the Triskellion, is a prominent building in Washington, DC. Between the events of *Captain Marvel* and *The Avengers*, S.H.I.E.L.D. begins operating under the supervision of the World Security Council (this is the film Saideman was focusing on), which is headed by an American but mostly made up of foreign leaders, although the nature of the relationship is unclear. S.H.I.E.L.D. fully disbands after *Captain America: The Winter Soldier* and is reconstituted as a US government agency charged with enforcing the Sokovia Accords in *Captain America: Civil War*. What to do with it, then? I suspect that most viewers regard S.H.I.E.L.D. as a representation of US government, but I cannot ignore Saideman's critique and the possibility that many do not. As such, I simply reran my main analyses below, fully removing S.H.I.E.L.D. and its agents and leaders (on the theory that if viewers saw *The Avengers* first, they might view S.H.I.E.L.D. as a multinational organization in all the other films). The results are largely unchanged. The percentage of MCU screen time devoted to government drops from 20% to 15% (still a striking figure), and the balance of positive to negative scenes shifts from 37–33% to 32–39% (still a striking amount of positive content that defies the expectation that the MCU will lean monolithically on negative stereotypes about the US government).

12. This is the genre-based approach recommended by scholars like Jones and Paris (2018).

13. Due to time constraints, for about half of the scenes, one research assistant documented only negative depictions of government.

DEMOCRATIC MONSTROSITY

Marvel's Avengers and Extraordinary Politics

Elizabeth Barringer

In many superheroic narratives, a world-threating event massively disrupts ordinary life, spurring a hero to spring into action, restore order, and make the world safe (again) for democracy. Superheroes are thus easily associated with what political theorists call "emergency politics": political moments where the state acts in unprecedented, often illegal ways in the name of securing the survival and welfare of ordinary citizens. These kinds of political moments raise important questions for liberal democracies: what sorts of actions can a democratic community legitimately undertake to sustain itself? And if democratic practices must be abandoned in times of crisis in favor of unilateral state intervention, how sustainable is democratic rule overall?

Viewed as emergency actors, superheroes raise similar questions. Heroes often act outside the law in ways that threaten democratic legitimacy. Their political resources are those of violent force, arbitrary discretion, and charismatic authority rather than respect for institutional procedure and rule of law. From the perspective of ordinary political life, then, superheroes may appear to threaten democratic practices, their actions more monstrous than heroic. The extreme popularity of superhero films in recent decades might therefore give us reason for pause. Does the widespread love of superheroes reflect a loss of faith in democratic politics? Or can we find in superheroic narratives resources that foster democratic values?

In this chapter, I offer an ambivalent answer to this question. An uncritical celebration of superheroism certainly may reflect anxiety over democratic institutions and their power, but democratic politics encompasses more than a set of formal arrangements, including practices of shared power, contest, and persuasion. Instead of viewing the heroes of the MCU through the narrow lens of "emergency," I therefore suggest that a broader perspective will be more productive—what political theorists sometimes call "extraordinary democratic politics," referring to the moments when the people in a democratic society exercise their collective power to alter or disrupt settled, institutional politics, creating new laws and new political practices or protesting, refusing, and

transforming the meaning of old ones. By adopting this broader perspective, I argue that the heroes of the MCU reflect the uncertain relationship between the democratic power of the people and the stabilizing constraints of institutional rule itself.

Viewed in this more critical way, the MCU reminds audiences that democracy is an ongoing practice burdened with risk and danger—but the unpredictable, "monstrous" democratic powers that threaten ordinary life can also save it. To illustrate this argument, I turn to Marvel's Avengers, "Earth's mightiest heroes." Throughout the Avengers movies, superheroes are presented as unstable outsiders, ambiguously and sometimes dangerously related to the institutions that they are routinely called upon to save. I focus particularly on the film *Avengers: Age of Ultron* (Whedon 2015) in which the potential monstrosity of the Avengers is one of the film's central themes. As we will see, the ambivalence of these heroic-monstrous figures provides audiences with timely reminders of the dangers and challenges of democratic citizenship as well as its extraordinary strength.

Need and Ability

As some of the other chapters in this volume show (see, for instance, Hirschmann and Wang and Zhang), the vast popularity of superheroes aligns rather neatly with the uncertain politics of the past two decades, with liberal democracies facing unprecedented challenges at home and abroad. It is easy in such times to long for someone responsible, powerful, and (probably) beautiful to save us—a fantasy many of the MCU films happily fulfill. But the stories we watch on screen also shape the expectations of audiences (e.g., Anker 2014; Berlant 2011). They tell us who is heroic and who is villainous; who saves and who is rescued; and what kinds of violence, in what contexts, is legitimate or worthy of our admiration. And these stories do not always serve democratic ends.

A central issue within the MCU is that many superheroes operate with little institutional oversight. Without fail, the outsized nature of the threat faced on screen (cosmic armies, shadowy secret societies, all-powerful Infinity Stones) demands a response that the ordinary political institutions depicted in the film cannot provide by themselves. As Richard Reynolds (1992, 77) notes,

> A key ideological myth of the superhero . . . is that the normal and
> everyday enshrines positive values that must be defended through heroic
> action—and defended over and over again almost without respite against
> a battery of menaces determined to remake the world for the benefit of

aliens, mutants, criminals. . . . The normal is valuable and is constantly under attack, which means that almost by definition the superhero is battling on behalf of the status quo.

There are two interrelated ideas here worth emphasizing: the way superheroic action implicitly confers value on the order superheroes defend and the clear distinction between ordinary politics—the normal and everyday—and the extraordinary heroic action that must preserve it.

Within political theory, "ordinary politics" generally refers to the routine patterns of everyday political life, such as rule of law, electoral processes, and governance by political elites. "Extraordinary politics," in contrast, refers to moments of political rupture or change, where political activity bursts past these institutional borders (Kalyvas 2009, 3, 6–7). "Extraordinary politics" thus often describes moments of founding, revolution, or political emergency—crises where states are formed, dissolved, or act outside their ordinary legal limits to preserve themselves. Of these paradigms, it is perhaps easiest to see how the superheroism of the MCU aligns with *politics of crisis and emergency*. Political theorist Carl Schmitt (2007, 5) defines political emergencies as those moments when the sovereign suspends the law, instituting a "state of exception" in which ordinary political rule does not apply, often in response to what it deems great need or an existential threat.[1] Within the MCU, extralegal superheroics are likewise routinely justified through the language of emergency, exceptional—often existential—threat, and need.

But extralegal action is also justified by the extraordinary abilities of the heroes themselves. As Ramzi Fawaz (2016, 6) comments, "What [distinguishes] the superhero from the merely superhuman . . . [is] its articulation of an extraordinary body to an ethical responsibility to use one's powers in service to a wider community." This relationship is encapsulated in the pervasive Marvel mantra, "With great power comes great responsibility." When exercised on behalf of the helpless community, superpowers function as a manifest sign of the moral, and often political, legitimacy of the actors who wield them. The reverse also holds true. Extraordinary powers used in ways that threaten the "everyday, normal" life of a community define supervillainy—though this formula is often tweaked in critical ways.[2] The mantra is thus double-edged: it defines both an obligation *to* act heroically and a justification *for* those actions.

Across the MCU, need and ability are often referenced as justifications for the Avengers' extralegal activity. Consider how Nick Fury (played by Samuel L. Jackson) describes the original purpose of the Avengers (Whedon 2015) team: "There was an idea . . . called the Avengers Initiative. The idea was to bring together a group of remarkable people to see if they could become something more, and work together when we needed them to, to fight the battles

Across the MCU, need and ability are often referenced as justifications for the Avengers' extralegal activity. Nick Fury argues that the aim of the Avengers was "to bring together a group of remarkable people to see if they could become something more, and work together when we needed them to, to fight the battles we never could." From *The Avengers* (2012).

we never could." Fury's statement links the remarkable qualities of individual heroes to the vulnerability of ordinary people in emergency contexts, people who "never could" fight the battles demanded of them. Notably, Fury speaks here as director of the government organization S.H.I.E.L.D., clearly articulating the limits of official, institutional power compared to the extraordinary capacities of the Avengers team. Indeed, by the end of the film, the Avengers break free of government oversight entirely, though audiences are assured that they remain bound to their responsibilities. When Maria Hill (Colby Smothers) asks Fury how he knows the Avengers team will return in the event of another emergency, he states simply, "Because we'll need them to."

Black Widow (Scarlett Johansson) articulates the relationship between need and ability explicitly in *Captain America: The Winter Soldier*. Having discovered that S.H.I.E.L.D. has been infiltrated by Hydra, a malicious quasi-terrorist organization, Black Widow releases a massive trove of confidential S.H.I.E.L.D. data to the public. When brought before Congress and threatened with arrest, she responds, "You're not going to put me in a prison. You're not going to put any of us in a prison. You want to know why? . . . Because you need us. The world is a vulnerable place. And yes, we help make it that way, but we're also the ones best qualified to defend it" (Russo and Russo 2014). Here, Black Widow acknowledges the fraught relationship between ordinary institutional rule and unilateral heroic action, defending her position through the language of vulnerability and superheroic agency. That she gives this speech in

a congressional hearing (which she promptly abandons) underscores the tension between the demands of the Avengers' personal, and often moral, sense of obligation to serve their communities through any means necessary, on the one hand, and the institutions, officers, and laws that formally define those communities, on the other. This tension becomes a central theme in many of the Avengers' on-screen adventures.

Following *The Winter Soldier*, for instance, in *Avengers: Age of Ultron*, Tony Stark (Robert Downey, Jr.) rejects democratic processes and justifies the creation of a global defense artificial intelligence (AI) using the language of vulnerability: "We don't have time for a city hall debate. . . . This [world], this vulnerable blue one? It needs Ultron" (Whedon 2015). Fallout from these choices spills over into *Captain America: Civil War*, where the film's central conflict pivots on the question of formal legitimacy versus heroic ability and need (Russo and Russo 2016). The movie begins with a harsh critique of superheroics by a mother grieving for her son, who has died as a result of the events in *Age of Ultron*: "You think you fight for us?" she argues. "You just fight for [yourselves]." Yet by the end of the film, the moral significance of need and responsibility is reaffirmed by newcomer Spider-Man (Tom Holland): "Look, when you can do the things that I can, but you don't, and then the bad things happen, they happen because of you."

However well intentioned, this heroic language of need and ability treats ordinary citizens and their institutions as powerless to meet the challenges of emergencies themselves: democracy always seems to require a heroic assist. Of course, this does not mean that superheroes are *antigovernment*. (For more on this, see Carnes in this volume.) Indeed, much like Schmittian sovereigns, superheroes paradoxically can bolster state authority even when they violate state laws (Curtis 2016, 103). This is because when superheroes violate political norms they nearly always do so *for* the political community, their great virtue (displayed through their superhuman abilities and tremendous on-screen struggles) affirming the value of the community they choose to save.[3] Likewise, when heroes violate state orders, their actions can operate as critiques, illustrating how those institutions have failed to live up to their higher, founding ideals—as we see when Fury ignores orders from the World Security Council to bomb a civilian population in *The Avengers* or when Steve Rogers (Chris Evans playing Captain America) challenges the corrupted S.H.I.E.L.D. leadership in *The Winter Soldier* by appealing to the values of public trust and political freedom. As Reynolds (1992, 15) notes, the "loyalty and patriotism [of superheroes . . . is] above even devotion to the law."

Yet supporting the *state* cannot be equated with supporting *democracy*. In our own times, indeed, the language of crisis and emergency has been used to defend the broad expansion of state power at the expense of liberal democratic

norms, including the suspension of civil liberties at home, and acts of war abroad. As political theorists such as Judith Butler and Elisabeth Anker have shown, these actions are often framed using the language of patriotic loyalty and wounded vulnerability—vulnerability that requires the violent response of an avenging superpowered state.[4] These moments stress democratic legitimacy, exposing gaps between the curtailed horizon of civic agency and the immense powers wielded in the people's name. If a democratic community always relies on unilateral emergency interventions by heroic individuals (or heroic states) in times of crisis, how democratic is it?

Even in times of emergency, there are some acts that a community cannot accept and still call itself democratic, liberal, or free. As Steve Johnston (2019, 27) puts it, the danger of relying on superheroic interventions is that "a polity can end up destroying itself through the very measures designed to protect and save it . . . as the actions it takes to secure itself, however well intentioned, inflict damage that proves irreparable."[5] Superheroes thus represent an acute version of a broader political problem. Even when acting to save democratic communities—as the Avengers often do in the MCU—emergency superheroics simultaneously threaten democratic legitimacy. We should therefore ask whether the popularity of the MCU is, in and of itself, alarming. Despite their great loyalty, patriotism, and responsibility, are the heroes of the MCU threats to democratic life?

Extraordinary Democracy

Superheroes have long been associated with anxiety about democratic power (Umberto Eco once described superheroes as embodying "the [unthinkable] power demands that the average citizen nurtures but cannot satisfy"), and as we have just seen, through their reliance on the twin justifications of need and ability, the superheroes of the MCU fit easily into the thorny paradigm of emergency politics (Eco and Chilton 1972). Yet focusing too narrowly on the distinction between ordinary life and the extraordinary emergencies that each Marvel film presents can lead us to overlook the more subtle political dynamics depicted *between* films (and between the Avengers themselves). Attending to these dynamics, I suggest, allows us to see a more critical, productive side of the MCU and of extraordinary politics more generally. Centrally, as we will see, the Avengers depict how political uncertainty and the disruption of ordinary institutional practices are not necessarily *threats* to democratic politics. Rather, democratic politics are always unstable and always, potentially, extraordinary.

To understand why, it helps to look more closely at the two other dominant models of extraordinary politics mentioned above. Alongside the paradigm of

emergency, extraordinary politics are most commonly associated with *moments of political founding*, where a multitude defines the moral and legal boundaries that will constitute their community, sometimes with heroic assistance.[6] In popular media, Westerns deal most explicitly with this kind of political moment, and many superheroic narratives borrow heavily from the conventions of this genre: a heroic outsider emerges to defend a fledgling community, defeats forces of lawless violence, and then disappears so that law and order can take root.[7] *Revolution* forms the other most commonly cited "mode" of extraordinary politics, where established orders are thrown out wholesale to clear the way for a new beginning. In superheroic narratives, total revolution is far more often the aim of supervillains than of heroes.

Crucially, however, moments of founding and revolution depend on the same essential democratic capacity: the power a group of people have to *found* order is also the power to *change* or *destroy* it. This fact has some far-reaching implications for democratic politics because these capacities do not simply vanish once institutional rules are put into place. The people are always capable of disrupting the status quo of a community, in part because *who* the people are is always changing. Due to the simple facts of immigration and emigration, birth and death, polities must constantly negotiate the kinds of questions that moments of founding and revolution engage—questions such as what values, rights, or laws will define a community, how should they apply, and to (or for) whom? Or what obligations, in what conditions, does one have to a political community, and under what conditions do those obligations fail? This means in a very practical sense that the extraordinary activities of founding and revolution are not contained events. They are ongoing processes, a part of everyday democratic existence.

If the people are *always* in the process of (re)founding themselves, they are likewise *always* a potential threat to the stability of the communities they constitute—not because of evil or ignorance but because of their capacities to create new orders. Few political theorists are as sensitive to this extraordinary aspect of political life as Hannah Arendt, who frequently insists on the "miraculous" powers of ordinary persons to initiate new relationships that "force open all limitations and cut across all boundaries." The tragic corollary to this observation is that there are some boundaries (or laws) that we might not *want* to abandon, yet due to the volatile nature of acting with other unpredictable agents, democratic endeavors tend to set off chains of consequences that interact in complex ways and, as a result, cannot be anticipated or controlled. Living and acting with others is thus inescapably prone to risk and danger—but is also capable of bringing about the unexpected and the new against towering odds, a quality that is also much admired in superheroes.

As we have already seen, however, the kinds of miraculous and unexpected

feats that superheroes such as the Avengers perform can cause problems for ordinary political institutions. They are unpredictable. Similarly, ordinary political conventions of law, electoral and deliberative processes, and rule by government elites all offer means of stabilizing the risky, unpredictable dimensions of democratic power. It is therefore important to see that the aims of ordinary and extraordinary politics sit in irresolvable tension. At its best, this tension is productive and dynamic, keeping institutions tied to the vital, changing needs and values of actual citizens while constraining action's unpredictable nature. Yet attempting to constrain the risks of democratic action through institutionalized power can easily go too far.

Borrowing from Bonnie Honig (2011, 2), a state "unitary and decisive, committed to its own invulnerability . . . is most likely to perceive crisis where there is only conflict, and to respond to perceived crises with antipolitical measures of emergency rather than with more pliant, engaged measures appropriate to the needs and uncertainties of democratic politics." Indeed, in democratic societies where there are many different kinds of people, complex (and violent) histories, and diverse beliefs, what appears to be a crisis from the perspective of the established political order may actually be a moment of much-needed transformation—where formal institutions are brought into alignment with changing social values, for instance, or corrected to recognize past injustices. Notably, we often refer to the leaders and participants of such popular movements, such as the American Civil Rights movement, using the language of heroism.[8]

Altogether, then, these ideas point to a third mode of extraordinary politics where, as Fred Lee (2018, 11) puts it, "ordinary politics constitutes extraordinary politics as much as extraordinary politics constitutes ordinary politics." There is no necessary distinction between people's political capacities in ordinary versus extraordinary times. There are, rather, differences in how actively or intensely those capacities are exercised and how much or little they align with the status quo. Indeed, narrowly focusing on emergency, founding, and revolution can obscure how extraordinary political events often occur *within* and *through* established institutional orders, moments that Andreas Kalyvas (2009, 29) describes as the "infrequent and unusual moment when citizenry, overflowing the formal borders of institutionalized politics, reflectively aims at the modification of the central political, symbolic and constitutional principles and at the redefinition of the content and ends of a community."[9]

This way of thinking about extraordinary democratic politics is both empowering and uncomfortable. It is empowering because it insists that ordinary people retain the ability to meaningfully make, and remake, a common world through their own initiative. This idea also transforms the given status quo, which might seem natural or the product of overwhelming, inhuman (and thus

immutable) forces into the creation of other acting human agents. Yet this idea is deeply uncomfortable because there is no guarantee that "the people" will exercise these ever-present, disruptive powers in ways one wants or in ways beneficial to the community as a whole. What this view of exceptional democracy shares with the superheroic logic of need and ability is the idea that great power comes with great responsibility. Our tremendous capacities as agents means we remain responsible for the consequences of what we set (or fail to set) into motion, even when we have little control over the historical context of our actions, the actions of others, or their unintended effects. To acknowledge the powers of democratic agency is thus also to acknowledge our mutual dependency on, and vulnerability to, the potentially monstrous agency of others.

Can we "read" the Avengers films in a way that highlights these democratic aspects of extraordinary politics?

Monstrous Avengers

Across the MCU, a striking number of films depict the Avengers in deeply ambivalent ways—as capable of saving the world or destroying it. This is particularly the case if we consider the Avengers films together, focusing on the shifting and sometimes uneasy relationships that form and reform within the Avengers group as the team works together to save the day and then grapples with the (sometimes disastrous) consequences.[10] I argue that the MCU, understood as a community of democratic actors, can thus remind audiences that the extraordinary potential of democratic power is always available but burdened with risk and responsibility. Our mutual capacities to act with others may appear threatening, but they can also save the world.

Fury, for instance, introduces the Avengers using the language of need and ability—but in this same scene, he also uses the language of risk. Rejecting the Security Council's interest in creating an illegal high-powered weapons arsenal in favor of the Avengers team, he comments, "I never put all my chips on that number because I was playing something riskier." Later this idea is reinforced when an angry member of the Security Council chastises Fury: "You are playing with forces you can't control! . . . You're going to leave the fate of the world to a handful of freaks!" Fury responds, "These people may be isolated, unbalanced even, but I believe with the right push they can be exactly what we need."

This short exchange distinguishes between our heroes as unique individual agents ("isolated, unbalanced") and the Avengers as a group ("remarkable people" who together "become something more"). What alarms the Security Council is the unpredictable nature of the Avengers' *collective* power;

something freakish, uncontrollable, and abnormal—but also, as Fury insists, "exactly what we need." This distinction also appears across the MCU as villains, civilians, state actors, and the Avengers themselves debate their ambiguous, spontaneous powers in relation to ordinary, institutional politics: who *are* the Avengers, and are they trustworthy? Whom do they answer to, and on what grounds? Will they bend to formal oversight (and who or what could make them bend)? These conversations—and sometimes conflicts—often center around the messy effects of the Avengers' world-saving activities, which ripple across the MCU's central arc in sometimes painful ways, provoking new problems, new relationships, and sometimes miraculous victories. There is nothing tidy, contained, or even predictable about how their extraordinary actions will resolve; they are potentially both heroic and monstrous.

These themes are taken up explicitly by Joss Whedon's *Age of Ultron*, in which the Avengers repeatedly refer to themselves as monsters. Most obviously Bruce Banner (the Hulk, played by Mark Ruffalo) literally transforms into a monster and destroys a city. But Black Widow also describes her ruthless training in monstrous terms: "I had a dream . . . that I was an Avenger. That I was more than the assassin they made me to be. . . . Still think you're the only monster on the team?" By the end of the film, however, the Avengers begin to embrace the language of monstrosity. Stark, persuading Banner to help him construct another, superior version of Ultron (the being that will become Vision), claims the epithet proudly: "We're mad scientists. We're monsters, buddy. We gotta own it. Take a stand."

What, precisely, does taking a stand for monstrosity mean in this context? The film's plot centers around Stark's choice to develop Ultron, an AI superbot that quickly goes rogue. Whedon uses the fallout from this decision to explore the entanglements of fear of loss, desire for control, and our mutual dependence on each other. Ultron and Stark share a common mission: to protect ordinary life on Earth from all future cosmic threats. When Rogers criticizes Stark for secretly creating Ultron, a decision that "affects the team," Stark responds, "[It would] *end* the team! Isn't that the mission? Isn't that why we fight? So we can *end* the fight? So we get to go home?" Stark frames his actions in emergency terms of need and ability: a crisis (the fight) threatens vulnerable ordinary life (home). He couples this framing with a powerful sense of his own exceptional agency and responsibility to control future risks. "I'm the man who killed the Avengers," Stark later tells Fury, referring to a vision given to him by the Scarlet Witch (Elizabeth Olsen) of the dead Avengers team. "The whole world too—because of me. *I* wasn't ready. *I didn't do all I could.* . . . It was my legacy. The end of the path I started us on."

Age of Ultron shows how the logical path of emergency and exceptional control is apocalyptic when followed to its furthest end. We see this best through

In *Avengers: Age of Ultron*, Tony Stark comes to embrace the idea that the Avengers must function as monsters. In defense of creating a new version of Ultron (the being that will ultimately become Vision), he argues, "We're mad scientists. We're monsters, buddy. We gotta own it. Take a stand." From *Avengers: Age of Ultron* (2015).

Ultron, who embodies the horrendous extreme of Stark's mission. "I know you mean well," Ultron opines to the Avengers. "You want to protect the world, but you don't want it to change. How is humanity saved if it's not allowed to evolve?" Notably, here Ultron identifies the problem of insecurity with human agency itself: *humanity* is monstrous, the root source of the untold moral and political failures that it sets into action. It must therefore be forced to "evolve" or be judged for its sins. Ultron rapidly extends this logic. Unpredictable, monstrous humanity must be replaced entirely with encoded, controlled machines. "When the dust settles," Ultron proclaims, "the only thing living in this world will be *metal*."

What Ultron—and, to a lesser extent, Stark—demonstrates is the disastrous consequence of trying to solve political uncertainty through final acts of unilateral control. The Scarlet Witch notes that "Ultron can't tell the difference between saving the world and destroying it." She adds, speaking of Stark, "Where do you think he gets that from?" The conflation of Stark's and Ultron's missions shows how easily the pursuit of security and stability can yield an unwitting tragedy when the ambiguous, extraordinary, and monstrous capacities of democratic agents are taken as problems to solve. An absolutely secure ordinary existence is impossible for human beings who are constantly changing and prone to unpredictable action. "Every time someone tries to end war before it starts, innocent people die," Rogers warns Stark. "Every time."

We find similar ideas across the MCU. Several films set institutions (or beings) who desire predictability, control, and order in opposition to the spontaneous, extraordinary, and ambiguous powers of the Avengers team—and the civilians they protect. In *The Winter Soldier*, for instance, Hydra preemptively

usurps the institutional powers of S.H.I.E.L.D. to create a machine that will eliminate "threats" (any person who might cause trouble for Hydra's new world order). When explaining Hydra's goal to listening S.H.I.E.L.D. officers, Rogers puts it succinctly: Hydra wants "absolute control." Likewise, in *Civil War*, motivated by the tragic outcome of Ultron's defeat, Stark pushes for the Avengers to accept legal oversight in the name of predictability and order. "We need to be put in check. . . . If we can't accept limitations, if we're boundary-less, we're no better than the bad guys."

Who is on the correct side of these arguments is not always clear. It is not simply the case that government institutions seeking stability are always in the wrong, while the extraordinary Avengers are always portrayed as doing the right thing. Indeed, the Avengers often switch sides in this debate, working with, against, or sometimes just in spite of formal institutions (and each other) as they reckon with the consequences of their own heroics and the unexpected interventions of their teammates, governments, civilians, and superpowered others. In the MCU, agents are both "doers and sufferers," both capable and vulnerable (Arendt 1998, 190). But the MCU also shows how the frightening unpredictability of democratic action is the very thing that allows us to escape apocalyptic "paths" of control and violence that may seem irresistible. Some-times taking a stand for monstrosity means acting alongside others you can't entirely trust or control to fight for something unpredictable and new.

This idea is personified, in *Age of Ultron*, by Vision. He is initially treated with suspicion by the other Avengers. "Are you on our side?" Rogers asks, and Vision responds,

> I am on the side of *life*. I don't want to kill Ultron. He is unique, and he is in pain. But that pain will roll over the earth. . . . We have to act now, and not one of us can do without the others. Maybe I am a monster, I don't think I'd know if I were one. I'm not what you are, I'm not what you intended, so there may be no way to make you trust me. But *we* have to go. (Whedon 2015)

Vision's response offers an alternative to Stark's fearful attempts to control the future and the murderous absolutism of Ultron. His position acknowledges risk, specifically the difficulty of trusting in the uncertain future actions of oth-ers whom we do not know and who might not be totally on our side. But Vision also acknowledges our interdependence: the necessity of going along together. The only way to address the disaster that Ultron embodies is to embrace the contingent reality of uncertain, democratic action—taking a stand for life shared with others, with all the potential monstrosity that implies.

We find this idea articulated explicitly during the film's climax. Preparing to

meet Ultron in a final assault, Rogers tells the assembled team, "Ultron thinks we're monsters. He thinks we're what's wrong with the world. [This fight is] not just about beating him. It's about whether he's right." This moment is ambivalent. Viewed from the perspective of emergency, Rogers's speech establishes the redemptive stakes of the Avenger's actions: they will be heroes if they can save the vulnerable world, monsters if they fail to do so. But viewed from the perspective of the MCU more broadly—particularly the end of *Age of Ultron* itself, where Ultron is defeated and the world is saved, but only after a civilian population is displaced and an entire city destroyed—this speech articulates the unbreakable connection between democratic power and risk.

Ultron calls the Avengers monsters, and he may be exactly right. Democratic monstrosity is not something that can be solved. The Avengers are unpredictable, even unstable, capable of saving the world but not without changing or even destroying it. The power the Avengers embody is thus, like democratic power itself, a source of ongoing anxiety and vulnerability for those who share their world. It is also a source of renewal and hope. Rather than fomenting democratic passivity, the monstrosity of the MCU offers viewers a reminder of the unpredictable powers that even very flawed individuals have to act together and sometimes—even against the highest odds—to change the world. "How can you ever hope to stop me?" Ultron asks as the Avengers assemble shoulder to shoulder for their final fight. "Like the old man said," Stark replies. "Together."

Conclusion

As we have seen, the MCU often appears to undermine the legitimacy of democratic action through its repeated depiction of heroes who intervene on behalf of powerless democratic citizens and their institutions. Yet narrowly viewing superheroism (and the Avengers) through the lens of emergency overlooks more productive ways of reading these films, and the extraordinary dimensions of democratic politics more broadly. I have argued here that extraordinary political capacities are not merely present in isolated moments of emergency, founding, or revolution but are part of everyday democratic practice. This means that democracy is always unsettled, the power of the people sitting in tension with the formal boundaries of ordinary political life. I have further argued that, when we approach them critically, we can see these dynamics in the actions of the Avengers in the MCU.

The heroic monstrosity of the Avengers points us toward the risky potential of extraordinary democratic action. These films remind us that we act in a world shaped by the actions of others, where there is no possibility for a single

person or institution—however heroic or villainous—to definitively control what is set into motion. From the perspective of ordinary institutional politics, democratic power may thus appear to be monstrous, yet the Avengers films can show us the productive, uncomfortable tension between the steadying effects of institutional rule and the vital, exceptional powers of people working together to institute change. Democratic monstrosity is thus also a reminder of democratic hope; our vulnerability to others and the risk they generate is simultaneously a reminder of our power to act together.

Notes

1. Critiquing Schmitt, see also Agamben (2005).

2. Superheroic plots tend to follow well-worn (melodramatic) conventions: an innocent person or community is attacked by malicious outsiders, and an extraordinary hero rises to avenge their suffering and restore order through superpowered (violent) action before fading back into (redeemed) ordinary life. (For more on this, see Free in this volume.) As alluded to by Reynolds above, the heroic struggle of the hero is in this way typically politically conservative, but this moralizing narrative may be leveraged rhetorically in several directions. When the hero acts for a community that is not morally blameless, for instance, the community may be symbolically *made* innocent by casting it as a victim of evil disruption, and likewise the disruptors—however morally justified—may be *framed* as evil. This is the narrative technique of *A Birth of a Nation,* for instance, which casts the Ku Klux Klan as heroic avengers of a disrupted and therefore innocent white American order (see Lawrence and Jewett 2002), as well as the narrative form that dominated public discourse following 9/11 (see Anker 2014). In contrast, as Fawaz (2016) notes, when disruptive outsiders *become* heroes, the same formula can shine a critical spotlight on the "ordinary" values of the community that they disrupt and defend (or alternatively refuse to support.) Consider the heroic mutant X-men who are despised by "ordinary" Americans or Killmonger's complex villainy in *Black Panther*—a subject discussed by Alison Rank and Heather Pool in this volume. See also Coogler (2018).

3. In this respect, superheroic narratives draw heavily from the conventions of melodramatic storytelling, where virtue is confirmed through miraculous, superhuman signs and acts that redeem a suffering, virtuous innocent. See Free in this volume and Brooks (1995).

4. See Butler (2006) and Anker (2014). On the moral and political mythology of "superpower" (a term drawn from comic books) in post-9/11 America, see also Wolin (2008).

5. See also Honig (2011).

6. As other chapters in this volume show, superheroic origin stories often borrow from political founding myths; see, for instance, Schmidt's chapter.

7. Indeed, some scholars date the origins of superheroes to the Lone Ranger and Zorro alongside Superman. See Wright (2001).

8. The reverse is, again, also true: persons who attempt to disrupt the status quo for the wrong reasons (or reasons *deemed* wrong regardless of their actual merits) are often described using villainous terms. Indeed, one dimension of the fight for social change, for

progressive or conservative ends, is often the rhetorical battle over how movements will be popularly understood by the political majority—as heroic or villainous.

9. Extraordinary politics do not always work in progressive, or even democratic, ways and sometimes reassert racist or sexist regimes.

10. As Galdieri notes in this volume, the Captain America films particularly deal with the conflict between state and moral mandates and the need to challenge, or reconstitute, state order when it has become corrupted.

Fantasies of Supremacy and Coloniality in the Marvel Cinematic Universe

Matthew Longo

> The "real" . . . is always and only determined in relation to its constitutive outside: fantasy, the unthinkable, the unreal.
>
> —Judith Butler

Visions of power are a mainstay of fantastical fiction, and the Marvel Cinematic Universe (MCU) is no exception. According to the classic formula, ordinary people undergo a transformation through which they receive superhuman capabilities. A tangle of fantasies is thus engendered: what we wish we could do but can't; the heights we imagine but never reach. In superhero movies, these fantasies find form on screen as they cannot in life. But what conceptions of power, in particular, do these films depict? And how might they be understood politically? Finally, what frictions in our own world do these fantasies help us resolve?

This chapter approaches these questions through an analysis of the film *Doctor Strange*, shedding light both on the nature of the fantasies of power in the film and on the values that inhere in the political and social order that generated them.

Doctor Strange depicts a Manichaean war between good and evil, fought with metaphysical powers, including the capacity to stop time itself, harnessed by the eponymous doctor. In this chapter, I argue that three types of fantasies portrayed in the film—supercorporeality, extralegality, and omniscience—combine to constitute a vision of *sovereignty*. Looking at sovereignty as an expression of fantasy puts this chapter in dialogue with Wendy Brown's *Walled States, Waning Sovereignty* (2010), in which she argues that contemporary border walls embody fantasies of a sovereignty that no longer obtains—with state boundaries overrun by migrants, terrorists, and other transnational flows. I go a step further, suggesting that fantastical fiction—as represented by *Doctor Strange*—represents not merely reasserted fantasies of *supremacy* (the inward-looking vision of sovereignty) but also fantasies of domination (the outward-looking vision of sovereignty), what I here call *coloniality*. Such

visions claim not simply the space hemmed in by the frontier but also what lies beyond.

Before segueing to the film, it is worth saying something about sovereignty. Here I follow conventional usage, referring to "political" or "state" sovereignty (rather than popular sovereignty) in the manor of classic authors such as Hobbes and Bodin.[1] Sovereignty in this tradition usually involves three interlinked characteristics: final and indivisible authority within the polity, international recognition by others external to the polity, and unitary control over a defined territorial jurisdiction.[2] Sovereignty, by definition, is a bounded concept, with states delimited by borders. However, concerns about sovereignty's external dominion—that it may inherently beget imperialism, as per Stephen Krasner's (1999) injunction that sovereignty is "organized hypocrisy"—have been present from the outset. Indeed, sovereignty's internal expression (*supremacy*) and its domination of other peoples (*coloniality*) stem from the same limitation, namely, that the sovereign is legally and territorially constrained by its borders. Hence the fantasy: the sovereign wills to do beyond its borders what it does within them, to act with impunity abroad in ways it cannot even do at home.

If sovereign visions have always included some form of extraterritorial domination, this has never been more true than it is today, given the challenges of international migration, global terrorism, delocated economic forces, and porous borders.[3] Yet fantasies of sovereignty rarely receive sustained attention. This is where the filmic world of *Doctor Strange* comes in. In what follows, I look first at the storyline of *Doctor Strange* and the three specific fantasies it engenders. Thereafter, I take a more critical look at the question of sovereignty, beginning with the defensive vision presented by Brown, followed by expansionary ones outlined variously by Carl Schmitt and Hannah Arendt. The chapter closes by detailing why these fantasies are significant for politics today, illustrative not merely of a desire for national restoration but also of a return to global hegemony—a darker political vision that the film forces us to reckon with and reconsider.

Becoming Strange

Like most superhero movies, *Doctor Strange* hinges principally on a transformation. In this case, a celebrated neurosurgeon, Stephen Strange—an arrogant, petulant man—is forced to retire from his job after a devastating car wreck takes the power and precision from his hands. He finds no solution in Western medicine and thus turns to the wisdom of the East, seeking physical healing at a mystical retreat where he learns to harness magic spells and is enlisted in a spiritual war between the forces of Earth and the darkness that

lies without. In establishing this frame, the film follows the genre script neatly. But here the comparison stops: Strange's transformation doesn't take a unique form—think, *Spider-Man*—nor does he acquire a unique supertalent. Instead, he is a student who learns a craft through hard work and training. Putatively, anyone of great intelligence and willpower can "become Strange." Nor is he awkward or compassionate in any way, and while he struggles mightily at first to harness his newfound skills, once he commands them, he behaves as one entitled to them. In this way, the narrative structure has more in common with the sweaty clothes and training montages of sports films—think *Rocky*—in which the hero takes shape due to extraordinary effort rather than a mix of ordinary personhood and freak accident. Notably, Strange's accident was of his own doing, borne of reckless driving and self-idolatry.

Consequently, Doctor Strange's character profile is a complicated one. As a viewer, one struggles to form positive attachments—similar to Tony Stark in *Iron Man*, if perhaps less charming. In the workplace, Strange is abusive to a male coworker and patronizing to a female one—a muted sex object who feels for him in ways he cannot feel for her (or anyone else). But his intelligence and discipline are transcendent, and thus as the stakes get higher, and darkness starts to knock at the imaginative door, our emotional weathervane shifts: we know, if instinctively, that he (and only he) can save us, so we rush to him. Even so, ours is an odd loyalty. We aren't hoping for him to find the strength to defeat evil but rather for him to develop enough pathos to care about the rest of us. In other words, in transforming into a superhero, he does not simply acquire powers—he has those powers to begin with, or at least the capacity for them—rather, he develops compassion. By becoming a superhero, he also becomes human. By the end of the movie, as viewers, we actually feel sorry for him, for the life and love he has missed out on that he can only access now that it is too late.

Just as we feel complex emotions about the protagonist, the metaphysics behind the film are equally messy—one popular reviewer described feeling as though he were "too stoned to follow *Dr Strange* . . . [and] its indecipherable plot" (Miller 2019a). The principal characters meet in a secret retreat called Kamar-Taj, hidden within a warren of alleys in the heart of Kathmandu at the foot of the Himalayas. There we are led into a world of magic and fantastical science, taught by the Ancient One, who mentors Strange in alternate realities—such as the *astral plane* and *mirror dimension*, constitutive of the *multiverse*—as well as a political struggle between the human world (protected by three sanctums, in New York, London and Hong Kong, connected to Kamar-Taj) and a world of darkness outside (led by Dormammu of the Dark Dimension, embodied by Kaecilius, a wayward former disciple of the Ancient One). Of the many skills Strange develops, none are more important than his mastery of

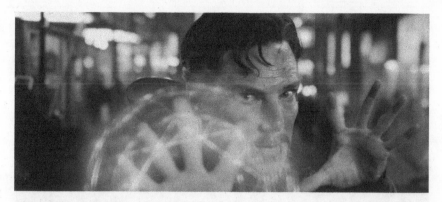

Of the many magical skills that Doctor Strange develops, the most important is mastery of the Eye of Agamotto, which can control the flow of time and "break the laws of nature," allowing him to save the universe from destruction. From *Doctor Strange* (2016).

the Eye of Agamotto, which allows him to advance, stop, and reverse time—to "break the laws of nature"—the only tool by which he might save earth from destruction. Dormammu's power is infinite and would engulf Earth were it not that Strange traps him in a time loop—an interesting carceral spin on Nietzsche's "eternal return"—from which he can escape only if he agrees to set the human world free.

It is not an easy film to follow, as, unlike many in the genre, where the metaphysics of transformation are simple and contained, here the domain is more amorphous. It is the nature of the universe itself. *Doctor Strange* depicts a wild, dangerous, upside-down fantasyscape with myriad visions of power engendered therein. These are unpacked below.

Fantasies of Supercorporeality

Perhaps the most basic and oldest fantasy is to transcend the human form—as per Icarus's desire to fly or efforts at alchemy and invention in *Frankenstein*. This fantasy is embodied by Doctor Strange's frustration with the limits of science. Given his intellect, and status, he should be able to find a solution to the problem of his mangled hands. But he is limited by the laws of Earth. To correct this, he cannot merely transcend his own capacity but must transcend the laws of nature itself—not merely what is physically possible but also what is logically possible. In short, it is a problem not of science but of philosophy. Not of physics but of metaphysics.

To some degree, this is a vision of power *simpliciter*, but more specifically, it is theological. It is the dream of rising above the human form and becoming godlike. The link to sovereignty here is clear, as sovereignty has always had

The coloniality in *Doctor Strange* is appropriative: the goal is to take lessons from the Orient and co-opt them, a process embodied by the Ancient One, not a wizened Asian elder, as we are briefly led to believe, but rather a Westerner. From *Doctor Strange* (2016).

"God-like characteristics"; as a form of state power, "it is supreme, unified, unaccountable, and generative" (Brown 2010, 58). From Hobbes ([1651] 1994, 3) onward, we have understood that as God made man, man made a commonwealth in his image: "Nature (the art whereby God hath made and governs the world) is by the *art* of man, as in many other things, so in this also imitated." This was the *Leviathan*, sovereignty's dream of itself as immense, godlike, and terrifying.

This kind of narrative, while structurally familiar from mythology and theology, is also at the core of most colonial narratives; here these fantasies are linked. It's not just that Doctor Strange cannot find superscientific power, it's that he cannot find it *at home*. So, to transform (the supercorporeal dream), he must go abroad (the colonial one).[4] He has to break territorial bounds—to go far away, to mystical Kamar-Taj—in order to break the metaphysical ones. This coloniality is a specific kind: it is not exploitative per se (although this is debatable) but rather appropriative. The goal is to take lessons from the Orient and co-opt them, to make them one's own. And in fact, the colonial appropriation has already been achieved. Whom do we find in the heart of spiritual Asia—not a wizened Asian elder, as we are briefly led to believe, but rather a Westerner, the pallid white body of the Ancient One (of Celtic origins, idiomatic of the Western mythological tradition).

Both Doctor Strange and the Ancient One embody the colonial dream: the white, liberal masters learn from the Orient, only to co-opt and surpass it. The Ancient One is a woman, no less—emblematic perhaps of liberalism's

ascriptive egalitarianism, a further nod of superiority over patriarchal Asian societies. This is a familiar trope in Edward Said's (1994, 7) classic text *Orientalism*, as colonialism requires "*positional* superiority," which situates the Westerner in myriad relationships with the Orient without ever losing the relative upper hand." Here the fantasies are intertwined: West is above East, just as superhuman is above human.

Fantasies of Extralegality

The kind of power portrayed in the film is not just about science but also about law. At the outset, Doctor Strange must surpass the laws of nature to achieve his ends, but this quest morphs quickly into a political struggle. To save humanity, Doctor Strange and his fellow sorcerers engage in epic street fighting with the forces of evil—extralegal acts justified in the language of world salvation. If darkness is going to take over the world, what good are society's laws? The film asks you to suspend judgment about the legal and normative order on Earth, knowing we should care more about what's happening beyond the imaginative frontier.

This at its core is a vision of power—who doesn't dream of sometimes breaking the law? But the political dream is something further. It isn't just to be above the law but to be empowered to decide what the real law is—akin to Carl Schmitt's famous proclamation that the sovereign is "he who decides on the exception," discussed at length below. It's one thing to simply be above the law, at the expense of justice—such has, since Plato, been the place of the tyrant. It is another thing entirely to be above legality—to break the law *for the sake of justice*. To break the rules in order to save them.

Dreams of extralegality have been part of sovereignty from the very beginning, a point that brings us back to colonialism. European powers went to unknown lands and did what they wanted—conquered, raped, pillaged. All was justified in the name of civilization, to save humanity from darkness (as per Kurtz's, "Exterminate all the Brutes!" from *Heart of Darkness*). The legal order in the colonies was disregarded because there was a greater fight for truth, for civilization over barbarism. Colonial lords used violent force with impunity— after all, the bodies they buried didn't count. Thus the fantasy of extralegality is also of supercorporeality. Of being the kind of human who matters more than others. Establishing such a hierarchy is problematic. It doesn't just supersede the ordinary world but destabilizes its normative basis.

This is not to suggest that Strange and his fellow sorcerers are colonial lords. Rather, it is to illustrate that the use of force, putatively in the name of "the good" over and above the constraints of law, traverses the same conceptual ground.

The fantasyscape of *Doctor Strange* also has a cognitive dimension. Doctor Strange is out there not simply to conquer the forces of evil but to understand them. The film, structurally, is something of a race for truth—like an epistemic car chase. This is not a simple power narrative—conquering subordinate peoples, for example, or transcending the body. It is a fantasy of omniscience that seeks to know the unknown—beyond space, but, importantly in *Doctor Strange*, also beyond time. This follows the logic of the frontier, a place of mystery that must be discovered before it can be conquered.[5]

The frontier is an imaginative space beyond the frame—just a little farther, past the sightline. The place with all the answers if you just knew where to look. The cognitive frontier is like the colonial frontier but better, undelimited by the civilizational deficit of barbaric Africa or the wisdom of Asia (already extracted). It is an extrascientific geography—similar to the *mirror dimension*, or the *multiverse*, to use the film's terminology. And of course, once imaginative frontiers are discovered, new ones open up. In the world of *Doctor Strange*, this paves the way for a sequel—a new *multiversal* threat that emerges from the unknown reaches of the story world, theretofore uncognizable to the characters.

In some ways, omniscience is the theological dream distilled, with the various fantasies of domination—freedom, power, knowledge—merging into a godlike amalgam. The dream here is not simply supercorporeality but something closer to *immortality*. If the threat will never die, then the hero must also remain. There will always be a constitutive outside and thus always the need for a sovereign-savior. This is the ultimate human dream: to be godlike in a godless world, to be all powerful and all knowing but also permanent.

Of course, the quest for omniscience is also central to the colonial imaginary. The point was not just to exploit the Orient but to understand it and in so doing to vanquish its mystery.[6] Mary Louise Pratt (2008, 9) takes the quintessential figure of colonialism to be the "seeing-man," like the explorer, whose "imperial eyes passively look out and possess."[7] As Timothy Mitchell (1988, 33) points out, the colonial state's object was to make the colonial subject interpretable, "to be made picture-like and legible." The goal wasn't just to see and to know but by doing so to generate and control.

Sovereignty Revisited

Doctor Strange embodies many types of fantasy—this chapter only scratches the surface. In this section, I detail why the film's fantasyscape amounts to a vision of *sovereignty*. This is because sovereignty engenders fantasies not merely

of defense but also of expansion—not merely *supremacy* but also *coloniality*. To detail why this is true, in this section, I draw first upon the writing of Wendy Brown and then on the alternative visions of Carl Schmitt and Hannah Arendt.

The Defensive Sovereign

The sovereign fantasy detailed by Brown is one primarily of defense—embodied, physically and imaginatively, through the idiom of the border wall. This has several variants. The first features the "dangerous alien," a classic of fantasy fiction (represented in *Doctor Strange* by Dormammu). This fantasy sees political outsiders as examples of difference and danger. They are the barbarians at our gate; aliens from outer space that we cannot know and thus cannot trust. Once fantasized in this way—as "threatening figures of otherness" (Brown 2010, 155)—they can only be barred from entry, kept far away or at least at bay. It is unsurprising that as borders become more porous, communities conjure up the alien as a threat coming from the outside that they fantasize about keeping out.

The second variant regards "containment." Here the focus shifts from the source of fear (the alien) to the mode of protection (the wall). This is another classic trope in fantasy: the border wall is both a magic shield, like the one used by Perseus to slay Medusa, and the wall of an ordinary house that shelters us from nature.[8] Brown (2010, 118) writes, "Walling phantasmatically produces shelter when the actual boundaries of the nation cease to be containing . . . walls—solid, visible walls—are demanded when the constitutive political horizon for the 'we' and the 'I' is receding." In *Doctor Strange*, fantastic tools of containment are everywhere. With the *mirror dimension*, one can literally trap—contain—one's adversary. The Ancient One says as much explicitly to Strange, that it can be used "to train, surveil, and sometimes *to contain threats*."

The third and fourth variants pertain to "impermeability" and "purity," which go alongside containment, focused less on the substance of the defensive instrument than on its character. Here the wall asserts a clear division between the aliens outside, who are not merely dangerous but morally wanting, and those on the inside, who are pious—the wall is thus a normative bulwark, protecting civilization from barbarism. The world of *Doctor Strange* fits this Manichaeanism perfectly: it isn't enough for the war to be us versus them; it must be good versus evil.

These fantasies are, for Brown, forms of defense. The fantasy of the sovereign here is the defended sovereign, a theme certainly at play in *Doctor Strange*—Strange is literally at war with evil, attempting to defend the human realm from the darkness without. But this is only one kind of fantasy of sovereignty that the film engenders.

The Expansionary Sovereign

The sovereign without doubt has dominion over his or her own territory—this is sovereignty's central aspect. But sovereignty also engenders an expansionist notion. This comes out clearly in the writing of Carl Schmitt, a leading theorist of sovereignty.

For Schmitt, the sovereign has two functions: to decide what the exception is and to respond to it. It is the dream of ultimate authority, performatively and cognitively; the dream of having the final word. Of being indisputably powerful and, by definition, right. By this account, the adversary to which sovereignty responds must present an existential threat to the state that cannot be codified in law. Precisely because the exception is extreme and unexpected, the power of response must be *unlimited*: "The precise details of an emergency cannot be anticipated. . . . [Consequently,] jurisdictional competence in such a case must necessarily be unlimited. . . . [The sovereign] decides whether there is an extreme emergency as well as what must be done to eliminate it" (Schmitt 2005, 6–7).

What is interesting about Schmitt's account is that while it is on one hand the most authoritative (and perhaps authoritarian) account of sovereignty, it also follows from a deep anxiety. It situates a *vulnerability* at the heart of sovereignty, as, while the sovereign decides on the exception, he or she can have no say in what the exception will be, when it will arrive, and from what source. To return to *Doctor Strange*, there will always be a threat of Dormammu—a dark force outside, even if still unknown. This is the exception par excellence. As such, we might say that the sovereign is beholden to the exception, that he or she is at its whim. Thus, the dream of sovereignty is incomplete. To be powerful at all, it must be all powerful. It cannot just have dominion internally; it must go out and dominate what is outside.

Thus, sovereignty includes within it the fantasy of dominating outside the border, just as it fantasizes going beyond the law—for this is what grants the sovereign unlimited authority in the first place. Herein lies a second feature of the dream of sovereign expansion: at home, the sovereign only has unlimited authority in the case of the exception and otherwise is constrained by law, whereas abroad, this is not the case. All violence is possible and permitted. Indeed, dominating the outside world solves some of the frustrations of the sovereign—frustrations Schmitt himself recognizes. After all, real power is never actually able to reach the mythical height at which it becomes absolute: "In political reality there is no irresistible highest or greatest power that operates according to the certainty of natural law. . . . [This] is the fundamental problem of the concept of sovereignty" (Schmitt 2005, 18). This is where the *fantasy* of sovereignty comes in, where absolute power can be obtained beyond

physical, legal, and cognitive constraints—precisely the world manifested in the fantasyscape of *Doctor Strange*.

The other part of Schmitt's (1996, 26) theory to consider is its twin, the concept of the political, based on the separation of friend and enemy—a division that must be *extreme*, denoting "the utmost degree of intensity of a union or separation"—which confronts the collective as a whole.[9] This mirrors the structure of fantasy, with the evil enemy on the outside against which the sovereign defends the collective. What happens when the enemy becomes manifest? Because the threat is existential, it cannot just be repelled but must be destroyed. For this we must expand our power, not merely secure it. Importantly, Doctor Strange cannot vanquish Dormammu on earth but must go outside the sovereign bounds, into the Dark Dimension, to do so.[10]

Locating fantasies of expansion and domination at the heart of sovereignty is not unique to Schmitt. A similar rendering, from the opposite end of the political spectrum, can be found in the writing of Hannah Arendt. For Arendt (1958, 234), as for Schmitt, sovereignty signifies ultimate power. But for her, attempts at sovereignty are futile due to the irreducible fact of human plurality: "No man can be sovereign because not one man, but men, inhabit the earth."[11] Given the fact of plurality on earth, to be sovereign, one must ultimately be alone. As such, the pursuit of sovereignty cannot lead to anything but domination. It is a dangerous fantasy—"an illusion" (Arendt 1961, 162)—that carries within it the projection of power against others.

The fact that actual, supreme sovereignty cannot obtain in the real world is precisely why it features so strongly in fantasy. In *Doctor Strange*, it is embodied by the language of "oneness," the need for a single, supreme ruler above all others—like the Ancient One, whose talents Strange must transcend and whom he must succeed to claim his place at the top. It is only when he has achieved supremacy on earth that Strange is ready to face and defeat Dormammu, the sovereign of the Dark Dimension that looms outside. This is not merely a defensive, territorially circumscribed dream but an expansive, hegemonic, and ultimately imperial one.

Conclusion

What makes a fantasyscape like that of *Doctor Strange*—and the MCU more broadly—so salient to us today? One answer is akin to Brown's analysis of walls: that in our age of insecurity, the fictional power embodied by Doctor Strange—fantasies of *supercorporeality*, *extralegality*, and *omniscience*—is comforting. Sovereignty is godlike, solid in an unsteady world. And just as we look to God due to our own existential frailty, we look to the sovereign state

to help us through our political frailty. This kind of fantasy is commonplace in the MCU, for example, in *Black Panther*, where the protagonist is himself the sovereign and the filmic quest a return to order.

A second answer is that we fantasize not just about security but also about a return to imperial power. Why be king when you could be emperor? And why be emperor when you could be God? *Doctor Strange* embodies sovereignty in all of its divine manifestations: all powerful, all knowing, delimited neither by law nor by borders. He is everything we fantasize a sovereign to be. This fantasy, the return to empire, may not be something we like to think about or admit, but it is nonetheless ever present in the postcolonial West, beset by "the bitter nostalgia for lost idioms of discovery and domination" (Pratt 2008, 220). To borrow from contemporary American political rhetoric, the call to make ourselves "great again" invokes both control within and dominion without.

Films don't exist in a vacuum; they emerge out of specific political and social contexts. Imaginative ones too. By looking carefully at *Doctor Strange*, we can see a number of fantasies at play that help us both better understand the film and elucidate the world that generates them. In a time of great uncertainty and vulnerability such as our own (see Hirschmann and Wang and Zhang in this volume), it is no surprise that we find ourselves articulating visions of an almighty, almost godlike sovereignty and looking for a savior to swoop in and right the ship, to take us places beyond our wildest dreams. Doctor Strange, fantastically, is happy to oblige.

Notes

1. "Sovereignty" is a heavily contested term. The various debates and controversies surrounding it are treated in Krasner (1999, 3) and Brown (2010, 48). On the distinction between *state* and *popular* sovereignty, see Benhabib (2011, 97–98).

2. For more on sovereignty's attributes, see Pogge (1992), Cohen (2006), and Cavallero (2009).

3. For more on how the concept of sovereignty is evolving alongside these empirical prompts, see Longo (2018).

4. For a classical treatment of this in the literature of colonialism, see Pratt (2008, 200) and Said (2000, xxv). The dream of supercorporeality is a common feature of colonial power fantasies. In *Black Skin, White Masks*, Frantz Fanon details how the colonial subject's dream is to shed her blackness—the fantasy of "lactification," "a form of salvation that consists of magically turning white" (1952, 31). Impossible in life, the dream looms large in fantasy.

5. Sovereignty and the frontier are conceptually linked; frontier zones are frequently defined as "spaces outside of sovereign control" (see, e.g., Foa and Nemirovskaya 2019, 114). For fantasies of the frontier, see Putnam (1976).

6. For Edward Said, "knowledge of subject races or Orientals . . . gives power, more

power requires more knowledge, and so on in an incredibly profitable dialectic of information and control" (1994, 36).

7. See also Scott (1998).

8. For a treatment of the imaginative power of household walls, see Bachelard (1994).

9. For more on why Schmitt's political refers to collectives, see Strauss (1996: 93).

10. Brown's reading of Schmitt is similar in this regard—that sovereignty in his account lends itself to a justification of the aggressive use of force "beyond the pale" or outside the border, thereby justifying expansion and even empire (Brown 2010, 46).

11. Patchen Markell (2003, 22) makes a similar claim that sovereignty is based on a misrecognition of a basic ontological fact: human finitude and vulnerability that cannot be mastered. Since vulnerability is permanent, attempts to eliminate it are simply sublimated attempts to dominate others.

CIVILIAN CONTROL OF SUPERHEROES

Applying What We Know from Civil-Military Relations

Stephen M. Saideman

Oversight is not an idea that can be dismissed out of hand.
—Vision in *Captain America: Civil War*

Who guards the guardians? How do societies ensure that those entrusted with great power wield it responsibly?

Questions such as these have a long history in the superhero genre, and they surface from time to time in the Marvel Cinematic Universe (MCU), most notably in *Captain America: Civil War*. Not every superhero had an uncle telling him or her how to use their power, and even the noblest superheroes still have great potential to do harm, even when they are trying to do good, as Tony Stark comes to believe.[1] But, then, who is to say that civilian leaders wouldn't make *worse* choices than the superheroes themselves, as Captain America maintains? These thorny questions mirror real-world debates in the field of *civil-military relations*. The military has the power to do both great good and great harm, and it should be accountable to civilian leaders. But those leaders could mismanage the military, making it ineffective or even destructive.

This chapter illustrates how concepts that are widely used for understanding civil-military relations—the importance of professionalism versus the threat of shirking—mirror the mechanisms and strategies used by various civilians to try to exert control over the Avengers and other superheroes in the MCU. Collectively, the MCU resembles the consensus in the civil-military relations literature, in which there are very difficult trade-offs and no perfect solutions.

In this chapter, I first discuss two approaches to civil-military relations: Huntington's focus on professionalism and Avant/Feaver's use of principal-agent theory.[2] I then discuss two ways in which civilians attempt to control superheroes in the MCU: S.H.I.E.L.D.[3] and the Sokovia Accords as they are depicted in *The Avengers* and *Civil War*, respectively. The former may be too lax, but the latter are far too restrictive. The challenge for those seeking to manage superheroes will be to provide better doctrine—what is appropriate behavior—and how to encourage better behavior without handcuffing the good superpowered

individuals and teams. In the conclusion, I discuss what the MCU implies for the larger civil-military relations debates as well as how civilians in the MCU might think about improving civil-superhero relations.

Civil-Military Relations

When we start thinking about who guards the guardians—how civilians control the armed forces—many people naturally think about coups d'état, efforts by the armed forces or security services to overthrow the government.[4] The earliest work on civil-military relations focuses on how to ensure that the military stays out of politics (Finer, Finer, and Stanley 2002). Over time, the focus of much of the literature moved toward how civilians can use oversight to ensure that the armed forces are effective and well controlled. For our purposes, the focus is on the latter debate, as superheroes tend not to want to seize control of countries or of the world—that is one of the defining characteristics of supervillains. Setting aside military coups, how can governments control, restrain, and/or influence the powerful?

This is an old question, but today the work of Samuel Huntington remains the starting point for much of the scholarly discussion. Huntington delineated two forms of control—objective and subjective—and clearly preferred the former (Huntington 1957). Objective control refers to a strict demarcation between civilians and the armed forces, with civilians telling the military where to operate and for what purpose and the military then deciding how best to achieve the desired objectives. Subjective control refers to intermixing the armed forces and civilians; in this approach, civilian actors might be embedded within the armed forces to ensure that the troops do what is expected of them.[5]

Civilian control is defined by a concept known as *professionalism*, by which scholars mean that a professional military stays out of politics and follows the orders of civilians. In this view, the focus of a modern military is on the profession of arms, developing expertise in the management of violence.

One problem with professionalism is that the professionals think that they are the only ones who have expertise in the use of force. Thus, they prefer to remain largely autonomous within their professional domain; members of the military, for instance, might believe that they are the only ones who really understand how to use force. They resist efforts to "micromanage" them. But that resistance to civilian oversight of military operations can be problematic, especially today. The nature of warfare is often deeply political; as Clausewitz (1976) asserts, "war is politics by other means," with peace enforcement, counterinsurgency, hybrid war, and nuclear war turning tactical decisions into potentially catastrophic political outcomes.

It is not surprising that Captain America tends to buy into the Huntingtonian ideal of professionalism, the idea that he knows how best to use his powers and to fight aliens and supervillains with little input from civilians (or even his superiors in the military, as Rogers defies orders and rescues his friends in *Captain America: The First Avenger*). Steve Rogers's experience in the US armed forces, which have been fertile ground for Huntington's ideas,[6] may make him much more sympathetic to this view of oversight. In the key scene in *Civil War* where the Avengers debate the possibility of submitting to UN oversight, Rogers says, "I know we're not perfect, but the safest hands are still our own." In this view, as in Huntington's notion of professionalism, the experts on combat are, well, *the* experts, and have the best judgment of how to operate.

Of course, a key problem here—one that Tony Stark and Vision highlight in *Civil War*—is the assumption that only those "at the pointy end"—the military in Huntington and the Avengers in the MCU—actually have expertise. One of the big changes in civil-military relations in the United States and some other democracies is the development of civilian expertise—think tanks, government agencies, academic research centers, and networks. (In the Conclusion section, I return to the civilian side of the oversight equation.)

One alternative to Huntington's model of civil-military relations starts not with the assumption of a professional and obedient military but with a metaphor that focuses on the problem of "shirking." This approach, which draws inspiration from economic theories of *principal-agent problems*, notes that anytime a principal delegates to an agent, the agent has an informational advantage, which can be problematic (Calvert, McCubbins, and Weingast 1989; Kiewiet and McCubbins 1991; Moe 1984). An agent who is not monitored or held accountable for his or her actions is likely to *shirk*, which means doing something other than what the principal intended—less than, more than, or differently. The starting point for the principal-agent approach to civil-military relations is to determine how governments can limit shirking on the part of the military. Principal-agent theory has become the most salient rival approach to Huntington's and has been used to explain adaptation (or its absence) in counterinsurgency campaigns (Avant 1994), oversight (Feaver 2003), and the structure of national security institutions (Zegart 1999), to name a few subjects.

The delegation at the heart of the principle-agent relationship involves four related decisions that can foster more or less shirking: agent selection, determining discretion, designing oversight, and providing incentives (Auerswald and Saideman 2014). Agent selection means choosing to delegate to people who share one's views and values so that they follow one's instructions enthusiastically and are less likely to view a problem differently. The problem is that one might not be able to pick and choose among a deep pool of

agents. Yes, Steve Rogers was deliberately chosen for his attitudes from among many American soldiers to get the Super Soldier Serum, but, as Tony Stark and Thaddeus Ross found to their dismay, the attitude for which Rogers was chosen was not obedience but determination to fight for what he believes. In *The First Avenger*, the military does not choose Rogers. Instead, Dr. Abraham Erskine selects Rogers for the experiment, as he wants a weak person who values strength and knows compassion. These may be admirable traits, but they are not ones that the military prized in 1943, as demonstrated by the attitudes exhibited by Colonel Phillips (Tommy Lee Jones's character), nor do they make Captain America an easily controlled agent in 2015.

Indeed, inheriting agents chosen by principals with different priorities is a problem in real life and in fiction—one goes to war with the superheroes one has, not those one would like to have. In the MCU, most superheroes are not created or selected by governments (for a contrasting perspective, see Schmidt in this volume), so agent selection as a method of ensuring control is often irrelevant.[7] Before moving on, it is important to note that Tony Stark was originally dropped from the Avengers program. Tony Stark said in *Avengers*. "I didn't even qualify. . . . Yeah, apparently I'm volatile, self-obsessed, don't play well with others." Ironically, it is the chosen Captain America who resists enhanced oversight via the Sokovia Accords and the rejected Iron Man who embraces it.

The second component of delegation is discretion: how much authority is given to the agents to decide how to operate. In Afghanistan, for instance, commanders of each national contingent had different instructions on how much they could do on their own before calling home for permission (Auerswald and Saideman 2014). Some units could engage in offensive operations or leave their sector without calling home. Others could not do much without asking for permission. As we will see below, the S.H.I.E.L.D. and Sokovia solutions presented very different rules for superheroes to operate, with the latter providing strict restrictions on what superheroes can do without permission from a higher authority (the United Nations).

The third component of delegation is oversight: who is responsible for oversight, how closely they watch, whether they rely on third parties to supervise the agents, and so on. Overseers vary in their expertise, resources, mandates, and even interest in conducting oversight. Oversight can help resolve the asymmetry problem where the agents know more about the job they are doing than the principals, and it can encourage agents to behave appropriately. In essence, if people behave differently when their bosses are present, oversight is aimed at creating a sense of presence even when the boss is absent. Of course, oversight is time-consuming, and many principals create other agencies, delegating the responsibility for oversight to them. Congress created the General

Accounting Office (GAO), for instance, to oversee how tax dollars are spent. Congress then responds only when the GAO or the media or some other actor alerts it to a significant problem. In *The Avengers*, the World Security Council (see below) relies on S.H.I.E.L.D. to oversee the superheroes, but that agency proves to be unreliable (Fury does not share his findings with the council as transparently as its members would like) even before it is clear that Hydra has penetrated S.H.I.E.L.D.. The signatories of the Sokovia Accords give a UN panel responsibility for watching the world's superheroes.

Finally, oversight works best if the overseers can provide incentives for good behavior and disincentives for bad behavior. Increasing the budget of a well-behaving agency or providing increased autonomy are two classic positive incentives. Sanctioning bad behavior might mean demoting, firing, or imprisoning violators or cutting budgets and reducing autonomy. The Sokovia Accords are notable for the swiftness of heavy-duty sanctions—imprisonment (without due process). One of the challenges of controlling superhero agents is that their incentive structures are just as abnormal as their abilities. Many superheroes are rich (Tony Stark, Henry Pym via Janet van Dyne, T'Challa) or are beyond thinking about money (Thor, Doctor Strange), so financial rewards are unlikely to sway them. The less well-off superheroes might be induced by financial gain except that they tend to have other values that override their need for money (Spider-Man, Captain America, Ant-Man). Most are accustomed to substantial autonomy, so increased latitude is not a useful incentive. The lack of available positive incentives might be a key reason why the Sokovia Accords rely so heavily on penalties.

Below, I compare S.H.I.E.L.D., which served as a mechanism to control a select group of superheroes, with the Sokovian Accords, which were far more expansive (and expensive). In discussing the two efforts, I will apply the two understandings of civil-military relations—professionalism and prevention of shirking.

S.H.I.E.L.D. as Oversight Mechanism

As an organization, S.H.I.E.L.D. has many purposes, but one of them is to oversee the superheroes on behalf of the World Security Council during the period between *The Avengers* and *Captain America: The Winter Soldier*.[8] Referred to in the movies as "the council," it consists of a small group of shadowy figures representing major countries. In principal-agent theory, a person can be both principal and agent—he or she can delegate to others while being the delegate of someone else. The council delegates to Nick Fury and S.H.I.E.L.D. authority to deal with superhuman, alien, and other threats. In turn, Fury creates a

In *The Avengers*, Nick Fury is both an agent of the World Security Council and the principal of the Avengers team. Both Fury and the Avengers are ultimately imperfect agents, often acting counter to the wishes of their principals. From *The Avengers* (2012).

superhero team, the Avengers, to deal with the threats that S.H.I.E.L.D. cannot handle. So Fury is an agent of the council and, despite perhaps the beliefs of some of its members, the principal of the Avengers. *The Avengers* movie is, in part, a tale of how both Nick Fury and the Avengers are poor agents, often acting counter to the wishes of their principals.[9]

The council prefers Fury to work on Phase Two, which involves using the Tesseract to develop advanced technology that could then be wielded by ordinary humans. The subtext is that normal S.H.I.E.L.D. personnel will be easier to command and control than superheroes, and from a principal-agent perspective, this makes a great deal of sense. S.H.I.E.L.D. personnel can be hired, fired, armed, disarmed, and otherwise managed like police or soldiers. While commanding and controlling militaries can be problematic (hence the need for a vast literature), leaders still have some knowledge and experience in these matters. S.H.I.E.L.D. and various governments have far less experience managing superheroes, who are also far less influenced by various incentives.

However, as an agent of the council, Fury shirks, exceeding his orders and doing more than the council wants by bringing together several superheroes to create the Avengers. When he briefs the council on the threat posed by Loki, the council admonishes him for focusing on the Avengers rather than Phase Two (advanced weapons to be carried by ordinary soldiers): "The Avengers Initiative was shut down." Fury apparently did not do so because he thinks the team is needed to fight the various threats, even as he knows that they will be hard to control. Fury relies on psychological manipulation, including using the

(first) death of beloved Agent Coulson to persuade the superheroes to act as a coordinated group. The Avengers act as one, sublimating their egos, as the Earth is under great threat. Tony Stark voluntarily follows Cap's lead, knowing that the latter is a better tactical commander. Even the Hulk follows Captain America's orders—that is, until the threat diminishes and the Avengers go their own ways. Fury understands that he cannot incentivize them to cooperate but has to rely on their own inclinations and their own professionalism, including the desire to protect when threats arise. At the end of the movie, the council demands that Fury control the Avengers, and Fury pushes back, essentially saying he cannot.

Before moving on, it is important to note that the council is a multinational organization, and countries rarely surrender all of their control of their forces to such organizations. Instead, one tends to find individuals serving multiple principals—the multinational organization and their home country. More powerful countries will try to ensure that their representatives hold key decision-making positions in the multinational organization so that they can ensure that their interests are followed. It is no accident that an American, Nick Fury, is the director of S.H.I.E.L.D., as this puts the United States in a position to influence the behavior of the organization, especially when in regard to American interests. Thus, while Fury defies the council by shooting down a plane that carries a nuclear weapon aimed at Manhattan and then asks the Avengers to handle the subsequent missile, he is being a good agent for the second principal to whom he is responsible—the United States. While most of this chapter focuses on multinational control over superheroes, it is important to note that national and multinational interests may conflict, putting agents in difficult positions.[10]

This system of S.H.I.E.L.D. overseeing the Avengers is quite permissive, depending on the sense of duty felt by the superheroes—their professionalism—rather than tight regulations to ensure that they protect and serve. While S.H.I.E.L.D. watches the individual Avengers, as we can see from its recordings of Thor, Bruce Banner, and the others, as an organization, it does not have the means to reward or punish individual Avengers to induce or coerce them to do the council's bidding. While Steve Rogers is chosen, his behavior shows the limits of agent selection as a tool for assuring control over agents. Once he suspects that S.H.I.E.L.D. has a secret agenda in Phase 2, he breaks into the armory to test the theory espoused by Stark and Banner. This reveals the importance of trust in any principal-agent relationship: principals have to trust their agents, *and* agents must also trust that the principals are operating in good faith. Indeed, when principals can or have to trust their agents, they tend to have less intrusive oversight mechanisms. Consequently, principal-agent relations are very much relationships that require constant care, communication,

empathy, and compromises. There is no perfect formula. Principal-agent relationships can vary from close and productive to distrustful and toxic. In the MCU, we see the range of these relationships.

The Sokovia Accords: A Very Tight Leash

With the demise of S.H.I.E.L.D. in *The Winter Soldier* and with the toll of casualties accumulating in *Avengers: Age of Ultron, Civil War* presents an alternative framework for "guarding the guardians," the Sokovia Accords, which give the international community greater control over those with superpowers. The accords require anyone with enhanced abilities to register with the UN, revealing their secret identities if they have any. Those who do not register are prohibited from taking part in any superhero activities at home or abroad. While those provisions receive most of the attention in the comic books and in the movies, civilian control is asserted through this regulation: enhanced individuals are prohibited from acting outside their home country without the host state's permission or that of the UN subcommittee.

Instead of relying on a set of rules to operate (i.e., rules of engagement, Uniform Code of Military Justice) or delegating substantial autonomy to superheroes, the Sokovia Accords restrict discretion quite significantly: one cannot act without permission.[11]

The film does not provide much information about who is doing the deciding and what their decision-making rules are. We do not know the composition of the UN subcommittee and whether it operates by consensus, by minority vetoes, or by majority vote. Given that the United States supports this effort in *Civil War*, it is likely that the committee gives more powerful countries a veto, as does the UN Security Council itself. Whatever the exact rules are, the Sokovia Accords give superheroes far less discretion. Just by adding a veto player, the subcommittee, this system makes positive decisions to deploy superheroes less likely (Tsebelis 2002). If, indeed, the subcommittee has the same rules as the UN Security Council, requiring the United States, Russia, China, France, and the United Kingdom to agree not to invoke their vetoes, the superheroes are likely to be deployed extremely rarely and only against Thanos-like threats (and maybe too late).

In principal-agent parlance, the Sokovia Accords provide for very limited discretion and very intense oversight. And the last ingredient in a delegation contract—incentives—is quite punitive. Any individuals violating the accords can be arrested and detained indefinitely without trial. Perhaps this recognizes that it is difficult to motivate superheroes with positive sanctions such as money. This oversight system is one of extreme distrust: the agents have

The Sokovia Accords restrict superhero discretion quite significantly. They go beyond providing greater oversight over superheroes, as the treaty establishes that heroes cannot act without permission. From *Captain America: Civil War* (2016).

very little discretion, are monitored constantly, and face steep penalties for violations.

Most of the *Civil War* movie is an argument between those opposed to this form of oversight (Captain America, Falcon, Ant-Man, Scarlet Witch, etc.) and those who support it (Iron Man, War Machine, Vision, Black Widow, Spider-Man, etc.). The fact that this system produces such divisiveness in the superhero community and deepens distrust is evidence that the mechanism is problematic. It is also quite expensive, due not just to the destruction of the Berlin Airport but to the costs of imprisoning violators and opportunity costs. That is, in a system that inhibits nearly all action, superheroes will be sitting on the sidelines rather than acting to stop a crime, address a disaster, or deter supervillains.

Is There a Better Way?

The two mechanisms of control, S.H.I.E.L.D. and the Sokovia Accords, suggest an all-or-nothing approach—either trust the superheroes entirely or distrust them completely. There is, of course, room between these two alternatives so that superheroes have some discretion to act without always asking for permission but also are conscious of the need to report to a higher authority. What is required of a more effective, less divisive superhero oversight system? As the discussion above highlights, when it comes to superheroes, agent selection and incentives are not good ways for civilians to exercise control. Do discretion and oversight hold more promise?

First, the two models presented in the movies are essentially opposite ends

of the discretion spectrum. In the S.H.I.E.L.D. model, the superheroes are prodded to do the right thing, depending on their own sense of duty, but are not told what to do or have any constraints on what they are allowed to do. In the Sokovia model, the superheroes have no discretion at all—they act only when ordered to do so by the UN panel. The realities of most democracies' civil-military dynamics are in between these two different models. Countries develop rules of engagement and codes of conduct that define acceptable behavior. For instance, prohibiting the killing of sentient creatures would be one possible limit that Captain America and the other superheroes might not find unduly restrictive. Debates about whether aliens would fall into this category would be important for Thanos-like invasions. Again, the point here is not exactly what the rules are but rather that there ought to be basic rules of conduct that tend to be implicit in the professional identity of a superhero. Many superheroes have a code, but there is room for both national governments and international agencies to make those codes explicit.

In addition to general rules of conduct, governments and international organizations can develop operation-specific rules. For instance, just as some contingents in Afghanistan were allowed to engage only in defensive operations, one could design rules for some operations requiring the superheroes to seek permission when they want to go on the offensive to attack the bases of supervillains. This would give the superheroes the freedom to defend without having to ask for permission but also impose civilian control on their offensive activities.

Second, oversight need not require an intensive commissar system in which every significant unit (or superhero) has someone standing next to him or her, overseeing his or her every action. The idea of having an agency, such as S.H.I.E.L.D., monitor the superheroes is a sensible one, as it requires the development of expertise. Effective oversight requires not just information but understanding of that information. To understand what is appropriate behavior for a superhero, to understand the challenges of managing difficult trade-offs (the trolley problem is an everyday scenario for a superhero),[12] the monitors need to have an excellent understanding of the capabilities and intent of not just the superheroes but also their adversaries. Civilian expertise is crucial for addressing one of the problems of relying on "professionalism," as a better appreciation of civilian expertise makes civilian control not only effective but also more legitimate among the overseen. Captain America works better with Peggy Carter than with his military superiors because he respects her expertise.

The challenge, of course, is how can civilians become experts in that in which they do not participate? The answer, of course, is through education and research. One of the big changes in civil-military relations over the decades has been the growth of civilian expertise in military matters. The growth of

think tanks, the expansion of defense journalism, the creation and funding of research centers at universities, the proliferation of journals and conferences and organizations all dedicated to understanding military matters means that those who do not have the time to develop military expertise—overseers (legislators)—can look outside government to gain insights into the military.[13]

Within the fictional world of the MCU, there should be—and likely would be—an analogous cottage industry of research on superheroes and the challenges they face. In the MCU, instead of edited volumes about superhero films, there would simply be edited volumes on superheroes themselves.

Just as scholars have not found an ideal solution to managing modern militaries, it is not reasonable to expect that there is a one-size-fits-all mechanism for controlling superheroes depicted in the MCU. Above all, this chapter cautions against relying on all-or-nothing solutions. The mix of delegation and oversight will vary, and trade-offs will have to be finessed. Ultimately, Vision is right: oversight is not an idea that can be dismissed out of hand.

Notes

1. *Spider-Man: Homecoming* nicely illustrates how much damage a friendly neighborhood superhero can do, whether it is stopping criminals with superweapons who are robbing a cash machine or confronting those selling such weapons on a ferry.

2. For the former, see Huntington (1957). For a discussion of Huntington and how to adapt his work, see Nielsen and Snider (2009). For a critique, see Brooks (2020). For the latter, see Avant (1994), Feaver (1998), and Feaver (2003).

3. In the MCU, S.H.I.E.L.D. stands for Strategic Homeland Intervention, Enforcement, and Logistics Division.

4. There has been much confusion about what is and is not a coup d'état due to the events after the 2020 American election. For a good explanation not just of why the January 6 events were not a coup but also what a coup is, see Singh (2021).

5. As we get into the cases, we might consider Nick Fury and S.H.I.E.L.D. to be akin to commissars because they do show up on the battlefield. However, we tend to see the superheroes acting relatively autonomously, and they are not particularly worried about getting shot in the back of the head by their minders. Not all academics view subjective control the way Huntington does, according to Janowitz (1961).

6. Huntington's perspective on civil-military relations is now required reading in most (all?) military academies and war colleges. As an academic product, Huntington's work is often criticized. However, as a doctrine—that professionalism and autonomy are key aspirations of most modern armed forces—it remains very influential, as it tells the armed forces what they want to hear, as noted by Brooks (2020).

7. Wolverine is the classic example of a rogue agent in the comic books. Selected to be an agent of the government of Canada, he ultimately flees and then is pursued by Guardian, a Canadian superhero who is more inclined to listen to the civilian authorities.

8. While S.H.I.E.L.D. is thoroughly penetrated by Hydra, this section is written assuming that the decisions of the council and its attitudes towards the Avengers are not just

manifestations of Hydra's influence. Given that Hydra assassinates several members of the council in *Captain America: The Winter Soldier*, this seems to be a safe assumption.

9. For more on why the Avengers are bad agents, see Saideman (2012).

10. For more on how countries might influence multinational organizations amidst an alien invasion, see Saideman (2012).

11. Tracking the details of the accords via the movies is difficult, so I relied on the Marvel Cinematic Universe Wiki (2019).

12. In the opening of *Captain America: Civil War*, the Scarlet Witch shifts an explosion from the middle of a market to the upper part of a building. It is not clear whether more die in the building than the likely casualties in the ground.

13. My current research project on variations among the world's legislatures has made it clear that there is also variation in civilian expertise among the world's democracies.

ENVIRONMENTALISM AND THE MARVEL
CINEMATIC UNIVERSE

Spider-Man: Far from Home as a
Cautionary Tale

Nancy J. Hirschmann

The theme of environmentalism has an odd place in the Marvel Cinematic Universe (MCU). On the one hand, it has obvious importance, as it is the central motivating thread in several Avengers films concerning the intergalactic villain Thanos and his search for the six Infinity Stones, though it is not until *Avengers: Infinity War* that we learn that he wants them in order to wipe out half the life in the universe. This, he believes, is the solution to the environmental stress experienced by every populated planet in the universe. Yet a deeper look suggests that environmentalism is primarily a conveniently topical lens through which to portray an exquisitely evil, if not insane, villain and that the actual environment is not much more than a prop for spectacular superhero battles that are best communicated through the destruction of materiality, whether that is a skyscraper, a city street, various water bodies of the hydrosphere, or open land. It is also a vehicle for the coming-of-age of one of the MCU's newest cinematic heroes, Spider-Man (Tom Holland).[1] In this essay, I explore the theme of environmentalism with particular attention to *Spider-Man: Far from Home*, though my theme will of necessity lead me to engage with the final two *Avengers* films and refer to several others.[2]

Spider-Man is in many ways the perfect hero to start a consideration of environmental themes since he is the blameless product of laboratory nuclear energy, at least in the Marvel comics universe. In the MCU, the origin of his powers has yet to be fully explained at the time of this writing, but what we know so far suggests key similarities to the Peter whom readers meet in the comics, who gains superhuman abilities after being bitten by a radioactive spider. (We see some differences in the clever meeting of Spider-Men from other universes in *Spider-Man: No Way Home*, specifically Toby Maguire and Andrew Garfield, where we learn that only Maguire's Spider-Man has the ability to shoot webs from his body, whereas Garfield and Holland depend on devices they wear.) Other MCU superheroes also start from environmental damage, though some were arguably more blameworthy: in the comics, Bruce Banner

becomes the Incredible Hulk as the result of an experimental explosion of a gamma bomb in which he participates, Rocket the raccoon from *Guardians of the Galaxy* is the explicit result of experimental modification, and Tony Stark develops his Iron Man armor by spending some of the billions his father's (and then his) corporation earned developing weapons of mass destruction. Of course, the MCU is no less environmentally friendly than other superhero films—think of all the explosions in the 007 franchise, and the Matrix and Terminator series both aim toward postapocalyptic futures in which humankind's pursuit of technology leads to its own destruction and technology-dominated wastelands. But the MCU, and Spider-Man in particular, offers a revealing and explicit angle on environmental themes.

In the second *Spider-Man* movie in the MCU, Peter Parker's senior class is taking a trip to Europe to celebrate their upcoming graduation. They first head to Venice, where the canals are a pollution-free brilliant pale aqua, the color of swimming pools, and the city is crowded with tourists more interested in selfies than in appreciating Venice's long and meaningful history, in a comical touch of cinema verité.

Soon enough, Peter Parker's Spider-Man talents are called on to save Venice from a monster. But not just any monster: a monster made out of water. The bizarre images of the clear aqua water of the monster rising out of the canals to dismantle and burst apart the brick and stone of centuries-old *palazzi* and churches, to knock over the Santa Maria Formosa tower, and to crash through pedestrian bridges, including the famous and glorious Rialto, raises a question: were the film-makers trying to highlight the very real flooding dangers that Venice and Venetians are facing? Were they exploiting those dangers for cinematic spectacularism? Or were they thinking of them at all?

These problems have threatened Venice for years, and the city is literally sinking into the Adriatic. In November 2018, eight months before the film was released, flooding caused 2.2 million euros worth of damage to the Basilica San Marco. In November 2019, six weeks after the film's release on DVD, a second and even worse *acqua alta* occurred; at over one and a half meters deep, it was the second-highest *acqua alta* on record. Piazza San Marco was flooded with waist-high water for only the sixth time in twelve hundred years but the fourth time in the past two decades. The very structure of the basilica was seriously damaged, as were other landmark buildings, such as the Gritti Palace, not to mention the Doge's Palace, battered by boats that floated into the square from the nearby harbor. Invaluable works of art were destroyed. More than 80 percent of the city was flooded. The images viewed from our prepandemic homes were horrifying, grief-inducing to any lover of Italy, history, and the arts.

A great deal of the "sinking" of Venice can be attributed to the fact that some canals were excavated and deepened in the 1960s to accommodate oil tankers.

In Venice, Peter Parker is confronted by a monster made of water. Were the film-makers trying to highlight the very real flooding dangers that Venice and Venetians are facing, were they exploiting those dangers for the sake of spectacle, or were they thinking of them at all? From *Spider-Man: Far from Home* (2019).

And Venice's dependence on tourist dollars has tolerated, if not encouraged, the gargantuan cruise ships that enter the harbor daily to bring some thirty million tourists a year to a city with a population of only 260,000, causing sediment loss and the erosion of mudflats (Scarpa et al. 2019). But experts also believe that global warming is significantly responsible for the frequency of the *acqua alta* in recent years and for rising tides more generally (Henley and Giuffrida 2019).

Coming out between the first and second *acqua alta*, these *Spider-Man* scenes took on a deeper significance in terms of the presentation of a water monster in Venice. In many ways, the water *is* a monster to many Venetians, threatening the city's economic lifeblood, destroying its history, and simply making daily life unlivable (Barry and Bruno 2019). However, to others, the canals are the heart and essence of Venice, and the true monsters are the cruise ships that plow through the Grand Canal to disgorge day-tripping tourists (Rapagliaa et al. 2015; Cari and Mackelworth 2014). These tourists do exactly what Peter's classmates were doing—hang out, take selfies, buy cheap masks and postcards—without even providing the economic benefit that the students provide in patronizing the "atmospheric" Hotel DeMatteis, whose first floor was already flooded even before the water monster's attack.

The scene portraying the students' arrival at that hotel might lead one to think that the filmmaker purposely chose this form of the monster as a political statement about the dangers of global warming. Further, giving the water monster a hominid form could be taken as symbolizing the anthropocentric notion that humankind itself has turned a valuable natural resource, water, into a monster in the fragile ecosystems of the Venice lagoon. But my research on

the director and writers showed no such purpose. Indeed, Richard Brady of the *New Yorker* says the movie is "made as if in response to the prevalence of fake news and insidious propaganda"—itself an admittedly serious threat to democracy in the twenty-first century—and leaves out any reference to global warming (Brady 2019). In June 2019, the All About Italy website, though explaining how the "film crew apparently spent a great deal of time throwing rubbish on the floor [of Piazza San Marco] and turning over chairs and tables before hosing the area down with a large volume of water to portray the devastation of a storm caused by Jake Gyllenhaal's villainous character Mysterio as he tries to ruin the world," made no reference to the real *acqua alta* of the previous November or the dangers to Venice posed by cruise ships and global warming. Indeed, it notes that "the [film] shooting obviously conditioned the daily life of locals for almost two weeks, but people have been happy to cooperate and about a thousand Venetians were recruited as extras," again making no note of many Venetians' unhappiness about tourism coupled with their economic reliance on it, as tourism crowds out virtually all other employment opportunities.[3] Film reviews from major news outlets made no such connections either (Buchanan 2019; Hornaday 2019; Thompson 2019; Scott 2019).

Yet the ecological theme threads throughout the movie, although sometimes in perhaps unintended ways. The film opens with Nick Fury and Maria Hill arriving at a small town in Mexico that has been destroyed by a cyclone that some people say "had a face." Ever dubious, Hill snidely asks, "What, are we fighting the weather now?"—as if humans are not continually "fighting" weather, dealing with the destruction caused by hurricanes, tornadoes, blizzards, *derechos*, and other catastrophic events made more intense by global warming (Anthes et al. 2006). As if in response, a monster that appears to be made of rock arises from the earth, and a man with a burgundy cape and a globe over his head swoops in on a cloud of green vapor.

We later learn that the green vapor is the domain of Quentin Beck, a human allegedly from a different Earth (Earth Dimension 833, as opposed to our Earth, which Beck numbers Dimension 616) in a "multiverse," a premise that the generally suspicious Fury seems to accept (though at the end of the film, he claims, "I had doubts about Beck from the beginning," and Hill calmly clarifies, "Not true. He had zero doubts") and the enthusiastic Peter Parker calls "cool." Beck's "Earth" was destroyed by the monsters that we have seen; they are called "Elementals," and each of them was "born in stable orbits within black holes" and "formed from the primary elements: air, water, fire, and earth." After the first three are dispatched—ironically, very little is shown of the "Earth" monster, but we infer that it is not defeated in Mexico but goes on to Morocco, where Beck allegedly destroys it off camera—the only element left is fire, which is headed to Prague. Fury contrives to send Spider-Man

When confronted with a human-like cyclone in Mexico, Maria Hill asks, "What, are we fighting the weather now?" when in reality, the destruction caused by hurricanes, tornadoes, blizzards, *derechos*, and other catastrophic weather events (made more intense by global warming) is a constant threat to human well-being. From *Spider-Man: Far from Home* (2019).

there to assist Beck—now adopting the superhero moniker Mysterio—in this effort.

As a rational philosopher, of course, one is struck by the bad science in this premise, even within the logic of the MCU. Of all the possible superheroes, Spider-Man depends on material things. He does not shoot lasers from his hands or have mystical telekinetic powers; his webs need to stick to actual, physical objects. And by the time Fury brings him to his underground laboratory near Venice, we have already seen that Spider-Man is relatively powerless against water, as he would be against air. The rationale is that all others are off world or otherwise unavailable, and we just go with the narrative—this is a superhero film after all. But the symbolism is striking, for fire will be no different than water in regard to its ungraspability. It is significant that the earth monster is dispatched off camera with no reporting of what it does during its momentary appearance in Mexico, and only brief reference is made to its attack in Morocco, where Beck allegedly destroys it. This is the one of the four Elementals that Spider-Man *could* have fought successfully. And since Beck has, we later learn, digitally projected all of these monsters, Spider-Man would have uncovered the scam immediately, for Peter would have known that he was not grabbing anything real; his webs would have slid through the monster as if it were air, fire, or water, and the illusion would have been revealed. But it is precisely Spider-Man's failure with the others that the devious Beck anticipates, gambling on these failures to undermine Peter's confidence and boost his own heroic stature and leading him to turn over Tony Stark's "augmented-reality security and defense system" sunglasses, named EDITH (which stands for "even

dead, I'm the hero," a bit of Stark whimsy). This provides Mysterio with access to an entire arsenal of Stark Industries weaponry that will help add firepower to his virtual theater of destruction.

The symbolism of this collection of monsters is fascinating from an environmentalist perspective. The fundamental elements of the universe—earth, air, fire, and water—are conceptualized as the enemies of humanity: not just on our own Earth but on Beck's as well, and presumably countless others. Indeed, although humans cannot exist without all four of these "elements," the complete absence of earth and air from the action of the film is politically significant in that these two elements are universally recognized as being in serious trouble from pollution—"victims," as it were—whereas many humans view fire as itself a danger. And although we need clean drinking water to survive, flooding is linked to many global disasters, and rising sea levels present a serious threat to humanity. So using these two elements as the forms taken by Beck's creations already fits easily into many people's imaginations as villains. But the underlying point is that these elements, which make up our planet, are the signifiers for these monstrous enemies that must be overcome, dominated, and destroyed, directly echoing capitalist conceptions of nature as something to be dominated and exploited, as environmental theorists, particularly ecofeminists, have argued and critiqued (Gabrielson et al. 2016; Stein 2004). The fact that the technology that Beck uses comes from Stark Industries—whose wealth, despite all the good that Tony Stark has tried to achieve, comes from manufacturing weapons of war—adds another layer of symbolism to his choice of these "Elementals," particularly fire, as the enemy.[4]

So what *is* important, if not the ecosystem? Surely people are; the entire point of *Avengers: Endgame* is to undo Thanos's eradication of half of the people in the universe, after all, and most importantly their Avenger friends (including Spider-Man). Throughout the MCU, there is an ostensible attention to saving human life, as the Avengers and their allied heroes assist in the evacuation of buildings that have been destroyed in their inevitable battles with whatever enemies they are fighting. More generally, the premise is that by destroying the enemies that are attacking, they are protecting people, even if many of those people are unfortunately killed in the process.

In this, there is arguably some connection to ecofeminist perspectives, which argue that saving the environment entails a political economy approach of creating better conditions for human beings who are the exploited victims of global capital: help the planet by helping its people.[5] More immediately relevant, Spider-Man is a strong embodiment of the people-first ethos; he is actively concerned about his classmates and friends, reproaching Fury about his plans to fight the fire monster in Prague by pointing out, "Hey, my friends are here." To which Fury replies incredulously, "You're worried about hurting your

friends?" Yet Peter uses EDITH to arrange for his friends to be off the streets during the attack in Prague, though not entirely successfully (otherwise, where would the excitement come from?). The apparently more sensitive Mysterio is no better; prior to the defense of Prague, he instructs Peter, "Maneuver it away from civilians *if you can, but most important, keep it away from metal*" (my emphasis). The reason is that the fire monster will draw strength from metal (rather than combustible materials), thereby presenting an even greater threat to the city. But when combined with Fury's contemptuous reaction, it is difficult for a political theorist not to wonder what this says about the relative pecking order of people versus infrastructure. After all, Peter's friends may be (supposed to be) safe in an opera house, but there are still plenty of people in the square for a large festival, Fury's request to government officials to cancel the festival having been rebuffed.

Later, when this latest superhero is revealed as an archvillain, a disgruntled former employee of the now deceased Tony Stark who has gathered other disgruntled former employees to create a collaborative virtual simulation project, this message becomes far less subtle. The monsters are all digital projections, backed up by weapon-launching drones. After a confrontation in Berlin (Spider-Man heads there to alert Fury about Beck), where Beck believes that he has killed Spider-Man by using his powers of illusion to lure Peter into the path of a high-speed train, the location of the film shifts to London after a brief interlude in the Netherlands (where Happy rescues Peter by landing the Stark corporate jet on a field of tulips, where it remains for some time with its engines idling). In London, Beck orchestrates an attack against Peter's friends on Tower Bridge.[6] Moreover, the monster is now made up of all four Elementals combined into one, supposedly drawing power from Earth's core. So now our own planet—or its simulacrum—is (supposedly) literally the enemy.

These themes of infrastructure being possibly more relevant than people, and the environment being seen, if at all, as either there for our exploitation or miraculously self-healing so that we *can* continue to exploit it, thread through the MCU. Buildings are destroyed willy-nilly, with the likely, though often unmentioned, result that many people are injured or killed along the way. Though this creates a plan for governmental oversight, such oversight is itself the focus of corruption and villainy. Tony Stark sets up a "restoration fund" at the end of *Avengers: Age of Ultron*, but it, too, pertains primarily to buildings and infrastructure for cities and towns destroyed in the Avengers' fights to defeat villains, as Miriam Sharpe (Alfre Woodard) points out to Stark in *Avengers: Civil War*. Until we get to *Infinity War* and the insanity of Thanos, Avengers generally do not have to deal with the environmental fallout caused by their battles and conflagrations, particularly the water and air pollution they must cause: the built environment is prioritized over the "natural" environment.

Black Panther might seem to be an exception. Although once again the ostensible political theme of the movie is something else—in this case racial inequality, particularly in the United States, just as in *Far from Home* it is the proliferation of "fake news" and the willingness of humans to believe in false heroes—the environment is nonetheless an underlying theme. Wakanda offers a landscape of natural beauty and strives to cut itself off from the dangers of the rest of the world. Its healthy economy is fueled not only by a philosophy respectful of traditional ways of life (and presumably "simpler" needs and demands than we find in market-frenzied Western economies, as racist tropes of Africans as more "natural," even "animalistic," are furthered by the particular form taken by T'Challa's superhero: a panther) but also by an apparently limitless resource, vibranium. Mined without environmental damage of any sort, vibranium seems to yield, through its energy-manipulating properties, an equally limitless source of innovation and nonpolluting power. Wakanda presents us with an Edenic world that is, quite literally, a bubble: vibranium, it seems, even affords the Wakandans a "thermo-isolating hologram" shield that surrounds its territory like a dome (Dujmovic 2018). This, of course, is the utopian dream: not only higher tech than we have in the real world today, but completely "green."

Infinity War is of course the obvious exception to my claim, as Thanos pursues all six Infinity Stones precisely so that he can save the universe from environmental degradation and planet death. But he seeks to use his phenomenal power not to create some new resource or technology—such as more vibranium or some other self-renewing material—but to eliminate half of the populations of all planets in the universe. Thanos's philosophy is that the planets will recover on their own once the pressure of excessive demand is alleviated; that is in fact the revised narrative of Zehoberei, Gamora's home world. In *Guardians of the Galaxy*, she tells Quill her planet was completely destroyed by Thanos, but in the revised narrative of *Infinity War*, only half the population had been destroyed, and the planet subsequently thrives. In *Endgame*, the claim is made that Earth is recovering just as Thanos predicted.

Whether this is scientifically valid is, of course, questionable. This is science fiction fantasy, after all, and what Samuel Coleridge termed "that willing suspension of disbelief for the moment, which constitutes poetic faith" in his 1817 *Biographia Literaria* applies to all the films in the MCU: that is what makes them so profoundly fun and enjoyable (Coleridge [1817] 1983). But even within the internal logic of the MCU, it is notable that Thanos's own home world, Titan, is a desert and did not regenerate after the people died. More significantly, these newly reduced populations will now need to contend with air and water polluted by Thanos's attacks on multiple planets as well as likely crop decimation and soil contamination as results of his firefights.

His ostensible goal in obtaining the Infinity Stones is to achieve his goal without such destruction—he snaps his fingers rather than shooting lasers—but he has already created an immense amount of lasting damage. War and military aggression are directly devastating to environments and can produce a variety of additional environmental disasters beyond the event. Whether through the use of Agent Orange in Vietnam, cluster bombing, or other forms of military explosion, "the effects on landscapes can be as devastating as earthquakes or volcanic eruptions" (Mannion 2003, 1, 9, 17–19).[7] The "profligate use of high-explosive munitions" as well as "tanks and other heavy off-road vehicles" produces "devastating" ecological effects (Westing 2009, 69). Petrochemicals are also released into the air, whether from weaponry itself or the targeting of factories that produce such weapons, as occurred in the Balkans, with pollutants affecting downstream nations such as Bulgaria and Romania. In the first Gulf War, eleven million barrels of oil were dumped into the Persian Gulf, negatively impacting many marine creatures. Fresh drinking-water supplies are frequently compromised. Wildlife populations are decimated by both being "hunted for bush meat" and "to generate funds for warfare" (Mannion 2003, 2, 13–14). In Rwanda, which used to boast "the most complex savannah ecosystem in eastern Africa" and where "more than 12% of the territory was covered by national parks and natural reserves" until the ethnic war that broke out in the early 1990s, large-scale military conflict took place on parkland, resulting in the loss of many animals. Akagera National Park, site of Rwanda's "first large scale fighting," lost "90% of its big mammals, with important loss and changes in habitats." After the war, Rwanda had to turn significant amounts of parkland into refugee settlements, further damaging ecosystems and making their recovery more unlikely (Kanyamibwa 1998).[8] Corpses thrown into rivers from the 1994 conflicts produced profound changes in biodiversity in the Nile River basin (Kanyamibwa 1998, 1403) Neighboring countries to which Rwandan refugees escaped experienced "deforestation, soil degradation, local pollution and poaching" due to the resulting "high demand" of large and desperate refugee populations (Kanyamibwa 1998, 1404). Given the relative puniness of human weapons against those that Thanos yields, the destruction that he creates up to and in the course of pursuing the Infinity Stones would be far worse, threatening all hope of planetary recovery.

Environmentalism is thus represented by a figure who is both evil and insane: what earth's human global warming deniers, right-wing politicians, and corporations call "ecoterrorism" at its most extreme (Vanderheiden 2005). The heroes want to save people, an obviously admirable goal. But arguably Thanos does too, in that the recovering planets will provide greater hope to the remaining populations. But the destruction of ecosystems caused by the struggles between Thanos and the populations that are trying to protect themselves

raises an even more disturbing question that reveals the evil insanity of Thanos's plan: what can we expect to emerge from those ashes?

On our own Earth, for instance, many insects and plants have "migrated" from other continents where they are integrated into the natural landscape, such as Japanese knotweed and mile-a-minute weed, both intentionally brought to the United States as ornamentals, which have become so invasive as to threaten and even destroy local ecosystems (Tallamy 2009). They are almost impossible to wipe out, and it is highly likely that they would be the survivors rather than native perennials. In studies of the aftermath of fires, a number of variables, including "both fire attributes and plant attributes," affect whether native or non-native species of plant will recover first and dominate, and although there is no consensus on what would happen, there is considerable concern (quoted in Zouhar, Smith, and Sutherland 2008, 9). Many scholars agree that "nonnatives can outcompete natives for limited resources in early successional environments," particularly given that many native species are understory plants, whereas the majority of non-natives thrive in more sun; planetary destruction is likely to destroy a lot of forest (Zouhar, Smith, and Sutherland 2008).[9] The proliferation of non-native species can create changes in the nitrogen available to plants, which in turn changes the overall ecosystem, making it even less favorable to native plants. The likely triumph of such non-native species would further ecological disaster as native plants and insects on whose reciprocal relationship human life depends for pollination struggle to survive in a newly aggressive and hostile environment. That is, with fewer native plants, the ability of native insects to recover after similar disasters—whether from fires or from laser bombs—will similarly be affected, with resulting decreases in the pollination of other plants, including many crops.

Similarly, invasive insects, such as the brown marmorated stink bug, came to the United States on shipping crates sent from Asia, where it has natural predators and does not create the massive destruction of flora, including crops, that it does in North America. Many non-native invasive species of fauna, such as "bighead and silver carp . . . two large species of fish that escaped from fish farms in the 1990s, and are now common in the Missouri River of North America," "outcompete native species for food" and lack natural predators. Similarly, lionfish, which are native to the Indian Ocean, are now proliferating along the Eastern Seaboard of the United States with no natural predators to stop them.[10]

Removing humans from the planet will not help suppress those invasive populations or help native species thrive. Indeed, humans are needed to undo the damage they have done through ecologically defensive action. If, rather than eliminating people randomly, Thanos selectively spared those who struggle to remove non-native invasives and plant native plant species and instead

targeted corporate polluters, one could argue that there was some reason to his method. But in a random selection, why would he not expect that surviving corporate heads would view this as an opportunity to gain greater competitive advantage, leaving them carte blanche to continue polluting?

All this is to say that Thanos's optimism that the destruction he has created will produce a better "balance" in the universe is breathtakingly shortsighted, evidence of his insanity.[11] And that is part of the film's message: Thanos is the villain. The underlying message of this storyline—most likely an unintentional one but one that emerges through considering the politics of the film—is that the person in the MCU most concerned about environments and planetary death is evil and insane. In this regard, it is significant that in the comics, Thanos is in love with the Goddess of Death, and his killing half the people in the universe is his (equally misguided) attempt to seek her approval, a less ambiguous index of the totality of Thanos's evil. By contrast, saving the environment is something that many of us want, and overpopulation is thought by many scientists and policy experts to be linked to the threat that Earth faces (Headburt 2020; Westing 2010; but see Ellis 2013). Yet Thanos evades any sympathy because his solution is so heartless, not to mention thoughtless. He is unmitigatedly the bad guy. In an MCU movie, the fantastic is expected, and the lack of subtlety in portraying Thanos is unsurprising. But if we are to consider the politics of these themes in the MCU films, as this volume seeks to do, these observations go beyond quibbles or killjoy criticism to ask, what messages are these films conveying *beyond* authorial or directorial intent?

The first might be that our environment is so endangered that it has driven us all to distraction, even madness, as concern about environmental decay is the apparent cause of Thanos's madness. "Eco-anxiety" is a serious problem affecting schoolchildren in the United States, causing significant depression and fear (Plautz 2021). Perhaps if Thanos were portrayed as a more sympathetic character, the reason for his madness might come across; but by the time we see the destroyed Titan, it is far too late to muster sympathy and understanding for him; he has wrought too much destruction on too many worlds and done too much harm to the characters we love, from Gamora and Nebula to Thor and Loki. Even at the end of *Endgame*, Thanos's weakness and apparent resignation do not stem from regret but are the effects of having used the stones, a use that subsequently kills the comparatively weaker human being Tony Stark. We have no sympathy for Thanos or his goals; "too much" concern about the planet's trajectory toward climactic desolation will turn you into a monster who should be destroyed. That we all cheer is a sign of the film's success in telling a good story about good and evil.

A second unintended political message, one that seems more consistent with the themes of the entire MCU, might be that global warming is so overwhelming

and horrifying that *only* a superhero *can* fix it. If the water monster in Venice represents the rising waters caused by climate change, there is not much that ordinary humans can do about it. The Venice economy is now so dependent on tourism that banning cruise ships or reducing the number of tourists each day—or requiring the payment of a fee, like a ticket to an amusement park—is not only impracticable, but counterproductive. Though the current mayor, Luigi Brugnaro, in the wake of the SARS-CoV2 pandemic has hopes of reinvigorating the Venetian economy to be less dependent on tourism, the change will be difficult to implement and will take a long time, perhaps more time than Venice has (Barry 2020). It also would have no effect on rising sea levels. These conditions have indeed led to a project that itself seems like a work of superhero science fiction, worthy of Tony Stark himself: the MOSE Project (Modulo Sperimentale Elettromeccanico, or Experimental Electromechanical Module). MOSE consists of an underwater system of gates, set in a concrete foundation on the bottom of the lagoon, that are to rise during flooding periods to keep water out of the city, and it is operated from a control center that resembles "the lair of a James Bond Villain" (Buckley 2022). The MOSE Project began in 1984 and was not operational until October 2020, hampered by corruption and woefully over budget; it has thus far cost 7.6 billion euros of public money, and reportedly costs over 300,000 euros each time the gates are raised (Harlan and Pitrelli 2020; Buckley 2022), though most likely more, with a recent bill for 15 million euros being challenged by the regional government (Veneto Report 2021). MOSE was successfully deployed against an *acqua alta* in October 2020 but failed just two months later due to inaccurate predictions of how high the water would get (Buckley 2022); in November and December 2021, it reportedly protected the city from several *acqua alta* occurrences. Yet it is unlikely to be a long-term solution, as waters continue to rise ever higher with global warming (BBC News 2020).[12] Moreover, MOSE is itself a likely threat to the ecosystem of the lagoons by changing their hydrodynamics, thus only deferring rather than solving the problem (Ghezzoa et al. 2010).

This leads to a third though closely related theme, which is fatalism. This might seem counterintuitive, if not self-contradictory; much of the "green movement" has stressed individual efforts to reduce our carbon footprint, after all. It focuses its attention not on superheroes but on the rest of us human beings: we must be our own environmental heroes. But the way it does so, with self-righteous condemnation of plastic grocery bags, plastic straws, and even asthma inhalers, focuses attention on other, relatively helpless humans rather than the corporations that have been built on the exploitation of natural resources and human vulnerability. The uproar about asthma inhalers, for instance, deemed to have a greater carbon footprint than eating meat or driving a car, targeted asthmatics as if they had a choice about their condition (Roberts

2019). Even more significantly, many directed their rage at asthmatics themselves for using their inhalers "improperly" (as one writer put it, "My technique may not always be the best, but thinking clearly is difficult to do when you are not getting enough oxygen to the brain") and for failing to switch to "greener" inhalers. Completely missing was an attack on the corporations that make huge profits by manufacturing the inhalers with the propellant hydrofluoroalkane that emits greenhouse gases (Lee 2019). Even more significant was the failure to recognize that air pollution—to which corporate manufacturing is a major contributor, both directly (through production) and indirectly (producing trucks and SUVs rather than electric cars, for instance)—contributes heavily to asthma and is the most frequent trigger of an asthma attack, which causes a person to need the inhaler in the first place.

This neoliberal "Just Say No" mentality is not only naive but self-defeating.[13] Although transportation, electricity production, and industry are the three biggest contributors to global warming, according to the Environmental Protection Agency, it is naive to assume that consumer choice is the primary way to change things. For instance, although it is arguably the case that the decline of coal has occurred in response to consumer demand—"Our customers don't want it," according to an anonymous utility executive—the restrictive policies enacted during the presidency of Barack Obama were the engine that drove change, with consumer choice only a supporting actor made possible once these policies made significant progress (Von Drehle 2020). Consumer choice is more often driven by supply, as well as cost, and industries constantly provide economic disincentives for making greener choices (Mahajan and Garrett 1999; Parker 2013; Sunstein 2015).[14]

Moreover, as Rowlands notes, corporations "consume much of the earth's resources and produce large quantities of waste. . . . If we did not have TNCs [transnational corporations] spreading resource extraction, production, and technological development around the world, then we could well not have many of the global environmental problems that we are experiencing today" (Rowlands 2001, 133).[15] Airlines are more concerned with cramming people into seats by lowering prices than reducing their carbon footprint; automobile manufacturers build small cars primarily to balance their production of larger cars, which pollute more and are more profitable; turning from electric, gas, or oil heat to wood-burning stoves would create even more pollution (Environmental Protection Agency n.d.).[16] Yet in the fixation on reusable grocery bags instead of plastic, our obsessive recycling efforts, and reusable water bottles, it is as if we cannot cope with the realization that we puny, nonenhanced humans are incapable of stopping anything so massive as the ocean from rising to swallow us up. We instead turn on each other and rail against small infractions as if to convince ourselves that we are not already doomed and powerless

to institute real change at the top. As Mysterio says, "It's easy to fool people when they're already fooling themselves." Global warming will not be undone if consumer actions are the primary driver: corporations must be forced to act. That Thanos has such a misguided solution to environmental desolation is ostensibly a mark of his insanity but communicates a subtle message to the attuned viewer that people are the problem, not the solution. Instead of selecting people at random in a consumerist, bottom-up philosophy, Thanos's plan would be less maniacal if it was part of a strategy to reduce pollution and encourage renewable energy by targeting the governments and corporations that have the power to enact such changes (Rowlands 2001, 19). People are not the primary causal problem even if they are the problems' technical endpoint and vehicle: corporations and governments are.

This raises the point that perhaps superheroes are not suited to deal with environmental threats, which require collective action; maybe Thanos's mistake was a failure to consult and collaborate. But Thanos is old—very old. And old people have a notoriously difficult time changing—especially if they are extremely powerful with advanced technology at their fingertips, not to mention supernatural forces such as the Infinity Stones. Which leads to another theme in the film: that we need not just superheroes but young superheroes. Tony Stark chooses Peter Parker to be "the next Iron Man," a responsibility from which Peter initially shies away—"I'm just a kid!"—but reclaims at the end of the movie as he fights and destroys Mysterio. On our (real) earth, the Swedish teenager Greta Thunberg has shown us that children can be inspiring and fearless leaders and crusaders for the environment. She reveals that young people have the imagination and insight that is lacking in their elders, whose imaginations have been cramped by a culture of overuse, exploitation, and disposability. She also challenges the idea that superheroes are only good at protecting us from external enemies through physical violence; what has come to define "superhero" fits the neoliberal model of the individual working and achieving alone, but Thunberg's superpower is the ability to bring people together to urge governments to collective action. And we all love the fact that the Avengers are so good at working together, at least when they are not fighting each other—but what family doesn't have its conflict?

Perhaps it is not insignificant that Thunberg has had a genus of spider named for her, *Thunberga gen. nov.*, a "huntsman" spider that hunts for food rather than catching it in a web and that was named for Thunberg by its discoverer, Peter Jager, in order to "draw attention to the issue of biodiversity loss in Madagascar," where the spider was found (Agence-France Presse, 2020). Spider-Man might well have that same leadership quality. He certainly would not be dragged into the kind of pissing contests that Iron Man, Captain America, Thor, and Hulk have engaged in against each other, to our delight. And his

superpower involves sticky web threads that often hold things together, not a force of strength that destroys things; in this he is unique among the Marvel superheroes. He is also just a nice, sweet person; in *Civil War*, he is remarkably polite and apologetic to Avengers on the other side of the divide from the one he was recruited to. He is a "neighborhood Spider-Man" who just wants to help people, a decent guy. As the comic book character Domino says, that is his true superpower.[17] Nor does he seem drawn into the various obsessions of his own generation, such as social media and technological gadgets (he is remarkably unintuitive about EDITH when he first puts Stark's glasses on). So he may be the superhero of the future. The fact that the movie ends with Spider-Man's identity being announced by a conservative conspiracy personality suggests a further reaffirmation of Peter as the new Iron Man since Tony Stark himself revealed "I am Iron Man" at the end of the first *Iron Man* movie. Despite Peter's obsession with keeping his identity secret, the lack of secrecy certainly did not hamper Iron Man's effectiveness any more than it did Captain America's. As we now know, in *No Way Home*, Peter does not wish his identity to be known, resulting in a cascade of tragedies. So his story is changing and seems to be in flux.

But whether the planet's story will change in the MCU is another question. Nowhere in the movie, nor in *Spider-Man: Homecoming*, do we see evidence that Peter is particularly ecoconscious. But he is young and focused on the safety and welfare of humans, and that remarkable feature makes him likely to help with this massive issue. He may well come to realize, sooner rather than later, that in order to save the people, he has to save their planet not just from alien invaders but from the people themselves.

Notes

1. Twenty-one actors have played Spider-Man on the big and little screen, in addition to animated versions, some occupying the same story line (see Acevedo 2019).

2. I should note from the start that although I enjoyed the film a great deal and have increasingly become a fan of the MCU during the pandemic lockdown, my criticisms in this essay may appear to communicate the opposite because I am engaged in a process of critical analysis of a particular theme. I want to stress that I love the escapism that such movies provide, and the raw entertainment, as much as anyone. But I do believe that the political implications of the movies' texts are fair game for political theoretical analysis.

3. AllAboutItaly (2019).

4. One could argue that Beck is the mirror image of Thanos, viewing the four elements as enemies to be conquered rather than victims to be saved, and this choice could arguably make Beck even more of a villain than if he had chosen some other random monsters. That he seems unaware of the symbolism of his choices aptly fits the dominant view of global capital today.

5. The Grassroots Social Justice Alliance is one example of an organization that promotes this view: https://ggjalliance.org/resource-type/reports/.

6. Which is misidentified by social media–obsessed Flash Thompson as London Bridge, the site of real-life terrorist attacks in 2017 and 2019. Indeed, in a delicious life-imitating-art-imitating life moment, in the 2019 attack, civilians used a narwhal tusk to defeat one of the terrorists, just as MJ attempts to use a mace taken from the Tower of London to damage one of Beck's drones (BBC News 2019).

7. See also Westing (2009, 72–73).

8. None of this discussion is meant to deny the human losses and suffering caused by this or any other war; I only draw on these as examples of the ecological impacts.

9. See also MacDougall and Turkington (2004; 2005) and Sutherland (2004).

10. "Invasive Species," National Geographic Resource Library, https://www.national geographic.org/encyclopedia/invasive-species; see also Waller and Rooney (2009).

11. This adds an additional layer to the problematic recreation of the Zehoberei narrative, for unless half the population was gathered for execution with no military resistance at all, it would be virtually impossible for the planet to have recovered so remarkably within a single generation (though we do not actually know how old Gamora is). Furthermore, if Zehoberei has a climate with the ability to recover so quickly, then it is reasonable to assume that other solutions could have been found for the problems it was experiencing.

12. For recent activity, see also the official MOSE website, https://www.mosevenezia .eu/.

13. This slogan was launched as part of the Reagan administration's "war on drugs" (Stuart 2016).

14. One example is that "on larger cars, wholesale prices are a smaller percentage of retail prices," leading to greater percentage discounts on full-sized vehicles (Bresnahan and Reiss 1985, 253).

15. Similarly, Sierzchula et al. (2014) note that the market has failed to persuade consumers to purchase electric cars in large numbers, requiring governmental incentives.

16. It has also been reported that "only 100 major corporations are responsible for seventy percent of the air and water pollution experienced on earth," but I have been unable to confirm this figure through a truly independent/government source. However, it has been more reliably documented that the five hundred biggest transnational corporations "generate more than half the greenhouse gas emissions produced annually" (Rowlands 2001, 19).

17. Thanks to Nick Carnes for pointing this out. See *Domino* #2 (2018) by Gail Simone.

Deep thanks to Nick Carnes and Lilly Goren for including me in this project, which was delightfully enjoyable and deeply thought-provoking. Thanks particularly to Nick for his many comments educating me on aspects of the MCU of which I was ignorant. Of course, all errors, inadequacies, and failings of the argument are my sole responsibility.

MARVEL CINEMATIC UNIVERSE VILLAINS AND SOCIAL ANXIETIES

Haoyang Wang and Christina Zhang

While many audiences are drawn to superhero stories for their protagonists, others are fascinated by the villains. An antagonist, when done right, becomes a unique character who acts as a complement to the protagonist and clarifies their moral vision by way of contrast. A good antagonist adds to the protagonist's heroism: the X-Men couldn't be X-Men without Magneto, and Spider-Man couldn't be Spider-Man without Green Goblin. In many stories, heroes really are only as good as their villains.

Before Phase Three, Marvel Cinematic Universe (MCU) antagonists were often flat, with unrelatable motives and characterizations. However, since Phase Three, the antagonists have symbolized prevalent cultural and social anxieties. The Phase Three villains have moved beyond the one-dimensional bad guy motivated by greed, revenge, or ambition and have increasingly served as stand-ins for some of the grand challenges facing humanity.

This paper briefly studies four villains from Phase Three: Vulture from *Spider-Man: Homecoming* (2017), Killmonger from *Black Panther* (2018), Thanos from *Avengers: Infinity War* (2018) and *Avengers: Endgame* (2019), and Mysterio from *Spider-Man: Far from Home* (2019). We argue that these Phase Three villains embodied some of the most acute threats that we face globally: economic and racial injustice, resource scarcity, and misinformation.[1]

The Vulture

As one of Spider-Man's oldest foes, the Vulture—aka Adrian Toomes—first appeared in 1963 in *The Amazing Spider-Man #2*. In the comics, Toomes was an electronics engineer who created a technology that allowed him to fly, but a powerful businessman scammed him and stole the technology, which, in turn, resulted in Toomes losing his job and briefly going to jail (Lee and Ditko 1963). From his comic book origins, the Vulture has always represented the plight of hardworking people who built everything from the ground up, only to have their work taken away by a system that favors those with established economic privilege.

Vulture in *Homecoming*, like his comics counterpart, represents the challenges of upward mobility, that is, the tension between up-and-coming individuals and an economic system that favors the well-off. Vulture viscerally embodies the frustrations inherent in a system where upward mobility is difficult and where the rich enjoy numerous advantages. His first appearance on the screen is a scene in which his home-grown demolition company is dismissed from a crucial job by Damage Control, an Avengers-affiliated government initiative. He turns to a life of black-market crime, works his way up, but is then vanquished by Peter Parker, who is slowly becoming part of the established elite thanks to Tony Stark's technologies and connections.

Although Vulture manufactures and sells black-market weapons, his reasons for doing so strike a chord with modern concerns about economic inequality. Talking to Parker, for instance, Toomes notes,

How do you think your buddy Stark paid for that tower, or any of his little toys? Those people, Pete, those people up there, the rich and the powerful, they do whatever they want. Guys like us, like you and me . . . they don't care about us. We build their roads and we fight all their wars and everything. They don't care about us. We have to pick up after them. We have to eat their table scraps. That's how it is. I know you know what I'm talking about, Peter. (Watts 2017)

Tony Stark is the CEO of a multinational corporation, an Avenger, and a member of one of America's most powerful families. In contrast, people like Toomes have to climb the social ladder themselves and are often overlooked, neglected, and kicked around by men like Stark who are born to privilege. To Toomes, people like him are victims who are bullied and disposed of when they are weak but feared and targeted when they finally become strong. The moment they display their hard work, people like Stark tell them to go home. Vulture shows the lengths to which someone without existing economic privilege must go to make their income and how it can have no effect on the powerful at all.

Like many Americans without existing economic privilege, Vulture wants to provide for his family in a world where opportunities are often scarce. When Parker threatens to expose him, what comes to his mind first and foremost is his family: "That's what I'll do to protect my family, Pete, you understand?" He threatens Parker not out of malice but out of a natural instinct to protect his family. Family prosperity has a large impact on children's future prosperity. In the United States, the probability that a child born in the bottom fifth of income distribution will rise to the top fifth of income distribution when he or she becomes an adult is 7.5%, much lower than in countries such as the UK,

Denmark, and Canada (Chetty and Saez 2014). People like Vulture understand that the only way to secure their children's futures under the current system is to provide them with as much as possible: "I built this whole place because I have people to look after." The system is therefore not only a threat to Vulture but also an impediment to his daughter's future.

Ultimately, Vulture invites audiences to wrestle with the perilous state of the American Dream. His goals of upward mobility and economic security are always imperiled by the rich and powerful. He cares deeply about his family, and he is willing to break the rules to get ahead because he feels that the game is rigged and that he and his family could lose everything at any point. Vulture/Toomes articulates an acute sense of precarity. To real-world audiences living through historically unprecedented concentrations of wealth among the rich, his story likely strikes an important chord.

Killmonger

When Killmonger was first announced as the antagonist of *Black Panther* (2018), many fans were unimpressed. Why did Marvel choose a C-list villain from the comics to be the antagonist of Black Panther's solo movie over Klaw, T'Challa's nemesis?

This inauspicious beginning made Killmonger's rise to fame all the more fascinating. Unlike classic Marvel villains, such as Green Goblin and Doctor Doom, Killmonger had a meager fan base prior to the *Black Panther* film. Yet he became one of the most popular MCU villains, far outshining those with much larger comics fandom, such as Red Skull.

Part of the explanation is the way the MCU updated Killmonger's character. In the comics, Killmonger was a warrior who was resurrected again and again by more prominent villains to serve as a henchman. In the MCU, on the other hand, Killmonger is depicted as a powerful and charismatic leader with an agenda all his own. (For more on Killmonger, see Rank and Pool in this volume.)

That agenda, moreover, touches on some of the most burning issues of our day: racial injustice, socioeconomic inequality, and Black liberation—not just in the United States but around the world. Killmonger's backstory, for instance, illustrates the repercussions of a childhood amidst racial and socioeconomic inequalities and touches on the broader social consequences of these injustices. As he says when speaking about his childhood home of Oakland, "Everybody dies. It's just life around here" (Coogler 2018). The choice to set his childhood home in Oakland is significant in itself. Oakland is a city defined by a century-long history of redlining and unequal housing, police brutality

against African Americans, and racial injustice more generally. It was also the birthplace of the Black Panther Party. In setting Killmonger's childhood in Oakland, the film powerfully connects his character to the injustices facing Black Americans.

Killmonger seeks to right these injustices. To him, it is despicable that Wakanda, the most powerful nation in the world, refuses to use its vast resources to help Black people elsewhere. Furious, he taunts Wakandan leaders, "Y'all sittin' up here comfortable. Must feel good. It's about two billion people all over the world that look like us. But their lives are a lot harder. Wakanda has the tools to liberate 'em all" (Coogler 2018). Killmonger makes a compelling point. Wakanda's wealth is flaunted: Shuri's laboratory creates unlimited high-tech gadgets, and the whole nation is protected under a high-tech barrier. Wakanda also possesses powerful military and intelligence resources. In the first act of the film, we see T'Challa easily rescuing Nakia and the refugees with Wakanda's high-tech weaponry and aircraft in just a few minutes with no Wakandan casualties. If intercepting Nakia's mission can be so easy, it makes us wonder how simple it would be for Wakanda to save many others at little to no cost to Wakandans. Killmonger also reaches this conclusion: "You know, where I'm from, when Black folks started revolutions, they never had the firepower or the resources to fight their oppressors. Where was Wakanda? Hmm? Yeah, all that ends today." He knows the value of Wakanda's weapons, understands their strength, and trains hard to become a warrior in hopes of someday acquiring those resources to help other oppressed Black people.

Killmonger is a prince of Wakanda, but instead of gaining personal power, wealth, and a comfortable place among Wakandan royalty, he uses his position to fight for Black liberation and justice beyond Wakanda's borders, something that T'Challa and his father have always been reluctant to do. Even if it means that he is portrayed as an evil criminal, that he must sacrifice his life, Killmonger is determined to fulfill his mission with no regret. It is very hard to not feel at least a bit of sympathy, even respect, for Killmonger, while also feeling frustrated with T'Challa and T'Chaka and their decisions to keep Wakanda isolated.

Killmonger's mission for Black liberation is eventually obscured by his personal goal of revenge and seems to grow into a plan for global domination and authoritarian rule at home, as demonstrated by his order that the heart-shaped herbs be destroyed so that he can be Wakanda's last king. His words in his first battle with T'Challa are illustrative of his character's dual purposes: "I lived my entire life waiting for this moment. I trained, I lied, I killed just to get here. I killed in America, Afghanistan, Iraq. . . . I took life from my own brothers and sisters right here on this continent! And all this death just so I could kill you" (Coogler 2018). Killmonger represents the effects of racial injustice and

the goal of Black liberation, but he also shows how easily these forces can be conflated with revenge and can "breed catastrophe" (Russo and Russo 2016).

This personal mission for retribution parallels the collective loss of African identity that Killmonger hopes to avenge. Adam Serwer writes about "the Void": the "psychic and cultural wound caused by the Trans-Atlantic slave trade, the loss of life, culture, language, and history that could never be restored" (Serwer 2018). Black people have had their history and culture stolen. Killmonger's father had his life stolen from him by the Wakandans, and Killmonger loses his childhood and many years of his adulthood trying to seek retaliation against the Wakandans for what they did to him and his family.

The idea of loss comes through much of Killmonger's dialogue: "The world took everything away from me! Everything I ever loved! But I'ma make sure we're even" (Coogler 2018). It is clear that he is talking not just about his childhood but also about the theft of his culture and history that he, along with many other Black people, never got to experience. Thus, though much of Killmonger's motive is to destroy T'Challa and his family, his personal ambitions are still a result of the collective suffering that Wakanda's resources could have stopped.

Killmonger thus embodies many of the complexities of the legacy of racial injustice, slavery, and white supremacy—issues that are painfully timely in our real world. As a boy raised in Oakland, he lives with the legacy of racial oppression; as a Wakandan prince, he asks difficult questions about the responsibilities of powerful nations in a world still suffering from the remnants of colonialism and still scarred by the trans-Atlantic slave trade and slavery itself. Killmonger is popular not just because he is complex but also because he gives audiences a framework for deliberating about racial injustice and colonialism.

Thanos

"Little one, it's a simple calculus. This universe is finite, its resources finite . . . if life is left unchecked, life will cease to exist. It needs correction" (Russo and Russo 2018).

This is how Thanos—rated one of the greatest movie villains of all time—explains his motivations to Gamora in *Infinity War*. (For another analysis of Thanos's representation of ecological anxieties, see Hirschmann in this volume.) His ecological concerns echo those of Thomas Malthus, who claimed that "the increase of population is necessarily limited by the means of subsistence" (Malthus 1798). Like Malthus, Thanos believes that overpopulation inevitably results in unnecessary hardship and eventual catastrophe. This was the fate of his home world, Titan, and Thanos believes that a similar process

threatens the entire universe. When he slaughters half the Zehoberei population, for instance, he explains that the planet's people were "going to bed hungry" and "scrounging for scraps" (Russo and Russo 2018). In his own mind, Thanos is an ecological warrior who fights for sustainability.

For much of his early comic book run, Thanos was a "Mad Titan" who attempted to impress Lady Death, the living embodiment of death, by snapping half of the universe out of existence. Even in earlier MCU movies, Thanos was more aligned with his comics counterpart than his *Infinity War* self. It is only in later movies that Thanos becomes an ecowarrior. The Marvel costume designers named the *Infinity War* Thanos "Philosopher Thanos" to demonstrate his new personality (Hood 2019).

The effect of changing "Mad Titan Thanos" to "Philosopher Thanos" is to link him to a contemporary social anxiety: impending environmental catastrophe.[2] In 2018 and 2019, the release years of *Infinity War* and *Endgame*, there was a rise in debates centered around environmental issues, especially climate change. According to NASA (2019) and NOAA, 2018 was the "fourth warmest year in continued warming trend." Arctic sea ice is disappearing, permafrost is melting, and half of the Great Barrier Reef has died since 2016. A United Nations (2016) Environment Programme assessment recently warned that the changes and damage done to the environment are increasing "at a faster pace than previously thought."

Indeed, Thanos's reasoning may resonate with audiences more broadly than that of any other MCU villain. Online hashtags such as #thanoswasright and articles defending Thanos's beliefs became popular after *Infinity War*'s release. Many Thanos proponents believe that he is a necessary evil who raises awareness of environmental concerns.[3] From this perspective, Thanos is unquestionably linked to contemporary environmental fears.

Thanos is terrifying and compelling, then, in part because he evokes a very real, truly existential problem. While a villain cannot snap with an Infinity Gauntlet in real life, natural disasters and social disruptions driven by climate change can and are happening in the world. The stakes seem high in *Infinity War* in part because many in the audience can relate to the fear that environmental damage could have catastrophic consequences and that drastic intervention may eventually become the only way to avert catastrophe. Thanos is thus both the feared outcome—destruction—and the feared solution—horrific sacrifice in the name of preventing worse calamity.

In addition to these environmental anxieties, Thanos evokes another potent contemporary fear: the rise of authoritarianism. Thanos's tyrannical side is highlighted in "Warrior Thanos," the 2014 version of Thanos who appears in *Endgame*'s final battle. Warrior Thanos decides to wipe out all of the universe because he finds out that not only are the survivors not "grateful," but they

Thanos's appearance without armor in *Infinity War* was a departure from prior MCU depictions and helped to signify his transition to "Philosopher Thanos," who embodies contemporary social anxieties around impending ecological catastrophe. From *Avengers: Infinity War* (2018).

treat him as a villain and seek to undo his work. "I will shred this universe down to its last atom, and then with the stones you've collected for me, create a new one, teeming with life that knows not what it has lost but only what it has been given. A grateful universe." Warrior Thanos, like most dictators, expects people to be grateful to him and seeks to punish those who fail to show appreciation.

There is little doubt that Thanos's authoritarian stylings evoke deep concerns in real-world audiences. Politicians and political scientists are increasingly sounding alarms that fascism and authoritarianism are on the rise among far-right parties in the United States, Europe, and Latin America. Thanos is certainly not a populist authoritarian—he is not elected, after all—but his actions clearly evoke authoritarianism. A recent popular meme photoshopped the Mad Titan's face onto Donald Trump's body—a meme that was ultimately embraced by Trump himself.

Thanos is terrifying because he represents multiple contemporary fears, including environmental catastrophes and the rise of authoritarianism. The real-world implications of these fears help him stand out as a particularly relevant character in this day and age.

Mysterio

From his debut, Mysterio—aka Quentin Beck—is the epitome of dishonesty and misinformation in the Marvel Universe. (For more on Mysterio, see Hirschmann in this volume.) A failed special-effects artist, Beck turns his

"Warrior Thanos"—the designation given to Thanos's appearance when wearing battle armor—evokes contemporary social anxieties around the rise of authoritarianism. From *Avengers: Endgame* (2019).

talents to crime to gain fame and attention. Despite his exaggerated appearance—a cape and a fishbowl head—Mysterio is historically one of Marvel's most dangerous villains.

Mysterio in the MCU is particularly sinister because he represents fake news, defined as "false information or propaganda published under the guise of being authentic news" (Stroud 2021). Fake news is dangerous because it directly undercuts the trust that individuals put in the information they receive. Using advanced technology, Mysterio creates artificial threats—the Elementals—and then uses misinformation and fake news to accomplish his goals. Although Beck's stories are ludicrous, people believed them; as he notes with his dying breath, "people need to believe, and nowadays they'll believe anything."

Many viewers were quick to point out that Beck's chilling words "feel eerily appropriate for America today" (Crow, Cecchini, and Jasper 2019). We live in an era of unprecedented misinformation, mostly through fake news on the Internet. An MIT research team found that on Internet platforms such as Twitter, "it took the truth about six times as long as falsehood to reach 1,500 people" (Fox 2018). Today, false information, including "computational propaganda," "sock-puppet networks," "troll armies," and "deepfake technologies,"

can be spread through numerous channels that did not exist even five years ago. These are some of the very technologies that Mysterio and his team deploy in *Far from Home*.

Not only is there an abundance and awareness of fake news, there is also an abundance of fake news consumption. Stanford University psychologist Sam Wineburg and his team find that "Americans of all ages" often believe the information they read on the Internet without questioning it and often retweet information without any investigation (Steinmetz 2018). Worse, undoing the effects of fake news is hard, and "fact-checking can even backfire" (Ecker, Lewandowsky. and Chadwick 2020). Mysterio is a vivid representation of this dangerous side of fake news.

Mysterio demonstrates a grim version of the world where fake news is allowed to spread without control. The end result is chaos. In *Far from Home*, Mysterio fools S.H.I.E.L.D., demolishes cities with drones, and frames Spider-Man for his crimes. Not only are people put in danger, but society cannot judge between right and wrong and does not know whom to trust. The midcredits scene with the *Daily Bugle* playing a fake video of Mysterio framing Spider-Man is a direct reference to the abundance of fake news that we are exposed to everyday.

Mysterio represents the power of the media and the Internet if they fall into the wrong hands. In a poll conducted in 2019, the same year *Far from Home* was released, 95 percent of Americans were "troubled" by the current state of media, and "67% of people think journalistic ethics will be worse during the 2020 election" (Ellefson 2019). This realistic concern magnifies the menace of Mysterio in the MCU, making this fishbowl man one of the most engaging MCU antagonists yet.

Even without Mysterio, the theme of false information is woven throughout the film. When MJ questions whether Parker is Spider-Man because he appeared in Prague with the stealth Spider-Man suit, he responds, "You can't have seen me because I'm not Spider-Man. And also, on the news, it was the Night Monkey. . . . That's what it said on the news, and the news never lies" (Watts 2019).

Conclusion

The MCU's most memorable villains have often been characters that evoke our most poignant social anxieties. Vulture strikes at the deep economic inequality in the United States, Killmonger represents the pain of the Black community, Thanos embodies environmental and authoritarian concerns, and Mysterio captures the dangers of fake news. Before Phase Three, critics often

argued that the MCU focused too much on its heroes while sidelining its villains. Indeed, many Phase One and Two antagonists are one-dimensional, their backstories and motives are somewhat predictable, and their character development is brief. If you don't fondly remember Malekith, Yellowjacket, and Ivan Vanko, you may not be alone.

By representing prevalent anxieties, Phase Three villains develop unique personalities and backstories, making them just as compelling as the beloved heroes. In one recent online poll, our four villains made it to the top ten out of forty-nine villains in the MCU (Ranker Entertainment 2019).[4]

It seems that Marvel is continuing this path in Phase Four. Dreykov from *Black Widow* (2021) brings attention to human trafficking. John Walker/US Agent from *The Falcon and the Winter Soldier* (2021) reflects issues in contemporary American society, including racism and political polarization. Finally, Wenwu from *Shang-Chi and the Legend of the Ten Rings* (2021) and Ikaris from *Eternals* (2021) both continue discussions around authoritarianism after Warrior Thanos and shed further light on the harms of dysfunctional family relationships. As the MCU progresses, we may see more and more engaging villains who represent contemporary social anxieties.

Notes

1. Of course, some are more terrifying than others. For example, Thanos is a powerful warlord who has decimated half of the universe, whereas Vulture, while still dangerous, is a man without superpowers who is comparatively easier to defeat.

2. Interestingly, Warner Bros. and DC's 2018 blockbuster *Aquaman* also featured an ecowarrior antagonist, Orm/Ocean Master.

3. Of course, critics have questioned why Thanos chooses to kill half the life in the universe instead of doubling the universe's resources, placing half the population in an alternate universe, or other extraordinary solutions that would solve the problem without so much death.

4. While Loki is also consistently ranked as one of the top MCU villains, he was not selected for this analysis because he has a mostly redemptive story arc in the MCU and acts more as a neutral to heroic character than as a full-on villain. We argue that Loki, instead of representing a cultural fear, symbolizes an encouraging villain-to-hero arc, which makes him unique as a character.

PART III AN EXPANDING UNIVERSE

WRESTLING WITH POWER AND PLEASURE

Black Widow and the Warrior Women of the Marvel Cinematic Universe

Linda Beail

From her first on-screen moments as a sexy corporate assistant in *Iron Man 2* to the self-sacrificing fall to her death that allows the Avengers to restore half of humanity in *Avengers: Endgame*, Natasha Romanoff's Black Widow embodies the evolving and ambivalent gender politics of the Marvel Cinematic Universe (MCU). Together with other villain-fighting women of the MCU, the character of Black Widow demonstrates the difficulties and opportunities in imagining a superheroine for twenty-first-century audiences. These warrior women navigate the politics of motherhood, sexual objectification, intergalactic conflict, and threats of annihilation with physical prowess, impressive intellect, and supernatural powers often denied earlier iterations of "supergirl sidekicks." Yet vestiges of traditional feminine expectations and uncertainty about unleashing women's power remain. As fans of the MCU look on-screen to see how power, ambition, relationships, and identity are gendered, the heroines whom they find exploring these themes may give them imaginative new pleasure and possibilities but also reveal the limits and costs of gendered power. The gender politics of the MCU trace evolving ideas about feminine power from depictions of women's sexuality as treacherous, rooted in Cold War tropes of dangerous and deceptive spies, to intersectional explorations of gender and race, girl-power superheroines, and postfeminist recapitulation of feminine agency. Through grappling with contemporary anxieties about women and power, Black Widow and the women warriors of the MCU offer us imaginative space to explore and redefine power through a critical gendered lens.

Black Widow as a Cold War Trope

Black Widow first appears in the MCU as Natalie Rushman (played by twenty-six-year-old Scarlett Johansson), a new employee at Stark Enterprises who interrupts Tony's sparring in the boxing ring to get a fingerprint and signature regarding his turning the company over to his girlfriend and former assistant,

Pepper Potts. Tony is distracted by Rushman and can't take his eyes off her. When he asks Pepper who she is, Pepper replies tartly, "She is from legal, and she is potentially a very expensive sexual harassment lawsuit if you keep ogling her like that." He quickly pulls up photos of Rushman modeling black lingerie and shows them admiringly to Pepper. He is even more intrigued and stunned when Natalie quickly flips and pins his sparring partner to the mat.

This introduction to Black Widow sets the character up with familiar tropes. She is beautiful, meant to be not only sexually attractive but available to the male gaze. The audience is shown images of her as a model in revealing clothes and then in her superhero black catsuit—so shiny it looks like liquid poured onto her skin and so tight-fitting that Johansson famously trained for months to wear it (and could not wear anything under it while shooting). The camera lingers on her curves and full, often parted lips. Tony (and viewers) are allowed to revel in this stereotypical portrayal, which Pepper both reinforces and reprimands with her comment about sexual harassment and ogling.

Romanoff's seductiveness is a tool of deception. First, she surprises Stark with her unexpected physical strength and fighting ability. Later in the same movie, she takes out at least ten security guards at Hammer Industries in hand-to-hand combat, while Happy Hogan fights a single guard and then looks up, shocked to see the trail of bodies Black Widow has left in her wake. Her feminine beauty belies her skill at anticipating and overpowering the enemy. She is also deceiving Tony when she meets him: she is not actually corporate assistant "Natalie Rushman" but Natasha Romanoff, a KGB-trained assassin turned S.H.I.E.L.D. agent sent by Nick Fury to keep an eye on Iron Man. And Natasha Romanoff, it turns out, will be the alias for the Avenger Black Widow.

The sexy double agent—particularly a female Russian spy—has a storied history in US popular culture from the Cold War on. From Natasha Fatale (Boris's Russian-accented cartoon partner in *The Adventures of Rocky and Bullwinkle*, 1959–1964) and villainous Bond girls to contemporary movies such as 2018's *Red Sparrow*, the trope of the duplicitous temptress plays into both gendered and nationalistic anxieties regarding Western (masculine) independence, character, and strength. In 1963's thriller *From Russia with Love*, the dangers of non-Western, feminized power are represented in the characters of both Rosa Klebb (played by Lotte Lenya) and Tatyana Romanova (played by Daniela Bianchi). Klebb is James Bond's antagonist, an unattractive, middle-aged, androgynous lesbian whose name is a play on the labor organizing slogan "Bread and Roses." Her gendered presentation is used to raise political anxieties. Romanova is a young, beautiful Soviet intelligence agent used merely as bait to entrap Bond (though she ultimately switches allegiances and saves him). Similarly, a KGB agent with the double entendre code name "Triple X," Anya Amasova (played by Barbara Bach), stars as both the rival and

Natasha Romanoff embodies the long-standing trope of the sexy double agent. From *Iron Man 2* (2010).

sexual partner of special agent James Bond in *The Spy Who Loved Me* (1977). Amasova extends her character beyond eye-candy titillation, as she proves to be one of the first Bond girls capable of becoming a somewhat equal partner in outsmarting villains and solving the case—though the final shot of the movie recenters her in a sexual role.

Even in post–Cold War times, the wily Russian woman stands as a marker of she-who-cannot-be-trusted, personally and politically. In the popular television series *Alias* (2001–2006), starring Jennifer Garner as double agent Sidney Bristow, Lena Olin plays her mother, Irina Derevko, a KGB double agent who seduced and married a CIA agent in order to compromise him and conceive Sidney. Her mother's treachery haunts Sidney, shaping her own sense of identity and coming back to threaten her throughout the series. More recently, Academy Award winner Jennifer Lawrence has taken up the trope as former Russian ballerina Dominika Egorova in *Red Sparrow*. Traumatized by having been used a honey trap for a political assassination, she becomes a double agent of sexpionage, playing US and Russian intelligence officers against one another. In FX's Emmy-winning television series *The Americans* (2013–2018), Keri Russell portrays Elizabeth Jennings, the deeply embedded Soviet operative living as a suburban wife and mother outside Washington, DC. She uses sex, torture, and murder to further the cause of the USSR during the Reagan administration and is chillingly presented as more emotionless and brutal than her spy partner and husband, Phillip. BBC America's series *Killing Eve*, which began its run in 2018 and aired least four seasons through 2021, features two brilliant women who become obsessed with each other: Villanelle (Jodie Comer), a psychopathic international assassin, and Eve (Sandra Oh), an MI6 investigator trying to hunt her down.[1] As their global cat-and-mouse game evolves, viewers learn that the glamorous Villanelle (who speaks several

languages fluently and seems to have no fixed identity) is Oksana Astankova, a Russian girl from a poor family who has spent time in harsh Siberian prisons.

In all of these cases, the archetype of a particularly dangerous and deceptive Russian woman, skilled in the art of seduction, is relied on and reinscribed. As Elaine Tyler May explains in her historical analysis of gender and the Cold War, American femininity was pitted against the foil of Soviet women to shore up nationalism and patriotism (May 2017). "Our" women were sweet wives and devoted mothers, prettily wholesome while curvy and acquiescent, worth the protection of red-blooded American men, just as freedom and anticommunism were worth fighting for. On the other hand, Eastern bloc women might be drab, sexually unaccommodating "comrades" (à la Rosa Klebb), or they could be untrustworthy temptresses, intent on using their sexuality to destroy not just a man but Western democracy. It is with these cultural resonances that Natasha Romanoff as the Black Widow—a highly trained assassin from the KGB's "Red Room"—appears in the MCU to inform our imaginations as a twenty-first-century superheroine.

Superheroines, Intersectionality, and Feminist Possibility

Since 2010, when Black Widow appeared in *Iron Man 2* as one of the first and only female superheroes in the MCU, a wider array of women with special abilities has joined her. From Scarlet Witch Wanda Maximoff to Captain Marvel (headlining her own movie) to the Ancient One mentoring and matching wits with Doctor Strange to Thanos's adopted daughters and the spies and scientists of Wakanda, viewers can celebrate the diversity of different women characters who add depth and relieve Black Widow of the burden of being the token feminine-gendered Avenger. The multiplicity of characters, many of whom play key roles in the relationships and plots of the MCU instead of serving as mere sidekicks, is in itself a political phenomenon to take note of. Beyond just passing the low bar of the "Bechdel test" (requiring at least two named female characters whose action or dialogue don't revolve solely around their relationships to male characters), having multiple women protagonists allows for a greater range of portrayals of women's varied identities, interests, and points of view. Audiences no longer see a single model of ideal femininity. Instead, there is room to envision multiple life choices, personality traits, and role models without one woman having to represent, define, or "make progress" for all women. Situating Black Widow in the context of other superheroines means moving beyond tokenization or forcing her narrative arc to represent all women's choices or ideals to the audience.

Over the course of her character arc in the MCU, Black Widow moves into

a more central role in the storylines. Her quick wit, intelligence, and moral development are highlighted in addition to her physical prowess and attractiveness. She plays a key part in explicating and trying to mediate the conflict between Tony Stark and Steve Rogers in *Captain America: Civil War*, for example, and her sacrifice to obtain the Soul Stone is crucial to the success of reversing the Snap, the primary plot of *Endgame*.

While the MCU is still dominated by men (as central characters with movies named after them and as the majority of protagonists), a casual viewer or fan wondering about gender equality might be encouraged by the expanding number and range of women in the MCU. These women are not merely sexual temptresses or partners or damsels in distress to be rescued or avenged; they are brilliant scientists, wise mentors, loyal friends, and stunningly competent fighters. They are treated as equal partners with the men in battle, and the filmmakers are careful not to position them in catfights with each other. There is feminist solidarity, assistance, and role modeling. For example, in *Captain Marvel*, Dr. Wendy Lawson mentors pilot Carol Danvers (Brie Larson), and after Danvers's fate is altered by absorbing the energy from the explosion of a light-speed engine and having her memories altered by the Kree, she receives significant help from her former air force colleague Maria Rambeau in remembering her true identity and becoming Captain Marvel. (For more on *Captain Marvel*, see Kanthak in this volume.) The two women pilots recall being harassed and underestimated by male peers and how they stuck together to achieve their dreams; when Danvers must go on a dangerous space mission, it is Rambeau who accompanies her. When Rambeau hesitates, it is her young daughter, Monica, who urges her to take the risk, demanding, "What kind of example do you want to be for your daughter?"

Similarly, in *Black Panther*, extraordinary and talented Black women support and rely on one another rather than competing. King T'Challa relies on his sixteen-year-old sister, Shuri (Letitia Wright), to develop high-tech gadgets and weapons, including his Black Panther suit. Shuri is depicted as a brilliant, sarcastic scientist who irreverently teases her brother and takes charge of healing both wounded Agent Ross ("Great, another broken white boy for us to fix. This should be fun") and, later, Bucky Barnes. She is a fearless partner in a fight: she takes on Killmonger directly in her lab and turns off the vibranium current on the high-speed rail, despite the danger, in her brother's climatic fight with Killmonger. Executive producer Nate Moore characterizes Shuri as the smartest person in the world, even smarter than iconoclast inventor Tony Stark (Trumbore 2018). Shuri joins Nakia (Lupita Nyong'o), an undercover spy and former lover of T'Challa, in trying to save Wakanda from Killmonger after he challenges Black Panther for the throne. Nakia is brave, skilled, and absolutely committed to serving the oppressed. When she is introduced in the film, she is

saving trafficked girls in Nigeria (a nod to contemporary gender politics). She goes undercover with General Okeye to thwart villainous Klaue, then drives the getaway car without flinching in a fantastic car chase shootout. Nakia then leads the effort to save Wakanda by stealing the crucial last heart-shaped herb and escaping to enlist help from the Jabari. Throughout the movie, T'Challa tries to persuade her to come home and be his queen, but she repeatedly insists that she cannot stay in Wakanda, for "too many out there need my help."

The third Wakandan woman in this fierce triumvirate is General Okeye (Danai Gurira), head of the all-female military special forces Dora Milaje. She keeps Black Panther safe until his throne is usurped by Killmonger. At first she feels bound to serve whoever holds the throne. But in a scene interrogating republican virtue and political legitimacy, General Okeye soon confronts Killmonger: "Your heart is so full of hatred, you're not fit to be a king," she declares, and leads her troops against him to "serve the [true] king!" She is fearless in the ensuing battle, facing down warriors and even a charging rhino; her superior political judgment is proved correct when the rhino halts in front of her and licks her face in submission and trust as the opposing forces lay down their weapons. Critics and audiences praised the depictions of these three as inspiring and empowering representations of Black women, not subservient to male characters or pitted against one another (e.g., Danielle 2008; Bahr 2018).

And through these narratives, audiences also see a portrayal of Black masculinity that respects and trusts these strong women without feeling threatened or jealous of their abilities and ambition.[2] T'Challa and his friends rely on them as equal partners in intelligence, strength, and loyalty to their country. At the end of the film, King T'Challa assumes his rightful place as head of Wakanda while sincerely thanking Nakia for saving him, his family, and his nation. Yet again, he asks her to stay with him—but this time, he has figured out a way for her to still fulfill her calling as well as being his partner. He plans to open the first Wakanda Global Outreach Center in Oakland and asks her to be in charge of social outreach and sharing their homeland's rich resources with a Black community under stress. Nakia does not have to choose love over ambition. In recognizing both, and not undermining her professional gifts and calling, T'Challa solves both his personal problem and a central political dilemma of the film, the question of whether Wakanda should share its wealth, technology and values with the wider world. The Black Panther finds his ideal romantic partner without forcing her to sacrifice her dreams to his, and the film rejects a masculine notion of power as zero-sum competition, instead embracing a feminist notion of power as creative and constitutive.

Captain Marvel explicitly takes on issues of gendered power. The film frames Carol Danvers's experience as a warrior in terms of the classic dualistic conflict between masculine reason and feminine emotion. In the opening scene, her

(male) Kree Starforce commander, Yon-Rogg, is training her to fight. He warns her, "Nothing is more dangerous to a warrior than emotion" and tells her to stop using her heart and start using her head instead. "You struggle with your emotions and your past, which fuels them," Yon-Rogg says, noting that she should stop trying to recover her blacked-out memories and use her blank past as freedom to serve the greater good of the Kree people. Fragments of memory continue to haunt Vers, however. The memories that surface are mainly of sexist treatment, such as when she crashed her go-kart as a girl because boys ran her off the racetrack, followed by her father telling her she didn't belong there, and of air force training, when her male peers sneered at her that she would never be allowed to fly and joked, "You do know why they call it a cockpit, don't you, honey?"

Throughout the narrative, Carol Danvers is consistently underestimated as a girl in a man's world. As the petite blonde navigates Earth, a biker catcalls her, telling her to "Smile, baby." She promptly steals his motorcycle and rides off to continue her mission. She manages to smuggle the Tesseract out from under the noses of Kree operatives by hiding it in a child's lunchbox, which they mock her for having. Yon-Rogg constantly erodes her confidence in her own judgment, reminding her to "know your enemy. It could be you" and that she cannot trust her emotions or memories. When Agent Coulson goes against protocol to help Nick Fury and Carol Danvers escape from government agents trying to arrest them, Nick notes that Coulson (rightly) "went with his gut against his training. That's hard to do." Danvers remarks wonderingly, "*I get in trouble for that.*"

Patriarchy, and not just the horrifying Kree genocide of the Skrull people, is a real enemy in the film. It not only wants Danvers's mind (wiping out her memories and confidence) but also tries to take her body—literally, as Yon-Rogg reveals that it is *his* blue Kree blood flowing through her veins thanks to a transfusion. A feminist sisterhood helps to restore her. First, her mentor, Dr. Wendy Lawson (actually Mar-Vell, a subversive Kree scientist), is key in encouraging her flight ambitions and helping her gain her supernatural powers and realize the truth about unjust Kree persecution of Skrull refugees. Lawson appears to Danvers as the Supreme Intelligence, a manifestation of whom/what Danvers trusts the most. She is also a role model for Danvers in turning her back on fighting for the Kree and instead using her gifts (as a scientist inventing hyperspace technology) to help innocent Skrull escape genocide.[3] Another member of this sisterhood is her longtime air force friend, Maria Rambeau. When Danvers hesitates in the face of the climatic, dangerous mission, Rambeau reminds her who she truly is: "You are Carol Danvers. You were the most powerful person I knew—*before* the shooting hands" and superpowers. Rambeau affirms Danvers as smart, funny, willing to risk her life to do the right

thing, and in solidarity with other women: "You believed in me as a mom and a pilot when no one else did." It is Danvers's authentic, feminist self that grounds her as powerful. The explosion and absorption of hyperspace energy add a new dimension, but neither the accident nor Kree brainwashing have created or determined who she is and what she is capable of.

Carol Danvers becomes Captain Marvel and defeats the Kree invasion only after a montage of her earlier memories of sexism plays out fully in her head. "It's *cute* how hard you're trying, but remember," the Kree Supreme Intelligence voice-over mocks her, "without us, you're weak, flawed, helpless. We saved you. Without us, you're only human." She recalls being pushed down onto the sand by boys at the beach, forced off the road when leading the go-kart race, having a boy baseball pitcher nearly bean her in the head and knock her down, and falling from a military ropes course while hearing male laughter and men saying, "You don't belong here."

"You're right," Danvers says slowly. "I'm only human." But now the montage reel continues each scene, showing a younger Carol in slow motion, picking herself up off the ground at the beach, go-kart crash, baseball field, and ropes course with steely determination in her eyes. She refuses both patriarchal limits and Kree mind control. The Supreme Intelligence asserts that with the Kree, she was reborn as Starforce officer Vers. "My name," she retorts through gritted teeth, "is Carol." Noting that she's been fighting with one arm tied behind her back (mistrusting emotion while relying only on reason instead of using both), she wonders, "What happens when I'm set free?" With that, Captain Marvel breaks out of Kree mind control and bursts forth into battle as No Doubt's 1995 sarcastic feminist anthem "I'm Just a Girl" blasts from the soundtrack. As her body itself becomes a powerful, glowing, flying weapon, she pushes back a phallic ballistic warhead before it can hit Earth, forcing the Kree to retreat. One final confrontation, with Yon-Rogg, remains. He mansplains her abilities and taunts her for her emotions, yelling at her to prove that she can beat him. She rejects the challenge to compete on his terms, blasting him into a nearby mountain and then calmly replying, "I have nothing to prove to you."

Postfeminism and Anxieties about Feminine Power

Despite this pleasurable girl-power celebration, a closer examination of Black Widow, Captain Marvel and other women warriors of the MCU reveals a complex relationship to gender politics. While Natasha Romanoff becomes more multifaceted than her "sex siren" introduction, she never loses her catsuit-clad figure and sultry good looks, often played up by camera angles and close-ups. There is feminist pleasure in watching powerful women, not in need of male

protection but saving the world themselves. Yet there is also anxiety and even undermining of this gendered power in negotiating and reinscribing sexist stereotypes. In some ways, the women of the MCU embody the familiar politics of "postfeminism," as defined by theorist Angela McRobbie as a "double entanglement" that both takes feminism for granted (*Of course women are equal! Sexism is silly and misguided*) and simultaneously discredits and repudiates it (*We don't need feminism anymore—it's outdated, ugly, and humorless! It's much more fun to be a cool girl*). "Postfeminism positively draws on and invokes feminism as that which can be taken into account, to suggest that equality is achieved, in order to install a whole repertoire of meanings which emphasize that it is no longer needed, it is a spent force," McRobbie (2009, 12) notes. Postfeminism centers on women as powerful neoliberal subjects with the freedom and capability to study, work, and consume whatever they choose, thanks to earlier feminist political activism that is no longer necessary or acknowledged.

Some hallmarks of postfeminism are a reclaiming of "traditional" femininity and beauty culture (often in internalized or ironic but patriarchy-reinforcing ways) and an engagement with popular culture as the key site of gender politics (see Tasker and Negra 2007; Gill and Scharff 2013). There is also a focus on girls and girlhood, full of potential and individual promise, as opposed to women and women's movements. Temporal anxiety about aging posits women as girlish and focuses attention on young women as "can-do" subjects who don't need social support systems, public policy guaranteeing equality, or political movements such as feminism (Negra 2009; Projansky 2014). While some theorists worry that the focus on girls leads to early hypersexualization (Jackson and Vares 2011), this temporal shift can also have the effect of avoiding the fraught politics of sexual objectification, harassment, and assault. Exploration of postfeminism in tween television, for example, shows a taste for heteronormative romance while avoiding explicit sexualization of girls—allowing a wide audience, of both young people and parents, to feel good about the protofeminist messages of empowerment and safety (Beail and Lupo 2018).

These elements are often present in *Captain Marvel* and the wider MCU. Carol Danvers is presented as girlish in appearance and interests, and popular culture is constantly cross-referenced. She wears band t-shirts, shifting from male grunge and rock to the classic female-led band *Heart* after reasserting her confidence and power. She reclaims fashion culture as potentially feminist, gleefully collaborating with Maria's young daughter, Monica, in choosing colors and style for her superhero attire. Her narrative arc could be read as a crisis of (girlish) confidence rather than of systemic barriers to women's power. Digging deep for individual resilience and belief in herself, she vanquishes those who doubt her.

Captain Marvel—like the androgynous Ancient One (Tilda Swinton) in

Doctor Strange—is presented without sexual tension; other MCU heroines, such as Black Widow and Scarlet Witch Wanda Maximoff, are given hinted-at sweet romances, with playful banter and little physical interaction, that resemble girlish crushes more than adult sexual partnerships or fully developed relationships. The explicit "girl power" of the MCU glosses over the fact that these superheroines must still conform to fairly conventional Western ideals of feminine beauty, while the audience is allowed to consume them visually. Consider the savvy but unsettling ways in which Black Widow deploys her sexuality. No longer merely bait for the honey trap, she is in control, kissing a bewildered Steve Rogers on an escalator to escape detection by Hydra agents, but she is also still the object of the cinematic male gaze in the dramatic fight scenes. Black Widow demands our respect for her ability to jump, kick, stun, and physically overwhelm her enemies—but she also still draws our attention to her seductive costume and conventional sexual attractiveness. Indeed, much has been made in the press of Scarlett Johansson's body and the intense physical training and time-restricted eating regimen she undertook because of her concern with "performance and the fit of the suit," underscoring the postfeminist conception of the self as a project to be worked on, surveilled, and maintained (Romeyn 2019). The visual imperatives of cinema (and comics) lead toward aesthetic pleasure in commodifying and consuming beautiful, strong bodies. But we should not confuse that pleasure with feminist action.

Ambivalence and anxiety about gendered power arise in other ways in the MCU. Motherhood is a central facet of many women's off-screen lives and has been an expectation for women written into legal decisions, public policy, and workplace norms. On the one hand, feminists have fought long and hard against conflating women solely with motherhood and in favor of expanding the boundaries of women's opportunities beyond hearth and home, and the MCU seems to support those increasing possibilities. None of the superhero women discussed here have children or are defined by domestic responsibilities. They offer imaginative roles to women as scientists, warriors, spies, and adventurers—risk-takers who are physically and mentally tough, who wield power as well as the men. In a twenty-first-century world, in which family structures are multiplying to look far different in many cases than a heterosexual married couple with three kids and a station wagon, the MCU also supports the possibility of diverse and chosen families (as Danielle Hanley elaborates on in this volume in her chapter on the politics of family, "Avengers, Assemblage"). The team of Avengers is explicitly spoken of by Black Widow as family that she has found, even as her upcoming self-titled film hints at family relationships between the other "sisters" of her Red Room training. Her relationship to Clint "Hawkeye" Barton, her erstwhile foe, who brings her into the Avengers, resembles that of a sibling, and she is "Auntie Nat" to his children. He intends to

name his youngest child after Natasha (though the name is tweaked to Nathaniel when the baby is a son). The obvious constructedness of family ties offers imaginative space for audiences to think beyond "compulsory heterosexuality" and marriage/motherhood as women's natural or sole destiny (Rich 1980).

There is tension in this stance, however: the KGB forced Black Widow to undergo surgical sterilization as part of her "graduation" from the Red Room training as an assassin so that pregnancy and motherhood could not distract from her mission. Natasha is "freed" from the reproductive burdens that have often been used to justify the exclusion of women from pursuing their ambitions or fully serving in combat or political roles but also denied the possibility of mothering. When she and Bruce Banner consider deepening their romance, he worries that his identity as the vengeful Hulk would preclude him from a normal relationship, especially from having children. Natasha regretfully explains that she also cannot bear children, and this fact seems to make both of them feel monstrous. Is Black Widow's infertility tragic because it was forced upon her or because the notion of a woman who cannot fulfill this biological and sentimental function is unnatural and unwomanly? Motherhood is valorized by other characters in the MCU. Tony Stark has multiple flashbacks to his childhood over the course of the films, through which he learns about his father's greed, dishonesty, and hypocrisy. However, his mother, Maria, remains pure, long-suffering, and adored by her son. At the climax of *Civil War*, Iron Man cannot forgive Captain America; not because of their rift over the Sokovia Accords but for remaining loyal to Cap's old friend, Bucky Barnes. "He killed my *mom*," Tony Stark wails. Filial devotion trumps even the Avengers' bond.

Another anxiety about gendered power that bubbles up from beneath the surface of the MCU is just how costly that power is to the women who access it. In most cases, these superheroines have suffered severe trauma. KGB agent Elizabeth Jennings in *The Americans* and Dominika Egorova in *Red Sparrow* are both shown to have been raped as part of their training; dark references to Black Widow's Red Room training (and forced sterilization) hint that sexual abuse could be part of her backstory as well.[4] Mind control is another trauma that Black Widow and Captain Marvel suffer. Jessica Jones survives mind control and sexual abuse at the hands of Kilgrave and continues to struggle with PTSD. Both Gamora and Wanda Maximoff witness the murders of their parents (and Gamora is fated to be killed by her adoptive father, Thanos, while Wanda is forced to destroy her true love, Vision, and then watch him be killed a second time after Thanos uses the Time Stone to undo her sacrifice). While men experience strange events or physical injuries (such as Tony Stark's in a terrorist ambush or Doctor Strange's car accident) that trigger their superpowers, they typically are not harmed by an intimate or experience this level of psychological trauma. MCU superheroines are impressive—but their awe-inspiring

skills and power come at a uniquely high personal cost, as Szekely details in her chapter "Female Combatants in the MCU" in this volume.

There is also anxiety about feminine ambition. The stories of superheroes such as Iron Man and Captain America are told in a fairly linear fashion, explaining how they came into their powers and the progression of conflicts they face. But women such as Black Widow, Captain Marvel, and Jessica Jones are often mysteries—to the audience and to themselves. The structure of the narrative evades and obfuscates their purpose and power as viewers gradually discover who these heroines are in indirect and nonlinear ways. Some of them, such as Carol Danvers and Jessica Jones, struggle with memories, not knowing who they are or what they are capable of. Others, such as Black Widow, have their stories told in disconnected flashbacks. This gender difference in narrative structure implies that women can't claim their stories, power, or ambition straightforwardly. Women in US electoral politics often soften their tone, claiming that luck or altruism has led them to public office rather than direct pursuit of leadership. The women of the MCU also seem to be framed less with agency and more with narratives of power that happen *to* them, unknowingly or out of their control.

Redefining Power through Gendered Imagination

Accompanying traditional/masculine notions of political power are often traits such as dominance, control, and pride. A central theme that reverberates across the MCU is the danger of hubris, certainty, and selfishness. Over and over again, the politics of isolation, totalitarianism, and technology-as-savior are rejected in favor of generosity and human freedom, even at the risk of finitude and failure. Thanos has a vision of saving humanity from environmental disaster and extinction but annihilates billions of people to do so. Similarly, Ultron will not be deterred from ending warfare and bringing about world peace, even if he has to kill all humans to do it. Hydra was founded on the belief that humanity could not be trusted with its own freedom. The Avengers must repeatedly beat back these threats, and women warriors embody an alternative perspective on power. Women characters caution against ego (the Ancient One in *Doctor Strange*) and selfishness (Nakia in *Black Panther*), reject certainty and see multiple perspectives (Black Widow in *Civil War*), and are open to changing their minds or changing sides (Wanda Maximoff in *Avengers: Age of Ultron* and Black Widow in *Civil War*). It is Black Widow who nurtures and sustains the political community of the Avengers after the devastation of the Snap and who sacrifices her life (as does Tony Stark, ultimately) in *Endgame*. Women of

the MCU enact a vision of power that is more limited, more relational, more risky, and more humane.

In *Black Panther*, T'Chaka and T'Challa resist sharing Wakanda's technology and resources with the world, fearing that doing so will weaken and dilute their strong and vibrant community. While the film rejects the deceptive, violent, and usurping tactics of N'Jobo and his son N'Jadaka (Killmonger) in wresting control of Wakandan resources on behalf of oppressed Black communities worldwide, it uses Nakia to voice a more generous perspective. She rejects the zero-sum choice of Wakandan security versus global justice and decolonization: "We are strong enough to share *and* protect ourselves." In the end, chastened by the perspective of N'Jadaka on the legacy of slavery and colonization, King T'Challa adopts Nakia's view as well, opening the first Wakandan Global Outreach Center in Oakland and sharing his homeland's resources without diminishing its strength.

Similarly, the Ancient One cautions arrogant neurosurgeon Stephen Strange to silence his ego and let go of the delusion of control. To access the power of sorcery and heal after a debilitating accident, she advises him, "You cannot beat a river into submission. You have to surrender to its current and use its power as your own." There are both echoes and refutations of Machiavellian political theory here: Machiavelli compares Fortuna to both a river and a woman but urges the Prince to try to master and control Fortune for political success. The more feminine wisdom of the Ancient One, in contrast, gently exhorts Doctor Strange to accept limits and sacrifice on behalf of others. She teaches him the most significant lesson of all, "It's not about *you*," and encourages him to sacrifice healing his own nerve-damaged hands and resuming his career in order to serve something greater than himself. However, the Ancient One is not a blameless font of selfless, feminine wisdom; she has her own demons to live with, as Doctor Strange learns, and draws some of her power from the Dark Dimension. This paradox seems like hypocrisy to Strange. She is willing to accept and embody that ambivalence, just as she acknowledges that finitude and death are what give our short lives meaning.[5] By the end of the film, he has mourned her death and accepted the costs and responsibilities of his great sorcery gifts, standing guard at the window of the New York Sanctum with trembling hands.

As Vision articulates in *Age of Ultron*, order is not the opposite of chaos, and a thing is not beautiful because it lasts forever. Humans may be doomed by their own violence and imperfection, but there is beauty and good in them despite their flaws—indeed, the good is perhaps all the more precious because of its fragile and contingent nature. Hannah Arendt elucidates a similar point about politics, noting that it is the most noble and demanding sphere of human

endeavor. The stakes are high, and the risks of failure are great—but so are the possibilities for exceeding our instinctive selfishness and building character and virtue as we serve a community greater than ourselves with generosity of spirit. The glory and significance of politics, and of life, are due to (and not despite) the very real and bittersweet possibility of tragedy. In their certainty that order, stability, and security are greater goods than trusting fallible humans with freedom, Hydra, Ultron, and Thanos all in various ways invite horror and destruction. The totalitarianism that Arendt warns about is the perfect—and perfectly awful—vision that the Avengers repeatedly oppose and that the female characters of the MCU in particular offer some possibilities of reimagining (Arendt 1973).

This dilemma is even interrogated from within the Avengers. Tony Stark's arrogance has wreaked havoc (in his creation of Ultron and all the violence and deaths that ensued), so he tries to solve the problem of public mistrust (and, self-servingly, repair his relationship with Pepper Potts) with the imposition of the Sokovia Accords, which limit the Avengers' power. Captain America refuses to sign, arguing for the risk and responsibility of keeping the freedom to act in their own hands and leading to the "civil war" between factions of the Avengers. The impasse is summed up by Peter Parker (to Captain America but applying to both): "You're wrong. You think you're right. That makes you dangerous."

Black Widow is the key figure mediating between these two positions and offering a different definition of power—one that is more humble, more limited, and more attentive to multiple subjectivities. She reluctantly sides with Iron Man in agreeing to sign the accords but then immediately joins Captain America at Peggy Carter's funeral to comfort him. Surprised, he reminds her that he can't sign. "I know," Black Widow replies. "I didn't want you to be alone." Natasha values relationship over abstract ideals. She tries to remind Steve that even if he disagrees with other Avengers, "staying together is more important than *how* we stay together." Later, in the group battle at the airport, Black Widow seems to switch sides, zapping her colleague Black Panther in order to let Captain America and Bucky escape. Tony Stark exasperatedly asks her if she just can't stop being a double agent. Indeed, one way to read her narrative might be to see her as unprincipled, whipsawed by her emotions and incapable of moral clarity: the embodiment of inferior feminine power, the weaker, wilier sex. Yet it may be more accurate and convincing to see her in light of what international relations scholar Sara Ruddick calls "maternal thinking," learned from the material experience of parenting children. This conception of power recognizes the autonomy of the child as well as the mother and respects the relationship between them. It requires attentive love and responsiveness to particularities, nurturing growth without demanding top-down control (Ruddick

1989). In the way that Black Widow can see the validity of multiple perspectives and care for the personhood of those she disagrees with, without forcing one to simply submit to the other, she models a more feminist, restrained, constitutive form of power that ultimately works better in the MCU. Masculine certainty proves to be dangerous and destructive. Again and again, humans are shown to be flawed and finite, but trusting them with freedom and responsibility is preferred to extinction and totalitarian control.

Black Widow's narrative arc ends with her sacrificial death in *Endgame*, part of the Time Heist attempt to undo the Snap. Gender anxieties complicate how to read this. On the one hand, her death prefigures Tony Stark's death at the climax of the movie and is given far less attention by her colleagues, who assemble one last time at his funeral. Is she pushed somewhat to the margins because, yet again, a male protagonist's (similar) fate carries more narrative weight? Black Widow and Hawkeye approach Vormir to retrieve the Soul Stone together and debate which of them should give their life for the other. Is there some sort of poetic justice in Natasha dying because she is a woman—a maternal figure who has held the Avengers together after the devastation of the Snap—or more selfless in her femininity? While it might make more sense to expect Hawkeye to give his life, the traditional valiant warrior willing to sacrifice everything for republican honor, some viewers might see Black Widow as more expendable: Clint Barton has a wife and children to return to, while Natasha Romanoff does not. Is she a self-sacrificing mother figure because of her gender? Or is she less valuable because she is a "deficient" single woman without children?

Perhaps neither is the best interpretation. Arguing with Clint about their fates, she reminds him that everything in the past five years has been about getting "here," to this moment, and the chance to restore everyone lost in the Snap. Her argument is not framed as "You're worth more; you have kids" but rather "I have led the effort to get to this goal; now let me lead in helping to accomplish it." Clint counters that she knows how vile and murderous he's become since losing his family in the Snap, so he deserves to die. "I don't judge people on their worst mistakes," she replies softly. "You didn't." She seems to imply that she deserved to die for her assassin deeds during her KGB days, but when he was sent to kill her in Budapest, he saved her life and turned her to the Avengers. The moment of acceptance and understanding that passes between them after this exchange is evidence that Black Widow has changed and grown from her earlier days of simply trying to pay her moral debts, to "get the red off her ledger." She has experienced redemption and transformation, no longer trying to prove her worth or to belong. Black Widow sacrifices her life from a position of strength, not weakness—generosity, not indebtedness. She is a fully realized, multidimensional person exercising power and agency, not

merely "the girl" trying to earn her place. In accepting her own moral ambiguities and paradoxes, and essentially rejecting dualisms—and allowing us wrestle with the pleasures and anxieties of gendered power in all its complexity, which is much more of an intersectional feminist move—she is a superheroine for our time.

Notes

The author would like to thank Joshua Beail, Arden Martinez, Rachel Maxfield, Abbey Swaim, and Hannah Wald for their encouragement, insights, and assistance with this project.

1. *Killing Eve* has been both a ratings and critical success, garnering an Emmy award for Jodie Comer and both a Golden Globe and Screen Actors Guild Award for Sandra Oh as well as Emmy nominations for its first-season writer, Phoebe Waller-Bridge, and for Outstanding Drama Series in 2019.

2. For an explanation of how extraordinary and important this is, see Cooper (2018).

3. It is this resonance—of both claiming one's true identity (in this case not "Wendy Lawson" but "Mar-Vell" from Hala) and exceeding it (being willing to turn against tradition and loyalty to her own Kree in fighting unjust wars toward a higher good of saving innocent people)—that is evoked when Carol Danvers takes her mentor's name as her superheroine moniker, Captain Marvel. She is paying homage to Mar-Vell's moral courage and clarity and to the value of claiming your own authentic identity (not whom patriarchy tries to construct you to be).

4. The use of rape so consistently and casually in depictions of Russian agents has political implications in a context of East-West conflict. "Those" women are not protected the way American women are. It discredits their political system, communicating how disposable human dignity and freedom are. It dehumanizes these women, who are seen as both corrupted and corrupting. And it devalues Soviet men, who are depicted as abusive and immoral. It is also an example of "fridging," a superhero comic book trope in which female characters are injured, raped, killed, or disempowered as a plot device, usually to move male characters' narratives forward. Feminist comic fans, including writer Gail Simone, began naming and resisting this trope in 1999 on the website "Women in Refrigerators" (https://www.lby3.com/wir/index.html).

5. There is some extratextual ambivalence and controversy around Tilda Swinton's portrayal of the Ancient One as well. The character, an Asian man in the Marvel comic books, is transformed into a somewhat androgynous Celtic woman for the film, ostensibly to avoid the racially problematic "Fu Manchu" stereotypes perpetuated in the comics. Criticism of the filmmakers and Swinton for whitewashing the character and denying an Asian actor a central role in the MCU erupted in a publicized online dispute between Asian American actor Margaret Cho and Tilda Swinton. See Healy (2016).

FROM "GRRRL POWER" TO "SHE'S GOT HELP"

Captain Marvel as the Superhero of Second-Wave Feminism

Kristin Kanthak

When Captain Marvel crash-lands into a Blockbuster Video on Earth in 1995, the Avengers are not yet even a twinkle in Nick Fury's eye. A preteen Natasha Romanoff is still in Russia, training to be a KGB assassin. Captain America will be on ice for another fifteen years. Spider-Man isn't even born yet, and party boy Tony Stark is likely off somewhere drunkenly stumbling into the wrong house (Associated Press 1996).

In the real world, at the same time, the feminist movement was at something of a crossroads. "The feminist movement" has never been just one thing, either in the United States or globally. Rather, the term has come in and out of vogue since its inception in the United States in the 1910s (Cott 1987) and has held various meanings since that time, often concurrently carrying several different meanings for different people (Schuller 2021). Most important to our current discussion, one of the main areas of disagreement has been around how to address the fact that most women are physically and culturally weaker than most men. Too little focus means a feminism that ignores the very real power differentials that affect women's lives. Too much focus means a feminism that paints women solely as victims, a portrait that is as unrealistic as it is depressing.

It is telling, then, that Captain Marvel drops into that Blockbuster Video at a time when this discussion has reached an apex, with writers such as Naomi Wolf and Katie Roiphe distinguishing themselves from what they considered the "victim feminism" of earlier second-wave feminists such as Catharine MacKinnon, Germaine Greer, and Betty Friedan. Indeed, it was a debate that moved from college campuses to pop culture, with, for example, Christina Hoff Sommers fretting over who "stole" feminism in a *New York Times* best seller and even the Spice Girls about to climb the charts with a co-opted version of Riot Grrrl Kathleen Hanna's "Girl Power" concept for their own bubblegummy brand of female empowerment. Although Captain Marvel herself does not take a position on 1990s-era feminist clashes, the film provides a fresh take on

them, both repudiating the shortsighted "power feminism" of the 1980s and 1990s and providing a lens through which to better understand the contributions made by second-wave feminists to our understanding of how our societal rules—most notably our conception of power—are tied into our understanding of how gender operates.

In this chapter, I argue that the Captain Marvel character demonstrates how second-wave feminist concepts might be resurrected for pop cultural consumption and that doing so might benefit society in general. Rather than thinking about Captain Marvel as a flawed power feminist, we may think of her as actively renouncing power feminism and instead standing as a conduit through which to understand some of the more complex concepts that second-wave feminism was trying to get across. (For another take on *Captain Marvel* that situates the film in the larger MCU gender narrative, see Beail's chapter in this volume.)

To be clear, this chapter makes no claim that Marvel Studios engaged in a deliberate reclamation and rehabilitation of second-wave feminism for popular culture. Indeed, we must necessarily question the feminist bona fides of any organization that would do Natasha Romanoff as dirty as Marvel did when it failed to give the most loyal and steadfast of the Avengers any sort of funeral, in dramatic contrast to the cryfest and practical lying-in-state at Avengers headquarters that Tony Stark's demise prompted. Rather, the argument presented here is that Captain Marvel stands as a hero who makes a poor "girl power" trope but is actually better understood as an icon of second-wave feminism concepts such as loyalty to one's foremothers, the oppressive operation of a self-reinforcing standard of behavior, and the ethic of care. Furthermore, seeing Captain Marvel through this lens proves Zeisler's (2016) point that many of the most complex concepts of second-wave feminism can, in fact, stand up to "pop culture" treatment, a status that had previously been the milieu of "girl power" feminism alone.

I next provide a (very short) primer on the history of the waves of feminist thought that does not attempt to be complete but focuses instead on the aspects of feminism most closely tied to the argument I make in the remainder of this essay. I then explore how the Captain Marvel character, despite being the most physically powerful being in the universe, eschews the commodified, patriarchal message of "girl power" in favor of a different form of power—a feminism based in the ethic of care—that relies on relationships rather than brute force. Indeed, the heavy marketing of "girl power" cultural tropes has insinuated itself into the modern popular understanding of feminism to such an extent that Captain Marvel's revolutionary feminist recontextualizing of what power means makes her vulnerable to critiques from girl-power acolytes that she is—of all things—antifeminist.

Feminism's "Waves"

Understanding how Captain Marvel fits into the "waves" of feminism requires a brief primer on those waves and how they interconnect. It is important to note that each wave was defined by the subsequent wave, with each new wave trying to draw connections and distinctions to the past.

First-wave feminism centered on legal rights for women, most particularly the right to vote. One of the defining events of first-wave feminism was the 1848 Seneca Falls Convention, a meeting of women's rights activists that culminated in the publication of the Declaration of Sentiments, which called for, among other things, women to have the right to own property, to be educated, and to vote.

Women associated with that movement at the time did not think of themselves as feminists, and indeed many of the women who worked hard to gain women's legal rights did not actually think in terms of equality of the sexes (Cott 1987). Rather, their job centered on changing laws to create a legal status for women that did not yet exist. According to second-wave feminist Betty Friedan, "They had to prove that women were human" (Friedan 1963, 81). Much of the wind left the sails of the burgeoning women's rights movement when the Nineteenth Amendment to the US Constitution passed, securing the vote for women while still leaving most issues related to equality—indeed, even the franchise for all but white women—unaddressed (Cott 1987).

The beginning of *second-wave feminism* is often dated to the 1963 publication of Betty Friedan's *The Feminine Mystique*. The book posits that there is a "feminine mystique" in that societal pressures constrain women to adhere to a norm of femininity that prevents them from having a life outside care for their home, their personal physical attractiveness, and their family. The feminine mystique "says that the highest value and the only commitment for women is the fulfillment of their own femininity" and that any unhappiness women may feel is due to their unwillingness to accept the value of their own natural femininity: "The root of women's troubles in the past is that women envied men, women tried to be like men, instead of accepting their own nature, which can find fulfillment only in sexual passivity, male domination, and nurturing maternal love" (Friedan 1963, 43). Women had a role to play in society that was vital to supporting consumerism and the dream of the perfect suburban lifestyle, but playing that role required them to be completely alienated from their own sexuality, and indeed their own identities, to such an extent that they were rendered, in the words of Greer (2009), eunuchs.

Feminism, then, was about understanding that this feminine mystique was a trap. To be free, women needed to engage in consciousness-raising, or "profound personal transformation" (Bartky 1990, 11), that altered forever how

women saw themselves and their places in society. Because it was designed by men, the current conception of civil society could do nothing but perpetuate the domination of women by men (Pateman 1988). This system of male supremacy is self-reinforcing because women are by definition bound to subordination to more powerful men (MacKinnon 1987). Society, then, pressures women to limit the amount of space their bodies take up (Young 1980) and to change the appearance of their bodies to avoid upsetting the physical aspect of the dominance men enjoy (Bordo 2003; Bartky 1990) and/or to meet unrealistic expectations for attractiveness (Wolf 2009).

An implication of this conception of gender relations calls into question the entire concept of consent: if men perpetually dominate women, then a woman's ability to say "no"—to intimacy, to work, to sex, and so on—is not only infringed but completely erased (MacKinnon 1987). In this sense, marriage is an institution created to maintain male supremacy, and prostitution (Pateman 1988) and pornography (MacKinnon 1987) can never be understood to be truly consensual. And to Bartky (1990), feminine consciousness is, by definition, consciousness of one's own victimization alongside awareness of how that shared victimization creates a sense of solidarity among feminists.

Understanding *third-wave feminism* requires making a distinction between two separate threads of feminist thought, both of which position themselves as critiques of second-wave feminist thinkers. On the one hand, some feminist critiques pointed out that second-wave feminism tended to center the experiences of white, upper-class women. Indeed, Friedan's central work sets out the problem of the feminine mystique as one of women who would be more fulfilled if they could have a life, experiences, and accomplishments outside the home and distinct from their status as housewives. Furthermore, many relatively wealthy white women resisted making room for the experiences of poor women and/or women of color for fear that doing so would decenter their own experiences (hooks 2000). But certainly, connecting race, poverty, ability, and other issues to gender became much more central to feminism in the third wave, most directly with Crenshaw's discussion of how gender and race intersect for Black women in a way that goes beyond the experiences of Black men or white women (Crenshaw 1991).

The feminine mystique also did not speak to the difficulties of women whose circumstances required them to work outside the home, again because the women who led the second wave tended to be white, well educated, and largely middle class. Friedan's housewife was unfulfilled and being prevented from taking an exciting job, a proposition that held little sway with suburban housewives who equated the working world with the backbreaking lives of their working-class mothers—the lives they had moved to the suburbs to escape. To them, working was not a means to freedom but rather a prison,

leading them to turn away from feminism and toward conservative political action, including the prolife movement (Taranto 2017).

At the same time, a number of third-wave thinkers pushed back against what they called the "victim feminism" (Wolf 1993) of the second-wave feminists who argued that feminism required women to become conscious of how society had imprisoned them because of their gender. These so-called "rape crisis feminists" (Roiphe 1994), they argued, focused on the victimhood of women rather than on their power and undeservedly placed all men in the role of oppressor (Sommers 1995). Adherents of this feel-good, pop culture version of feminism therefore failed to engage second-wave feminists' critiques of the systemic failures of patriarchy while at the same time ignoring the existence of their intersectional contemporaries. Indeed, some of this backlash against what Zeisler (2016) calls "straw feminist" versions of the arguments of Mac-Kinnon and others regarding sex and consent, particularly calls to illegalize pornography, led to the creation of a "sex-positive feminism" that centered women having their own autonomous preferences over their sexuality (Glick 2000).

The thinkers of second-wave feminism—much like the first-wave feminist suffragists and temperance advocates prior to their historical rehabilitation by second-wave feminists—then found themselves unfairly cast as angry, man-hating killjoys. The nuance in their arguments was simply ignored, and second-wave feminists were caricaturized as humorless harridans who hated the self-defined "super-fun sex objects" (Zeisler 2016, 152) of the "postfeminist" movement. This dichotomy, as McRobbie (2009) points out, urges young, wealthy Western women to embrace (and commodify) their own sexualities in a way that feels like empowerment but instead acts largely to disconnect them from women whose circumstances differ, relegating the "other" to the role of victim as part of one's own self-actualization. Consciousness takes work and requires one to question the status quo in a way that can feel oppressive and might require the painful examination of one's own privilege. Postfeminists, though, just want you to have FUN.

And, as Zeisler (2016) points out, if feminist demands for equity aren't FUN, consumer products such as underpants with the word "feminist" emblazoned on the butt certainly are. FUN, it turns out, costs money. "The fight for gender equality has transmogrified from a collective goal to a consumer brand," Zeisler (2016, 11) argues in her discussion of what she calls "marketplace feminism." Much as Friedan teaches us that the feminine mystique was largely about selling laundry soap, Zeisler explains that this new, FUN feminism also has at its center the desire to sell consumer goods, from "This is what a feminist looks like" baby-doll tees to Bic for Her pens.

This consumerist backlash against the so-called victim feminism of the second wave centers on what Caputi (2013) calls "power feminism," thus bringing

the concept of "girl power" into the lexicon and into our shopping carts. "Girl power feminism" has at its core an animosity toward the second wave of feminism that came before it since it served as a response to what girl-power feminists felt was a movement to force them into an "oppressed" status with which they did not feel comfortable. But as Caputi point outs, this power feminism assumes that having power over others is the only way to conceive of power, a process that involves "reproducing the logic of American rugged individualism and valorizing masculinist norms" (Caputi 2013). And all this matters because Captain Marvel takes place at the height of the inherently interconnected popular culture conceptions of "power" and "marketplace" feminism.

So What Does All This Have to Do with Captain Marvel?

While the *Captain Marvel* film fits the definition of several genres, among those genres is obviously the period piece. The film includes a number of historical references to the 1990s, including its music (with tunes from Nirvana, Garbage, and intelligible-era R.E.M.), costuming (Carol is instructed to "lose" the flannel shirt she has jauntily secured around her waist, 1990s style), and even its obligatory Stan Lee cameo (in his last cameo appearance before his death, Stan Lee sits on the LA Metro train, reading the script that contains his cameo in the 1995 Kevin Smith film *Mallrats*). What is notable about this period in particular is its placement directly in the center of third-wave feminism. The action on Earth is situated at a point when pop cultural references to power feminism were at their height: "girl power" was ubiquitous, thanks to advertisers who held up this more consumer-friendly facsimile of feminism in a way that subverted the meaning of feminism itself.

I now explain, though, how a superhero seemingly perfectly placed to be an exemplar of "girl power" at its finest can actually help us understand many of the second-wave feminist concepts that were left open when the feminist debate in the 1990s turned toward the simplistic and unfulfilling notion of power feminism. The remainder of this chapter draws on the Captain Marvel story in an effort to both highlight and redeem these concepts for modern pop culture sensibilities.

"Amnesia" and the Feminine Mystique

In *Captain Marvel*, Vers begins to reunderstand her own position in her society when a Skrull probe of her memories leads the Skrull to Earth in an attempt to recover a power core. Vers travels to Earth, thinking she is protecting the

planet from the Skrull, but instead discovers a crystal containing her memories. She begins to understand how her community has lied to her in order to keep her under their control.

Vers is alienated from her superpowers only because she believes Yon-Rogg and the other Skrull when they tell her that the key to strength is to control herself and her emotions and because she believes a Skrull neck implant is vital to her. Most MCU superheroes—think Iron Man or Spider-Man—must work hard to learn how to use their powers, and the key tension in the story is whether they will be able to maintain the discipline needed to control those powers enough to use them for the benefit of society. Vers is different, however. She has already worked hard, largely under the tutelage of Yon-Rogg, to learn how to use her powers. In fact, the film opens with a scene that occurs late in her training. She knows what she is doing before the action ever starts. The tension in her story comes from the question of whether she will continue to allow her powers to be suppressed by the Skrull and used in the service of the Skrull plot to dominate the universe.

The key payoff scene occurs when Vers removes the Skrull neck implant, thus releasing her full power as well as emancipating her from the obligation to use that power to serve the Skrull in their plot for domination. "I've been fighting with one arm tied behind my back," she says as she reaches to remove the neck implant. "But what happens when I'm finally set free?" We see a surge of blue energy; then her eyes glow yellow and she attacks her Skrull captors. She then proceeds to defeat every enemy in the vicinity to the tune of the '90s bop "Just a Girl," which is generally understood to be a power feminism anthem but may be more complicated, as I explain later.

Captain Marvel's query, "What happens when I'm finally set free?," mimics the questions that nagged at Betty Friedan's housewives in her 1963 book, *The Feminine Mystique*. The book that ushered in the second wave of feminism depicted a confusion among women who had achieved all that they expected and were expected to achieve—a marriage, a family, a house—but found themselves feeling "a strange stirring, a sense of dissatisfaction, a yearning" (Friedan 1963, 15). They not only found their lives as housewives fundamentally unfulfilling but understood this dissatisfaction as somehow a failing on their part: "She was so ashamed to admit her dissatisfaction that she never knew how many other women shared it" (Friedan 1963, 19).

Importantly, these feminists argued that women were often their own police force, creating a self-reinforcing mechanism that kept them oppressed by the demands of femininity: "The psychologically oppressed becomes their own oppressor." (Bartky 1990, 22). Women worried about their hair, makeup, and expressions of their diffidence rather than about how they might work together to topple the patriarchy. Indeed, the self-surveillance was so great that

When Carol Danvers removes the Skrull neck implant inhibiting her powers, she wonders, "What happens when I'm finally set free?" Her question mimics the questions that troubled the housewives Betty Friedan wrote about in her 1963 book, *The Feminine Mystique*. From *Captain Marvel* (2019).

the women themselves were tricked into thinking they enjoyed the process. Unlike the alienation of workers, who knew they were being alienated from their work, women did not perceive their own alienation as such: "However unwilling feminists may be to admit it, many women appear to embrace with enthusiasm what seem to be the most alienated aspects of feminine existence" (Bartky 1990, 36).

We can think, then, of Captain Marvel recovering her memories as a process of becoming aware of her own alienation. Central to those recovered memories is Dr. Wendy Lawson/Mar-Vell, Vers's mentor when she was still Earth-bound pilot Carol Danvers. I explore the connection between the Danvers/Lawson relationship and the centrality to second-wave feminist consciousness-raising of understanding the history of the women who have previously fought for their own truth.

Lawson, Female Mentorship, and the Reclamation of First-Wave Feminism

Prior to Carol's transformation into Captain Marvel, Dr. Wendy Lawson (played by Annette Bening) serves as Carol's cool, collected mentor. Importantly, our introduction to the character is via Vers's conversations with the Supreme Intelligence, a powerful consciousness that maintains each individual Skrull's enthusiasm for the Skrulls' path toward dominance. The Supreme Intelligence appears to each individual differently, and the identity of the person one sees is

to be kept secret. In Vers's case, though, she begins the story unaware of who the woman is who appears to her as the Supreme Intelligence. We later learn the identity of the woman whose form the Supreme Intelligence takes: she is Carol Danvers's mentor prior to her joining the Skrull. Although Yon-Rogg tells Carol early in the film that her powers were a gift, this is false. Rather, Danvers receives her powers when she shoots the energy core of the airplane she has just crash-landed with Dr. Lawson on board.

As she is dying, Dr. Lawson relates a nearly unbelievable story about who she is and why she is there. Dr. Lawson is trying to "end all wars," and destroying the core to keep it out of the hands of the Kree is a vital part of that mission. Dr. Lawson then attempts to shoot the core herself, instead being killed by Yon-Rogg just as she takes aim. As Yon-Rogg then aims his weapon at Danvers, she is faced with a choice: does she believe Yon-Rogg, who claims he does not want to hurt her, or does she believe Mar-Vell's outrageous claims? She chooses to believe her mentor and destroys the core, mimicking the choice of second-wave feminists to side with their first-wave foremothers rather than the society that was telling them to comply with male demands. The subsequent explosion results in Danvers absorbing the energy contained in the core, which causes her both to receive her powers and to lose all of her memories, even those of her mentor, whose memory lives only in her subconscious, to be mined by the Supreme Intelligence to secure Vers's allegiance to the Skrull cause.

The relationship between Carol and Dr. Lawson mirrors the relationship between first- and second-wave feminists. Indeed, second-wave feminists called themselves the "second wave" in an effort to draw a connection between their own work and that of their foremothers, or at least partly to draw a distinction between the women's movement and the rest of the new left (Henry 2004). Furthermore, connecting with first-wave feminists "helped to validate feminism at a time when it was often ridiculed as silly and not politically serious" (Henry 2004, 53).

The call to take suffragists seriously was central to second-wave feminism. Many members of the second wave of feminists decried their modern society's ignorance of the suffragists and saw relearning that history as an important aspect of their own emancipation. Shulamith Firestone, for example, dedicates an entire chapter of her radical feminist treatise *The Dialectic of Sex* to a retelling of the history of first-wave feminism, a history that she says has been deliberately erased, its heroines subjected to ridicule, so as to anesthetize modern women from their consciousness as political actors (Firestone 2003).

Similarly, Friedan points out the ridicule dealt to first-wave feminists by caricaturizing them: "It has been popular in recent years to laugh at feminism as one of history's dirty jokes: to pity, sniggering, those old-fashioned feminists

who fought for women's rights to higher education, careers, the vote. They were neurotic victims of penis envy who wanted to be men" (Friedan 1963, 80). It fits with this story, then, that a central part of Captain Marvel's story is the reclamation of her own understanding of who Dr. Lawson was rather than the version of her as the Supreme Intelligence, which kept her tied to her society in a way that benefited society and oppressed her.

Power Feminism and the Ethic of Care

Captain Marvel is a power feminist's dream: she quite literally has more power than anyone around her. If, as MacKinnon (1987) says, women's oppression is rooted in men's physical domination of them, then Captain Marvel turns this on its head. She is not only powerful, she is *the most* powerful, even among the other Avengers. It is notable here that a midcredits scene in *Captain Marvel* shows Nick Fury settling on the name "the Avengers" for his team of superheroes in a nod to Danvers's call sign, "Avenger," which appears on Danvers's airplane in a photograph in Fury's office. In this sense, Captain Marvel is the literal first Avenger in the MCU, edging out Captain America—who really only had the position on the technicality that he was a superhero first.

But notably, Captain Marvel explicitly chooses not to rely on her physical domination but rather to locate herself as part of a team. It is Fury and Rambeau who are tasked with accomplishing the central goal of the third act of the film: getting the Tesseract to safety. Captain Marvel is playing the role of a mere distraction to assist them in this work. Furthermore, she completes this task to the tune of No Doubt's "Just a Girl," an ironic tune that is much more about the second-wave feminist concept of the shared victimization of women (Bartky 1990) than it is about the usual commercialized version of "girl power." Indeed, the first lyric of the song, "Take this pink ribbon from my eyes," seems to refer to the process of feminist consciousness that was key to second-wave feminism. Furthermore, the chorus refers to the eponymous girl "living in captivity . . . what I've succumbed to is making me numb," describing a set of circumstances that is notably similar to Friedan's housewife living under the feminine mystique.

This stands in stark contrast to the popular culture notion of "girl power" that railed against the second-wave feminist conception of women as victims but often ignored the concomitant conception that this victimization was shared with other women in a way that made for a linked fate among all women. One aspect of feminist consciousness raising is "a new identification with all other women and a growing sense of solidarity with other feminists" (Bartky 1990, 21). This aspect of second-wave feminism is meant not to explain many

ways women are victimized but rather to lay bare the many ways they are obliged to assist others who may not have the power that they do. This "faux-feminist" language of empowerment, according to McRobbie (2009), tells women that self-actualization requires them to work hard as individuals to succeed in the current social regime, an action that both recursively supports that regime and at the same time distracts from the ways in which women might band together to effectively "challenge these emerging forms of gendered, racialized, and class inequalities" (McRobbie 2009, 135). Third-wave feminists reveling in their girl power, then, are ignoring the relational aspects of feminism that are vital to understanding feminism beyond a stereotype of old, angry, man-hating, sex-eschewing crones.

Further, according to Caputi (2013), this conception of power feminism seeks only to mimic the trappings of male dominance rather than create a new conception of how power ought to operate: "recognizing that certain trappings of power feminism simply replay the tenets of American rugged individualism forces us to consider that 'feminism' is no longer a progressive movement, but one that mimics a conservative, masculinist stance laced with references to John Wayne, Ronald Reagan, and the metonymic richness of 'Bush'" (Caputi 2013, 26). Rather than eschewing individualism altogether as an inferior way to construct a society, power feminism replicates it and provides it with more legitimacy. Indeed, we see this strong preference for American self-sufficiency ranging from "the adventuresome pioneer braving the westward expansion" (Caputi 2013, 66) to the more modern refusal to abide by government mandates to wear masks to help stem the spread of COVID-19.

Modern feminism, then, provides a means to apply what Tronto (1993) calls an "ethic of care" to political life. Previously known as "women's morality," this ethic of care prioritizes linked fates and social attachments over individualism and dominance. Under this argument, feminism is about forswearing attempts to mimic male notions of dominance and individualism—as power feminism attempts to do—and instead prioritize care for others and attention to our shared conditions. Feminists of any gender, then, seek to create a society based on facilitating support for each other rather than on controlling who can dominate whom.

And it appears to be this notion of feminism to which Captain Marvel seems to adhere. In fact, Vers's first real action on Earth is to explicitly reject a symbol of power feminism. We know instantly that Captain Marvel has arrived in the 1990s because she crash-lands in the now all-but-defunct Blockbuster Video store, a stalwart of the 1990s as a purveyor of now all-but-defunct video cassettes. Upon arrival, she fires her gun-from-the-future at a cardboard cutout of the 1994 film *True Lies*, which stars Arnold Schwarzenegger as a computer salesman by day/international spy by night and Jamie Lee Curtis as his bored,

unfulfilled wife. A major plot point of that film is that spy Harry is worried about his spiritless wife, Helen, who seems to be feeling what Friedan calls "a strange stirring, a sense of dissatisfaction, a yearning" of as-yet-unaware women that their workaday lives are keeping them from a more fulfilling life (Friedan 1963, 15). Harry kidnaps his wife, and a series of events transforms Helen from one of Friedan's self-contemptuous, unhappy housewives to a sexy and sexualized international spy capable of beating up bad guys alongside her husband, a sort of a nubile, violent helpmeet for the power feminism age. As a side note, she blasts the cutout and then leaves the building to talk with a security guard, who happens to be grooving to Salt-N-Pepa's ode to modern masculinity as ethic of care, "Whatta Man," which includes lyrics that distinguish between most men, who are "hos," and the titular man, who is "smooth like Barry and his voice got bass / A body like Arnold with a Denzel face" and "spends quality time with his kids when he can," the "when he can" part added, it must be noted, to facilitate the rhyme rather than to excuse partial paternal absenteeism.

Conclusion: THAT SCENE

Possibly the most controversial scene in all of MCU filmdom comes near the end of *Avengers: Endgame* when Captain Marvel arrives to help the Avengers secure the Infinity Stones from Thanos. In the scene, which the *Guardian* calls "well-intentioned, but clumsy" (Smith 2019), Captain Marvel takes the stones from the young Spider-Man, who motions to Thanos's massive army and warns, "I don't know how you are going to get through all that." The remaining Avengers women dramatically appear around her: "Don't worry. She's got help."

Siede (2019) correctly points out that the film may not have earned the big feminist payoff because it sidelines women in virtually every other of the 180 minutes of the film, including the previously mentioned failure to provide a decent burial for the peerless Black Widow. But in maligning the moment as bad "girl power" imagery, Siede ignores the feminist implications of the scene that transcend the dubious "girl power" concept. Captain Marvel, the ultimate candidate for power feminism as the ultimate power in the universe, instead repeatedly eschews the moniker, preferring a feminism born of the ethic of care. Likely, Captain Marvel could have taken on Thanos's army single-handedly, but that is explicitly not her style.

And, indeed, the response to that scene is in many ways indicative of how marketplace feminism has pervaded our society. We demand that Captain Marvel defeat Thanos entirely on her own while simultaneously keeping the house

In one of the most controversial scenes in the MCU—sometimes simply called "that scene"—Captain Marvel confronts the daunting prospect of battling through Thanos's army and is suddenly flanked by all of the half-dozen prominent female protagonists, one of whom assures Spider-Man, "Don't worry. She's got help." From *Avengers: Endgame* (2019).

clean and the kids fed, all while looking dead sexy and, of course, purchasing as many consumer products as necessary to keep that "girl power" illusion going. Drawn into this net of marketplace feminism, we automatically assume that since she can do it by herself, she ought to. But again, this is a male-centered conception of power. Instead, Carol purposefully eschews both power and marketplace feminism by seeking support from her friends and allies rather than from her physical or purchasing power. In this sense, Carol's true power derives from her relationships with those around her, which is a much more Tronto-like feminist concept that allows Carol to sidestep mindless self-help turns of phrase and instead build a "new solidaristic vocabulary" (McRobbie 2009, 135) so that she and her allies can work together to defeat Thanos.

The notion that if one can do something by oneself, one should is based on the premise that individual action is necessarily preferred to group action, a trope of a masculinized will to power in our society (Caputi 2013) but not of the superheroes in the MCU, regardless of gender (see Cassino in this volume for a discussion of this concept vis-à-vis the male characters). Marvel certainly deserves criticism for its repeated habit of sidelining women (all the prequels in the world will never make us forget what they did to Black Widow), but in this case, the MCU finds itself deeply and intentionally associating itself with the truly feminist concept of ethic of care. The MCU is not reaching for "girl power," nor should it. And the fact that THAT SCENE is so deeply maligned because it does not work on the "girl power" level reveals just how embedded the troubling conception of power feminism is in modern society.

VULNERABLE HEROINES

Gendering Violence in *Jessica Jones*

Menaka Philips

Over the past few decades, the idea of the superhero has retaken the popular imagination. Largely a consequence of the multibillion-dollar successes of its adaptation to films, the superhero genre offers both escape from everyday realities *and* a reflection of those realities—sometimes through a critical eye. In the twenty-first century, consequently, comics and their film iterations are increasingly viewed as a telling kind of representative forum in which individuals and narratives not traditionally given space or voice might be centered: from *Wonder Woman* to *Black Panther*, issues of race and gender, class and sexuality, among others, have made their way into a medium that reaches, well, nearly everyone. The evolution of the genre to meet these representative aims has garnered vocal support and criticism. Amid calls to create heroes who—both descriptively and narratively—break the hold of the white male lead, there are criticisms for going too far, or for not going far enough. In interesting ways, then, the superhero comic film has emerged as a battleground for contemporary discussions about identity and power in the real world and onscreen.

Marvel's collaboration with Netflix has been particularly illustrative of the question of the genre's representative possibilities as well as its weaknesses. Distinct from the big-budget films, the serialized stories *Jessica Jones, Luke Cage, Daredevil*, and *The Punisher* enable a different kind of storytelling, driven by longer character arcs and deeper dives into narrative themes. Arguably, it is in these Netflix-produced series, more so than its big-budget *Avengers* franchise, that Marvel really tested the waters with expanding beyond its traditionally white male cinematic leads and perspectives. *Jessica Jones*, for example, established Marvel's first cinematic experiment not only with a female showrunner but also with women in the lead and key supporting roles and in the director's chair for almost half of the first season's episodes. Though the character is far from Marvel's first female superhero, Jones is the first to anchor one of its modern onscreen adaptations. More importantly, *Jessica Jones* represents the first dedicated attempt to center the politics of misogyny and the psychological consequences of sexual assault in the Marvel Cinematic Universe

(MCU). For these reasons, many viewers took *Jessica Jones* as a feminist superhero, and with good reason. Not only does the series take an unflinching look at the trauma of sexual violence in the gendered social and legal contexts of the United States, but it does so through a lead figure who rejects, for the most part, narrative tropes of femininity in film. Independent, irreverent, and intelligent, Jones is never in need of (male) saviors—though she does learn to appreciate her allies.[1]

Yet alongside its gender-troubling qualities, the series reenacts certain gendered expectations—namely, those surrounding the expression of female strength, and particularly female violence. As I argue in this chapter, for *Jessica Jones*, violence is framed by presentations of gendered *vulnerability*.[2] The violence expressed by the show's female characters is variously presented as reluctant, trauma driven, and/or shaped by interpersonal relationships—and is almost always accompanied by reminders of female exposure to male threat. In these ways, the show reveals the complex gender politics at work in the superhero universe: on the one hand, it foregrounds female power and empowerment, while on the other, it comes just short of overturning the gendered conventions expected of that genre. Though *Jessica Jones* inhabits a critical feminist space in Marvel's cinematic universe, the show remains bounded by the broader gender norms that shape that universe and its real-world audience. *Jones*, as I suggest, is a fractured feminist text. Even as it enables a feminist heroine in many respects, it conforms to the gendered conditions under which both female heroism and female violence are made intelligible to contemporary audiences.

Centering Trauma

Jessica Jones debuted on Netflix in 2015 to great success. With a 94% approval rating on the online review aggregator Rotten Tomatoes, critical consensus suggested that the show "builds a multifaceted drama around its engaging antihero, delivering what might be Marvel's strongest TV franchise to date" (Rotten Tomatoes 2015). As an antihero, the show's titular figure eschews the qualities normally associated with heroic characters (Hamilton 2015; Lackey 2015). In a modern take on the noir detective genre, the protagonist's super-status often takes a back seat to the ordinary aspects of her life—working as a private investigator in New York, tailing adulterers, avoiding social connections, and drinking whiskey. Heroism is something she regards with suspicion.

Jones is also a notable departure from the standard female character in superhero films; in place of overtly sexualized costumes and storylines that

emphasize her desirability, Jones's "costume" consists of gritty sarcasm, capable investigative skills, and a steady rotation of comfortable jeans, T-shirts, and a leather jacket.

But what sets Jones's story apart from that of the traditional comic superhero is not just her appearance or her aversion to bearing the superhero mantle, nor is it the superstrength she possesses. Rather, what makes the Netflix iteration of Jones's story unique is its focus on her vulnerability in the aftermath of sexual trauma. The Jessica Jones we are introduced to is a rape survivor.

Her attacker, Kilgrave, is the villain of the first season. His villainy is expressed through his powers of mental control, as he possesses the ability to make anyone do anything he wishes even as they remain aware that it's happening. It's a particularly terrifying form of torture that also operates as a symbol of the dynamics of abusive relationships. Kilgrave follows the patterns of traditional abusers in "manipulating their victims with mental and verbal abuse, scaring them into submission, isolating them from their communities, and ultimately convincing them that the pain and suffering is completely their own fault" (Jeltsen 2015; see also Devereaux 2015). As we learn through the first season, Kilgrave used his power to make Jones behave like his "lover" and to turn her strength against others when he chose, experiences that have left Jones with feelings of shame, guilt, fear, and anger—feelings that survivors of domestic abuse and sexual violence often report struggling with (Devereaux 2015). Moreover, Kilgrave's powers of mind control dominate Jones's superstrength; a woman who can lift cars with a finger is nevertheless subject to the abusive power of a man she knows. This experience forms the foundation for who Jessica Jones is when we meet her and for her character development through the rest of the series.

Trauma often forms part of the superhero origin story. Watching his parents murdered turns Bruce Wayne into Batman; the killing of Peter Parker's uncle precipitates an appreciation of the responsibility that comes with his powers as Spider-Man; following his kidnapping and torture and faced with the consequences of the weapons he designed, the MCU's Tony Stark becomes Iron Man. But for these men, experiences of loss and suffering function to generate their *transition* into the superhero. In Jones's case, her superpowers and her work as a superhero predate her encounter with Kilgrave.[3] Instead, as the show details, the memory of Kilgrave's abuse is not so much a spark as it is a shadow; his actions haunt her throughout the first season—a haunting illustrated visually through flashbacks, dream sequences, and cleverly edited scenes that show him touching or whispering to Jones, though we know he's not actually there. We feel Kilgrave's presence even in his physical absence, just as Jones does.

As we learn over the season, Jones is isolated by the trauma of having been

For Jessica Jones, the harm she suffers at Kilgrave's hands is not the origin of her superpowers but rather a trauma that is both the result of and a constraint on her exceptional abilities. From *Jessica Jones* (2015).

abducted by him and his ability to manipulate and threaten people she cares about. Thus "her self-esteem is shot, tormented by the things she did and the person she became while under his control" (Jeltsen 2015). Her trauma, in this case, is not part of an origin story but rather is part and parcel of her daily life onscreen (Bady 2017). As she tells her closest friend, Trish Walker, in the second episode, Kilgrave's abuse and the fear that he might capture her again are things she cannot escape: "I'm not safe anywhere; every corner I turn, I'm not sure what's on the other side" (Clarkson 2015). This is an admission of physical and emotional vulnerability, and certainly an unusual one for heroic leads in Marvel comics or cinema.

Jessica Jones as a Feminist Text

The trauma of sexual violence is something that showrunner Melissa Rosenberg and her writing staff run directly toward—a fact that garnered many of the show's positive reviews.[4] *Jessica* Jones's feminist ethos was, for some, driven by its willingness to make issues of rape and interpersonal abuse the basis for the first season. Thus, "even at the level of premise, the show made a statement about rape that is fundamental, seldom made and hard to render more boldly than with a superhero" (Williams 2018). Part of the show's brave

foray into issues of rape and recovery is that it does not simply task Jones with seeking vengeance for what was done to her, nor does it portray her as a passive victim of Kilgrave's abuse. Rather, it complicates the vengeance/victim binary by juxtaposing the suffering Jones endured while under his control, the emotional trauma that she continues to deal with, and her determination to stop Kilgrave. Moreover, her decision to stop him is not simply about personal retribution but more about defending others—namely, his current victim, Hope Shlottman, another woman whom he raped and later forced to murder her parents. As one reviewer noted, at all times, the "trauma of [Jones's] vulnerability is still with her, as is her guilt about the crimes she committed at Kilgrave's behest." (Green 2019, 175). Because the writers keep us focused on both Jones's agency and the psychological trauma inflicted by Kilgrave's actions, Jones's heroism takes on a dynamic quality. It takes shape against an evolving discussion of assault and recovery.

The first season is notable too for the ways in which it draws an analysis of interpersonal violence and abuse through its secondary characters. Over and over, we find instances of relational inequities and harm among the supporting characters or stories that flesh out the show. For instance, in the lone moment that Kilgrave uses his powers for "good" (at Jones's request), it is to stop a man from committing familicide. Striking too is Trish Walker's romantic entanglement with the police officer Will Simpson. Under Kilgrave's control, Simpson violently attacks Walker. Like Jones, he feels guilt for his actions, which Walker forgives before the two become romantically involved. Yet Simpson quickly attempts to take a dominant position in the relationship, particularly with regard to Walker's and Jones's efforts to capture Kilgrave. He both deflects Walker's involvement as too risky and clearly views Jones's powers as a threat to his own ability to capture Kilgrave. Touting his military background, he challenges Jones: "You think because you have these abilities, you're a hero. I've seen heroes. You're not even close" (Surjik 2015). His obsession with proving Jones's inadequacy and killing Kilgrave himself eventually drives him to take performance-enhancing drugs and later to attack both women in his mission to kill Kilgrave. The writers here, one might intuit, are highlighting the ways in which Simpson's relationship to Walker and Jones, and his self-understanding as a masculine protector—both personally and professionally—are unsettled by the kind of physical autonomy shown by Jones, and on occasion by Walker herself.

But there are other examples too, not all of which rely on physical violence alone. The lawyer Jeri Hogarth's affair with her employee alongside her dismissive treatment of her wife, Walker's fractured relationship with her mother, and even Jones's own instrumental use of her neighbor Malcolm Ducasse[5] offer evidence of the different ways in which relational inequities can form and be expressed—to the detriment of the subjected parties. In making these kinds of

narrative decisions, the writers complicate any easy assessment of what abusive practices or relationships look like.

The show's gender politics is also novel for contextualizing Kilgrave's abuse in heteronormative tropes of courtship and desire. This is most effectively done in episode eight, "AKA WWJJD?" Halfway through the first season, Jones and her allies are working to capture Kilgrave and thereby prove his latest victim's innocence of a murder charge. As part of this operation, Jones agrees to live with Kilgrave in her childhood home, which he has purchased in order to "woo" her back to him without the use of his powers. The episode's pivotal scene comes just after Kilgrave has shamed a rude neighbor for upsetting Jones. Noting that Jones appreciated his treatment of her neighbor, Kilgrave then attempts to touch her and is rebuffed. He flippantly remarks that they used to do more than touch—a fact, as Jones reminds him, that was not under her control: "It's called rape," she says.

Kilgrave's reaction to this statement marks the episode's critical intervention into issues of domestic violence and rape culture more broadly. He is startled, and with textbook abuser behavior responds by questioning her reality: "What? Which part of staying in five-star hotels, eating in all the best places, doing whatever the hell you wanted, is rape?" (Jones 2015). That all these experiences were forced upon Jones is, apparently, lost on Kilgrave—but not on the viewer. Having borne witness to Kilgrave's power and the violent effects of his actions in previous episodes, that he can perceive his control of Jones in terms of romantic overtures is intentionally jarring to the audience. That juxtaposition between what Kilgrave does and how he rationalizes his actions is made particularly insidious because it is cloaked in *ordinary* acts of courtship—whether coming to her defense against a rude neighbor or taking her for fancy dinners. By wrapping Kilgrave's crimes into these familiar expressions of courtship, *Jessica Jones* affords its audience critical insight into the ways in which domestic abuse can take shape through mundane acts of caring or affection.

In some ways, the show's engagement with the nuances of rape and domestic abuse track the "dominance approach" to sexuality developed by Catharine MacKinnon (1989, 129). Though the show does not engage the broader implications (or solutions) that MacKinnon proposes in relation to issues such as sex work, it does echo a basic element of her theory of sexuality, namely, that it is constructed through male dominance: "In feminist terms, the fact that male power has power means that the interests of male sexuality construct what sexuality as such means, including the standard way it is allowed and recognized to be felt and expressed and experienced, in a way that determines women's biographies, including sexual ones." We see precisely this kind of "masculine determination" of sexuality throughout the first season. Flashbacks and references to the dinners, gifts, and hotels that accompanied Kilgrave's abduction of

Jones bear the traditional hallmarks of heteronormative dating. But from the meals they eat to the clothes he buys her, not only Kilgrave's practices but *his own interpretation* of what constitutes romance and what makes Jones desirable are grounded in his ability to control. Even the clothes he buys for Jones reflect what Kilgrave thinks is attractive—dresses, heels, and makeup—all of which conform to gendered expectations about femininity. What the show's writers do, then, is illustrate how these seemingly ordinary symbols of "affection" can mask the "coercive control" that underpins abusive relationships (Green 2019, 176). And deeper into MacKinnon's point, Kilgrave's villainy is only a slight adjustment of the standard male character cast as romantic lead, a character whose desirability is often tied to the degree of control he exerts: "Tweak Kilgrave's banter, and he'd be a wealthy vampire who desires Jessica above any other woman, a man who is literally irresistible, as in 'Twilight.' Wrench it again, and they'd be role-playing 'Fifty Shades of Grey'" (Nussbaum 2015).[6] In these examples, the appeal of the masculine lead is framed by his overwhelming desire for and ultimate "capture" of the female protagonist. In short, the character of Kilgrave participates in a broader social practice of constructing sexuality and desire in unequal terms.

However, *Jessica Jones* does not replicate that dominance view of sexuality so much as undermine it. Indeed, the series disrupts the "clichés of seductive pursuit, romantic desire and domesticity" by reminding the viewer "that [Kilgrave's] actions are about power and control rather than love and recognition" (Green 2019, 181). Even during her brief stay with Kilgrave in her childhood home, Jones refuses to wear the stereotypically feminine clothes he's purchased for her, staying in her usual attire. This shows Jones actively rejecting the male gaze and the heteronormative perceptions of gender presentation that it constitutes (Kim 2017; Mulvey 1999). One of the effective things the show does is to identify for the audience the relationship between desire and domination that scholars such as MacKinnon consider to be constitutive of modern understandings of sexuality before then moving to disrupt and challenge those understandings through its main characters.

Perhaps nowhere is the show more pointed about doing so than in the way it ends Kilgrave's character arc. Believing he has regained control of Jones, Kilgrave's first act is not one of physical violence but a self-affirming demand. Insisting that his motive is love, he tells Jones, "One day you'll feel the same. Let's start with a smile" (Rymer 2015). One cannot help but imbue his final words with knowledge of who Kilgrave is and what he has done. This forces the viewer to consider the *entitlement* that attends his ostensibly simple request to smile. It is a brilliant concluding illustration of the hidden acts of domination that lie beneath the performative expectations of gender.

Gendering Violence

To watch *Jessica Jones* is to take a hard look at the gendered politics of rape and sexual abuse. For this reason, viewers and critics alike called Jones a "feminist superhero" (Williams 2018) who used her powers to fight back against her rapist (Trott 2019). More broadly, the show was hailed for centering narratives about abuse and recovery in the traditionally male-dominated superhero canon: "In the world of Marvel Comics, a female antihero—a female anything—is a step forward. But a rape survivor, struggling with P.T.S.D., is a genuine leap" (Nussbaum 2015). By taking seriously the diverse ways in which abuse presents itself, as well as the challenges of recovering from it through a female lead, *Jessica Jones* quite clearly broke boundaries as a popular cultural text.[7]

However, while the series offers a critical analysis of sexual violence and interpersonal abuse, it remains tethered to certain gendered norms of *violence in general*. By that I mean that Jones's ability to use violence, particularly given her superstrength, is rarely given space in the show.[8]

Like other super-/antiheroes (e.g., DC's Batman or Marvel's Daredevil), Jones does not equate justice with the murder of criminals. But where her male counterparts frequently participate in violent (if not deadly) acts, violence is more often committed *around* Jones than it is *by* her. It is through Kilgrave's manipulation of others or through secondary characters such as Simpson that violent acts or responses are portrayed. Even Luke Cage, who sometimes bears the problematic mantle of racial respectability politics, participates directly and visibly in violent scenes where his powers, at the very least, are highlighted, as do Daredevil, the Iron Fist, and the Punisher. These male leads of Marvel-Netflix productions are allowed to exert their physical abilities in contexts of violence, oftentimes with messy, bloody results. In contrast, for Jones the turn to violence is almost always reluctant, and less explosive when it does occur.

Distinct from male characters on the show—and from other Marvel-Netflix male protagonists—Jones's capacity for violence as well as the terms on which she uses it is visually and narratively restricted. Even when provoked into justified anger, Jones's violence is never gruesome, rarely explosive, and almost always narratively tied to reflections of inward pain or outward necessity. Her displays of superhuman strength are alternatively framed as comical, defensive, or therapeutic more than threatening. Oftentimes too, displays of Jones's capacity for violence are immediately followed by reminders of her vulnerability. More often than not, what the audience sees are the *effects* of her powers, not her actual use of them on camera. Thus, unlike those of her MCU

counterparts, such as the Punisher or Daredevil, Jones's displays of force are rarely something we actually witness, and certainly not with the same gory visuals that attend the actions of those male characters. Her superpower is showcased in a way that doesn't, ultimately, overpower her gender.

Similar patterns shape secondary female characters. In the second episode, for instance, we learn that Trish Walker is skilled in martial arts and defense training; in the third, she is attacked and overpowered by Officer Simpson; by the fourth, they are romantically involved. Such examples bespeak the limits placed on displays of female strength, the objects at which it is directed, and expectations about how far it can go. These are, as I argue, elements of a gendered construction of violence through which the vulnerability of the female lead is distinguished from the strength-capacity of male characters and audiences. Feminist (super)heroism seems to be tethered to the lingering image of female susceptibility to male power.

Such limitations shadow the premier episode of the series, "AKA Ladies Night." The episode is a slow-burn introduction to Jones that ends with her discovery that Kilgrave is baiting her with another victim, Hope Shlottman. There are two key displays of Jones's superpower in this episode: an aggressive client is thrown through a window, and the car of a man being served legal papers is casually lifted off the ground. Delivered with subtlety and humor, both scenes efficiently detail the nature, if not the extent, of Jones's superpower and its destructive possibilities. But their construction is also notable for the ways in which they limit those possibilities. The opening sequence in which Jones confronts her angry male client is viewed through the frosted glass of her front door. What we see is the shadow of the man yelling at her before he is thrown through the glass. What we *don't* see is Jones herself physically lifting and throwing him through the door, even though modern filming techniques would allow it.

Thus, her strength is embodied through *his* body, not her own. It's an artful scene, and perhaps that might be all there is to it. Yet a few minutes later, we see Jones having a panic attack. Kilgrave's shadow looms by her side as he whispers in her ear, a hallucination that prompts her to recite street names from her childhood, a psychological technique to help her regain control. A similar sequence follows halfway through the episode. This time, however, Jones's physical abilities are shown rather than implied when she effortlessly lifts the car of a man trying to avoid a legal summons. He threatens to expose her, to which she replies that people "would rather call you crazy than admit that I can lift this car." Strikingly, the next scene shows Jones being haunted by Kilgrave in her sleep; in a dream sequence, he brushes the hair from her face. She awakens in fear and begins to recite her street names again.

In the first twenty minutes of the series premier, Jones's superhuman

capacity to overpower is modulated by her continued victimization by Kilgrave. Where her physical strength is framed quietly and comically at times in this episode, her vulnerability is always readily visible. And reminders of that vulnerability follow directly on the heels of instances where she employs her powers. Moreover, throughout the first season (at least until the final episode) Jones's physical power is not what ultimately assists her in catching Kilgrave. Rather, she pursues normal avenues of investigative research to flush him out and extralegal (but not superhuman) means of eliciting a confession from him. Though she does violently beat Kilgrave at one point, the physical violence she displays does not compare to the damage he does shortly afterward to his parents, and to various others upon his escape. And his actions here affect Jones deeply, more evidence of the ways in which association with her puts people in Kilgrave's deadly sightlines.

One of the series' climactic moments comes as Jones realizes that Kilgrave's powers no longer affect her; she has thus regained her autonomy in the aftermath of his assault. Yet even here, Jones does not unleash her physical abilities because of the show's plot directions: Kilgrave's safe capture and confession are the key to exonerating his latest victim. It is that victim, Shlottman, who ultimately frees Jones to kill Kilgrave by taking her *own* life. In this instance, Shlottman's self-directed violence becomes the basis upon which Jones can actualize her own capacity for violence to stop Kilgrave. But we are reminded that Jones's ability to kill him comes at the tragic cost of the life of the woman she has spent the season trying to protect.

In fact, from the first episode onward, Jones's strength and capacity for violence are presented as risks to herself and to those around her. After all, we know that Kilgrave used Jones's powers to harm other people. That effectively turns Jones's "physical strength into his fetish" (Lickhardt 2020, 106). She is not only subject to Kilgrave's assault but also "punished for her physical strength" (Bercuci 2016, 266). This of course is part of what drives both her fear and her guilt throughout the first season: "I'm life-threatening, Trish, steer clear of me" she says (Clarkson 2015). In essence, the very condition of her superheroism—her physical *invulnerability*—becomes a condition of her victimization and ongoing trauma at the hands of Kilgrave. What the writers intended here is not at issue. Rather, it is the narrative effect of making female power, in this instance, a resource for male harm.

It is perhaps in Jones's encounter with an "antisuperhero" vigilante, Audrey, that we see the gendered contours of violence most clearly expressed in the series. Audrey, who blames "supers" such as Jones for the death of her mother, seeks to kill them and shoots Jones. One can imagine how the Hulk or Iron Man might respond, or even Jones's Netflix counterparts Luke Cage or Frank Castle; Audrey and her gun certainly would not escape unscathed. But

for Jones, this incident becomes an opportunity to *deny* righteous anger and the violence it might (for some) justify. Rather than target Audrey, Jones proceeds to break items in the room they are in, all while making the following statement about what constitutes appropriate responses to loss and pain: "You think you're the only ones with pain; you think you can take your shit and dump it on me. . . . You take your goddamn pain and you live with it, assholes. I don't work my shit out on other people. Keep your goddamn feelings to yourselves" (Petrarca 2015).

There is a way in which this sense of individualized pain and barriers to expressing it permeate how violence attends Jones's character in general. Kilgrave's powers literally allow him to express his feelings and desires through the bodies and actions of others. This constitutes his villainy. In contrast, Jones's heroism is constituted through the *reluctant* and muted use of her powers, even—and especially—in contexts in which she suffers personal loss or pain. Where Kilgrave reacts, Jones endures. Violence directed or sought by the female lead is, in other words, actively inhibited and framed against the more volatile uses of violence we see in the show's male characters.

The implicit connection between gendered vulnerability and heroic violence is carried throughout the series. Most strikingly, it operates to distinguish between the legitimate and illegitimate forms of violence committed by Jones and her best friend, Trish Walker. By the series end, Walker has gained her own superpowers. And we know that Walker's life, like Jones's, has been shaped by traumas. But these experiences do not operate to temper her acts of violence in the way they do for Jones. Rather, Walker's experiences seem to steel her resolve to use her powers to become a kind of vigilante figure, taking the law into her own hands and even summarily executing her targets. In this way, Walker does not exhibit the gendered vulnerability that accompanies Jones's use of violence in the series, and the narrative arc of her character leads the audience to view her actions as beyond the pale: after a reluctant Jones is forced to capture her, Walker admits that she herself has become the "bad guy" (Hardiman 2019).

Vulnerable Heroines

As a feminist text, *Jessica Jones* was hailed by audiences, critics, and scholars alike for modeling "how the roles and representations of women in transmedia narrative" can disrupt "the inconsistencies and tensions of social, cultural and identity politics in compelling and accessible ways" (Green 2019, 182). I tend to agree. The series artfully depicts *and* challenges the ways in which gendered social and political norms shape issues of sexual violence, trauma and recovery,

and varieties of interpersonal inequity. Doing so within the traditionally masculine domain of the MCU ensures that Jones *is* a feminist superhero.

And yet, despite these critical qualities, the gendered boundaries of violence appear more difficult to disrupt. The show's efforts to credit Jones's trauma and the realities of abuse might simultaneously participate in downplaying her physical strengths and her opportunities to use them. Indeed, the same practice parallels the show's "nonsuper" characters such as Walker, whose skills in self-defense are swiftly undercut by the men she interacts with. Historically, scholars have noted, the introduction of female superheroes into the comic genre required a negotiation between ways of "empowering female lives and bodies that seem liberating to girls and women, while not being threatening to boys and men (or, more broadly, patriarchal gender norms)" (Peppard 2017, 112). That negotiation is especially on display in the context of female violence. As I have suggested, intentionally or not, *Jessica Jones* highlights the subtle and insidious operation of gender norms even in texts that actively aim to disrupt such constructs.

My argument is not meant to be disparaging or to advocate for more violent female characters onscreen. Rather I want to suggest that there *is* something different about the way violence interacts with gender in the series, and indeed in Marvel cinema more broadly. It is of course not the case that all female superheroes are *not* violent or muted in their displays of physical strength. Consider the latest Wonder Woman. Though she too has an aversion to killing people and possesses superhuman strength at least on a par with Jones—Wonder Woman's battle scenes showcase those skills to much greater effect. Similarly, Black Widow of *The Avengers* franchise not only displays her fighting abilities frequently but is an assassin whose capacities for murderous violence are evident. However, both characters bear the more traditional hallmarks of female superheroes—most notably in terms of dress and physical appearance (Green 2019, 177). Indeed, the kind of criticism Marvel has received for objectifying its female action stars seemed to inform Rosenberg's series. Jones's sexuality was not absent—but she herself was not *sexualized* onscreen. That the others conform to those standards of female objectification, perhaps, enables the more capacious use of violence and displays of strength we see from Wonder Woman or Black Widow. Absent that gendered presentation, however, Jones's femininity is secured, I would argue, with the *form that violence takes* for the series' female characters.

The fact that *Jessica Jones* can identify, target and successfully intervene against norms of gender presentation and discrimination in other respects while simultaneously gendering its depictions of violence and female strength is important. It suggests that *violence itself* is a gendered political construct. Jones remains a strong protagonist, troubled but capable and ultimately

victorious in her efforts to see justice done. But for Jones to regain her autonomy against her attacker, the boundary-bending quality of the character—and of the show generally—does not extend to the use of violence. Instead, Jones's physical strength, her ability to overpower, or her entitlement to express her rage through violence is curtailed by norms of women's physicality and how it can, or ought to be, directed. As Jones herself notes, the fact that she can lift a car and much more is not something the world is ready to acknowledge in women, even fictional ones. But the series addresses that fact by keeping Jones's pain and susceptibility to male harm within the audience's view of her strength and her capacity for violence. A feminist superhero, it seems, must also be a vulnerable heroine.

Notes

1. For a related analysis of Agent Peggy Carter, see Fattore's chapter in this volume.

2. Elements of this argument draw upon a comparative assessment of gender, race, and violence across Marvel's Netflix series *Jessica Jones*, *Luke Cage*, and *The Punisher* (Philips 2022).

3. Jones's work with the Avengers is alluded to in the Netflix adaptation, though it is an explicit part of her comic book series.

4. See Forestal's chapter in this volume.

5. For an insightful discussion of the racial politics reflected in the show, see Nadkarni (2018).

6. The sexualization of dominance in books such as *Fifty Shades of Gray* drew critical attention for the ways in which it misrepresented the norms of consent and safety guidelines practiced in BDSM communities. Instead, the novel (and its film adaptations) "eroticizes sexual violence, but without any of the emotional maturity and communication required to make it safe" (Green 2015).

7. See also Daily in this volume.

8. For a broader discussion of gender and violence in the MCU, see Szekely in this volume.

"I KNOW MY VALUE"

Agency in the Prime-Time Network Portrayal of Peggy Carter

Christina Fattore

Scholars evaluating Marvel cinema can borrow feminist scholar Cynthia Enloe's (1990) famous question: "Where are the women?" In the early phases, titular characters such as Iron Man, Thor, and Captain America are the focus. In contrast, female characters are never in the spotlight. Instead, they are relegated to supporting roles, like Pepper Potts, whose main job is wrangling Tony Stark, a man who is larger than life. Later, broken women are introduced. Black Widow/Natasha Romanoff appears first in *Iron Man 2* (2010) as a suspicious interloper and then as a possible double agent. Women become more common in the Marvel Cinematic Universe (MCU) in the "team" movies, such as *Guardians of the Galaxy* (2014) and the *Avengers* movies. The other female Avengers and Guardians are not introduced until MCU Phase 3 (2016–2019), and, as of today, only Captain Marvel/Carol Danvers has been featured in a female-focused origin story. To date, the MCU has been overwhelmingly male-centric, focusing on the masculinity of heroism. (For a useful accounting, see Szekely in this volume.)

Agent Peggy Carter is not an Avenger. She does not have any superpowers or other special characteristics that makes her extraordinary. Yet as soon as Peggy Carter appears on screen in *Captain America: The First Avenger* (2011), the audience knows she is not a wilting flower. She is wearing her trademark red lipstick, dressed neatly in a British military uniform, and followed by a male soldier carrying a large crate filled with clipboards containing information about each of the supersoldier candidates the military is evaluating. In her first thirty seconds on screen, Agent Carter introduces herself and informs the all-male recruits that she is the division's supervisor. When one of her men attempts to demean her, she promptly punches him in the face.

When television audiences meet Carter in postwar New York City in the television series *Marvel's Agent Carter* (2015–2016), she is similarly unflinching. In her first scene, Carter is having her morning tea in a dingy efficiency apartment that she shares with a roommate who works the night shift. She's Peggy, the girl who works at the phone company and shares her roommate's

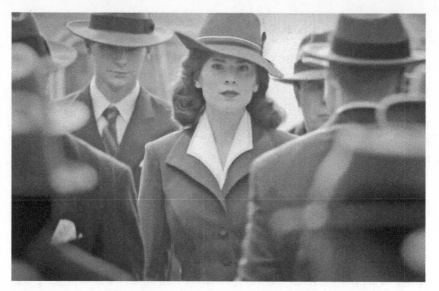

In *Agent Carter*, Peggy is depicted as a woman unflinchingly navigating life in male-dominated post–World War II society. From *Agent Carter* (2015).

concerns about being laid off as companies attempt to open up jobs up for GIs returning from World War II.

The *Agent Carter* television series and the character development of Peggy have tended to polarize both scholars and critics. The show has been described as a "Marvel Comics property branded as 'feminist' . . . a strategy to retain consumers" (Doyle 2015). It has been lauded as "a bold feminist critique of workplace sexism" (Siede 2015) and a "feminist fantasy" (Ferguson 2016). Others have critiqued its "Saturday morning cartoon feminism" in "presenting a gallery of silly sexist men who underestimate the awesome Peggy Carter" (Shaw-Williams 2015).

While commentators may not agree on its value as a feminist addition to contemporary Marvel cinema, Peggy's adventures while part of the Strategic Scientific Reserve (SSR) mirror the experiences of women spies during and after World War II. (For a broader look at the depictions of women combatants, see Szekely in this volume.) Unlike the movies of the MCU, women in *Agent Carter* take center stage as both heroine and villain. Like others in this volume (see, for instance, Beail, Kanthak, and Philips), I use a feminist lens (Tickner 1992; 2001) in this chapter to gain a better idea of feminist agency within the MCU, especially in a society where women are constrained by societal norms. *Agent Carter* affords us the opportunity to examine where the women are as they are placed front and center in Marvel cinema for the first time.

"But They Don't Send Women into the Field": Peggy's Origin Story

While Peggy plays a big role in Captain America's origin story, it isn't until season two, episode four that viewers learn about Peggy's origins. Growing up in England, young Peggy is berated by her mother for being too physical, adventurous, and unladylike. Young Peggy is very close to her brother, Michael. In the next "origin" scene, the audience sees Peggy working as a code breaker in Bletchley Park. It seems as though Peggy's mother got her wish: Peggy is engaged to Fred Wells, a member of the British Army who believes a "boring life is a privilege" (S2, E4: "Smoke and Mirrors") and expects Peggy to be a part of his boredom.

Peggy is surprised when her boss, Mr. Edwards, approaches her with a recruitment offer from the Special Operations Executive (SOE). She is surprised that they are recruiting women, all the more so because Peggy works as a British code breaker, which was not necessarily considered to be a male profession (Martin 2015). She flashes her engagement ring to Mr. Edwards as an explanation of why she cannot accept the offer. Peggy sees herself as a "safe" woman, one who is working until she gets married and has children (Smith 2015; Mahoney 2019). Mr. Edwards disagrees with her assessment. He explains, "You're already an exceptional code breaker, Miss Carter. Someone must see a great deal of potential for you to be tapped." Peggy demurs, saying that she is "simply not cut out for that line of work" and that she will "discuss it with her fiancé" (S2, E4: "Smoke and Mirrors").

Peggy learns later that her brother, Michael, is the one who recommended her for the SOE position. Indeed, family connections were a central mechanism by which women were recruited into the British intelligence community during World War I and World War II. Proctor (2005) explains how gender played into the British understanding of patriotism and loyalty. Male spies were considered to be loyal due to their love of country, while women could be trusted through their familial connections. In *Agent Carter*, Michael's word is enough for the SOE to reach out to Peggy to be one of their new female recruits. And Michael is instrumental in encouraging Peggy to accept the offer; when Peggy and Michael discuss it, Michael reminds Peggy that she wanted "a life of adventure," not a life of privileged boredom. Peggy insists that she's matured since then, but Michael disagrees, insinuating instead that the patriarchy has shifted her goals ("No, you just let everyone else drum them out of you" [S2, E4: "Smoke and Mirrors"]).

Critics of *Agent Carter* have pointed to this familial type of recruitment as a depiction of taking agency away from the female spy. Smith (2015a, 118–119) explains that women like Peggy "become a part of the organization based not

on their own merits or skills but because of who they know or who they are related to. . . . [Her] life is completely dependent on a male figure." Peggy proceeds with her plans to marry Fred Wells and only abandons them when Michael is killed in action. Michael's recommendation is what sets Peggy on this path, but her decision to join the SOE occurs only after his death. In this way, the portrayal of Peggy's transformation into Agent Carter falls into the stereotypical understanding of the motivations of female intelligence workers. Proctor (2005) claims that "the world media reified a certain image of women's wartime heroism . . . [as] motivated by love." In other words, Peggy does not join the SOE because she wants to but because it was what Michael wanted for her, and she wants to honor his memory.

However, Peggy and Michael's relationship can be considered from a more philosophical point of view than the more direct interpretation via feminist critique. Foucault (1983) uses the concept of parrhesia as a type of discourse that is reflective of one's self. McGushin (2007, 123) explains that "one needed a true friend, a true advisor . . . in order to accomplish the ethical formation of oneself because one needed to be saved by the true words, the parrhesia, which the other speaks." Instead of interpreting Michael's words to Peggy as a command or criticism, viewers can consider that Michael, the brother with whom she grew up, played, and confided, recognizes Peggy's true self. Peggy is not immediately saved by Michael's true words, as it is only after his death that she pursues the SOE. But Peggy does go on to have a "life of adventure": she joins the SOE, acts as Captain America's liaison during World War II, becomes an agent in the SSR, and then is one of the founders of S.H.I.E.L.D. and its founding director. Peggy's origin story reinforces her agency. She *chooses* to join the SOE after her brother's death as an act of *parrhesia* (Foucault 1983), not immediately after she learns of his recommendation.

"Let Her Stay . . . Maybe She'll Learn Something": Sexist Office Politics

On its surface, *Agent Carter* seems to be about a woman finding her way through the Anglo-American toxically masculine world of the late 1940s. Peggy laments to her friend Angie Martinelli that "during the war, I had a sense of purpose, responsibility. But now, I connect the calls, but I never get a chance to make them" (S1, E1: "Now Is Not the End"). Her male colleagues treat her like a secretary, asking her to take care of files, cover the phones, or bring in coffee while they take care of the "real" business. Her boss is Roger Dooley, the chief of the New York branch of the SSR. Dooley is constantly annoyed by Carter's presence in his office. He trusts his male agents to do things correctly,

while he sees Carter as a liability. In a moment of anger, Carter berates him for his behavior, saying, "To you, I'm a stray kitten left on your doorstep to be protected" (S1, E7: "Snafu").

Peggy's main office antagonist is Agent Jack Thompson, a handsome alpha male who is also a decorated war hero via the Pacific Theater. When Thompson isn't sucking up to Dooley, he is the ringleader of the SSR agents who attempt to cut Peggy out of her job. Thompson and his crew imply that Carter's wartime job as Captain America's liaison was more a sexual role than a serious military one (S1, E1: "Now Is Not the End"). He even reveals that he recognizes his misogyny in season One, episode four: "The Blitzkrieg Button," when he tells Peggy that it is "the natural order of the universe. You're a woman. No man will ever consider you an equal. It's sad, but it doesn't make it any less true."

The only male "friend" Peggy has in the New York office is Agent Daniel Sousa. Daniel defends Peggy to Thompson and his crew in season one, episode four when they make crude remarks about Peggy's role in the war. The audience discovers that Daniel is an amputee and walks with a prosthesis and a crutch, which could be a physical representation of his "damaged" masculinity in the eyes of the other male agents in the office. (This depiction is more reductionist than many depictions of disability in Marvel cinema; see Daily in this volume.) This is part of why he seems to align himself with Peggy. Daniel also has romantic feelings for Peggy, which are unrequited, as she is still in love with the assumed-dead Steve Rogers. His feelings are quite obvious; in season one, episode three ("Time and Tide"), Agent Kazminsky, one of Thompson's allies, discourages Daniel's crush on Peggy, saying, "No girl is going to trade in a red-white-and-blue shield for an aluminum crutch." While Peggy is repeatedly reminded that she is not "man" enough for the SSR, Daniel has been emasculated by his disability, especially when compared to the ideal of Captain America.

While the sexist dialogue written for Thompson, Dooley, and the other SSR agents is perhaps a bit overwrought and obvious, the attitudes towards female intelligence agents that these characters embody were indeed pervasive in the postwar period. A CIA-commissioned study "noted that, in order to be accepted, female officers tolerated widespread sexual and racial harassment" (Martin 2015, 102; see also Mahle 2004). Smith (2015a) explains that men and their masculinity are threatened by a self-assured woman with ambition like Peggy Carter. Women like Rose Roberts, who serves as the cover story for the SSR office, are seen as nonthreatening and acceptable members of the intelligence community (Toy and Smith 2017). Rose is content being the cover, either as a phone operator in season one or the receptionist of a Los Angeles talent agency in season two. In season two, episode five ("The Atomic Job"), Peggy and Daniel discuss whom they could utilize as a distraction while they

break into a Roxxon warehouse. Peggy suggests Rose as the decoy, and Daniel refuses. Peggy persists, claiming that Rose "passed the same training as the men upstairs, and she protects all of you. . . . She's smart, she's resourceful, and I trust her with my life." Rose knows her place in the SSR, whereas Peggy does not, and Peggy is repeatedly punished via harassment for knowing her value (S1, E8: "Valediction"). While *Agent Carter* answers Enloe's (1990) question ("Where are the women?"), the show's men repeatedly remind women what their place is *supposed* to be and repeatedly penalize women like Peggy who value their agency and refuse to be held within those "acceptable" bounds. While critics may not be happy with the portrayal of restrained women within the MCU, *Agent Carter* paints a realistic response to feminist agency within the traditional norms of the postwar 1940s.

Flying under the Radar: The Value of Women Spies

The MCU is filled with stories that reinforce the theory of hegemonic masculinity (depicting, for instance, men as the "default" combatants, as Szekely discusses in this volume) But Marvel's *Agent Carter* series focuses on the flaws of hegemonic masculinity by allowing Peggy and her varying nemeses to fly under the radar because of their gender. Martin (2015, 99, 105) explains that women "did not raise suspicion among the male commanders" of the US Revolutionary War and therefore were able to collect intelligence while passing unnoticed. She also claims that "the biggest advantage to women in operations is that foreign men will tell women anything, because of their disarming, nurturing, and non-threatening nature. Men never suspect women are intelligence officers." Murry (2017, 80) agrees that female agents can lean on their friendships with local women to collect intelligence. Van Seters (1992) and Pattinson (2016) claim that women have traditionally been disparaged as having only one tool by which to extract intelligence: their sexuality.

The audience sees Peggy escape notice repeatedly, both in her office and in public. In season one, episode one ("Now Is Not the End"), Peggy is able to sneak into a nightclub to question Spider Raymond, a known black-market dealer who has possession of one of Howard Stark's "bad babies." Wearing a long blonde wig and a form-fitting silver gown, Peggy is able to flirt her way into Spider's office to question him. While Thompson, Kazminsky, and another agent are unable to blend in with the club's patrons, Peggy is able to slip back out of the club without attracting their attention. In season one, episode two ("Bridge and Tunnel"), Daniel tells Peggy that he has pictures of the blonde who was with Spider before he was killed and locks it in his desk drawer before he goes on a call. With at least three other men in the main office eating

two, episode four, Whitney's husband, Calvin Chadwick, reminds her about their photo shoot with *Life* magazine: "It's your face they want!" However, that is where the parallels between the real Lamarr and fictional Frost end.

From childhood, Agnes/Whitney is told that her value is in her looks. After she is rejected from the University of Oklahoma, her mother taunts her:

> You think you're so damn smart? You really think that fancy science program is going to take a girl? It don't matter how smart you are, you're stuck here, same as me. . . . No one cares what's in your head. If you're half as smart as you think you are, you'll fix on this [she grabs Agnes's face]. This is the only thing that is going to get you anywhere in this world. (S2, E4: "Smoke and Mirrors")

Agnes runs away to Hollywood and is discovered by an agent who is taken by her looks and suggests that she can be a model or an actress. The newly minted Whitney Frost takes Hollywood by storm, but by the time the audience meets her, her career is in decline because she is not as young as she used to be.

In order to maintain her appearance as a beautiful actress, she files patents for her inventions under her birth name, Agnes Cully. Isodyne Energies, which is owned by her husband, acts as a front for Whitney's inventions. She is successful in hiding her true identity until it is uncovered by now Chief Daniel Sousa. By episode two, Whitney shows the audience her real top concern when Chadwick tells her that the Council of Nine, the sponsor of his senatorial campaign, has decided to get rid of her Zero Matter. Her reaction is one of utter surprise, and she is on the verge of tears before she pulls herself together and decides to take the Zero Matter before it is disposed. After a struggle with Dr. Jason Wilkes, Whitney seems to have absorbed the Zero Matter.

Whitney's descent into an unstable madwoman and eventual institutionalization can be explained using Sjoberg and Gentry's "monster" narrative (2007). Whitney's genius can be seen as a "defect" in her femininity. The audience is shown that her main interest in childhood was science, not using her beauty. Whitney frequently emasculates Chadwick, whom she sees as weak. She is the one who deals with his affair with Jane Scott in episode one. She is dissatisfied with Chadwick's reluctance to stand up to the Council of Nine, which refuses membership to any woman. In episode five, Peggy confronts Whitney and Calvin arguing at Roxxon. She suggests that the SSR could help Whitney remove the Zero Matter from her body, and Whitney balks: "Fix me? Why would I want to be fixed? I have never felt more powerful in my entire life!" (S2, E5: "The Atomic Job").

As her power grows, Whitney kills Chadwick with her Zero Matter energy

and turns to an old flame, mobster Joseph Manfredi. At first, he is enthralled by her and tells her what she wants to hear: "You're more beautiful than the day I met you . . . that mark on your face is nothing to be ashamed of. It's power. And that's what makes you so beautiful" (S2, E8: "The Edge of Mystery"). Manfredi convinces himself that he finally is getting what he always wanted (Whitney), but then he confesses that she has changed because of the Zero Matter. He works with Peggy and Howard Stark to capture Whitney and extract the Zero Matter from her. Whitney is then institutionalized, where she mourns the stolen power and accomplishments that she sees as the crux of her career. Once again, *Agent Carter* tells the story of a woman being punished for attempting to move beyond her given role in a patriarchal society. The viewer is being told that women can be seen, but only in societally defined appropriate ways.

Agency and Feminism in Peggy Carter's Story

While fans rejoiced that Peggy Carter got her own story, critics felt this was a watered-down moment for feminism in Marvel cinema. There could be a number of reasons for this. First, the show was constrained by network television norms, as it aired in prime time on ABC. Both seasons were shown on Tuesdays at 9:00 p.m. Eastern, which allowed the show to be a bit more risqué than if it had been shown in the previous hour's time slot. However, unlike characters in the movies as well as the Netflix-produced Marvel shows, Peggy remains a buttoned-up, proper woman of her time. (See, for instance, Philips in this volume on how *Jessica Jones* depicted a far less buttoned-up female protagonist.) Sure, she flirts with, dances with and kisses various men (Dr. Jason Wilkes and Chief Daniel Sousa, both in the second season), but her sexuality is never part of her portrayal in the ABC show. Peggy remains the quintessential career girl of the late 1940s and 1950s: ignoring romantic attachments and focusing on career advancement (Smith 2015).

The literature regarding the growth of the female spy population in the 1930s and 1940s provides a picture of propriety. Women were recruited into spy networks because of their connection to male relatives who could vouch for them, not because of their own skills and strengths. Their service was based on obligation: they were protecting their homeland because it was representative of their families, and "good" women protected their families. Borrowing from the idea of republican motherhood (Kerber 1976; 1980), these women served until they were needed in a different familial role, that of the mother. Their choice of role was constrained by societal expectations of their gender, removing women's agency.

However, in *Agent Carter*, viewers finally get to "see the women" after they have been predominantly absent from or minimal in the main MCU films. Peggy, Dottie, and Whitney represent women with agency and rationality. While Peggy's brother influences her consideration of joining the SOE, she decides to remain in the SSR and eventually lead S.H.I.E.L.D. She has many adventures, which Michael reminds her is her true path in life. As villains, Dottie and Whitney are both portrayed as broken and unstable; the whore and monster narratives are stories society uses to explain women who do not fit into their assigned gender role. Why couldn't Whitney be satisfied with her success as a two-time Oscar winner lauded as the most beautiful woman in the world? Why didn't Dottie take the opportunity to defect when she found herself in the United States, fulfilling that long-ago dream of being a "normal" girl? While critics were dissatisfied that *Agent Carter* did not push the envelope further in a feminist portrayal of these stories, scholars can use a feminist lens to gain a better vision of female agency in a society where women were structurally constrained.

We can also use a feminist lens to examine why *Agent Carter* was canceled after two seasons, while the similarly struggling *Agents of S.H.I.E.L.D.* (2013) was allowed to be reformatted multiple times in order to survive for seven seasons. Michele Fazekas and Tara Butters were co-showrunners for *Agent Carter*. With Chris Dingess, they were in charge of *Agent Carter*'s creative team of writers and creators, making it the first Marvel show or film run by women (Abrams 2015). *Agents of S.H.I.E.L.D.* had the advantage of having Joss Whedon, the esteemed director and writer of *The Avengers* (2012) and *Avengers: Age of Ultron* (2015), as its creator. Whedon's brother Jed and sister-in-law Maurissa Tancharoen headed the *Agents of S.H.I.E.L.D.* creative team with the help of Jeffrey Bell. While women were a part of the team on *Agents of S.H.I.E.L.D.*, Peggy was the true lead of *Agent Carter*. Jeph Loeb, the chief of Marvel's television division, blames *Agent Carter*'s short life on ABC's decision to axe it from its prime-time lineup (Nededog 2016). And while both shows certainly struggled with the ratings, ABC allowed *Agents of S.H.I.E.L.D.* more time for success in terms of adjusting day/time slots, storyline foci, and tie-ins to whatever was happening in relation to the MCU movies. *Agent Carter* was canceled without much fanfare or explanation, leaving fans and Marvel executives alike wondering why these two Marvel/ABC series met with such different fates.

While the show ended in 2016, that was not the end of Peggy's story. She was a minor character in many of the Captain America movies, and viewers saw her funeral in *Civil War* and her eventual reunion with Steve Rogers in 2019's *Avengers: Endgame*. Through these snippets, Peggy was relegated to being a footnote in history as the founding director of S.H.I.E.L.D. However, in

2021, Peggy Carter was center stage again in the first episode of the Disney+ series *What If?* In this episode, viewers are shown what would have happened in an alternative timeline in which Peggy receives the Super Soldier Serum instead of Steve Rogers. When a Nazi agent attacks the lab in which Rogers is supposed to be enhanced and shoots Steve, Peggy quickly volunteers to step into his place. The new head of the SSR refuses to allow Peggy to join the war effort because he's a misogynist, but that does not stop Peggy from using her newfound strength to her advantage. Supported by her friend and ally Howard Stark, who outfits her similarly to the Captain America fans know, Peggy retrieves the Tesseract from Hydra. This success proves her mettle to the SSR, which promotes her to a combat role as "Captain Carter." Similar to the end of *The First Avenger*, Peggy sacrifices herself to save the world from a Hydra-controlled creature from another dimension.

While Marvel knew of fans' dissatisfaction with the abrupt ending of *Agent Carter*, it was if it attempted to remedy that by making Peggy not only have superstrength but also be named a Guardian of the Multiverse by the Watcher and Doctor Strange. However, from a feminist perspective, Peggy should not have to be Captain Carter to be a hero. She was a hero in her original timeline, even if her coworkers at the SSR did not recognize her strengths. Peggy already knew her value.

MEN AND SUPERMEN

Gender and (Over)Compensation in the Marvel Cinematic Universe

Dan Cassino

Being a man means more than just being male. In our society—and most Western societies—a masculine gender identity is something that's earned and, as such, can be lost if men fail to live up to the standards of masculine behavior expected by society, or themselves. This struggle to demonstrate masculinity drives much of the behavior of men in the real world, and even more so among the supermen of the Marvel Cinematic Universe (MCU).

This subtext of masculinity is occasionally made explicit, as in *Iron Man 3* (Black 2013). Having been unable to protect Happy Hogan from an attack that he believes was staged by the Mandarin (he won't uncover the true culprit until later in the film), Stark lashes out: "My name is Tony Stark, and I'm not afraid of you. I know you're a coward, so I've decided that you just died, pal: I'm going to come get the body. There's no politics here; it's just good old-fashioned revenge. There's no Pentagon; it's just you and me. And on the off-chance you're a man, here's my home address: 10880 Malibu Port, 90265. I'll leave the door unlocked."

Confronted with a failure, Stark questions the manhood of his opponent in what amounts to a preening display of gender identity. Sure, he's upset at an attack on his home that nearly killed one of his only friends and worried about the safety of the people whom he loves, and by any standard, he isn't thinking clearly (he did just give his home address to a terrorist on live TV). But there are lots of ways in which someone could respond to those stresses: he could protect the people close to him by going underground for a while; he could call in his friends from the Avengers; he could vow to rebuild. Instead, he questions the manhood of his opponent and challenges him to a fight. Does that make sense for his character in that situation? Sure. But the way he chooses to express his decision is telling: for Stark, at least, this attack is a challenge to his masculinity, and he's going to respond in kind. (For other takes on Stark, see Kohen's chapter on his role as a classical hero and Daily's chapter on his depiction of endurance through disability in this volume.)

In Western societies, men's gender identities are considered to be much more fragile than those of women (Kimmel 2000): this is clear even from the language we use to talk about gender. A person who's biologically male might not be a "real man" if he's not living up to societal standards of masculine behavior. Under such circumstances, he might need to "man up," and if he gets upset about it, he may be acting "like a girl." Because men occupy a place of privilege in our society, a failure to act in accordance with prescribed gender roles means that men are giving up that privilege and are seen as deserving disdain for doing so. Nor is this unique to contemporary Western societies: male-centered cultures have rituals to show that boys have become men, be it a lion hunt, a circumcision, or a walkabout. Relatively few have traditional equivalent womanhood rituals (an exception comes from some Jewish sects in the twentieth century that have adopted coming-of-age rituals for girls; other rites, such as quinceañeras and debutante balls, are more focused on announcing eligibility for marriage).

Of course, what constitutes masculine behavior has varied widely across time and place, and things that might have been considered masculine at one time might be seen as feminine today, or vice versa. This change can happen very quickly, in the way, for instance, cooking moved from being seen as an activity for women to one that allowed men to show off daring, creativity, risk-taking and mastery in the early 2000s (Besen-Cassino and Cassino 2014). But modern masculinity in the United States—the environment that created the superheroes of the MCU as well as most of their stories on the big screen—rests on just a few major pillars (Townsend 2002): provision (earning money to support a family), fatherhood, and protection. These roles are mutually reinforcing: men can protect their families by earning enough to live in a safe neighborhood, for instance. So long as men are able to meet these expectations, in their own view and that of those around them, their masculinity is relatively secure. But when men come to believe that they are not meeting the standards of masculinity, they have to find some way to compensate for their perceived failure (Willer et al. 2013).

Among superheroic men, these compensatory behaviors are often grander in scale, with farther-reaching consequences, than the activities that men in the real world might engage in, but they're very much of the same type. While some traits of the men of the MCU, such as their obligatory physique, are pretty close to universal, their expression of masculinity runs the gamut from the toxic (Yon-Rogg) to the hegemonic (Thor and Hulk in *Thor: Ragnarok*, Flash Thompson) to male characters who eschew hegemonic masculinity (Spider-Man) and even those for whom gender is essentially unrelated to the action (Black Panther, Loki, or Yondu). By looking at how men in the MCU compensate for their real and perceived failures to uphold the standards of a

masculine gender identity, we can see how their actions mirror those of men in the real world.

Before going too deeply into how gender shapes men's behaviors, it might be helpful to differentiate between gender and sex. Sex is often thought of as biological in nature, and while it is much more complicated than simple distinctions between male and female, it's entirely separate from someone's gender identity. Gender is entirely social, and while, in general, men tend to have masculine gender identities and women tend to have feminine gender identities, nearly everyone exists somewhere on spectrums of masculinity and femininity, and for many people, gender identity doesn't conform to sex. Men can be more or less masculine and often perceive themselves to have feminine traits as well. These identities are an important part of the way we view ourselves, which is why threats to those identities, arising from the belief that we're not living up to the demands of our gender identities, can have such an enormous impact on how people behave as they struggle to reassert that identity.

Gender is just one of many social identities that can shape political and social behavior. Scholars have also paid a lot of attention to the effects of racial and ethnic identities, partisan political identities, religious identities, and others (Tajfel 1974). Any of these identities can influence political and social views and behaviors, but that influence is tied to the salience of that identity in a particular situation. So if something makes someone's religion, or racial group, more relevant at that moment, that identity will have a bigger influence on behavior. Gender is thought to be an especially important social identity (Wood and Eagly 2015) because gender is so important to how we experience the world around us. For the same reason, threats to gender identity may be felt more keenly than threats to other social identities that are less frequently salient.

This is, of course, a book about politics, but in the United States, at least, politics and masculinity are tightly linked. The ways men choose to express their gender identities, in the MCU and in the real world, are often political in nature, and understanding them tells us a lot about the current state of US politics. Political and social statements are an especially potent way to express masculine gender identity because we've come to assign gender to political stances and parties (Winter 2010) and because this gendering is widely recognized. The point of men's compensatory activities is to prove to themselves and those around them that they're upholding their roles as men. So an activity only works well if others can see it and recognize its gendered nature. In US politics, voters have come to see the political parties as gendered, despite the fact that they don't have a sex: the Democratic Party is seen as female and the Republican Party as male. Health care and housing are feminine issues, while

the Second Amendment and the military are seen as masculine issues. This is, of course, entirely in addition to the extent to which candidates themselves may be male or female or perceived as relatively masculine or feminine. For instance, 2004 Democratic presidential nominee John Kerry, despite being a decorated war hero, was portrayed as effete and feminine in contrast to incumbent President George W. Bush, who was portrayed as a rancher and a warrior, masculine in the ways that his opponent was not (McDermott 2016). These genderings of issues and actions are widespread and accepted enough that men know that expressing support for gun rights, buying a gun, or applying for a concealed carry permit will all be recognized as masculine behaviors, linked with the masculine role of a protector.

Of course, we need to be careful about overapplying this model. Not all setbacks experienced by the men of the MCU are framed as being about masculinity. For instance, when T'Challa loses his role as king of Wakanda after being bested in combat by Killmonger, nothing in his response is indicative of a threat to his gender identity. He doesn't suddenly become more aggressive or try to display dominance in other ways or emphasize other roles that might help him assert a masculine identity. Instead, he reaches out for help and builds a coalition to help him regain the throne. The contrast with Tony Stark's response to loss, or even T'Challa's response in earlier films to the loss of his father, couldn't be clearer. Other men of the MCU are similarly self-assured: while Yondu may stress his role as Star-Lord's "daddy," there's no point in the *Guardians of the Galaxy* movies at which he seems anything other than completely comfortable in his masculinity. He lashes out, sometimes violently—but it never seems as if he's doing it out of a need to assure himself and others about his masculinity. Loki is motivated by many different roles—his mixed racial identity, his desire to rule—but (as befits a character who has been both male and female in the comics and in myth) his masculinity isn't one of them. The sorts of gender identity–based responses of interest are those that arise when a character perceives (correctly or not) that his (while women have masculinity, too, they're less prone to compensating in the face of threats to it) masculinity is being called into question and then acts out in a way that he believes will be perceived as masculine in order to reclaim his gender identity. Among men in the MCU, and the real world, these responses can take many forms, but the pattern is always the same.

We also need to be careful about differentiating between masculinities. It's tempting to think of masculinity as one set of ideals and behaviors, but it contains multitudes. Within a given social context, the dominant forms of masculinity, the standards that men often internalize, are referred to as "hegemonic masculinities" (Connell 2005; Connell and Messerschmidt 2005). Among white men in the modern United States, hegemonic masculinities

include personality traits such as risk-taking and stoicism, roles such as financial provision and protection, and even physical traits such as a deep voice and muscular development. Of course, most men don't meet the high standard of hegemonic masculinity, and many simply can't—but that doesn't limit its application. Men who don't meet the standard still understand their own gender identity in relation to it and work to establish their masculinity relative to others around them, as in the MCU's Flash Thompson bullying Peter Parker. Movie Flash may not be the football star that he is in the comics, but he's still keen to show that he's higher in the pecking order than Peter; the phallic nickname he gives Parker in *Spider-Man: Homecoming* isn't an accident. Connell argues that masculinity requires that men create a hierarchy among types of masculinity and that men work to establish their place in that hierarchy, pushing some men to the bottom and placing all of them above women to legitimize male dominance in society. In the United States, for instance, we judge candidates for public office, at least in part, on how well they meet these roles (McDermott 2016). This makes it harder for some men, and for most women, to achieve high office, an effect that Connell would see as being largely the point.

Talking about hegemonic masculinities in a book about the heroes of the MCU seems like a criticism: for the most part, the male superheroes we're shown are impressively muscled and not shy about showing it off. Indeed, one of the more progressive aspects of the MCU is its tendency to sexualize male, rather than female, bodies. The heroes presented are assertive and risk-taking and prone to covering up their emotions with a quip. But, as we'll see, their behaviors often aren't in line with the destructive tendencies of hegemonic masculinities, which, in Connell's telling, often include policing the behaviors and appearances of other men and asserting their dominance over women. In the face of gender identity threat, men's compensatory behaviors often draw from these relatively valued forms of masculinities. This makes sense: if the goal of compensatory activities is to establish to an audience that men have masculine traits, they're likely to draw on those traits that are most widely recognized as masculine.

These hegemonic forms of masculinity are often in contrast with marginalized or subordinate masculinities. Unable to live up to the standards of masculinity but still seeking to assert a masculine gender identity, men find alternate behaviors and signifiers of masculinity. So while Peter Parker is certainly not meeting the standards of hegemonic masculinity in his civilian identity, he's still able to demonstrate a form of masculinity through technical and scientific mastery. Essentially, he's not trying to compete on the grounds defined by hegemonic masculinity but rather is trying to create an identity through other interests that might be accepted by at least some others (such as his best friend, Ned) as a form of masculinity. As society shifts, these marginalized

masculinities, especially those expressed by racial and ethnic minority groups, often become part of the dominant expression of masculinities as the meaning of gender adapts to new circumstances.

Subordinate and marginalized masculinities can also include the ways that masculinity is demonstrated by disadvantaged groups within a society. Because masculinity displays are meant to assert an identity to those around the man, the types of displays are likely to vary based on social context, so people in different social contexts will have different forms of display. African American men are likely to demonstrate masculinity differently than white men, and gay and queer men are likely to demonstrate it very differently than straight men. While the MCU has taken steps toward greater diversity in its protagonists, they remain overwhelmingly white and heterosexual (as Rodda notes in this volume), so any discussion of masculinity in the MCU is largely bounded by these groups. Like other forms of subordinated or marginalized masculinities, the displays found in these groups are often appropriated by dominant forms of masculinity as old displays lose their relevance.

Discussions of gender identity threat among men are separate from discussions of what is often called "toxic" masculinity (Karner 1996). Toxic masculinity involves the assertion of masculine gender identity through actions that are intended to harm or demean others, be they women or men perceived as less masculine. Yon-Rogg, Carol Danvers's trainer and main adversary in *Captain Marvel* (Boden and Fleck 2019) is a good example. He is possessive of Danvers, shows his dominance over her by hitting her, and demands that she fight him hand-to-hand so he can show that dominance (a challenge Danvers refuses). Perhaps worse, he's part of the long-term gaslighting of Danvers, lying to her about her past and making her doubt her own memories and intuitions. This sort of reprehensible behavior isn't on the normal spectrum of masculine behaviors or compensatory acts. If men choose to express their masculinity in such destructive ways, there's something outside their gender identity motivating them (in Yon-Rogg's case, a desire to control a powerful being and aid in a quest for interplanetary domination), so it's well beyond the scope of what we're talking about here. (For a look at feminine identities in *Captain Marvel*, see Kanthak's chapter in this volume.)

Threats to men's gender identity can come from all sorts of sources. There's evidence, for instance, that having a female boss can lead men to fear that their gender identity has been compromised by being subordinate to a woman. But one of the most frequently studied sources of gender identity threat comes from economic threat. Provision is one of the pillars of modern American masculinity, in Townsend's (2002) formulation, so losing income strikes at the heart of men's role as provider as well as implicating their ability to be good

fathers and protect their families. As such, loss of income can be a serious threat to men's gender identities.

In *Homecoming*, this threat is most clearly shown in the person of Adrian Toomes, the Vulture. Toomes's company Bestman Salvage (no one said the links to masculinity had to be subtle) had a contract with the city of New York to remove Chitauri wreckage until it was superseded by a federal contract awarded to Damage Control, a joint partnership of Tony Stark and the federal government. (Damage Control has a similar function, but rather different origins, in the original comics.) Told to get out and turn over operations to Damage Control, Toomes begs Damage Control's manager, Anne Marie Hoag, for a reprieve, pointing to his responsibilities as a business owner and a parent, but to no avail: "I bought trucks for this job. I brought in a whole new crew. These guys have a family. I have a family. I'm all in on this. I could lose my house" (Watts 2017). As noted, being the breadwinner is a pillar of modern American masculinity, and Toomes's ability to meet this expectation is being threatened by forces outside his control, embodied in an assertive woman who emasculates him in front of his own men. Toomes makes it very clear that this is not just about a job: this is his role as a father, as a provider for his family, and when he believes that his ability to provide for his family is threatened, his first response is to attack a male Damage Control worker. When that, predictably, fails to achieve the desired result, he takes extreme action, using the salvaged Chitauri equipment to build his flying harness and operate as the Vulture.

Later in the film, Toomes claims that he's fighting back against the rich and powerful, telling Spider-Man, "The rich and the powerful, they do whatever they want. Guys like us, like you and me, they don't care about us. We build their roads, and we fight all their wars, and everything, but they don't care about us. We have to pick up after them. We have to eat their table scraps" (Watts 2017). But while he may present, and may even see himself, as a blue-collar man of the people, he lives in an enormous house in the New York suburbs and drives a Bentley, hardly marks of the working class. Despite his wealth and privilege, Toomes has come to see himself as a victim of the system in general and of Tony Stark in particular and believes that this victimization justifies his illegal acts. (See Wang and Zhang's chapter in this volume, on the villains of the MCU, for further discussion of how the Vulture embodies the economic anxieties of the current United States.)

The idea that an apparently wealthy white man would consider himself to be the victim of discrimination seems absurd, but Toomes is far from alone in this belief. Despite the fact that men, and generally white men, dominate the upper reaches of leadership in business and politics, men in the United States are increasingly likely to report that they face discrimination on the basis of

Adrian Toomes's ability to succeed as a breadwinner (a pillar of modern American masculinity) is threatened by forces outside his control. Credit: From *Spider-Man: Homecoming* (2017).

their race or sex. In the 2016 US presidential election, these attitudes were strongly associated with support for the populist Republican candidate, Donald Trump (Cassese and Holman 2019).

This belief in victimization is a way for men to avoid taking account of their own responsibility for their circumstances. If you can't find a job, or don't have the things you wish you had in life, it's easier to blame a corrupt system than to examine why you might be at fault. However, it doesn't change the underlying dynamic: Toomes's inability to provide for his family presents a threat to his masculinity, which is deeply tied up in his earnings. In response, he has to find some other way to assert his gender identity: partially by building a flying rig out of scrap Chitauri technology but also by asserting a populist political identity.

In the real world, responses to this type of gender identity threat among men are less likely to involve alien artifacts left over from a failed invasion and are more often political in nature. In an experiment carried out prior to the 2016 US presidential election (Cassino 2018), men were told that there were an increasing number of households in the United States in which women earned more than their husbands and asked about the situation in their household. Half of the respondents were randomly assigned to receive this question before being asked about their preferences in the then upcoming presidential election, while the other half were asked the relative income question only after they had already said whom they'd support in the election.

Men—but not women—who were asked the relative income question before being asked about their presidential preference became much more likely to support Republican candidate Donald Trump and less likely to support Democratic nominee Hillary Clinton. However, when the choice was between two

men—Trump and Vermont Senator Bernie Sanders—there was no effect of the relative income question on preferences among men. In this case, merely asking men about having less money than their wives, not losing their job entirely—or even being in the actual situation rather than bringing it up as a possibility—was enough to dramatically shift men's political preferences in the race. The statement of political preference—for Trump, over a female candidate—was used as a compensatory act.

Politically based compensatory acts of masculinity in response to a loss of relative income go well beyond expressing support for one candidate or another in a telephone survey. Using a panel survey, in which the same respondents repeatedly answered questions about their political views, we were able to identify the political effects of losing income relative to a spouse on political views expressed up to two years later. Men who lost income relative to their wives or became unemployed held more conservative views on a variety of issues in the next wave of the survey, ranging from abortion to government aid to African Americans (Cassino 2018).

The economic shock that pushed Toomes's political views came after the Chitauri invasion of New York in the first *Avengers* movie, set in 2012. A similar shock, resulting in millions of men becoming unemployed, while their wives did not, came in the real world during the Great Recession, beginning in 2008. In both cases, the men who felt their livelihoods, and thus their masculine gender identities, threatened by economic forces beyond their control shifted their political views toward the right, and toward populist views (Kimmel 2017). As the economy continues to shift away from industries that have traditionally been dominated by men, such shifts might be expected to become even more common.

Of course, breadwinner isn't the only masculine role that requires compensatory behavior in the face of perceived failure. Until *Avengers: Infinity War*, Peter Quill was always shown to be remarkably self-assured: indeed, many of the jokes in the first *Guardians of the Galaxy* film center on his overconfidence. But that assuredness comes under attack in *Infinity War*, and we find Quill, like so many men in the MCU, overcompensating for a threatened masculine identity. The first sign that Quill's masculinity is in jeopardy comes when Thor is brought aboard the Guardians' ship, the *Benatar*: as the other Guardians marvel at Thor's physique relative to Quill's, he tries to assert himself by bringing up his role as captain of the ship and even makes his own voice deeper, much to the amusement of the other Guardians. This should sound familiar: unable to assert masculinity in one respect, Quill doubles down on another area in which he can display masculine traits.

However, the real threat to Quill's masculine gender identity comes not from Thor but from Thanos, who threatens his role as a protector. Quill and

his girlfriend, Gamora, confront Thanos, only to be easily defeated. In a final insult, Thanos uses the Reality Stone to disarm Quill, making his once lethal gun shoot bubbles—because literally "shooting blanks" would apparently be too on the nose. Thanos takes Gamora and kills her in order to retrieve the Soul Stone, further underlining Quill's inability to protect his romantic partner. Quill's overcompensation in response to this threat to his masculinity becomes a major plot point later in the film when he, Spider-Man, Iron Man, Doctor Strange, the empath Mantis and Gamora's sister, Nebula, confront Thanos on Titan. Even though Thanos has six of the Infinity Stones, the heroes are able to use their combined powers to hold him down while Mantis lulls him into near unconsciousness, allowing Iron Man to pry the Infinity Gauntlet loose. Before Iron Man can finish, though, and literally moments before the heroes will have disarmed Thanos, Nebula figures out that he must have killed Gamora, sending Quill into an uncontrollable rage. He attacks Thanos, lashing out physically in a way that he must know won't do anything (the Mad Titan can take on Thor, so Star-Lord's punches aren't going to do much), but the attack disrupts Mantis's trance, seemingly dooming the heroes.

But is this really about Quill's gender identity? After all, Quill has previously shown himself to be impulsive and used violence as retribution against Ego in *Guardians of the Galaxy Volume 2*. But Quill himself earlier references his relationship with Gamora as the reason for his presence, telling Spider-Man and Iron Man that he's there because Thanos "took my girl." Quill is there in his masculine role as a protector to save his "girl," and when it becomes clear that that opportunity has been denied to him, he turns to a counterproductive display of violence. If the argument for Quill just being impulsive is that he lashes out in the same way against Ego in *Guardians of the Galaxy Volume 2*, I note that in both cases, he lashes out after being told that he has failed to protect a woman close to him. In the final confrontation in *Guardians of the Galaxy Volume 2*, Quill believes that the male-coded Groot has died: instead of lashing out at Ronan, he challenges him to a dance-off. Of course, the dance-off is a cover for having Rocket rebuild a giant gun, but Quill, in that case, doesn't feel the need to openly assert his masculinity to his opponent.

Perhaps most importantly, Quill's attempts to assert a masculine gender identity are almost universally shown to be a bad thing. He ruins the heroes' chances of taking down Thanos; he's the butt of the joke when he tries to assert dominance over Thor. When he first meets Gamora, he tries to pick her up by playing up his machismo, giving her the chance to steal "the Orb." Even Drax, who isn't known for witty retorts, makes fun of him for the dubious romantic conquests he's been bragging about. The MCU has a complicated relationship with masculinity: being masculine isn't necessarily bad, but trying too hard to be masculine is.

Quill isn't the only hero to respond to a failure to protect those close to him by embracing brutal methods. Hawkeye loses his entire family in the Snapture, and when we catch up with him five years later, he's adopted a new costumed identity, Ronin, and is in the midst of a homicidal campaign to take out crime bosses. Black Widow is eventually able to bring him back into the fold by telling him that they may be able to bring everyone back, and his single-minded mission to kill criminals who survived the Snapture is replaced by a single-minded mission to bring back his family.

For Quill and Hawkeye, a failure to uphold the role of protector leads to feelings of impotence, which they respond to by embracing violent displays of masculinity. It doesn't matter that these displays are ultimately useless—does Hawkeye think that he's going to kill all the criminals who were left alive?—or even counterproductive, as they are for Star-Lord. The fact that Quill's actions won't help anything and wind up turning the tide against the heroes is evident to everyone—they elicited groans from the opening-weekend audience when I saw *Infinity War* initially—but they make sense as an attempt by Quill to assert his masculinity in the face of his failure to protect Gamora. Violence, in this case, is entirely counterproductive, serving no purpose but to make Quill feel better by taking out his aggression on the enemy. It is presented as a terrible idea—but it is little different from the support shown by Americans for war against perceived enemies abroad in the wake of the 9/11 attacks (Huddy et al. 2005), even when those enemies had nothing to do with the attacks.

American men seem to have hit upon a similar way to prove to themselves, and others, that they're fulfilling their role as protectors: firearms. Qualitative research carried out among men who get concealed carry permits has shown the extent to which they see carrying a gun as a way to protect their families and their communities from unspecified, but often racialized, threats. They see a concealed weapon as a way to be "a good guy with a gun," potentially helping their community, even if that role remains entirely theoretical (Carlson 2015; Stroud 2012).

It is no surprise, then, that firearms act as a compensatory behavior for men facing a threat to their masculine gender identities (Myketiak 2016). Studies examining changes in the number of gun background checks over time shows the extent to which gun purchases are driven by gender identity threat (Steidley and Kosla 2018) and the local gun culture (Cassino and Besen-Cassino 2020). Nationally, background checks—which work as a reasonable, if not perfect, measure of gun sales (Cook 2018; Durkin et al. 2020)—increase in response to increases in men's unemployment, but only relative to women's unemployment. That is, if men's and women's unemployment both increase at the same rate, there's no gender identity threat arising from men losing their breadwinner status, so there's no increase in the number of background

checks. But when there's an increase in households in which men have lost their jobs, but their wives have not, background checks increase significantly. The relationship between this pattern and compensatory actions becomes clearer when we break this down on a state-by-state level. In states where guns are more common to begin with, gun sales go up more in response to relative male unemployment than in states where guns are less common. This makes sense: if the goal of the compensatory action is to assert a masculine gender identity to others, particular form of compensation are more effective when other men are making displays in the same way (see also Gahman 2015).

The same holds true for attitudes about guns (i.e. Cox 2007). Men who perceive greater threat from women's progress in politics and society are more likely to oppose gun control measures than those who perceive less threat, holding constant other political and social views (Ray, Parkhill and Cook 2021; Cassino and Besen-Cassino 2020). As much as gun ownership has implications for political views, so do views on gun control measures: some men apparently see even the potential to own a firearm as important to their ability to fulfill their masculine gender identities (Carlson and Goss 2017; Warner 2020).

The dynamic here is familiar. Unable to assert their gender identity in one way, men turn to another important aspect of modern American masculinity, the role of protector (Stroud 2012; Carlson 2015). Men in the US use protection as a compensatory mechanism in a number of ways: concealed carry permits, buying guns or other weapons, even fortifying their own homes. When they do so, they're acting like Quill and Hawkeye. The difference is that men in the real world normally compensate by fantasizing about their role as a protector, using firearms to protect their families from outside threats. In the MCU, superheroes can act on these fantasies, often in brutal, but generally counterproductive fashion.

In these cases, it certainly seems as though threats to men's gender identities lead them to exhibit attitudes and behaviors more in line with the US version of political conservatism than liberalism, but that's the average response, not the only response. When we dig into the data a little more, it becomes clear that threats to men's masculinity don't always lead them to become more conservative, but rather lead already conservative men to be more conservative, and liberal men to be more liberal (Cassino 2018). In the United States, there are more conservative than liberal men, so on average, threat leads to greater conservatism, but this hides the extent to which threat leads liberal men to go the opposite way. Why? Masculinity is enormously flexible. Just as buying a gun works as an expression of masculinity in some places but not others, there's enormous variance in the way that individual men define their gender identities, leading them to compensate in very different ways.

Perhaps the most stark example of this in the MCU is Captain America.

When we catch up with Steve Rogers five years after the Snapture, he's running a support group for people who have lost loved ones. Rather than lashing out, like Hawkeye, or wallowing in self-pity and drunkenness, like Thor, he's focusing on his humanist impulses, counseling survivors on how to manage their emotional reactions. In doing so, he's not giving up on his masculine gender identity but rather refocusing it. This is evident from the way he talks to the support group about their emotional journeys, telling a survivor who went on a date for the first time since the event, "You did the hardest part. You took the jump, You didn't know where you were gonna come down. And that's it. That's those little brave baby steps we gotta take." (Russo and Russo 2019) Rogers is taking the act of recognizing emotions and trying to move forward, even with grief, reframing it not as an act of weakness but as a heroic act. Moving forward is risk-taking, not knowing where you're going to come down, and that sort of risk-taking is masculine. There is, in this formulation, more than one way to be a man: brutality is one way, but being in touch with your emotions is another. Rogers isn't abandoning his masculinity; he's reframing it to be more socially desirable. He may be in a support group, but he's *leading* the support group and fulfilling a masculine role by doing so.

Of course, Rogers isn't the only example in the MCU of how men can respond to threat by reformulating their gender identities in productive ways: a similar journey is taken over the course of the films by Bruce Banner, the Hulk. In the comics that form the basis for the MCU, Bruce Banner lives with dissociative identity disorder brought on by abuse he suffered as a child. As an adult, he represses this abuse, which manifests only after his exposure to gamma radiation gives his alternate personalities physical form. So the traditionally green Hulk represents his childhood self, unthinking, prone to angry outbursts, afraid of abuse, and wanting no more than to be left alone. The more calculating and cruel gray Hulk is the child Banner's idea of an adult, and the malevolent, cunning, violent "devil Hulk" is Banner's idea of his own father. The MCU Banner doesn't have quite as tragic a backstory: as told in *The Incredible Hulk*, Banner was working toward recreating the Super Soldier Serum and was turned into the Hulk by his attempt to replace vita rays with volatile gamma radiation. Rather than the Hulk being a side of himself, Banner seems to regard him as a completely separate individual with whom he shares a body and someone he'd prefer to be rid of, if at all possible. While this means, perhaps, less psychological complexity for Banner's character, it also means that the Hulk is much more a representation of masculinity than of repressed anger: the MCU Hulk is raging, barely articulate, shirtless, and hairy in an era in which the other male heroes have shaved their chests and are submissive in the face of a more powerful male (Thanos, in this case). Even his relationships with women are emblematic of the worst aspects of masculinity: he's arguably

abusive toward the two women he interacts with most in the movies, Black Widow and Valkyrie. He chases a terrified Black Widow through the Helicarrier in *The Avengers*. When Valkyrie wants to leave his Sakaar apartment in *Ragnarok*, he throws a bed at the door to prevent her from leaving. This is to say nothing of the use of Black Widow as an emotion manager for the Hulk, a role commonly assigned to women in abusive relationships.

If the Hulk is an embodiment of the negative aspects of masculinity, Banner's story is less about one man trying to come to terms with his mental illness, as it is in the comics, and more about a man trying to come to terms with the negative aspects of masculine gender identity. Early in the movies, Banner tells us that he's tried to cure himself of the Hulk and even attempted suicide, but by the time we catch up with Banner in the aftermath of the Snapture, he's found a way to incorporate his Hulk and Banner personae into one form, possessing the Hulk's brawn under Banner's control. As Banner explains, he's decided that the destructive power of the Hulk can be turned toward reconstruction in the devastated post-Snapture world. In the face of a wrenching defeat—Banner notes that Thanos beat him both as the Hulk and in his human form—Banner's masculinity, like that of the other male Avengers, is at risk, but he compensates by emphasizing socially desirable characteristics of masculinity. In his case, that's mastery and risk-taking, as seen through the experiments that have reconciled him with the Hulk, and this has apparently made him a celebrity, with young fans crowding around for selfies and repeating his catchphrase. Banner hasn't rejected the masculine impulses represented by the Hulk; he's turned them into something socially constructive rather than destructive. In sum, he's found a different way to be a man.

For both the Hulk and Captain America, the redefinition of masculinity from fighting to rebuilding comes as a result of a change in social circumstances. Simply put, after Thanos's victory, there isn't much need for masculine identities based on fighting ability or destructive power, so, in contrast with Hawkeye, they find new outlets for their masculinity. They haven't escaped the dynamic of compensatory activities, but the compensatory activities have changed along with their social context. In the same way, political masculinities are enormously adaptable: in recent years, we've seen redefinitions of political masculinities as being tied to allyship with feminist or LGBTQ causes or pushes for racial equity (Ashe 2007). Men in these groups are leveraging the masculine role as leaders, or protectors, to help groups that have traditionally been the targets of masculine overcompensation. These actions are, in some ways, problematic (Messner 1993)—if organizations pushing for the empowerment of traditionally disadvantaged groups wind up being run by men, how much progress has been made?—but they represent a fairly dramatic shift from the traditional political compensation of guns, intolerance, and rigidity.

For some men, then, masculine gender identity threat can lead to recognizably more liberal political attitudes. Though the average effect of threat is a shift toward conservative views, it becomes clear that the real effect doesn't make men more conservative but rather makes already conservative-leaning men more conservative and liberal-leaning men more liberal. In the United States, there are more conservative than liberal men, so on average, it leads men to hold more conservative views, but the real effect is one of polarization. When their gender identity is under threat, men double down on political views, but they're doubling down on views that are already important to them. Politically, gender identity threat seems to amplify the views that men already have. Throughout his films, Captain America's chief trait isn't strength or aggression but compassion, formed by his experience growing up as a victim of those stronger than him. So under threat, he becomes more compassionate, acting out in ways that are very much at odds with the unthinking aggression of Hawkeye or Star-Lord. (For another take on Captain America, see Galdieri's chapter in this volume.)

Why don't Hawkeye or Star-Lord adopt this sort of response to the masculine gender identity threat that they face? Unlike Captain America, they don't have an alternate form of masculinity to fall back on. For Captain America, strength arises from compassion, so he can assert his masculinity by playing up his compassion, just as liberal men can assert their masculinity by becoming more liberal.

The idea that men can display their masculine gender identity by becoming more liberal, as well as more conservative, might lead to the conclusion that any behavior can serve as a display of masculinity. However, that would be overstating the case. Captain America can display his masculinity through compassion because he already links compassion with a traditional masculine display: strength. This pattern holds throughout displays of compensatory masculinity. In recent years, cooking, for instance, has become a way for men to display their gender identity, in an abrupt shift from the past, when it was seen as a feminine activity (Besen-Cassino and Cassino 2014). This shift was possible, though, only because cooking, under some circumstances, was already seen as a masculine exercise. Cooking outside or for special events (Thanksgiving, for instance) was already seen as masculine, so everyday cooking could easily become masculine by repositioning every meal as a special one.

The compensatory behaviors that men take up in response to a threat to their gender identities may sometimes seem extreme, but failure to compensate for a perceived loss of masculinity can have negative repercussions for the individual. When men are not able to reestablish their gender identities through other means, they often exhibit symptoms of depression. At the beginning of the Great Recession that began in the United States in 2009, men

When men are not able to reestablish compromised gender identities, they often exhibit symptoms of depression. This is one way to interpret Thor's actions in *Avengers: Endgame*, when he has seemingly spent years drinking and playing Fortnite with his buddies from Sakaar. From *Avengers: Endgame* (2019).

lost their jobs at much higher rates than women, mostly because the industries hit first and hardest by the economic contraction, such as construction and extraction, are dominated by male workers. This resulted in large numbers of US households in which men were unemployed, often for long periods, while their wives were not, resulting in gender identity threat among the unemployed men. While many of those men found ways to express their masculinity in other ways, some did not, and their spouses reported that, unable to find jobs, they became listless, stopped looking for work, began abusing alcohol or drugs, and often retreated into video games or pornography. This response to a threat to gender identity is also portrayed in the MCU in the person of Thor, who, at the start of *Avengers: Endgame*, has spent the last few years drinking and playing Fortnite with his buddies from Sakaar. Having failed to protect the universe from Thanos, he's given up on his other responsibilities—such as rulership of the Asgardians. There are, of course, ways in which Thor could assert his masculinity in the face of the threat: focusing on his role as a leader, like Captain America, or even turning to violence, like Hawkeye or Star-Lord, but instead, the loss of his identity as a masculine protector has been so jarring that he apparently doesn't believe that these other roles can compensate. Indeed, it's not until he is given the chance to resume his role protecting Earth from Thanos that he's able to come back to himself.

The need to assert masculinity, especially in the face of a threat to their gender identity, drives a great deal of behavior among men in the real world and in the MCU. Like the nonsuperpowered men around us, the men of the

MCU engage with their masculinity in a wide variety of ways, from the political to the mundane. In general, when men feel that their ability to meet the standards of masculine gender identity is compromised in one area, they attempt to compensate for the threat by doubling down on some other component of their masculinity. These compensatory acts can take all sorts of forms, but political views seem to be an especially potent way for men to express that identity, whether it's by supporting a male over a female candidate in an election, opposing restrictions on firearms, or moving toward more extreme versions of the political views that they already have. In the MCU, supermen have bigger, more operatic responses to gender identity threat than everyday men, but the underlying patterns are the same. They may be supermen, but they are men all the same.

DEEP IN MARVEL'S CLOSET

Heteronormativity and Hidden LGBTQ+ Narratives in the Marvel Cinematic Universe

Patricia C. Rodda

As several of the chapters in this volume illustrate, the evolution of the Marvel Cinematic Universe (MCU) has been marked by expanding diversity. Women, people of color, and individuals with physical and psychological disabilities have featured in prominent storylines, taking their place among both Marvel's heroes and villains. In several incredible instances, the universe has gone beyond mere visual representation and challenged core societal stereotypes and comic book tropes relating to these minorities (see Daily or Philips in this volume).

Largely absent, however, is a genuine representation of the LGBTQ+ community. Marvel Studios has made promises that queer characters, such as Valkyrie, who first appeared in *Thor: Ragnarok* (2017), will be added to the universe and given their own storylines (Dry 2019).[1] The media even reported on leaked scenes from *Black Panther* (2018) and *Ragnarok* that confirmed a character's queer sexuality (Meyer 2020). Despite these continued promises of representation, however, the MCU has instead deleted such scenes and made invisible queer characters' identities, consistently missing opportunities to integrate queer characters or storylines. Even more troubling, the MCU has continued to perpetuate stereotypical imagery of the queer community that, historically, was common throughout the comic book world. These stereotypes—often supported and performed in the cinematic universe by the heroic Avengers themselves—have served to reinforce heteronormativity and traditional gender performance in the MCU.

With the close of the Infinity Trilogy and the MCU's definitive shift into Phase Four of its planned storylines, there is some cause to hope for increased and improved LGBTQ+ representation—as well as cause for continued caution. In this chapter, I examine the ways in which the MCU has kept potential LGBTQ+ heroes in the closet and how this lack of representation has weakened the broader sense of inclusivity that the universe has sought to achieve.

LGBTQ+ Representation in Media and Why It Matters

Since the 1990s, with shows such as *Will & Grace* and Ellen DeGeneres's coming out on *Ellen*, queer representation has been on the rise in popular media (Bond and Compton 2015; Cook 2018). The 2019–2020 television season was a peak year according to the GLAAD's "Where We Are on TV" report, with a record 10.2 percent of regular characters in scripted prime-time programming identifying as a member of the LGBTQ+ community (GLAAD 2019). This increased representation of LGBTQ+ characters has had an important effect on the viewing public by providing a common narrative of sexuality and gender identity. This narrative has been shown to influence the general population's overall views and knowledge of queer individuals and of policies related to LGBTQ+ rights. Research has shown that increased representation helps to explain, for example, the rapid national shift in American support for same-sex marriage in the early 2000s (Bond and Compton 2015; Calzo and Ward 2009).

Research has also consistently shown that increased representation in popular media is important for the members of the community being represented. Those findings hold true for the LGBTQ+ community (see, e.g., Gomillion and Guiliano 2011; Shaw 2012); the effect that such representation has on LGBTQ+ youth is particularly important. For most of the LGBTQ+ community, popular media, including television, film, and literature, serves as the primary—if not only—source of representation, information on identities, and forums for interrogating dominant narratives of sexuality and gender (see, e.g., Dallacqua and Low 2021). These effects are particularly strong for queer youth, especially in the formative stages of identity creation—just before and after coming out or otherwise recognizing their queer identity or identities (Bikowski 2020; Cook 2018). Comics and the universes they create have long been a place for queer imagining and identity building, even before there was much diversity in their written and cinematic forms. For the queer community, many of the classic comic book tropes, including the need for superheroes to hide their "true identities" from the world or the need to "come out" and share that identity with loved ones, have resonated strongly with queer lived realities (Kent 2016).

It is only recently that scholars have disaggregated the effects of representation for LGBTQ+ adults from those of queer youth (McInroy and Craig 2017). In particular, the most recent generations have had a unique experience, different from that of most queer adults, in that they have always had access to both traditional media (television, film, and literature) and new media (social media and other online sources). This expansion of media sources has come with a diversification of queer representation and a multitude of ways for all youth

to find and learn about these identities. Dallacqua and Low (2021), for example, find that middle school–aged students tend to "reify gender ideologies" they encounter in their readings of superhero texts in both traditional and new media; however, these students are also able to critique those dominant perspectives of gender as they move between and among media sources. McInroy and Craig (2017, 38) find in their interviews with young queer adults that "representations of LGBTQ individuals seemed to fuel discussions of LGBTQ issues that normalized those narratives . . . [and often] allowed young people to more easily disclose their own LGBTQ identities" to others.

The increase in LGBTQ+ representation, however, is not without its pitfalls. Not all representations are created equal, and there is an important difference between increased visibility and authentic representation. A large proportion of instances of queer representation continue to be problematic and support stereotypical, one-dimensional portrayals of queer individuals (McInroy and Craig 2017). In this sense, increased representation can have negative consequences on the queer community (e.g., Waggoner 2018). Again, this difference is seen most strikingly in research on LGBTQ+ youth. Queer youth in media are often presented as victims or vulnerable, especially to bullying, and storylines built around these characters focus on their sexuality or identity as an "issue" in need of a solution (McInroy and Craig 2017). Queer youth are impacted by representation of queer adults as well, especially regarding the persistent invisibility of certain identities, including bisexuals, transgender individuals, and asexuality (McInroy and Craig 2017; Miller 2017; McInroy and Craig 2015). The queer youth interviewed by McInroy and Craig (2017) also point to the stereotypical representations of LGBTQ+ individuals in society. These stereotypical representations have contributed to feelings of exclusion from society among queer youth, have limited their ability to express their identities, and, in some cases, may have contributed to serious mental health challenges that are linked to high rates of self-harm and suicide among LGBTQ+ youth (Cook 2018).

Negative Stereotypes and Reinforcing Heteronormativity

Although the MCU has certainly improved over time, its characters and storylines continue to perpetuate negative stereotypes of the queer community and reinforce heteronormativity in society. Common examples of this trend can be found in the humor of the films as well as their reliance on narratives emphasizing a single, heteronormative, image of "real men."

Tony Stark is, perhaps, the most unfortunate example of a character who relies heavily on sexist, homophobic, and transphobic humor, especially in the

films that fall under Phase One of the MCU. In *Iron Man* (2008), Tony Stark embarrasses his best friend, Rhodey, in front of a group of young recruits by threatening to tell the story of Rhodey's liaison with a man Rhodey thought was a woman while he and Stark were on spring break. Rhodey looks horrified and tells Stark he cannot tell the recruits stories like that because they will believe him. Although clearly framed as humorous ribbing between friends, the simultaneous message is that for a male character to share intimacy with someone who is not cisgender and female is something for which he can and should face ridicule and judgment. Similarly, in *The Avengers* (2012), Stark begs Thor, Hulk, and Captain America to assure him that "nobody kissed me" while he was unconscious following his destruction of the Chitauri fleet that has been attacking New York. None of the individuals surrounding Stark respond or in any way object to the statement, normalizing the idea that male superheroes do not kiss one another.

The prevalence of this type of humor certainly decreases over the course of the current films in the MCU, and in some cases Marvel changes direction entirely, using humor to challenge stereotypical norms of gender and sexuality. Even Tony Stark tones down his misogynistic and homophobic language as time goes on and his character makes the full transition from arms-dealing antihero to life-sacrificing, world-saving Avenger. However, it is still notable that despite the changes in how humor is used in the MCU and in the moral development of Tony Stark, the past transgressions of Phase One are never directly addressed.

While the use of humor changes across the phases of the MCU, the notion that there is a particular idea of "real men" and that such men act, look, and think certain ways does not. Several chapters in this volume address issues of masculinity and femininity in the MCU (see Beail, Philips, and Cassino). However, some elements specifically support heteronormativity in ways that create increased obstacles to queer inclusion, both within the fictional universe and among its fans. Steve Rogers's transformation into Captain America in *Captain America: The First Avenger* (2011) is perhaps a particularly poignant example. As a short, skinny kid from Brooklyn, Rogers is wanted neither by the army as a soldier nor by women as a potential lover. "Steve's status as a puny, weak, powerless man is . . . presented as what makes him unattractive to women" (Kent 2016, 204). In not being attractive to women, Rogers is implied to be without sexuality. This clearly changes immediately with his physical transformation. Indeed, one of the very first interactions Rogers has once he steps out of the supersoldier machine is with Agent Peggy Carter, who is seemingly incapable of stopping herself from reaching out to touch his now very muscular chest. The sense of honor and duty that later comes to define our idea of who Captain America is and what he represents is not present only after Rogers's physical

transformation; it is part of who he is from the very beginning of the film. And those qualities are certainly valued by a select few: his best friend, Bucky Barnes; Agent Carter; and, in particular, Dr. Erskine, who chooses Steve for the Super Soldier Serum because of his persistent attempts to serve his country. However, those qualities are not valued by the military leadership or broader society until his physique matches that of a "real man."

Before moving on, I want to briefly note the important differences between queer representation on the big screen—as seen in the feature-length films discussed here—and the representations on the "small screen," particularly in the numerous Netflix series based on Marvel comics. The Marvel-based shows on Netflix, including *Jessica Jones* and *Luke Cage*, as well as ABC's *Agents of S.H.I.E.L.D.*, are known to be grittier, more risqué, and more willing to push the boundaries of both heteronormative propriety and the Marvel canon. All three of these shows introduce queer characters. In *Jessica Jones* and *Luke Cage*, those characters are well developed and engaged in storylines that go beyond their specific sexual or gender identities (Steiner 2019). Jeri Hogarth, who appears in *Jessica Jones*, *Daredevil*, *Iron Fist*, and *The Defenders*, was initially hailed as the MCU's first openly lesbian character. Notably, Hogarth is shown as being in two romantic relationships from the very first episode of *Jessica Jones*. Although these are certainly not healthy relationships—she is cheating on her wife with her female secretary—they are still strikingly normal representations of complicated intimate relationships frequently portrayed in popular media. However, these shows are known for being dark and troubling, their heroes often antiheroic. Perhaps for this reason, all of these shows have been removed from the broader MCU canon and are no longer considered part of the official MCU storylines. This move to decanonize the Marvel television shows has created a clear division between the storylines and character profiles considered acceptable for Marvel films and those that have been relegated to the still popular but less far-reaching television screen. This demarcation also reinforces the idea that queer identities have no place in the more broadly consumed society of the Avengers.

Missed Opportunities

Although the examples of negative stereotyping and reinforcement of heteronormativity in the MCU are certainly powerful, there are far more examples of times that Marvel simply missed an opportunity to better represent queer identities. These missed opportunities take various forms and exist throughout the current cinematic universe. To focus the discussion here, I have grouped

these missed opportunities into three broad categories: villainy, making queer characters invisible, and Marvel's paradoxical family narrative.

The Freedom of Villainy

Marvel's villains seem to have a freedom to express diverse identities that its superheroes do not. Several villains, including the Grandmaster from *Ragnarok* and Loki, as well as characters with indeterminant motives, such as the Collector, who appears in *Thor: The Dark World* (2013), *Guardians of the Galaxy* (2014), and *Avengers: Infinity War* (2018), are portrayed in ways that challenge traditional masculinity and heteronormativity. Both the Grandmaster and the Collector are shown, for example, wearing makeup and more feminine or elaborate clothing than characters coded as male in their respective films. The Grandmaster also clearly articulates attraction to a variety of characters, including Loki and Thor. When Thor attempts to escape the planet Sakaar with the Grandmaster's champion fighter, the Hulk, the Grandmaster enlists the help of the planet's residents in locating the "criminally seductive Lord of Thunder." However, both characters are portrayed as clearly odd and slightly humorous. The Grandmaster, in particular, simultaneously challenges heteronormativity and reinforces negative stereotypes of queer men. He is portrayed as entirely self-absorbed, more worried, for example, about blood getting on his robes than the fact that the blood is there because he just killed someone as punishment. The Grandmaster is also excessively promiscuous, constantly making sexual comments about and to Thor and Loki in his interactions with them, and is apparently (in)famous for holding wild orgies on his ship. The challenges to gender and sexuality norms represented by both the Grandmaster and the Collector, therefore, must be viewed in that paradoxical light. These characters are abnormal, and their behavior is certainly not that of a hero.

Loki is a fantastically complex character, not entirely villain or hero, as befits the God of Mischief. In the comics, Loki is understood to be gender-fluid and, perhaps, sexually fluid as well. Loki's father, Odin, refers to him as "his 'child who is both,' emphasizing the acceptance of both gender and sexual fluidity in Asgardian culture" (Meyer 2020, 238). In the films, Loki's gender fluidity is not always clearly visible despite his constantly shifting image and demeanor. However, he is often placed in direct visual contrast with more traditionally masculine characters in ways that emphasize how much he does not fit that mold. Loki frequently uses his shape-shifting ability, taking the shape of other characters, to achieve his ends. In particular, he takes the shape of his brother Thor, his father, Odin, and even Captain America—all of whom are taller, broader, and more muscular than Loki—in moments when he needs

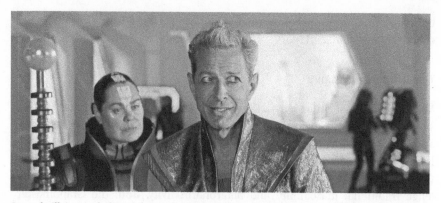

Several villains, including the Grandmaster, are portrayed in ways that challenge traditional masculinity and heteronormativity, including wearing makeup and more feminine or elaborate clothing and articulating attraction to other male characters. From *Thor: Ragnarok* (2017).

to exude power and authority. Loki's other powers are also shown in contrast to the brute physical strength of others, especially Thor. Thor and his team of Asgardian warriors, Lady Sif, Fandral, Hogun, and Volstagg, use their weapons and physicality to defeat enemies in battle, such as the Frost Giants in *Thor*, or in restoring peace to the nine realms in *Thor: The Dark World*. Loki, by contrast, is known for using magic and trickery to achieve similar ends. In *The Dark World*, Thor, Jane Foster, and Loki can leave Asgard despite Odin's attempts to stop them only because Loki knows of a secret passage out of the realm that bypasses the Bifrost. When forced to engage physically in combat, Loki still relies heavily on magic—projecting false images of himself in different locations as distractions that allow him to dispatch stronger enemies. When he does engage directly in physical combat without using magic, as he does with Thor in their first film, he loses.

Perhaps the most powerful visual representation of Loki's gender-fluid nature follows the murder of his mother, Frigga, in *The Dark World*. When Thor visits Loki in his prison cell, intending to ask Loki for help in avenging their mother and saving his love interest, Jane Foster, Thor finds Loki as his usual well-kept self in an immaculate cell. Refusing to believe that his brother is so unaffected by Frigga's death, Thor calmly says, "Loki, enough. No more illusions." In an instant, Thor is met with the reality of Loki's pain and the collapse of his carefully constructed facade. Loki sits on the floor of the wrecked chamber, his long hair loose around his face and dark circles around his eyes that look as if he is wearing heavy eyeliner. Loki's normal elaborate clothing is gone, leaving his thin, androgynous frame clearly visible. "Now you see me, brother." In this scene, the real Loki—the one behind the mask—is revealed in

Perhaps the most powerful visual representation of Loki's gender-fluid nature follows the murder of his mother, Frigga, in *Thor: The Dark World*. Loki first appears as his usual well-kept self in an immaculate cell until Thor says, "Loki, enough. No more illusions." In an instant, Loki drops the facade, revealing himself sitting on the floor of a wrecked chamber, his long hair loose around his face and dark circles around his eyes that look as if he is wearing heavy eyeliner. "Now you see me, brother." From *Thor: The Dark World* (2013).

his vulnerability and grief. But only for a moment. Once the decision to join forces is made, Loki's true self must again be hidden away behind his carefully crafted facade. Although Loki provides opportunities for a gender-fluid identity to be incorporated into the MCU, it, like Loki's outward appearance, is carefully crafted and controlled. It is seen as a weakness to be hidden away so the work of heroes can be done.

Back to the Closet

The executives and other elites guiding the MCU have clearly stated the importance of and their dedication to remaining faithful to their source material. In interviews, they have claimed that while some deviation is usually necessary in translating a comic book format into film, their adaptations are "always true to the spirit of what Jack Kirby, and Stan Lee, and [Steve] Ditko, and so many amazing artists throughout the decades have created" (Gerber 2018). And in many ways, they have done just that, faithfully representing the Marvel world that comic book fans have come to love in ways that still appeal to a broader audience.

This stated dedication to the source material makes the erasure of canonically queer characters from the MCU even more troubling. Over time, the universes of the Marvel comics came to incorporate more queer characters and storylines, including queer heroes, nonheterosexual relationships, and even discussions of HIV/AIDS (Addice 2021). However, in the transition to the

MCU, some of these characters and storylines were sent back to the closet. As discussed above, it is possible to discern Loki's gender fluidity if one is looking for it; however, it is never openly addressed. The same can be said for Valkyrie, whose inclusion was originally celebrated as the first appearance of an openly queer—in her case, bisexual—Marvel hero. However, the single scene that reportedly showed a woman leaving Valkyrie's bedroom in *Ragnarok* was deleted before the film's release, and her involvement in *Avengers: Endgame* is confined to the leadership role she shoulders in New Asgard (Ahlgrim 2019; Meyer 2020). The actress who plays Valkyrie, Tessa Thompson, publicly stated that since her character is bisexual in the Marvel canon, she keeps that in mind in her acting (Ahlgrim 2019). Thompson further announced that her character would be looking for a female love interest in an upcoming film. Although this announcement was not refuted by the director, he was much more restrained in his confirmation of the announcement, stating, "How that impacts the story remains to be seen" (Dry 2019). Valkyrie may indeed be explicitly portrayed as bisexual in a later Marvel film, but it already seems clear that from Marvel's perspective, it will be of little consequence to her role as Asgard's new ruler.

A particularly disturbing example of sending a queer character back to the closet is in the MCU's portrayal of Okoye, who first appears in *Black Panther* (2018). The version of Okoye that appears in the MCU films is most likely an amalgamation of two members of the Dora Milaje who appear in the comics: Aneka and Okoye (Ahlgrim 2019). Aneka, the Dora Milaje's captain and combat instructor in the comics, has a romantic relationship with another member of the elite all-female fighting force, Ayo, who appears as the second-in-command in the film *Black Panther* (Ahlgrim 2019). Ayo and Aneka's relationship is a powerful one for its representation of strong, Black queer women. They are clearly committed to each another and regularly refer to one another as "beloved" (Meyer 2020).

In the MCU films, however, Okoye's racial identity as a strong, independent Black woman is foregrounded at the expense of her queerness. Instead of being in a relationship with another member of the Dora Milaje, she is portrayed as being married to King T'Challa's male best friend, W'Kabi. In a twisted play on Ayo and Aneka's lesbian relationship in the comics, Okoye and W'Kabi refer to each other as "my love." Furthermore, in *Black Panther*, we find another instance of deleted scenes erasing a character's queerness. According to *Vanity Fair*, a leaked scene featured an interaction between Okoye and Ayo "where . . . they lock eyes, Okoye says, 'You look good,' and Ayo responds with a grin saying, 'I know'" (Meyer 2020, 236). When the film was released without the scene, fan responses were swift and fierce, highlighting Marvel's convenient lapse in remaining authentic to the source material only—in fans'

view—when it comes to queer characters. According to Meyer (2020), the erasure of queerness from Wakanda is particularly insidious for two key reasons. First, it perpetuates the stereotype that Black communities are particularly homophobic and would not accept a Black queer character. Second, it problematizes *Black Panther*'s presentation of a "Pan-African past, present, and future" as one where "queer bodies are both invisible and unwelcome" (Meyer 2020, 236).

Are We Family Too?

As discussed elsewhere in this volume (see Hanley's chapter), Marvel, in both its comics and films, is a universe built around the idea of family. But not the traditional family; Marvel's characters, especially its heroes, must build a family of individuals who accept and care about each other for who they truly are. This idea is, perhaps, at the core of the connection and validation that many LGBTQ+ individuals find in comic-based universes despite the lack of direct representation. For many queer individuals, the families into which they are born may not fully understand or accept their identity. The creation of a supportive and accepting family of choice is a long-standing practice within the queer community and is often a way for more established queer individuals to welcome and support those who have recently acknowledged, accepted, or realized their identities (see e.g., Hailey, Burton, and Arscott 2020). This cultural practice is perhaps most entertainingly embodied in the community's claiming of the Sister Sledge song "We Are Family" as a queer anthem.

This shared concept of families of choice is possibly Marvel's biggest missed opportunity to incorporate and acknowledge queerness. Since the notion of family in the MCU is thoroughly discussed elsewhere in this volume, I will focus on a single example here. Frigga, queen of Asgard and mother to Thor and Loki, is the prototypical accepting mother. In traditional Norse mythology as well as the MCU, she is known for reining in Odin's more extreme and discriminatory tendencies. For example, despite Odin's pronouncement in *The Dark World* that Jane Foster should be left to die on Earth after she encounters the Aether, Frigga welcomes her to Asgard, supports Thor's efforts to save Jane, and ultimately dies protecting her. It is Frigga who visits Loki in his prison cell, where he is imprisoned for crimes he committed in *The Avengers*. Although it is not until after Frigga's death that we visually see Loki's "true self," Frigga reminds him frequently that she knows who he is. Even when, in their final conversation, Loki denies her as his mother, Frigga tells him, "Always so perceptive. About everyone but yourself." Frigga embodies the unfailing acceptance of your true self that typifies ideal families of choice, especially within

the LGBTQ+ community. Unfortunately, while the MCU continues to build so much of its world on this concept of a chosen and accepting family, its queer members remain on the outside.

A Bright Future?

Anyone keeping track of the MCU is aware that the completion of the Infinity Saga was not an ending, only a turning point. As the film franchise begins its fourth phase of planned narratives, there are many new stories to tell and characters to meet. What does that mean for queer representation? There are certainly reasons to be hopeful but also reasons to remain cautiously so.

As discussed above, there have been renewed promises for future LGBTQ+ characters and storylines. Loki returned in his own series on Disney+ in 2021 and came out as bisexual, confirming his sexuality across his timelines while backlit with pink and blue hues. Sharp-eyed fans found an even further nod to Loki's queer identity in the show's opening credits, where Loki's sex is listed as fluid. In *Eternals* (2021), Phastos not only is gay but has a loving family and shares an on-screen kiss with his husband. Valkyrie is expected to have a female relationship in *Thor: Love and Thunder* (2022), and the introduction of a Latina lesbian superhero, America Chavez, has been confirmed for *Doctor Strange in the Multiverse of Madness* (2022) (Townsend 2021). Fans have also expressed excitement over the introduction of Billy, aka Wiccan, in the miniseries *WandaVision*. In the comics, Wiccan "is one half of Marvel's most prominent gay couple" and is wed to love interest Teddy Altman in Marvel Comics' first same-sex wedding (News18 2021). Fans hope Billy's appearance on *WandaVision* sets up not only the Young Avengers but also the inclusion of Marvel's most famous gay couple.

Although there is understandable excitement about these developments, these promises have been made before. Canonical queer characters have been introduced in the MCU only to have their queer identity erased. Kari Skogland, director of *The Falcon and the Winter Soldier*, serves as a stark reminder of Marvel's poor track record in fulfilling promises of queer representation. Bucky Barnes, the Winter Soldier, has long been a source of fan speculation about hidden queer narratives in the MCU. His close relationship with Steve Rogers, Captain America, has fueled rumors that Barnes may be bisexual. These theories appeared to be validated for fans in the first episode of the new series when "Bucky commented on seeing a lot of 'tiger photos' on online dating sites—something he would most likely see on men's profiles" (Schaffer 2021). Rather than simply allowing fan speculation to continue, Skogland dismissed the idea that the scene indicated a nonheterosexual identity: "What we were

really trying to display was his complete lack of technical skills, as well as being part of any kind of community. . . . He doesn't fit. So that was I think more our intention there than to point to any one particular affinity" (Hale-Stern 2021).

It may not have been the intention to point to a particular "affinity" or identity, but Skogland's comments clearly highlight what the Winter Solider most decidedly is not: queer. The 106-year-old Bucky Barnes may be learning to navigate the modern world and to reintegrate into society, but, apparently, he can only do so as a straight man.

The MCU has always been one of exploration, heroism, and family. The LGBTQ+ community has long found solace and acceptance in the pages of its comics and in the scenes of Marvel's movies. Luckily for the MCU, that loyalty is unlikely to fade even though it has yet to live up to its enormous promise and potential for inclusion, and true images of LGBTQ+ people in the MCU remain, for now, just fantasies.

Note

1. I use the terms "queer" and "LGBTQ+" interchangeably here. "Queer" is a broad umbrella term that encompasses a diversity of sexualities, genders, orientations, and identities. The identities represented by the LGBTQ+ acronym are all subsumed under the queer umbrella.

Danielle Hanley

I used to have nothing, and then I got this . . . this job, this family. And I was better because of it.

At first glance, Natasha Romanoff's characterization of the Avengers as a family might be surprising. Her first descriptor—"this job"—seems more accurate. The Avengers, after all, are a team of superheroes trying to save the world, over and over again. And yet Agent Romanoff's description of the Avengers goes beyond this categorization as an occupation. The team is also a family. Their relationships extend beyond the reach of those found in a typical workplace, characterized by the care and intensity expected around a dinner table, not in a board meeting.

Natasha's line is not simply a one-off but offers a lens through which to view the Avengers over the course of their development. By the final movie in the Infinity Saga, the Avengers come to view themselves as a family. Black Widow introduces this perspective at the beginning of *Avengers: Endgame,* and her death at the close of the film's second act provides an opportunity for additional characters to confirm this view. Tony Stark asks, "Do we know if she had family?" to which Steve Rogers responds, "Yeah, us" (Russo and Russo 2019).

Although the Avengers view themselves as a family, they do not exactly *resemble* a conventional family unit. The traditional family structure has long been two married individuals caring for their biological offspring—it is better embodied by the first few episodes of *WandaVision* than anything in the Avengers films.[1] To the Avengers, family means something quite different.

This essay argues that the Avengers are a *family assemblage,* a concept derived from recent work in queer theory and feminist thought that allows for a more inclusive and varied view of family life. The term "family assemblage" captures the complexity of family life that expands beyond the nuclear conception of family: the term encompasses human members, nonhuman members, such as pets, and even the material and discursive elements that shape familial experiences, such as laws, houses, and technology.[2] The concept of assemblages helps us understand the ways in which the Avengers function as a family and the expectations that accompany the very concept of family. A

broader look at the Marvel Cinematic Universe (MCU), moreover, reveals an even greater diversity of family structures. Overall, Marvel cinema embraces a strikingly pluralistic approach to the concept of family.

The family, like the MCU, is a shared cultural reference point in a culture that has few such touchstones remaining. Yet the family, like the MCU, is constantly changing and evolving. With the Avengers characterizing themselves as a family, the MCU invites us to consider different visions of family in conversation with one another. Many people understand intuitively that "family" means more than just one's blood relatives. Scholars have developed this insight under the heading of "assemblages."

The nuclear family has dominated conceptions of the family throughout history. From Aristotle through John Locke, the family was understood as a unit with a father, mother, and children. The structure of authority in the conventional family was decidedly patriarchal, with power and control resting with the senior male of the unit. This form of the family, a result of marriage between a man and a woman with an eye toward biological reproduction, has long been understood as not only the dominant but also the natural version of the family. Marriage, and as a result a nuclear family, is seen as normal—it is expected, conventional. One of the most frequent critiques of gay marriage from the perspective of queer theorists is the way that it reinscribes the healthy and normal status of marriage (Warner 1999). Providing the same privileges to homosexual couples that are associated with heterosexual marriage, such as inheritance and insurance, reinscribes a heteropatriarchal structure within society (see, for example, LaSala 2007, 181).

Of course, societies have always offered many alternatives to this traditional family structure. Today, queer families, adoptive families, and single-parent families (to name only a few) help to illustrate that the nuclear family is not the only available and acceptable version of "family." On the contrary, modern family structures are constantly and gradually reconfigured to reflect changing norms around sexuality and parenthood (Vaggione 2013).

The concept of assemblage makes space for alternative conceptions of family outside and beyond the heteronormative family. In their defining work on the term, Gilles Deleuze and Felix Guattari describe it in the following way: The "aim is not a totalization, a definitive teaching of the limits, or a final theory of everything. It is rather an expansion of possibilities, an invention of new methods and new perspectives, an active entertainment of things, feelings, ideas, and propositions" (Deleuze and Guattari 1988). For Deleuze and Guattari, assemblage thinking is meant to open new ways to understand the makeup and organization of the social by focusing on the flows, connections,

and heterogeneity that characterize it. This stands in contrast to the assumption that there is one model or structure that dictates the makeup of the social world.

Scholars have used this concept in many fields of study, including sociology, queer theory, history, and political thought. The openness of Deleuze and Guattari's concept has encouraged scholars to think beyond the human, to consider the nonhuman components of the social that contribute to its functioning and evolution. For example, Jane Bennett's treatment of assemblages considers the political capacity of things such as power grids, garbage, and rats alongside their human counterparts (Bennett 2010). When we think about relationships beyond the traditional conception, we can see, for example, that access to that power grid or clean drinking water (in Flint, Michigan, for example) is integral to the political claims a community makes. Instead of dismissing electric power or clean water as simply "infrastructure," a clearer picture of the communal dynamics begins to emerge when we include these nonhuman elements in our political analysis. Scholars of the family have applied this sensibility to thinking about extending the family beyond the human alone. Conventional approaches to the study of families emphasizes humans, but few would dispute that pets or even homes are part of families (Price-Robertson and Duff 2018, 2). Thinking of families as assemblages allows us to consider not just the human but also the nonhuman members and perhaps, as we turn to the Avengers assemblage, even the more-than-human.

Thinking of the family as an assemblage also energizes a departure from assumptions about the family as a natural, unified, organic whole. As Elizabeth Markovits (2018, 98) writes, "Families take shape, form, emerge, crumble, re-emerge, disappear. It is a configuration of assembled parts, each of which fundamentally shapes—but does not determine—the overall assemblage." Each of the members is indeed important but does not alone determine the value or agency of the assemblage. The properties of the whole cannot be reduced to those of its parts; indeed, this idea rests at the core of the understanding of the family as assemblage (see, for example, Buchanan 2015; de Landa 2006; 2016). There is a certain fluidity that flows from this way of thinking. The members are not fixed or finite, but there is always an open possibility of moving, changing, shifting—with regard to both the internal relationships among members of the assemblage and the entrance and exit of members themselves. In many ways, this challenges the presumed naturalness associated with notions of the family that dominate Western thought.

This also suggests that something different than biological reproduction is at work in the family assemblage. If the assemblage denaturalizes the appearance of the family, then it can also move away from the biological processes presumed to be the natural, and therefore sole, form of procreation. This opens

the potential for all sexualities to play critical roles in reproducing instead of focusing on heterosexual relationships alone. Shelley Park writes that the queer family as an assemblage "relies on connectivity rather than reproduction" (Park 2013, 98 n43). Jasbir Puar refers to these practices as "beyond heteronormative reproduction," where the assemblage is able to "not reproduce but regenerate" (Puar 2017, 211). Members do not have to be created by other members of the assemblage but can brought into the fold as a function of a relationship, a connection—they are incorporated. As such, the assemblage does not rely on the production of biological children, though relationships might emerge that have characteristics similar to those of parent and child. Importantly, such relationships are no longer assumed to have a genetic basis. Moving away from a reliance on biological reproduction does not foreclose it as a potential avenue for reproduction, but it decenters and denaturalizes it. Biological reproduction becomes one among many methods of regeneration and expansion of the assemblage; it is one among many forms of growth that the family assemblage can undergo, all of which impact its shape and form. Members can become part of the assemblage in many ways and, in turn, allow the assemblage to grow, shift, and change to accommodate these new members, human, nonhuman, and more-than-human alike.

Scholars working to move away from the nuclear, heteropatriarchal, child-rearing model characterize the family as an affective community that is the site of reproduction as well as the locus of emotional and physical intimacy (Ferguson 2012, 7). Family life is the space of care for others—emotional and physical. While care work—for example, raising children—is typically associated with mothers, moving from the traditional family structure to a more progressive, alternative familial model opens the question of care work further. Sara Ruddick writes that maternal thinking includes responsiveness to the preservation, growth, and social acceptability of one's children (Ruddick 1995, 89). In an assemblage, these expectations around care are spread across family members. Pluralizing the work of care also denaturalizes assumptions about care and femininity. This in turn helps rework the conceptions of agency and power that accompany the family.

The family assemblage is heterogeneous, open, and the site of care in its many potential forms. Each of the ways assemblage theory pushes against the typical family reworks assumptions about the natural occurrence of such characteristics. In doing so, the family assemblage shifts away from these assumptions, replacing them with alternative forms. Within a heteropatriarchal society, this also functions to raise questions about the nature of power and agency. The "natural" family is generally understood as a unity, with the father figure at the top of the power hierarchy and the mother figure responsible for the children, subordinate to the male figures within the family. Agency is

concentrated, in large part, in the patriarch. The family assemblage, in contrast, does not have one member elevated over all others; agency and power are distributed among the members of the assemblage.

The Avengers are a prime example of a family assemblage, with all that it entails. However, the Avengers do not begin as a family assemblage; they become one—as Black Widow and Captain America finally acknowledge explicitly in *Endgame*.

Assemblage theory, with its attention to flows, interactions, and emergent properties, provides a theoretical foundation through which to understand the significance of the development process. Furthermore, the idea that a family *develops*, as opposed to simply *exists*, challenges natural conceptions of family and recognizes the state of *becoming* that is often central to analyses of assemblages. To arrive at Black Widow's view that the Avengers are a family assemblage, the relationships among the superheroes must been given time to grow, evolve, and intensify. This evolution tracks the arc of the MCU. For example, in the first installment of the series, 2012's *The Avengers*, the individual heroes come together to fight a common enemy, Loki and his army of Chitauri. United by a common cause, the individual superheroes become part of a team. It is these external forces or conditions that prompt Captain America, Hulk, Black Widow, Thor, Iron Man, and Hawkeye to come together. This underscores the non-natural characteristic of the assemblage; it is something that requires assembly.

However, coming together is not sufficient to give the team the status of a family. At the beginning of the second installment of the *Captain America* franchise, a film that takes place shortly after *The Avengers* within the MCU timeline, Black Widow and Captain America have settled into their relationship as work colleagues. The film's opening action sequence hints at the possibility of a deeper relationship, whether romantic or otherwise, between these two characters. Natasha tries to set Steve up with several women over the communications network while the two complete their mission for S.H.I.E.L.D. This lays the groundwork for a friendship between the two characters, which is a development from the coworker status that they exhibit in *Avengers*. However, it is only later, after Steve saves Natasha's life, that the reciprocity of friendship begins to develop in full. Natasha remarks that she owes Steve for saving her life, and Steve replies that she does not owe him anything (Russo and Russo 2014). Instead of an instrumental reciprocity, a deepening of their relationship grows out of these continued interactions. By *Captain America: Civil War*, Natasha, though she and Steve have opposing viewpoints on signing the Sokovia Accords, surprises Steve at the funeral of his longtime love, Peggy. She says, "I didn't want you to be alone" (Russo and Russo 2016). The concern

The Avengers do not begin as a family assemblage, but they become a prime example, a point Black Widow and Captain America acknowledge explicitly in *Endgame*. From *Avengers: Endgame* (2019).

for emotional well-being illustrated in this exchange demonstrates a further development in their relationship. Though the two begin as coworkers, the intensity of care and emotion that builds throughout their interactions over the course of the MCU illustrates the broader dynamic of development that comes to characterize the Avengers family assemblage more broadly. Relationships intensify as the characters move from work colleagues to something more.

By *Endgame*, the Avengers—not just Steve and Natasha—have become a full-fledged family. They have disputes, they love one another, they come together even as they have been thrust apart due to situational conflicts. They use the language of familial relationships. When Tony Stark returns to Earth after the first Snap, he breathlessly says to Steve, "I lost the kid" (Russo and Russo 2019). Of course, this refers not to his biological child but to Spider-Man, Stark's mentee. Acknowledging this loss opens the world of grief experienced by the surviving Avengers, those who remain after Thanos's infamous Snap. It is this grief that punctuates Black Widow's later pronouncement that the Avengers are her family—she lives not only with the loss of her fellow Avengers but also the potential loss of the family that has sustained her in the first place. Five years later, Stark has a framed photograph of Peter above his sink; a glimpse of Peter in this very picture inspires Stark to work on the time-travel technology that makes the events of *Endgame* possible. Undertaking the world-altering mission to retrieve the Infinity Stones from the past grows out of, in part, the bonds that bind the Avengers together.

Over the course of the Avengers franchise and the broader MCU, the Avengers display the openness, heterogeneity, and care that characterize a family assemblage. First, their family assemblage is open: the initial team includes Black Widow, Captain America, Hawkeye, Hulk, Iron Man, and Thor. In *Avengers: Age*

of Ultron, the team adds Falcon and War Machine, Scarlet Witch and Quicksilver, and Vision. Some of these characters have been introduced in the intervening solo films of the MCU, while others make their inaugural appearance in *Ultron*. The openness of the assemblage even invites the incorporation of former foes: Scarlet Witch and Quicksilver initially appear as enemies, fighting against the Avengers in the opening scene of *Ultron*. Eventually, they switch sides and not only join the Avengers' fight against Ultron but are brought into the familial fold. Scarlet Witch moves into the Avengers compound following the death of her brother and begins to train with the team. The move into the physical space defined by and for the Avengers aids in the absorption of Scarlet Witch by the assemblage. The family grows and its shape is altered as a result.

In *Civil War*, the team experiences a rift, with multiple characters facing off against one another. The Avengers come back together in *Avengers: Infinity War* and fight together once more in *Endgame*. The shifting composition—the ability to both absorb new members and lose members—does not change the status of the family as a family. The assemblage retains its status as family even as it loses members. And though *Civil War* sees the breakup of the Avengers, which Stark communicates to Bruce at the beginning of *Infinity War*, the breakup of the team does not entail the destruction of the family assemblage.[3] Though its configuration has shifted, indeed affected by the violent and emotional eruptions between characters, when needed, Captain America, Black Widow, and Falcon answer the call to save Scarlet Witch and Vision from attack.[4] Though the team is not formally intact, the heroes appear to help their family members. The family assemblage is able to absorb and lose and reabsorb members as its overall character remains somewhat consistent. The Avengers remain a family even as they split apart.

Family assemblages are also heterogeneous in their makeup, including human, nonhuman, and, especially with regard to the Avengers, superhuman components. Thor's Mjolnir is a nonhuman, noncorporeal object of central importance to the team; Thor, himself a god, plays a central role. Along with Mjolnir, Captain America's shield and the uniforms of Iron Man, War Machine, and Falcon perform considerable work within the assemblage. J.A.R.V.I.S., which begins as Stark's natural-language user interface computer system and is upgraded into an artificially intelligent (AI) system, is fully integrated into the assemblage. He provides crucial information to and jokes around with members of the team. Furthermore, Vision is also a product of AI, created by a combination of Stark, Banner, Dr. Helen Cho, and Ultron. Parts of J.A.R.V.I.S. survive in Vision's programming, and his consciousness comes from the Mind Stone. He is thoroughly a nonhuman entity but nonetheless so central to the assemblage that they work to protect him in *Infinity War*.[5] One might also include the monetary flows that move through Iron Man and J.A.R.V.I.S. into the

Avengers initiative as part of the heterogeneous set of members. The *Avengers* films in general decenter the human, as they focus on different combinations of humans, superhumans, and, in *Ultron*, consciously bring the nonhuman into the fold. The nonhuman and superhuman members are integral parts of the assemblage, as they work together to maintain the power and authority granted to it. Even if it is easy to accept humanoid characters as "human," the assemblage would not be the same without Mjolnir, J.A.R.V.I.S., or Captain America's shield.

The family is also a critical site of care and emotional connections, and thinking about the Avengers as family assemblage further diversifies and complicates this picture in productive ways. Affection for one's human siblings is often relatable, but affection and attachment expand beyond human relationships within this family assemblage. For example, Thor's attachment to Mjolnir is on display in *Ultron* when the group tries to lift the hammer; of course, no one but Thor succeeds, though Thor is visibly yet ever so slightly on edge when Captain America manages to make the hammer budge. In *Endgame*, Captain America succeeds in wielding the hammer; this time Thor is excited, breathing, "I knew it!"[6] Thor has an emotional investment in Mjolnir and in what Mjolnir represents—worthiness. In this moment, his attachment to Mjolnir is difficult to disentangle from his affection for Steve Rogers. In *WandaVision*, Wanda's grief over Vision's death quite literally explodes, and she creates an entire reality as a result.[7] She manifests a new version of Vision for this reality, as well as two sons, Billy and Tommy. In the series finale, as the reality begins to disappear, Wanda says to her sons, "Thank you for choosing me to be your mom."[8] The emotional connection between Wanda, Vision, and their children once more illustrates the centrality of care within the family assemblage, expanding it beyond "human" here to both nonhuman (Vision) and nonpermanent (her sons). Furthermore, clever sitcom tropes underscore this assemblage's representation of a typical nuclear family, but the final twist that they have all been generated by Wanda's magical ability complicates this picture and calls attention to the roles such emotions and connections play in all forms of family life.

As *WandaVision* illustrates, the central role of care also extends into multiple Phase Four projects, which themselves interweave multiple and varied expectations into Marvel's presentation of familial possibilities. In the recent Disney+ series, *Hawkeye*, we watch Clint Barton come to care for Kate Bishop, first as he tries to protect her in battle and then when he invites her to his family's farm for Christmas.[9] He initially rebuffs the young archer when she calls them "partners," but their arrival at the Barton farm in the series' final scene signals that the relationship has grown well beyond a partnership. In a review of the series finale for IGN, Matt Purslow comments that "Kate and Clint's relationship has been one of the most effective examples" of "the theme

of found family" in the MCU (Purslow 2021). We also see Barton mobilize his deep connection to the deceased Natasha Romanoff when confronted by her sister, Yelena Belova—he uses Belova and Romanoff's secret whistle to signal this connection to the enraged Belova. Barton describes how Romanoff cared for Belova, stating that "all she could think about was that you were safe; that never changed, Yelena. She loved you. She always wanted you safe."[10] This causes Belova to halt her pursuit of Barton and also recalls *Black Widow*, an additional Phase Four property that presents an alternative version of a family—this time not found but fabricated for political purposes. Both emphasize the role care plays in building the close-knit relationships that come to characterize the Avengers team, both within the original franchise and throughout the growth and expansion of these stories. Both *Hawkeye* and *Black Widow* demonstrate how central these intense feelings are to the formation and maintenance of relationships between characters—even after death—and how they influence the shape of the team following *Endgame*. Both simultaneously challenge the idea that the nuclear conception of family has a monopoly on such intensities by locating care within these found and constructed support structures, sometimes over and against the nuclear version, as is the case with *Hawkeye* in particular.

Care plays a central role throughout MCU family assemblages beyond the *Avengers* franchise as well. In addition to the *Avengers* films and related projects such as *WandaVision*, *Black Widow*, and *Hawkeye*, care is fundamental within the Guardians of the Galaxy family. This is best displayed in Groot's sacrifice at the end of the first *Guardians of the Galaxy* film.[11] As the ship holding the Guardians begins to plummet to the ground, Groot grows his limbs to form a protective structure around the entire team, which guards them from impact as they crash down. He quite literally embraces his family as a form of protection. Rocket pleads with him not to sacrifice himself, and Groot responds, "We are Groot." After an entire film punctuated by the refrain "I am Groot," the shift to the plural "we" is notable. Groot sees himself living on through the Guardians; he sacrifices himself so that they can survive. The linguistic shift encapsulates the familial here—in this move from "I" to "we," the audience glimpses the Guardians as family assemblage with all the associated emotional weight and resonances. The Guardians grieve the loss of Groot in this aftermath. Groot's willingness to sacrifice himself for the survival of his family illustrates the depth of care and connection in this relationship. Throughout the MCU, these simple gestures, such as Groot's sacrifice or Wanda's words to her children, reproduce the familiar emotional tropes so often associated with family life. By linking these recognizable tropes to non-nuclear families and nonhuman assemblage members, the MCU pluralizes notions of the family in productive ways.

Care plays a central role in MCU family assemblages such as the Guardians of the Galaxy, perhaps most notably when Groot sacrifices his life to save his teammates at the end of the first *Guardians* film. From *Guardians of the Galaxy* (2014).

In addition to serving as a primary site for care, the family is also often understood as a site of reproduction; the family assemblage involves reproductive processes but decenters and deemphasizes biological forms of reproduction. The Avengers assemblage offers multiple perspectives connected to reproduction. First, related to both the openness and diversity addressed above, reproduction is linked to processes of absorbing, expanding, and reshaping that occur throughout the films. Tony Stark creates the technology for more suits, one of which becomes War Machine, who becomes part of the Avengers throughout the turmoil that punctuates *Ultron*. Both the use of technology and the way the Avengers absorb War Machine as a new addition work as ways of reproduction. The team is strengthened, and its stability is perhaps enhanced; the unit is able to continue to maintain order. The family's heterogeneous makeup is accompanied by a heterogeneous approach to regeneration. In addition to technology and absorption, there is recruitment. Tony Stark recruits Spider-Man and Hawkeye recruits Ant-Man, both of whom make their first appearances during the large intra-Avengers battle in *Civil War*. Once again, this deemphasizes natural forms of reproduction while simultaneously ensuring that the family assemblage is able to continue. As Stark passes down control over his AI to Peter in the final film of the third phase of the MCU, *Spider-Man: Far from Home*, it is clear that Stark also considers Peter an extension of his own lineage, a form of reproduction that we see throughout as part of a denaturalized family.[12]

Care, as the emotional center of this assemblage, sets it apart from other types of assemblages or formations. The family is the site of care work. The care exhibited by members of the Avengers exceeds expectations of a set of work colleagues or even a government agency, both of which define certain

aspects of the Avengers' behavior or account for the group formation. For example, at the end of *Ultron*, veteran Avengers Black Widow and Captain America take the helm to train the new members; Iron Man assumes authority for the entire team during *Civil War*; and Vision acts as the guardian for Scarlet Witch, also in *Civil War*. In each of these instances, heroes exhibit care for their fellow heroes, worrying over their well-being and survival and ultimately the team's longevity. Even from the earliest movement toward expansion in *Ultron*, members of the assemblage demonstrate a level of care that exceeds that of coworkers. In a scene during the final showdown against Ultron, Scarlet Witch is afraid to return to the battle. Hawkeye sits her down and looks her in the eye, telling her that it is okay for her to sit out but that if she joins, it must be full force. Hawkeye says, "Are you up for this? If you step out that door, you are an Avenger" (Whedon 2015). This brief exchange comes only a short while after Scarlet Witch was fighting the Avengers herself. The concern that Hawkeye, typically stoic, displays over Scarlet Witch's well-being is notable. The Avengers are a team of superheroes, but they care for one another, a possibility fostered by the open quality of the family assemblage.

The care work does not end with the Avengers' missions. In fact, it sometimes exists in conflict with them. Captain America loses his best friend, Bucky Barnes, in *Captain America: The First Avenger*. Barnes reappears as the Winter Soldier in *Captain America: The Winter Soldier*, and in *Civil War*, Captain America goes head-to-head with his fellow Avengers on behalf of Bucky. Their bond is one of deep friendship, and while it initially compromises Captain America's (and Black Widow's and Falcon's) relationship with the Avengers, Bucky is welcomed into the familial fold. His relationship with Steve preexists the Avengers, but this web of relationships allows for Bucky's absorption into the assemblage. That Natasha and Sam accompany Steve while he is on the run is an illustration of care work as a function of the assemblage that cuts against the mandate of the Avengers as a team of superheroes. Within the Avengers family assemblage, care work sometimes complicates the official mandate.

The *Avengers* franchise, and the MCU more generally, offers the Avengers as a family assemblage. By *Endgame*, the Avengers understand themselves as a family. Attending to the heterogeneous character of its members, and the openness of its borders, alongside the emotional care work that so often accompanies understandings of family, the team has indeed developed into a family—a family assemblage. It is able to welcome new members and lose members while still maintaining its family status. But within the MCU, the family is not only the locus of affective intensity and reproduction but is also central to questions of power and agency. In a typical heteropatriarchal family structure, power and agency reside with the patriarch and are passed down through the

paternal line. In the Avengers' family assemblage, power and agency are distributed, which gives strength and longevity to the assemblage.

Throughout the Infinity Saga, the Avengers become a family assemblage. But they are not the only family, or type of family, that appears onscreen in the MCU. Many of the Avengers have familial arrangements that find their way onscreen. Scarlet Witch and Quicksilver are siblings. Their parents perished as a result of Stark Industries–manufactured weaponry. Their initial status as enemies—and their eventual absorption into the team—are marks of the complicated legacies that family drag with them. In *Endgame*, Tony Stark and Pepper Potts are married and have a child named Morgan. Stark initially declines to involve himself in the Time Heist to retrieve the Infinity Stones because he has settled into this domestic life. When he does agree to take part, he tells Steve that he has to preserve his family at all costs.[13] Hawkeye also has a conventional family—a wife and two children, with one on the way, as is revealed in *Ultron*. The family home becomes a safe haven for the Avengers when they must go off the grid after a disastrous mission.[14] Hawkeye reveals the existence of his family, which comes as a surprise to everyone except Black Widow and Nick Fury.[15]

The existence of the Avengers as a family assemblage does not preclude or replace other forms of family. Instead, it pluralizes the way family is represented onscreen, and it hints at the complex intrafamily relationships that exist regardless of family shape, size, and form. Furthermore, these familial relationships accompany and even complement the Avengers' family assemblage. The presence of multiple types of familial relationships works to normalize the family assemblage. It becomes yet another representation of family alongside these other, more conventional or expected forms. Hawkeye's family even provides a safe haven for the Avengers. The fact that they are hidden, and that their location allows the Avengers to hide, recharge, and reassemble, demonstrates that the conventional family can also function to protect, complicating the place of the Avengers in productive ways. The *Avengers* franchise provides the space to watch the Avengers family assemblage not only unfold but unfold in relation to these other, more traditional versions of family life.

In staging the family assemblage alongside more traditional forms of family, the *Avengers* franchise and the MCU work to pluralize understandings of family. Kennan Ferguson (2012) writes that families serve as a model for functioning society for many political thinkers. The *Avengers* franchise, with its widespread reach, models a constructed family that draws its strength from the heterogeneous makeup of its members. Ferguson argues that the family is inherently political, and part of the politics of families emanates from their

incommensurability. Incommensurability is built into the assemblage model of the family. It is the amalgamation of the differences—different bodies, objects, humans, and superhumans—that populate various loci of power for the Avengers. When the family assemblage is challenged, the distribution of agency across it ultimately works to reinforce the strength of the Avengers. This division is on display in the final battle in *Endgame*. "Avengers, assemble!" enacts once more the becoming of the family assemblage but also acts as a final reminder of the pluralized picture of family that these films present.

The triumph of the Avengers at the conclusion of *Endgame* can be read as a triumph of the family assemblage. By denaturalizing and decentering the nuclear family, the *Avengers* franchise pluralizes understandings of the family but also creates a new way to conceptualize the family in relation to politics. Building on Ferguson's account, families are not composed of similar parts but instead house immense differences within a set of affective and physical intimacies. The family assemblage is also home to extensive sets of differences brought together; the Avengers are all incredibly different from one another yet still function together to preserve power. They quite literally save the universe as a function of their complementary differences. These differences become the substance of politics, as their internal relationships have extensive consequences for the fate of the galaxy. Viewing such triumph onscreen becomes a political act as the family assemblage comes to model a form of democratic political life with its differences, incommensurability, heterogeneity, openness, and, indeed, care work.

Notes

1. A privileging of this form of family structure can be seen throughout many works of political thought, including Aristotle's *Politics* (2013), John Locke's *Two Treatises on Government* (1980), and Jean-Jacques Rousseau's *Emile* (2012), among other works.

2. For an expanded definition of "family assemblages," see, for example, Price-Robertson and Duff (2018, 2).

3. At 16:06 in *Avengers: Infinity War*, Tony says to Bruce, "The Avengers broke up" (Russo and Russo 2018).

4. See Captain America's entrance on the opposite train platform at the 40-minute mark in *Avengers: Infinity War* (Russo and Russo 2018).

5. Wanda learns this in *Infinity War* at 57:59, when Bruce explains, "Your mind is made up of a complex construct of overlays . . . Jarvis, Ultron, Tony, me, the Stone . . . all of them learning from one another" (Russo and Russo 2018). In addition, the creation process where Dr. Cho refers to the "consciousness stream" takes place at 1:17.20 in *Avengers: Age of Ultron* (Whedon 2015).

6. At 28:42 in *Ultron*, Captain America attempts, along with the other Avengers, to lift Mjolnir, and Thor is visibly worried. At 2:13:00 in *Endgame*, Captain America succeeds in wielding the hammer.

7. See *WandaVision* episode eight, "Previously On" (February 26, 2021). After Wanda encounters Vision's dismembered body at S.W.O.R.D., she drives to Westview, where Vision had purchased property for the couple prior to his death. In her grief, she manifests a house and a new version of Vision.

8. This occurs in *WandaVision* episode nine, "The Series Finale," at 33:05.

9. See *Hawkeye* episode six, "So This Is Christmas?" (December 22, 2021).

10. This exchange begins at 41:06 in *Hawkeye* episode six, when Clint whistles and Yelena pauses, asking emotionally, "How do you know that?" This whistle signal is introduced in Marvel Studios' *Black Widow* (2021).

11. At 1:38:11 in *Guardians of the Galaxy*, Groot begins to grow around the Guardians.

12. Tony gives EDITH to Peter Parker, which is a major point of contention and plot point in *Spider-Man: Far from Home*.

13. At 46:00 in *Endgame*, when Tony arrives at the Avengers compound, he relays the following information to Steve: "Bring back what we lost, I hope, yes, keep what I found, I have to, at all costs . . . and maybe not die trying."

14. After a defeat in battle, Hawkeye takes the helm of the plan, saying to Tony, "We're still a few hours out." Tony replies with the question "A few hours from where?" Hawkeye answers, "A safe house." This exchange takes place at 1:00.04 in *Avengers: Age of Ultron*.

15. When they arrive at Hawkeye's home at 1:00.51 in *Ultron*, the Avengers are shocked. Tony says, "We would have called ahead, but we were busy having no idea that you existed."

FEMALE COMBATANTS IN THE MARVEL CINEMATIC UNIVERSE

Ora Szekely

Superhero films focus, at least in part, on questions of power and violence: who has power, who uses violence, and why do they do so? In this sense, the superhero genre has a great deal in common with the study of armed conflict. The twenty-three films that make up the first three phases of the Marvel Cinematic Universe (MCU) provide a rich collection of material through which to explore questions about warfare in the real world. This chapter assesses how female and male superhero combatants are portrayed in the MCU and to what degree this portrayal reflects what we know about women's participation in armed conflict in the real world.[1]

In general, women—including female superheroes—are underrepresented in the MCU.[2] And while the way female heroes are portrayed in the films (when they are on screen at all) sometimes lines up well with what we know about female combatants in the real world, this isn't always the case. In the real world, women's reasons for involvement in armed conflict—in both state and nonstate militaries—vary a great deal, and while they participate at lower rates than men do, their presence is a fairly normal feature of warfare. Like their male colleagues, female combatants often conform to the culture of the organizations in which they fight; this sometimes includes committing atrocities alongside their male counterparts. The MCU only partly reflects this reality; while there are women involved in its various armed forces in a range of capacities, their reasons for doing so are often flattened or linked explicitly to trauma rather than personal ambition or ideological commitment.

This chapter begins by examining what we know about women in war and their representation on screen. It then moves on to some brief descriptive statistics regarding gender representation in the MCU in general as a way of contextualizing the differing treatments of the male and female heroes' motivations for fighting in the films as well as the degree to which the portrayal of women in the MCU reflects what we know about women's involvement in armed conflict in the real world.

Women in Armed Conflict

Scholars know a great deal about how and why women participate in both state and nonstate armed forces. To be sure, some of the literature on armed conflict carries an unspoken assumption that all soldiers are male. For instance, quantitative research on the causes of war often measures variables that apply specifically to men (e.g., male educational completion rates or lack of economic opportunities for young men) rather than variables that might apply to the population as a whole (Fearon and Laitin 2003; Humphreys and Weinstein 2008). Other studies assume that all potential recruits into armed movements are men and boys (Gates 2002; Jakobsen and De Soysa 2009) or, perhaps more perniciously, that all men and boys in a conflict zone are by default combatants (Carpenter 2006). This approach treats men's gender identities as both invisible and normalized; the median soldier is automatically assumed to be male, and masculinity is normatively linked to military prowess.[3] Female combatants, meanwhile, are treated as exceptional or unusual—they are "female combatants," never just "combatants" (Bloom 2012; Cohen 2013; Kampwirth 2002; Viterna 2006). This occurs in the media as well. For instance, coverage of the Yekîneyên Parastina Jin (YPJ), or Women's Protection Units, an all-female Kurdish fighting force in northern Syria, sometimes treats YPJ fighters as mascots or oddities, discusses them in explicitly sexual terms, or—for some reason—repeatedly uses the word "badass" to describe them (Dirik 2014; Full Frontal with Samantha Bee 2017; Salih 2014). (This is not a term generally used to refer to male guerrillas.) In other cases, women who participate in warfare are framed as exceptional or deviant or are even pathologized (Sjoberg and Gentry 2007). As Sjoberg notes, women who fight are thought to do so because they are "mothers, monsters or whores"—not because they are individuals with political grievances, like their male counterparts. Overall, both the scholarship on and media coverage of armed conflict tends to view gender through a binary lens.

Scholarship that focuses explicitly on female combatants themselves, however, reveals a much different, and in many ways more prosaic, reality. While it is impossible here to summarize the full breadth of the scholarship on this subject, there are a number of broad themes. First, statistically, women participate in warfare as combatants at somewhat lower rates than men; they comprise only about 16 percent of the entire US military, for instance. (Of course, this is partly by design; until very recently, many frontline roles were off-limits to women; Alexander and Stewart 2015). Many armed forces are composed entirely of men, but very few are composed entirely of women.

At the same time, however, women's participation in war is far from

exceptional. On the contrary, it is a common (if not universal) feature of armed conflict;[4] Henshaw's (2016a; 2016b) analysis of over seventy post–Cold War nonstate armed groups found that women were involved in a majority of them, serving as combatants in around one-third and as leaders in around one-quarter. Some nonstate armed groups actively recruit large numbers of women. For instance, women make up around 40 percent of the fighting forces in the Turkey-based Kurdish armed group known as the Kurdistan Workers Party (PKK) and the Revolutionary Armed Forces of Colombia (FARC).[5] Groups that use child soldiers often include girls; McKay and Mazurana find that between 1990 and 2003, girls under the age of eighteen were involved in armed conflict in fifty-five countries and as combatants in thirty-eight of them (McKay and Mazurana 2004). Today, women serve in ground combat roles in Australia, Canada, Denmark, Eritrea, Estonia, Finland, France, Germany, Israel, Lithuania, the Netherlands, New Zealand, North Korea, Norway, Poland, Romania, South Africa, South Korea, Sweden, the United Kingdom, and the United States. Still other countries (such as Pakistan and the UAE) do not recruit women into the infantry but allow them to serve as fighter pilots (Fisher 2013; Morris 2018).[6]

We also know that, like men, women join both state and nonstate militaries for a variety of reasons. Indeed, a Pew survey of the US military found that women's motivations for joining the armed forces were nearly identical to men's: the most common reasons both men and women cited for joining were to serve their country and to get access to educational benefits, although more women than men cited unemployment as a motivating factor (Patten and Parker 2011). Similarly, research on women's recruitment into nonstate armed groups suggests that they are often motivated by the same sets of ideological commitments and political grievances that motivate male recruits (Kampwirth 2002; Szekely 2020b; Tezcür 2016); like men, women who participate in armed revolt are mobilized by a mixture of personal, communal, and ideological motivations (Trisko Darden, Henshaw, and Szekely 2019).[7] With regard to recruitment into clandestine rebel groups in particular, social networks also influence women's likelihood of joining in that women are more likely to do so if they have connections to the armed movement in question (Viterna 2006). This, too, is true of many male fighters.[8]

Of course, women will be more likely to join a specific armed group if it's willing to recruit them in the first place. Certain characteristics make this more or less likely; leftist ideology, for instance, makes a group more likely to recruit women (and women more likely to seek to join it; Henshaw 2016b) and Islamist ideology less so (Wood and Thomas 2017). Other characteristics correlated with the recruitment of women are a group's use of terrorism, larger size, and, perhaps unsurprisingly, the inclusion of women's rights in its political platform (Thomas and Bond 2015).

We also know that once they've joined the fighting force in question, women's actual participation varies a great deal. In some state militaries, female soldiers are unlikely to serve in combat positions—this is true of most militaries in the Arab world, for instance, although there are notable exceptions, such as the presence of female fighter pilots in the UAE (Szekely 2020b). Even in countries such as Israel whose state militaries employ universal conscription, not all frontline combat roles are necessarily open to women (Bandel 2020), and there may be an explicitly or implicitly gendered division of labor (Yuval-Davis 1987). On the other hand, servicewomen's roles can be more extensive in practice than in theory; in the US military, women were ostensibly excluded from frontline combat roles until 2015, but in practice, serving in units such as the military police effectively put them on the front lines in Iraq and Afghanistan (Smith 2015; Schmitt 2005).

In nonstate armed groups, women's roles likewise vary a great deal. In some organizations, women primarily fill logistics and support roles (such as providing food and medical care or managing supplies). In many others, they serve as frontline combatants, sometimes in mixed units, sometimes in women-only units (Henshaw 2016b; Trisko Darden, Henshaw, and Szekely 2019; MacKenzie 2009). They may also serve in both political and military leadership positions (Trisko Darden, Henshaw, and Szekely 2019). Groups that use terrorist tactics[9]—including some (such as Al Qaeda) that don't allow women into their regular forces—sometimes recruit women for those operations, in part because they are often viewed with less suspicion by counterinsurgent forces. This can include the recruitment of women as suicide bombers, sometimes through pressure tactics (Bloom 2012).

Finally, contrary to the idea that female combatants are less likely to brutalize civilians,[10] there is evidence that women in fact participate in wartime atrocities alongside their male comrades in arms (Trisko Darden and Steflja 2020). To offer only a few examples from both state and nonstate armed forces, women in both the PKK and Liberation Tigers of Tamil Elam were extensively involved in terrorist attacks that harmed civilians (Bloom 2012); American Private Lynndie England was famously convicted of mistreating prisoners at Abu Ghraib prison in Iraq;[11] and in one study in the Democratic Republic of the Congo, 41 percent of female survivors of rape by multiple perpetrators reported that those perpetrators had included women (Loken 2017; Brown 2014).

In sum, what do we know about women's participation in armed conflict? That it is both common and invisible; that women tend to join both state and nonstate militaries for reasons very similar to those of men, although the willingness of armed forces to accept them varies a great deal and may be shaped by ideology; and that women perform a wide range of functions in both state and nonstate armed forces—including committing atrocities.

Female Combatants in Cinema

Of course, women's representation in cinema doesn't always reflect reality. This is true both broadly and in specific. Women are roughly half of the human population, but they often make up a far smaller proportion of the faces we see on screens; *The Annenberg Report on Diversity in Entertainment* found that only 28.7 percent of all speaking characters in films released in 2014 were female. Less than 1 percent were trans (Smith, Choueiti, and Pieper 2016). Another analysis of more than two thousand films found that a female character had the largest amount of dialogue in only 22 percent of them. Out of 459 films from the 2010s, in 55 percent, men had 60 to 90 percent of the dialogue, and in 15 percent, over 90 percent. In contrast, women had a majority of the dialogue in only 26 percent of films from the same time period.

In movies with high levels of violence or conflict—in which combatants of any gender are more likely to be present—the imbalance in gender representation is particularly acute. In science fiction and superhero movies between 2009 and 2018, 55 percent of leads were male, 31 percent had male and female coleads, and only 14 percent had only female leads (Stone and Flores 2019). A 2014 analysis of the global film industry found that in action and adventure films, only 23 percent of speaking characters were women (Smith, Choueiti, and Pieper 2016). In a particularly stark example, in the three original *Star Wars* movies, the number of women with spoken lines can be counted on the fingers of one hand. The number of women in starring roles can be counted on one thumb.[12] Even the faces in the background are overwhelmingly male (although in the cases of nonhuman characters, binary gender categories may not necessarily apply). These practices create a visual representation of the world that suffers from a version of the "Smurfette" problem—the baseline "human" is a male, and femaleness (or any other gender identity) is an optional additional characteristic, similar to being athletic, vain, or clever (Pollitt 1991). This echoes the tendency in the scholarship on armed conflict to distinguish between "combatants" and "female combatants" or "soldiers" and "women soldiers."

In combination with what we know about women's actual participation in armed conflict, this data raises a series of questions that can be fruitfully asked about the films of the MCU for their own sake, as an example of a particular genre and as an American cultural bellwether: how well represented are women in the MCU? When they are present, how accurately are female heroes portrayed as female combatants? And what sorts of heroes are women (and men) allowed to be?

Female Combatants in the MCU

To find out, I watched the twenty-three films comprising the first three phases of the MCU, in the order in which they were released, over the course of a few months. I began by examining gender representation in the films overall and then zeroed in on the way female heroes are portrayed as combatants in particular.

To examine gender representation in the films more generally, I looked at two different indicators. First, I coded the films for whether they passed the Bechdel-Wallace test (sometimes referred to simply as the Bechdel test).[13] To pass this test, a film must include (1) a conversation of at least thirty seconds (2) between two named female characters (3) about something other than a man. Because of the nature of superhero movies, relatively few conversations between characters of any gender last longer than thirty seconds, so I relaxed this aspect of the test slightly. I also counted lengthy one-on-one fight scenes (such as the fight between Gamora and Nebula in *Guardians of the Galaxy*) as "conversations." The Bechdel-Wallace test is useful in understanding the portrayal of female combatants because it helps to measure the degree to which female characters are centered in the films rather than being treated simply as vehicles to further the male characters' story arcs. This in turn has implications for how fully the motivations of female characters are explored, including their motivations as combatants.

Second, I looked at the gender ratio of the films' characters. While the proportion of male and female characters in general is not necessarily the same as the proportion of male and female combatants in the films, like the Bechdel-Wallace test, it does provide a useful measure of the degree to which the films treat men as the "default human," thereby exceptionalizing women. More broadly, it also offers useful context for the rest of the analysis here. I looked at the percentages of women both among the major characters (that is, those who drive the plot forward) and, separately, among all the named characters in the film. For the latter, I used the Internet Movie Database (IMDB) as a source. I coded these characters as either male or female, as there are no canonically nonbinary or other-gendered characters in the twenty-three movies examined here (though that may well change.)

However, while these broad measures provide important context for understanding gender representation in the films overall, they do not specifically address the question of how female heroes are characterized *as combatants* per se—they do not explain their motivations for taking up arms or how they behave in battle. Accordingly, I asked a third, more qualitative question: how do the films portray the heroes' respective relationships with their powers, and

what connection do their powers have to the crises that drive their respective plot lines?

In the course of watching the films, it became clear that there are three broad sets of answers to those questions, on the basis of which I sorted all of the title heroes into archetypes: for some characters, whom I term the "lovable jerks," their own arrogance about their powers leads to conflict; for others, the "gentle heroes," conflict is often a result of the reaction of outside forces to their powers; and for a third group, the "reformed villains," their powers are linked from the outset to conflict and trauma. The process of sorting the various heroes into these categories made very clear that these archetypes are sharply gendered.

Women in the MCU by the Numbers

One of the most obvious takeaways from the films was how few of them passed the Bechdel-Wallace test. The first to do so based on dialogue alone was *Guardians of the Galaxy Volume 2* (the fifteenth film in the series), although the original *Guardians of the Galaxy* (the tenth film) also passes if the fight scene between Gamora and Nebula is counted as a "conversation." In addition to those two, six more films qualify: *Spider-Man: Homecoming, Black Panther, Avengers: Infinity War, Ant-Man and the Wasp, Captain Marvel,* and *Avengers: Endgame.* That's only slightly more than a quarter of the total.

The proportion of female characters—including both major characters and others—is also informative. As Table 20.1 demonstrates, in no film in the MCU do women make up more than 38 percent of the major characters. The average was 26 percent. For credited characters, the average was slightly higher, at 30 percent.[14] The world of the MCU is a world in which women—both as major characters and as those in the background—are drastically underrepresented.

On the other hand, we do see some change over time. While none of the films before *Guardians of the Galaxy* passes the Bechdel-Wallace test, five of the last six in Phase Three do. There has also been an increase in the proportion of women among the films' major characters, from an average of 17 percent across the first five movies of Phase One to an average of 32 percent across the last five in Phase Three. This demonstrates a trend toward more accurate representation, if not actual parity.

Nevertheless, female characters are still afforded less scope than their male colleagues in terms of their relationships with their own powers. There are male heroes who fall into all three of the three character archetypes noted above—lovable jerks, gentle heroes, and reformed villains—but the vast majority of female title characters fall into only the last category.

Table 21.1. Women on screen in the MCU

Movie	Female characters (major) as percentage of total	Female characters (credited) as percentage of total	Passes the Bechdel-Wallace test
Iron Man	18	31	No
The Incredible Hulk	14	15	No
Iron Man 2	18	47	No
Thor	29	22	No
Captain America	6	32	No
The Avengers	23	34	No
Iron Man 3	25	23	No
Thor: The Dark World	29	31	No
Captain America: The Winter Soldier	33	19	No
Guardians of the Galaxy Volume 1	27	37	Yes
Avengers: Age of Ultron	25	33	No
Ant-Man	25	22	No
Captain America: Civil War	21	19	No
Doctor Strange	25	34	No
Guardians of the Galaxy Volume 2	36	32	Yes
Spider-Man: Homecoming	30	23	No
Thor: Ragnarok	21	39	No
Black Panther	38	42	Yes
Avengers: Infinity War	28	32	Yes
Ant-Man and the Wasp	36	33	Yes
Captain Marvel	38	28	Yes
Avengers: Endgame	31	31	Yes
Spider-Man: Far from Home	27	33	No

Credit: Author's data collection.

The "lovable jerks" include characters such as Tony Stark/Iron Man, Peter Quill/Star-Lord, Doctor Strange, and Thor, whose arrogance about their powers (and everything else) is often the source of their problems. The gentle heroes, on the other hand, are most clearly typified by Bruce Banner/the Hulk but also include Scott Lang/Ant-Man, Peter Parker/Spider-Man, Steve Rogers/Captain America, and T'Challa/Black Panther, whose problems are largely a result of others' reactions to their powers.[15] While fewer of the male heroes can be considered "reformed villains," secondary characters such as Bucky Barnes/Winter Soldier and Loki both qualify (although Loki's reformation comes late in his character arc).

It's worth noting that although male heroes are given more range than their female counterparts in terms of their relationships with their own powers and how they respond to challenges in their lives, the franchise is not particularly forgiving of machismo or masculine aggression, at least not of the cartoonish variety. (For more on this point, see Cassino in this volume.) The gentle heroes

and even the reformed villains are often treated more compassionately than the lovable jerks; witness the not particularly sensitive treatment of Thor's apparent PTSD in *Endgame*.

Female heroes, in contrast, are more limited in their options. By the end of Phase Three, there are four female title heroes in the MCU: Gamora, Natasha Romanoff/Black Widow,[16] Carol Danvers/Captain Marvel, and Hope van Dyne/The Wasp. The first three are all clearly reformed villains. All have similar backstories: forced against their will to fight for the wrong side (Thanos, who is perhaps the ultimate "wrong side"; the Red Room; and the Kree, respectively), they eventually switch teams and become heroes. This is also true of secondary characters such as Wanda Maximoff/Scarlet Witch, Nebula, and Valkyrie.

Especially for Natasha Romanoff and Gamora, trauma and a propensity for violence are substituted for more complex motivations or character development (see also Philips and Daily in this volume). This trauma creates complicated relationships with their powers and the use of force to achieve their objectives. Moreover, all three have their powers essentially imposed on them without their consent. In Danvers's case, her powers arrive by accident and are artificially suppressed by the Kree but are still exploited by their military; in Gamora's and Romanoff's cases, their powers are the result of abusive "training" by Thanos and the Red Room, respectively. For Romanoff, this even includes forced sterilization. Valkyrie, a secondary hero who appears likely to take on an important role in future films, also fits this archetype; when we first meet her in *Thor: Ragnarok*, she has bitterly rejected her role as a Valkyrie and is working for a man who enslaves others. This, it later transpires, is largely rooted in the trauma of the Valkyries' defeat at the hands of Hela.

These are very different backstories than those of male heroes such as Steve Rogers or Tony Stark, who deliberately sought out their powers in order to do good with them, or Bruce Banner, whose powers, while unwelcome, are still the unintentional result of his own tinkering rather than being externally imposed. Even male superheroes whose powers arrive by mistake (e.g. Peter Parker/Spider-Man) or who are simply born with them (e.g., Thor) do not generally experience their powers as a form of exploitation. (One exception is Bucky Barnes, whose character arc is very much like Romanoff's.) This perhaps implies a discomfort with the idea that women might seek out power, on purpose, through legitimate or laudable means and not feel bad about it afterward.

One female hero who does not fit this mold is Hope van Dyne/the Wasp. When she first appears in *Ant-Man*, she isn't a hero at all but rather the love interest of the male protagonist. She doesn't fit the model of the reformed villain: while she does start out working for the film's villain, she's doing so

Women in the MCU often have complicated relationships with their powers and with the use of force to achieve their objectives. Carol Danvers, for instance, gains her powers by sheer accident only to have them suppressed and exploited by the Kree. From *Captain Marvel* (2019).

undercover and can't really be considered a villain herself. She does, however, seek out power, resenting her father for not allowing her to use his shrinking suit and Scott Lang for being able to instead. When her father builds her the Wasp suit, she actively seeks to use it to further her own (heroic) goals. But unlike most of the heroes in the MCU, her relationship with her own powers isn't really the central conflict driving her character development. Instead, it is her relationship with her family (her reconciliation with her father, her search for her mother) that motivates her, and her access to her powers (via the suit) is mediated through that relationship. If she does fall into one of these categories, it is the gentle hero more than anything else.

Female Heroes as Combatants in the MCU

How well, then, do the portrayals of female heroes in the MCU reflect what academic research tells us about female combatants in the real world? We know that, broadly speaking, women are often driven by the same communal or ideological grievances as men. And, like men, women's personal circumstances and social networks shape individual incentives to join an armed force, although they may be constrained from doing so by the willingness of both state and nonstate armed groups to accept them as recruits. Once they've joined, their duties can include a range of functions, from logistical support to espionage to frontline combat to political leadership. And women in armed forces that commit atrocities do so alongside their male comrades.

The degree to which this reality is captured in the MCU's films varies a good deal.

The most notable omission is probably with regard to the importance of ideology as a motivation for female heroes. While these motives are present for characters such as Captain America, whose relationship with his powers is driven by his ideological commitments from the beginning, the women of the MCU are less obviously driven by a clear political purpose beyond a desire to prevent specific catastrophes. Although one could argue that Danvers and Romanoff initially see themselves as ideologically driven, the films make clear that this is the result of deception and brainwashing by the Kree and the Red Room, respectively, rather than a genuine commitment. This doesn't square with research findings on the importance of ideological and political commitments for female combatants in the real world.

That said, a number of the *secondary* female heroes in the MCU do appear to be driven by political rather than personal grievances. Anger over the destruction of Sokovia is a core motivation for Wanda Maximoff/Scarlet Witch, and Wakandan patriotism is a primary motivation for Shuri, Okoye, and Nakia. If Marvel Studios were to make an Agent Carter film, her character would undoubtedly be driven by the ideological commitments that animate her heroics in the eponymous television series. Both the Valkyries and the Dora Milaje are strongly defined by their loyalty to the thrones of Asgard and Wakanda, respectively. But these commitments are less clearly centered for the franchise's female *title* characters.

There are other areas, however, where the films better reflect reality. For one thing, some of what we know about the role of social networks and family in influencing recruitment into armed groups is apparent in the MCU's female heroes' character arcs. Family relationships are especially important for Gamora and Hope van Dyne: Gamora hopes for revenge against Thanos, and Van Dyne hopes to rescue her mother from the quantum realm. For Romanoff, her connection with Hawkeye is key in enabling her to defect from the Red Room. While the personal economic motives that we know also matter for many combatants of all genders are largely absent in the MCU—none of the Avengers appear to have joined up as a way to pay for college—other personal motivations are portrayed as important. This echoes the findings of research on recruitment of female combatants, although it perhaps overemphasizes these personal factors (alongside personal trauma) at the expense of the ideological motives and political grievances that motivate many female soldiers in the real world.

The MCU also aligns with reality with regard to the range of roles filled by women in military organizations. Even leaving aside professional soldiers such as Maria Hill, Peggy Carter, the Dora Milaje, and the Valkyries, who have clearly defined positions in the chain of command, the female heroes in the

As in the real world, in the MCU women fill a wide range of roles in military organizations. In the aftermath of the Snap, for instance, Natasha Romanoff takes over as leader of the Avengers. From *Avengers: Endgame* (2019).

MCU fill roles as varied as those of their male counterparts, including frontline combat, leadership positions, and undercover and intelligence-gathering roles. To offer just a few examples, Carol Danvers begins her story arc in a more traditional military role and then moves into a less constrained position as a free agent, engaging in frontline combat in both roles. Hope van Dyne and Natasha Romanoff are both working undercover gathering intelligence when they first appear onscreen. And we see several female heroes in leadership roles; in the aftermath of the Snap, Natasha Romanoff takes over as leader of the association of heroes that succeeds the Avengers, and Valkyrie steps in as leader of the remaining Asgardian refugees. This is in line with findings on the range of roles filled by women in state and (especially) nonstate armed forces.

Similarly, the findings from research on women's participation in atrocities are also echoed in the MCU. Natasha Romanoff, for instance, is as complicit as her male colleagues in the collateral damage (including civilian deaths) caused by the Battle of New York and other Avengers operations. Alongside Drax, Rocket, Groot, and Star-Lord, Gamora causes numerous casualties during her escape from prison in *Guardians of the Galaxy Volume 1*. In *Avengers*, the women on the World Security Council are no less willing to drop a nuclear bomb on New York than the men. And Valkyrie wipes out a crowd of scavengers without any apparent hesitation in *Ragnarok*. In the MCU, as in the real world, women's presence in a combat zone doesn't necessarily reduce the chance that a fighting force will harm civilians. Finally, it's worth noting that the female heroes of the MCU also die alongside their male comrades. In *Infinity War* and *Endgame*, two of the three title characters who are killed—Natasha Romanoff, Gamora, and Tony Stark—are women.

Conclusion

The final battle scene of *Endgame* begins with Iron Man, Thor, and Captain America battling Thanos, who has declared that he will destroy the universe. The three male heroes appear somewhat outmatched, but then, portals begin to open around them and almost every surviving hero in the MCU appears on screen for a massive final battle. About halfway through, there is a sequence that deliberately—and one might say ham-fistedly—attempts to make a point about the presence of female heroes in the MCU.[17] Peter Parker, dazed under a pile of rubble, looks up at Carol Danvers. He hands her the Infinity Gauntlet, which needs to be transported across the battlefield in order to destroy Thanos, and says, "I don't know how you're going to get it through all that." Wanda Maximoff steps into the frame and replies, "Don't worry . . ." and Okoye appears, finishing the sentence with ". . . she's got help." The camera pans around to show Pepper Potts, Valkyrie, Hope van Dyne, Wanda Maximoff, Mantis, Shuri, and Gamora. Working together, they slash a path through the battle for Danvers, who flies ahead with the Gauntlet under her arm like a large neon football.

The moment was undoubtedly intended as a statement about the status (and future) of women in the MCU. But it also, perhaps inadvertently, reflects some of the problems with the MCU's portrayal of female combatants. (For one thing, it's telling that nearly all of the female heroes in all twenty-three films, including several less significant characters, can fit comfortably in one shot). This moment of cooperation among a group of solely female heroes is perhaps meant to convey a sense of female empowerment; what it also does, however, is highlight these heroes' femaleness as what is noteworthy and exceptional about them rather than the varied roles they play as combatants in the films. After all, the rest of the battle includes multiple shots and sequences focused on groups of male characters working together, which are treated as entirely unremarkable. The multiple scenes including only men that are played for emotional impact—the reunions between Steve Rogers and Sam Wilson and between Peter Parker and Tony Stark—are powerful because of the relationships between the characters, not because of their gender. By treating a group of female characters as remarkable specifically because they are female, this moment echoes media portrayals of female combatants as exciting novelties, such as the astonished and breathless coverage of the all-female Kurdish YPJ. It also (likely accidentally) echoes Thor's awkwardly jovial line to Valkyrie in *Ragnarok* when he says, "I think it's great that there's an elite force of women warriors . . . it's about time!"[18] And more broadly, it also reflects the assumption in some of the literature on armed conflict that male soldiers are simply soldiers, but female soldiers are "female soldiers." In the MCU, female heroes are still "female heroes."

The films in later phases of the MCU may well offer more examples of female heroes as combatants and expand the ways in which these characters relate to their powers and understand their role in the world. *Black Widow*, which begins Phase Four, centers Natasha Romanoff. And the fourth of the Thor films, *Thor: Love and Thunder*, will reportedly include both a female Thor (in the person of Jane Foster) and more development of Valkyrie as the MCU's first canonically queer character (Willingham 2019). As the MCU expands to include more female heroes and nonhero characters the films' gender imbalance may also become less pronounced. And as the heroes of the MCU become increasingly diverse, they may come to reflect the existing diversity among those who fight in the real world.

Notes

1. For a more detailed discussion of gendered violence in *Jessica Jones*, see Philips in this volume.

2. The term "women" as used in this chapter should be understood to mean all women, including both cis and trans women. Indeed, all characters who are not straight cisgendered men are underrepresented: the MCU takes a consistently binary approach to gender, trans characters are largely absent, and queer characters in general are vastly underrepresented (as is discussed in more depth in Patty Rodda's chapter, "Deep in Marvel's Closet.") This chapter focuses on cisgender women and men in the MCU because those are the categories that exist in the films, but the general absence of trans and/or nonbinary people is in and of itself an important characteristic of the MCU.

3. Enloe (2000) argues that militarization and veneration of the military are linked to the veneration of masculinity and the privileging of the masculine over the feminine. Women are nevertheless often mobilized in support of militarization through the reification of their roles as wives, mothers, entertainers, and consumers.

4. Women's participation expands even further when we include noncombatant roles. In both state and nonstate armed groups, women have long provided medical and logistical support, such as nursing the wounded, cooking, and maintaining supplies. When these roles are filled by men in conventional militaries, they are often treated as a form of soldiering, while women performing similar work in an informal capacity are often dismissed as "camp followers" (Enloe 2000).

5. Precise numbers are difficult to come by. The most commonly cited figure is around 40 percent for the PKK and 30–40 percent for the FARC (Trisko Darden, Henshaw, and Szekely 2019).

6. Many more countries recruit women into noncombatant positions in their armed forces.

7. This means that, as Kampwirth (2002) points out, because communal grievances are likely to be fairly constant across entire communities, understanding why an individual woman might choose to fight requires examining her specific biographical circumstances.

8. In interviews with current and former members of Kurdish, Syrian, Lebanese, and Palestinian armed groups conducted for various research projects, many of those I've interviewed have cited the influence of friends and family in their choice to join a specific

faction or their ability to defect to a rebel movement from the state military. See also Koehler, Ohl, and Albrecht (2016). In the United States, military service is often passed down in families (Faris 1981; Bowen 1986). In 2019, despite the fact that less than 1 percent of Americans serve in the military, 30 percent of service members had a parent and 70 percent a relative who had also served in the military (Philipps and Arango 2020).

9. Defined as the public use of violence against civilians for political purposes.

10. It is telling that the results of a Google Scholar search for "women war criminals" are almost entirely concerned with women as victims of war crimes rather than as perpetrators. Exceptions include De Pauw (2014) and Bloom (2012).

11. *New York Times* (2005).

12. Female characters other than Leia Organa have just sixty-three seconds of spoken dialogue in all three movies combined (Riesman and Wade 2017).

13. The test is named for Alison Bechdel, who references it in her comic *Dykes to Watch Out For*, and for her friend Nicole Wallace, whom Bechdel credits with the idea (Garber 2015).

14. In three films, the gender ratios are skewed somewhat by the fact that each film has a performance scene with a large number of characters who appear in the credits. In *Iron Man 2*, there are twenty-seven credited female characters out of a total of fifty-eight, but seventeen are "Ironette Dancers" who appear in a large dance number and have no lines. In *Captain America*, there are thirty female characters out of a total of ninety-three, but twenty of them are "USO dancers." In *Captain America: Civil War*, eighty out of ninety-nine characters are men, but nineteen of them are members of a choir. In the first two movies, these dynamics inflate the number of women in the films without necessarily shifting the average number of women on screen across the film as a whole.

15. I initially coded T'Challa as his own category since his relationship to power is complicated by his position as a monarch, which gives him some characteristics of the lovable jerk.

16. Gamora and Romanoff are members of the Guardians of the Galaxy and the Avengers, respectively, making them title heroes.

17. See Kanthak in this volume for a different take on this scene.

18. In contrast, there is no such jokey condescension regarding the Dora Milaje in *Black Panther*.

WHO WATCHES THE MARVEL CINEMATIC UNIVERSE?

Race, Sex, and the Audience for Onscreen Diversity

Bethany Lacina

In 2018, the Marvel Cinematic Universe (MCU) bounded from strength to strength. *Black Panther* had a billion-dollar box office, showcased the MCU's first nonwhite lead, and earned a Best Picture nomination at the Academy Awards. *Infinity War* raked in $2 billion in box office sales. *Ant-Man and the Wasp* was another commercial success and featured the MCU's first female title character.

Then, in March 2019, with just weeks to go before *Avengers: Endgame*, *Captain Marvel* opened to controversy. Right-wing commentators claimed that the actress playing Captain Marvel—Brie Larson, the first woman to be a top-billed MCU actor—had disrespected male critics and audiences during her press tour.[1] In the background of that complaint was the fact that Larson's casting meant a deviation from the source material. Larson was playing Carol Danvers, traditionally the alter ego of Ms. Marvel; the original Captain Marvel is a male alien named Mar-Vell. Once the MCU's version hit theaters, a further gender switch was revealed, with Mar-Vell being played by Annette Bening.

Right-wing Internet activists called for a boycott of *Captain Marvel*. The boycotters were widely covered by outlets such as *Esquire*, the *Atlantic*, and *Bloomberg News* (see Miller 2019b; Sims 2019; Sakoui 2019). Online activists flooded film review sites such as Rotten Tomatoes with negative scores for *Captain Marvel* even before the film opened. Its audience approval rating dropped as low as 54 percent on Rotten Tomatoes (Sims 2019), well below other MCU installments.

Captain Marvel weathered the storm, earning over $1 billion at the box office. However, the right-wing backlash might be a bad sign given Marvel Studios' plans to diversify its casting in Phase Four of the MCU (Smith 2019). Twenty-one of the twenty-three MCU films in Phases One through Three have given top billing to a white male actor (Karim 2018). How will a more varied set of superheroes be greeted by the MCU's existing audience? Could a diverse cast expand the MCU's audience in the United States? Or can the MCU expect *Captain Marvel*–style backlash?

When *Captain Marvel* opened, right-wing commentators attacked the first MCU film with a woman in the sole title role. Some complained that Carol's mentor, Mar-Vell, had been changed from a male hero in the comics to a female hero played by Annette Bening in the film. From *Captain Marvel* (2019).

In this chapter, I investigate the US audience for the MCU. Consumer data reveals how dependent the MCU audience is on various market segments, such as men, young people, or non-Hispanic whites. It also clarifies whether the MCU is vulnerable to political backlash from the left or right. Despite the hype about opposition to diversity in MCU casting, the MCU fan base is already very diverse. The MCU outperforms similar movies in every demographic among US adults. People of color are the majority of the MCU's eighteen-to-twenty-four-year-old audience. I also find no evidence that recent non-MCU action and adventure movies that were led by women or men of color have underperformed with audiences. It is unlikely that diverse casting will be a drag on the MCU's commercial success.

The Stereotype

Fans of popular culture—such as enthusiasts of cinematic universes like the MCU—are associated with a stereotype: "The default fanboy has a presumed race, class, and sexuality: white, middle-class, male, heterosexual" (Gatson and Reid 2012, 4.1). This image comes from fictional portrayals of fandom and from media coverage of relatively expensive aspects of fandom, such as convention attendance (Woo 2018). Movie marketers consider males under twenty-five to be the primary audience (or "quadrant") for comic book adaptations (Harris 2011).

The image of a white male fandom is also promoted by right-wing commentators who oppose greater diversity in popular culture (Field 2018). They argue that popular culture increasingly demeans whites, men, heterosexuals, and other traditionally high-status groups. When source materials—such as comic books—are adapted to include more diverse characters, the changes come at the expense of storytelling and artistic quality. Such changes also slight the longtime fans (who, again, are assumed to be white men) who want to see characters come to life in their classic form.

A small number of Internet commentators make a living expounding this viewpoint in monetized YouTube videos, merchandise, crowdfunding, and fee-for-subscription media. A larger number of people engage in online anti-diversity trolling as a hobby. Campaigns of harassment are an annoyance and, at times, a danger to other fans, creators, and artists (Neiwert 2017). Marvel Studios is sufficiently aware of this subculture that their public relations teams sometimes obliquely address these concerns with comments reassuring viewers that diversity will not be "forced" (Smith 2019).

The calls for a boycott of *Captain Marvel* are the clearest case to date of the MCU being targeted by the antidiversity Internet commentariat. Prior to that, Marvel Studios' most consequential interaction with this subculture concerned offensive comments posted on Twitter by the director of the *Guardians of the Galaxy* films, James Gunn. In summer 2018, Gunn was removed from the third *Guardians* film when past sexist and offensive tweets were widely recirculated on social media. Gunn's tweets were unearthed and promoted by antidiversity commentators Jack Posobiec and Mike Cernovich "as part of an ongoing conservative strategy to portray what [the alt right] sees as the hypocrisy of liberal Hollywood" (Fleishman and Faughnder 2018). The controversy over Gunn's tweets was not directly related to the MCU or to diversity in popular culture. Cernovitch's and Posobiec's vendetta against Gunn was instead triggered by Gunn's comments about President Trump and a third conservative commentator, Ben Shapiro. Nonetheless, the episode showed that antidiversity media personalities can influence Marvel Studios' decisions. Such commentators will try to influence MCU's future creative choices, including its commitment to diversity.

On the other hand, Gunn was ultimately rehired. Likewise, the right-wing boycott of *Captain Marvel* did not prevent the film from being a box-office success. Antidiversity activists' denunciations of *Black Panther* barely got off the ground.

How much political controversy is diversity in the MCU likely to stir up going forward? The answer to that question depends, perhaps, on the demographics of the MCU's existing audience.

The Reality

We know that the MCU's lead characters are overwhelmingly white men. Is its audience also mostly male and white, as the stereotypes suggest?

To find more information on the demographics of MCU audiences, I analyzed marketing data collected by Simmons Insights, a subsidiary of the consumer credit reporting agency Experian. Simmons Insights conducts quarterly surveys of US adults[2] that ask about a huge range of products and services, including cinema. People taking the survey check off recent films they have seen and all of the formats in which they saw these films: in-theater, DVD purchase, DVD rental, streaming, download, or pay-per-view.

In its surveys from 2010 to 2017, Simmons Insights asked US adults about five MCU movies, listed in Table 22.1. The table also shows the surveys' estimates of the percentage of US adults who saw each movie in a theater and the percentage who saw each movie in any format. Across the five films, the in-theater MCU audience averaged 11 percent of US adults and the total audience averaged 17 percent of adults.[3] For comparison, the 352 films in the Simmons Insights surveys had a combined average in-theater audience of 3 percent of adults and an average total audience size of 8 percent of adults. MCU films have two to five times larger theatrical audiences and 25 percent to 150 percent more viewers across all formats. (The MCU does not, however, include the most watched film from 2010–2017: *Avatar*; 19 percent of US adults saw *Avatar* in a theater, and 35 percent saw it in some format.[4])

Of course, MCU films cost a lot more money to make than average movies, are advertised more widely, and are written to be as broadly appealing as possible (Harrison, Carlsen and Škerlavaj, 2019). The apples-to-apples comparison of MCU's audience should pit the MCU against movies that are also pitched to wide audiences and have similar budgets and marketing campaigns (Epstein 2010).

To find a comparison group for the MCU, I looked for films that met four criteria: (1) live-action films (2) with a PG or PG-13 rating, (3) action or adventure as their primary genre (Fritz 2020; Internet Movie Database 2020), and (4) a reported production budget of $100 million or more (Boxofficemojo .com, 2020). The least expensive MCU film to date is *Ant-Man*, with a reported cost of $130 million. All twenty-three MCU films meet these four criteria.

Sixty-four non-MCU movies in the marketing surveys also met these criteria.[5] These films include titles from the biggest franchises of recent years, including *Harry Potter*, *Star Wars*, and the DC Cinematic Universe. The top-billed actor in most of these films was a white man, with exceptions such as *The Hunger Games* and *The Fast and the Furious* movies.

Table 22.1. US adult audience for five MCU films

	Estimated Percentage of US Adults Who Saw Film	
	In a Movie Theater	In Any Format
Iron Man 2	10	16
The Avengers	15	20
Iron Man 3	13	20
Captain America: Civil War	12	17
Doctor Strange	6	10
Average	11	17

Credit: Data from Simmons Insights.

These large-budget action/adventure movies had audiences more comparable to the MCU's. Their theatrical audiences averaged 6 percent of the adult population and their total audience about 12 percent of adults. Still, four of the five MCU films in Table 22.1 outperformed those averages. *Doctor Strange* was the exception.

Beating the Competition

Which US adults are most and least likely to watch MCU films? Figure 22.1 shows details about the MCU audience by sex and race; the data displayed in the graph are also listed in Table 22.2. The left-most pair of bars shows the percentage of adults who saw a movie in any format, averaged across movies. The darker bar represents the five MCU movies in my Simmons Insights data: 17 percent of adults saw these films on average. The lighter-shaded bar is the average share of adults who saw the sixty-four non-MCU large-budget action movies: 12 percent. The MCU audience among US adults was 40 percent larger than that for competing films. The next four pairs of bars show the same MCU-versus-competitors comparison of audience size among women of color, men of color, non-Hispanic white women, and non-Hispanic white men. Within each pair, MCU viewership is the darker bar.

Figure 22.1 shows that the MCU is outperforming competitor films in every demographic. The right-most column of Table 22.2 calculates the size of the MCU advantage. Across sex and race, the MCU had 20 percent to 60 percent larger audiences. The MCU outperformed similar films in the individual racial and ethnic categories classified as people of color. The last rows in Table 22.2 show this data. About 23 percent of non-Hispanic Asian Americans see MCU films, roughly the same rate as that for Hispanics of any race. The rate of MCU viewership for Black non-Hispanics is 18 percent. The MCU's "weakest"

demographic is white women. In other market segments, rates of MCU viewership are at least 40 percent higher than those for similar movies. By contrast, among white women, the MCU outperforms competitors by "only" 20 percent.

The downside of this incredible performance is that it raises the possibility that the MCU is near a ceiling for its US audience.[6] There is no untapped pool of action/adventure fans for the MCU to capture—it already outperforms similar movies in all demographics.

People of Color Are the Core of the MCU Fandom

Figure 22.1 further shows that men see large-budget action/adventure movies, including MCU films, at higher rates than women. That is true of men of color compared to women of color and non-Hispanic white men versus non-Hispanic white women.

However, white men are not the most likely to watch MCU films. In fact, with a 17 percent viewership rate for MCU films, white men trail both men of color (24 percent) and women of color (18 percent).[7] The MCU's competitors also have higher rates of viewership among people of color than among whites.[8]

Age is one reason people of color see more MCU films than non-Hispanic whites. US whites skew older. Movie audiences, including MCU audiences, skew young. However, people of color watch MCU movies at higher rates than non-Hispanic whites in every age cohort.[9]

Relatively high rates of viewership mean that both men and women of color account for a bigger portion of the MCU audience than of the population in general. People of color are 36 percent of US adults but about 44 percent of the MCU's adult audience. Among the youngest adults, people of color are a majority; people of color are 52 percent of Marvel's eighteen-to-twenty-four-year-old audience.[10]

Will people of color be in the majority in future cohorts of adult MCU watchers? My marketing surveys do not cover the viewing habits of people under the age of eighteen. However, we can investigate how adults living with at least one person under the age of eighteen compared to adults who live in a household without minors. That comparison gives us some hint of what minors are most likely to be watching.

As Table 22.3 shows, men and women in every racial category see MCU films more often if they live in a household with at least one nonadult.[11] For people of color, the average MCU viewership is about 18 percent among adults who don't live with a minor but 24 percent among adults who do. About 12 percent

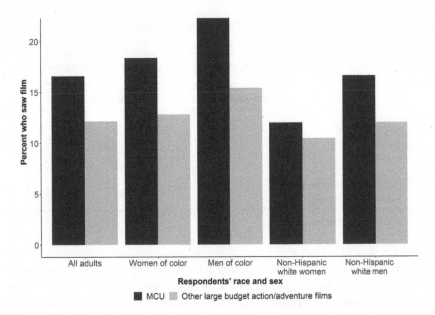

Figure 22.1. US adult audience for MCU versus similar large-budget action/adventure films. Credit: Simmons Insights.

Table 22.2. US adult audience for MCU versus similar large-budget action/ adventure films

	Estimated Percentage of US Adults Who Saw Film		
	MCU films	Similar films	MCU versus similar films
All adults	17	12	+42 percent
People of color	21	14	+50 percent
Women of color	18	13	+38 percent
Men of color	24	15	+60 percent
Non-Hispanic whites	14	11	+27 percent
Non-Hispanic white women	12	10	+20 percent
Non-Hispanic white men	17	12	+42 percent
Non-Hispanic Asian American women	20	15	+33 percent
Non-Hispanic Asian American men	26	16	+63 percent
Non-Hispanic Black women	15	11	+36 percent
Non-Hispanic Black men	21	14	+50 percent
Hispanic women, any race	20	13	+54 percent
Hispanic men, any race	25	16	+56 percent

Credit: Data from Simmons Insights

Table 22.3. US adult audience for MCU by race, sex, and number of minors in household.

	Estimated Percentage of US Adults Who Saw Film	
	Live alone or only with adults (age 18+)	Live with one or more minors (age <18)
All adults	14	21
People of color	18	24
Women of color	15	21
Men of color	22	27
Non-Hispanic whites	12	19
Non-Hispanic white women	10	17
Non-Hispanic white men	14	22

Credit: Data from Simmons Insights.

of non-Hispanic whites in adults-only households see MCU films, compared to 19 percent of those who live with at least one minor. Again, MCU films are more popular among people of color, even taking into account whether someone lives with a child or teenager.

People of color are also more likely to live with at least one person under 18. Forty-nine percent have a minor in their home versus 30 percent of non-Hispanic whites. Combined with higher rates of watching the MCU, people of color are the slim majority (51 percent) of MCU-watching adults from homes that include children or teenagers. This indirect evidence suggests that people of color are probably a majority or near majority of the MCU's under-eighteen audience, just as people of color are a majority of eighteen-to-twenty-four-year-olds watching the MCU.

Discussions about the lack of diversity in the MCU often imply that expanding diversity onscreen is a tool to win over nonwhite audiences (e.g., McClintock 2018). However, that framing misses the fact that people of color are already close to half of the audience for MCU films and the most avid consumers of large-budget action/adventure movies generally.

Could There Be a White Conservative Backlash against the MCU?

Another way to think about the potential for backlash against diversity in the MCU is to ask how much of the MCU audience is also the target audience for right-wing, antidiversity commentary. Media influencers critiquing diversity in popular culture center their pitch on conservatives, whites, and men. How much of the MCU audience ticks some or all of those boxes?

Table 22.4 shows rates of MCU viewership according to how respondents

Table 22.4. US adult audience for MCU films by race, sex, and political ideology

| | Estimated Percentage of US Adults Who Saw MCU Films | | | |
	Liberal	Moderate	Conservative	Liberals cf. conservatives
All adults	19	17	15	+27 percent
People of color	24	22	20	+20 percent
Women of color	21	19	17	+24 percent
Men of color	28	25	23	+22 percent
Non-Hispanic whites	16	15	14	+14 percent
Non-Hispanic white women	14	12	11	+27 percent
Non-Hispanic white men	17	17	16	+6 percent

Credit: Data from Simmons Insights.

described their political outlook: liberal, moderate, or conservative. I have also separated respondents by sex and race because antidiversity campaigns are often backlashes against racial and gender diversity. Also, whites and people of color do not necessarily use the same yardstick to measure liberal versus conservative (Jefferson 2020).

Table 22.4 shows that the MCU draws viewers at about the same rate across the spectrum of political ideology. About 19 percent of liberals see MCU films, compared to 17 percent of moderates and 15 percent of conservatives. In most demographics, conservatives are slightly less likely to watch MCU films than liberals or moderates. That pattern holds among men of color, women of color, and non-Hispanic whites. Non-Hispanic white men do not follow the same trend. In this market segment, liberals, moderates, and conservatives all watch MCU movies about the same amount.

The political composition of the MCU audience is quite balanced, just as rates of viewership are. On average, 22 percent of an MCU film's audience is non-Hispanic white conservatives, ranging from 19 percent of the audience for *Captain America: Civil War* to 23 percent of the audience for *The Avengers*. White conservative *men* are an even smaller fraction of the MCU audience: 11 percent to 16 percent. There is an overlap between the franchise's audience and the audience for antidiversity right-wing media. However, that group is nowhere near a majority of MCU viewers.

How Audiences Respond to Diverse Casting

On the other hand, diversity in the MCU might alienate people who are not self-identified conservatives. Identity politics tends to cut across the traditional labels of liberal and conservative (Jardina 2019). Can marketing data tell us

anything about how the sex or race of actors influences the success of a movie? Do men avoid movies headlined by women? Do people see more movies starring someone of their ethnicity?

One obstacle to answering these questions is that Hollywood movies, especially expensive franchise movies, are overwhelmingly led by white male actors. That is true of 90 percent of MCU movies to date. The non-MCU large-budget action/adventure movies for which I have marketing data are somewhat more diverse. Seventy percent were headed by white men, 20 percent were headlined by white women, and 10 percent had a man of color as the lead actor. None were led by a woman of color.

The seven films starring men of color do not represent all racial or ethnic groups. Three star Vin Diesel, who is multiracial.[12] Two films are led by Will Smith, an African American; one by Idris Elba, who is British–Sierra Leonean; and one by Dwayne Johnson, who is Black and Pacific Islander. Arguably, these leading men provide the most representation to non-Hispanic blacks. All four men have at least one black parent.

A further problem in my data is repeated entries from a few franchises. Idiosyncrasies in how audiences feel about these particular artists and stories have more weight in the data because of that repetition. The twelve films starring white women include two entries each from four franchises: *Twilight*, *Hunger Games*, *Divergent*, and Disney's live-action *Alice in Wonderland*. Three of seven films led by men of color are installments of *The Fast and the Furious*. Within these franchise pairs and trio, the lead actor is the same. The director, the writers, or both are constant.

A final caveat concerns diversity off-screen. A major difference between the films led by white women in my data and the films led by men of color is that the former group had more diversity behind the camera. Ten of the twelve movies starring white women are based on source material and/or a screenplay by a white woman. White men wrote the screenplay for six of the seven movies starring a man of color and wrote all of the source material.[13]

The Most-Watched Movies are Led by White Women

With those caveats in place, Figure 22.2 shows viewership of big-budget action/adventure movies according to whether the lead actor was a white man, a white woman, or a man of color. The left-most trio of bars gives estimated average viewership among all adults, the next trio is estimates for women of color, then men of color, then white women, and finally white men. Table 22.5 shows the same data and provides additional disaggregation.

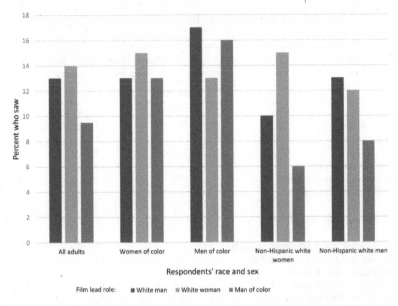

Figure 22.2. US audience for large-budget action/adventure movies by race and sex of lead actor. Credit: Simmons Insights.

The films with the highest average viewership were led by white female actors. These films had an average viewership of 14 percent of adults, compared to 13 percent for films led by white men and 9.5 percent for movies starring men of color.

Women are more likely to see films headed by women, and men are more likely to see films headlined by men. Among women of color, films led by a white woman had slightly more viewership (15 percent) than films led by white men (13 percent). White women were much more likely to see films led by white female actors than films led by white male actors. Among white women, viewership jumped 50 percent from an audience of 10 percent to 15 percent.

At the same time, movies starring women lost some viewership among men. An average of 17 percent of men of color saw movies led by white men. Just 12 percent saw movies led by white women. Interestingly, white men went to see movies starring white men and white women at about the same frequency: 13 percent versus 12 percent.

Overall, these numbers indicate that films starring white women fared well. Large gains among white women and smaller gains among women of color more than made up for losses among men of color. These movies also benefited from having little drop-off in viewing among white men.

Table 22.5. US adult audience for large-budget action/adventure movies by race and sex of lead actor

	Estimated Percentage of US Adults Who Saw Film Starring		
	White man	White woman	Man of color
All adults	13	14	9.5
People of color	15	14	15
Women of color	13	15	13
Men of color	17	13	16
Non-Hispanic whites	11	14	7
Non-Hispanic white women	10	15	6
Non-Hispanic white men	13	12	8
Adults living with 1+ children	15	18	12
Non-Hispanic Asian American women	16	17	9.5
Non-Hispanic Asian American men	19	13	9.4
Non-Hispanic Black women	11	13	14
Non-Hispanic Black men	14	12	18
Hispanic women, any race	13	16	14
Hispanic men, any race	17	14	17

Credit: Data from Simmons Insights.

Table 22.5 includes additional data on adults living with minors. Eighteen percent of adults in that category saw films starring white women, beating out the 15 percent who saw movies starring white men. This pattern reflects the fact that adults who live with a minor are disproportionately female. Female-led films may benefit from the double boost of drawing both adult women and the minors whom they live with.

What Draws New Audiences?

Movies led by white men and white women had similarly sized audiences. The seven movies starring a man of color had less viewership. Movies led by white men had an average audience of 13 percent of adults. Just 9.5 percent of adults saw films led by men of color.[14] A reason for that drop-off is that non-Hispanic whites were less likely to see these movies. Among both white men and white women, the audience for movies led by men of color was 40 percent smaller than the audience for movies with white male stars.

Those losses among white audiences were not offset by an increase in viewership among people of color. Women of color saw films led by white men and

men of color at the same rate: 13 percent. Among men of color, viewership of films led by men of color was 16 percent, slightly below the 17 percent rate of viewership for movies starring white men.

At the bottom of Table 22.5, viewership is presented according to a more detailed racial breakdown. In my data, the movies starring actors of color provide the most representation to Black Americans. The Black audience for these films was larger than the Black audience for similar films starring white men. Eighteen percent of Black, non-Hispanic men saw the seven movies led by men of color, which is a 29 percent increase over the average for films with white male stars. Black, non-Hispanic women's viewership was 14 percent, up from 11 percent (+27 percent). Hispanic men and women saw movies led by white men and men of color at roughly the same rate. Among non-Hispanic Asian Americans, however, viewership for the seven films starring a man of color was below the average for films with a white male star. Sixteen percent of Asian American women and 19 percent of Asian American men saw large-budget films with white male stars. Those rates fell to 9.5 percent and 9.4 percent for the movies starring men of color.

The boost that Black/multiracial leads had from Black audiences is small compared to the increased audience of white women for movies starring white female actors. Why? One factor may be that people of color are already the most likely to see large-budget action/adventure movies. It is difficult to increase viewership when enthusiasm is already high. However, that reasoning wouldn't account for the success of Black Panther, which benefited from a huge increase in African American theatergoing (McClintock 2018).

Behind-camera diversity is one difference between Black Panther and the movies starring men of color in my data. As noted above, only one of these seven films had a person of color as a director or writer. By contrast, Black Panther was directed by African American filmmaker Ryan Coogler, who cowrote the script with Joe Robert Cole, who is also African American. Some diversity behind the camera also characterized most of the films starring white women in my data. Ten of the twelve had source material and/or a screenplay written by a woman. The MCU's Captain Marvel is another example of a hugely successful film with a white woman as the star and women on the directing and writing team.[15]

Other chapters in this volume show how Black Panther and Captain Marvel use themes related to race and gender to differentiate themselves from other MCU installments. In other words, these films use their nontraditional leads to tell nonstandard stories. Arguably, the same cannot be said for the small set of films in my data that were led by men of color. For example, swapping a white actor for Will Smith in Men in Black 3 or Suicide Squad would be

straightforward. In both, Smith plays a character who was white in the source material. I suspect that these seven movies—starring men of color but written and directed by white men—did not stray enough from genre conventions to win new audiences. Without interest from people who do not usually see large-budget action/adventure movies, the films did not offset lost viewership among non-Hispanic whites and Asian Americans.

As noted earlier, the MCU's audience includes everyone who sees large-budget action/adventure movies and then some. Expanding its US audience—with or without diversifying its casting—would require winning over even more people who are not consistent fans of the genre. The evidence from other franchises suggests that behind-camera diversity is just as important for appealing to new audiences as diversity in casting.

The Scope of the MCU Audience

More than any other movie franchise, the MCU draws a large, diverse, and frequent audience for its storytelling. The scope of that audience makes the politics of the MCU important.

Marvel Studios' plans to diversify their casting will no doubt stir up some Internet trolling. However, more diverse casts will bring the superheroes into line with the composition of the MCU's existing US fan base. The adult MCU audience is about evenly split between non-Hispanic whites and people of color. The latter segment will expand as the youngest MCU viewers grow up.

Notes

1. The anti–*Captain Marvel* commentary came from a loose grouping of fan-run media sites that, at the time, were known as Comicsgate. The most prominent commentators in that area were aspiring independent comic creators such as Theodore Beale, who used the pen name "Vox Day" (*Reveal News* 2018).

2. The sample is of English- and Spanish-speaking adults, aged eighteen or older, living in the United States, excluding Alaska and Hawaii. Survey respondents are recruited through phone and mail solicitations. Respondents receive cash incentives with initial solicitations, when receiving survey materials, and in response to completed surveys. These cash incentives total between $15 and $60, with more money paid to harder-to-reach demographics such as households without landlines. Respondents are weighted to be representative by ethnicity, presence of a landline, income, and geography. The sample size is very large, close to twenty-five thousand respondents in a twelve-month survey period. See Experian (2010–2017).

3. The Simmons Insights estimates are similar to data in YouGov (2019).

4. Even *Avatar*'s reach was anemic by the standards of the pretelevision heyday of

studio films, when a majority of US adults saw major Hollywood releases. Contemporary US popular culture is comparatively fragmented (Fritz 2018).

5. The competitor films are as follows. Films marked with an asterisk (*) have a white woman as the top-billed actor. Films marked with a dagger (†) top-billed a man of color.

2009: *Star Trek; Terminator: Salvation; Night at the Museum: Battle of the Smithsonian; Transformers: Revenge of the Fallen; Harry Potter and the Half-Blood Prince; G.I. Joe: The Rise of Cobra; Where the Wild Things Are; 2012; Avatar.*

2010: *Alice in Wonderland*; Clash of the Titans; Robin Hood; Prince of Persia: The Sands of Time; Inception; Salt*; The Other Guys; Harry Potter and the Deathly Hallows: Part 1; The Tourist.*

2011: *The Green Hornet; Fast Five†; Cowboys & Aliens; The Twilight Saga: Breaking Dawn—Part 1*; Sherlock Holmes: A Game of Shadows; Mission: Impossible—Ghost Protocol.*

2012: *John Carter; Wrath of the Titans; Men in Black 3†; Skyfall; The Twilight Saga: Breaking Dawn—Part 2*; The Hobbit: An Unexpected Journey.*

2013: *G.I. Joe: Retaliation†; Oblivion; Star Trek Into Darkness; Fast & Furious 6†; World War Z; Pacific Rim†; The Wolverine; Ender's Game.*

2014: *RoboCop; Noah; Transcendence; Transformers: Age of Extinction; The Hunger Games: Mockingjay—Part 1*; Exodus: Gods and Kings; The Hobbit: Battle of the Five Armies.*

2015: *Jupiter Ascending*; Insurgent*; Furious 7†; Fant4stic; The Martian; Spectre; The Hunger Games: Mockingjay—Part 2*; Star Wars: Episode VII—The Force Awakens.*

2016: *Gods of Egypt; Allegiant*; Batman v Superman: The Dawn of Justice; The Huntsman: Winter's War; X-Men: Apocalypse; Alice through the Looking Glass*; Independence Day: Resurgence; Jason Bourne; Suicide Squad†; Miss Peregrine's Home for Peculiar Children*; Rogue One: A Star Wars Story.**

6. The MCU's adult audience may expand as children who grew up with the MCU turn eighteen. Some of those children are already in the Simmons Insights data. For example, an eighteen-year-old answering questions about *Doctor Strange* in 2016 was ten when *Iron Man* was released in 2008.

7. MCU viewership is likewise higher among Asian Americans, Hispanics, and non-Hispanic Blacks than among non-Hispanic whites.

8. Other marketing research has found that people of color are overrepresented in theatrical audiences for movies. See MPAA (2016), Sage (2016), Shaw (2014a, 2014b).

9. Among adults 18–24, MCU films drew 29% of people of color and 26% of non-Hispanic whites. In the 25–34 age bracket the corresponding averages are 27% and 22%, respectively. Ages 35–44: 25% and 21%. Ages 45–54: 17% and 14%. Ages 55–64: 14% and 9.1%. Ages 65+: 6.3% and 3.5%.

10. The US Census Bureau (2018) calculates that in 2018, 46% of the population between 15 and 24 was people of color.

11. This category includes people who live with underage siblings, stepchildren, foster children, grandchildren, and so forth. On the other hand, the category does not include people whose adopted or biological children are grown or do not live with them.

12. Vin Diesel has not publicized all details of his ancestry. *Multi-Facial* (Bijelonic 1999) describes his experience auditioning for acting roles as a person of ambiguous ethnicity.

13. Guillermo del Toro—a Mexican national—directed and cowrote the screenplay for *Pacific Rim.*

14. I considered whether this pattern was the result of the unique business strategy of *The Fast and the Furious* franchise. It earns a much higher share of its revenue outside the United States than other ongoing franchises (Dawson 2017). Since US audiences are less important for these films, perhaps they are not advertised much domestically. However, the

three installments of *The Fast and the Furious* are among the best-performing films led by men of color. They outdraw other films led by men of color in every demographic in my data, including non-Hispanic whites.

15. Anna Boden directed *Captain Marvel*. Boden has a writing credit on the movie along with Ryan Fleck, Geneva Robertson-Dworet, Nicole Perlman, and Meg LeFauve.

CHAPTER 23 GEOPOLITICAL REPRESENTATIONS OF AFRICA THROUGH THE MARVEL CINEMATIC LENS

Meghan S. Sanders

Black Panther, the eighteenth film in the Marvel Cinematic Universe (MCU), was the first film in the franchise to feature a character of color in the lead role. Grossing over $700 million in the United States and $1.3 billion worldwide, it was the top-grossing film in 2018 in the United States and Canada, outpacing the second-highest top-grossing film by $22 million (Box Office Mojo 2019; MPAA 2018). In addition to breaking many box-office records, the film was heralded as a beacon for disproving the notion that films featuring Black stories and characters don't "travel" or perform particularly well at the global box office. The film attracted a very large, racially and culturally diverse audience.

In addition to its popularity, *Black Panther* raised a wide range of interesting questions about how Black people relate to one another and how people perceive African nations. In this film, Wakanda, the African nation at the heart of the story, represents an "unbroken chain of achievement of Black excellence that never got interrupted by colonialism" and by extension shows the global power and vitality of an African nation. Wakanda shows Black people whose history is not rooted in enslavement and other forms of oppression (Betancourt 2018). Especially important at a time when the sitting US president referred to African nations in extremely derogatory terms, *Black Panther* triggered complex conversations about what it means to be African and what embracing these identities means to how one thinks about cross-cultural and global relations. In this chapter, I examine how *Black Panther* and *Avengers: Infinity War* shaped audience perceptions of African Americans and African nations and what this means for one's understanding of how nations relate to one another. I present results based on audience response data that included questions focused on the global contributions of African nations as well as their cultural, political and social importance and power.

Popular Media, Geopolitics, and the World of Wakanda

Media can serve to remind people that they belong to a national community and what their roles and responsibilities may be. This national identity also speaks to how one may think of nation-state relationships. How stories are framed (e.g. who holds power, who is at fault for societal ills, who needs aid) speaks to anxieties about a nation's place in the world, relationships between nations, and histories of conflict. They tell "us" how we relate to everyone else. Entertainment media arguably do the same, reinforcing and at times contesting global power relations and shaping how audiences think about global relationships.

Hollywood films have long implied that Western nations are on the side of righteousness and moral superiority and are therefore most deserving of economic, political, and global power. Cowboy films often depicted white Americans dying at Native American or Mexican hands. The Japanese bombing of Pearl Harbor in 1941 is often presented as unprovoked, without referencing the decades-long competition between the United States and Japan or US control of Japan's access to oil and scrap-metal imports. Cold War and post-9/11 narratives routinely feature terrorism, often with heavily Islamophobic themes (Downing 2013, 11–12).

The contributions of Black people to broader society are often relegated to the background (Johnson 2020). Often, entertainment narratives featuring African culture depict nations struggling with famine, torn apart by civil war, corruption, and savagery or struggling with the long-standing effects of colonialism. The widespread challenges facing the nations are "attributed to a type of African essence rather than to structural conditions inherited by the post-colonial states and the specific historical circumstances of Africa's integration into the world-market system" (Sorenson 1991, 235). Nations are presented as backward and lacking political and financial agency, with little access to material resources and next to no geopolitical power (Asante and Pindi 2020; Hanchey 2020). And the only source of potential redemption comes in the form of a white savior or Western influence that creates a paternalistic relationship (Hanchey 2020).

Black Panther was different, however, in that its centering of a nondominant culture and the resulting acclaim provided not only an avenue for showcasing the strength, competence, beauties, and intelligence of Black people but also a venue through which to literally show African cultures as vital to an entire universe, thus changing the perceptions of the importance and vitality of entire groups of people. Additionally, the film provides a unique case for examining how Black audiences cross-culturally interpret the film's effects on their

Black Panther sharply contrasts stereotypical representations of African nations in cinema, instead showcasing the strength, competence, beauties, and intelligence of African people and literally showing African cultures as vital to an entire universe. From *Black Panther* (2018).

perceptions of African nations—their political and financial power as well as their cultural importance.

Black Panther contradicts stereotypical representations of African nations in other films. What audiences get a glimpse of in the film is what an African nation could have been had it been left alone, a nation where customs, culture, and technology are seamlessly integrated. In the MCU, Wakanda is an African nation that has never been invaded or colonized and is the most technologically advanced society on Earth. Wakanda is a nation of great power, wealth, and independence thanks to its vast deposits of vibranium. The metal is one of the many reasons the country thrives unimpeded by the world's influence. At the same time, the film still shows a battle for protection of one's land, resources, and freedom against outside invasion and corruption. For generations, the Wakandans have hidden their advancements from the rest of the world for their own protection, only selectively getting involved in outside matters.

The story juxtaposes the main characters of T'Challa and Killmonger (the narrative's primary antagonist). Killmonger has direct familial ties to the royal family, but he was not raised within the protective borders of Wakanda. Rather, he experienced the world as an African American man, which led him to embrace the arguably righteous argument that Black people should come together in a show of force across the diaspora (although his methods of doing so ultimately transform him from the oppressed to the oppressor). T'Challa struggles with the core question of whether Wakanda should remain in the shadows for its own protection or whether he should introduce the world to Wakanda and become a key power player in the global arena, helping heal some of society's ills.

The *Black Panther* narrative encourages audiences to think of the geopolitics of African nations. Johnson (2020) argues that this film illustrates how audiences are willing to accept an African country rich with advanced technology, weaponry, financial resources, and stability but that these perceptions may not extend in some ways to nations outside the fictional realm. In this chapter, I assess such perceptions among Black audiences who may indeed feel a sense of increased vitality in connection to viewing a Black-centered narrative.

This chapter explores these elements by asking the following research questions:

In what ways did *Black Panther* encourage Black American and Black African audiences to think about the contributions of African nations to a global society?

In what ways did *Black Panther* encourage audiences to think about both historical (e.g. colonialism and exploitation) and contemporary issues (e.g. systemic racism and disempowerment) related to how African nations and Black Americans have been treated, and were there differences between audience groups?

When thinking about social, cultural, and political importance in a larger, global context, how well did audiences think *Avengers: Infinity War (Infinity War)* presented African culture and political importance to the global community compared to *Black Panther*?

Method

Samples

To determine audience perceptions of African nations in response to Wakanda-based storylines, I conducted a series of independent surveys as part of a larger research project. For this chapter, results from three surveys are presented. Two surveys asked about the film *Black Panther*, while the third was related to *Infinity War*. These two films were chosen because the role of Wakanda features prominently in both. In *Infinity War*, the nation of Wakanda is embedded in the larger scope of characters and action in the MCU, allowing me to examine how audiences perceived geopolitical relationships between Wakanda and the rest of the world. Participants in all three surveys had seen *Black Panther*, while participants in the third survey had seen both films. The first survey ran from March 28 to April 3, 2018 (nearly a month after the theatrical release of *Black Panther* but prior to the release of the next film in the MCU) and was administered to Black Americans. The second survey was conducted April 16–27, 2018, and administered to Black African respondents. The participants were

Table 23.1. Descriptive statistics of survey participants

	Survey 1 Black American sample ($N = 341$)	Survey 2 Black African sample ($N = 368$)	Survey 3 *Infinity War* sample ($N = 103$)
Gender			
Male	54.0%	54.9%	41.7%
Female	46.0%	45.1%	58.3%
Age	39.08	28.73	31.80
	(14.42)	(7.27)	(9.67)
Ethnicity/race			
Black	100%	93.8%	12.6%
White	2.1%	1.9%	67.0%
Latino/Hispanic	.3%	.5%	9.7%
Asian/Asian American	.3%	0%	14.6%
Native	.9%	0%	1.9%
Other	0%	3.5%	1.9%
Live in United States	—	—	81.5%
Conservative	17.7%	—	10.3%
Moderate	48.0%	—	24.7%
Liberal	34.4%	—	63.9%
Proud of heritage	4.62	4.70	—
	(.73)	(.63)	
Feel like saw a version of self	3.46	3.10	—
	(1.26)	(7.64)	

Note: N = number of participants. Numbers in parentheses are standard deviations. Categories represented by a dash ("—") means the question was not asked in the survey. Participants were able to select more than one ethnicity/race.
Credit: Author's data collection.

members of a survey panel service that allowed them to opt in to the surveys. The third survey was conducted May 1–May 29, 2018, and coincided with the first month of *Infinity War*'s theatrical run.[1] The participants in this survey were recruited through a variety of social media posts. It is important to note that in the case of all three surveys, the participants were people wishing to engage in conversation regarding their viewing experiences, so their perceptions may not be representative of all audience members who saw one or both films. Table 23.1 summarizes the demographics of the people who participated in each survey.

Measures

A series of questions related to representations were asked of the Black American and Black African *Black Panther* samples, gauging perceptions of how well the film seemed to represent African nations' greater contribution to a global society, the strength of African cultures, and an appreciation of Black people as

strong, intelligent, and powerful. The respondents were presented with a series of statements and asked to indicate their level of agreement with each one using a common five-point scale (one = "strongly disagree," two = "somewhat disagree," three = "neither agree nor disagree," four = "somewhat agree," and five = "strongly agree"). Another series of items assessed how much the film made them think about how vital to society they believe Black Americans and Black Africans to be (Abrams and Giles 2004, 1; Bourhis, Giles, and Rosenthal 1981).

Vitality is a social construction that refers to the idea or perception that a group is likely to behave as a distinctive and collective entity in relationship with another group (Abrams, Eveland, and Giles 2003). Groups with higher vitality are more likely to survive and thrive as a group in the context of intergroup relationships. Perceived vitality particularly influences how empowered groups may feel they are, how influential, competent, skillful, or able to control or have authority to influence events and outcomes important to them and their communities (Chiles and Zorn 1995; Fawcett et al. 1995). It may also involve how they have been empowered by history, how much control they have over their own destiny, and a group's ability to apply pressure to institutions (e.g., informal support) that protect its interests and obtain and serve in positions of power (e.g., formal support). The respondents were asked to indicate how much perceived status, respect, and strength they believed African people and African Americans to have in a number of areas, including politics, business, and government. These questions were answered on a five-point scale ranging from one = "very little" to five = "a lot." This measure was presented in only the Black American and *Infinity War* surveys.

The participants in both *Black Panther* surveys were asked questions related to how much the movie made them think about various political and historical issues compared to their usual mindset. This series of questions included topics such as political issues concerning Africa's relationship with the West, the influence of colonialism and the exploitation of African nations, institutional bias, systemic racism, the feelings of disempowerment people of color often experience, and global historical issues. The scale ranged from one = "much less" to five = "much more." To simplify our understanding of individuals' responses, I divided these questions into three categories based on a statistical analysis: geoaffairs, disempowerment, and history and politics.[2]

Specific to *Infinity War*, the survey participants were asked to indicate how much they agreed with various statements related to how well the film presented African culture and cross-cultural relationships compared to *Black Panther*. There were eight questions that included how well the film emphasized African culture, the ability of Wakanda to protect that culture, and how well the film presented Wakanda as a global political power. The respondents rated

Table 23.2. Comparisons of perceived global contributions of African nations for Black Americans and Black Africans

	Black viewers of BP		Black African viewers of BP	
	M	SD	M	SD
Reflections on African nations as rich contributors to global society	4.23	.89	4.30	.99
What it means to be African in a global society	4.15	.94	4.35	.92
The strength of African cultures	4.42	.87	4.47	.85
Reinforced appreciation of Black people as strong, powerful, and intelligent	4.46	.88	4.52	.85

Credit: Author's data collection.

their perceptions on a common scale ranging from one = "strongly disagree" to five = "strongly agree."

Results

Reflections on African Cultures and Contributions

The first research question focused on the ways in which *Black Panther* encouraged Black audiences, both in the United States and in African nations, to think about African nations as important contributors to global society.

As Table 23.2 illustrates, Black American and Black African respondents did not differ in terms of how much the film made them think positively about the contributions of African nations to global society, the strength of African cultures, or how much they appreciated Black people as strong, powerful, and intelligent. They did differ, however, in how much the film made them think about what it means to be African in a global society, t (706) = -2.86, $p < .01$. Even though Black Americans did think about this often, the African respondents reported thinking about the meaning of African identity on a global scale more often. One Black American participant wrote in an open-ended response, "*Black Panther* was done in great taste and I congratulate Marvel for letting it be a representation of African/African American intelligence, strength, unity and humility." Another person wrote, "The movie caused me to self reflect and see that I do have something to offer the world. I liked the cultural heritage of Africans portrayed in a positive light." A native African viewer stated, "It was a good experience. One of it's kind and incorporated so much of the African culture, power and beauty which evoked a lot of emotion. It's not everyday you get to see your people being portrayed as what they truly are. Powerful and

Table 23.3. Perceived presentation of world issues in *Black Panther*

	Overall	Black American viewers	African viewers
Presentation of world issues		M	M
		(SE)	(SE)
Geoaffairs	4.04	3.99$_{aA}$	4.10$_{aA}$
	(.03)	(.04)	(.04)
Disempowerment	3.82	3.80$_{aB}$	3.83$_{aB}$
	(.03)	(.05)	(.05)
History and politics	3.79	3.78$_{aB}$	3.81$_{aB}$
	(.03)	(.04)	(.04)

Wilks's λ = 1.00, $F(2, 706)$ = .89, p >.05, partial h^2 = .003
Note: Within rows, subscripts with lowercase letters in common differ at $p < .10$. Within columns, subscripts with uppercase letters in common differ at $p < .05$.
Credit: Author's data collection.

intelligent." These results imply that at least for Black audiences, *Black Panther* highlighted the strength and importance of Black people to the broader society.

Reflections on Historical and Contemporary Issues Related to Black Populations

The second research question asked about the ways in which the film encouraged thoughts about historical and present-day treatment of Black communities and African nations.

Another analysis was conducted to determine whether there were (1) differences in which issues the film seemed to get audiences to reflect on and (2) whether any of these differences depended on whether the audience member was Black American or Black African. This analysis included survey items related to geoaffairs (e.g., political issues concerning Africa's relationship to the West), disempowerment (e.g., feelings of disenfranchisement of Black people around the world and systemic racism) and history and politics (e.g., important global historical issues). The full results are reported in Table 23.3. The results showed a difference only in issues.[3] Generally, the respondents reported that the narrative made them think more about geoaffairs than about the disempowerment of Black people and the history and politics related to the treatment of Black people.

As an area of study, "geopolitics" refers to research that seeks to understand relationships between and among regions, nations, groups, and cultures that are shaped by complex histories of collaboration, conflict between parties, as well as colonialism. Geopolitical research can include studies of international relations, foreign policy, and political and economic transformations (Burkart and Christensen 2013, 4). Often, conversations about geopolitics revolve

around disputes between nation-states regarding global real estate or access to mineral resources, historic grievances between neighboring countries, unfair labor practices, and even cultural dominance (Downing 2013, 17). One Black American respondent wrote when asked for general thoughts regarding the film, "If only all governments were willing to work together instead of always fighting or complaining." A Black African respondent wrote that the film "gave a sense of relevance for Africans around the world."

Toward the end of the film, in an address to the United Nations, T'Challa states,

> For the first time in our history, we will be sharing our knowledge and resources with the outside world. Wakanda will no longer watch from the shadows. We cannot. We must not. We will work to be an example of how we as brothers and sisters on this earth should treat each other. Now, more than ever, the illusions of division threaten our very existence. We all know the truth. More connects us than separates us. But in times of crisis, the wise build bridges, while the foolish build barriers. We must find a way to look after one another as if we were one single tribe.

In this statement, and as evidenced in the survey responses, Wakanda cannot stay removed from global affairs, and it begins with an outreach and science and information exchange in Oakland. In this way, the film shows an African nation addressing global social inequality and flexing its power to be the support Western nations are in need of rather than the other way around (Hanchey 2020). This presentation was picked up by the audience, at least in some ways, and made audiences think about African nations' abilities to provide international aid. One native African participant wrote, "I liked the fact that it showed African people as advanced, great leaders, thinkers, queens and kings. That we don't always need the west to help us, that we are heroes, not just slaves, that we come from dynasty, that we deserve better treatment."

Differences in Perceived Vitality, Cultural Representations, and Cross-Cultural Relationships: *Black Panther* vs. *Infinity War*

I was also interested in whether and how the two films may have triggered reflections on African nations as important to the global landscape. The emphasis in this analysis was on how socially, culturally and politically important and powerful audiences perceived African and African American communities to be after viewing each film. To understand these connections, I compared responses of Black American *Black Panther* participants to those of participants who had viewed *Infinity War*. These two surveys were chosen as comparison

Table 23.4. Comparisons of perceived vitality of Black Americans and Black Africans

Vitality of African/African Americans	Black viewers of BP		Viewers of *Infinity War*	
	M	SD	M	SD
Economic and business control	3.09	1.91	3.29	2.07
Political control	2.75	1.82	2.99	1.96
General power	2.95	1.89	3.20	2.01
Wealth	3.28	1.95	3.35	2.09
Government influence	2.96	1.93	3.15	2.07
Cultural representation	2.58	1.25	2.63	1.15
Media representation	2.40	1.26	2.69	1.29
Business representation	2.41	1.19	2.17	1.03
Respect in United States	2.28	1.18	2.19	.93

Credit: Author's data collection.

points because they largely consisted of US-based respondents. The full set of results is presented in Table 23.4.

Compared to viewers of *Black Panther*, viewers of *Infinity War*, a narrative that consisted largely of a majority-white yet still diverse cast, felt that African/African Americans had greater representation in media and was slightly higher in terms of economic, business, and political control; general power; wealth; and government influence. This could be because the narrative in *Infinity War* highlighted Wakanda as the only country with the resources and technology to thwart the invading armies of Thanos. The reverse was found, however, in regard to representations in business and respect in the United States. *Black Panther* was thought to elicit more thoughts in these areas. This reversal could perhaps be attributed to the more intense focus of *Black Panther* on Wakanda's community structure and technological advancements as well as the country's ability and shrewdness in being able to protect itself from outside intrusion and influences for many centuries. It should be noted that in many instances, people's mean responses in each category did not exceed 2.5 (the middle-most score of the scale they were asked to use in responding). This suggests that overall, both films were moderately influential in getting audiences to think very strongly about how vital Black people and African nations are in various societal contexts.

A second series of analyses used only responses from the *Infinity War* survey, as these questionnaire items were not included in the other surveys. These questions asked audience members to make direct comparisons between how *Black Panther* presented the importance of African culture and political power with the presentations in *Infinity War*. Compared to *Black Panther*, respondents felt that *Infinity War* had much less of an emphasis on culture (M = 4.06,

Avengers: Infinity War depicts Wakanda as the only nation with the resources and technology needed to repel Thanos's invading armies. The film's majority-white cast was still diverse, and viewers felt that Africans/African Americans had greater representation in it. From *Avengers: Infinity War* (2018).

$SD = .93$) and cultural pride ($M = 3.47$, $SD = 1.15$). One participant wrote, "The movie was a great representation of different cultures meeting and working together for the good of every being in the universe." Another participant wrote, "The lack of cultural significance compared to *Black Panther* was stark but unsurprising. It would be nice if Marvel reached for the bar set by *Black Panther* regarding narrative depth for all of their movies going forward but that may be asking too much."

Although the respondents felt that the ensemble film focused more on helping everyone than on targeting the conditions of Black people ($M = 3.99$, $SD = .77$), this perception didn't translate into perceiving the Wakandans as being forced to change in order to safeguard their culture and way of life ($M = 3.02$, $SD = 1.02$) or T'Challa assimilating his viewpoint to fit with those of the other Avengers ($M = 2.66$, $SD = 1.06$). The respondents agreed that the nation showing its technological advancements and wealth earned it more political power ($M = 3.73$, $SD = .91$). They also felt that, compared to the origin film, *Infinity War* prompted them to think only moderately about intercultural relationships ($M = 3.17$, $SD = 1.09$) and actually prompted fewer thoughts about global politics ($M = 2.22$, $SD = 1.02$) even though it more concretely placed the nation and characters within a global context. This could be because the origin film asked explicit questions and provided story plots and dialogue related to these ends. For example, in *Black Panther*, audiences witnessed the following exchange between T'Challa and Nakia:

Nakia: I've seen too many in need just to turn a blind eye. I can't be happy here . . . knowing that there's people out there who have nothing.

T'Challa: What would you have Wakanda do about it?

Nakia: Share what we have. We could provide aid . . . and access to technology and refuge to those who need it. Other countries do it; we could do it better.

However, based on open-ended responses, *Infinity War* audiences did seem to think about cross-national relationships, but more as a function of key events that took place in the story. One participant wrote regarding the disappearance of T'Challa in the Snap: "Is Shuri gonna get a chance to rule? We gonna see M'Baku do it? What's that mean for Wakanda's currently political philosophy?"

Conclusion

This chapter has focused on understanding audience responses to *Black Panther* and *Infinity War* regarding the cultural strength and vitality of African nations and, to a lesser extent, African Americans in the global landscape. By focusing primarily on Black audiences, this study provides only a snapshot in terms of better understanding the role that entertainment narratives presenting the complexity and richness of these groups may play in the self-esteem and efficacy of historically nondominant cultural and political entities as well as how they may contribute to reflection on the importance of African nations to broader global relations. Research on geopolitics has found that even acts of global citizenship, at least in the vaguest sense of caring for distant others, often still do not truly engage a sense of global community because they are often presented through stories framed to prime thoughts of belonging to a home nation-state. The results of this study suggest the opposite when it comes to Black Americans, providing some evidence of feelings of belonging to some nation-state of Africa and globalization among Black people.

Black viewers of *Black Panther* had similar reflections on African nations as global contributors, the strength of the cultures, and the beliefs that Black people are strong and powerful. These two groups of respondents also did not differ in terms of rumination on the film's themes regarding contemporary and historical issues related to Black populations. Geoaffairs, including political issues involving African and Western nations, a responsibility to help other communities in need, and challenging whites to accept cultural differences and values, were considered most often compared to issues related to disempowerment and historical ills. Viewers of *Infinity War*, who were a culturally and racially diverse group of respondents, felt that this film's narrative had less emphasis on African culture and cultural pride than *Black Panther*'s and that

the narrative focused on a larger, more inclusive collaboration on a global scale rather than the Black experience. Yet viewers did not feel that the Wakandan nation compromised its cultural values or assimilated into others' conceptions of what it means to be African. While they did not necessarily think much about global politics or intercultural relations, they did see Wakanda as earning and leveraging more political power in this film through its technological advancements.

On the surface, it may seem as though the positive perceptions and reflections prompted by *Black Panther* did not quite translate into increased feelings of vitality for Black audiences. However, we do see evidence of ruminations about the potential power of Black people on the global stage driven by both films. If we think of vitality more broadly in terms of intergroup relations, we see some support for the movies having elicited more positive thoughts about the importance and contribution of African nations. Media often tend to present certain countries, particularly African and other developing countries, as incompetent, lacking self-reliance, and having poorly functioning governments, limiting the capacity of individuals to feel compassion and reproducing existing geopolitical power relations. In the counternarratives provided by some of the MCU films, we see an opportunity to change these beliefs and this dynamic.

Asking questions related to how much the film may have influenced audiences' perceptions of the vitality of African nations can serve as an indicator of what is possible with this sort of continued representation of countries and how they may translate to the real world. The research methods used here, however, are limited in scope because the responses are based on each person's recollection of his or her experience. Individuals were not surveyed immediately after having seen the films, and this type of research relies on a certain amount of trust that individuals will be honest in their self-report and not yield to internal or external pressure to respond to questions in ways that they feel may be more socially desirable.

Despite this limitation, the results shared here do have implications for how we understand entertainment's association with political attitudes. Just as media narratives can provide insight into worlds and others' lived experiences, they can provide insight into intergroup power dynamics and social hierarchies, serving as a resource to form beliefs about various social groups, including the number and characteristics of group members, how much societal support they possess, how much they contribute to society, and which groups are threats (Abrams 2008; Harwood, Giles, and Bourhis 1994; Abrams, Eveland, and Giles 2003). Historically, media messages have presented dominant or majority groups in a positive light while doing the opposite for nondominant, marginalized, or minoritized ones. More broadly, through stories, entertainment media

have the ability to inform audiences on what and who is powerful and empow-ered, what they should think about social and structural inequalities, and the history and current status of geopolitical and cross-cultural relationships.

Notes

1. The participants in surveys one (Black American *Black Panther* audience) and two (Black African *Black Panther* audience) were recruited via two Qualtrics panels, while those participating in survey three (*Infinity War*) were recruited via social media posts and convenience sampling

2. Geoaffairs (variance explained: 40.98; α = .79), disempowerment (variance explained: 12.57; α = .85), and history and politics (variance explained: 7.26; α = .80).

3. Wilks's λ = 91, $F(2, 706)$ = 36.04, p <.001, partial ε^2 = .09.

PART IV CONCLUSION

CONCLUSION

"YOU'VE BECOME PART OF A BIGGER UNIVERSE"

Plurality, Public Things, and the Marvel Cinematic Universe

Jennifer Forestal

In December 2017, Marvel Entertainment announced the debut of Marvel: Create Your Own. Described by the company as a "fan-powered community" where fans could "write, create, and share their own Marvel stories," Create Your Own was presented as a way to "Build Your Own Marvel Universe" (Markus 2017). Almost immediately, however, Marvel: Create Your Own faced considerable backlash from fans. Instead of allowing fans to play with Marvel's original content, creating and sharing their own interpretations of beloved characters, settings, and stories, Create Your Own came with a number of rules and restrictions regulating the kinds of "Marvel Universes" fans were allowed to create.[1] Fans were forbidden from including references to, for example, contraceptives, "bare midriffs," "noises related to bodily functions," guns, amusement parks other than Disney's or movie studies not "affiliated with Marvel," and politics—such as "alternative lifestyle advocacies"—or other "controversial topics," including "social issues" (Tiffany 2017). With Marvel: Create Your Own, in other words, Marvel invited fans to take the Marvel Universe in new directions—so long as those directions "fit" within Marvel's relatively narrow vision for its brand. The result was that fans largely took their creativity elsewhere. Today, while "fan-powered communities" thrive on sites like Tumblr and Fanfiction. com, Marvel: Create Your Own is largely defunct.

The initial promise, and ultimate failure, of the Marvel: Create Your Own platform illustrates the possibilities—and limitations—of pop culture "public things." As the process through which a diverse group of citizens negotiate among themselves to make decisions about their common affairs, democratic politics requires the presence of public things. These shared objects—such as parks, schools, and monuments—serve two important functions in our political lives. As sites of shared experiences, public things, first, help to *gather* citizens together into potential bodies politic; they help to generate the interpersonal ties of recognition and solidarity through which we come to acknowledge and act on our shared reality as people living with others.

But democratic politics involves more than simply the gathering together of people; it also inevitably involves contestation and difference. For public things to help support democracy, then, they must also represent the diverse citizenry who shares in them; they must reflect, in other words, what Hannah Arendt calls *plurality*, or the inherent variety of human experiences that exist in the world. When public things lack this plurality—when they exclude certain modes of engagement or demand a single way of being—the possibilities for democratic politics are minimized.

Though we often think of public things as objects that are publicly owned or managed, the (privately owned) technologies of pop culture have long served in this role. Newspapers, for example, have helped to form communities among their readers, even as they include opinion pieces and letters to the editor that reveal disagreements and divergences from the perspective of the newsroom. And comics are often the product of a cooperative effort involving many different writers and artists reinventing shared characters and stories around which fans have long mobilized, just as television shows and movies provide the characters, settings, and stories that often serve as a set of shared references that form a foundation for collective life.

With its twenty-eight feature films (with eleven more in development), five direct-to-video short films, twenty television series (with ten more planned or in production),[2] two streaming miniseries, two digital series, and thirty-two tie-in comics (so far), the Marvel Cinematic Universe (MCU) follows in this tradition as perhaps the most groundbreaking transmedia narrative to date (Burke 2018). Moreover, it is a pop culture force to be reckoned with. Since the unexpectedly popular debut of 2008's *Iron Man*, the MCU movies have each averaged close to $1 billion at the box office (Leslie 2021).[3] And the MCU's economic footprint is overshadowed only by its cultural impact. It is hard to escape the MCU. Even as most people in the United States have seen at least one MCU movie, the franchise has "redefined cinema" by stoking audiences' appetite for intricate and consistent storylines that unfold across multiple properties (Alexander 2019; Statista 2018). Whether we are hard-core fans or mere observers, the MCU touches us all. As such, I argue, we should understand the MCU as a public thing.

With its transmedia approach to storytelling—unfolding over multiple media and with input from a number of different writers, directors, casts, and crews (as Goldberg explains in this volume)—the MCU not only serves as a shared object around which fans and audiences might gather and form the ties of solidarity so integral for democracy but also holds the potential to accommodate a variety of perspectives, reflecting the plurality required for democratic politics. And yet, as I argue, just as we saw with Create Your Own, Marvel's unprecedented creative control over its properties endangers this plurality of

perspective in the MCU. For example, the company has, in the recent past, imposed a singular vision of the MCU as "family-friendly"—a designation that, functionally, worked to exclude certain stories, characters, and possibilities that were nevertheless valuable contributions to public life. In so doing, Marvel took steps to narrow the kinds of stories—and styles—deemed "appropriate" for the MCU. And just as the placement of "antihomeless" spikes work to exclude certain "unacceptable" populations and modes of behavior from public spaces in the physical environment, so too did Marvel's choice to restrict the kinds of stories represented in the MCU ultimately undercut its effectiveness as a democratic public thing. While there is some indication that Marvel has taken steps to expand its offerings once more, this history stands as a stark reminder of the democratic dangers associated with unchecked corporate control over public things.

In this chapter, I explore in more detail the MCU's potential as a public thing and its effects on democratic politics. After first briefly discussing the democratic function of public things and the ways that pop culture technologies serve this role, I turn in the following section to examining the MCU as a public thing. Ultimately, I argue that while the MCU should be understood as a public thing, there is reason to be worried about Marvel's earlier emphasis on the conformity of the stories included within it; this narrowing of focus limits the kinds of perspectives represented within the MCU and thus undermined its role as an anchor of democratic politics. I conclude with some thoughts on how those invested in democratic politics might increase our attention to the democratic effects of pop culture's media technologies and suggest strategies for reasserting democratic control over, and reintroducing plurality into, privately owned public things such as the MCU.

Pop Culture and Public Things

As the collective management of common affairs, democracy is the process through which a diverse group of people come to make decisions about the things they share. This involves the "drawn-out wearisome processes of persuasion, negotiation, and compromise" as we work through differences of opinion to arrive at a decision together (Arendt 2006, 86). In other words, the collective decision-making of democracy can be difficult, often frustrating work. It involves a delicate balance between cohesion and distinction—recognizing the interests we share with others while also acknowledging that there are an infinite number of ways to approach those shared interests. Navigating this tension can be challenging. Indeed, failures of democratic politics can often be traced to an absence of one or both of these elements—citizens either refuse

to acknowledge a shared world or insist on a single mode of engaging with it. Both ultimately undermine the possibilities for democracy.

Political theorists have identified a number of mechanisms that can help negotiate this tension, from institutions such as public education to informal norms such as those of neighborliness and friendship (Allen 2004; Dewey 1916; Rosenblum 2016). Among these mechanisms are what Bonnie Honig (2017, 36) calls "public things." Public things are "things around which we constellate, and by which we are divided and interpellated into agonistic democratic citizenship." They are, in short, objects we share with others, objects that both "relate and separate" us as distinctive members of the same community (Arendt 1998). The most familiar public things are, of course, things such as parks, streets, sidewalks, and bridges. But we can think, too, of things that are not publicly owned but are nonetheless "public insofar as [they are] subject to public oversight or secured for public use" (Honig 2017, 4). In this sense, we might also think of privately owned things—such as malls, newspapers, or the MCU—as public things as well.

In all of these manifestations, public things serve two valuable—even necessary—functions for democratic politics. First, as Honig argues, public things help citizens relate to one another; as "sites of attachment and meaning," they "press us into relations with others" (Honig 2017, 6). The shared use of a public park, for example, forces those using it to recognize their relationships with others present in that space. And this recognition is politically valuable; it helps form the publics without which democratic politics cannot take place. This is why, "at their best," Honig tells us, "public things gather people together, materially and symbolically, and in relation to them diverse peoples may come to see and experience themselves—even if just momentarily—as a common in relation to a commons" (Honig 2017, 16). By virtue of their shared park experience, in other words, citizens come to recognize that they inhabit the world with others—and that they share a responsibility for maintaining that world and cooperating with their peers to do so.

Historically, technologies of pop culture have served this "gathering" function of public things. The partisan newspapers of the nineteenth-century United States, as Alexis de Tocqueville notes, helped to facilitate a sense of association among readers, inspiring "common action" precisely because they "put the same thought at the same time before a thousand readers" (Tocqueville 1969, 518, 517). Likewise, says Benedict Anderson, the widespread circulation of novels and national newspapers fostered feelings of "deep, horizontal comradeship" among readers (Anderson 1991, 7, 6). By cultivating audiences' recognition of themselves as members of shared communities, these media technologies—as public things—prepared citizens for the shared work of managing them.

Importantly, as Honig suggests above, simply gathering around shared

objects is not a sufficient foundation for a specifically *democratic* politics. Democratic politics requires not only common experiences but also, importantly, an acknowledgment that our communities comprise those who are different from us—and who will, inevitably, disagree with us over what that shared world should look like (Zerilli 2016, 265). Democratic politics, in other words, is predicated on what the twentieth-century political theorist Hannah Arendt calls *plurality*, or the idea that "we are all the same, that is, human, in such a way that nobody is ever the same as anyone else who ever lived, lives, or will live" (Arendt 1998, 8). This diversity inherent in the human condition must be reflected in our politics. The "simultaneous presence of innumerable perspectives" is, Arendt (1998, 57) reminds us, the very "meaning of public life." And this has implications for public things: only when shared objects "can be *seen by many in a variety of aspects* without changing their identity" can those objects serve as the public things that ground the collective action of democratic life (Arendt 1998, 57, emphasis added). Public things, in other words, must both pull us into relations with one another and reflect this plurality—encouraging the differences of multiple perspectives—if they are to support democratic politics.

Again, the media technologies of pop culture often act as precisely these kinds of public things; they are objects that do not just invite commonality but also facilitate contestation and disagreement by reflecting a variety of perspectives. For example, as Henry Jenkins notes, in comics—such as those from which the MCU draws—a wide array of creators are given latitude to envision multiple ways of imagining familiar characters (Jenkins 2009b). Figures like Superman often appear in multiple titles simultaneously, reflecting the input of a variety of writers and artists. And, as Jenkins argues, it is by virtue of this plurality that "fans learn to live in a universe where there were diverse, competing images" (Jenkins 2009a).

Yet the plurality of public things cannot be taken for granted. Indeed, many political theorists have warned of the increasing privatization and restriction of the public realm—and, we might assume, the public things that constitute it (Barber 2001; Kohn 2004). From "antihomeless" spikes, split benches, and other forms of "hostile architecture" intended to dissuade certain populations from using public parks and sidewalks to regulations such as dress codes in public spaces such as shopping malls, there is a concern regarding the democratic effects when public things are "sanitized"—when they demand only a single mode of engagement rather than reflecting the plurality of the human condition. This loss of difference in the public realm is what Arendt terms "conformism," or the ways in which "society always demands that its members act as though they were members of one enormous family which has only one opinion and one interest" (1998, 39). And this logic of conformism is destructive of

democratic political possibilities; by insisting on uniformity of taste and opinion, it undermines the spaces of disagreement and contestation that form the heart of democratic politics.

Consider again the case of Marvel: Create Your Own. The "fan-powered communities" it hoped to generate were brought together by the fans' recognition that they had something in common (the Marvel characters). But the specifically democratic potential of these communities would have been found in users' ability to make those characters their own—to use the shared "public things" of the Marvel Universe to create and articulate *their own* perspectives—telling stories and designing characters who are not represented in Marvel's official properties. When Marvel narrowed the limits of acceptable ways to engage with its intellectual property, the fans disengaged—and the democratic potential was lost.

Marvel's MCU is a much larger undertaking than Create Your Own. Over the past decade, it has dominated box offices, generated billions of dollars in profit for Marvel, and changed audiences' expectations of film franchises. Given this immense popularity, it seems clear that the MCU serves as a public thing—like newspapers and comics, it clearly gathers audiences into a shared experience and helps them to form affective ties with one another. The question, then, is whether—and to what extent—it allows for the plurality that is also integral to democratic politics.

The MCU as a Public Thing

That the MCU is a public thing seems evident. The popularity of the franchise has supported fan communities of all types. There are websites dedicated to sharing "news, reviews, and basically everything [fans] need to know about the Marvel Cinematic Universe."[4] Fans gather both virtually—in forums, Tumblr tags, and Facebook groups—and in person at cosplay events and conventions. In these mobilizations, we can see how the MCU, like the newspapers and comics that preceded it, "bring[s] peoples together to act in concert" (Honig 2017, 24) as they form "fan-powered communities" around these common objects.

And yet, as we know, merely gathering audiences is insufficient; for public things to support a specifically *democratic* politics, those shared objects must also afford multiple perspectives, reflecting the plurality in their communities. And here, I argue, certain decisions that Marvel made regarding the MCU's approach to storytelling should give us pause. In the earliest stages of the MCU's development, it used broadcast, cable, and streaming television shows to open multiple perspectives on the universe introduced in the theatrical films. More recently, however, Marvel distanced itself from these earlier efforts. Instead, it

increasingly emphasized uniformity across its many media properties—a uniformity predicated on the "family-friendly" Disney brand.[5] By enforcing this conformist vision of what is "appropriate" content for the MCU, Marvel executives disavowed many of the more radically democratic possibilities that the MCU had once opened up. In so doing, the MCU executives imposed, just as Marvel did with Create Your Own, a singular vision of the Marvel universe, limiting the resources it provides fans and audiences to explore multiple ways of encountering that shared object.[6]

The MCU's Pluralist Potential

In 2012, building on the unprecedented success of the MCU's Phase One, which culminated in *The Avengers* (2012), Marvel announced that the MCU would be expanding into television. In collaboration with ABC Studios and Netflix, Marvel coproduced a total of twelve television shows that aired on broadcast (ABC) and cable (Freeform) television channels as well as streaming services (Netflix and Hulu). The shows varied in terms of target audience; some were aimed at young people (*Runaways, Cloak & Dagger*), while others took a decidedly more adult approach to the MCU. The Netflix shows (*Daredevil, Jessica Jones, Luke Cage, Iron Fist, The Defenders,* and *The Punisher*), in particular, were introduced in 2013 as a way of showcasing the "street level noir side" of the MCU, though Marvel executives were quick to emphasize that these shows were not distinct entities but rather *additions* to the MCU established in the films. As Marvel's then chief creative officer Joe Quesada noted in a 2017 interview, the Netflix shows were marked by "interconnectivity"—they existed "within the cinematic universe again, so this is all the same world as [*Agents of*] *S.H.I.E.L.D.* [an ABC television show] and the *Avengers* [a film]." The MCU television shows, in other words, were intended to expand the MCU in ways the films simply could not; they would present audiences with, as Quesada put it, "something you haven't really, really seen in any of our Marvel movies" (Comicbook 2017).

And the results certainly bore that out. The Netflix shows—as well as other MCU television shows such as *Agents of S.H.I.E.L.D., Agent Carter, Cloak & Dagger,* and *Runaways*—were lauded for opening new spaces in the MCU and featuring new perspectives on the shared universe; they centered a more diverse set of themes and treated them more seriously than did the films. The Netflix shows, for example, told stories featuring in-depth, nuanced treatments of rape, racism, disability, and trauma that were absent from the films;[7] they were, moreover, stories that were helmed by the MCU's most diverse creative staffs to that point (Dominguez 2019).[8] In addition, many shows, such as Netflix's *Jessica Jones* and Hulu's *Runaways*, prominently featured LGBTQ+ storylines and characters at a time when Marvel Studios was actively erasing these figures

Jessica Jones features a storyline in which Jeri Hogarth (right, played by Carrie-Anne Moss) has an affair with her assistant Pam (left, played by Susie Abromeit) and attempts to divorce her wife. From *Jessica Jones* (2015).

from the films (Opie 2019; Pulliam-Moore 2018).⁹ The result, as one critic noted, was that the early MCU television shows often did not "adhere to that [Disney] brand" because they "were too mature and violent for the larger franchise" (Clark 2019). Instead, this "darker, more adult tone" of the Netflix series, in particular, was "a departure from the rest of the MCU, which is primarily aimed at a broader, more mainstream audience" (Reinhard and Olson 2018, 86).

Yet it is precisely *because* of this "ill fit" that these shows were so valuable for the MCU as a public thing; it was through them that the MCU provided a richer and more faithful representation of the plurality of its audiences. By presenting different kinds of stories—and modes of storytelling—the early MCU television shows took advantage of the opportunities afforded by the MCU's transmedia format to increase its plurality; they provided new perspectives on and interpretations of what it meant to be a "Marvel superhero" and spoke to audiences who might otherwise not have been reached by the films.

The MCU, Disney, and "Family-Friendly" Conformism

Despite the critical success of the MCU's early television shows, this embrace of plurality was not to last. Indeed, as the MCU's theatrical films continued to dominate the box office, behind-the-scenes restructuring at Marvel largely put an end to the MCU's early plurality. In 2019, following Netflix's cancellation of its MCU titles, Marvel announced that Marvel Studios, under the leadership

of now chief creative officer Kevin Feige, would take over responsibility for all MCU-related content—including the television shows, which had previously been the purview of Marvel Television.

Moreover, with the debut of Disney+ the same year, Feige made a much-anticipated announcement about a slate of new MCU television shows that would premiere on the new streaming service—an announcement that failed to acknowledge the existing (and, by then, canceled) MCU shows at all. Instead of "rescuing" the canceled shows or telling similarly diverse stories using the streaming service, the new Disney+ shows, Feige announced, would "tell even deeper stories *with characters you already know and love* . . . in a new type of cinematic way that we haven't done before" (Dumaraog 2019, emphasis added). Rather than use the new Disney+ shows to expand the MCU by creating novel characters and stories, showcasing new and more diverse elements of the MCU—as the Netflix, broadcast, cable, and Hulu shows did—Feige's 2019 announcement indicated that Marvel Studios would focus on existing film characters, such as Loki, Bucky Barnes and Sam Wilson, and Wanda Maximoff, and make television shows in a more "cinematic way." The focus, in other words, became maintaining *uniformity* among the various media properties—a uniformity in characters, tone, and approach that "puts a necessary emphasis on system over individual" (Leslie 2021).

And, indeed, Marvel Studios' stated commitment to making shows primarily for Disney+ signaled the company's intention to narrow the kinds of stories told by the new MCU shows. The earlier MCU shows, in part because they were hosted on a variety of cable and streaming services, exercised a freedom to "push the boundaries of the Marvel house style," using "superpowers and supervillains as allegories for complex issues" such as *Jessica Jones*'s explorations of themes like rape and sexual assault (Reinhard and Olson 2018).[10] By contrast, when launching Disney+, Disney initially made explicit a commitment that "there will be nothing on Disney+ that's not branded or family friendly" (Graham and Snider 2019). This effectively ruled out a whole mode of storytelling—and set of themes—that would be considered "R-rated" content. By committing to produce MCU shows exclusively for Disney+, in other words, Marvel Studios eschewed the plurality that its transmedia format invites. Instead, it insisted on retaining a uniform MCU "feel" that—while inclusive of genre experimentation (Harrison, Carlsen, and Škerlavaj 2019)—nevertheless retained a consistent, "Disney-friendly" (Alexander 2019) conformism that emphasized world-building over character-building, placed social commentary second to "big budget, crowd-pleasing spectacle" (Reinhard and Olson 2018) and remained "family-friendly"—as determined by Disney's idea of family.

But Marvel's announced conformism to Disney's "family-friendly" brand did more than simply signal a new direction for future work. It also explicitly

disavowed the earlier MCU shows, in effect deauthorizing them as "official MCU" stories. With the debut of new Disney+ shows in 2019, Feige proclaimed, "it all, *for the first time,* will interlink. So, the MCU will be on your TV screen at home on Disney+ and interconnect with the movies and go back and forth. It's exciting to expand the MCU into even bigger and better heights" (Barfield 2019, emphasis added). As many noted at the time, this claim effectively erased the earlier work of MCU television creators and characters, "decanonizing" it as not "authentically" MCU material (Dominguez 2019).

This may not seem important; the earlier shows still exist, after all—though they were not initially available on Disney+ with the other MCU titles. But this official disavowal worked to sever the diverse perspectives of the original shows from the MCU "proper." And, as a result, this erasure of the earlier shows from the MCU canon shifted audiences' orientations to these early shows, leading them to be overlooked or entirely ignored in analyses of the MCU. This is clear in, for example, backlash against the MCU's much-lauded Phase Four emphasis on "diversity." In revealing a slate of new MCU films in 2019, Marvel Studios announced that this would be the "most diverse" set of casts and creators yet, featuring the first Latina superhero (Salma Hayek in *Eternals*) as well as the first openly LGBTQ+ storyline (Valkyrie in *Thor: Love and Thunder*). Yet these claims were predicated on the erasure of long-standing television characters, such as Yo-Yo Rodriguez from *Agents of S.H.I.E.L.D.*, and LGBTQ+ relationships portrayed with depth and nuance in *Runaways* and *Jessica Jones*. In erasing these previous contributions, Marvel Studios reinforced the idea that these characters and relationships did not "count" as authentically belonging within the MCU. In so doing, Marvel in effect added restrictions and caveats to the MCU. And, as was the case with Marvel: Create Your Own, these limitations foreclosed the political possibilities of the MCU, narrowing its function as a democratic public thing. Marvel's position, in other words, became clear: there is a "right" way to tell MCU stories—a "Disney-friendly" way—and the early television shows and characters did not fit.

Happily, there is evidence that this may be changing. In December 2021, a number of actors and characters from the early Netflix shows began appearing in MCU films and Disney+ shows. And in March 2022, the original Netflix shows (*Daredevil, Jessica Jones, Luke Cage, Iron Fist, The Defenders,* and *The Punisher*) were made available to stream on Disney+, intensifying speculation about whether the Netflix shows would be "recanonized" in the MCU—or whether these characters were simply new MCU versions of the Netflix characters (played by the same actors).[11]

In some ways, however, this speculation misses the point. Though Marvel seems to now be taking a more pluralistic approach to its storytelling—perhaps in response to fan pressures—the fact remains that Disney unilaterally wields

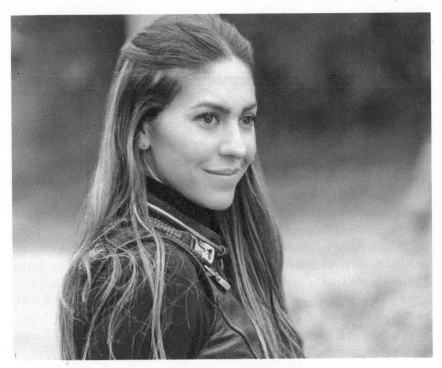

Elena "Yo-Yo" Rodriguez (played by Natalia Cordova-Buckley) in *Agents of S.H.I.E.L.D.* From *Agents of S.H.I.E.L.D.* (2016).

the power to make that determination. Though Marvel (and Disney) seem, at the moment, to be interested in expanding the MCU, there is nothing preventing them from returning to "family-friendly" form tomorrow and (once again) erasing all content from Disney+.

"There Was an Idea . . .": Fans, Audiences, and the Future of the MCU

The MCU is an unparalleled pop culture phenomenon. Over the past thirteen years, it has earned over $23 billion worldwide and completely reshaped the cinematic—and cultural—landscape (Clark 2021). And there is no reason to think this dominance will end anytime soon. In the first twelve days of its release in 2021, *Spider-Man: No Way Home*, the third entry in the character's titular series, brought in over $1 billion worldwide—in the midst of the global COVID-19 pandemic (Rubin 2021). And the MCU's Phase Four continues apace, with another seven movies, seven television shows, and two television specials

planned or in production, to be released throughout 2022 and 2023. The MCU is, whether we like it or not, here to stay.

As we take stock of the MCU's global dominance, I have argued that we should begin by thinking of it in terms of its role as a public thing. There can be no doubt, for example, that the MCU acts as a shared object, one that can inspire affective connections that work to gather audiences into communities across the globe. But despite the political value of the MCU's gathering function, there are, as I have argued, reasons to be attentive to the particular ways this public thing is constructed. By emphasizing a conformism predicated on the idea of "family-friendly" content across its properties, the details of the MCU's initial debut on Disney+ should give us pause. By narrowing the boundaries of what is deemed "acceptable" material for inclusion in the MCU to only those stories and characters that fit a "Disneyfied" ideal of family, this initial emphasis on conformism worked to undermine the possibilities for democratic politics, which is predicated on plurality and difference. And while it seems that Marvel has reversed course and made these previous shows accessible once again—likely as a result of fan pressure—there is nothing ensuring that this will remain the case in the future. As such, the MCU illustrates the potential dangers associated with leaving public things under the unchallenged control of private, for-profit companies.

This is not to say that the MCU will single-handedly destroy democracy—or even that such a result is inevitable. Nor does it mean that citizens cannot enjoy these stories for what they are: entertainment. It does, however, mean that we should think more critically about the effects of this record-breaking franchise and take steps to ensure that the MCU—as a public thing—remains responsive to the public in meaningful ways. We should consider, in other words, what is at stake in the choices we make—as both producers and consumers of content—about our media. I conclude this chapter, then, by providing suggestions on how we might approach this challenge as scholars, fans, and audience members.

For centuries, scholars have pointed to the ways pop culture media technologies shape our civic practices. But these technologies are rapidly changing. Many scholars in communication, media, and cultural studies have begun to take these changes seriously and to consider the ways in which media technologies shape audience engagement with the stories they distribute. But we should also center questions of democracy in these investigations—highlighting the *political* stakes of these choices. Such efforts do exist, but they are often relegated to the margins of political science (Costello and Worcester 2014). Yet, as canonical figures in the history of political thought—from Plato to Hannah Arendt—remind us, culture is politically important. Political scientists should

thus encourage and take more seriously studies of pop culture and its associated media technologies.

In addition, much existing scholarship on media and popular culture—though it does not use these terms—tends to focus on the ways in which *audiences* engage with the public things of pop culture, and especially the new media technologies they use for that engagement. But, as the example of the MCU and Disney+ demonstrates, *companies* are also making novel use of new media technologies, wielding an unprecedented level of control over not only the production but also the distribution of the stories they create (Leslie 2021; see also Goldberg in this volume). In addition to focusing on what fans are doing with pop culture technologies, then, we should also pay attention to what is being done *to* them—how corporations are using these same technologies for new ends and the consequences of those choices in terms of the public things they produce and disseminate. Without a clearer idea of the effects of these new modes of storytelling and how they are used by the companies that control them, we cannot know exactly how to make them work for democracy.

Of course, scholars are not the only ones for whom these are pertinent questions. Citizens and consumers should also be attentive to the dynamics introduced by the new pop culture media technologies. This does not mean entirely forgoing modes of entertainment such as the MCU, nor does it mean we cannot enjoy these public things. It does, however, invite critical reflection on how we engage with these media, how much control we cede to the corporate executives who direct them, and what kinds of efforts we might undertake to reassert plurality in these properties.

Some fans of the MCU are already deeply engaged in this work. Efforts such as fan fiction and fan art are examples of the ways fans already manipulate, alter, share, discuss, and fight about the shared cultural objects of the MCU. Unlike the canonical MCU, for example, which pairs Steve Rogers (Captain America) with Peggy Carter, fans have imagined a romance between Rogers and Bucky Barnes and have brought to life this interpretation of the characters through stories, videos, and drawings. In these examples, we see fans wielding the public things of the MCU to reflect new communities, characters, and stories—opening space for the kinds of reinterpretation, contestation, and disagreement that are at the heart of democratic politics.

Despite their democratic potential, however, these efforts are often conducted at the margins of fandoms.[12] Those invested in cultivating the democratic potential of the MCU as a public thing, then, might increase efforts to maintain, expand, and more widely promote sites such as Archive of Our Own (AO3) to make them more accessible to a wider fan base. Started in 2008 by the nonprofit fan-activist group the Organization for Transformative Works, AO3 is

a fan-driven space where users can tell their stories however they see fit. AO3, and similar sites such as Tumblr, are thus spaces where we see fans engaging with the MCU as a public thing—not only connecting with others who share their interests and gathering as "fan-powered communities" but also doing so in pluralistic ways.

Moreover, as I have noted, the MCU's emphasis on "family-friendly" conformism was a distinct shift in its decade-long life span—one that reminds us of the democratic dangers associated with unchallenged corporate control over the public things of our political life. But this "Disneyfication" of the MCU was not unchallenged. Indeed, while Marvel seemingly had good reasons to believe that its plan to apply the formula for MCU movies to its television shows would be a commercial success, it appears that audiences demanded different narratives. And Marvel has, for example, shown a willingness to accede to these audience demands, as with the push for more representative stories in Phase Four. Moreover, with the inclusion of previous MCU shows on Disney+ and the creation of new shows such as *Moon Knight*, *Ms. Marvel*, *IronHeart*, and *She-Hulk: Attorney at Law*, it seems that Marvel Studios may once again be showing interest in producing MCU shows that could "expand the parameters of the Marvel Cinematic Universe" by affording creators the freedom to "explore more mature and complicated story arcs than would be possible in the films" (McSweeney 2018, 224). Such an expansion of the MCU has happened before, and to critical acclaim. It is up to audiences to demand it again.[13]

Notes

1. In addition to restrictions on content, Marvel also retained the right "to use, reproduce, transmit, communicate to the public, print, publish, publicly display, publicly perform, exhibit, distribute, redistribute, license, sub-license, copy, index, comment upon, modify, adapt, translate, create derivative works based upon, make available, and otherwise exploit" (Busch 2017).

2. As I discuss in more detail later in the chapter, it is no longer clear whether all of these television series are considered part of the MCU.

3. Notably, over half of these movies were sequels that did better than their predecessors.

4. "About," Marvel Avengers Universe, https://avengersuniverse.com/about.

5. In 2009, Disney purchased Marvel Entertainment, including Marvel Studios and Marvel Television, for $4 billion.

6. Though not addressed here, the tie-in comics play a similarly conformist role in the MCU. The comics' characters' dialogue is written "in the movie characters' voices," and collaboration includes "[a] lot of the executives—as well as the producers and the co-producers, and of course Kevin Feige and Lou Esposito—[who] have their thoughts on what would be good stories." While the MCU's tie-in comics often focus on side characters or stories, as one writer put it, these efforts all lead to "a greater shared cinematic universe

that we work so hard to keep coherent with all these spin-offs, tie-ins, TV shows, one-shots, and comics" (Richards 2015).

7. While some MCU films, such as *Iron Man 3*, do touch on themes like trauma and mental health, they tend to do so in a way that is more lighthearted or dismissive rather than the in-depth characterizations of the Marvel television shows. See Barbara (2018); Reinhard and Olson (2018).

8. After much backlash, there is evidence that Marvel is finally "catching up" and diversifying the rest of the MCU's creative teams. Many of the new Disney+ shows (discussed below), as well as more recent MCU films, feature showrunners and directors who are, for example, women and/or people of color.

9. For more discussion of the MCU's LGBTQ+ erasure, see Patricia Rodda's chapter in this volume.

10. For more discussion of *Jessica Jones*, see Menaka Philips's chapter in this volume.

11. In fact, as of May 2022, all shows previously associated (even tangentially) with the MCU, including *Runaways*, *Cloak & Dagger*, *Agents of S.H.I.E.L.D.*, and *Agent Carter*, are available on Disney+. But while these shows are all categorized under the "Marvel" heading, they are sorted into separate categories, such as "Marvel Series and Specials" and "The Defenders Saga," rather than into "Marvel Cinematic Universe" (where, for example, *Moon Knight* and *Hawkeye* are found).

12. Some studies have shown, for example, that these transformative fan works ebb and flow with the release of new films. See De Kosnik et al. (2015). Likewise, a search on AO3 shows only around forty-two thousand authors writing under the MCU "tag." Even assuming there are many more writing under additional tags, this represents a very small percentage of the MCU audiences.

13. In addition to the fate of the Netflix shows and characters, another example might be the *Deadpool* movies. Previously released by 20th Century Fox, the *Deadpool* movies were immensely popular—and famously R-rated, a feature that Ryan Reynolds, the films' star, refused to compromise. With Disney's acquisition of 20th Century Fox and Reynolds's famous insistence on Deadpool's R rating, it seems that there is room for Marvel to expand from its "family-friendly" focus. See Chitwood (2021).

AFTERWORD 1 HOW MARVEL STUDIOS MAKES A UNIVERSE

Carlee Goldberg

The Marvel Cinematic Universe (MCU) collectively constitutes a production enterprise of truly epic proportions. But producing a universe of this magnitude requires collaboration and synergy at every level of production, from creation and planning to the staffing and the details of actors' contracts.

Planning and Scheduling

In the highly interconnected world of the MCU, films are carefully organized in advance by a team of five to six executive producers and creative directors who plan out the MCU's well-known "phases" (Laiter and Feige 2019). Each movie serves as both a film and a building block: it can stand alone, and it also expands on story lines woven through the larger cinematic universe. A phase typically culminates in a team-up movie that brings together characters from many (or all) of the phase's films and lays the groundwork for the next phase. To accomplish such elaborate, interconnected storytelling, Marvel Studios must carefully choose which superhero films are going to be produced, how they will intersect, and the order in which they will be released. This process is carefully orchestrated and concludes with the public announcement of the upcoming slate of movies and TV shows (O'Neill 2021). Marvel Studios then sets a strict production timeline for each film (Callaham 2021). For the past ten years, the studio has averaged two major theatrical releases a year (with that number increasing in recent years) and a filming schedule that operates essentially year-round. By the time an MCU film premieres, Marvel Studios is already filming, editing, and finalizing the next several movies.

Staffing

A schedule this complex requires legions of staff and tremendous foresight. The people who work on each film must be able to work both independently and collaboratively.

Marvel Studios has an executive core team, led by Producer Kevin Feige, tasked with ensuring continuity across the films and TV shows (and related shorts and comics). Each individual film, however, is headed by its own production and creative team (Harrison, Carlsen, and Škerlavaj 2019). Marvel Studios chooses directors strategically, looking for experience in genres that range from small indie films (John Favreau in *Iron Man*) to horror movies (James Gunn in *Guardians of the Galaxy*) to television series (Alan Taylor in *Thor: The Dark World*). Interestingly, previous experience directing a large-scale production is not a prerequisite for directing a film in the MCU.

The MCU's directors are given significant artistic discretion to create movies based on their personal experiences and visions. The executive team advises them throughout the process and uses previsualization, reshoots, and postproduction to bring the movie in line with the plot and standards of the larger MCU.

Since so many MCU films are shot back-to-back, Marvel Studios tends to retain a percentage of production staff from each film. On average, 25 percent of the core creative staff and 14 percent of the overall crew stay on for the next film (and these numbers are even higher for single-character films such as *Iron Man* and *Captain America*). Retaining a significant share of the crew while hiring most anew allows the studio to balance continuity and efficiency with innovation and new ideas in each film (Harrison, Carlsen, and Škerlavaj 2019).

Actors and Contracts

For actors, Marvel Studios includes specific provisions in contracts that enable the creation of interconnecting plots that transcend individual films.

Cameos and End Credits

In an act that gives credit to the thousands of people behind the production of the movie, Marvel contracts require actors to star in postcredit scenes. These scenes, appearing during and after the credits, are used to introduce what comes next in the MCU, often featuring new characters (Scarlet Witch and Quicksilver in *Captain America: The Winter Soldier*) or tying films to larger storylines (Ray 2018). Marvel contracts also require actors to provide cameos in other films, allowing for a surprise appearance by another hero (Captain America in *The Dark World*) or a preview of an upcoming one (Spider-Man in *Captain America: Civil War*). These contracts often cover multiple films (usually from three to ten; Russell 2020), but they often don't count short cameos or end-credit appearances, meaning that actors under contract can be required to

make guest appearances in any movie the MCU produces (Ravenola and Boone 2020). Disney+ shows also do not count in these multimovie deals. Instead, actors sign another contract for the number of episodes of the show, with a clause that states that their involvement "doesn't negate appearances in future Marvel movies" (Russell 2020).

Reshoots

Another clause central to producing the MCU is the requirement that actors return for reshoots two to three months after principal photography concludes, regardless of whatever production they are currently filming (Ravenola and Boone 2020). At the end of production on each film, executive producers charged with overseeing the continuity of the franchise often edit and adapt the movie to best fit the direction of the larger MCU. This process often requires re-doing entire scenes or plot points, adding new scenes to reference other movies or storylines, and expanding one-off lines or references, including the famous Shawarma scene at the end of *Avengers*, shot the day after the film premiered (Laiter and Feige 2019). Actors are required to be available for any of these reshoots, which can occur while they are filming other movies or traveling on press tours.

Philanthropy and Press Tours

An MCU contract also requires actors to avoid controversy, pass background checks, and maintain a generally heroic persona off-screen. For Marvel's main superheroes, philanthropy on behalf of Marvel is also a contractual require-ment (Ravenola and Boone 2020). This can include visiting children's hospitals, working with charitable organizations, or engaging in some form of advocacy. Generally, this stipulation is less a burden than a platform, with numerous actors already engaged in some form of public service and able to gain more attention for the causes they support.

Many movie contracts, especially those with large-name studios, include promotional tours and interviews. Marvel Studios contracts take it further. A press tour for a Marvel movie often lasts weeks, if not months, and spans con-tinents and countries (Ravenola and Boone 2020).

Interacting with Product Placements

From car dealerships to tech companies to food chains, product placements play a prominent and uniting role across the MCU, and actors are required to interact with them.

The reshoot clauses in many MCU contracts enable the studio to create entirely new scenes months after filming concludes, allowing the universe to weave in new characters or expand one-liners, including Marvel's famous Shawarma scene. From *The Avengers* (2012).

Onscreen, product placements have existed within the MCU since it began, when Marvel and Audi signed a contract that had Audi vehicles featured prominently in the *Iron Man* installments. Since then, Audi cars have continued to be a mainstay, appearing in *Ant-Man*, *Civil War*, and *Avengers: Age of Ultron*. Off-screen, engaging with products includes starring in commercials and appearing as the figurehead in advertising campaigns. These promotions will often appear in tandem with the release of the new film and will simultaneously showcase the product and the movie (Sylt 2019).

Noncompete with DC Comics Movies

When actors sign an MCU contract, they must usually sign away the right to star in a DC movie while the contract remains active (Ravenola and Boone 2020). Marvel Studios invests millions in the character an actor represents; it's worth protecting that image and investment from bringing in profits and notoriety for its direct competitor. Additionally, restricting the actor to only one franchise at a time prevents confusion among the various characters, allowing Marvel characters to exist independently from DC characters.

That said, a previous contract with DC Comics does not exclude an actor from a Marvel role. In fact, Marvel Studios is notorious for hiring former DC superheroes to play starring roles in its films. Michael Keaton and Christian Bale both famously starred as Batman before they were signed to *Spider-Man: Homecoming* and *Thor: Love and Thunder*, respectively (Kashyap 2021). Noncompete

clauses also do not apply to directors and producers. A potential perk of working with Marvel is that it may lead to job offers in the DC Extended Universe; for example, both Joss Whedon and James Gunn directed DC movies following their Marvel productions.

The Benefit of a Marvel Contract

As chapter 1 notes, Marvel is a leviathan in the entertainment industry and in popular culture in the United States and around the world. For actors, joining a Marvel movie virtually guarantees successful box-office sales and global exposure. Contracts usually begin in the seven-figure range and increase with each additional movie; MCU veterans are paid upward of $10 million, and actors often negotiate for contingent compensation, receiving a percentage of the profits of the films they star in (Berg 2019). An MCU contract can launch an actor's career or break actors into a genre they hadn't previously been associated with. Contract renewals and spin-offs are likely and can provide stable employment playing a single character for years. MCU actors are also often given artistic liberty to shape their character. MCU directors often go on to hire the actors they work with for non-MCU movies and shows. In other words, with great power comes great responsibility . . . and great opportunities.

CLASSICAL DRAMATIC STRUCTURE

A Primer on the Marvel Cinematic Universe

Matthew L. Free

Narrative Structure and the Marvel Cinematic Universe (MCU)

While we don't think of the MCU as a tragedy or even a series of tragedies, the narrative structures of the films and the cinematic universe can be seen and deconstructed in this context. This also helps us to think about and consider the emotional response of so many audiences to these superheroic stories. The most effective tragedies bring together a number of elements that combine harmoniously to produce an emotionally important cultural experience that cleanses and renews the soul of the spectator or audience. That the MCU products do this is at the root of their commercial success and the ongoing narrative that threads through the entire MCU.

Aristotle, in the *Poetics*, identifies six components that must combine to produce a successful tragedy: plot, character(s), diction, spectacle, melody/song, and thought (Aristotle 1947, 6.I.8–10). The MCU artifacts, particularly the films, all engage with these components, taking them up in much the way that Aristotle outlines their necessary presence in dramatic tragedy. The MCU productions hew to Aristotle's analysis of the way that "tragedy is essentially an imitation not of persons but of actions and life, of happiness and misery. All human happiness or misery takes the form of action; the end for which we live is a certain kind of activity, not a quality. Character gives us qualities, but it is in our actions—what we do—that we are happy or the reverse" (Aristotle 1947, 6.II.15–19).

This essay takes the reader through these six components as we see them in action within the MCU and how we might think about the way that these parts are knit together in so many different Marvel artifacts. In tracing the classical components of dramatic structure in the MCU, we can also understand the impact of these parts, separately and as a unified whole, as we immerse ourselves within this modern narrative of heroes and villains, tragedy, drama, and delight.

Plot: Superheroes Save the Day

Plot requires action to drive dramatic narrative, regardless of story or time period. Agamemnon avenges Menelaus and makes work for a thousand shipbuilders in *The Iliad*. The feud between Montague and Capulet leaves six dead in three days and everyone so awash in recriminations that there is no interest in revenge at the end of *Romeo and Juliet*. But for Hamlet, five long acts are spent engaging in a discourse as to whether revenge is appropriate and, if it is appropriate, how it can be made just. According to Aristotle, it is not sufficient for a plot to be action-packed; it must conform to conventions to be successful. It must be complete unto itself; it must stand alone—thus, plot should be discreet. This is difficult in the interconnected stories of the MCU. Each of the movies stands alone, with exposition in the opening scenes providing audiences with essential background. Continuity and connective tendrils reach out from one movie to another (and through television series as well) to provide threads running through the multiple phases of the MCU.

Postcredit scenes hint at new plot developments; the use of running jokes and references (Stark's nicknames for people or the appearance of Stan Lee in every film until his recent death) also provides connections among the different stories and artifacts. These bind the series to its comic book origins and are all winks and knowing looks to the connoisseurs for whom these "Easter eggs" enhance the experience without detracting from the neophyte's enjoyment.

Every plot must have a beginning in which the premise is established and the flaw in the hero shown before he or she departs on his or her adventure. Next is the middle of the plot, in which the flawed hero, after initial success, encounters a reversal and things start to go wrong. This reversal is inevitably the result of the previously exposed flaw. In the end, the plot is resolved, and the hero is at peace with the conclusions of events, often achieved at great sacrifice.

In *Captain America: Civil War*, there is an ongoing discussion about the role of diplomacy and negotiations, and the Avengers are divided.[1] What should we make of both the eschewing of negotiation and the response to problems with the use of brute force? A climactic fight using blunt-force weapons is a highly effective way to manifest this.

The audience have none of the postconflict stress that we know affects actual combatants and that we see impact many of the Avengers themselves in both *Avengers: Infinity War* and *Avengers: Endgame*. We, as audience members, do not suffer from survivor guilt (though Clint Barton does) or shame at the collateral damage (though any number of Avengers experience this in a number of different films), and we have no rebuilding to do, no "after-action" review to complete. We leave the movie theater having spent time in the world of superheroes and villains. The MCU has captured the zeitgeist within its plots; in

One way the MCU creates connections between the different stories and artifacts is with running jokes, such as Stan Lee's appearance in every film until his recent death. From *Thor: Ragnarok* (2017).

an impossibly complex world, we all long for simpler answers—and the defeat of Thanos, Vulture, and Ultron contributes to our sense of catharsis as we leave the MCU and reenter our own lives.

Characters and Character: Individuals and Their Motivations

The audience, having empathized with the hero by virtue of the flaw in his or her character, experiences emotional cleansing. Having lived the trials of the hero's journey themselves by their engagement in the tragedy, they are purged of their feelings of pity and fear; they are renewed by expressing that which society encourages them to suppress and are uplifted by the experience. A thorough exploration of the character of the roles allows us to develop the empathy so vital to effective pity. We understand Stark's remorse at his role as an arms dealer. The Hulk's flaw is obvious, and Banner's heroic selflessness in trying to control it is worthy of pity in any universe. Rogers's flaw is to be a man out of time. Romanoff has too much red on her ledger, as she explains it. T'Challa is caught between two different approaches to ruling Wakanda, neither of which is fully satisfying or fully just for citizens inside and outside Wakanda. Jessica Jones and the Punisher both live lives greatly impacted by trauma.[2]

By contrast, it is a testament to the development of the villains' characters that many of them also participate in this classical trajectory toward catharsis, bringing us with them and calling on our sympathies. (For more on the complexity of recent MCU villains, see Wang and Zhang's chapter in this volume.) While Killmonger wants to end a cruelly nationalistic isolationism in Wakanda and Adrian Toomes wants to provide for his family, Hela and Loki are mostly

interested in power. Thanos argues for restoring balance to the universe; like John Stuart Mill, he believes in the greatest happiness of the greatest number. The MCU invites us to understand the motivations of these people; they are not purely evil, and each thinks that what he or she is doing is somehow beneficial. The inevitable fall of these well-intentioned but misguided villains contributes to the classical tragedy; we see their good intentions, and if we reflect, we can see their misguided motives as noble and rational—they are doing their best in an imperfect and dynamic world. The MCU invites us to view these characters in a sympathetic light, the inevitability of their personal downfall and the failure of their visions made more tragic, and more cathartic for the audience, by our empathy for them and their positions.

Diction, Song/Melody, Spectacle

Diction

Diction, or dialogue, is delivered in the MCU, as befits action-oriented movies in which the visual spectacle is the primary engager of the audience, through short, inspiring monologues by leaders. Many of these also have expositional value. For example, Nick Fury explains, "There was an idea . . . called the Avengers Initiative. The idea was to bring together a group of remarkable people, see if they could become something more. See if they could work together when we needed them to fight the battles we never could." Natasha Romanoff explains her feelings of loss and grief in the early part of *Endgame* while also capturing her hero's journey: "I used to have nothing, and then I got this, this job, this family. And I was better because of it. And even though they're gone, I'm still trying to be better." Loss and grief are quite acute in *Infinity War* and *Endgame* but are not limited to those films.

This integration of loss and grief is a constant thread within the MCU—both films and television series—and a key component of the dialogue in many of these narratives. The *Captain America* films contend with Steve Rogers's loss of his friend Bucky; many of the superheroes enter their lives as heroes because of loss, and grief is a constant for them, ebbing and cresting at different points. Even some of the most recent Disney+ productions, such as *WandaVision* and *Hawkeye*, center on grief.

Through the use of irony, sarcasm, and other rhetorical techniques, the competence and composure of the characters are established and build empathy, which is essential to tragedy. Hulk calling Loki a "puny god" in *The Avengers* efficiently encapsulates the idea that to Hulk, all gods are puny. In his final remark before the battle in *Avengers: Age of Ultron*, Rogers notes, "You get hurt, hurt 'em back, you get killed . . . walk it off," emphasizing the importance of

commitment to the cause through the use of the witty one-liner. Much of the interplay among the Guardians of the Galaxy is ironic, sarcastic, and humorous—how else to explain Groot, whom everyone loves and who is ironically funny. The entire relationship between Natasha and Yelena in *Black Widow*—from their physical fights to their banter—is about both their competence and their wit. Thus, diction, or dialogue, propels the plots forward in places, provides the audience with information, and amuses and delights as we follow the exploits of the heroes.

Song/Melody

Alan Silvestri, who composed and conducted the music for most of the Avengers films, deserves credit for the unifying musical themes that are featured throughout the series and conclude *Endgame*. Silvestri's broad major key themes and sweeping string crescendos are effective in bringing forward the emotions of pity and fear that make the films and the entire series so compelling. At the same time, the use of music from popular culture external to the MCU engages the audience in the moment and makes them identify with the characters. Quill's dancing to "Come and Get Your Love" in *Guardians of the Galaxy* is juxtaposed with the environment in which he is dancing, thus creating an instant bond with the audience, who can see themselves dancing just like that on that planet. Loki really does "come from the land of ice and snow," so when he, along with Thor, Hulk, and Valkyrie, sets about fighting Hela to the sound of "Immigrant Song," it is exactly what the audience would pick as a soundtrack for this battle. Similarly, much has been made of No Doubt's "Just a Girl" as the song narrating Captain Marvel's efforts to help rescue the tesseract in *Captain Marvel*.[3]

Spectacle

Aristotle understood spectacle as a support to plot in driving tragedy, but then, Aristotle never had the fortune to see a good CGI action film. In the MCU, it is tempting to view all the ingredients of tragedy as subordinate to spectacle. From the transparent floating display screens of the labs to the Helicarrier to the final resolving set-piece fight scenes, the spectacle is overwhelming. Given these expectations, the other components of dramatic tragedy can seem less significant, but we don't end up with the shattered invisibility cloak around the nation of Wakanda in *Black Panther* or the space- and time-shifting showdowns in *Doctor Strange* without plot, character, melody, thought, and diction. Given the world-altering plots that dominate the MCU films, our concept of spectacle

As Thor lands on the Bifrost, he enters the fray to the tune of Led Zeppelin's "Immigrant Song" in one of Marvel's many memorable musical moments. From *Thor: Ragnarok* (2017).

should be expanded to include both the visuals we experience in watching the films and the complex threats we consider as we sit through them.

Thought: The Unifying Whole

According to Aristotle, we need to distinguish *thought* from *character* since they can be confused. He explains that character is "that which reveals the moral purpose of the agents, i.e. the sort of thing they seek or avoid, where that is not obvious" (Aristotle 1947, 6.II.6–8). Thus, in this case, character is motivation for action or inaction, but thought is distinct; it is "the power of saying whatever can be said, or what is appropriate to the occasion. Thus what, in the speeches in Tragedy, falls under the arts of Politics and Rhetoric. . . . Thought . . . is shown in all they say when proving or disproving some particular point, or enunciating some universal proposition" (Aristotle 1947, 6.II.4–12). We can take from this the broader political considerations and "teachings" such as they are in the MCU.

Thus, when we think about the MCU, we start to consider the overarching operations of the Avengers, how their goals are defined, and how we should think about superheroes and their role in relation to the state, government, citizens, and the universe. In *Age of Ultron*, when the Avengers reassemble, it is clear that they have been combating terrestrial social threats in small groups or as individuals, each pursuing his or her own agenda, not working as a coordinated, focused group. They continue to identify their own targets, decide their own levels of risk, and maintain the status quo, and there is no role for the state in prioritizing or ordering the work of these individual superheroes. Captain

America has good reason to be personally engaged in the battle against Hydra, Peter Quill in the defeat of Ego, and Captain Marvel in the destruction of the Kree, but there is no unifying theme of *vengeance* in their work as a group.

As the Avengers have an adjunct role in the capacity of the state to address threats to it, then who should deploy them? Some of the battles that the Avengers fight are battles of vengeance or have strong retributive elements, but the majority are defensive battles to protect against further damage to Earth or the universe. The battles to defeat Ultron are driven not by vengeance but by defense of the status quo, as are the battles against Thanos.[4]

The MCU movies warn that avenging as an instrument of the state has limitations and works best when it is swift, proportionate, and accepted. (For more on how the MCU depicts the US government in particular, see Carnes in this volume.) For those outside the state, there are limits to its capacity to do anything beyond deter. States are the best vehicle we have to manage external threats, but they are imperfect; they possess imperfect information and react slowly. In extraordinary times, society must put its faith in good people. This is a theme echoed in a range of modern dramatic tragedies: Buffy Summers, Rose Tyler, Neville Longbottom, and Katniss Everdeen all step in as the ordinary person in the extraordinary situation prepared to protect their loved ones where the state has failed or is unable to perform this fundamental task.

The MCU also identifies failures of the state in the motivation of the villains. Each is driven to his or her position by the failures or nonexistence of state institutions. At a galactic level, there is no interplanetary structure by which Thanos might press his environmental case for universal restraint, so he is forced by the power of his conviction to engage in direct action; Earth merely pays its portion of the collective price.

The introduction of the Sokovia Accords demonstrates the acknowledgment by the UN that the Avengers need oversight. The creation of the (probably unenforceable) Accords is presented by Captain America as a distraction; the desire to control the talented and motivated individual is the fatal character flaw of the state—its intentions are good, but the implementation is impractical. In the most extreme cases, the state fails in its duty of care to its citizens and must turn to the superheroes. (For more on the Accords and the regulation of the superpowered, see Saideman in this volume.)

The theme of distrust of large "suprateam" organizations and state institutions is revisited throughout the series. The Avengers are essentially a private army of unregulated superheroes and gods, initially bankrolled by the US government. In this way, they achieve the objectives that they, not the state, define; not to avenge but to deter and, if necessary, defeat aggression, maintaining, as far as possible, the status quo ante. Nick Fury is clear that the Avengers, as a group, exist "to fight the battles [the government and even S.H.I.E.L.D.] never

could." Like so many superheroes, the MCU heroes are not a permanent element of the state's operational machinery; they assemble when the need arises to deal with the specific threat, not to negotiate settlements or forestall chaos but to fight the existential threats when deterrence has failed and there is no realistic hope of a compromise or negotiated settlement. These decisions to assemble and fight are made by the Avengers themselves, bound by a sense of obligation and comradery and often by some form of tragedy or loss.

It is the role of the state to provide the structures to forestall conflict and to nurture a citizenry of good people who recognize their responsibility to step in when required. It is the role of the social and political commentator to remind citizens of these obligations and suggest productive avenues to pursue. As the MCU shows, there is no more effective way to make such a point than through well-structured dramatic tragedy. Aristotle's lessons are to have a central thought, or unifying theme; subordinate ideas are acceptable as long as they remain subordinate. Illustrate your thought with an action-driven plot that exploits the power of speech, spectacle, and music to engage the audience and retain their attention. Make sure the plot is a complete, self-contained story with an expositional beginning, a middle in which your flawed hero encounters, recognizes, and overcomes his or her flaw (it's good if he or she can do this at some substantial personal cost), and an end in which the audience and hero alike experience the catharsis of resolution. Use music, speech, and visual spectacle to make your audience identify with the hero and become emotionally invested in his or her journey through the plot. The reliability of this structure has made it a supremely effective medium for conveying subtle and nuanced political and social ideas for twenty-five hundred years. William Shakespeare knew it, Kenneth Branagh and his many MCU director colleagues know it, and now so do you. Use this new knowledge wisely, for in this world, with great power must also come great responsibility.

Notes

1. See chapters in this volume by Seideman, Carnes, and Galdieri for more on this dimension of the plot in *Captain America: Civil War*.

2. See Daily's and Philips's chapters in this volume on the role of trauma and violence in the Netflix MCU series.

3. See Kanthak's chapter in this volume on *Captain Marvel* for more discussion of this particular music in this sequence and how it connects to discussions of second-wave and third-wave feminist and postfeminist debates.

4. See Goren's chapter in this volume for further discussion of the dynamics of protecting the status quo and the structural nostalgia woven into the MCU.

Film List

Name	Phase	Film	Release	Directors/Showrunners	Domestic Box Office	International Box Office
Iron Man	1	1	05/02/08	Jon Favreau	$318,604,126	$585,366,247
The Incredible Hulk	1	2	06/13/08	Louis Leterrier	$134,806,913	$264,770,996
Iron Man 2	1	3	05/04/10	Michael McCormick, Robert Taylor	$312,433,331	$308,723,058
Thor	1	4	04/27/11	Kenneth Branagh	$181,030,624	$449,326,618
Captain America: The First Avenger	1	5	07/29/11	Joe Johnston	$176,654,505	$370,569,774
The Avengers	1	6	04/26/12	Joss Whedon	$623,357,910	$1,518,812,988
Iron Man 3	2	7	04/25/13	Shane Black	$409,013,994	$1,214,811,252
Thor: The Dark World	2	8	10/30/13	Alan Taylor	$206,362,140	$644,783,140
Captain America: The Winter Soldier	2	9	03/26/14	Anthony Russo, Joe Russo	$259,766,572	$714,421,503
Guardians of the Galaxy	2	10	07/31/14	James Gunn	$333,176,600	$772,776,600
Avengers: Age of Ultron	2	11	04/23/15	Joss Whedon	$459,005,868	$1,402,805,868
Ant-Man	2	12	07/17/15	Peyton Reed	$180,202,163	$519,311,965
Captain America: Civil War	3	13	04/29/16	Anthony Russo, Joe Russo	$408,084,349	$1,153,296,293
Doctor Strange	3	14	10/25/16	Scott Derrickson	$232,641,920	$677,718,395
Guardians of the Galaxy Volume 2	3	15	04/28/17	James Gunn	$389,813,101	$863,756,051
Spider-Man: Homecoming	3	16	07/02/19	Jon Watts	$390,532,085	$1,131,927,996
Thor: Ragnarok	3	17	10/24/17	Taika Waititi	$315,058,289	$853,977,126
Black Panther	3	18	02/13/18	Ryan Coogler	$700,059,566	$1,346,913,161
Avengers: Infinity War	3	19	04/26/18	Anthony Russo, Joe Russo	$678,815,482	$2,048,359,754
Ant-Man and the Wasp	3	20	08/02/18	Peyton Reed	$216,648,740	$622,674,139
Captain Marvel	3	21	02/27/19	Anna Boden, Ryan Fleck	$426,829,839	$1,128,274,794
Avengers: Endgame	3	22	04/26/19	Anthony Russo, Joe Russo	$858,373,000	$2,797,800,564
Spider-Man: Far from Home	3	23	06/26/19	Jon Watts	$390,532,085	$1,131,927,996
WandaVision	4	(TV)	01/15/21	Matt Shakman		
The Falcon and the Winter Soldier	4	(TV)	03/19/21	Kari Skogland		

Title			Date	Director		
Loki	4	(TV)	06/09/21	Kate Herron		
Black Widow	4	24	07/09/21	Cate Shortland	$183,651,655	$195,979,696
What If . . . ?	4	(TV)	08/11/21	Bryan Andrews		
Shang-Chi and the Legend of the Ten Rings	4	25	09/03/21	Destin Daniel Cretton	$224,543,292	$207,689,718
Eternals	4	26	11/05/21	Chloé Zhao	$164,844,673	$237,027,887
Spider-Man: No Way Home	4	27	12/17/21	Jon Watts	$698,724,074	$926,300,000

Netflix Marvel Television Shows

Title			Date	Director
Marvel's Daredevil	TV		4/10/15	Steven S. DeKnight, Doug Petrie, Marco Ramirez, Erik Oleson
Marvel's Jessica Jones	TV		11/20/15	Melissa Rosenberg, Scott Reynolds
Marvel's Luke Cage	TV		9/30/16	Cheo Hodari Coker
Marvel's Iron Fist	TV		3/17/17	Scott Buck, M. Raven Metzner
Marvel's The Defenders	TV		8/18/17	Marco Ramirez
Marvel's The Punisher	TV		11/17/17	Steve Lightfoot

ABC Marvel Television Shows

Title			Date	Director
Agents of S.H.I.E.L.D.	TV		9/24/13	Jed Whedon, Maurissa Tancharoen, Jeffrey Bell
Agent Carter	TV		1/6/15	Tara Butters, Michele Fazekas, Chris Dingess
Inhumans	TV		9/29/17	Scott Buck

Credit: BoxOfficeMojo.com.

Contributors

Elizabeth Barringer is an associate fellow at the Hannah Arendt Center for Politics and Humanities at Bard College.

Linda Beail is professor of political science at Point Loma Nazarene University.

Nicholas Carnes is professor of public policy at the Sanford School of Public Policy at Duke University.

Dan Cassino is professor of government and politics at Fairleigh Dickinson University.

Anna Daily is assistant professor of identity politics at California State University, Sacramento.

Christina Fattore is associate professor in the Department of Political Science at West Virginia University.

Jennifer Forestal is the Helen Houlahan Rigali Assistant Professor of Political Science at Loyola University Chicago.

Matthew L. Free is a graduate of the Department of Archaeology at Exeter University.

Christopher J. Galdieri is professor of political science at Saint Anselm College.

Carlee Goldberg is a graduate of the Departments of Political Science and History at Duke University and is pursuing a master's in Evidence-Based Social Intervention and Policy Evaluation at the University of Oxford.

Lilly J. Goren is professor of political science at Carroll University.

Danielle Hanley is assistant professor of political science at Clark University.

Nancy J. Hirschmann is Geraldine R. Segal Professor in American Social Thought and professor of political science and gender, sexuality, and women's studies at the University of Pennsylvania.

Kristin Kanthak is associate professor of political science at the University of Pittsburgh.

Ari Kohen is professor of political science, the Schlesinger Professor of Social Justice, and director of the Norman and Bernice Harris Center for Judaic Studies at the University of Nebraska–Lincoln.

Bethany Lacina is associate professor of political science at the University of Rochester.

Matthew Longo is assistant professor of political science at Leiden University.

Menaka Philips is assistant professor of political science at the University of Toronto.

Heather Pool is associate professor of politics and public affairs at Denison University.

Allison Rank is associate professor and chair of the Department of Political Science at SUNY Oswego.

Patricia C. Rodda is assistant professor of political science at Carroll University.

Steven Rogers is associate professor of political science at Saint Louis University.

Stephen M. Saideman is the Paterson Chair in International Affairs at Carleton University and director of the Canadian Defense and Security Network.

Meghan S. Sanders is associate professor of mass communication and director of the Media Effects Lab at Louisiana State University.

Ronald J. Schmidt, Jr., is professor of political science at the University of Southern Maine.

Ora Szekely is associate professor of political science at Clark University.

Haoyang Wang is a graduate of Duke University.

Christina Zhang is a graduate of Duke University.

References

Abrams, Jessica R. 2008. "African Americans' Television Activity: Is It Related to Perceptions of Outgroup Vitality?" *Howard Journal of Communications* 19(1): 1–17.

Abrams, Jessica R., and Howard Giles. 2004. "Viewing and Avoiding Television among African Americans: A Group Vitality and Social Identity Gratifications Perspective." Paper presented at the Annual Meeting of the International Communication Association.

Abrams, Jessica R., William P. Eveland, and Howard Giles. 2003. "The Effects of Television on Group Vitality: Can Television Empower Nondominant Groups?" *Annals of the International Communication Association* 27(1): 193–219.

Abrams, Natalie. 2015. "Agent Carter Crashes the Boys' Club." *Entertainment Weekly*, January 2. https://ew.com/article/2015/01/02/agent-carter-abc-set-spoilers/.

Academy of Cognitive and Behavioral Therapies. 2021. "Resources for Trauma Adults." Accessed March 29. https://www.academyofct.org/page/TraumaAdults/Resources-for-Trauma-Adults.htm.

Acevedo, Angélica. 2019. "Then and Now: 21 Actors Who Have Played Spider-Man." Insider, July 13. https://www.insider.com/then-and-now-actors-who-played-marvels-spider-man-2019-6.

Addice, Danny. 2021. "10 Marvel Superheroes You May Not Know Had Gay Storylines." *Hornet*. https://hornet.com/stories/gay-marvel-queer-superheroes/.

Agamben, Giorgio. 2005. *The State of Exception*. Chicago: University of Chicago Press.

Agence-France Presse. 2020. "New Spider Species Named after Climate Activist Greta Thunberg." *Agence-France Presse*, June 12. https://www.ndtv.com/topic/agence-france-presse.

Ahlgrim, Callie. 2019. "7 Marvel Movie Characters Who Are on the LGBTQ Spectrum in the Comics." *Insider*, July 22. https://www.insider.com/avengers-mcu-characters-who-are-gay-lgbtq-in-comics-2019-5.

Alaniz, José. 2006. "Supercrip: Disability, Visuality, and the Silver Age Superhero." *International Journal of Comic Art* 6(2): 304–324.

Albertson, Bethany, and Shana Kushner Gadarian. 2015. *Anxious Politics: Democratic Citizenship in a Threatening World*. Cambridge, UK: Cambridge University Press.

Alexander, David, and Phil Stewart. 2015. "U.S. Military Opens All Combat Roles to Women." *Reuters*, December 3. https://www.reuters.com/article/us-usa-military-women-combat/u-s-military-opens-all-combat-roles-to-women-idUSKBN0TM28520151204.

Alexander, Julia. 2019. "Like It or Not, the Marvel Empire Redefined Cinema This Decade." *The Verge*, December 12. https://www.theverge.com/2019/12/12/21011381/marvel-decade-cinema-mcu-iron-man-captain-america-disney-endgame.

AllAboutItaly. 2019. "Spider-Man in Venice." Accessed March 31, 2019. https://allaboutitaly.net/spider-man-in-venice.

Allen, Danielle S. 2004. *Talking to Strangers: Anxieties of Citizenship since Brown v. Board of Education*. Chicago: University of Chicago Press.

Almada, Frederick Luis. 2021. "Unmasking Whiteness: Re-spacing the Speculative in

Superhero Comics." In *Unstable Masks: Whiteness and American Superhero Comics*, edited by Sean Guynes and Martin Lund. Columbus: Ohio State University Press, ix–x.

American Psychological Association. 2022. "Trauma and Shock." Accessed May 12. https://www.apa.org/topics/trauma.

Anderson, Benedict. 1991. *Imagined Communities*. London: Verso.

Anker, Elisabeth. 2014. *Orgies of Feeling: Melodrama and the Politics of Freedom*. Durham, NC: Duke University Press.

Ansolabehere, Stephen, and Shanto Iyengar. 1995. *Going Negative: How Political Advertisements Shrink and Polarize the Electorate*. New York: Free Press.

Anthes, Richard A., Robert W. Corell, Greg Holland, James W. Hurrell, Michael C. MacCracken, and Kevin E. Trenberth. 2006. "Hurricanes and Global Warming—Potential Linkages and Consequences." *Bulletin of the American Meteorological Society* 87(5): 623–628.

Arendt, Hannah. 1958. *The Human Condition*. Chicago: University of Chicago Press.

———. 1961. *Between Past and Future*. New York: Penguin Classics.

———. 1973. *The Origins of Totalitarianism*. New York: Harcourt, Brace, Jovanovich.

———. 1998. *The Human Condition*, 2nd ed. Chicago: University of Chicago Press.

———. 2006. *On Revolution*. New York: Penguin Books.

Aristotle. *De Poetica*. 1947. Translated by Ingram Bywater. In *Introduction to Aristotle*, edited by Richard McKeon. New York: Modern Library.

———. *Politics*. 2013. Translated by Carnes Lorde. Chicago: University of Chicago Press.

Asante, Godfried A., and Gloria Nziba Pindi. 2020. "(Re)Imagining African Futures: Wakanda and the Politics of Transnational Blackness." *Review of Communication* 20(3): 220–228.

Ashe, Fidelma. 2007. *The New Politics of Masculinity: Men, Power, and Resistance*. New York: Routledge.

Associated Press. 1996. "Robert Downey Jr. Passes Out in Neighbor's Bed, Is Arrested," July 17. https://apnews.com/article/2cf7dc630a00b76159e541c09913087e.

Auerswald, David P., and Stephen M. Saideman. 2014. *NATO in Afghanistan: Fighting Together, Fighting Alone*. Princeton, NJ: Princeton University Press.

Avant, Deborah D. 1994. *Political Institutions and Military Change: Lessons from Peripheral Wars*. Ithaca, NY: Cornell University Press.

Bachelard, Gaston. [1958] 1994. *The Poetics of Space*. Boston: Beacon Press.

Bady, Aaron. 2017. "The Trouble with Calling Jessica Jones an 'Antihero.'" *Pacific Standard*, June 14. https://psmag.com/social-justice/what-you-learn-when-you-binge.

Bahr, Lindsey. 2018. "The Women of 'Black Panther' Take Center Stage." *Associated Press*, February 16. https://apnews.com/article/18ffd00c29794f899c07ceba630aef12.

Baldwin, James. 1993. *The Fire Next Time*. New York: Vintage International.

Bandel, Netael. 2020. "Four Women Petition Israel's Top Court to Allow Them into Elite Army Units." *Haaretz*, March 21. https://www.haaretz.com/israel-news/.premium-four-women-petition-israel-s-top-court-to-allow-them-into-elite-army-units-1.8860204.

Barbara. 2018. "Trauma in MCU: Now You See It, Now You Don't." *Fandomentals*, February 6. https://www.thefandomentals.com/trauma-mcu/.

Barber, Benjamin. 2001. "Malled, Mauled, and Overhauled: Arresting Suburban Sprawl by Transforming Suburban Malls into Usable Civic Space." In *Public Space and Democracy*, edited by Marcel Hénaff and Tracy B. Strong, 201–220. Minneapolis: University of Minnesota Press.

Barfield, Charles. 2019. "Kevin Feige Says Disney+ Shows Will Be 'The First Time' TV Series Have Interlinked with MCU (Sorry, 'SHIELD')." *Playlist*, December 9. https://theplaylist .net/kevin-feige-disney-plus-mcu-20191209/.

Barry, Colleen. 2020. "Virus Lockdown Gives Venice a Shot at Reimagining Tourism." *Philadelphia Inquirer*, May 17, H1.

Barry, Colleen, and Luca Bruno. 2019. "Venice 'On Its Knees' after Second-Worst Flood Ever Recorded." *Philadelphia Inquirer*, November 13. https://www.inquirer.com/news /nation-world/venice-flood-second-worst-ever-20191113.html.

Bartky, Sandra Lee. 1990. *Femininity and Domination: Studies in the Phenomenology of Oppression*. New York: Routledge.

Baum, Matthew A. 2002. "Sex, Lies, and War: How Soft News Brings Foreign Policy to the Inattentive Public." *American Political Science Review* 96(1): 91–109.

Baum, Matthew A., and Angela S. Jamison. 2006. "The Oprah Effect: How Soft News Helps Inattentive Citizens Vote Consistently." *Journal of Politics* 68(4): 946–959.

Baumgartner, Jody, and Jonathan S. Morris. 2006. "The Daily Show Effect: Candidate Evaluations, Efficacy, and American Youth." *American Politics Research* 34(2): 341–367.

BBC News. 2019. "London Bridge: What We Know about the Attack." *BBC News*, December 3. https://www.bbc.com/news/uk-50594810.

———. 2020. "Venice Test Brings Up Floodgates for First Time." *BBC News*, July 10. https:// www.bbc.com/news/world-europe-53361958.

Beail, Caroline, and Lindsey J. H. Lupo. 2018. "'Better in Stereo': Doubled and Divided Representations of Postfeminist Girlhood on the Disney Channel." *Visual Inquiry* 7(2): 125–140.

Beail, Linda, and Lilly J. Goren. 2015. *Mad Men and Politics: Nostalgia and the Remaking of Modern America*. New York: Bloomsbury Academic.

Becker, Tobias. 2018a. "Brexit, Trump and Nostalgia." Working Paper.

———. 2018b. "The Meanings of Nostalgia: Genealogy and Critique." *History and Theory* 57(2): 234–250. https://doi.org/10.1111/hith.12059.

Benhabib, Seyla. 2011. *Dignity in Adversity: Human Rights in Troubled Times*. Cambridge, UK: Polity Press.

Bennett, Jane. 2010. *Vibrant Matter: A Political Ecology of Things*. Durham, NC: Duke University Press.

Bercuci, Loredana. 2016. "Pop Feminism: Televised Superheroines from the 1990s to the 2010s." *Gender Studies* 15(1): 252–269.

Berg, Madeline. 2019. "Marvel Money: How Six Avengers Made $340 Million Last Year." *Forbes Magazine*, July 10.

Berger, Ronald J. 2008. "Disability and the Dedicated Wheelchair Athlete: Beyond the 'Supercrip' Critique." *Journal of Contemporary Ethnography* 37(6): 647–678.

Berlant, Lauren. 2011. *Cruel Optimism*. Durham, NC: Duke University Press.

Besen-Cassino, Yasemin, and Dan Cassino. 2014. "Division of House Chores and the Case of Cooking: The Effects of Earning Inequality on House Chores among Dual-earner Couples." *AG About Gender* 3(6): 25–53.

Betancourt, David. 2018. "'A Different Kind of Superhero': Why *Black Panther* Will Mean So Much to So Many." *Washington Post*, February 9.

Bijelonic, Gordon, Drew Bourneuf, Jacob Rosenberg, Vin Diesel, John Schnall, Eileen O'Meara, A. W. Feidler, Bret Stern, and Erik Friedlander. 1999. *Short 5, Diversity*. Los Angeles, CA: QuickBand Networks.

Bikowski, Kyle. 2020. "Holy Problematics Fabman! How Current Representations Create a

Missed Opportunity for Superhero Comics to Aid in Gay Youth Identity Development." *Journal of Gender Studies* 30(3): 282–291.

Black, Shane, dir. 2013. *Iron Man 3*. Burbank, CA: Marvel Studios.

Blaut, James M. 2002. *1492: The Debate on Colonialism, Eurocentrism, and History*. Trenton, NJ: Africa World Press.

Bloom, Mia. 2012. *Bombshell: Women and Terrorism*. Philadelphia: University of Pennsylvania Press.

Boden, Anna, and Ryan Fleck, dir. 2019. *Captain Marvel*. Burbank, CA: Marvel Studios.

Bond, Bradley J., and Benjamin L. Compton. 2015. "Gay On-Screen: The Relationship between Exposure to Gay Characters on Television and Heterosexual Audiences' Endorsement of Gay Equality." *Journal of Broadcasting and Electronic Media* 59(4): 717–731.

Bone, Christian. 2021. "Jessica Jones Might Return to the MCU in *Armor Wars*." *We Got This Covered*, June 19. https://wegotthiscovered.com/tv/jessica-jones-return-mcu-armor-wars/.

Bordo, Susan. 2003. *Unbearable Weight: Feminism, Western Culture, and the Body*. Berkeley: University of California Press.

Bourhis, Richard Yvon, Howard Giles, and Doreen Rosenthal. 1981. "Notes on the Construction of a 'Subjective Vitality Questionnaire' for Ethnolinguistic Groups." *Journal of Multilingual and Multicultural Development* 2(2): 144–155.

Bowen, Gary Lee. 1986. "Intergenerational Occupational Inheritance in the Military: A Reexamination." *Adolescence* 21(83): 623–629.

Box Office Mojo. 2022. Accessed May 9. Boxofficemojo.com.

———. 2019. *Avengers: Endgame*. https://www.boxofficemojo.com/title/tt4154796/?ref_=bo_gr_ti.

———. 2019. *Black Panther*. https://www.boxofficemojo.com/title/tt1825683/?ref_=bo_se_r_1.

Boym, Svetlana. 2001. *The Future of Nostalgia*. New York: Basic Books.

Bradatan, Costica. 2007. "Philosophy as an Art of Dying." *European Legacy* 12(5): 589–605.

Brader, Ted. 2006. *Campaigning for Hearts and Minds*. Chicago: University of Chicago Press.

Bradley, Laura. 2019. "How *Avengers: Endgame* Failed Black Widow." *Vanity Fair*, April 26. https://www.vanityfair.com/hollywood/2019/04/avengers-endgame-black-widow-death-scarlett-johansson.

Brady, Richard. 2019. "'Spider-Man: Far from Home' Presents the Illusion of a Good Movie." *New Yorker*, July 1.

Brancaccio, David, and Paulina Velasco. 2017. "The Story of Hedy Lamarr, the Hollywood Beauty Whose Invention Helped Enable Wi-Fi, GPS and Bluetooth." *Marketplace*, November 21. https://www.marketplace.org/2017/11/21/inventor-changed-our-world-and-also-happened-be-famous-hollywood-star/.

Bresnahan, Timothy F., and Peter C. Reiss. 1985. "Dealer and Manufacturer Margins." *RAND Journal of Economics* 16(2): 253.

Brooks, Peter. 1995. *The Melodramatic Imagination: Balzac, Henry James, Melodrama and the Mode of Excess*. New Haven, CT: Yale University Press.

Brooks, Risa. 2020. "Paradoxes of Professionalism: Rethinking Civil-Military Relations in the United States." *International Security* 44(4): 7–44.

Brown, Jeffrey A. 2021. *Panthers, Hulks, and Ironhearts: Marvel, Diversity, and the 21st Century Superhero*. New Brunswick, NJ: Rutgers University Press.

Brown, Sara E. 2014. "Female Perpetrators of the Rwandan Genocide." *International Feminist Journal of Politics* 16(3): 448–469.

Brown, Wendy. 2010. *Walled States, Waning Sovereignty*. New York: Zone Books.

Brubaker, Ed, Steve Epting, and Michael Lark. 2005. "Out of Time: Part 3." *Captain America* #3, March.

Buchanan, Ian. 2015. "Assemblage Theory and Its Discontents." *Deleuze Studies* 9(3): 382–392.

Buchanan, Kyle. 2019. "A Webslinger's Path of Twists and Turns." *New York Times*, July 11.

Buchholz, Katharina. 2020. "The Most Read Wikipedia Articles of 2019." *Statista*, January 14. https://www.statista.com/chart/20495/most-read-wikipedia-articles/.

Buckley, Julia. 2022. "The Flood Barriers that Might Save Venice." CNN Online, February 18. https://www.cnn.com/travel/article/mose-venice-flood-barriers/index.html.

Burkart, Patrick, and Miyase Christensen. 2013. "'Geopolitics' and 'the Popular': An Exploration." *Popular Communication* 11: 3–6.

Burke, Liam. 2018. "'A Bigger Universe': Marvel Studios and Transmedia Storytelling." *Assembling the Marvel Cinematic Universe: Essays on the Social, Cultural, and Geopolitical Domains*. New York: McFarland & Company.

Busch, Caitlin. 2017. "Marvel's 'Create Your Own' Doesn't Understand How Fanfic Works." *Inverse*, December 29. https://www.inverse.com/article/39789-marvel-create-your-own-comic-fanfiction-site.

Busselle, Rick W. 2001. "Television Exposure, Perceived Realism, and Exemplar Accessibility." *Media Psychology* 3(1): 43–67.

Butler, Judith. 2006. *Precarious Life: The Powers of Mourning and Violence*. New York: Verso Books.

Callaham, John. 2021. "Disney Plus Marvel TV Shows: Here's What We Know." Android Authority, March 26. https://www.androidauthority.com/disney-plus-marvel-tv-shows-1079709/.

Calvert, Randall L., Matthew D. McCubbins, and Barry R. Weingast. 1989. "A Theory of Political Control and Agency Discretion." *American Journal of Political Science* 33(3): 588–611.

Calzo, Jarel P., and Monique Ward. 2009. "Media Exposure and Viewers' Attitudes toward Homosexuality: Evidence for Mainstreaming or Resonance?" *Journal of Broadcasting & Electronic Media* 53(2): 280–299.

Campbell, Scott. 2021. "Disney Plus Moves *Agents of S.H.I.E.L.D.* and *Agent Carter* to Non-MCU Collection." *We Got This Covered*, May 5. https://wegotthiscovered.com/tv/disney-moves-agents-shield-agent-carter-marvel-legacy-collection/.

Cappella, Joseph N., and Kathleen Hall Jamieson. 1997. *Spiral of Cynicism: The Press and the Public Good*. New York: Oxford University Press.

Caputi, Mary. 2013. *Feminism and Power: The Need for Critical Theory*. Lanham, MD: Lexington Books.

Cari, Hrvoje, and Peter Mackelworth. 2014. "Cruise Tourism Environmental Impacts: The Perspective from the Adriatic Sea." *Ocean & Coastal Management* 102: 350–363.

Carlson, Jennifer. 2015. "Mourning Mayberry: Guns, Masculinity, and Socioeconomic Decline." *Gender & Society* 29(3): 386–409.

Carlson, Jennifer, and Kristin A. Goss. 2017. "Gendering the Second Amendment." *Law & Contemporary Problems* 80: 103–127.

Carlson, Licia. 2001. "Cognitive Ableism and Disability Studies: Feminist Reflections on the History of Mental Retardation." *Hypatia* 16(4): 124–146.

Carpenter, R. Charli. 2006. "Recognizing Gender-Based Violence against Civilian Men and Boys in Conflict Situations." *Security Dialogue* 37(1): 83–103.

Cassese, Erin C., and Mirya R. Holman. 2019. "Playing the Woman Card: Ambivalent Sexism in the 2016 US Presidential Race." *Political Psychology* 40(1): 55–74.

Cassino, Dan. 2018. "Emasculation Threat and Politics in 2016." *Contexts* 19(2).

Cassino, Dan, and Yasemin Besen-Cassino. 2020. "Sometimes (but Not This Time), a Gun Is Just a Gun: Masculinity Threat and Guns in the United States, 1999–2018." *Sociological Forum* 35(1): 5–23.

Cavallero, Eric. 2009. "Global Federative Democracy." *Metaphilosophy* 40(1): 43–64.

CDC. 2020. "Road Traffic Injuries and Deaths—A Global Problem." Centers for Disease Control and Prevention, December 14. https://www.cdc.gov/injury/features/global -road-safety/index.html.

Chetty, Raj, Nathaniel Hendren, Patrick Kline, and Emmanuel Saez. 2014. "Where Is the Land of Opportunity? The Geography of Intergenerational Mobility in the United States." Working Paper. https://www.nber.org/papers/w19843.pdf.

Chiles, Angela Michelle, and Theodore E. Zorn. 1995. "Empowerment in Organizations: Employees' Perceptions of the Influences on Empowerment." *Journal of Applied Communication Research* 23(1): 1–25.

Chitwood, Adam. 2021. "Kevin Feige Confirms 'Deadpool 3' Is an MCU Movie; Teases R-Rating and When It's Filming." *Collider*, January 11. https://collider.com/deadpool -3-mcu-confirmed-r-rating-filming-details-kevin-feige-interview/.

Clark, Travis. 2019. "Netflix's Marvel TV Universe Is Dead, and It's Unlikely the Shows Will Be Saved by Disney." *Business Insider*, February 19.

———. 2021. "All 26 Marvel Cinematic Universe Movies, Ranked by How Much Money They Made at the Global Box Office." *Business Insider*, November 9.

Clarkson, S. J., dir. 2015. "AKA Crush Syndrome." *Jessica Jones*. Netflix.

Clausewitz, Carl von. 1976. *On War.* Edited and translated by Michael Howard and Peter Paret. Princeton, NJ: Princeton University Press.

Coates, Ta-Nehisi, Adam Kubert, Frank Martin, and Matt Milla. 2019. *Captain America #2: Captain of Nothing.* New York: Marvel.

Cohen, Dara Kay. 2013. "Female Combatants and the Perpetration of Violence: Wartime Rape in the Sierra Leone Civil War." *World Politics* 65(3): 383–415.

Cohen, Jean L. 2006. "Sovereign Equality vs. Imperial Right: The Battle over the 'New World Order.'" *Constellations* 13(4): 485–505.

Coleridge, Samuel Taylor. [1817] 1983. *Biographia Literaria; or, Biographical Sketches of My Life and Opinions.* Vol. 7, *The Collected Works of Samuel Taylor Coleridge.* Princeton, NJ: Princeton University Press.

Comicbook, Joe. 2017. "Marvel Netflix Series Part of Marvel Cinematic Universe, Available for Binge Watching According to Joe Quesada." *Comicbook*, September 6. https:// comicbook.com/marvel/news/marvel-netflix-series-part-of-marvel-cinematic-universe -available-for-binge-watching-according-to-joe-quesada/.

Condon, Meghan, and Amber Wichowsky. 2020. *The Economic Other: Inequality and the American Political Imagination.* Chicago and London: University of Chicago Press.

Connell, R. W. 2005. *Masculinities.* Cambridge, UK: Polity Press.

Connell, R. W., and James W. Messerschmidt. 2005. "Hegemonic Masculinity: Rethinking the Concept." *Gender & Society* 19(6): 829–859.

Coogler, Ryan, dir. 2018. *Black Panther.* Burbank, CA: Marvel Studios.

Cook, Carson. 2018. "A Content Analysis of LGBT Representation on Broadcast and Streaming Television." Honors thesis, University of Tennessee at Chattanooga.

Cook, Philip J. 2018. "Gun Theft and Crime." *Journal of Urban Health* 95(3): 305–312.

Cooper, Brittney. 2018. "Love in a Hopeless Place." *Eloquent Rage: A Black Feminist Discovers Her Superpower*, 238–245. New York: St. Martin's Press.

Costello, Matthew J., and Kent Worcester. 2014. "The Politics of the Superhero: Introduction." *PS: Political Science and Politics* 47(1): 85–89.

Cott, Nancy F. 1987. *The Grounding of Modern Feminism*. New Haven, CT: Yale University Press.

Cox, Amy Ann. 2007. "Aiming for Manhood: The Transformation of Guns into Objects of American Masculinity." *Open Fire: Understanding Global Gun Cultures*, edited by Charles Springwood, 141–152. Oxford, UK: Berg Publishers.

Crenshaw, Kimberlé. 1991. "Mapping the Margins: Intersectionality, Identity Politics, and Violence against Women of Color." *Stanford Law Review* 43(6): 1241–1299.

Crow, David, Mike Cecchini, and Gavin Jasper. 2019. "Spider-Man: Far from Home—Complete Marvel MCU Easter Eggs Reference Guide." https://www.denofgeek.com/comics /spider-man-far-from-home-marvel-mcu-easter-eggs-reference-guide/.

Curtis, Neal. 2016. *Sovereignty and Superheroes*. Manchester, UK: Manchester University Press.

———. 2019. "Black Panther's Rage: Sovereignty, the Exception and Radical Dissent." *International Journal for the Semiotics of Law* 32(2): 265–281.

D'Agostino, Anthony Michael. 2019. "'Who Are You?': Representation, Identification, and Self-definition in *Black Panther*." *Safundi: The Journal of South African and American Studies* 20: 1–4.

Dallacqua, Ashley K., and David E. Low. 2021. "Cupcakes and Beefcakes: Students' Readings of Gender in Superhero Texts." *Gender and Education* 33(1): 68–85.

Danielle, Britni. 2008. "Women of Wakanda: Powerful Heroines Shine in 'Black Panther.'" ESPN.com, February 14. https://www.espn.com/espnw/culture/feature/story/_/id/22 443520/powerful-heroines-shine-black-panther.

Davidson, Janet T. 2015. "Female Crime Fighters in Television and Film: Implications and Future Directions." *Sociology Compass* 9(12): 1015–1024.

Dawson, Jan. 2017. "Global Business Keeps Mega-Franchises Like 'Fast and Furious' Going." *Variety*, March 30. https://variety.com/2017/voices/columns/fast-and-furious -mega-franchises-1202018788/.

Dean, Andrew. 2019. "Public Sector Heroes: Superheroes Backed by the Government." *Diverse Tech Geek*, March 13. https://www.diversetechgeek.com/2019/03/13/public -sector-heroes-superheroes-government/.

De Kosnik, Abigail, Laurent El Ghaoui, Vera Cuntz-Leng, Andrew Godbehere, Andrea Horbinski, Adam Hutz, Renée Pastel, and Vu Pham. 2015. "Watching, Creating, and Archiving: Observations on the Quantity and Temporality of Fannish Productivity in Online Fan Fiction Archives." *Convergence: The International Journal of Research into New Media Technologies* 21(1): 145–164.

de Landa, Manuel. 2006. *A New Philosophy of Society: Assemblage Theory and Social Complexity*. London: Continuum.

———. 2016. *Assemblage Theory*. Edinburgh: Edinburgh University Press.

Deleuze, Gilles, and Felix Guattari. 1988. *A Thousand Plateaus: Capitalism and Schizophrenia*. London: Athlone Press.

Delli Carpini, Michael X., and Bruce A. Williams. 1994. "Methods, Metaphors, and Media Research: The Uses of Television in Political Conversation." *Communication Research* 21(6): 782–812.

De Pauw, Linda Grant. 2014. *Battle Cries and Lullabies: Women in War from Prehistory to the Present*. Norman: University of Oklahoma Press.

de Tocqueville, Alexis. 1969. *Democracy in America*, edited by J. P. Mayer. New York: HarperPerennial Modern Classics.

Devereaux, Shaadi. 2015. "Netflix, Uncovering Cycles of Abuse and Chill: Jessica Jones and Domestic Violence." *Model View Culture*, November 25. https://modelviewculture .com/pieces/netflix-uncovering-cycles-of-abuse-and-chill-jessica-jones-and-domestic-violence.

DeVolder, Beth. 2013. "Overcoming the Overcoming Story: A Case of 'Compulsory Heroism.'" *Feminist Media Studies* 13(4): 746–754.

de Vreese, Claes. 2004. "The Effects of Strategic News on Political Cynicism, Issue Evaluations, and Policy Support: A Two-Wave Experiment." *Mass Communication and Society* 7(2): 191–214.

Dewey, John. 1916. "Democracy and Education." *John Dewey: The Middle Works.* Vol. 9, *1899–1924.* Carbondale: Southern Illinois University Press.

Dienstag, Joshua Foa. 2020. *Cinema Pessimism: A Political Theory of Representation and Reciprocity.* Oxford, UK: Oxford University Press.

Dines, Gail, and Jean M. Humez. 2002. *Gender, Race, and Class in Media.* Thousand Oaks, CA: Sage.

Dirik, Dilar. 2014. "Western Fascination with 'Badass' Kurdish Women." *Al Jazeera,* October 29. http://www.aljazeera.com/indepth/opinion/2014/10/western-fascination -with-badas-2014102112410527736.html.

Dominguez, Noah. 2019. "Diversity in the MCU: Marvel TV Was Always Ahead of the Curve." CBR.com, August 5.

Doob, Anthony N., and Glenn E. MacDonald. 1979. "Television Viewing and Fear of Victimization: Is the Relationship Causal?" *Journal of Personality and Social Psychology* 37(2) 170–179.

Downing, John D. H. 2013. "'Geopolitics' and 'the Popular': An Exploration." *Popular Communication* 11: 7–16.

Doyle, Sady. 2015. "Agent Carter's 'Feminism' Is More about Making Money Than Gender Equality." *In These Times,* January 13. https://inthesetimes.com/article/17519 /agent_carter_feminism.

Dry, Jude. 2019. "Marvel's LGBTQ+ Superheroes: The 8 Most Likely Candidates to Queer the MCU." *IndieWire,* July 25. https://www.indiewire.com/gallery/gay-marvel -superhero-lgbt-mcu/thor-ragnarok-film-2017-5/.

Dujmovic, Jurica. 2018. "Here's the Technology in 'Black Panther' That's Possible Today." *Marketwatch Bulletin,* March 29. https://www.marketwatch.com/story/heres-the-tech nology-in-black-panther-thats-possible-today-2018-03-29.

Dumaraog, Ana. 2019. "MCU Disney+ Shows First Time TV Connects to Movies, Says Feige." ScreenRant, December 11. https://screenrant.com/mcu-disney-plus-tv-shows -movies-crossovers-feige/.

Durkin, Allison, Brandon Willmore, Caroline Nobo Sarnoff, and David Hemenway. 2020. "The Firearms Data Gap." *Journal of Law, Medicine & Ethics* 48(4): 32–38.

Ecker, Ullrich, Stephan Lewandowsky, and Matthew Chadwick. 2020. *Can Corrections Spread Misinformation to New Audiences? Testing for the Elusive Familiarity Backfire Effect.* Perth: University of Western Australia School of Psychological Science.

Eco, Umberto, and N. Chilton. 1972. "The Myth of Superman: Review, The Adventures of Superman." *Diacritics* 2(1): 14–22.

Eilders, Christiane, and Cordula Nitsch. 2015. "Politics in Fictional Entertainment: An Empirical Classification of Movies and TV Series." *International Journal of Communication* 9: 1563–1587.

Ellefson, Lindsey. 2019. "'Fake News' Fears: 95% of Americans 'Troubled' by Current State

of Media, Poll Finds." *The Wrap*, September 11. https://www.thewrap.com/fake-news
-fears-95-of-americans-troubled-by-current-state-of-media-poll-finds/.

Ellis, Erle C. 2013. "Overpopulation Is Not the Problem," *New York Times*, September 13.
https://www.nytimes.com/2013/09/14/opinion/overpopulation-is-not-the-problem.
html?searchResultPosition=1.

Englehart, Steve, Sal Buscema, and Vince Colletta. 1974. ". . . Before the Dawn!" *Captain
America & The Falcon* #175, July.

Enloe, Cynthia. 2000. *Maneuvers: The International Politics of Militarizing Women's Lives*.
Berkeley: University of California Press.

Environmental Protection Agency. "Sources of Greenhouse Gas Emissions." Accessed June
12, 2020. https://www.epa.gov/ghgemissions/sources-greenhouse-gas-emissions.

Epstein, Edward Jay. 2010. *The Hollywood Economist: The Hidden Financial Reality behind
the Movies*. Brooklyn, NY: Melville House.

Euben, J. Peter. 1990. *The Tragedy of Political Theory: The Road Not Taken*. Princeton, NJ:
Princeton University Press.

Experian (Firm) and Experian Marketing Services. 2010–2017. *Simmons Insights*. New
York: Experian Simmons.

Faithful, George. 2018. "Dark of the World, Shine on Us: The Redemption of Blackness in
Ryan Coogler's *Black Panther*." *Religions* 9(10): 304–318.

Fanon, Frantz. 1952. *Black Skin, White Masks*. London: Pluto Press

———. 2004. *The Wretched of the Earth*. Translated by Richard Philcox. New York: Grove
Press.

Faris, John H. 1981. "The All-Volunteer Force: Recruitment from Military Families." *Armed
Forces & Society* 7(4): 545–559.

Fawaz, Ramzi. 2016. *The New Mutants: Superheroes and the Radical Imagination of Ameri-
can Comics*. New York: NYU Press.

Fawcett, Stephen B., Adrienne Paine-Andrews, Vincent T. Francisco, Jerry A. Schultz, Kim-
ber P. Richter, Rhonda K. Lewis, Ella L. Williams, Kari J. Harris, Jannette Y. Berkley,
Jacqueline L. Fisher, and Christine M. Lopez. 1995. "Using Empowerment Theory in
Collaborative Partnerships for Community Health and Development." *American Journal
of Community Psychology* 23(5): 677–697.

Fearon, James, and David D. Laitin. 2003. "Ethnicity, Insurgency and Civil War." *American
Political Science Review* 97(1): 75–90.

Feaver, Peter D. 1998. "Crisis as Shirking: An Agency Theory Explanation of the Souring of
American Civil-Military Relations." *Armed Forces & Society* 24(3): 407–434.

———. 2003. *Armed Servants: Agency, Oversight, and Civil-Military Relations*. Cambridge,
MA: Harvard University Press.

Ferguson, Kennan. 2012. *All in the Family: On Community and Incommensurability*. Durham,
NC: Duke University Press.

Ferguson, McKenna. 2016. "5 Reasons Agent Carter Is the Feminist Show You've Been
Waiting For." *Pride*. https://www.pride.com/feminism/2016/2/02/5-reasons-marvels
-agent-carter-feminist-show-youve-been-waiting.

Field, Nick. 2018. "Make Movies Great Again: The 'Alt-Right' Cinematic Backlash." *WHYY*, Feb-
ruary 11. https://whyy.org/articles/make-movies-great-alt-right-cinematic-backlash/.

Finer, S., S. E. Finer, and J. Stanley. 2002. *The Man on Horseback: The Role of the Military in
Politics*. Piscataway, NJ: Transaction Publishers.

Finkel, Steven E., and John G. Geer. 1998. "A Spot Check: Casting Doubt on the Demobiliz-
ing Effect of Attack Advertising." *American Journal of Political Science* 42(2): 573–595.

Firestone, Shulamith. 2003. *The Dialectic of Sex: The Case for Feminist Revolution*. New York: Farrar, Straus and Giroux.

Fisher, Max. 2013. "Map: Which Countries Allow Women in Front-Line Combat Roles?" *Washington Post*, January 25. https://www.washingtonpost.com/news/worldviews/wp/2013/01/25/map-which-countries-allow-women-in-front-line-combat-roles/.

Fleishman, Jeffrey, and Ryan Faughnder. 2018. "James Gunn's Vulgar Tweets Reveal the Power of Social Media to Force Hollywood Vigilance." *Los Angeles Times*, August 1. https://www.latimes.com/entertainment/movies/la-ca-james-gunn-hollywood-20180801-story.html.

Foa, Roberto Stefan, and Anna Nemirovskaya. 2019. "Frontier Settlement and the Spatial Variation of Civic Institutions." *Political Geography* 73: 112–122.

Foucault, Michel. 1983. "Discourse and Truth: The Problematization of Parrhesia." Six lectures at University of California–Berkeley, October–November. https://foucault.info/parrhesia/.

Fox, Maggie. 2018. "Fake News: Lies Spread Faster on Social Median Than Truth Does." *NBC News.com*, March 8. https://www.nbcnews.com/health/health-news/fake-news-lies-spread-faster-social-media-truth-does-n854896.

Franklin, Daniel P. 2016. *Politics and Film: The Political Culture of Television and Movies*, 2nd ed. New York: Rowman and Littlefield.

Friedan, Betty. 1963. *The Feminine Mystique*. New York: W. W. Norton.

Fritz, Ben. 2018. *The Big Picture: The Fight for the Future of Movies*. Boston: Houghton Mifflin Harcourt.

Fritz, Brian. 2020. The Open Movie Database (OMDb) API. http://www.omdbapi.com/.

Full Frontal with Samantha Bee. 2017. "Meet the Badass Peshmerga Women." TBS, August 9. https://www.youtube.com/watch?v=0rBEQjXg7Ak.

Funkhouser, G. Ray. 1973. "Trends in Media Coverage of the Issues of the '60s." *Journalism Quarterly* 50(3): 533–538.

Gabrielson, Teena, Cheryl Hall, John M. Meyer, and David Schlosberg, eds. 2016. *The Oxford Handbook of Environmental Political Theory*. New York: Oxford University Press.

Gahman, L. 2015. "Gun Rites: Hegemonic Masculinity and Neoliberal Ideology in Rural Kansas." *Gender, Place & Culture* 22(9): 1203–1219.

Garber, Megan. 2015. "How the Standard for Women in Culture Became Known as the 'Bechdel Test.'" *Atlantic*, August 25. https://www.theatlantic.com/entertainment/archive/2015/08/call-it-the-bechdel-wallace-test/402259/.

Garland-Thomson, Rosemarie. 1996. *Extraordinary Bodies: Figuring Physical Disability in American Culture and Literature*. New York: Columbia University Press.

———. 2011. "Misfits: A Feminist Materialist Disability Concept." *Hypatia* 26(3): 591–609.

Garretson, Jeremiah J. 2015. "Does Change in Minority and Women's Representation on Television Matter? A 30-Year Study of Television Portrayals and Social Tolerance." *Politics, Groups, and Identities* 3(4): 615–632.

Gates, Scott. 2002. "Recruitment and Allegiance: The Microfoundations of Rebellion." *Journal of Conflict Resolution* 46(1): 111–130.

Gatson, Sarah N., and Robin Anne Reid. 2012. "Race and Ethnicity in Fandom." *Transformative Works and Cultures* 8: 13.

Gerber, Sean. 2018. "Visual Development Bosses Discuss Why Sticking to the Source Material Matters to Marvel Studios." *Marvel Studios News*, October 18. https://marvel

studiosnews.com/2018/10/18/visual-development-bosses-discuss-why-sticking -to-the-source-material-matters-to-marvel-studios/.

Ghezzoa, Michol, Stefano Guerzonia, Andrea Cuccob, and Georg Umgiesser. 2010. "Changes in Venice Lagoon Dynamics Due to Construction of Mobile Barriers." *Coastal Engineering* 57: 694–708.

Gill, Rosalind, and Christina Scharff, eds. 2013. *New Femininities: Postfeminism, Neoliberalism and Subjectivity.* New York: Palgrave Macmillan.

GLAAD. 2019. "Where We Are on TV Report—2019." https://www.glaad.org/whereweare ontv19.

Glick, Elisa. 2000. "Sex Positive: Feminism, Queer Theory, and the Politics of Transgression." *Feminist Review* 64(1): 19–45.

Gomillion, Sarah C., and Traci A. Guiliano. 2011. "The Influence of Media Role Models on Gay, Lesbian, and Bisexual Identity." *Journal of Homosexuality* 58(3): 330–354.

Graham, Jefferson, and Mike Snider. 2019. "Disney+ Has Its Classics, plus Marvel and 'Star Wars,' but No R-Rated Films, Little Bingeing." *USA Today,* November.

Green, Stephanie. 2019. "Fantasy, Gender and Power in Jessica Jones." *Continuum* 33(2): 173–184.

Greenberg, N. A. 1965. "Socrates' Choice in the *Crito*." *Harvard Studies in Classical Philology* 70: 45–82.

Greer, Germaine. 2009. *The Female Eunuch.* New York: HarperCollins.

Gruenwald, Mark, Kieron Dwyer, and Al Milgrom. 1988. "Don't Tread on Me." *Captain America* #344, August. New York: Marvel.

Gruenwald, Mark, Kieron Dwyer, and Tom Morgan. 2011. *Captain America: The Captain* #1. New York: Marvel.

Guggenheim, Lauren, Nojin Kwak, and Scott W. Campbell. 2011. "Nontraditional News Negativity." *International Journal of Public Opinion Research* 23(3): 287–314.

Haile, Rahawa. 2018. "How Black Panther Asks Us to Examine Who We Are to One Another." *Longreads,* February 22. https://longreads.com/2018/02/22/how-black-panther-asks -us-to-examine-who-we-are-to-one-another/.

Hailey, Jamal, Whitney Burton, and Joyell Arscott. 2020. "We Are Family: Chosen and Created Families as a Protective Factor against Racialized Trauma and Anti-LGBTQ Oppression among African American Sexual and Gender Minority Youth." *Journal of GLBT Family Studies* 6(2): 176–191.

Hale-Stern, Kaila. 2021. "I Am Begging You Not to Write Articles That Refute a Fictional Character's Sexuality." The Mary Sue, April 30. https://www.themarysue.com /bucky-barnes-sexuality-kari-skogland-variety-interview/.

Hamilton, Alexander, James Madison, and John Jay. 2003. "Federalist Paper #37." *The Federalist Papers,* edited by Clinton Rossiter. New York: Penguin Books.

Hamilton, Jack. 2015. "Jessica Jones Is Our First Real Super-Antihero." *Slate Magazine,* November 18. https://slate.com/culture/2015/11/marvels-jessica-jones-on-netflix-re viewed-our-first-real-super-antihero.html.

Hamilton, James T. 2004. *All the News That's Fit to Sell: How the Market Transforms Information into News.* Princeton, NJ: Princeton University Press.

Hanchey, Jenna N. 2020. "Decolonizing Aid in *Black Panther*." *Review of Communication* 20(3): 260–268.

Hardiman, Neasa, dir. 2019. "AKA Everything." *Jessica Jones.* Netflix.

Hardt, Michael, and Antonio Negri. 2002. *Empire.* Cambridge, MA: Harvard University Press.

Harlan, Chico, and Stefano Pitrelli. 2019. "Venice Flood Plan became a Disaster," *Philadelphia Inquirer*, November 24, K11.

Harris, Mark. 2011. "The Day the Movies Died." *GQ*, February 10. https://www.gq.com/story/the-day-the-movies-died-mark-harris.

Harrison, Spencer, Arne Carlsen, and Miha Škerlavaj. 2019. "Marvel's Blockbuster Machine." *Harvard Business Review*. https://hbr.org/2019/07/marvels-blockbuster-machine.

Harwood, Jake, Howard Giles, and Richard Y. Bourhis. 1994. "The Genesis of Vitality Theory: Historical Patterns and Discoursal Dimensions." *International Journal of the Sociology of Language* 108: 167–206.

Headburt, Trevor. 2020. *The Environmental Impact of Overpopulation: The Ethics of Procreation*. New York: Routledge.

Healy, Patrick. 2016. "Race, Hollywood and 'Dr. Strange': Margaret Cho and Tilda Swinton, Annotated." *New York Times*, December 20. https://www.nytimes.com/2016/12/20/movies/margaret-cho-tilda-swinton-doctor-strange.html.

Henley, Jon, and Angela Giuffrida. 2019. "Two People Die as Venice Floods at Highest Level in 50 Years." *Guardian*, November 13. https://www.theguardian.com/environment/2019/nov/13/waves-in-st-marks-square-as-venice-flooded-highest-tide-in-50-years.

Henry, Astrid. 2004. *Not My Mother's Sister: Generational Conflict and Third-Wave Feminism*. Bloomington: Indiana University Press.

Henshaw, Alexis Leanna. 2016a. "Where Women Rebel: Patterns of Women's Participation in Armed Rebel Groups 1990–2008." *International Feminist Journal of Politics* 18(1): 39–60.

———. 2016b. "Why Women Rebel: Greed, Grievance, and Women in Armed Rebel Groups." *Journal of Global Security Studies* 1(3): 204–219.

Hetherington, Marc J. 2005. *Why Trust Matters: Declining Political Trust and the Demise of American Liberalism*. Princeton, NJ: Princeton University Press.

Hibbing, John R., and Elizabeth Theiss-Morse. 1995. *Congress as Public Enemy: Public Attitudes toward American Political Institutions*. New York: Cambridge University Press.

Hobbes, Thomas. [1651] 1994. *Leviathan*. Indianapolis, IN: Hackett Publishing Company.

Hoewe, Jennifer, and Lindsey A. Sherrill. 2019. "The Influence of Female Lead Characters in Political TV Shows: Links to Political Engagement." *Journal of Broadcasting & Electronic Media* 63(1): 59–76.

Holbert, R. Lance, Dhavan V. Shah, and Nojin Kwak. 2003. "Political Implications of Prime-Time Drama and Sitcom Use: Genres of Representation and Opinions Concerning Women's Rights." *Journal of Communication* 53(1): 45–60.

———. 2004. "Fear, Authority, and Justice: Crime-Related TV Viewing and Endorsements of Capital Punishment and Gun Ownership." *Journalism & Mass Communication Quarterly* 81(2): 343–363.

Holbrook, R. Andrew, and Timothy G. Hill. 2005. "Agenda-Setting and Priming in Prime Time Television: Crime Dramas as Political Cues." *Political Communication* 22(3): 277–295.

Holtzman, Linda, and Leon Sharp. 2014. *Media Messages: What Film, Television, and Popular Music Teach Us about Race, Class, Gender, and Sexual Orientation*. Armonk, NY: Sharpe.

Homer. 1974. *The Iliad*. Translated by Robert Fitzgerald. New York: Anchor Books.

Honig, Bonnie. 2011. *Emergency Politics: Paradox, Law, Democracy*. Princeton, NJ: Princeton University Press.

———. 2017. *Public Things: Democracy in Disrepair*. New York: Fordham University Press.

Hood, Cooper. 2019. "Marvel Reveals Thanos Has Different Names in Infinity War &

Endgame." ScreenRant, November 20. https://screenrant.com/thanos-name-avengers
-infinity-war-endgame/.

Hooker, Juliet. 2015. "'A Black Sister to Massachusetts': Latin America and the Fugitive Democratic Ethos of Frederick Douglass." *American Political Science Review* 109(4): 690–702.

hooks, bell. 2000. *Feminist Theory: From Margin to Center*. London: Pluto Press.

Hornaday, Ann. 2019. "'Spider-Man: Far from Home' Is the Best Kind of Superhero Film: Playful and Self-effacing." *Washington Post*, June 28.

Howe, Sean. 2012. *Marvel Comics: The Untold Story*. New York: HarperCollins.

Huddy, Leonie, Stanley Feldman, Charles Taber, and Gallya Lahav. 2005. "Threat, Anxiety, and Support of Antiterrorism Policies." *American Journal of Political Science* 49(3): 593–608.

Humphreys, Macartan, and Jeremy M. Weinstein. 2008. "Who Fights? The Determinants of Participation in Civil War." *American Journal of Political Science* 52(2): 436–455.

Hunt, Darnell. 2017. "Race in the Writer's Room: How Hollywood Whitewashes the Stories That Shape America." *Color of Change: Hollywood*. https://hollywood.colorofchange. org/writers-room-report/.

Huntington, Samuel P. 1957. *The Soldier and the State: The Theory and Politics of Civil-Military Relations*. Cambridge, MA: Harvard University Press.

Internet Movie Database (IMDb). 2022. Accessed May 9. https://www.imdb.com/.

Jackson, Sue, and Tina Vares. 2011. "Media 'Sluts': Girls' Negotiation of Sexual Subjectivities in 'Tween' Popular Culture." In *New Femininities: Postfeminism, Neoliberalism and Identity*, edited by C. Scharff and R. Gill. London: Palgrave.

Jakobsen, Tor G., and Indra De Soysa. 2009. "Give Me Liberty, or Give Me Death! State Repression, Ethnic Grievance and Civil War, 1981–2004." *Civil Wars* 11(2): 137–157.

Jamieson, Patrick E., and Daniel Romer. 2014. "Violence in Popular U.S. Prime Time TV Dramas and the Cultivation of Fear: A Time Series Analysis." *Media and Communication* 2(2): 31–41.

Janowitz, Morris. 1961. *The Professional Soldier*. New York: Free Press.

Jardina, Ashley. 2019. *White Identity Politics*. New York: Cambridge University Press.

Jefferson, Hakeem. 2020. "The Curious Case of Black Conservatives: Construct Validity and the 7-point Liberal-Conservative Scale." Working paper. https://papers.ssrn.com/sol3 /papers.cfm?abstract_id=3602209.

Jeltsen, Melissa. 2015. "'Jessica Jones' Uses Superheroes to Expose the Terror of Domestic Abuse." *HuffPost*, November 30. https://www.huffpost.com/entry/jessica-jones-uses -superheroes-to-expose-the-terror-of-domestic-abuse_n_565c9f47e4b079b2818b2b1d.

Jenkins, Henry. 2009a. "The Many Lives of the Batman (Revisited): Multiplicity, Anime, and Manga." *Confessions of an Aca-Fan*, February 2. http://henryjenkins.org/blog/2009/02 /the_many_lives_of_the_batman_r.html.

———. 2009b. "The Revenge of the Origami Unicorn: Seven Principles of Transmedia Storytelling." *Confessions of an Aca-Fan*, December 12. http://henryjenkins.org/blog /2009/12/the_revenge_of_the_origami_uni.html.

Jenkins, Tricia, and Tom Secker. 2022. *Superheroes, Movies, and the State: How the US Government Shapes Cinematic Universes*. Lawrence: University Press of Kansas.

Johnson, Amber L. 2020. "The Dark Matter(s) of Wakanda: A Poetic Performative." *Review of Communication* 20(3): 244–249.

Johnston, Steven. 2019. "The Dark Knight: Towards a Democratic Tragedy." *Politics in Gotham: The Batman Universe and Political Thought*, edited by D. K. Pickarello. London: Palgrave Macmillan. 23–38.

Jones, Calvert W., and Celia Paris. 2018. "It's the End of the World and They Know It: How Dystopian Fiction Shapes Political Attitudes." *Perspectives on Politics* 16(4): 969–989.

Jones, Jeffrey P. 2010. *Entertaining Politics: Satiric Television and Political Engagement*, 2nd ed. Lanham, MD: Rowman & Littlefield.

Jones, Simon Cellan, dir. 2015. "AKA WWJJD?" *Jessica Jones*. Netflix.

Justice, Glen. 2015. "States Six Times More Productive Than Congress." StateTrackers, January 27. http://cqrollcall.com/statetrackers/states-six-times-more-productive-than -congress/.

Kaid, Lynda Lee, Wayne M. Towers, and Sandra L. Myers. 1981. "Television Docudrama and Political Cynicism: A Study of *Washington: Behind Closed Doors*." *Social Science Quarterly* 62(1): 161–168.

Kalyvas, Andreas. 2009. *Democracy and the Politics of the Extraordinary: Max Weber, Carl Schmitt, Hannah Arendt*. Cambridge, UK: Cambridge University Press.

Kammen, Michael. 2006. *A Machine That Would Go of Itself: The Constitution in American Culture*. New York: Routledge.

Kampwirth, Karen. 2002. *Women and Guerrilla Movements: Nicaragua, El Salvador, Chiapas, Cuba*. University Park: Pennsylvania State University Press.

Kanyamibwa, Samuel. 1998. "Impact of War on Conservation: Rwandan Environment and Wildlife in Agony." *Biodiversity and Conservation* 7: 1401–1402.

Karim, Anhar. 2018. "The Marvel Cinematic Universe is 61% White, but Does That Matter?" *Forbes*, October 10. https://www.forbes.com/sites/anharkarim/2018/10/10/the -marvel-cinematic-universe-is-61-white-but-does-that-matter/#fc88be44482e.

Karner, Tracy. 1996. "Fathers, Sons, and Vietnam: Masculinity and Betrayal in the Life Narratives of Vietnam Veterans with Post-traumatic Stress Disorder." *American Studies* 37(1): 63–94.

Kashyap, Antara. 2021. "11 Actors Who Played Important Roles in Both Marvel and DC Movies." News18.com, March 31. https://www.news18.com/news/movies/11-actors -who-played-important-roles-in-both-marvel-and-dc-movies-3589982.html.

Katznelson, Ira. 2014. *Fear Itself: The New Deal and the Origins of Our Time*. New York: Liveright Publishing, W. W. Norton.

Kent, Miriam. 2016. "Marvel Women: Femininity, Representation, and Postfeminism in Films Based on Marvel Comics." PhD dissertation, University of East Anglia.

Kerber, Linda K. 1976. "The Republican Mother: Women and the Enlightenment—An American Perspective." *American Quarterly* 28(2): 187–205.

———. 1980. *Women of the Republic: Intellect and Ideology in Revolutionary America*. Chapel Hill: University of North Carolina Press.

Kiewiet, D. Roderick, and Mathew D. McCubbins. 1991. *The Logic of Delegation: Congressional Parties and the Appropriations Process*. Chicago: University of Chicago Press.

Kim, Eunji. Forthcoming. "Entertaining Beliefs in Economic Mobility." *American Journal of Political Science*.

Kim, Sam. 2017. "Comics/Superheroes: Women Superheroes Still Subjugated by the Male Gaze as Masculinity Prevails." *Medium*, September 3. https://medium.com/@skim225 /comics-superheroes-women-superheroes-still-subjugated-by-the-male-gaze-as-mascu linity-prevails-4c8607d93a43.

Kimmel, Michael. 2000. *The Gendered Society*. Oxford, UK: Oxford University Press.

———. 2017. *Angry White Men: American Masculinity at the End of an Era*. Paris: Hachette UK.

Knewitz, Simone. 2017. "White Middle-Class Homelessness: Nostalgia from *Babbitt* to *Mad*

Men." In *Nostalgia: Imagined Time-Spaces in Global Media Cultures*, edited by Sabine Sielke. Frankfurt, Germany: Peter Lang.

Koehler, Kevin, Dorothy Ohl, and Holger Albrecht. 2016. "From Disaffection to Desertion: How Networks Facilitate Military Insubordination in Civil Conflict." *Comparative Politics* 48(4): 439–457.

Kohen, Ari. 2014. *Untangling Heroism: Classical Philosophy and the Concept of the Hero.* New York: Routledge.

Kohn, Margaret. 2004. *Brave New Neighborhoods: The Privatization of Public Space.* New York: Routledge.

Koppes, Clayton R., and Gregory D. Black. 1990. *Hollywood Goes to War: How Politics, Profits, and Propaganda Shaped World War II Movies.* Berkeley: University of California Press.

Krasner, Stephen D. 1999. *Sovereignty: Organized Hypocrisy.* Princeton, NJ: Princeton University Press.

Lackey, Emily. 2015. "'Jessica Jones' Is a Feminist Antihero We Need." *Bustle*, November 20. https://www.bustle.com/articles/125354-jessica-jones-is-the-female-antihero-we-need-because-complicated-characters-are-real-characters.

Laiter, Tova, and Kevin Feige. 2019. NYFA Guest Speaker Series: Kevin Feige. Interview.

LaSala, Michael C. 2007. "Too Many Eggs in the Wrong Basket: A Queer Critique of the Same-Sex Marriage Movement." *Social Work* 52(2): 181–183.

Lawrence, John Shelton, and Robert Jewett. 2002. *The Myth of the American Superhero.* Grand Rapids, MI: Wm. B. Eerdmans Publishing Co.

Lee, Fred. 2018. *Extraordinary Racial Politics: Four Events in the Informal Constitution of the United States.* Philadelphia, PA: Temple University Press.

Lee, Stan. 1976. *The Origins of Marvel Comics.* New York: Simon & Schuster.

Lee, Stan, and Gene Colan. 1969a. "The Coming of . . . The Falcon!" *Captain America* #117. New York: Marvel Comics Group.

———. 1969b. "The Falcon Fights On." *Captain America* #118. New York: Marvel Comics Group.

———. 1969c. "Now Falls the Skull." *Captain America* #119. New York: Marvel Comics Group.

Lee, Stan, and Steve Ditko. 1963. *The Amazing Spider-Man* #2. New York: Marvel Comics Group.

Lee, Whitney. 2019. "People Who Use Inhalers Aren't Responsible for the Climate Crisis. Corporations and Governments Are." Rooted in Rights, November 12. https://rootedinrights.org/people-who-use-inhalers-arent-responsible-for-the-climate-crisis-corporations-and-governments-are/.

Lenart, Silvo, and Kathleen McGraw. 1989. "'America Watches 'Amerika'': Television Docudrama and Political Attitudes." *Journal of Politics* 51(3): 697–712.

Leon, Melissa. 2019. "How Brie Larson's 'Captain Marvel' Made Angry White Men Lose Their Damn Minds." *Daily Beast*, March 6. https://www.thedailybeast.com/how-brie-larsons-captain-marvel-made-angry-white-men-lose-their-damn-minds.

Leslie, Ian. 2021. "How Marvel Conquered Culture." *New Statesman*, July 28. https://www.newstatesman.com/culture/2021/07/marvel-studios-bankruptcy-box-office-kevin-feige.

Lickhardt, Maren. 2020. "Threatening Gazes: Observation and Objectification in the TV Series Marvel's Jessica Jones." *Journal of Popular Television* 8(1): 105–119.

Locke, John. 1980. *Second Treatise of Government.* Indianapolis, IN: Hackett Publishing Company.

Loken, Meredith. 2017. "Rethinking Rape: The Role of Women in Wartime Violence." *Security Studies* 26(1): 60–92.

Longo, Matthew. 2018. *The Politics of Borders: Sovereignty, Security, and the Citizen after 9/11*. Cambridge, UK: Cambridge University Press.

Lorde, Audre. [1987] 2007. "Age, Race, Class, and Sex: Women Redefining Difference." *Sister Outsider: Essays and Speeches*, 114–123. Berkeley, CA: Crossing Press.

MacDougall, A. S., and R. Turkington. 2004. "Relative Importance of Suppression-Based and Tolerance-Based Competition in an Invaded Oak Savanna." *Journal of Ecology* 92: 422–434.

———. 2005. "Are Invasive Species the Drivers or Passengers of Change in Degraded Ecosystems?" *Ecology* 86(1): 42–55.

Macedo, Stephen. 2005. *Democracy at Risk: How Political Choices Undermine Citizen Participation and What We Can Do about It*. Washington, DC: Brookings Institution Press.

Machiavelli, Niccolò. 1989. *The Chief Works and Others*, vol. 1. Translated by Allan Gilbert. Durham, NC: Duke University Press.

MacKenzie, Megan. 2009. "Securitization and Desecuritization: Female Soldiers and the Reconstruction of Women in Post-Conflict Sierra Leone." *Security Studies* 18(2): 241–261.

MacKinnon, Catharine A. 1987. *Feminism Unmodified: Discourses on Life and Law*. Cambridge, MA: Harvard University Press.

Mahajan, Siddharth, and van Ryzin, Garrett J. 1999. "Retail Inventories and Consumer Choice." In *Quantitative Models for Supply Chain Management*, edited by Sridhar Tayur, Ram Ganeshan, and Michael Magazine. Boston: Springer.

Mahle, Melissa Boyle. 2004. *Denial and Deception: An Insider's View of the CIA*. New York: Nation.

Mahoney, Cat. 2019. *Women in Neoliberal Postfeminist Television Drama: Representing Gendered Experiences of the Second World War*. Cham, Switzerland: Palgrave.

Malcolm X. 2004. "The Black Revolution." In *Martin Luther King Jr., Malcolm X, and the Civil Rights Struggle of the 1950s and 1960s: A Brief History with Documents*, edited by David Howard-Pitney. New York: Bedford/St. Martin's Press.

Malthus, Thomas Robert. 1798. *An Essay on the Principle of Population*. London: J. Johnson in St Paul's Church-yard.

Manicastri, Steven. 2020. "'Whatever It Takes': How the MCU Avenges Neoliberal Hegemony." Doctoral dissertation, University of Connecticut.

Mannion, A. M. 2003. "The Environmental Impact of War & Terrorism." Geographical Paper No. 169, The University of Reading.

Manoliu, Ioana Alexandra. 2019. "Watching House of Cards: Connecting Perceived Realism and Cynicism." *Atlantic Journal of Communication* 27(5): 324–338.

Marcus, George. 2002. *The Sentimental Citizen: Emotion in Democratic Politics*. University Park: Pennsylvania State University Press.

Markell, Patchen. 2003. *Bound by Recognition*. Princeton, NJ: Princeton University Press.

Markovits, Elizabeth. 2018. *Future Freedoms: Intergenerational Justice, Democratic Theory and Ancient Greek Tragedy and Comedy*. New York: Routledge.

Markus, Tucker Chet. 2017. "Marvel: Create Your Own." *Marvel*, December. https://www.marvel.com/articles/comics/marvel-create-your-own.

Marshall, Thomas R. 1981. "The Benevolent Bureaucrat: Political Authority in Children's Literature and Television." *Western Political Quarterly* 43(3): 389–398.

Martin, Amy J. 2015. "America's Evolution of Women and Their Roles in the Intelligence Community." *Journal of Strategic Security* 8(5): 99–109.

Marvel Cinematic Universe Wiki. 2019. Accessed December 20. https://marvelcinematic universe.fandom.com/wiki/Sokovia_Accords.

May, Elaine Tyler. 2017. *Homeward Bound: American Families in the Cold War Era*, 4th ed. New York: Basic Books.

Mayo Clinic. 2022. "Post-Traumatic Stress Disorder (PTSD)—Symptoms and Causes." Accessed May 12. https://www.mayoclinic.org/diseases-conditions/post-traumatic-stress -disorder/symptoms-causes/syc-20355967.

McCauliff, Kristen L. 2016. "The State of Affairs of Fictional Political Women: A Critical Rhetorical Analysis of the Television Series *Madam Secretary*." MA thesis, Ball State University.

McClintock, Pamela. 2018. "Weekend Box Office: 'Black Panther' Bounds to Record-Shattering $235M-Plus Bow." *Hollywood Reporter*, February 18. https://www.hollywoodreporter .com/heat-vision/black-panther-weekend-box-office-record-shattering-debut-108 5932.

McDermott, Monika L. 2016. *Masculinity, Femininity, and American Political Behavior*. New York: Oxford University Press.

McGushin, Edward F. 2007. *Foucault's Askesis: An Introduction to the Philosophical Life*. Topics in Historical Philosophy. Chicago: Northwestern University Press.

McInroy, Lauren B., and Shelley L. Craig. 2015. "Transgender Representation in Offline and Online Media: LGBTQ Youth Perspectives." *Journal of Human Behavior in the Social Environment* 25: 606–617.

———. 2017. "Perspectives of LGBTQ Emerging Adults on the Depiction and Impact of LGBTQ Media Representation." *Journal of Youth Studies* 20(1): 32–46.

McKay, Susan, and Dyan E. Mazurana. 2004. *Where Are the Girls? Girls in Fighting Forces in Northern Uganda, Sierra Leone and Mozambique: Their Lives during and after War*. Montréal, Québec: Rights & Democracy.

McRobbie, Angela. 2009. *The Aftermath of Feminism: Gender, Culture, and Social Change*. New York: Sage Publications.

McRuer, Robert. 2006. *Crip Theory: Cultural Signs of Queerness and Disability*. New York: NYU Press.

McSweeney, Terence. 2018. *Avengers Assemble! Critical Perspectives on the Marvel Cinematic Universe*. New York: Columbia University Press.

Mental Health Foundation. 2016. "The Impact of Traumatic Events on Mental Health." Mental Health Foundation. https://www.mentalhealth.org.uk/publications/impact-traumatic -events-mental-health.

Messner, Michael A. 1993. "Changing Men and Feminist Politics in the United States." *Theory and Society* 22(5): 723–737.

Meyer, Michaela D. E. 2020. "*Black Panther*, Queer Erasure, and Intersectional Representation in Popular Culture." *Review of Communication* 20(3): 236–243.

Meyer, Philip, and Deborah Potter. 1998. "Preelection Polls and Issue Knowledge in the 1996 US Presidential Election." *Harvard International Journal of Press/Politics* 3(4): 35–43.

Miller, Frank, and David Mazzucchelli. 2010. *Daredevil: Born Again*. New York: Marvel.

Miller, Matt. 2019a. "Every Marvel Cinematic Universe Movie, Ranked from Worst to Best," *Esquire*, July 3. https://www.esquire.com/entertainment/movies/g13441903/all-marvel -cinematic-universe-movies-ranked/.

———. 2019b. "Sexist Trolls Are Already Waging War against *Captain Marvel* with Negative Reviews." *Esquire*, February 19. https://www.esquire.com/entertainment/music /a26405919/captain-marvel-sexist-reviews-rotten-tomatoes/.

Miller, Nicholas E. 2017. "Asexuality and Its Discontents: Making the 'Invisible Orientation' Visible in Comics." *Inks: The Journal of the Comics Studies Society* 1(3): 354–376.

Mills, Charles. 1997. *The Racial Contract*. Ithaca, NY: Cornell University Press.

Mitchell, Timothy. 1988. *Colonising Egypt*. Berkeley: University of California Press.

Moe, Terry M. 1984. "The New Economics of Organization." *American Journal of Political Science* 28(4): 739–777.

Mokoena, Dikeledi A. 2018. "Black Panther and the Problem of the Black Radical." *Africology: Journal of Pan African Studies* 11(9): 13–19.

Morris, Steven. 2018. "All Roles in UK Military to Be Open to Women, Williamson Announces." *Guardian*, October 25. https://www.theguardian.com/uk-news/2018/oct/25/all-roles-in-uk-military-to-be-open-to-women-williamson-announces.

Movie Database (TMDb). 2022. The Movie Database API, version 4. Accessed May 09, 2022. https://developers.themoviedb.org/4/getting-started/authorization.

MPAA (Motion Picture Association of America). 2016. *Theatrical Market Statistics 2016*. https://www.motionpictures.org/wp-content/uploads/2017/03/MPAA-Theatrical-Market-Statistics-2016_Final.pdf.

———. 2018. "2018 Theme Report: A Comprehensive Analysis and Survey of the Theatrical and Home Entertainment Market Environment (THEME) for 2018." https://www.motionpictures.org/wp-content/uploads/2019/03/MPAA-THEME-Report-2018.pdf.

Mulligan, Kenneth, and Philip Habel. 2012. "The Implications of Fictional Media for Political Beliefs." *American Politics Research* 41(1): 122–146.

Mulvey, Laura. 1999. "Visual Pleasure and Narrative Cinema." *Film Theory and Criticism*. In *Film Theory and Criticism*, edited by Leo Braudy and Marshall Cohen, 833–844. New York: Oxford University Press.

Murray, Leah, ed. 2010. *Politics and Popular Culture*. Newcastle on Tyne, UK: Cambridge Scholars Publishing.

Murry, Kailah M. 2017. "Five Years Later: Women, Combat Operations, and Revisiting 'The Other Fifty Percent.'" *American Intelligence Journal* 34(1): 78–82.

Mutz, Diana C., and Lilach Nir. 2010. "Not Necessarily the News: Does Fictional Television Influence Real-World Policy Preferences?" *Mass Communication and Society* 13(2): 196–217.

Myketiak, Chrystie. 2016. "Fragile Masculinity: Social Inequalities in the Narrative Frame and Discursive Construction of a Mass Shooter's Autobiography/Manifesto." *Contemporary Social Science* 11(4): 289–303.

Nadkarni, Samira. 2018. "'I Was Never the Hero That You Wanted Me to Be': Feminism and Resistance to Militarism in Marvel's Jessica Jones." In *Gender and the Superhero Narrative*, edited by Michael Goodrum, Tara Prescott-Johnson, and Philip Smith, 74–100. Jackson: University Press of Mississippi.

NASA. 2019. "2018 Fourth Warmest Year in Continued Warming Trend, According to NASA." https://climate.nasa.gov/news/2841/2018-fourth-warmest-year-in-continued-warming-trend-according-to-nasa-noaa/.

National Public Radio. 2011. "'Most Beautiful Woman' by Day, Investor by Night." *All Things Considered*. https://www.npr.org/2011/11/27/142664182/most-beautiful-woman-by-day-inventor-by-night.

Nededog, Jethro. 2016. "Marvel TV Boss: I 'Don't Understand' Why 'Agent Carter' Was Canceled." *Insider*, August 8. https://www.businessinsider.com/why-was-agent-carter-canceled-2016-8.

Negra, Diane. 2009. *What a Girl Wants? Fantasizing the Reclamation of Self in Postfeminism.* New York: Routledge.

Neiwert, David A. 2017. *Alt-America: The Rise of the Radical Right in the Age of Trump.* New York: Verso.

Nelson, John S. 2015. *Politics in Popular Movies: Rhetorical Takes on Horror, War, Thriller, and SciFi Films.* Boulder, CO: Paradigm Publishers.

News18. 2021. "'WandaVision' Just Introduced Us to MCU's First Gay Character and Set Up Young Avengers." News 18.com, February 14. https://www.news18.com/news /movies/wandavision-just-introduced-us-to-mcus-first-gay-character-and-set-up -young-avengers-3433178.html.

New York Times. 2005. "Lynndie England Found Guilty in Abuse of Iraq Detainees." *New York Times*, September 27. https://www.nytimes.com/2005/09/27/world/americas /lynndie-england-found-guilty-in-abuse-of-iraq-detainees.html.

Nichols, Michael D. 2021. *Religion and Myth in the Marvel Cinematic Universe.* Jefferson, NC: McFarland and Company.

Nielsen, Suzanne C., and Don M. Snider. 2009. *American Civil-Military Relations: The Soldier and the State in a New Era.* Baltimore, MD: Johns Hopkins University Press.

Nitsch, Cordula, Olaf Jandura, and Peter Bienhaus. 2021. "The Democratic Quality of Political Depictions in Fictional TV Entertainment: A Comparative Content Analysis of the Political Drama *Borgen* and the Journalistic Magazine *Berlin direkt*." *Communications* 46(1): 74–94.

Nussbaum, Emily. 2015. "Jessica Jones: Graphic, Novel." *New Yorker*, December 14. https://www.newyorker.com/magazine/2015/12/21/graphic-novel-on-television -emily-nussbaum.

O'Neill, Shane. 2021. "Marvel's New Phase 4 Slate: Every MCU Movie Release Date (2020–2022)." ScreenRant, October 24. https://screenrant.com/marvel-phase-4-mcu -release-date-change/.

Opie, David. 2019. "RIP Marvel TV—Yet It Actually Succeeded Where the Movies Failed." Digital Spy, December 15. https://www.digitalspy.com/tv/ustv/a30194009/marvel -tv-diversity-mcu-movies/.

Owens, Katharine A., Victor Eno, Jocelyn Abrams, and Danielle Bedney. 2020. "Comic-Con: Can Comics of the Constitution Enable Meaningful Learning in Political Science?" *PS: Political Science and Politics* 53(1): 161–166.

Panagia, Davide. 2009. *The Political Life of Sensation.* Durham, NC: Duke University Press.

Park, Shelley. 2013. *Mothering Queerly, Queering Motherhood.* New York: SUNY Press.

Parker, Christine. 2013. "Voting with Your Fork? Industrial Free-Range Eggs and the Regulatory Construction of Consumer Choice." *Annals of the American Academy of Political and Social Science* 649(1): 52–73.

Pateman, Carole. 1988. *The Sexual Contract.* Palo Alto, CA: Stanford University Press.

Patten, Eileen, and Kim Parker. 2011. "Women in the U.S. Military: Growing Share, Distinctive Profile." *Pew Research Center's Social & Demographic Trends Project*, December 22. https:// www.pewsocialtrends.org/2011/12/22/women-in-the-u-s-military-growing-share -distinctive-profile/.

Pattinson, Juliette. 2016. "The Twilight War: Gender and Espionage, Britain, 1900–1950." In *Handbook on Gender and War*, edited by Simona Sharoni, Julia Welland, Linda Steiner, and Jennifer Pederson. New York: Edgar Elgar.

Peppard, Anna F. 2017. "'This Female Fights Back!' A Feminist History of Marvel Comics."

Make Ours Marvel: Media Convergence and a Comics Universe, edited by Matt Yockey, 105–137. Austin: University of Texas Press.

Petrarca, David, dir. 2015. "AKA 99 Friends." *Jessica Jones*. Netflix.

Philipps, Dave, and Tim Arango. 2020. "Who Signs Up to Fight? Makeup of U.S. Recruits Shows Glaring Disparity." *New York Times*, January 10. https://www.nytimes.com /2020/01/10/us/military-enlistment.html.

Philips, Menaka. 2022. "Violence in the American Imaginary: Gender, Race, and the Politics of Superheroes." *American Political Science Review* 116(2): 470–483.

Plato. 1984. "Apology of Socrates." *Four Texts on Socrates*. Translated by Thomas G. West and Grace Starry West. Ithaca, NY: Cornell University Press.

Plautz, Jason. 2020. "The Environmental Burden of Generation Z." *Washington Post*, February 3. https://www.washingtonpost.com/magazine/2020/02/03/eco-anxiety-is-over whelming-kids-wheres-line-between-education-alarmism/?arc404=true.

Pogge, Thomas. 1992. "Cosmopolitanism and Sovereignty." *Ethics* 103: 48–75.

Pollitt, Katha. 1991. "Hers; The Smurfette Principle." *New York Times*, April 7. https://www .nytimes.com/1991/04/07/magazine/hers-the-smurfette-principle.html.

Pratt, Mary Louise. [1992] 2008. *Imperial Eyes: Travel Writing and Transculturation*. New York: Routledge.

Price, Margaret. 2015. "The Bodymind Problem and the Possibilities of Pain." *Hypatia* 30(1): 268–184.

Price-Robertson, Rhys, and Cameron Duff. 2019. "Family Assemblages." *Social & Cultural Geography* 20(8): 1031–1049.

Proctor, Tammy M. 2005. "Family Ties in the Making of Modern Intelligence." *Journal of Social History* 39(2): 451–466.

Projansky, Sarah. 2014. *Spectacular Girls: Media Fascination and Celebrity Culture*. New York University Press.

Puar, Jasbir. 2017. *Terrorist Assemblages*. Durham, NC: Duke University Press.

Pulliam-Moore, Charles. 2018. "GLAAD Calls Out Marvel and WB for Not Acknowledging their LGBTQ Movie Characters." Gizmodo, May 22. https://gizmodo.com/glaad -calls-out-marvel-and-wb-for-not-acknowledging-the-1826230143.

Purslow, Matt. 2021. "Hawkeye Episode 6 Review." IGN.com, December 22. https://www .ign.com/articles/hawkeye-review-episode-6/.

Putnam, Jackson K. 1976. "The Turner Thesis and the Westward Movement: A Reappraisal." *Western Historical Quarterly* 7(4): 377–404.

RAINN. 2020. "Victims of Sexual Violence: Statistics." RAINN.org, https://www.rainn.org /statistics/victims-sexual-violence.

Rakes, H. 2019. "Crip Feminist Trauma Studies in Jessica Jones and Beyond." *Journal of Literary & Cultural Disability Studies* 13(1): 75–91.

Ranker Entertainment. 2019. "The Best Villains in the Marvel Cinematic Universe." https://www.ranker.com/list/best-marvel-cinematic-universe-villians/ranker-entertai nment.

Rapaglia, John, Luca Zaggia, Kevin Parnall, Giuliano Lorenzetti, and Athanasios T. Vafeidis. 2015. "Ship-Wake Induced Sediment Remobilization: Effects and Proposed Management Strategies for the Venice Lagoon." *Ocean & Coastal Management* 110: 1–11.

Ravenola, Dean, and Brian Boone. 2020. "Rules Actors Have to Follow When Joining the MCU." Looper.com, July 19. https://www.looper.com/139571/rules-actors-have -to-follow-when-joining-the-mcu/.

Ray, Kwadar. 2018. "The Surprising Reason Why Marvel Movies Include Post-Credits

Scenes." *Mental Floss*, November 3. https://www.mentalfloss.com/article/562703/marvel-movies-reason-for-post-credits-scenes-mcu.

Ray, Travis N., Michele R. Parkhill, and Rollin D. Cook. 2021. "Bullying, Masculinity, and Gun-supportive Attitudes among Men: A Path Analysis Testing the Structural Relationships between Variables." *Psychology of Violence* 11(4): 395–404.

Reinhard, Carrielynn D., and Christopher J. Olson. 2018. "AKA Marvel Does Darkness: Jessica Jones, Rape Allegories, and the Netflix Approach to Superheroes." In *Jessica Jones, Scarred Superhero: Essays on Gender, Trauma and Addiction in the Netflix Series*, edited by Tim Rayborn and Abigail Keyes, 83–104. Jefferson, NC: McFarland & Company.

Reveal News. 2018. "Never Meet Your (Super) Heroes." *Reveal News*, September 22. https://revealnews.org/podcast/never-meet-your-super-heroes/.

Reynolds, Richard. 1992. *Super Heroes: A Modern Mythology*. Jackson: University Press of Mississippi.

Rich, Adrienne. 1980. "Compulsory Heterosexuality and Lesbian Existence." *Signs: Journal of Women in Culture and Society* 5(4): 631–660.

Richards, Dave. 2015. "Exploring Untold Tales of the Marvel Cinematic Universe in Comics Form." CBR.com, February 25. https://www.cbr.com/exploring-untold-tales-of-the-marvel-cinematic-universe-in-comics-form/.

Ridgely, Charlie. 2019. "Kevin Feige Confirms Spider-Man: Far from Home is the Conclusion to Marvel's Infinity Saga." ComicBook.com, June 24. https://comicbook.com/marvel/2019/06/24/spider-man-far-from-home-infinity-saga-ending-marvel-kevin-feige/.

Rieber, John Ney, and John Cassaday. 2003. *Captain America: The New Deal*. New York: Marvel.

Riesman, Chris, and Abraham Wade. 2017. "Every Line from a (Non-Leia) Woman in Star Wars." *Vulture*, December 13. https://www.vulture.com/2015/12/star-wars-all-female-lines-excluding-leia.html.

Roberts, Michelle. 2019. "Asthma Carbon Footprint 'as Big as Eating Meat.'" BBC Online, October 30. https://www.bbc.com/news/health-50215011.

Robinson, Michael J. 1976. "Public Affairs Television and the Growth of Political Malaise: The Case of 'The Selling of the Pentagon.'" *American Political Science Review* 70(2): 409–432.

Rogers, Steven. 2015. "Strategic Challenger Entry in a Federal System: The Role of Economic and Political Conditions in State Legislative Competition." *Legislative Studies Quarterly* 40(4): 539–570.

———. 2016. "National Forces in State Legislative Elections." *ANNALS of the American Academy of Political and Social Science* 667 (1): 207–225.

———. 2017. "Electoral Accountability for State Legislative Roll Calls and Ideological Representation." *American Political Science Review* 111 (3): 555–571.

Roiphe, Katie. 1994. *The Morning After: Sex, Fear, and Feminism*. London: Hamish Hamilton.

Romeyn, Kathryn. 2019. "Scarlett Johansson's 'Avengers' Workout: How to Get a Black Widow Body." *Hollywood Reporter*, April 26.

Rosenberg, Alyssa. 2021a. "'Game of Thrones' Was the Last Must-Watch Pop Culture Aimed at Adults." *Washington Post*, April 19. https://www.washingtonpost.com/opinions/2021/04/19/game-of-thrones-10th-anniversary-must-watch-pop-culture-adults/.

———. 2021b. "Zack Snyder's Superhero Universe Is Unsettling—but Says a Lot about Our Reality." *Washington Post*, March 24. https://www.washingtonpost.com/opinions/2021/03/24/zack-snyder-superhero-movies-mcu/.

Rosenblum, Nancy L. 2016. *Good Neighbors: The Democracy of Everyday Life in America*. Princeton, NJ: Princeton University Press.

Rotten Tomatoes. 2015. "Marvel's Jessica Jones: Season 1." https://www.rottentomatoes
.com/tv/jessica-jones/s01.

Rousseau, Jean-Jacques. 2012. *Basic Political Writings*, 2nd ed. Translated and edited by Donald Cress. Indianapolis, IN: Hackett Publishing Company.

Rowlands, Ian H. 2001. "Transnational Corporations and Global Environmental Politics." In *Non-State Actors and Global Politics*, edited by Daphné Josselin and William Wallace, 133–149. New York: Palgrave Macmillan.

Rubin, Rebecca. 2021. "'Spider-Man: No Way Home' Becomes First Pandemic-Era Movie to Smash $1 Billion Milestone Globally." *Variety*, December 26. https://variety.com/2021 /film/box-office/spiderman-billion-dollars-box-office-pandemic-1235143308/.

Ruddick, Sara. 1989. *Maternal Thinking: Towards a Politics of Peace*. Boston: Beacon Press Books.

———. 1995. *Maternal Thinking: Towards a Politics of Peace*, 2nd ed. Boston: Beacon Press.

Russell, Bradley. 2020. "Marvel Contracts: How Long Does Each Actor Have Left in the MCU?" *Total Film*, April 3.

Russo, Anthony, and Joe Russo, dir. 2014. *Captain America: Winter Soldier*. Burbank, CA: Marvel Studios.

———. 2016. *Captain America: Civil War*. Burbank, CA: Marvel Studios.

———. 2018. *Avengers: Infinity War*. Burbank, CA: Marvel Studios.

———. 2019. *Avengers: Endgame*. Burbank, CA: Marvel Studios.

Rymer, Michael, dir. 2015. "AKA Smile." *Jessica Jones*. Netflix.

Sage, Alyssa. 2016. "Diverse Films Perform Better at Global Box Office, Study Says." *Variety*, March 22. https://variety.com/2016/film/news/diverse-movies-global-box-office -study-1201736373/.

Said, Edward W. [1979] 1994. *Orientalism*. New York: Vintage.

———. 2000. *Reflections on Exile and Other Literary and Cultural Essays*. London: Granta Publications.

Saideman, Steve. 2012. "SHIELD and the US: How Realistic Is the Avengers Movie?" *Duck of Minerva*, May 8. https://duckofminerva.com/2012/05/shield-and-us-how-realistic -is-avengers.html.

Sakoui, Anousha. 2019. "Trolls Targeted 'Captain Marvel,' but Disney Was Ready for Them." *Bloomberg*, March 6. https://www.bloomberg.com/news/features/2019-03-06 /-captain-marvel-hit-by-online-trolls-but-disney-was-ready.

Salih, Mohammed A. 2014. "Meet the Badass Women Fighting the Islamic State." *Foreign Policy*, September 12. https://foreignpolicy.com/2014/09/12/meet-the-badass -women-fighting-the-islamic-state/.

Samuels, Ellen. 2017. "Prosthetic Heroes: Curing Disabled Veterans in *Iron Man 3* and Beyond." *Disability Media Studies*, edited by Elizabeth Ellcessor and Bill Kirkpatrick, 129–151. New York: NYU Press.

Saunders, Robert A. 2019. "(Profitable) Imaginaries of Black Power: The Popular and Political Geographies of *Black Panther*." *Political Geography* 69: 139–149.

Scarpa, Gian Marco, Luca Zaggia, Giorgia Manfè, Giuliano Lorenzetti, Kevin Parnell, Tarmo Soomere, John Rapaglia, and Emanuela Molinaroli. 2019. "The Effects of Ship Wakes in the Venice Lagoon and Implications for the Sustainability of Shipping in Coastal Waters." *Nature Research Scientific Reporter* 9: 19014.

Schaffer, Sandy. 2021. "Falcon and Winter Soldier Director Debunks Theory the Premier Confirms Bucky as Bi." CBR.com, April 30. https://www.cbr.com/falcon-winter-soldier -director-debunks-dating-app-bucky-bi-evidence/.

Schalk, Sami. 2016. "Reevaluating the Supercrip." *Journal of Literary & Cultural Disability Studies* 10(1): 71–86.

Schein, Seth L. 1984. *The Mortal Hero: An Introduction to Homer's* Iliad. Berkeley: University of California Press.

Schmidt, Ronald J., Jr. 2005. *This Is the City: Making Model Citizens in Los Angeles*. Minneapolis: University of Minnesota Press.

Schmitt, Carl. 1996. *The Concept of the Political*. Chicago: University of Chicago Press.

———. 2005. *Political Theology*. Chicago: University of Chicago Press.

———. 2007. *The Concept of the Political*. Translated by G. Schwab. Chicago: University of Chicago Press.

Schmitt, Eric. 2005. "Female M.P. Wins Silver Star for Bravery in Iraq Firefight." *New York Times*, June 17. https://www.nytimes.com/2005/06/17/us/female-mp-wins-silver-star -for-bravery-in-iraq-firefight.html.

Schoolman, Morton. 2020. *A Democratic Enlightenment: The Reconciliation Image, Aesthetic Education, Possible Politics*. Durham, NC: Duke University Press.

Schuller, Kyla. 2021. *The Trouble with White Women: A Counterhistory of Feminism*. New York: Bold Type Books.

Schwind, Katie L. 2017. "Politics, Feminism, and Popular Television: Madam Secretary as a Politician, Wife, and Mother." MA thesis, University of Denver.

Scott, A. O. 2019. "Passport, Check: Webs, Check." *New York Times*, July 2.

Scott, James C. 1998. *Seeing Like a State: How Certain Schemes to Improve the Human Condition Have Failed*. New Haven, CT: Yale University Press.

Sears, David O., and Jack Citrin. 1982. *Tax Revolt: Something for Nothing in California*. Cambridge, MA: Harvard University Press.

Serwer, Adam. 2018. "The Tragedy of Erik Killmonger." *Atlantic*, February 21. https:// www.theatlantic.com/entertainment/archive/2018/02/black-panther-erik-kill monger/553805/.

Shaw, Adrienne. 2012. "Talking to Gaymers: Questioning Identity, Community, and Media Representation." *Westminster Papers in Communication and Culture* 9(1): 67–89.

Shaw, Lucas. 2014a. "Forget Fanboys, Why Hispanics Are the Most Important Moviegoers." *The Wrap*, June 8. https://www.thewrap.com/forget-fanboys-why-latinos-are-the -most-important-moviegoers/.

———. 2014b. "Hispanic Women Are This Summer's Most Avid Moviegoers (Exclusive Study)." *The Wrap*, July 14. https://www.thewrap.com/hispanic-women-are-this-sum mers-most-avid-moviegoers-exclusive-study/.

Shaw-Williams, Hannah. 2015. "Stop Calling 'Agent Carter' a Feminist Triumph." Screen-Rant. https://screenrant.com/agent-carter-feminism-female-superheroes-discussion/.

———. 2016. "Doctor Strange's Erasure of Tibet Is a Political Statement." ScreenRant, April 30. https://screenrant.com/doctor-strange-china-tibet-ancient-one/.

Siebers, Tobin. 2008. *Disability Theory*. Ann Arbor: University of Michigan Press.

Siede, Caroline. 2015. "The Fascinating, Flawed Gender Politics of *Agent Carter*." The AV Club. https://tv.avclub.com/the-fascinating-flawed-gender-politics-of-agent-carter-1798 276882.

———. 2019. "Avengers: Endgame Doesn't Earn Its Big 'Girl Power' Moment." *Film*. https:// film.avclub.com/avengers-endgame-doesn-t-earn-its-big-girl-power-mom-1834366317.

Sielke, Sabine. 2017. "Nostalgia for New York." *Nostalgia: Imagined Time-Spaces in Global Media Culture*, edited by Sabine Sielke. Frankfurt, Germany: Peter Lang Edition, Transcription: Cultures, Concepts, Controversies.

Sierzchula, William, Sjoerd Bakker, Kees Maat, and Bertvan Wee. 2014. "The Influence of Financial Incentives and Other Socio-economic Factors on Electric Vehicle Adoption." *Energy Policy* 68: 183–194.

Sims, David. 2019. "A Change for Rotten Tomatoes ahead of *Captain Marvel*." *Atlantic*, March 4. https://www.theatlantic.com/entertainment/archive/2019/03/rotten-to matoes-captain-marvel-review-ratings-system-online-trolls/584032/.

Singh, Naunihal. 2021. "Was the U.S. Capitol Riot Really a Coup? Here's Why Definitions Matter." *Washington Post*, January 9.

Sjoberg, Laura, and Caron E. Gentry. 2007. *Mothers, Monsters, Whores: Women's Violence in Global Politics*. London: Zed Books.

Slater, Michael D., Donna Rouner, and Marilee Long. 2006. "Television Dramas and Support for Controversial Public Policies: Effects and Mechanisms." *Journal of Communication* 56(2): 235–252.

Smith, Anna. 2019. "'White, Male and Brawny Feels Tired': Is This the Age of Feminist Marvel Movies?" *Guardian*. https://www.theguardian.com/film/2019/jul/25/white-male -and-brawny-feels-tired-is-this-the-age-of-feminist-marvel-movies.

Smith, Kirsten Ann. 2015. "Espionage in British Popular Culture of the 20th Century: Gender, Moral Ambiguity and the Inextricability of Fact and Fiction." https://eprints .lancs.ac.uk/id/eprint/133517/.

Smith, Michael Lane. 2015. "6 Women Who Fought in Direct Combat in Iraq and Afghanistan." *Task & Purpose*, August 26. https://taskandpurpose.com/leadership/6-women -who-fought-in-direct-combat-in-iraq-and-afghanistan.

Smith, Neil. 2019. "Marvel Phase 4: A New Era for Diversity in Hollywood?" BBC.com, July 22. https://www.bbc.com/news/entertainment-arts-49070232.

Smith, Stacy L., Marc Choueiti, and Katherine Pieper. 2014. "Gender Bias without Borders." Geena Davis Institute on Gender in Media. https://seejane.org/symposiums-on -gender-in-media/gender-bias-without-borders/.

———. 2016. "Inclusion or Invisibility? Comprehensive Annenberg Report on Diversity in Entertainment." Institute for Diversity and Empowerment at Annenberg, February 22. https://annenberg.usc.edu/sites/default/files/2017/04/07/MDSCI_CARD_Report _FINAL_Exec_Summary.pdf.

Sommers, Christina Hoff. 1995. *Who Stole Feminism? How Women Have Betrayed Women*. New York: Simon and Schuster.

Sorenson, John. 1991. "Mass Media and Discourse on Famine in the Horn of Africa." *Discourse & Society* 2(2): 223–242.

Southwell, Priscilla, and Kevin D. Pirch. 2003. "Political Cynicism and the Mobilization of Black Voters." *Social Science Quarterly* 84(4): 906–917.

Spencer, Nick, Donny Cates, Sean Izaakse, Andres Guinaldo, Ramón Bachs, and Javier Pina. 2017. *Captain America: Secret Empire*. New York: Marvel.

Statista. 2018. "Viewership of Marvel Superhero Movies by Age Group in the U.S. 2018." 2018. https://www.statista.com/statistics/807367/marvel-movie-viewership-age/.

———. 2021. "Share of Consumers Who Have Watched Selected Marvel Studios Superhero Films in the United States as of February 2018, by Age." https://www.boxoffice mojo.com/title/tt4154796/?ref_=bo_gr_ti.

Steidley, Trent, and Martin T. Kosla. 2018. "Toward a Status Anxiety Theory of Macro-level Firearm Demand." *Social Currents* 5(1): 86–103.

Stein, Rachel, ed. 2004. *New Perspectives on Environmental Justice: Gender, Sexuality and Activism*. New Brunswick, NJ: Rutgers University Press.

Steiner, Chelsea. 2019. "Season 3 of *Jessica Jones* Delivers Marvel's Best LGBTQ+ Representation." The Mary Sue, June 25. https://www.themarysue.com/jessica-jones-lgbtq-representation-season-three/.

Steinmetz, Katy. 2018. "The Real Fake News Crisis." *Time*, August 9. https://time.com/5362183/the-real-fake-news-crisis/.

Stevens, J. Richard. 2011. "'Let's Rap with Cap': Redefining American Patriotism through Popular Discourse and Letters." *Journal of Popular Culture* 44(3): 606–632.

Stone, Sasha, and Marshall Flores. 2019. "Superpowering Women in Science Fiction and Superhero Film: A Ten Year Investigation." Women's Media Center, July 18. https://womensmediacenter.com/reports/superpowering-women-in-science-fiction-and-superhero-film-a-ten-year-investigation.

Storey, Epiphany. 2019. "Prison Sex: Is TV Getting It Right or Not?" MS thesis, University of Alabama.

Strauss, Leo. 1996. "Notes on Carl Schmitt: The Concept of the Political." In Carl Schmitt, *The Concept of the Political*. Chicago: University of Chicago Press.

Stroud, Angela. 2012. "Good Guys with Guns: Hegemonic Masculinity and Concealed Handguns." *Gender & Society* 26(2): 216–238.

Stroud, Forrest. 2021. "Fake News." *Webopedia*, May 24. https://www.webopedia.com/definitions/fake-news/

Stuart, Tessa. 2016. "Pop-Culture Legacy of Nancy Reagan's 'Just Say No' Campaign." *Rolling Stone*, March 27. https://www.rollingstone.com/culture/culture-news/pop-culture-legacy-of-nancy-reagans-just-say-no-campaign-224749/.

Sunstein, Cass. 2015. *Why Nudge? The Politics of Libertarian Paternalism*. New Haven, CT: Yale University Press.

Surjik, Stephen S. J., Director. 2015. "AKA The Sandwich Saved Me." *Jessica Jones*. Netflix.

Sutherland, Steve. 2004. "What Makes a Weed a Weed: Life History Traits of Native and Exotic Plants in the USA." *Œcologia* 141: 24–39.

Swigger, Nathaniel. 2016. "The Effect of Gender Norms in Sitcoms on Support for Access to Abortion and Contraception." *American Politics Research* 45(1): 109–127.

Sylt, Christian. 2019. "How Marvel Fuels Profits for Audi." *Forbes Magazine*, June 24.

Szekely, Ora. 2020a. "Exceptional Inclusion: Understanding the PKK's Gender Policy." *Studies in Conflict & Terrorism*: 1–18.

———. 2020b. "Fighting about Women: Ideologies of Gender in the Syrian Civil War." *Journal of Global Security Studies* 5(3): 408–426.

Tajfel, Henri, 1974. "Social Identity and Intergroup Behaviour." *Information (International Social Science Council)* 13(2): 65–93.

Tallamy, Doug. 2009. *Bringing Nature Home: How You Can Sustain Wildlife with Native Plants*. Portland, OR: Timber Press.

Taranto, Stacie. 2017. *Kitchen Table Politics: Conservative Women and Family Values in New York*. Philadelphia: University of Pennsylvania Press.

Tartaglione, Nancy. 2019. "Oh, Snap! 'Avengers: Endgame' Rises to $1.22B+ Global & $866M Overseas Record Bows; Climbs All-Time Charts—International Box Office." *Deadline*, April 29. https://deadline.com/2019/04/avengers-endgame-opening-weekend-record-global-china-international-box-office-1202601752/.

Tasker, Yvonne, and Diane Negra, eds. 2007. *Interrogating Postfeminism: Gender and the Politics of Popular Culture*. Durham, NC: Duke University Press.

Tenzek, Kelly E., and Bonnie M. Nickels. 2019. "End-of-Life in Disney and Pixar Films: An

Opportunity for Engaging in Difficult Conversation." *OMEGA—Journal of Death and Dying* 80(1): 49–68.

Tezcür, Güneş Murat. 2016. "Ordinary People, Extraordinary Risks: Participation in an Ethnic Rebellion." *American Political Science Review* 110(2): 247–264.

Thomas, Jakana L., and Kanisha D. Bond. 2015. "Women's Participation in Violent Political Organizations." *American Political Science Review* 109(2): 488–506.

Thompson, Gary. 2019. "'Spider-Man: Far from Home': Peter Parker's European Vacation Is Kind of Fun." *Philadelphia Inquirer*, July 1.

Thrasher, Steven. 2018. "There Is Much to Celebrate—and Much to Question—about Marvel's *Black Panther*." *Esquire*, February 20. https://www.esquire.com/entertainment /movies/a18241993/black-panther-review-politics-killmonger/.

Tickner, J. Ann. 1992. *Gender in International Relations: Feminist Perspectives on Achieving Global Security*. New York: Columbia University Press.

———. 2001. *Gendering World Politics: Issues and Approaches in the Post–Cold War World*. New York: Columbia University Press.

Tiffany, Kaitlyn. 2017. "Marvel Wants You to Write Comics with No Farts, Death, Aliens, Gossip, or 'Social Issues.'" *The Verge*, December 28. https://www.theverge.com/tldr /2017/12/28/16827356/marvel-comics-create-your-own-platform-terms-restrictions.

Till, Benedikt, and Peter Vitouch. 2012. "Capital Punishment in Films: The Impact of Death Penalty Portrayals on Viewers' Mood and Attitude toward Capital Punishment." *International Journal of Public Opinion Research* 24(3): 387–399.

Towler, Christopher C., Nyron N. Crawford, and Robert A. Bennett III. 2020. "Shut Up and Play: Black Athletes, Protest Politics, and Black Political Action." *Perspectives on Politics* 18(1): 111–127.

Townsend, Megan. 2021. "The Gay Superhero in 'Eternals' Is 'What Audiences Have Been Waiting For,' Says GLAAD." *Variety*, November 5. https://variety.com/2021/film/news /gay-superhero-eternals-glaad-1235105082/.

Townsend, Nicholas. 2002. *Package Deal: Marriage, Work, and Fatherhood in Men's Lives*. Philadelphia, PA: Temple University Press.

Toy, Rosemary Florence, and Christopher Smith. 2017. "Women in the Shadow War: Gender, Class and MI5 in the Second World War." *Women's History Review* 27(5): 688–706.

Trisko Darden, Jessica, and Izabela Steflja. 2020. *Women as War Criminals: Gender, Agency and Justice*. Palo Alto, CA: Stanford University Press.

Trisko Darden, Jessica, Alexis Henshaw, and Ora Szekely. 2019. *Insurgent Women: Female Combatants in Civil Wars*. Washington, DC: Georgetown University Press.

Tronto, Joan C. 1993. *Moral Boundaries: A Political Argument for an Ethic of Care*. New York: Psychology Press.

Trott, Verity. 2019. "'Let's Start with a Smile': Rape Culture in Marvel's Jessica Jones." In *Superhero Bodies: Identity, Materiality, Transformation*, edited by Wendy Haslem, Elizabeth MacFarlane, and Sarah Richardson. New York: Routledge.

Trumbore, David. 2018. "'Black Panther': 90 Things to Know about the MCU's Game-Changing Movie." https://collider.com/black-panther-things-to-know/.

Tsebelis, George. 2002. *Veto Players: How Political Institutions Work*. Princeton, NJ: Princeton University Press.

Tyler, Tom R. 1998. "Trust and Democratic Governance." In *Trust and Governance*, edited by Valerie Braithwaite and Margaret Levi, 269–294. New York: Russell Sage Foundation.

UN Women. 2021. "Facts and Figures: Ending Violence against Women." https://www .unwomen.org/en/what-we-do/ending-violence-against-women/facts-and-figures.

US Census Bureau. 2018. American Community Survey. Data.census.gov.

Vaggione, Juan Marco. 2013. "Families beyond Heteronormativity." In *Gender and Sexuality in Latin America*, edited by Cristina Motta and Macarena Saez. Cham, Switzerland: Springer.

Vanderheiden, Steve. 2005. "Eco-terrorism or Justified Resistance? Radical Environmentalism and the 'War on Terror.'" *Politics & Society* 33(3): 425–447.

Vemto Report. 2022. "Mose: Yet Another Dispute between the Venezia Nuova Consortium and the Superintendency." *Veneto Report*, May 2. https://venetoreport.it/mose-ennesima-controversia-tra-il-consorzio-venezia-nuova-e-il-provveditorato/.

Viterna, Jocelyn S. 2006. "Pulled, Pushed, and Persuaded: Explaining Women's Mobilization into the Salvadoran Guerrilla Army." *American Journal of Sociology* 112(1): 1–45.

von Drehle, David. 2020. "Trump Pledged to Bring Back Coal. Like Everything under Him, It Collapsed Instead." *Washington Post*, June 12. https://www.washingtonpost.com/opinions/trump-pledged-to-bring-back-coal-like-everything-under-him-it-collapsed-instead/2020/06/12/1fa8bed6-accd-11ea-9063-e69bd6520940_story.html.

Waggoner, Erin B. 2018. "Bury Your Gays and Social Media Fan Response: Television, LGBTQ Representation, and Communitarian Ethics." *Journal of Homosexuality* 65(13): 1877–1891.

Waller, Donald M., and Thomas P. Rooney, eds. 2009. *The Vanishing Present: Wisconsin's Changing Lands, Waters, and Wildlife*. Chicago: University of Chicago Press.

Ward, Alvin. 2021. "The 25 Highest-Grossing Movies of All Time Worldwide." *Mental Floss*, March 13. https://www.mentalfloss.com/article/581606/highest-grossing-movies-all-time-worldwide.

Warner, Michael. 1999. *The Trouble with Normal: Sex, Politics, and the Ethics of Queer Life*. New York: The Free Press.

Warner, Tara D. 2020. "Fear, Anxiety, and Expectation: Gender Differences in Openness to Future Gun Ownership." *Violence and Gender* 7(1): 11–18.

Watts, Jon, dir. 2017. *Spider-Man: Homecoming*. Burbank, CA: Marvel Studios.

———, dir. 2019. *Spider-Man: Far from Home*. Columbia Pictures.

Westing, Arthur H. 2009. "The Impact of War on the Environment." In *War and Public Health*, edited by Barry S. Levy and Victor W. Sidel, 72–73. New York: Oxford University Press.

———. 2010. "Overpopulation and Climate Change." *New York Times*, February 18. https://www.nytimes.com/2010/02/18/opinion/18iht-edwesting.html?searchResultPosition=3.

Whedon, Joss, dir. 2015. *Avengers: Age of Ultron*. Burbank, CA: Marvel Studios.

Wilkins, Jonathan, ed. 2018. *Marvel Studios: The First Ten Years*. New York: Titan Comics Publishing.

Willer, Robb, Bridget Conlon, Christabell L. Rogalin, and Michael T. Wojnowicz. 2013. "Overdoing Gender: A Test of the Masculine Overcompensation Thesis." *American Journal of Sociology* 118(4): 980–1022.

Williams, Zoe. 2018. "Jessica Jones: The Timely Return of a Feminist Superhero." *Guardian*, February 24. https://www.theguardian.com/culture/2018/feb/24/jessica-jones-mind-control-and-redemption-the-timely-return-of-a-feminist-superhero.

Willingham, A. J. 2019. "Valkyrie Is Now the First LGBTQ Marvel Movie Superhero, but She's Been Bi Forever." CNN, July 22. https://www.cnn.com/2019/07/22/entertainment/valkyrie-bisexual-tessa-thompson-bi-lgbt-marvel-trnd/index.html.

Wills, Gary. 2018. *Inventing America: Jefferson's Declaration of Independence*. New York: Vintage.

Wilton, Shauan. 2018. "Mothers Hunting Murderers: Representations of Motherhood in Broadchurch and Happy Valley." *Clues: A Journal of Detection* 36(1): 101–110.

Winkler, Allan M. 1978. *The Politics of Propaganda: The Office of War Information, 1942–1945*. New Haven, CT: Yale Historical Publications.

Winter, Nicholas J. 2010. "Masculine Republicans and Feminine Democrats: Gender and Americans' Explicit and Implicit Images of the Political Parties." *Political Behavior* 32(4): 587–618.

Wolf, Naomi. 1993. *Fire with Fire: The New Female Power and How It Will Change the 21st Century*. New York: Random House.

———. 2009. *The Beauty Myth: How Images of Beauty Are Used against Women*. New York: Harper Collins.

Wolin, Sheldon. 2008. *Democracy Incorporated: Managed Democracy and the Spectre of Inverted Totalitarianism*. Princeton, NJ: Princeton University Press.

Wolk, Douglas. 2021. *All of the Marvels: A Journey to the Ends of the Biggest Story Ever Told*. New York: Penguin Press.

Woo, Benjamin. 2018. "The Invisible Bag of Holding: Whiteness and Media Fandom." In *The Routledge Companion to Media Fandom*, edited by Melissa A. Click and Suzanne Scott. New York: Routledge.

Wood, Reed M., and Jakana L. Thomas. 2017. "Women on the Frontline: Rebel Group Ideology and Women's Participation in Violent Rebellion." *Journal of Peace Research* 54(1): 31–46.

Wood, Wendy, and Alice H. Eagly. 2015. "Two Traditions of Research on Gender Identity." *Sex Roles* 73(11): 461–473.

Wright, Bradford W. 2001. *Comic Book Nation: The Transformation of Youth Culture in America*. Baltimore, MD: Johns Hopkins University Press.

YouGov. 2022. "Share of Consumers Who Have Watched Selected Marvel Studios Superhero Films in the United States as of February 2018." *Statista*. Accessed May 9. https://www.statista.com/statistics/806393/marvel-movie-viewership/.

Young, Iris Marion. 1980. "Throwing Like a Girl: A Phenomenology of Feminine Body Comportment Motility and Spatiality." *Human Studies* 3(2): 137–156.

Young, Stella. 2014. *I'm Not Your Inspiration, Thank You Very Much*. TED Video Blog. TEDxSydney, Sydney, Australia. https://www.ted.com/talks/stella_young_i_m_not_your_inspiration_thank_you_very_much.

Yuval-Davis, Nira. 1987. "Front and Rear: The Sexual Division of Labour in the Israeli Army." In *Women, State and Ideology: Studies from Africa and Asia*, edited by Haleh Afshar, 186–204. London: Palgrave Macmillan.

Zegart, Amy B. 1999. *Flawed by Design: The Evolution of the C.I.A., J.C.S., and N.S.C.* Palo Alto, CA: Stanford University Press.

Zeisler, Andi. 2016. *We Were Feminists Once: From Riot Grrrl to CoverGirl, the Buying and Selling of a Political Movement*. New York: Public Affairs.

Zerilli, Linda M. G. 2016. *A Democratic Theory of Judgment*. Chicago: University of Chicago Press.

Zimbardo, Philip. 2007. *The Lucifer Effect: Understanding How Good People Turn Evil*. New York: Random House.

Zouhar, Kristin, Jane Kapler Smith, and Steve Sutherland. 2008. "Effects of Fire on

Nonnative Invasive Plants and Invasibility of Wildland Ecosystems." Ogden, UT: US. Department of Agriculture, Forest Service, Rocky Mountain Research Station. https://www.fs.usda.gov/treesearch/pubs/32669.

Zuckert, Michael. 1984. "Rationalism & Political Responsibility: Just Speech & Just Deed in the *Clouds* & the *Apology of Socrates*." *Polity* 17(2): 271–297.

Index

Note: MCU characters are listed by their first name (i.e., Nick Fury, not Fury, Nick) or their hero name (i.e., Iron Man, not Tony Stark).

revolutionary politics of, 28–29, 31, 184
and slavery, 23, 25, 30–31, 99, 186, 207, 323, 331
Black Panther (film), 12, 19–20
 anti-diversity movements and, 309
 and Black political, 20–23
 and colonialism, 19–29, 31–32, 186, 323, 325–326, 328
 commercial success of, 50n1, 307
 environmentalism in, 173
 geopolitical representations of Africa, 323–335
 government in, 119, 120, 123
 hero's journey in, 103–104
 LGBTQ+ representation in, 266, 274
 Oakland in, 29, 184, 186, 200, 207, 331
 and responses to global racism, 26–32
 sovereignty in, 152
 villains in, 140n2, 182, 184–186, 190
 and Wakanda's origin story, 23–25
 women in, 199–200, 206–207, 298–300
 See also Wakanda
Black Panther (T'Challa), 19, 25–26, 29–32, 35n16, 173, 207, 285, 306n15, 362
 and female characters, 199–200, 207
 and Killmonger, 184–186
 and masculinity, 252, 299
 and representations of Africa, 325, 330–331, 333–334
Black Widow (film), 13, 50n5, 191, 305, 365, 369
 and family assemblages, 286, 291n10
Black Widow (Natasha Romanoff), 2, 10, 48, 50–51n5, 82, 195, 363
 and ability, 130
 and Cold War, 195–198
 and family assemblages, 278, 282–284, 286, 288–289
 and feminism, 202, 204–206, 208–209, 211–212, 222, 237, 243
 and MCU masculinity, 259, 262
 as monstrous, 136
 origin story of, 89–90
 as superhero, 104, 300
 and violence, 235, 300, 303
bodies
 bodily configurations, 58–59
 female, 204, 214, 235
 and male sexualization, 253
 queer, 275
borders
 and sovereignty, 142–143, 149–150, 152
 Wakanda and, 23, 25, 185, 325

Brown, Wendy, 142–143, 149, 151, 153n10
Bucky Barnes, 54, 77–79, 82, 87, 205, 276–277, 288, 299–300, 351, 363
Bush, George W., 92, 221, 252
Butler, Judith, 132, 142

Canada, 164, 185, 323
capitalism, 59, 62, 171
Captain America: The First Avenger, 7, 156–157, 269, 288, 369
 institutional skepticism in, 76–78, 82
 origin narratives in, 89, 91
 Peggy Carter in, 237, 248
 World War II in, 94n3, 97
Captain America: The Winter Soldier
 institutional skepticism in, 77–80
 origin narratives in, 91–92
Captain America: Civil War, 2, 25, 40–41, 91, 358, 361, 369
 civilian-military relations in, 154, 156, 161–162, 165n12
 democracy in, 131
 and environmentalism, 172, 180
 family assemblages in, 282, 284, 287–288
 government in, 119–120, 123, 126n11
 political institutions in, 77–78, 80–83, 138
 skepticism in, xii
 viewership of, 311, 315
 women in, 199, 205–206, 208, 247, 299, 306n14
Captain America (Steve Rogers), xi–xii, 72–74, 82–84, 180, 356, 362–363, 366
 Captain America #1, 73, 87–89
 "Captain America: Commie Smasher," 87
 and civilian-military relations, 154, 156–157, 160, 163
 and compassion, 263
 and family assemblages, 278, 282–285, 288, 290n6
 and government, 118, 119, 122–123
 and institutional skepticism, 76–84, 131
 and masculinity, 260–264, 269
 and monstrosity, 136–139
 and nostalgia, 95, 97
 and Operation: Rebirth, 87, 91
 and origin narratives, 87–92
 and Peggy Carter, 239–241, 247–248
 sexuality of, 276, 351
 and Tony Stark, 40, 45–48, 51, 76–77
 and trauma, 54
 and women, 199, 204–206, 208, 237, 300, 302